The Expanding World of Art, 1874–1902

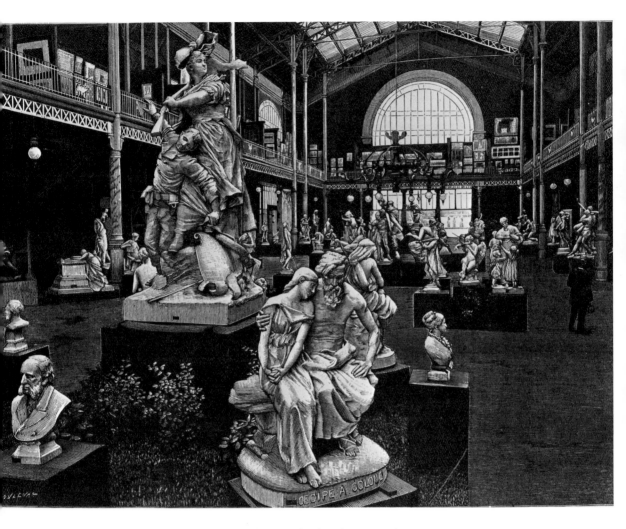

French Sculpture Section in the Grand Palais des Beaux-Arts
(© Arch. Phot. Paris/S. P. A. D. E. M.).

The Expanding World of Art, 1874–1902

VOLUME I

*Universal Expositions and State-Sponsored
Fine Arts Exhibitions*

Selected and edited by

ELIZABETH GILMORE HOLT

YALE UNIVERSITY PRESS
New Haven and London

Designed by James J. Johnson
and set in Sabon types.
Typesetting by The Composing Room of Michigan, Inc.
Printed in the United States of America by
Halliday Lithograph Corporation, West Hanover, MA.

Library of Congress Cataloging-in-Publication Data

Holt, Elizabeth Basye Gilmore.
 The expanding world of art, 1874–1902.

 Includes bibliographies and index.
 Contents: v. 1. Universal expositions and
state-sponsored fine arts exhibitions.
 1. Art, Modern—19th century—Themes, motives.
2. Art and society. 3. Art—Exhibitions. 4. Art
exhibition audiences. I. Title.
N6450.H598 1988 709'.03'4 87–10410
ISBN 0–300–03825–9 (v. 1 : alk. paper)

*The paper in this book meets the guidelines for
permanence and durability of the Committee on
Production Guidelines for Book Longevity of the
Council on Library Resources.*

10 9 8 7 6 5 4 3 2 1

Contents

Preface

In the last quarter of the nineteenth century the altered relationship among the different categories of the arts and their relative importance to European society was evident in the patronage and response each received. The shift in patronage that had begun at the end of the eighteenth century was fully accomplished by the end of the nineteenth. The two volumes of this anthology document the continuing change in the traditional framework of patronage and reflect the position of both the artist and particular art forms in society. All Europe must be taken into account in this period, for each nation contributed to the transformation of European art into the international art forms that emerged in the second decade of the twentieth century. The key to this transformation is found in a study of the universal expositions and state-sponsored fine arts exhibitions held throughout Europe, for they remained the instrument for communication among all categories of the arts and strata of society. What Emile Zola pointed out in 1880 was true for all of Europe: "The Salons [i.e., exhibitions], whether they are organized well or poorly, remain at this point the best way for a painter to become known" (see Part 2: Paris 1880).

During the period covered in these two volumes, 1874 to 1902, it became evident that the structure of the European institutions that had regulated the relationship between public officialdom and the community of artists was no longer effective. New attitudes coalesced to affect the role of the arts and architecture in society, the definition of what constitutes an art object, and the place and responsibility of the artist as creator-genius within Western society. The time span is only twenty-eight years, but the scope of the source material that mirrors the ongoing and shifting relationship among the public, the private or official patrons, and the community of artists (perforce international) is vast.

Volume 1 of *The Expanding World of Art* covers exhibitions of art sponsored and financed by official or semiofficial government bodies: universal ex-

positions (that is, expositions displaying primarily manufactured goods but also assigning a place to the decorative arts and eventually the fine arts); international fine arts exhibitions, in which chiefly paintings, sculpture, drawings, and prints from all nations were displayed; and national fine arts exhibitions, devoted to officially accepted art, mainly of a single nation. Volume 2 will document those exhibitions that were initiated and managed independently of the state: exhibitions of the fine arts and decorative arts arranged by independent groups and societies; exhibitions mounted by art dealers; and exhibitions held by individual artists.

Appreciation and a taste for what was displayed originated in the press. Therefore the sources for both volumes are for the most part drawn from French, American, German, Austrian, Italian, and Spanish periodicals, catalogues, illustrated magazines, and newspapers aimed at the general public, rather than at special-interest groups. The texts selected from this wide spectrum were written by persons of literary or professional significance rather than by staff reporters. In order to foster an international perspective, an attempt has been made to select texts by commentators from outside as well as from within the sponsoring nation.

The texts and illustrations obtained from valuable collections of serials and catalogues in and outside the United States were generously made available to me at the Library of Congress; Harvard University; the University of Chicago; the Kunsthistorisches Institut, Florence; Zentralinstitut für Kunstgeschichte, Munich; Kunsthaus, Zurich; Victoria and Albert Museum, London; Società per le Belle Arti de Esposizione Permanente, Milan; and Museo de Arte Moderno, Barcelona, whose directors, curators, keepers, and librarians assisted me.

This book, no less than those that preceded it, benefited from the counsel and encouragement of the late Ulrich Middeldorf, friend and mentor for fifty years. The late Horst W. Janson enthusiastically approved both the concept and the contents.

Once more, it is my pleasure to express gratitude for unfailing counsel and encouragement to Paola Barocchi, Ruth Butler, Jim H. Chichester, Wolfgang Freitag, Sandra Galigani, Ernst Gombrich, Dora Jane Janson, Bartlett Hayes, Naomi Miller, Agnes Mongan, and Gabriel Weisberg. The collection has benefited from the criticism and suggestions of Robert Alexander, Jane Block, Norma Broude, Petra Chu, Margaret Daly Davis, Mireia Freixa-Serra, Lydia Gandini, Angela Giral, Reinhold Heller, Barbara Lane, Geneviève Lacombre, Marilyn McCully, Anne Roquebert, and many others.

The translations from the French are by Clare Wadleigh Hayes, Elizabeth Holt Muench, Margaret Cross Lippard, and Lucy MacClintock; from the Spanish by Ellenore van Dyck, Angela Giral, and Marilyn McCully; from the German by Margaret Breitenbach, Irene Giron, John B. Holt, and Clotilde Schlayer; from the Italian by Clare Wadleigh Hayes, Paul Kaplan, Clotilde Schlayer, and Richard Wadleigh.

All who use the anthology will be grateful as I am to Margaret Bentley Ševčenko, whose criticism and suggestions kept the intertwining relationship of

exhibitions and sponsors from becoming tangled. I am grateful to Judy Metro, the editor who early expressed interest in the concept; her cooperation and criticism were invaluable to its realization. To receive a Guggenheim Fellowship in recognition of the worthiness of the task was of inestimable assistance.

E. G. H.

Georgetown, Maine
1985

The Expanding World of Art, 1874–1902

Introduction

The universal expositions that were inaugurated by the Great Exhibition of the Works of Industry of All Nations in London in 1851 culminated a development that began when the monks of Saint-Denis were given a charter by the church to hold a fair in 642. By the eighth century fairs flourished all over Europe, as economies grew more complex and communication between consumers and the centers of production became necessary. As meeting places fairs also served to cross-fertilize different cultures and artistic traditions both inside and outside Europe (the Saint-Denis fairs, for example, had admitted Syrian traders). They fostered an international spirit and, free of the protective tariffs inflicted by the numerous petty states into which Europe was then divided, they encouraged a trade in goods and ideas that was to last for centuries.

These local fairs declined with the introduction of better forms of transportation by road, canal, and railroad, which allowed trade to concentrate in a few great centers of production. Between the seventeenth and the mid-nineteenth centuries travel to and trade with even very distant places became increasingly commonplace, and the influence of this exchange on the arts of Europe became more and more evident. By the end of the nineteenth century the great universal expositions brought art and industry of other cultures to Europe and America in such great quantity that European art could no longer be said to have one distinct and identifiable style.

Fifteen major expositions, along with a host of others, were held between 1851 and 1900, and all were designed not to conform with the mundane and familiar, but to suggest a radiance allied with hope for the future. Clusters of ephemeral edifices housed displays of everything from manufactured goods to musical instruments, ornaments, and industrial machinery in operation. The astounding attendance and the corresponding attention focused on the arts may reflect in part a late-nineteenth-century effort to fill the vacuum created by the declining religious impulse of previous centuries. In 1862 six million people vis-

ited the London exposition; in 1867 almost seven million visited Paris to view specimens of Swedish, Turkish, Swiss, Egyptian, and Japanese architecture surrounding the cast-iron exposition building temporarily set up on the Champ-de-Mars; in 1873 another seven million came to Vienna, where the largest iron dome ever constructed cast its shadow over the Prater Woods; in 1878 sixteen million walked along the Rue des Nations of vernacular architecture in Paris; in 1888 two and a half million were exposed to the vitality of Catalonian architecture in Barcelona, with its ceramic and iron decoration; in 1893 twenty-eight million wandered through dazzling displays of light and structural fantasy in Chicago; in 1900 forty-eight million viewed similar sights in Paris during the year that exposition was open; and in 1902 the first international exposition of the applied, or decorative, arts was shown at Turin, a testimony to their significance in the world of art as the new century opened.

The immense universal exposition building, constructed by an engineer like a market hall, railroad station, or department store, played an important role in the last half of the nineteenth century, directing the architect away from the historical styles that had been the basis of teaching in the academies and schools. Its use of the new materials, iron and glass, and the bold construction methods of the engineer helped to free the architect from a dependence on tradition. The exposition building offered new problems for solution. Since it was not to be permanent, rapid construction and ease of demolition became important factors that required the engineer to use prefabricated materials and oversee all phases of design, ordering, and construction, as had the *Baumeister* or the master mason in the thirteenth and fourteenth centuries. The enclosed space was assigned to interior designers to decorate in a way that was detached from a specific locality; its furnishing was to be conceived and designed solely in terms of the designated function of the space.

The London exposition of 1851[1] had excluded painting altogether as an exhibit category because it was not a mechanical product fashioned with industrial tools, but in 1855, at the first universal exposition held in Paris, that reasoning was rejected. Painting and sculpture were admitted, creating an international art exhibition, as distinct from the regularly held French national Salon or fine arts exhibitions held elsewhere. The jury was now international, but the rules and standards of the French Salon already generally observed were retained. The four classes (painting, sculpture, engraving, and architecture) that had constituted the fine arts since the seventeenth century were installed together in the main exhibition building. The other portions of the vast exposition structure allocated to the different classifications were filled with products from the participating countries and arranged in stalls, so that the interior resembled an enormous bazaar.

Biennial and annual exhibitions of the fine arts had long been arranged by academies in European capitals. In 1855, France had forged the link between

1. For this and the other universal expositions held between 1851 and 1873, see Elizabeth Gilmore Holt, *The Art of All Nations: 1850–1873* (New York, 1981).

nationalism and the fine arts. Thereafter, any state striving to take a place in the assembly of nations had first to identify the attributes of its "national style." A second step was to institutionalize its national art with visible symbols: the establishment of a fine arts academy in the nation's capital and an affiliate in Rome. The ultimate step, however, was to play host to an international fine arts exhibition. In these benign international contests, not only could medals be won, but the attendant publicity generated sales for a nation's artists and acclaim for the national school they represented. The success that the fine arts displays achieved, in competition with many other popular attractions of the universal expositions, prompted governments and semiofficial artists' associations to envision the fine arts as a salable commodity on the international market. To encourage such commerce, governments in such long-established art centers as Munich and Venice willingly provided support for international exhibitions, working in close cooperation with their fine arts academies and local artists' societies. An early international art exhibition that attracted wide attention was sponsored by the Bavarian government in 1869 in Munich. By the end of the century, wherever such international exhibitions were held, as in Munich, Vienna, Rome, or Venice, it had become customary to solicit the cooperation of prominent artists (not necessarily those with official affiliations) to serve as honorary sponsors.

While it is true that state-sponsored international fine arts exhibitions fostered conformity to an accepted style in the visual arts insofar as the members of the international jury shared a common academic training, the artists whose work was represented displayed varying degrees of national difference in technique, style, and subject matter. By encompassing in one arena or building the work of artists from Scotland to Russia and Turkey, from Spain to Scandinavia, the international fine arts exhibitions, like the larger universal expositions, became continual sources of cross-fertilization.

Although they attracted millions, neither the fine arts displays within the universal expositions nor the state-sponsored international fine arts exhibitions interfered with the schedule of the national art exhibitions that had been held by the various academies of fine arts for generations. The model for the national academy had been established in 1648, when Charles LeBrun formed the Académie Royale de Peinture et Sculpture by drawing off a select group of painters, sculptors, architects, and engravers from their ancient craft guilds to place them at the service of Louis XIV and his state. When in 1725 a select group was invited to attend an exhibition of this official work, the national fine arts exhibition was born. Other states soon followed suit. The subsequent revolutions in France and other nations did not change the responsibility of the artist in any essential way. His task, to supply the visual vocabulary for glorifying the nation, whether monarchy or republic, continued. In the catalogue written for the Paris Salon of the revolutionary year II (1793), we read: "May the arts speak to us always of the love of country, of humanity, and of virtue." In 1796 this sentiment was reiterated: "Liberty invites you to retrace her triumphs. Pass on to posterity the deeds which do honor to your country. What French artist does not feel the need for celebrat-

ing the grandeur and the strength which the nation has shown, the power with which she has governed events and created her destinies?"[2]

Each state academy exhibition was filled with representations of events from the nation's history and statues of its heroes. But just as the catalogue of the Salon of 1793 had exhorted artists to depict love of humanity as well as of country, so other fine arts exhibitions soon reflected social and not just patriotic concerns. A substantial group of art patrons continued to influence the members of both the official and semiofficial bodies on which the commission and sale of artworks depended, but others, equally influential, eschewed their official connections to encourage greater independence in style and subject matter. The result was that by the 1880s the traditional academy throughout Europe was either split in two, as in France, or was flanked by independents utilizing a private gallery to display their work as in England; in Germany and Austria the nonconformists turned to facilities provided by artists' associations to exhibit their efforts.

Journals and newspapers were yet another vehicle for the popularization and internationalization of the arts. Because the middle class were largely newspaper readers, the critics of the daily press tended to concentrate on works of art that might suitably embellish the bourgeois home rather than on the broader range of art and subject matter covered by the monthly journals. The latter were essential to anyone who wanted to keep abreast of current events in the international world of the fine arts. Europe's most widely read art periodical was the *Gazette des Beaux-Arts*, established in 1859 and directed by Charles Blanc. Blanc, who had once been a graphic artist and, during the Revolution of 1848, had briefly been national director of fine arts in France, had long been interested in the state manufactures and acutely aware of the importance of the decorative arts in the artistic world in which France had long enjoyed supremacy. He had compiled the much-used *Grammaire des arts du dessin* in 1867, *Art dans la parure et dans le vêtement* (1875), and *Grammaire des arts décoratifs* (1881). The prestigious *Art Journal* (1838) played an important role in increasing the interest of the English in both the fine and the "mechanical" arts. In 1851 it was the first fine arts journal to publish an illustrated catalogue of the mechanical arts on view in the Crystal Palace. The *Zeitschrift für bildende Kunst* (1866) with its supplement, the *Kunstchronik*, was the German-language equivalent of the *Gazette des Beaux-Arts*. Founded in 1866 by Carl Lützow, who was also its editor, it was published in Leipzig by E. A. Seemann, head of what had become the largest art publishing firm in Europe. *The Magazine of Art* (1878) provided coverage for the "progressive development of art power and good taste in relation to manufacture" in England, a development that, the magazine noted, was attributed on the continent to England's program of art education and to the establishment of the South Kensington Museum, later renamed the Victoria and Albert. *The Studio*, founded in 1893 by Charles Holme, had established the *International Studio* for worldwide circulation for English-language readers and had become such a dis-

2. Idem, *The Triumph of Art for the Public: 1778–1849* (New York 1980), p. 51.

seminator of information about the "new art" that the style was sometimes referred to as "studio art." *The Studio* discarded distinctions between applied and fine arts and soon became the leading periodical for the "new" or "modern" art on the continent. Another much-read journal was the *Emporium* (1895). The art journals generally assigned the review of national exhibitions to critics officially associated with the fine arts; the less broadly circulated belles-lettres periodicals, such as *Fraser's, Blackwood's, L'Artiste, Le Mercure de France, Grenzbote,* and *Nuovo Antología,* called on writers already recognized in the field of letters or looking forward to literary careers to write for them.

From their first appearance all these magazines also featured essays written by authorities in fields reflecting other interests of the time—archaeological discoveries in the Middle East and Southeast Asia, new attributions of earlier masterpieces, and authoritative analyses of noted contemporary artists and of architecture. Both the *Gazette des Beaux-Arts* and the *Zeitschrift für bildende Kunst* also issued supplements with invaluable lists of current events, sales auctions, notices of exhibitions, and committee meetings.

All this demand for articles about art served to open up employment as art critics for experts on various topics and for young writers unable to find an enthusiastic public for their literary works. Some of the latter turned to writing Salon reviews, publishing them at their own expense and then offering them for sale. Others took up careers as journal or newspaper critics; if they were successful, art criticism could then become an avenue to a successful literary career. The style of art criticism at the time, first invented by Denis Diderot in 1765, was not based on formal aesthetic principles, as literary criticism was, but simply on descriptions of what was seen and what the critic thought of it. Because it was so unconcerned with the technical aspects of painting and sculpture, the shift from writer to critic was not a difficult one to make. All the critic was expected to do was analyze the qualities and characteristics of what he saw and to judge without bias. In practice, of course, he tended to fit the works of art on view into his own particular cultural frame of reference, and what he wrote about a work was apt to be as affected by his own values and interests as it was by those of the artist who had created it. As a result, many reviews of the time were imaginative comments written by aspiring writers who were frequently protégés of already established authors connected in some way to the dailies, the belles-lettres journals, or the avant-garde "little" magazines, and to some sort of artistic coterie.

As the profits of the industrial revolution increased the rolls of the well-to-do middle class throughout the Western world, demand increased for the fine arts both as home decoration and as collector's items that would enhance social prestige. It is not surprising that public interest in the arts at the universal expositions, international fine arts exhibitions, and the regularly scheduled national exhibitions was great. It was indicative of the times as well that a universal exposition held in Turin in 1902 was devoted entirely to the decorative and applied arts displayed as furnishings for domestic architecture—interiors, exteri-

ors, and even the neighborhood street. The exposure to the crafts, ornament, architecture, and art of civilizations and cultures past and present by the many readers of the journals and press and by the millions of visitors to the universal expositions and the numerous exhibitions of the fine and decorative arts prepared the way for an international style that would characterize the art, ornament, and architecture of coming generations.

Universal Expositions:
Architecture and the Decorative Arts

The six major universal expositions that took place in the last quarter of the nineteenth century—in 1878, 1888, 1889, 1893, 1900, and 1902 (total attendance, 143 million)—and the twenty-two minor ones (total attendance, 38 million), as well as their six predecessors, held between 1851 and 1873,[1] were all born from the idea of one determined man. In 1845 Prince Albert of England was newly wed and collecting furnishings for the royal residence that he and Victoria were building at Osborne Hall. At first hand he became aware of the poor quality of domestic goods produced by British industry since it had been freed from the standards of design and craftsmanship required by the guilds. Albert had grown up in a small rural German principality where goods were still produced by the apprentice system, and his "grand tour" to Italy had exposed him only to the products of a guild system that dated from the Middle Ages. He was therefore unprepared for the shoddy goods he encountered in the British market. Barred from any role in political affairs, with determination and ingenuity he set about raising the standards of taste and craftsmanship in that most industrialized of nations.

In his capacity as honorary president of the Society for the Improvement of Arts and Industry, the Prince met and secured the services of Henry Cole, who was to become his astute and tireless partner. Cole had been an employee of the Public Record Office and the post office and had published inexpensive guidebooks to historic sites. In 1845, under the pseudonym Felix Summerly, he had received a medal for his design of a tea service for general use, and that recognition embarked him on another career. He founded Summerly's Art Manufactures, an organization of artists, designers, and manufacturers, to revive "the good old practice of connecting the best art with familiar objects of daily use."[2]

1. See the general introduction to this volume and Elizabeth Gilmore Holt, *The Art of All Nations, 1850–1873* (New York, 1981).
2. Henry Cole, quoted from ibid., p. 54.

To improve the standards of workmanship and design for industrial prod-
ucts, Prince Albert proposed a bold scheme: he would call the nations of the world
together to organize an exposition of their commodities. The program would
include not only displays of their wares but tours for the artisans and conferences
on the social implications of industrialization. Taken together these events would
both further concord among nations and elevate the quality of their manufactured
goods. The result was the Great Exhibition of 1851, and at first it appeared to
have all the beneficial effects Albert had hoped for. Among them were reforms,
instituted by France's chief delegate, Léon de Laborde, in the training of designers;
Laborde also co-founded the Union Centrale des Arts et de l'Industrie and the
Musée des Arts Décoratifs. The activities of the German architect Gottfried Sem-
per stimulated the establishment of the Kunstgewerbe Schule (Applied Arts
School) in Zurich. The movement also gathered momentum with the first of its
successor expositions—1855 in Paris, 1862 in London, 1867 in Paris, and 1873 in
Vienna.

All subsequent expositions followed the general scheme of organization initi-
ated in 1851. For each the government of the host nation assumed organizational
and financial responsibility and through its ministries requested the assistance of
the business community, educators, and voluntary associations; in the case of
France and Austria-Hungary, invitations to other countries to participate in ex-
positions were extended through diplomatic channels. In some cases—the Cente-
nary Exposition of Australia in 1888 and the international exposition in Bar-
celona, for example—governments sent official representation that was formally
received; in others there was no official representation between governments at
all. In 1883, the Netherlands administered an exposition in Amsterdam in which
it simply charged a fee to any participating country based upon the amount of
space it occupied.

The official display classifications established in 1851 (raw materials, ma-
chinery and mechanical inventions, manufactures, sculpture and plastic art) had
continually to be adjusted and expanded to provide a rational way of including
contemporary products and other categories not accommodated in the original
scheme. Among these were the fine arts. Painting had been excluded from the
original classification list of the first two English expositions because, unlike
sculpture, it was not a commodity produced by mechanical means or subject to
technological improvement. An independent exhibition of art was held elsewhere
in London at the same time, but the few paintings shown at the exposition itself
were hung solely to display the artist's prowess as a "preparer of colours."[3] The
French had added both painting and sculpture in 1855, but had placed them in a
building apart from the rest of the exposition. They used the classification system
followed in the Paris Salons, but the objects sent were juried by the countries
sending them and displayed by nation rather than by classification. In 1867
paintings were displayed in the exposition's principal building, but in confor-

3. Ibid., p. 56.

mance with the exposition's theme, they were restricted to works made between 1855 and 1867. "Inventions," i.e., new techniques in graphic art and printing, were admissible in technical displays because they indicated progress, but innovations in the techniques of painting and sculpture did not.

Participation in the international exhibitions was encouraged both through direct subsidies and by appealing to national pride. In a period of unbridled nationalism, expositions gave the host country a particular opportunity to enhance its national image. With the exception of the exposition of 1889 in Paris which, because it was a national celebration, was paid for entirely by France, a country that agreed to participate had to accept full financial responsibility for its representation. It also had to agree to the stipulations of the exposition plan, which usually included a theme proposed by the host country.

By the final quarter of the nineteenth century international expositions had become the place where products of industrial art, the fine arts, and displays reflecting social programs could be assembled, judged, and awarded prizes by an international jury, in recognition of a nation's achievement. While some remnant of the underlying purpose for holding an exposition—to further a friendly exchange of ideas and technologies that would improve the standards of commercial goods and thereby the standard of living—remained, the emphasis had undeniably shifted from social betterment and international concord to fierce competition for markets. By the 1870s protective tariffs sheltered national markets from each other, and at the same time each industrial nation was vying for new markets as they emerged in other parts of the world. Manufacturers were therefore eager for opportunities to present their wares to potential buyers, and expositions offered them.

Because among the raisons d'être for the expositions were improvements in the design and quality of consumer goods and the living conditions of industrial workers, who were both consumers and worker-producers, assembly rooms and auditoriums were provided in the exposition buildings for international conferences on social problems (an early meeting of what became in 1864 the International Workingmen's Association, or First International, for example, was held at the 1855 Paris exposition), as well as for artistic and educational events such as concerts and lectures. The ideas discussed there were inherited from the eighteenth-century humanists, who in turn found their inspiration in the Renaissance writings of Alberti, Rabelais, and Erasmus. Their first practical application was the royal salt works at Chaux (1775–80), built by the French architect Claude Nicolas Ledoux. The city in its entirety is known through his visionary designs, where living and working quarters were both planned to accommodate every possible requirement of the worker, including recreational facilities and specially designed work dress.

The ideas of reforming society and bettering the lot of the working man through proper design were implicit in the first London exposition and in the expositions of 1855 and 1862, but were not really spelled out until the 1867 Paris exposition, whose theme was announced as the "History of Labor." The rules for

participating required that the theme be illustrated in each country's display by showing the phases through which its economy had passed before attaining its current level of development—a requirement that obviously presented difficulties for those countries that could show no appreciable industrialization. Similarly, in 1878 in Paris the theme required that each exhibition demonstrate "progress" by comparing the modern with the old, a theme that allowed emphasis to shift almost entirely to the present.

In 1872 the Society for the Improvement of Arts and Industry, the same organization that had lent support to Prince Albert's original exposition, concluded that the international expositions were no longer performing the function—improvement of design and quality of manufactured goods—for which they were intended, and suggested that the aim might better be served by staging small exhibitions limited to specific products. The British government continued its participation in international expositions, but the movement both in England and on the continent split off into various reform movements that involved, among other things, not simply improving the quality of consumer goods but bettering the dwellings of people through a more rational use of interior space.

The European social reformers—the Frenchmen François Fourier and Claude de Saint-Simon; the Englishmen Robert Owen and William Morris; and the Germans Friedrich Engels and Karl Marx (who settled permanently in London in 1850), who also wished to improve the quality of life of the masses in a rapidly industrializing world, all left their mark on this movement and through it on art and design. They felt that it was society's responsibility to create an environment in which the results of labor accrued to the laborers as well as to the middle class, ending in a better standard of living for both. To that purpose public housing should be planned, its interior space rationally arranged, and suitable furnishings and objects for daily use designed and manufactured. Educational programs were set up to improve the design and quality of consumer products for this expanding market. The movement also drew upon the ideas of the American Andrew Jackson Downing, whose *Cottage Residences* (1842) enjoyed great popularity, and from *The Homes of the United States* (published in Sweden in 1849). In his introduction to the latter, Downing emphasized the advantages of "an ingeniously arranged and nicely adapted plan over one carelessly and ill-contrived." Downing wished everyone would "become aware that those superior forms, and the higher and more refined enjoyment derived from them, may be had at the same cost and with the same labor as a clumsy dwelling and its uncouth and ill-designed accessories."

William Morris was the acknowledged leader of the movement in England. He believed, as had his teacher John Ruskin, that social problems could be solved through the application of the arts to daily life. His aim was to regain for the artisan-craftsman the position both as designer and producer of household furnishings that he had held before being replaced by the machine. To this end, in April 1861 Morris formed a firm, with the painters Dante Gabriel Rossetti, Edward Burne-Jones, Ford Madox Brown, the architect Philip Webb, and the

engineer Charles Faulkner as partners. Its mission was to create utilitarian objects that would illuminate the life of creator and consumer alike.

Morris and Company first showed its wares to consumers at the 1862 exposition. They were arranged in two stalls as if in rooms of a dwelling, following the example of the architect A. W. Pugin, who in the Crystal Palace in 1851 came upon the idea of converting his allotment of space into a self-contained entity—in his case a medieval court appropriate for the display of liturgical objects. It was a display technique that was to reach its apex in the "new art" decors designed around 1900, but even in these earlier exhibits architects were given the opportunity to become architect-decorators and interior designers for planning and installing rooms in which manufacturers of accessories and furnishings could display their wares. In addition to Morris's partner Webb, C. F. A. Voysey, W. B. Lethaby, Richard Norman, Henry Shaw, Henry van de Velde, and Lorenz Gedon were among those who made names for themselves as interior designers at the international exhibitions.

In its search for the useful that would also be beautiful, Morris and Company did much to turn taste for interior furnishings to non-derivative styles appropriate for the new middle-class consumer. That change in taste was further stimulated by displays of contemporary wares produced outside Europe's core of industrialized nations, especially in the Middle and Far East. Morris's lectures, such as "The Lesser Arts" (1877), on behalf of the crafts movement had immense influence both in England and on the continent in bringing together the artisan and the designer and in arousing an awareness of the role decorative arts could play in the improvement of domestic design. Although the items produced by Morris's firm and others were too refined and expensive for the ordinary consumer, not to mention the working class, they influenced manufacturers and their designers, and their work was displayed in expositions for millions to see and compare with the products available to them. Visitors later learned from the press the names of the decorative-arts manufacturers who had won gold medals, and the manufacturer could use the award to promote the sale of his product.

The universal expositions also had a major influence on architecture. Exposition buildings presented special problems, but they were at first regarded as constituting an engineering, not an architectural, challenge: to invent a temporary structure in a new form, free from conventions and precedent, whose only prerequisite was that it cover, enclose, and illuminate as much space as possible in a way that would allow for a partitioning of the interior after construction. The Great Exhibition of 1851 launched the engineer into a new role as architect when Joseph Paxton, who had first employed his skills as a gardener and engineer to build an immense greenhouse of glass and cast iron in 1836–40, was chosen to design the Crystal Palace, that vast structure of glass and iron in Hyde Park that was to shelter the industrial products. His building, with all its many architectural innovations, not only proved that the engineer could be a designer and architect, but also ensured that the buildings devised for all subsequent expositions would be

taken seriously by the critics and discussed in terms of their relation and application to conventional architecture.

In the next few expositions it was again the engineer, with his growing expertise in spanning river chasms and providing shelter for railway travelers, who was called upon to build the immense halls needed for modern industrial displays. These men were trained at polytechnical schools rather than at fine arts academies whose curricula had been fixed since the seventeenth century.[4] As engineers they were responsible for highways and bridges and had to keep abreast of developments in metallurgy and improvements in cast iron and steel for struts and girders. When Napoleon established the Ecole Polytechnique in 1795, an army engineer, J. N. Durand, was named a professor of architecture. His ideas of structural rationalism and his concern for construction, materials, and methods were widely influential. His synthesis of the trends in theory and practice in France, *Précis des leçons d'architecture données à l'Ecole Polytechnique,* was first published in 1802–05 and frequently reissued. Its message was that utilitarian, functional, and logical architecture was required to satisfy contemporary society's needs.

Beginning with the Paris exposition of 1878, the engineers were once more displaced by the architects—but this time by architects who had had training from engineers—when an architect and a follower of Durand, Eugène Emmanuel Viollet-le-Duc, was named co-director of the exposition and became occupied with its general scheme from its inception. Through his influence and his writings in *Entretiens sur l'architecture* (1858–72) and elsewhere, he had adapted the engineer's materials and techniques to architecture, and in particular made the frank use of metal in architecture acceptable to the public taste.

The same Paris exposition also had a profound influence on the development of architecture in another of its innovations. In the center of the main building, the Palais du Champ-de-Mars, designed and constructed by the noted engineers Krantz, Dion, and Eiffel, was the Rue des Nations, a row of facades, each of which was designed in what the exposition committee had requested to be a "national" architectural style. While this requirement provided a lesson in comparative architecture for the public, it had raised troublesome questions for the architects: What indeed was a national style? What style of architecture should a recently constituted country have? Could anything new in architecture evolve if its inspiration came solely from the traditions of its past?

The expositions of 1889, 1893, and 1900 were concerned with resolving both questions—what constituted national architecture, and what constituted the proper roles of architect and engineer. All of them included a Rue des Nations, a row of pavilions or buildings sponsored by countries in an area adjacent to the

4. In France the Académie Royale d'Architecture was founded in 1671 and joined to the Académie Royale de Peinture et de Sculpture, which had been established in 1648. It was abolished in 1793 and reconstituted early in the nineteenth century as the Ecole des Beaux-Arts. In England, architects were trained, after an apprenticeship, at the Royal Academy of Arts, whose establishment was authorized by George III in 1768.

principal building, whose presence stimulated the search for, or definition of, what constituted a national style. The Catalan architect Lluís Doménech y Montaner, for example, tried to capture and define the essence of his native architecture through its history and from there proceed to a new one in line with the current theory that a new architecture could only evolve from the old. The United States, on the other hand, could not have followed that prescription to develop its national architectural form because of the brevity of its past, and so its national style could only be a newly devised one. For that it could—and did—use whatever architectural elements served the task at hand. The architects of the 1893 Chicago exposition, for example, chose a style designated "Greek-Roman" to provide uniformity to the cluster of buildings that housed the majority of the exhibitions. For other buildings, styles were adapted to suggest the class of objects exhibited within. For only one, Transportation, was the style of the exterior original. In the park surrounding the principal buildings, the customary foreign pavilions were placed alongside a new addition, the houses of the states, each built in a style and with an interior plan and furnishings that were regarded as characteristic of that state, but were in fact often reminiscent of the style native to the country from which the majority of the state's immigrating settlers had come.

To mark the close of the nineteenth century, the French government invited the countries of the world to join in a centennial exposition that would demonstrate the century's progress in all areas. The Ministry of Commerce and Industry was made responsible for its plan and organization, as it had been for the 1878 and 1889 expositions. The government, having come to regard international expositions as essential in maintaining France as a center of invention and the arbiter of taste and fashion in consumer goods, decided to make two of the exposition buildings for the 1889 exposition permanent and held a competition for them. Architects, trained at the Ecole des Beaux-Arts and schooled in bureaucratic methods of state commissions, were also entrusted once more with staging the huge, complicated exposition itself. Again the engineers kept to their secondary role, supplying the bridges and the skeleton iron or wood constructions that were then swathed in the decorative, sometimes innovative, design wrappings of a type called "staff," a method and material that had created the ephemeral white cities of the universal expositions since 1878. The total architectural effect was eclectic, reflecting the style practiced by and taught at the Ecole des Beaux-Arts. Architectural innovation played no role at all in the official architecture; it was to be found only in the restaurants, theaters, and cafes erected by commercial enterprises in the exhibition park.

Within the vast exposition buildings, nations and individual manufacturers assumed their usual responsibility for planning and filling their allotted space. None did so as effectively as the Japanese, since the notions that each room should serve a specific function and that each object was important in itself and should enhance the space in which it stood had long been part of their tradition. The responsibility for decorating these rooms was again that of the architect-designers, who determined both the design of the interior and the furnishings for it,

which were then made by the artists and craftsmen who worked with them so that the furnishings would be functionally related to the use of the room.

The ideas represented in these rooms and originally inspired by Ruskin and Morris's wish to bring together artisan and designer had combined into a movement variously called Art Nouveau, Jugendstil, "modern art," and "studio art," which reached its apogee in the first universal exposition that was devoted entirely to the decorative arts, held in Turin in 1902. Complete living environments were provided there that were supposed to inspire the manufacture of harmonious interiors for a mass market, though in fact they rarely reached below the taste or the purse of the well-to-do patron and connoisseur. In the last five years of the century, however, the German architect Herman Muthesius, a strong advocate of Morris's concepts, was influential in having them adopted by some manufacturers and thus to secure a matter-of-fact reasonableness (*Sachlichkeit*) in the modern movement that led to products intended for the average consumer. At least in the German-speaking regions, then, the broad social purpose of Morris's cause was furthered, for gradually both the design and the quality of objects within the price range of the worker-consumer were improved.

The universal expositions of the last quarter of the nineteenth century effected profound changes both in the taste of millions of visitors and in their attitude toward useful objects, living spaces, and their way of life. When national governments no longer sponsored the visits of their artisans to these industrial and decorative art displays, voluntary associations and trade unions assumed some of that responsibility. The ephemeral cities of the universal expositions generated worldwide and ever-expanding markets for every sort of art and at the same time allowed the viewing of goods from all over the world whose styles and materials could then be synthesized into still other new designs and products. The styles and forms they produced appealed to a wide range of consumers eager to acquire even a very small segment of what was contemporary "taste." Since, of the more than twenty categories on display at the 1900 exposition, only one represented the traditional fine arts, it was clear that the applied or "industrial" arts had been accepted as a suitable vehicle for tasteful aesthetic expression.

As the universal exposition established itself as a recurring event in a major city, it became customary to plan for at least one permanent structure in it. The architect joined the interior designer and the engineer to collaborate on what would become a permanent exhibition building (derived in plan from the museum which in turn it would later influence). This main building was then situated in a park surrounded by numerous temporary small buildings of mostly unrelated design, either the exact replicas of exhibitors' national buildings that constituted the Rue des Nations or the more freely designed structures used as exhibition spaces, restaurants, cafes, and theaters. Because most of these buildings were temporary, each exposition also offered some room for experimenting with materials and designs. The combination soon led the public to expect that all exposition grounds would look like fanciful cities complete with urban and park plan-

ning, and this too had its effects on urban buildings and plans. The recollection of the visual effects of these exposition cities staged in the last quarter of the nineteenth century, representing as they did a synthesis of the contributions of the engineer, the interior decorator, and the architect, were significant in shaping architectural forms for the twentieth century.

1878: Paris

In 1876 Jules Simon, then the premier of France's Third Republic, approved a proposal to hold a universal exposition, which was to demonstrate the nation's recovery from the humiliating defeat by the Prussians in 1870–71 and the resumption of its important place in the concert of nations. It was to be held on the Champ-de-Mars, the area between the Ecole Militaire and the Seine (plans 1, 2), also the site of the popular and successful exposition of 1867. The theme of that exposition had been technological progress by labor in concert with commerce and capital; the new one would display man's achievements in education, invention, and science. France's defeat by a Prussian army said to be superior in technology had strengthened a conviction among the French that world leadership depended on developing the best schools and scientific institutes. Expositions such as this one would educate the public and provide an opportunity for an open exchange of ideas between workers and savants.

An international competition was held for the design of a building that would house conferences, concerts, and exhibitions. The winners were Hector Martin Lefuel and Eugène Emmanuel Viollet-le-Duc, the architect who had been influential in shaping the exposition's overall plan. Jules Bourdais and Gabriel Davioud collaborated with them on the design and were responsible for the construction of the palace of art, to be called the Trocadéro after the fort in Cadiz which French forces had captured in 1823 when they went to the aid of the threatened Spanish monarchy.

The winning design for the Trocadéro was an immense building of cream-colored stone, with a 5,000-seat auditorium, surmounted by an iron dome and flanked by two minarets (fig. 1). A gallery with thirty statues representing the arts, sciences, and various industries encircled the dome's spring line. The building's surface was enlivened by bands of red stone and polychromatic decoration in tile and mosaic. A gallery extended in a semicircle from each side, giving the edifice a crescent shape. The galleries—"the noble part"—housed art assembled from museums and private collections as well as a sculpture gallery where originals and casts were arranged to educate visitors in the differences in treatment of the same subject in various epochs, a method adopted from scientific research. The building was, in the view of the *Fraser*'s correspondent,

surely one of the gayest, naivest, most amusing feats in architecture ever achieved. The lightness of its Byzantine dome and minarets and wide-reaching open galleries; the cheerfulness of its red walls, relieved with creamy white; the fairy-like grace and playfulness of all, are unique, perhaps desirably so. The architecture of the Trocadéro is not a style to imitate; yet, perched on its lofty height, this airy palace overlooking Paris, which looks as if a breath of wind would blow it away, commends itself and appears to be in its right place.[1]

The Trocadéro and its park (see figs. 2 and 10) were connected by the Pont d'Iéna to the Palais de l'Industrie (built in 1855). It was an immense building set in an area where "Chinese pagodas, Swiss chalets, Japanese villages, Turkish kiosks, with an infinite variety of pavilions—so called—light, gaily decorated structures of every imaginable shape and design, all fluttering with flags, and interspersed with flower gardens, fountains, parterres, slopes, statues, make up a charming and richly colored picture."[2] For the Palais, the commissioner-general of the exposition, Jean B. Krantz, who had devised an extraordinary elliptical building for the 1867 exposition, chose a rectangular form which made it easier to assign space to the nine principal groups of exhibits (fig. 3).[3] The building was formed of four vaulted galleries and supported by a series of iron pillars sixty feet high, which divided it into a grid plan. As in 1867, Krantz was assisted by the architect Leopold Hardy and the engineers Henri de Dion, responsible for the metal construction, and Gustave Eiffel, assigned the facades (fig. 4). Their experience in constructing railroad bridges, stations, and viaducts enabled them to increase the spans and lightness of the roof with a system of construction similar to that of a ship's hull. The strength of the transverse arches made buttresses unnecessary.

The American architect A. D. F. Hamlin wrote that "the most notable feature of the Fair was to my mind the superbly simple interior of the Machinery Hall, almost without walls, but with a noble roof of steel and glass spanning at a leap the whole width of 357 feet, its moderate height making the vastness of the hall all the more impressive."[4] This *galerie des machines*, the creation of Dion and Hardy, was inside the Palais du Champ-de-Mars. In enclosing the central hall they gave form to principles of architecture that Viollet-le-Duc had derived from his study of Gothic architecture and published in his ten-volume *Dictionnaire raisonné de l'architecture française du XIᵉ au XVIᵉ siècle* (1854–69). Viollet-le-Duc's influence was equally evident in the fillings of colored encaustic majolica tiles in stylized patterns used to relieve the starkness of the metal framework. This embellishment, while not strictly architectural in concept, supplied the unity of orna-

1. M. B. E., "Social Aspects of the Paris Exhibition," *Fraser's,* August 1878, pp. 209–10.
2. Ibid., p. 210.
3. The classifications for this exposition were as follows: (1) fine arts, (2) education, (3) furniture, (4) textiles and accessories, (5) raw and manufactured products, (6) tools and processes of mechanical industries, (7) alimentary products, (8) agriculture and pisciculture, (9) horticulture.
4. A. D. F. Hamlin, "Modern French Architecture," *Architectural Record,* 1900, p. 177.

ment he admired in Islamic architecture, and corresponded to practices he had called attention to in his introduction to Jules Bourgoin's *Les Arts arabes* (1873). Elsewhere he had written:

> One could already verify at the last exposition of the industrial arts [1873] that Oriental influences had contributed a great step forward in our French industry. The manufacture of decorative faience, among other things, had found its true path, and, a good sign, the artists who choose to practice this branch of the industry do not confine themselves to imitating, to pastiches; taking as their point of departure the observation and the study of Oriental objects, they are seeking their own route, and they are right to do so.[5]

For the exposition's *entrée d'honneur*, the facade facing the Seine, Eiffel adapted in glass and metal an innovation he had first employed in 1876 in the construction of the Bon Marché, the world's first department store. The facade had two corner domes, a central domed pavilion, and a projecting glass canopy (*marquis vitrée*) that ran the length of the glass wall to conceal the vertical support elements.[6] In this design Eiffel broke with a tradition that required load and support to have an apparent relationship and introduced an aesthetic innovation. Sculpture, still regarded as an essential decorative adjunct to architecture, was used throughout to accent structural supports. Staff, the new light, tough, inexpensive, stuccolike material manufactured by combining hemp with plaster, was used to cover the skeleton frames of temporary buildings.[7] Condensation, always a problem in an immense glass-enclosed space of still air, was avoided by Krantz's bold decision to elevate the entire building and install great fans and air ducts under the floor to ensure circulation.

The huge enclosed area was divided into sections, each to be allocated to one of the nine official categories of the arts, industry, and the industrial arts. The horizontal space was sectioned off, and the vertical space was divided at various heights by galleries connected by *passerelles*, or iron bridges, which permitted vertical as well as horizontal movement. France reserved the left area of the building for itself and assigned the right to the foreign exhibitors. The French side was divided into seven aisles that ran the length of the building; the rest was divided crosswise to accommodate the participating countries. The two immense machinery halls on either side enclosed the central core.

To provide variety along the aisles, elaborate mobile structures called *trophies* were often placed at intervals to display articles by a manufacturer or a country. The spaces on either side of the aisles were made into courts by the individual exhibitors. The floor plan was arranged to allow for an uninterrupted flow of visitors, who were expected to number as many as 200,000 in a single day.

5. Léon Parvillée and E. Duthoit, *Architecture et décoration turques au XVᶜ siècle* (Paris, 1874), preface.

6. See the description of the tower on pp. 76–77.

7. A French modeler, Desachy, had in 1856 patented a similar product which could be molded and painted.

The main entrance on the Seine opened directly into the central aisle, which then led to the sculpture galleries and continued into the painting galleries (fig. 5). As in 1867, the fine arts were not relegated to a separate building; they were displayed between the main entrance and the City of Paris pavilion (fig. 6) which was the heart of the exposition. The pavilion's design, credited to Joseph Bouvard, was built of iron and represented another of Viollet-le Duc's theories—the need to synthesize industrial techniques and decorative architecture.

In group 1, the fine arts, France was represented by a total of 2,071 objects— 861 oils, 204 watercolors, 389 sculptures and medals, 388 architectural designs, and 229 engravings and lithographs. At the other end of the scale, Sweden was represented by 102 entries. The standards for the fine arts in inventiveness, subject treatment, and technical proficiency, which the international corps of jurors and critics had to follow, were still those set by the French Academy and upheld throughout Europe since the eighteenth century. As the critic E. F. S. Pattison noted,

> Of schools indeed, there are but two—the French and the English. In this enormous crowd the little group of English arts alone show a character and quality of sentiment wholly distinct from the French school. All other nations are not only deeply imbued with traditions of old derived from France but are linked to her at present by closely approximating tendencies and aims. . . . The French school is, in fact, *the* School of the Continent.[8]

From the City of Paris pavilion the visitor proceeded to the most significant innovation, the Rue des Nations, a "broad, cheerful promenade flanked on either side by houses of every variety of national architecture from the solid Elizabethan mansion to the airy pinnacles of the cottages of Japan. The ensemble is very picturesque and pretty, a jumble of styles and materials worthy of the great Fancyfair."[9] Its facades provided visitors both with replicas of what might be seen on a world tour and with an opportunity to compare architectural styles, which furthered the already prevalent style of eclecticism (figs. 7–9). Architects the world over yearned for a new architecture that would satisfy the requirements of nineteenth-century society and at the same time their own national culture, but the instruction they received had convinced them that an architectural style could only emerge through the same evolutionary process that had seen Roman architecture emerge from the Greek and Renaissance architecture from a combination of both.

Through the respective facades one entered the national displays for group 2, furniture, and group 4, textiles. The objects in each category were exhibited by manufacturer; the artist or designer was rarely named. Because at this time prizes were awarded only to the manufacturer, each one sought to display his goods as advantageously as possible in the immense space, either by grouping them as in a

8. E. F. S. Pattison, in *The Academy*, June 1, 1878, p. 459.
9. *Blackwood's*, October 1878, p. 464.

bazaar on a covered stand or by showing them in a specially designed court or room. Minton's china works had had its room designed by Richard Norman Shaw, a founder and active participant in the arts-and-crafts movement. The designer Henry Scott placed the pieces from England's foremost manufacturers in the Prince of Wales's pavilion in one such court (figs. 11–12). Especially in the English furniture exhibits (fig. 14), the drift away from the conventional traditional forms to ones more suited to the requirements and living quarters of the contemporary consumer was evident.

Wide interest in the industrial art competitions required reviewers not only to assess the entries of their countrymen but to comment on their strength relative to the entries from other nations and to offer explanations for the discrepancies. The longest reports appeared in the industrialized countries, where the applied or mechanical arts were highly developed, and manufacturing firms had acquired the services of outstanding designer-artisans. The prestigious *Art Journal,* which played an important role in increasing the interest of the English in contemporary art, played an equally significant part in directing attention to the mechanical arts. In its review of the 1878 exposition it noted that overall there had been "enormous progress in other countries, though Paris still remained a center of artistic industry as well as of Art, and if her supremacy be not so commanding as it was, that is not because her ingenious artists and art workmen have lost any of their cunning, bur arises from the fact that the Art of other countries has reached more nearly than it has for a long time past the level of her own."[10]

The *Magazine of Art,* founded that very year to provide coverage for the "progressive development of art power and good taste in relation to manufacture" in England, agreed that France "holds her own but chiefly in the old lines of thought and practice." For the *Gazette des Beaux-Arts* Charles Blanc asked authorities on various industries to report: Léon Falize, fils, a noted goldsmith, reviewed the jewelry and bronze entries, remarking that while French jewelers were still superior, they were being challenged by the Italian Castellani and the American Tiffany, and the French firm of Christofle had been equaled in importance by the English firm of Elkington. Marius Vachon reported on furniture; A. R. de Liesville reviewed ceramics, noting the extensive use of faience in architectural decoration, a result of the Gothic Revival, and the high point it had reached at the hands of Paul Sedille, who decorated a portal to the fine arts galleries in the fifteenth-century Italian manner.

Carl Lützow assigned the review of the exposition for the *Zeitschrift für bildende Kunst* to twenty-seven-year-old Adolf Rosenberg, who was just beginning the career that would make him an influential art historian. The recently constituted German Empire had officially declined the French invitation to participate in the exposition, but unofficially sent a few paintings at the last moment.

Of the non-European exhibitors, Japan received the most attention from the press. In all classifications its participation was more extensive than it had been in

10. *Art Journal,* 1878, p. 197.

Vienna in 1873. A small farmhouse in which ceremonial tea was served stood in the park; a facade gateway, striking in its simplicity, had been erected in the Rue des Nations. Although at least one Japanese visitor to the exposition, a man named Wakai Kenzaburo, had found that the items Japan had sent were "beyond French understanding and not really things they wanted or even needed,"[11] apparently few agreed. *L'Art,* a splendidly illustrated periodical with a close association to England (its articles were usually summarized in *The Academy*), published quite a different judgment in a review by Philippe Burty.

Trained as a decorative designer at the Gobelins tapestry manufactory, Burty had been selected as book and print critic by Charles Blanc when the *Gazette des Beaux-Arts* was first founded. Attracted to Japanese art since it had been made available to Europeans in the 1860s, he became a collector and connoisseur of Japanese objets d'art, and it was he who coined the word *japonisme* in 1871 to designate European art that reflected Japanese influence. His enthusiastic and instructive reviews appeared in many French periodicals and furthered an appreciation not only for Japanese art, but for the work of those Western painters whose interpretation of nature was influenced by it.

Ever since Japanese objects had been introduced at the 1862 London exposition, European manufacturers had been trying to duplicate their glazes and lacquers and to compete with them for public favor at expositions. In 1878 the manufacturer William Watt displayed suites of Anglo-Japanese furniture (fig. 13) that attracted the attention, if not the approval, of the *Magazine of Art's* critic, who described it as

> the quaintest we have hitherto described. It is designed by Mr. Edward W. Godwin, the Bristol architect, and the painting is due to Mr. Whistler. The endeavor has been to attract attention by the use of various shades of yellow, though the accomplished artist [Whistler] consulted by Mr. Watt would hardly venture to call this group a "symphony in yellow." The background is primrose yellow and the carpet is a shade of yellow ochre. The furniture is of bright mahogany of light grain, and the seats and couch are covered with a pale citron yellow. The background is the side of a room with a dado, against which is a fireplace and mantlepiece. The fireplace being of polished brass, a considerable amount of brasswork is introduced into the furniture, which is of the Japanese type affected by Mr. Godwin. Mr. Whistler has painted a kind of scale ornament, intended possibly for clouds, on the wall and the mantlepiece. For its startling mode of attracting the attention of the visitor, the work of Mr. Watt is unrivalled. We cannot say that we should care to be surrounded in our homes by this 'agony' in yellow.[12]

The closing ceremony of the exposition, which had been visited by sixteen million people since opening on May 1, took place on October 28. Twenty-two

11. Mary Louis O'Brien, Martin Foulds, and Howard A. Link, *The Art of Shibata Zeshin: The Mr. and Mrs. James E. O'Brien Collection at the Honolulu Academy of Arts* (Honolulu, 1979), p. 75.
12. *Magazine of Art,* 1878, p. 116.

thousand people assembled in the festively decorated Palais de l'Industrie to witness the distribution of prizes in this peaceful contest among nations.

Seated on a dais were Marshal President Maurice MacMahon; the princes of Wales, Denmark, Sweden, and Norway, the duke of Aosta; and the diplomatic corps in gold-trimmed uniforms, except for the Chinese and Japanese, who were garbed in their own ceremonial robes. Orchestras, bands, and twenty-three choral societies were installed at the opposite end of the building. The recipients of the highest awards, the *grand diplôme d'honneur,* the *grand prix,* and the gold medal, with the jurors, had been assembled in a side gallery. From there the groups, preceded by an allegorical banner, hussars of the ministries in dress uniform, and a military unit of a foreign country, advanced in a cortege of nations up the nave to the officials' stand, to the accompaniment of Handel's "Chansons Victoire." The president of each group received from the Minister of Agriculture and Commerce a list of the awards given to the exhibitors in his group. The group then took seats beside the French and foreign winners who had ready received a gold medal or *prix d'honneur.* With the playing of Gounod's "Soldiers' Chorus" from Faust, the exposition that had reasserted France's position in the international community was declared officially closed.

One of the buildings erected for the 1878 exposition, the Trocadéro, remained standing until 1935. The Palais du Champ-de-Mars would be torn down and replaced by the audacious Galerie des Machines designed by the architect Charles Dutert and erected by the engineer Victor Contamin for the centennial exposition in 1889. With it, construction once again became its own expression, its own "style."

The Palais du Trocadéro
EUGÈNE VIOLLET-LE-DUC

I leave aside any question of style; each may approve or disapprove certain details according to his taste. That which I wish to bring out in this survey is the judicious employment of materials according to their destination and their properties, the spirit that has guided the builders, the sincerity of the means adopted. This constitutes progress, and a very evident progress over the latest buildings erected by our architects, buildings in which this quality, sincerity, is so rare. Add that M. Davioud and M. Bourdais have not departed from these principles, which are common to all the great epochs of art, whatever the forms used, and which are the first conditions of style.

It is said that we have no architecture of the nineteenth century; one has architecture only if one submits to those varied principles of structure, such as the needs which prompt them and the materials used. One does not discover a form of architecture; it imposes itself, it is a logical deduction, and it has always been so as

long as humanity has possessed the arts. If needs are modified, if materials change, the appearances that affect architecture—art in a word—are modified, and under pain of making only pastiches, the architect must find those forms that are deduced from the new elements put at his disposal, and he must submit to the conditions that they impose. We must consider the ancient arts, not at their decline but at the moment when, faithful to the principles without which they would not exist, one sees them attaining their apogee.

Take Egyptian architecture before its decadence under the Ptolemies; Assyrian architecture of the monuments of Nineveh; Greek architecture of the Ionians or the Dorians, during the period of progress of each of these peoples; Roman architecture at the moment when the force of the imperial organization affirmed itself; our French architecture, when it detaches itself from the monastic traditions and flowers freely. We see that these expressions of the same art differ in their form as well as in their constituent parts.

We could thus have a nineteenth-century architecture the day we decide to be men of our time and employ the new elements that modern industry furnishes, satisfying the needs of the nineteenth century, leaving behind those traditions precious from the point of view of study, but which cannot bend to the exigencies of our epoch. There is nothing better than to examine how others have found a form adapted to the practices and customs of the time, to the materials used, and to the manner of employing them according to the available resources. . . . not in order to reproduce these forms, because the conditions are different, nor in order to redo what others have done, but to proceed as they proceeded and thus arrive at different results because the elements differ. Let us have no illusions after all: classicism has led us astray. Classicism showed us an antiquity of convention and said to us, "Here is art arrived at its maturity; to digress from this expression by going backwards is to fall into infancy; to follow this expression in its [later] modifications is to be an accomplice to decadence." This manner of creating hierarchies, not established on an art issuing from our own foundations, but rather on a form that is two thousand years old and belongs to civilizations absolutely foreign to ours, is certainly one of the strangest fantasies of the human spirit, the like of which, I believe, one would not find anywhere else in history.

This fantasy has for a long time governed, and still governs, the domain of architecture. But as fashion has with us a certain sway, we became tired of these Greek and Roman pastiches, and we set to imitating later imitations of antique art, from the Renaissance to the age of Louis XVI! On this subject aesthetics has polished for us its best periods. It would have been better simply to say to us: "The art of architecture consists, above all, in the search for forms that are the most exactly adapted to the needs, materials, and methods of employing them, and those buildings that merit a place in the history of civilizations are those that do not stray from these principles established by peoples in whom genius is allied with common sense."

But the aesthetics of our time delights in nebulousness, and will never call a spade a spade, because then all would be said in one or two lessons; it must have

some developments which will charm the listener all the better if his mind is drawn away from its aim.

Translated from Eugène Viollet-le-Duc, "Les Bâtiments de l'Exposition Universelle de 1878: Le Palais du Trocadéro," *L'Art* 14 (1878):195–98.

The Palais du Champ-de-Mars
EUGÈNE VIOLLET-LE-DUC

Many people are ignorant of the difficulties that a large construction presents whose entire skeleton is joined with iron. This metal expands appreciably with heat; and this means that when the expanse of the structure is considerable the action of this dilation is so great that the stability of the construction is compromised unless many precautions are taken. Thus the elliptical building of the exposition of 1867, despite the careful measures taken, sustained such great pressure in warm weather that it seemed—for want of a better comparison—to open up like an artichoke; as a result, though its stability was not seriously threatened, a number of iron pins snapped, windows shattered, and it was impossible to keep the rain from coming inside.

To cover such a vast space it is important to keep the many parts of the structure independent so that they cannot act upon one another and can expand and contract freely without disturbing the equilibrium of the whole.

The general plan adopted for the palace on the Champ-de-Mars allows for expansion since it was possible to make all parts of the construction completely independent of one another. It is composed of galleries juxtaposed so that each of them cannot push or pull against its neighbors. One can observe that the vast covered space of the Champ-de-Mars consists of an enclosure of galleries 35.60 meters or 25.60 meters in width and proportionately high, and of six lower galleries 35 meters wide separated by passages of 5 meters. These six galleries, grouped in threes and divided by the two higher galleries, leave a free space of 65 meters in the middle of the palace, where the galleries of the arts and the central pavilion of the City of Paris exhibition are constructed entirely independent of the rest of the structure.

Quite apart from the advantages this disposition presents from the point of view of the expansion of iron, it also protects the buildings destined for the fine arts, isolated as they are and entirely rough-walled in plaster, from the possibility of fire, since this isolation permits both surveillance and rapid response, and plaster is the best fireproofing material.

The interior organism—if one can call it that—of the palace is well suited to the organization and viewing of the exhibited products. In the center it offers visitors a needed respite; it neatly separates the products of the various nations, making it easy to determine where one is and orient oneself, an advantage that the

organization used in 1867 did not have, for after an hour or two of looking through its sections, it was impossible, thanks to the winding galleries, to know if one was on the east or the west side of the palace.

For the machines the large galleries of the enclosure provide on their two long sides a rectangular area that is over 700 meters in length, suitable for showing mechanical instruments and the transmission of propelling forces, for the drive shafts are propelled from both ends by four steam engines. When these mechanical devices function together along a length of 700 meters it will be an amazing spectacle, since no factory in the world can present such a display of the power of modern industry.

The two other galleries on the short side of the rectangle, 25.60 meters wide and not as tall as the others, house those works which on account either of size or the variety of their industrial uses cannot be assigned to a particular section. They are two immense vestibules that provide access to the interior galleries and open into foyers where people can circulate comfortably and from where they can easily go off again to the places they want to visit. A glass canopy around the entire outside of the palace allows the public to move about and seek out the entrances of the large galleries under cover.

Such is the general plan of the largest space the building industry has ever covered by a single span.

Turning to the details of its construction, the notable progress made in ten years is evident despite the preoccupations that have interrupted French industrial life during this period.

Note first that cast iron, which played such an important part in the construction of the palace of 1867, is here used only in vertical supports and only in the lowest parts—throughout wrought iron has assumed the place of importance. The vertical supports of the large galleries of the enclosure, for example, whose width attained 35.60 meters, are made of iron riveted at the corners, with the angles filled by scarps; these hollow supports for the vestibules form empty spaces that have been filled in with staircases that can be used to inspect the supports and to gain access to higher levels. This innovation may seem minor, but it is nonetheless a sort of revolution in the art of construction. The reason is that so long as the buildings were constructed with primitive means, as the Egyptians who used only stone, an inert material, or the Greeks who used both concrete and wood as roofing, one had to heed only the most elementary laws of statics. The Romans took a further step when they adopted the vault. They needed to resist oblique action—lateral forces—through construction strategies.

In the Middle Ages in France builders went still further in the search for ways of applying the laws of equilibrium in masonry buildings to oppose the action of forces against each other. The masons of the Middle Ages, who anticipated modern discoveries in the science of construction, already realized that they had to provide easy methods of access in order to maintain a close and continual inspection of the fragile elements of the building. Today we must further develop this principle, since we no longer use stone or brick, but cast iron, a material of

complex properties which changes considerably with fluctuations in temperature, gives or resists under certain conditions, resists under pressure, is eminently flexible or rigid depending on how the element is placed. When using this material the builder must be able to keep constant vigilance over the effects produced, the more so since we are still ignorant of many of the phenomena this metal can display. The need easily to reach the interior of the points of support, which are nothing more than long boxes of plate iron rendered rigid through a combination of interior elements, is real and serious. The conclusions that we wish to draw from this apparently minor point are easily understood. The conclusions are: the builder dreams of openly adopting a structure of iron that would exploit the intrinsic qualities of the material; he attempts to abandon the systems that have the singular pretension of giving the iron the forms and appearance proper to stone or wood; he seeks first to establish combinations resulting from the properties of the material; and then he composes the visible form. Finally he deduces the section of the space, calculating it from the curve of the pressures, and thus reviving in the nineteenth century the laws that those *barbarous* architects of our Middle Ages applied. And like them, the modern builder obtains ensembles satisfying to the eye by the observation of scientific principle.

We might perhaps wish that the builder [of the Palais du Champ-de-Mars] had followed this principle to its limits, in the parts, in the detail of the structure itself, as well as in the architectonic forms. But it is very difficult to rid oneself of traditions and prejudices. The true builder of the Palais du Champ-de-Mars has not pushed audacity, if audacity it is, to its limits; he has pretended to make concessions to a conventional architecture. He repents of this, I do not doubt, but the error, or rather the discord, is no less manifest. He believed in the necessity of the *monumental,* and this so-called monumental imposes itself in a somewhat clumsy fashion. Yet this defect, which appears only in the corner pavilions of the large galleries of the enclosure, is overcome in the ensemble, and if we take note of it, it is only to show that hereafter it would be wise to dispense with these false concessions to an art that has the pretension of being absolute. Evidently the architect, who was asked by the builder of the Palais du Champ-de-Mars to add decoration to this vast building, did not understand that this decoration ought to be entirely subordinated to the structural conception, which it should not mask, but strengthen. But we will not dwell on this, the more so since on many points the pernicious influence of the Ecole des Beaux-Arts has not interfered with the proper decoration of the building. Certainly the fillings of enameled terra-cotta, for example, are a decoration entirely suitable for an iron construction, and in this respect the pavilion of the City of Paris in the center of the palace is entirely satisfactory. There the architect, far from trying to disguise an iron structure that is particularly well arranged and pleasing to look at, because it has been produced by proper calculation and an exact understanding of the properties of the metal, has used decoration to support the structure.

I also think that the method of decorating the ceilings of the two large

vestibules is perfectly appropriate to the building. Panels of staff fill the spaces left between the iron ribs; these panels are extremely light but durable enough for an interior, easy to install, and suitable for either high relief or painting. We find nothing to reproach in this decoration, whose principle is excellent, aside from its too-large scale and its lack of character.

At this point, we might mention a fact that merits note today, when our habits and our requirements necessitate the rapid erection of buildings, but object to the obstructions produced by worksites in a busy city.

Except for the job of laying foundations and terraces, all the labor involved in producing the Palais du Champ-de-Mars was done in factories and workshops. It is not difficult to recognize the advantages of such a system. The various parts of a building can be made in different places, and one need not fear bottlenecks. If ordered in time, the parts can then be brought from their manufacturing points on a given day to be put in place. This is where the division of labor on a large scale offers real advantages and practicality. But it must be understood that using this method requires absolute precision in execution, since if certain parts are off by so much as a centimeter more or less, it can cause enormous problems when the time comes to put them up. Rough drawings do not suffice, and the factory laborers who forge and fashion the pieces of iron must be given absolutely standard measurements by the administration.

One can see how much organization and method this sort of administration requires to ensure that each part of the building arrives at the site neither too early, which would cause overcrowding, nor too late, which would cause delays in the regular progress of the work.

Translated from Eugène Viollet-le Duc, "Les Bâtiments de l'Exposition Universelle de 1878: Le Palais du Champ-de-Mars," *L'Art* 14 (1878):137–40.

Art in Architectural Ornament
UNSIGNED

The two principal Exhibition Buildings are built of iron and glass and the problem of ornamenting them was a serious one, chiefly because of their immense size, the materials used in their construction, and the necessity of economy arising from the comparatively small sum of money available for the purpose. The first object of such edifices is to furnish shelter and protection for the goods stored in them— *prodesse quam conspici,* as the old Romans would express it; and their true excellence consists in fitness for this end, rather than in architectural beauty. But bare, rectangular sheds, however spacious, well-ventilated, sheltering, and strong, would scarcely be considered suitable even by the strictest utilitarian; while, the moment that the builder in iron gets beyond the use of straight lines and simple

designs, the expense of his work is greatly enhanced. The fact is, that the architectural treatment of iron materials has only recently acquired the dignity of an art. Buildings constructed of stone, of burned clay, or of wood, are easy to handle, for the experience of the centuries is the teacher of the architect; but the use of iron is of later date, and is conditioned, so far as architectural propriety is concerned, by processes which are only just beginning to be understood. The art of iron decoration has undoubtedly great possibilities, but they are possibilities nevertheless.

It is true that examples of this art are not wanting; that so long ago as the Middle Ages, for example, hammered ornaments of great beauty were produced; and that in our own day the carver and the moulder have used cast-iron with distinction, the fret-saw having made lacework of slabs of metal, and the instruments of piercing and chiselling having brought forth many trophies, but just now we are speaking of architectural decoration in its strict sense, and, beautiful as are these methods and specimens, they are not architectural; and, what is of more consequence, they are very costly. The question, therefore, is, "How shall iron buildings be finished off so as to produce an harmonious and pleasing whole?"

The building erected on the Champ de Mars is both like and unlike its predecessor of 1867 in the same place—like in the chief element of its construction, and unlike in form. This chief element in each case is the grand pillar made of plate-iron, cut or rolled to the required size, and fastened together with strong rivets having rounded heads. Its height is eighty feet, its breadth on its face two feet, and its depth three feet. It tapers in breadth to the top. The form of the 1867 structure was somewhat like an oval—a short central part finished off with two semicircular ends. The form of the present structure is rectangular, with projecting towers at each corner, and at the principal entrance in the western or river wall. Now, in decorating the building, several courses would have been possible. The grand pillars might have been made to act the part of the fine buttresses of old cathedrals—without, of course, any undue attempt to imitate them. The windows might have been made of free, flowing tracery, such as is successfully wrought in metal-work; not the fantastic tracery often seen in stone-work, but a more serious and less intricate sort. Noble pieces of iron in the form of brackets, &c., might have connected the pillars, the latter being made to taper, as do the most exquisite of pinnacles, and to melt, as it were, in harmony where they and the roof met. Upon and around the structure, statues of iron and bronze, decorative castings, and other pieces, might have been placed; while ornamentation of gold, silver, brass, copper, or gilt, might have been effectively and artistically introduced.

Well, what was done in 1867? Very little. After several experiments had been made with various colours, including bright green and creamy white, the whole of the iron-work was painted, as nearly as possible, the colour of the iron itself, with the exception of the bolt-heads and projecting parts, which were relieved by the application of gold-bronze powder, while the lower part of each grand pillar was surrounded by a series of caryatides figures. The fact that nobody who had once seen the building ever took the slightest notice of it again, is a negative testimony to the success of the decoration. That is to say, the decoration was not ugly or

monstrous enough to attract particular attention; and, in these days of architectural abominations, one should be grateful, perhaps, for even such testimony.

As for the building now on the Champ de Mars, where the other one stood eleven years ago, its decoration is bold and novel, and therefore invites criticism. The architect has followed no predecessor, and at the same time has displayed signal ability. The edifice consists of a series of pillars, such as we have already described, between which, in the grand vestibule—the only portion in which any special decoration has been attempted—the whole of the upper half on both sides, is occupied by window-frames, as is also the lower half of the front opposite the park; the lower portion on the other side consists simply of the ends of the eight galleries which run from end to end of the building, at right angles to the grand vestibule and that at the rear end. The pillars rise magnificently to the height of about eighty feet, and upon them rests, without any intervening frieze or covings, the ceiling, which is divided into several enormous square compartments that occupy the whole of the middle portion, and a triple series of long rectangular panels, nearly filling the remaining space, each of which is fitted with an oak frame, containing an ornamental casting. The middle compartments, referred to above, are not far short of forty feet square; and the weight of a casting of that size, and the enormous difficulty of securing it in place, will at once strike every one at all accustomed to decorative work. To obviate the difficulties of the case, a new kind of composition has been used, which is at once lighter and tougher, not only than plaster of Paris, but than *carton-pierre* or *papier-mâché,* and infinitely cheaper than either; it is known as "staff," and the ornaments in their frames as *châssis en staff,* and there appears no reason why there should not be a large application of it to decorative purposes. Its chief material is the commonest tow— a very low-priced article—and this, having been steeped in a solution of plaster of Paris, is then moulded as desired, and afterwards prepared and painted just as if it were plaster. The outer strips on each side of the ceiling are reserved and treated as covings, with palm-branches on a red ground. The oblong compartments are filled in with ornamental band-work and leaves, coloured with maize, stone, and other low tints heightened by gold. The immense middle compartments are each filled by a single concave ornament with a centre convex, and having little more than the indication of a four-petalled flower; this is of a maize-like tint generally, but all the prominent parts are gilded, and shaded with dusky red. The ceiling is of the form of a flat waggon-head roof. Just below the coving, or that which occupies the position of a coving, are the top bars of the window-frames; these are designed in a way which is pretty certain to be followed in many cases—it is the adaptation of the casement system on a large scale and in iron. These windows are of great height and width [. . .] Between these cold blue windows there is nothing but the upper part of the iron pillars, without addition of any kind but paint and bronze-powder. Just below the windows, gold medallions, bearing the letters of the republic, R.F., on a diapered ground, are inserted in the face of the pillars, in circular openings left for the purpose; and below, to the height of about six feet from the ground, are three long panels filled in with "staff" casts, like those of the

ceiling; these casts are ornamented with band-work and large leaves, and the colours employed partake of stone and maize, heightened with gold. This general system of ornamentation has not and could not have been carried uniformly throughout the entire building. The vestibule has three domes over the three grand entrance-doors, and the ceilings of these domes, and of their junctions with the roof of the building, are decorated with vertical strings of gold ornament, laid side by side on a dark maroon ground, the gold being so brilliant, and the maroon so insignificant, that the whole looks like beautiful metallic chain-work, and is exceedingly effective. On the outside the treatment is still different. Upon the face of the grand arch, within which swings the great central door, are depicted the arms of the various cities that have contributed to the Exhibition, the shields of each being painted in their proper heraldic colours; and above the arch is a large composition in "staff," containing two female figures, Liberty and Labour, and the word "Paix," in the midst of sheaves of corn, the whole representing France, republican and industrial. On a bold plinth, at the base of each principal pillar, stands a gigantic figure in plaster, the figure being the symbol of an exhibiting nation, and in many instances a noble piece of sculpture. Great as the French are in painting, they are still greater in the plastic arts; it is a significant fact that the three chief awards in the present *Salon* were made to sculptors. Above these colossal statues the pillars are ornamented with *faïence,* in which the colours are very vivid and the style is very broad.

To say that this mixed ornamentation is of the happiest kind would be scarcely the truth—if one's tastes in such matters can be said to dictate the truth. The glaring contrast between the large plaster masses of the statues, the brilliantly-coloured and highly-glazed earthenware, and the dull-painted wall of the building, is positively painful. Surely it would have been better to have introduced bronze, cast-iron, zinc, or leaden statues; or, for a temporary purpose like the present, plaster casts coloured to represent metal. Again, sufficient advantage has not been taken of the very simple method of giving finish to a building by means of light metal-work, stamped zinc, or galvanised iron, carried along the ridges of the roof and edges of gables and dormers—a kind of finish which French constructors have carried out with much ingenuity, and the English also to some extent. There is a little of this *crête,* or cockscomb-work, in the Exhibition, but it wants boldness and character. Returning within the building, the eye runs hopelessly up the pillars, and finds nothing bringing them in harmony with the coloured ceiling; the blue-tinted and opaque glass of the windows adds to the isolation of the latter, and, when the eye has fairly taken in the exquisite colouring of the Sèvres china, of the tapestry-work of the Gobelins and Beauvais, and, above all, of the gauzes, the shawls, and the carpets of India, and of the Prince of Wales's collection, the presence of the painted ceiling becomes a positive impertinence. The mere iron-work of the roof, treated as iron-work, and in harmony with the pillars—that is to say, painted with iron colour, enlivened with a little gold—would, under present circumstances, have been infinitely more effective, not than the present ceiling only, but than any plaster or other painted ceiling that could have been devised;

for then the structure would not have been hidden and falsified, and incongruity would have been avoided.

From "Art in Architectural Ornament," *The Art Journal: Illustrated Catalogue of the Paris International Exhibition, 1878*, pp. 267–77.

The Decoration of Iron Buildings
UNSIGNED

The subject of the decoration of iron buildings divides itself easily into two branches. In the last number of the *Art Journal* we considered the proper methods of temporary decoration, and pointed out some of the mistakes committed by the architects of the structures on the Trocadéro and the Champ de Mars; but, so general has become the use of iron in construction, and so probable is its increasing use for the same purpose, that the proper methods of permanent decoration constitute a matter of great interest. On this second branch of the subject, therefore, a few words are not out of place.

Let it be understood, however, at the outset, that our present concern is not with structures whose form or details have no metallic characteristics. There are iron buildings in which the metal has been used simply as wood is used, namely, as the material for construction, without reference to special laws regulating the employment of such material. In the cabin of a modern passenger-steamer, for example, we may notice that the beams are peculiarly thin and light, while their forms are not very different from those of timber-built vessels. They are painted, or, one might almost say, enamelled in gold in delicate colours, or in brilliant white, by means of which the iron is altogether or in part concealed. The steamer itself is so built that at a distance you could scarcely tell whether its outside is formed of wood or iron. Its shape, certainly, would in either case be the same.

Not with such structures have we now to do, but with those that possess distinct metallic characteristics, and that come within the scope of special laws. To the iron building proper our attention is directed, and this is not a building which has been designed for stone or for wood, and executed in iron, but one that has been both designed and executed in iron. The latter is a true building; the former is a hybrid, a pretence and a sham, having no claims upon the consideration of the architect or the lover of architectural beauty. A wooden edifice has laws of its own; so has a stone edifice, or an iron one. What, then, are the laws to which the builder of permanent iron structures is amenable? In the first place, not all ornamental elements are admissible here. Flying buttresses, for instance, should not be used. Originally they were a necessity, arising from the imperfection of mechanical science; and the manner in which the earlier architects converted this necessity into an ornament reflects great credit upon their ingenuity. Their ignorance had created a difficulty which their inventive faculties overcame. But the discovery of

the principle of the tie-beam at once set aside the flying buttress. The latter were no longer needed; and their presence in a modern building is an absurdity—most obviously and indisputably an absurdity in a modern iron building, for here there is no trouble in rearing pillars of any height, and in securely fastening them together. The roof of the Trocadéro Building, for example, is more than eighty feet from the floor. By-the-way, as the art of building in iron progresses, why should not open metal roofs be made as beautiful as timber ones?

Not less inadmissible than the flying buttress is the arched window, the lancet-window, the pointed, the perpendicular, and the flamboyant arch. These do not belong to iron architecture, which prefers long, horizontal lines, that no other material can span, and in which square-topped windows may be constructed of a size beyond the most roseate dreams of the finest architects of Dijon, Blois, or Elizabethan England. As far as pointed arches are concerned, the Burgundian, the Tudor, the Elizabethan, and the Renaissance, styles have already dispensed with them.

With the exception, however, of arched windows and flying buttresses, it may be said that cast-iron buildings admit of ornamentation in classic, mediaeval, or any other style. They are not confined to any particular mode; the elements of ornament in them are almost infinite. The simplest girder, cantilever, or bracket may be wrought into a thing of beauty; the cornice, the frieze, or the balcony, may be made attractive and admirable. There is, indeed, not a single subsidiary element of an iron building that cannot be made effective in a scheme of ornamentation. Stone-work, from its very nature, demands a certain thickness, unless it would be feeble and flimsy in effect, as well as in reality; but work in cast or hammered iron is independent of this condition, admitting equally well the most solid and the most delicate ornamentation. A pair of gates with superstructure of cast-iron, and body of modelled scroll-work, the whole finished with a crest of delicate floral design, may be taken as a type of what can be done with iron in the department of ornamentation. In the direction of solidity, there is no limit at all; in the direction of delicacy the limit is not positive. To say that "an iron building can never be anything but an ugly building," as some persons affect to believe, is to display very considerable ignorance of the possibilities, not less than the actualities, of the case.

Look, for example, at the peculiar fitness of the dome, the tower, and the spire, for execution in iron. Look at the use made by metal-workers of copper, brass, and gold, of pebbles, precious stones, and glass, in their schemes of decoration. Look at the harmonies produced by chandeliers, candelabra, railings, screens, and other fittings, all of them designed in keeping with the main features of the building itself; and, finally, look at the opportunities presented to the sculptor. Every kind of sculptural work in metal, from the simplest bas-relief ornament to the statue or group of statues cast in iron, in bronze, in silver, or in gold, may be brought into use. Not only castings, but also hammered pieces, like the fine colossal statues recently made in France and Germany—like the statue of 'Liberty enlightening the World,' now in the studio of M. Bartholdi, for example—may be turned to account; not only hammered pieces, but also statues built

up atom by atom by means of electricity in the vats of the metallurgical chemist and artificer. All these ornaments are of service in the decoration of iron structures; and even these do not comprise all the resources that may be drawn upon. One of the most costly and beautiful modes of decoration is *repoussé* work,[1] the art of which, a short time ago almost forgotten, has recently been revived with astonishing success, as in the celebrated Bryant Vase made by the Messrs. Tiffany, of New York, and in the fine collection of this firm at the present exhibition. [. . .]

The surface of iron will not bear exposure to the weather; and it is a somewhat curious fact that, in spite of the wide-spread and long-continued use of iron for architectural purposes, no perfect protection has yet been found for it. The difficulties of the case have been met in various ways, but none of these ways have so far been absolutely successful. [. . .] Meanwhile, various methods of enamelling are recommended. They serve, also, the purpose of decoration. An enamelled iron ceiling grows as naturally out of an iron building as does one of plaster out of stone or brick walls.[2] Panels, screens, running ornaments, and mural tablets, may also be enamelled. In conclusion it may be said that, as neither wooden, stone, nor brick buildings are confined to fittings or decorations of their own materials, so iron buildings need not depend exclusively upon metallic ornamentation. Pictures, carved woodwork, encaustic pavements, tapestry, china, carpets, and other accessories, will always be acceptable and becoming. In view of the increasing use of iron in architecture, it is the duty of artists and Art-lovers to see that iron structures are erected conformably to the dictates of an enlightened judgment and an educated taste. At the present time, and especially so far as processes of decoration are concerned, architects in iron do not seem fully to understand their business.

From unsigned, "The Decoration of Iron Buildings," *The Art Journal: Illustrated Catalogue of the Paris International Exhibition, 1878*, pp. 301–08.
 1. In *repoussé*, metal surfaces are ornamented with designs in relief that are hammered out from the back.
 2. Enameled iron ceilings like those installed by Gamble and Poyntner in the tearoom commissioned in 1864 by Henry Cole for the Victoria and Albert (South Kensington) Museum.

[Contemporary Architecture]
JORIS K. HUYSMANS

. . . The Second Empire, which had a mania for building, as everyone knows, but irremediably poor taste, dreamed of creating an architectural art that would bear its name. To this end it encouraged incongruous mixtures of all the styles; this abuse brought forth the heavy ornamentation which makes the Tribunal du Commerce one of the ugliest buildings of the century. As Mr. Boileau so aptly remarked in his very interesting book, *Iron*,[1] it did not want to admit that "the

combinations inherent in stone as a raw material for monuments were exhausted, [so] it persisted in wanting to create new effects with it, without even realizing that, on the contrary, in order to achieve the proposed goal, it was necessary to widen the use of a new raw material—iron—which, when employed in a limited way by modern architecture, had already given satisfactory results."

Thus the routine in the public offices continued on at the same rate, although many warnings had been given. Léonce Regnaud, Michel Chevalier, César Daly, and Viollet-le-Duc declared many times that iron and cast iron alone could produce new forms. Hector Horeau, who was the most daring architect of our time, drew up enormous plans for monuments made of iron; nothing was done about them. The movement was promising, but the state, which gave all the orders, persisted in its ideas which were backed up by the old school; it would allow the combined use of iron and stone only at certain times, and it resolutely rejected the idea of using the metal alone as a raw material for buildings.

Little by little, however, cast iron began to command attention. The work of engineers helped to reveal it; their metallurgical constructions shook architects and the public out of their normal apathy and architecturally mixed buildings—that is, buildings constructed with the two elements, quarry stone and iron—began to rise up in proportionately greater numbers.

Simply as a reminder, we may mention one of these buildings, the Bibliothèque Sainte-Geneviève, built by M. Labrouste. Since then, this artist has made iron play an even more important role in the construction of the reading room of the Bibliothèque Nationale. Artistic ironmongery has become implanted in his work with a very original form that would be impossible to find with other construction material. In 1854 iron was used for the first time in the structure of a place of worship: M. Boileau built [the church of] Saint-Eugène. The construction of Les Halles the year before had completely revealed this new art, but the use of drawn and cast iron as the principal materials for a church was still shocking at that time. Although the style was always imposed on the artist so that his work could never be anything but spurious, this was a new point in favor of the ironmongers' theories. A controversy was begun, but the innovator won out, and we see that later on, in 1860, the state accepted the use of iron in the construction of the church of Saint-Augustin, and even later it was used in the palace of the Ecole des Beaux-Arts, which was repaired in cast iron by M. Duban.

The large railroad corporations contributed a great deal to the movement. The Gare d'Orléans and the Gare du Nord, built in 1863 by M. Hittorf, are proof of these new endeavors. I shall leave aside in this list the Palais de l'Industrie, which is only a smaller version of the Crystal Palace in London, which itself was only a disastrous larger version of the conservatories of our Museum. That untoward attempt, with its terrible windowed roofs, could not possibly interest us from an artistic point of view, which is the only point of view that matters here.

After these rather limited examples of the use of metal, we will look at some more examples, not of architecturally mixed buildings, but of buildings constructed entirely of metal.

Built in 1853, Les Halles were, as I said above, a decisive success for the new school. The [Second] Empire, guided by its architect, M. Baltard, was still wavering in its decision at that time. It wanted to continue in its old ways, but finally the stone fortress that had first been erected by this architect as a market was demolished. This came about because, under pressure from public opinion, which agreed with the projects drawn up by the architect Horeau[2] and the engineer Flachat, M. Baltard was suddenly converted to what he formerly despised; he combined the proposed projects into one and, along with his colleague M. Callet, and with the help of Joly, the ironmaster, he erected this monument which is one of the glories of modern Paris.

After that, the cattle market and the slaughterhouse in La Villette took on the iron framework of Les Halles, which was enlarged by M. Janvier, according to M. Baltard's plans. Here the metal reaches grandiose proportions. There are enormous passageways, broken up by slender columns which rise up out of the soil and hold up light ceilings drenched by light and air. It's an enormous yard which swallows thousands of animals into its stomach, a vast plain whose covered sky looks down upon the feverish activity of business, on the incessant comings and goings of cattle and men, and a series of immense pavilions whose gloomy color and straight-built, but somehow squatty, aspect are quite suitable to the bloody, never-ending work that goes on there.

Now we must look at the Temple Market, which was rebuilt in cast iron according to Ernest Legrand's plans. It's a smaller, nicer, more stylish market. The passageways are not so wide and the arches do not soar up so high, so their color seems less gloomy. Its pace of life is slower, less brutal, than at La Villette, but it has more busybodies and gossips. It's a cheerful building composed of six little pavilions of which two, joined by an arcade, form the facade, which is flanked by square turrets topped by small steeples. It's a series of little streets whose bright, cheery look wards off the misery of cast-off clothes. It's almost like an aviary in this light building where the iron seems to become graceful in order to match the smart colorful displays of ribbons and jewels accumulated in the shops under its vaulted roofs.

Now we come to the halls of the universal exposition, which hold whole worlds in their immense, airy structures, in their gigantic avenues which rise out of sight over the working machines. In spite of their glass domes, which were supposed to look like diving bells, the exhibition hall of 1878, erected by M. Hardy, had a certain fullness of style which is quite rare in the architectural works of our time.

Finally, we come to the splendid interior of the Hippodrome built by the engineers from the Fives-Lille [Company]. With unparalleled boldness the cast-iron columns rise up to amazing, cathedral-like heights. The slenderness of the thin stone pillars in certain old basilicas seems timid and clumsy next to the casting of these light stems which reach up to the gigantic arches of this revolving ceiling; they are connected by extraordinary networks of iron going out from all sides, bisecting and crossing each other and getting tangled up in their fantastic girders;

they inspire a little of that feeling of admiration and fear you have when you see certain enormous steam engines.

If the outside of this circus were equal in originality and artistic value to the inside, the Hippodrome would certainly be the masterpiece of this new architecture.

From another point of view, the metallic structure of the reading room contained in the stone buildings of the Bibliothèque Nationale is wonderfully light and graceful. It's a vast room topped by spherical cupolas and filled with large bay windows. It's as if the room had been set down upon some slender stalks of cast iron; it's a room of incomparable distinction, which rejects the uniform grayish blue color in which metal is almost always coated, allows whites and golds on the arches holding up its skylights, and accepts the decorative help of majolica.

It might almost be said that the difference between the inside of the Hippodrome[3] and the inside of this room is analogous to the difference which exists between those other complete buildings, the Temple Market and that of La Villette: one is elegant and supple, the other superb and grandiose.

In none of the monuments I have just reviewed is there any borrowing from the Greek, Gothic, or Renaissance styles. They have a new, original form that cannot be achieved with stone and is possible only with the metallurgical materials produced by our factories.

I am afraid that M. [Charles] Garnier was wrong when, in his book titled *A travers les arts* [1869], he wrote sentences of this kind: "Metal is destined to build hangars . . . I will say right away that this is an error, a great error, for iron is a means, but it will never be an end. If large buildings, halls, and train stations, constructed almost exclusively of iron, have a different look than constructions of stone (which is surprising especially because of the nature of the use of these materials), that does not mean that they constitute a particular kind of architecture."

What does constitute it, then? The spuriousness of the ill-fitting styles of the Opéra, the last romantic effort in architecture? This part or that of the polychromy? This assemblage of thirty-three kinds of granite and marble jostling each other about, which will inevitably be altered in our rainy weather? The form of the great staircase that doesn't belong to it? Or the look of these massive, pompous cellar doors, which are crushed under the weight of this ramshackle place, and which have no true grandeur at all?

Furthermore, there is nothing less surprising than Garnier's opinion, for the raging romantic who thus described the Paris of his dreams—"Golden friezes will run along the sides of the buildings, the monuments will be arrayed in marble and enamels, and the mosaics will cause a love of movement and color . . . our way of seeing things will require in turn, a colorful change in our way of dress and the whole city will have a harmonious reflection of silk and gold"—. . . could not accept the magnificent simplicity of art that has very little concern for gilding and odd medleys of colors.

No, modern art cannot allow this backwardness nor this return to the tinselly

kind of beauty extolled by M. Garnier. The ostentatiousness of Veronese's costumes is far behind us, and it will never come back, for it no longer has a raison d'être in a bustling, struggling-for-life century like ours.

What is certain is that the old architecture gave all it had to give. It is thus quite useless to overwork it and to want to adapt outdated materials and styles to modern needs. Now, as M. Viollet-le-Duc said, it is a matter of looking for the monumental forms which proceed from the properties of iron. Some of them have already been discovered. The efforts of the so-called rationalist school have until now been especially directed at discovering models for train stations, circuses, and markets; tomorrow they will go on to models for theaters, town halls, schools, and all kinds of buildings that have to do with public life; they will abandon all the servile imitations of domes, frontons, and slender spires, and forsake all the impoverished combinations that are possible with stone.

Just as painting is following the lead of the impressionists and freeing itself from the tiresome precepts of the schools; just as literature, influenced by Flaubert, the Goncourts, and Zola, is throwing itself into the naturalist movement; in the same way architecture is also getting out of its rut and, because it is more fortunate than sculpture, it has been able to create a new art with entirely new materials.

Thus, Claude Lantier's predictions in [Zola's] *The Belly of Paris* [1873] about Les Halles and the church of Saint-Eustache, have partly come true. He says, "This piece of a church tucked into this street of cast iron is an interesting discovery. The latter will kill the former, iron will kill stone—and the time is near. You see—it's a proclamation of things to come; modern art has grown up in opposition to old art. Les Halles are a bold piece of work—and only a timid revelation of what the twentieth century has to offer."

From J. K. Huysmans, "Le Salon officiel de 1881," *La Revue littéraire et artistique*, November 1881, as reprinted in J. K. Huysmans, *L'Art moderne* (Paris, 1883), pp. 235–46. For the first part of this article, see part 2, 1879–81: Paris.

1. The reference is to one of the works of the architect Louis Auguste Boileau, *La Nouvelle Forme architecturale* (1853), *Les Principes et exemples d'architecture ferronnière*, and *Les Grandes Constructions edificataires en fer*.

2. [Huysmans:] Horeau's life was like that of all people who had ever wanted to break away from accepted routine. He died unknown and miserable, without having been able to apply his own ideas, which were appropriated and put into practice by others.

3. The Hippodrome was erected in 1878 near the Pont de l'Alma, where Courbet and Manet had built their exhibition sheds in 1867.

Ancient Japan and Modern Japan
PHILIPPE BURTY

Japan has just won a complete and decisive victory at the Universal Exposition in the exhibition of its arts and industries of the past and present. *L'Art* can well be proud. It freely offered its pages to works that seemed at the time sterile and

foreign. The articles were accompanied by illustrations—including astronomically costly chromolithographs—whose exotic flavor made them look like caricatures. We audaciously used as our title the word "japonisme," a word that we coined to convey our stream of thought, which caused the academicians to gnash their dentures.

Is it possible to imagine today how daring this was? At the time everything conspired to deny the very existence of the Japanese; the experts who knew nothing about Japan, the serious amateurs who considered that acknowledging "*les chinoiseries*"[1] was going quite far enough, the journalists who had no idea where to find the appropriate adjectives, and worst of all, the professors of aesthetics who feared that these sensitive, vibrant works of art, so perfect in theory and in execution, would give support to those hideous radicals who preach the radical philosophy of naturalism.

Today, if the svelte *Fame*[2] who stands on tiptoe atop the central dome of the Trocadéro could veer with the wind like the *Dogana,* we would see her blowing with puffed cheeks toward the Far East.

Japan deserves this change in attitude. We are pleased that this has been noted and confirmed by others besides ourselves. Japan has all that is necessary to take, and to keep, its place among the great peoples. The country seems to be in the hands of a young, zealous government convinced of the magnitude of its task and committed to every sacrifice in order to succeed. The men it sends to France, invariably chosen from among young people who are intelligent, studious, clear thinking, and passionately dedicated to the new order, have been received with both interest and cordiality by our most eminent statesman. The president of the Japanese section was a man of unusual energy, Mr. Masayoshi Matsugata, assistant minister of finance. . . . The general commissioner of the Japanese section was Mr. Masana Maeda. To this subtle, discreet, active, patient, tenacious young man fell the always difficult and sometimes disheartening task of organizing the exhibition, of making all the arrangements, of safeguarding the rights of all concerned parties, of spreading himself without being fragmented. Mr. Maeda rose to this challenge. He was one of the promoters of this exposition.

When news of the exhibition reached Japan, the new government was fighting a potentially fatal uprising in the province of Satsuma. It needed all of its financial resources and it hesitated to commit itself formally to the French exposition. Mr. Maeda took it entirely upon himself. He had lived in France; he was in Paris during the Terrible Year [1870]; he was aware of the expanding strength of the French genius; he knew that only the favorable judgment of the Parisians, subtle and so hard to please, could finally establish an artist's reputation. He showed his superiors that in order to guarantee the permanent value of their country's products after the successes at Vienna [in 1873] and Philadelphia [in 1876], it was necessary to submit them to the final test of the great international competition about to open on the banks of the Seine. He allied himself with a banking and shipowning family who have been the Rothschilds of Japan for

centuries, the Mitsui. He was given unlimited credit and was able to plan without stinting, to supply programs to all the ministries; to recruit the most skillful workers, freed by the recent revolution from their ancient bondage to the feudal princes; to persuade the manufacturers and merchants that in making an impressive showing, their interests as well as those of the new Japan were involved. The planning and the execution of these exhibits which produced such a magnificent effect are due to Mr. Masana Maeda, the rich and patriotic house of Mitsui, and the outstanding and intelligent support of the government and its ministers.

We remember what the Japanese section was like in 1867. The imperial diplomats [under Napoleon III]—always so well informed!—had been unable to ascertain within what political framework Japan was governed. They still believed the old myth of a shogun as "temporal sovereign" and a mikado as "spiritual sovereign." They were unaware that they faced a feudal country and that they were dealing with a prince whose seventeenth-century ancestors had relegated the mikado to second place without taking away his traditional rights, and that the only privileges he now enjoyed were but a gilded show. They assumed they need deal only with the taïkuon, and the prince of Satsuma could only present his very interesting exhibits—most of which remained in their crates—as coming from the island of Liou-Kiou [the Ryūkyū Islands]. Only the prince of Hizen, in whose domains so many porcelains were produced, consented to appear under the shogun's banner, stamped with the Tokugawa arms—three mauve leaves joined edge to edge. These showcases were scarcely noticed. The crowd remembered only the little enclosure where a large bell hung in front of some pine planks piled with cups, playthings, and picture books printed on crepe; the small open shelter with seated mannequins dressed as warriors; the kitchen where flat *sake* was poured into blue and white porcelain drinking cups; the wooden pavilion where three young girls were crouched, hiding themselves behind their silken sleeves from the visitors' bawdy laughter and throwing glances like those of caged does to those who showed them respect and sympathy.

However, the quality of Parisian discernment is such that poets and painters crowded into that miserable garden and fell passionately in love with the naive and lively illustrations of that small page from an album.

Now it is 1878. Walking down the Rue des Nations, let us look over the shoulder of the author [Charles Blanc] of *Grammaire des arts du dessin* at the notes which he is taking for that very serious newspaper, *Le Temps,* and which he has reprinted in full.

> . . . By contrast—that is to say after a severe attack on the Italian facade—the Japanese have given us here a sample of their architecture, which is remarkable and much remarked upon. The artists of Yedo [Tokyo] have brought all the pieces from their island and have assembled them on the site. Never has the maxim that architecture is essentially a relative art been more clearly and tellingly expressed. In a Japanese door there is something both primitive and refined. Two posts to support the swinging panels, two corner posts, two beams,

and two wooden piers—these are the natural structural elements, displayed without any refinement of the materials. The wooden framework is bare, thick, solid, and heavy; we feel its strength and its polish, we count its veins. The jambs are covered at the ends with a green copper seal, the color of antique bronze, which protects them from rot at the spot where the elements would begin to attack them. The ends of the beams are ornamented with the same copper, and they are also slightly turned up in the Chinese manner, but with a restraint and delicacy that proclaims men of taste. . . . A small refinement—unexpected in such a rudimentary construction—is added to the extreme simplicity of this elegant framework: the second bay, that is to say the actual entrance to the Japanese section, is surmounted by a pediment or rather a simple overhang, whose slanting lines are slightly curved, like those of the Parthenon pediment. This curve delicately inverts the up-turn of the beam. The green bronze revetments are echoed in the paintings on the panels of the door, at the height of the hinges. The two walls of the facade, on the right and the left, are decorated with two large maps, one of Japan, the other of Tokyo. Located between the Italian and Chinese facades, the Japanese facade emphasizes the insignificant elements of the former and the bizarre elements of the latter.

Charles Blanc, in this accurate description, omits only the two fountains of enameled faience in which water jets from the pistils of full-blown lotuses, on which pink crabs and green frogs are climbing. The fountains delicately complete the whole and are, though they perform the same function, prodigiously more original than the Wallace fountain,[3] that epitome of decorative emptiness. But let us emphasize the importance of this passage. A member of the Académie des Beaux-Arts has forsaken the Italian facade, a reasonably good imitation of one of those fifteenth-century Florentine galleries, so fashionable a few years ago that M. [Charles] Garnier used one to decorate the facade of the French Opéra. A professor of aesthetics at the Collège de France has dared to compare the wooden pediment, the weatherboard designed by Oriental barbarians, to the pediment of the Parthenon! These are true signs of the times! Surely, this "invisible curve" reminded every cultivated spirit of the voluptuous swelling of Ionic columns! . . .

Let us speak of fabrics, in particular those that the house of Mitsui is exhibiting. They have opened a store in Paris conveniently located on the rue Saint-Georges. Some of these fabrics are copied from sashes or women's robes from the mikado's court in the eighteenth century. They were lent by the Tokyo Museum. They remained folded in one of the Trocadéro display windows without being spread out. It was my good fortune to be able to touch them and see them. They were beautiful pieces of fabric, very varied in their designs but not with figures and landscapes like the girls' robes that have recently been seen in Europe. . . .

Even though these fabrics are interesting, they do not give as striking evidence of this people's originality and skill as do the embroidered robes of courtesans and actors on which are depicted the most ingenious scenes and the most fearsome characters. I will not try to describe them. It is enough to study the large albums of the theater which can be found today in every painter's studio and in

every art lover's library. The combinations in these models are infinitely varied. The fashion for robes embroidered with motifs taken from life blossomed in the eighteenth century. I have two volumes printed about 1760 which are actually advertisements that dressmakers sent out to the provinces to show their new styles. The fukusas—fabric squares used to wrap a lacquer box that contained a letter, fruits, or presents sent to a friend by means of a servant—are the most interesting of all. The boldness of the silhouettes, the beauty of the color contrasts are unrivaled in any other people's art. Our friends Edmond de Goncourt and G. de Nittis have collected the finest specimens known in France and have had them framed like masterpieces of painting.[4] The most beautiful seem to be those on a black ground, but this rule is not invariable: there are beautiful ones using every imaginable background color—pink, dove gray, kingfisher blue, cream. I have one of two carp on a green background which are signed "Zoï O" with a red seal. If I were going to write a monograph on these fukusas—about which the Japanese seem to know nothing, probably because they were designed and embroidered in princely households by unknown servants—I would describe one of a tiger licking its paw, which bears an astonishingly close resemblance to a painting by Eugène Delacroix. There is the same supple silhouette, the same sinuous construction, the same nervous musculature, the same brilliant fur on the chest—yellow and black, short and silky—and above all, there is the same impression of the possibility of a sudden lunge if some prey passes within reach. Behind the animal, a stream bounds over rocks and the rocks melt into shadows whose opacity is accepted unquestioningly by the imagination.

Sometimes these pieces are entirely covered with embroidery, either flat or in a relief calculated to catch and hold the light—as in the two pigeons in E. de Goncourt's collection. Sometimes they are partially painted with a brush with marvelous freedom and flow—as in the one of cranes, in the collection of G. de Nittis, washed in India ink on a taffeta as pink as the dying reflections of a winter sun.

Many interesting ones are still to be found in recent imports, but unfortunately done with speeded-up techniques. Someday our French ladies, who have abandoned the embroidering of slippers and sentimental suspenders for wall hangings, may try their hand at works similar to these.

Translated from Philippe Burty, "Le Japon ancien et le Japon moderne," *L'Art* 14 (1878):241–44.

1. *Les chinoiseries:* an eighteenth-century European style adapted from or based on Chinese art forms.

2. A statue sculpted by Antonin Mercié.

3. It was the property of Sir Richard Wallace, the English art collector and philanthropist and a British commissioner at the exhibition, who later bequeathed the Hertford Wallace Collection to the British nation.

4. The novelist Edmond de Goncourt was an early authority on Japanese art, and published *Outamaro* (1891), *L'Art japonaise* (1893), and *Hokousaï* (1896). Giuseppe de Nittis, an Italian painter working in Paris and London, shared that interest with Goncourt.

The Applied Arts at the Paris Universal Exposition
ADOLF ROSENBERG

General Survey: English Porcelain and Pottery . . . No other exhibit in the Champ-de-Mars has been as cunningly assembled and arranged as the English one. By heading the English exhibit, the Prince of Wales demonstrated his friendship with France. The French, for their part, hastened to reciprocate, assigning to England the best areas of the exposition, namely the entire right part of the *galerie d'honneur*, as well as allotting it more space than was given to all the other nations put together. The English took full advantage of this and assembled an exhibition which by dint of long experience was most carefully and critically prepared, and which put even the French exhibition in the shade. With it England has in an impressive survey for the first time shown the enormous progress of her industry over the past decade. We behold with astonishment a gigantic body of work achieved more or less silently, for, owing to a policy of high prices, English industrial art has not yet reached a dominant position in the world market; we are confronted with an industry which includes everything that other nations have discovered or originally possessed. In two important fields, the glass and ceramics industries, England has overtaken France, while in many others the English have either equaled the French or come dangerously close to it. In a word, the supremacy hitherto enjoyed by the industrial arts of France is broken. That is the most important result of the Paris universal exposition, a result that the French, thinking they could rest on their laurels, had least expected.

Regarding the exposition buildings, particularly the much-vaunted Trocadéro palace, the French have decidedly met with disaster. The exterior organization of the exposition, insofar as it depended on the French, was undertaken with an almost insulting nonchalance. Water and greenery, which should have constituted the first condition of life for one wandering in the desert of the Champ-de-Mars and Trocadéro, were almost totally absent; in the decorative layout of their own sections, the French—the most skilled practitioners in the world—were easily surpassed by the despised Germans.

Though the lion's share of the first victory over French industry falls to England, Austria, in second place, can also claim to have outstripped France in various branches of the industrial arts. The verdict on the upswing of Austria's industrial arts since the Vienna universal exposition,[1] steady because it was founded on a rational basis, would be still more favorable if the image presented by the Austrian section had been more versatile and more comprehensive. Certain important branches of Austrian industry—the manufacture of furniture, for example—were feebly represented, and participation was not very lively. Finally, the disadvantageous planning and the dim lighting of the Austrian exhibit were exceedingly detrimental. It was nevertheless clearly demonstrated that the educational and refining influence of the Austrian museum and the conscientious collaboration of the technical schools had everywhere produced happy results. They

were especially evident in the exhibits of the leather, lace, and glass industries, and in the products produced by the lathe.

The art of Austria-Hungary, in the nature of things, could not present such a harmonious picture. But it was nonetheless more many sided and richer in various kinds of artistic characteristics than that of any other country. From the indigenous stock, with its roots still in the Vienna Academy, shoots have branched off in all directions. No other group of artists has manifested such great ability to acquire the peculiarities and artistic style of other nations. Nevertheless, the art of Austria-Hungary is just as rich in original talent, in "self-made men" who draw their strength from their native soil. Along with those who are products of the schools of Brussels and Antwerp, Munich and Düsseldorf, or who have been influenced by the French approach to art, we encounter originals such as Matejko and von Angeli, to mention only two.

After the rich experience of the Vienna exposition, it was predictable that Austria would make remarkable progress, thanks to the systematic efforts directed to the encouragement of the decorative arts under the aegis of the state and to the guidance of numerous teachers who provided theory as well as practice. But the impressive advances made by Japanese industry over Vienna came as a totally unexpected surprise. Since 1873 persistent rumors have been prophesying trouble for Japanese industry, as a result of its coming into contact with that of Europe, and professing already to see certain signs of decline. These rumors have been decisively laid to rest by the Japanese exhibit at the Champ-de-Mars, which completely overshadows the Viennese, and was due to the initiative and cooperation of private industry. The Japanese government played a leading role in the Paris exposition; it not only funded it, but also provided for a representation of industrial arts that was as brilliant as it was systematic. Thus it is not possible for us to decide whether, within the span of four years, Japanese industry has made such advances specifically because of its technique in working bronze, or whether it is only the increased brilliancy and the choice of the best examples that raise it so significantly above the previous level. The fact is undeniable, however, that Japanese industry, as always, has maintained its originality untouched by European influences, and continues to operate according to old principles.

Owing to its excessively high prices, English industrial art will not in fact endanger the French as much as will the Belgian, which now competes successfully in nearly all fields. Admittedly, we find Belgian art lacking in any particular originality. It is derived entirely from the French, but has remained relatively free from the eccentricities and the crass excesses that offend us at every turn in the French galleries. An exceptionally advantageous arrangement, thanks in part to the policy of placing similar objects in closed, uniformly decorated rooms, has also greatly helped to put the Belgian exhibit in a more favorable light than the French. The art of Belgium is far more independent than its industry. [. . .]

Although with a few exceptions Italian painting remains under the spell of France, the plastic and industrial arts, which are almost indistinguishable from

each other, retain, as always, their national characteristics. In the fields of jewelry and all manner of decorative arts, Italian industry is as dominant as ever. It did not rise to the challenge to develop higher branches that would move away from the area of fancy hardware. Salviati's glass and Roman marble mosaics have already met with well-deserved recognition in Vienna.[2]

The other European countries play subordinate roles in the fields of arts and crafts. Some, such as Denmark, Russia, and Switzerland, appear in the world market with certain specialties derived either from their national industries or from their native products; the opportunity to develop these specialties is, however, generally very limited. Many reached their peak a long time ago, while many others have already passed it. When judging the exhibit of Russia in particular, the [Russo-Turkish] war [of 1877–78], which kept away many industries, especially the national ones, must be taken into account. Germans living in Russia were so strongly represented that they comprised almost the majority of the exhibitors. [. . .]

Although the most sincere efforts have been made by the applied-arts associations and by certain state governments, we do not dare to state that the judgment on German industry rendered in Paris as a result of successful participation could have turned out any more favorably. There are still certain branches that have been so highly developed in Germany that no other country can approach it; these branches, however—in particular textiles and ironwork, oleo- and chromolithography—do not fall into the category of industrial art [i.e., art produced solely by machine], which alone concerns us here. The political difficulties encountered up to now by the central government of the German empire have become more critical than ever before, and it will probably be some time before the Prussian state government includes in its program as splendid a support for the industrial arts as we have seen in Austria over the past ten years. [. . .]

The Near East, which played such a brilliant part in Vienna, fell quite into the background in Paris. The national cultures decline with the decline of political power. What was offered for sale in the bazaars and pavilions of the Trocadéro was almost without exception ordinary run-of-the-mill stuff, whose Oriental provenance was anyway highly suspect. The rubbish offered for sale must have originated mainly in the rue du Temple and its environs. In the Galerie du Travail, where the small industries had set up their headquarters, dainty little boxes were diligently painted, enameled and gilded, and later peddled in the Trocadéro by Moroccans and Tunisians dressed up in their national costumes.

We have already spoken of the important part played in Paris by Japan. After her, among the Asiatic nations only India was able to attract general attention. The Prince of Wales exhibited the valuable gifts he had received from the cities and vassal princes during his journey through India in 1875–76. These constituted a rich, wide-ranging museum that provided a complete survey of the manifold branches of India's art industry, based on most ancient traditions. In spite of the great efforts and the not inconsiderable funds that China expended on

outward appearances and decorations, it was not possible for the Middle King-
dom[3] to conceal the fact that its applied arts are in a state of complete stagnation.

Porcelain, faience, and glass represent the most brilliant aspects of English
industrial arts. Here we experience to the utmost degree the great adaptive ability
and cleverness of the English genius. There is absolutely nothing more, no style, no
mannerism or lack of mannerism, no manufacturing method, which has remained
untried. In the imitation of old Venetian glass the English compete with Salviati, in
the imitation of precious metals in glass with Candiani in Venice, in the Palissy
type of pottery with Barbizet, in large porcelain vases and in *pâte-sur-pâte* por-
celain with the Sèvres manufactory, and almost everywhere their efforts are
crowned with the greatest success.

The Staffordshire potteries, particularly Wedgwood and the Mintons, have
hitherto taken the lead in the wide field of faience. Ever since they were able
permanently to engage the services of the best porcelain painter of the Sèvres
factory, Marc-Louis Solon,[4] who went to England during the Franco-Prussian
War, they have shown themselves to be ahead, especially in French *pâte-sur-pâte*
painting [fig. 16]. [. . .]

There has been an attempt also to use jasperware for decorative purposes, in
which the single panels of an oak cabinet with glass doors are overlaid with pale-
blue tiles, where bas-reliefs in white depict scenes from Chaucer, Shakespeare, and
Milton, modeled with grace and liveliness by G. Tost. It cannot be denied, howev-
er, that at a time when unbroken color has once more assumed its proper place,
this naive type of decoration makes a very old-fashioned impression. The painted
and enameled tiles that are combined to create large paintings are more effective
than this delicate technique. Minton, Holkins and Company, whose factory is
also located in Stoke-on-Trent, devotes itself exclusively to the manufacture of
tiles of this type for floor and wall covering, both glazed and unglazed, with reliefs
and encaustic paintings. The English fondness for plagiarism has led them not to
reject even German motifs when choosing subject matter for paintings made out
of tiles. Thus we find in the exhibit of the above-mentioned factory a large-scale
reproduction of [Ludwig] Knaus's Madonna,[5] carried out in a beautiful brown-
gold shade against a white background, for the covering of a wall above a fire-
place.

These ceramic paintings are nevertheless modest—mere child's play—in
spite of their wide expanse, when compared with the incredible achievements of
the French in this field. On one of the outer walls of the art building there is a
colossal painting, some twelve feet high and thirty-five feet wide, composed of
some 1,500 tiles, which are also intended as a test of its weatherproof qualities. It
represents a hunting scene in natural tones, but of a depth and splendor of colors
which have not as yet been achieved by the English. The makers of this mon-
strosity are named Groll and Mortereau.

With this we have reached the realm of the prodigious that also thrives in the
English porcelain and faience industries. What distinguishes the Austrian and to a

larger extent the Italian industrial arts from the rest—namely taste—and what in both is, so to speak, the keynote—grace—seem to be entirely lacking in the English. Although the good predominates, even though everywhere what is graceful and pleasing delights the eye, this does not appear to be the result of a consciously creative spirit. Rather it occurs as the result of an intelligent, energetic desire to copy, which pulls everything within reach into the circle of its activity, the beautiful along with the ugly, the classically simple along with the bizarre, the elegant along with the cumbersome and clumsy. At the Vienna exposition justifiable complaints could already be heard concerning the oddities produced by English porcelain painters and designers. The Paris exposition has again delivered plentiful material for the Chamber of Horrors. Thus in the Wedgwood exhibit, which still represents relatively the best taste, we see a porcelain service on the plates of which the painter has scattered leaves in autumnal colors, yellow, ugly, shrunken and shriveled, which look as though a caterpillar or some other repulsive worm has crept in among them. Daniell and Son, one of the best-known firms, exhibits a white plate, decorated with a gold band, on which a growing strawberry plant in natural colors is represented in relief. [. . .]

The Royal Worcester Porcelain Company, while continuing production of its ivory porcelain, which is also made by Wedgwood and other firms in equally good quality, has turned to imitations of Japanese ware. It has successfully achieved the clumsiness of the shape, but not the captivating delicacy of the gold ornamentation that combines so charmingly with the yellowish base color in the Japanese originals.

Even more strange than the vagaries of the porcelain painters are those of the makers of terra-cotta ware, who misuse their material in the most extraordinary experiments. The colossal holds the greatest fascination for them. One of them exhibits a massive six-foot fountain supported by a pillar in the form of a satyr, around which two nude boys chase each other. Doulton and Company has decorated the garden of the pavilion of the Prince of Wales with another spiral-shaped fountain, six feet high and six feet in diameter. Twenty-two scenes from the Holy Scriptures, all of them connected in some way with water, for example, Eliezer and Rebecca at the well, Christ and the Woman of Samaria, appear on this enormous fountain, which is made of Doulton stoneware of an unusual mixture [of clay]. [. . .]

While England's industrial art may claim the reputation of having not only broadened but deepened itself by assimilating all actively existing branches of other nations' crafts, Austria is first in matters of taste. The noble early Italian Renaissance and the example of the fine German Renaissance run like golden threads through all the Austrian arts and crafts. In no other country is work carried out in accordance with artistic principles so conscientiously as in Austria: in no other country does such a pure, refined taste govern. The reason for this phenomenon becomes clear when we enter the Austrian exhibit from its dignified loggia in the Rue des Nations, the high point in this exposition building. The work of Austrian arts-and-crafts and technical schools and the opulent publications and

models from the Austrian museum rightly provide the introduction to the exhibition. The museum gave the initiative to the reform of arts and crafts, which was carried out with astonishing speed and which met with magnificent success; it developed a formal network of applied-art schools throughout the many states that comprise the Austrian empire. The clarion cry that rang out from Vienna was echoed in the furthest mountain regions of the monarchy. [. . .]

The French exhibit strives above all to impress by the quantity of materials offered. It was not important to the organizers to please the eye by skillful decoration and display, to dazzle through individual masterpieces, to satisfy the connoisseur by an elitist exhibition, but through massive offerings to give brilliant proof to the nations of the world that the productive capacity of France was not in the least reduced or shaken by the Franco-Prussian War.

One must concede that this aim has been highly successful. If, however, one seeks artistic gain from this massive offering, the actual result is very meager. The same signs that we observe in French art show up in French industrial art. It deviates more and more from the path of pure beauty and artless grace, and follows ever more eagerly the moods of dilettante collectors, who prefer what is most bizarre and most daring. The Rococo almost totally dominates the field of French applied arts [see fig. 15]. One realizes that constantly working in an artistic direction that represents decadence must finally lead to an inevitable decline.

The "Exposition des Manufactures Nationales" in the *galerie d'honneur* provided a brilliant opening for the French exhibit, for which huge pieces of pillared Greek architecture, with niches, architraves, and mouldings, had been erected on a high ground, in a sort of hall of fame, in which the products of the Gobelin works and of the Sèvres porcelain factory were brought together in a colorful unit. If the French have set out to dazzle, they have above all succeeded with their Gobelins.[6] Their aim is to ignore completely the individuality of a textile and instead to rival the original paintings to the point of illusion. Indeed, they have achieved their goal to such a degree that it does not seem to be humanly possible to improve upon it. Thus in this important branch of industrial art which is the pride of France, limits have been reached that the next generation cannot exceed. What remains is a perpetuation of the same thing, an ossification, a choking mannerism, or a slow decline from the present level. Since the Gobelins craftsmen could not soften their colors with a brush or blend the tones as did the painters, they had to find another way. A sharp-eyed observer discovered that the subtle transitions of one shade into another, by which the illusion is principally created, were achieved when "at the outer margin of one shade some threads of the following shade are incorporated into it." In this way incredibly sophisticated artistic effects were achieved. For example, in order to represent—and modify—the flesh parts, or even give them a certain pallor, in the whole skin area one green thread is interwoven for every two or four reddish threads. It is not surprising that such an effect can be achieved if one remembers that the wool of Gobelins provides a scale of twenty-four tones in each color. [. . .]

As it is not the purpose of this article to glorify once again the universally

known and much-acclaimed strong points of the French in their porcelain and bronze industries, but rather merely to confirm the progress made since 1873, we need only briefly dwell on the porcelains and faiences. The extended use of *pâte-sur-pâte* painting at Sèvres can be counted as one of the most significant innovations. Whereas at the exposition in Vienna only white painting on a dark background was to be seen, masses of color have now begun to be applied. However, neither the thinly liquid glaze nor the fine blending into the dark background have yet been achieved, as is possible in the white *pâte-sur-pâte* paintings. The whole effect is not yet that of a painting, but looks completely like a relief. In the luminosity of the applied colors the splendid quality of the material already shines triumphantly through. Unfortunately the taste of the painters in Sèvres has totally degenerated since Solon departed. The disease that affected the entire population of Paris, which the painter Alfred Stevens so neatly caricatured in his painting *Japanese Parisian,* also penetrated the quiet valley at Sèvres. The models for these short-trimmed branches and vines, in which colorful birds flutter about, were borrowed unchanged from the Japanese porcelain painters. The artlessness of the Japanese, however, was completely lost on its detour via Paris, and there is no trace left of the true French charm that inspired Solon's ornaments and figures, still in the classical style. A similar phenomenon is apparent in the painting of faience, which in general is still the most justly renowned branch of French industrial art. Along with the most wonderful imitations of Italian majolica and the most tasteful paintings after famous models, a new school is already prominent. Like Daubigny in his landscapes and the so-called Impressionists, it is concerned only with spattering loud colors next to each other, the chief effect of which is to arouse curiosity. Japan may also have been the model for these faience painters. [. . .]

The bronze manufacturers have also made a good thing for themselves. They have certainly cleared out their warehouses, brought together a colossal number of diverse objects, and arranged them in tasteful groups, so that no section so well achieved its goal to dazzle and surprise as did theirs. But whoever looked more closely found that besides the masterfully chiseled showpiece for which the Barbedienne foundry is ranked very high,[7] whole battalions of mechanically polished dolls are paraded, which we in our beloved Germany do so poorly. Nevertheless, such an observation does not prevent us from recognizing that in the bronze-ware industry, France is still the leading country in the world.

Translated from Adolf Rosenberg, "Das Kunstgewerbe auf der Pariser Weltaustellung," *Zeitschrift für bildende Kunst* 14 (1879):15–22, 81, 208–13.

1. In 1873; see Elizabeth Gilmore Holt, *The Art of All Nations,* pp. 545–76.

2. Antonio Salviati revived the art of glass manufacturing and mosaic in Venice, and soon became celebrated throughout Europe. In 1868 he established a glass factory at Murano.

3. Middle Kingdom, a designation for China, the Celestial Kingdom, here referring to its location midway between earth and heaven.

4. Marc-Louis Solon studied drawing under Lecoq de Boisbaudran, decorator at the Manufacture National de Sèvres from 1850 to 1870. He became a specialist in *pâte-sur-pâte,* a process in which the object must be kept moist while the artist places a colored clay on a white clay, then works

out the design with a knife. The result is a kind of cameo work. The object must be placed many times in the kiln for the white clay to obtain the proper transparency. At the time of the Paris Commune in 1870 Solon fled to England, where he was employed by Minton and Co. at Stoke-on-Trent until his death.

5. The Knaus Madonna, painted by Ludwig Knaus in 1874. Knaus was a favorite painter of the Prussian Court.

6. The Manufacture Nationale des Gobelins was founded when Louis XIV bought out the Gobelin brothers tapestry works in 1662 to provide hand-woven tapestries for wall hangings. Distinguished painters were frequently called upon to supply designs for some pieces.

7. Ferdinand Barbedienne established a factory in Paris in 1847 for the production of bronzes, silverware, and reproduction furniture. By the 1880s, in keeping with fashion, he was producing *japonaiserie* furniture and imitation bronzes.

1888: Barcelona

Catalonia remained aloof from the three centuries of westward expansion begun by the Spanish crown in 1492, and instead attempted to establish Catalonian independence. That goal led it to side with Austria and England against Louis XIV in the War of the Spanish Succession, but the Treaty of Utrecht (1713) that ended the war denied Catalan autonomy, and without outside support, Catalonia had no choice but to unite with Spain under Philip V, a monarch determined to forge a centrally administered state based upon the French model. Catalonia's principal city, Barcelona, continued to resist, however, and was besieged until it finally surrendered in September 1714. Much of the independence it had enjoyed in its heyday as a port city rivaling Genoa and Venice was lost when a governor and troops were installed in the ancient citadel, the Ciudadela.

Catalan national resolve stiffened once more in the nineteenth century, inspired by the emergence of the other national movements that had sprung up all over Europe. When the Spanish parliament, the Cortes, took away the rights of the Catalans to use their own language in the schools and to have their own coinage and regional administration—actions taken to strengthen the centralized government—they responded by reviving a traditional poetry event, the *jochs florals*, and by publishing a Catalan-language newspaper.

In 1841 the Bourbon princess Isabella was declared of age at fourteen and made queen of Spain, but a succession of military politicians retained effective control until the army and navy openly overtook the government in 1868 and forced the queen to flee. In search of a new ruler, the provisional government, led by generals Serrano and Prim, the latter a Catalan, first selected a Hohenzollern prince suggested by Chancellor Bismarck—an "interference" that provided the pretext Napoleon III needed to declare war on Prussia in 1870, even though the offer was declined. Now under French influence, the Spaniards turned to an Italian prince, Amadeo of Savoy, duke of Aosta. Unfortunately, the day he landed in Spain his sponsor and protector, General Prim, was assassinated. Lacking support, the maltreated Amadeo abdicated in 1873, and the government was seized by republicans. But, after four presidents—three of them Catalans—the Cortes gave up republicanism and returned to monarchy, offering the throne to Queen Isabella's eighteen-year-old son, who thereby became Alfonso XII in 1874. When he died in 1885 he was succeeded by his posthumous infant son, who

became Alfonso XIII. Even after the restoration, republican sentiments remained alive, however, and during Alfonso XIII's reign one of the briefly elected presidents of Spain, Pi y Margall, a Catalan, organized the Spanish Republican Federal Party, which remained identified with Catalan nationalism.

Barcelona, in size second only to Madrid, was splendidly situated as a port and along one of the two railroads that linked Spain with Europe, and for this reason it soon regained its earlier importance after its capitulation and developed rapidly. Catalonia's basic industries—shipbuilding, textiles, and machinery—combined with its art industries—furniture, ironwork, silversmithing, and glass-blowing—and its energetic, imaginative, astute leadership also made it a vigorous cultural and industrial center. In 1888 it took advantage of Spain's negotiations for tariff and commercial treaties with France and England (which were, together with Germany and the United States, Catalonia's principal trading partners) to secure, if not the whole-hearted support, at least permission from the central government to hold an international exposition in Barcelona. Such an event would attract visitors to the region and permit Catalan industrial and artistic products to be viewed in competition with those of other industrialized nations.

Catalonia's determination to compete successfully with other developing industrial centers was long-standing. As early as 1822 the Junta de Commercio had held an exhibition of industrial products. The Industrial Institute of Catalonia was established in 1851, and a new building was provided for exhibitions of *objectos artisticos* in 1869. Two years later Salvador Sanpere y Miquel had been deputized to supervise programs concerning industry and the arts in schools and museums similar to those established in England, France, and Germany in the wake of the first of the universal expositions. He had then played an active role in the subsequent expositions of industrial arts held in 1881, 1882, and 1884, which had interested the city's architects in the revival of the traditional relationship between ceramics, iron handicrafts, and building construction. The exhibition of decorative arts held in the building of an institute to encourage national industry in 1881 had given the young architect Antonio Gaudí an opportunity to publish a report on the situation of the crafts and industrial design in Spain in *La Renaixensa*,[1] a journal founded in Barcelona in 1878 by writers, musicians, and artists to further the revival of Catalan culture.

Barcelona was therefore a city reasonably well prepared and equipped by 1888 to stage a universal exposition. The second Marquis of Comillas, owner of the Compañia Transatlántica and brother-in-law of Catalonia's foremost textile manufacturer, Eusebio Güell y Bacigalupi, who was also an economist and publisher and the Maecenas for art in Barcelona, was appointed director. A suitable site was found in the area near the harbor that had once surrounded the Cuidadela. The fortress had been razed in 1868, and the area where it had once stood had been in the process of conversion into a park since 1872. A monumental, fantastic cascade with groups of figures had been erected between 1877

1. *La Renaixensa* (1881): 709–11, 739–40.

and 1882 at its north end by the park designer José Fontseré Mestre (d. 1897), with the assistance of Gaudí, who was then still an architecture student.

Elias Rogent i Amat, the respected architect of the university's new building and a revivalist who was known as the "Catalan Viollet-le-Duc" was put in charge of the exposition buildings (plan 3). The chapel of the Ciudadela was converted into a pantheon for Catalan luminaries and the palace of Philip V into a pavilion for the thirty-year-old queen regent and her two-year-old son Alfonso XIII. For the industry and commerce building, Serrano Casanova and Giacomo y Condia designed an immense semicircular building reminiscent of the elliptical structure built for the 1867 Paris exposition. The colorful Moorish style, which the French had borrowed for much of the decoration on the 1878 Paris exposition buildings, was here used in its native habitat for the main facade. The architect Adriano Casedemunt skillfully employed traditional Catalan brickwork in the twenty-one-meter-wide iron arches that spanned the main gallery of the machinery building.

At the north entrance of the exposition was the Palace of Fine Arts, built to remain as a permanent museum. The task of designing it had been assigned to August Font y Carrera, an architect trained in the French Beaux-Arts tradition. Near the museum was the colorful tile-decorated triumphal arch—which still stands today on the Pas de Sant Joan—designed by José Vilaseca y Casanovas. He, like Domènech y Montaner and Gaudí, was helping to revive the use of traditional decorative arts in architecture.

For the exposition, Gaudí had time only to design a completely Moorish style building for the Compañia Transatlántica of the second marquis of Comillas, the design of which had been inspired by his travels with the marquis to study Islamic architecture in Andalusia and Morocco. Gaudí was otherwise occupied designing buildings for the marquis's brother-in-law Güell's estate and as the architect of the Expiatory Church of the Holy Family, a task he had taken over from the architect Francisco de Paula del Villar y Lozano in 1886.

Lluís Domènech y Montaner, an ardent Catalan nationalist who had completed his studies in Madrid (which at that time had Spain's only accredited professional architecture school) was commissioned to design a hotel large enough to accommodate a thousand guests, in addition to a sumptuous cafe-restaurant to be built within the exposition grounds. The restaurant, constructed of bare brick and laminated iron, was a parallelepiped with towers at the four corners, which (at a distance) resembled a medieval fortress and was known as the Castle of the Three Dragons (fig. 17). In order to achieve a smooth exterior wall elegantly decorated with brick, it was buttressed in the interior nave. Shields of colored ceramic tile commonly used in the region for ornamentation were arranged below the castellated roof and emphasized the horizontal line. The battlements served to conceal the glass roof that illuminated the two-storied interior. The austerity of the wide interior space, achieved with bare iron arches, was alleviated by the arches themselves, by ornamental ironwork in the railing, and by capitals set with ceramic mosaic (fig. 18). For the colored ceramic tiles used to decorate the restaurant, Domènech enlisted the collaboration of the architect

Antonio Maria Gallissà y Soqué, yet another participant in the revival of orna-
ment and decorative arts in architecture.[2]

This gigantic cafe-restaurant gave Domènech another chance to apply the
ideas he had expressed in his essay, "In Search of a National Architecture." He
had already carried out these ideas in the design for the printing plant and office
building of the Editorial Montaner y Simon, his father's publishing firm. In the
essay, published in an early number of *La Renaixensa,* he had asked, "Can we
today really have a truly national architecture? Will we be able to have one in the
near future?" These questions were widely debated and discussed, stimulated
perhaps by the first Rue des Nations in the 1878 exposition in Paris. His convic-
tion that a national architecture must be created was also shared by his colleagues,
and their efforts to achieve one can be seen in the designs for the Casa Vicens and
Palacio Güell (1878–80, 1885) by Gaudí, the Museo Biblioteca Victor Balaguer
by José Fontseré Domènech (1882), the Academia de Ciencias by José Domènech
y Estapà (1883), the Industrias de Arte Francisco Vidal by José Vilaseca (1884),
and the Salenas by Juan Martorell Montells (1885).

When Barcelona's exposition opened in May 1888, it received adequate
press coverage and critical analysis only in the local press. One of the few critical
appraisals of the international fine arts exhibition, which appeared in the small
but widely circulated *Diario de Barcelona,* gave an appraisal of what was on view
in the industrial building and the fine arts exhibition. It was written by Francesco
Miquel i Badia, another supporter of the decorative arts who in the 1870s had
written articles in favor of measures to improve all branches of education in
Catalonia. In his review of the painting he defended the anecdotal realism and
technical virtuosity exemplified in the work of his friends Francisco y Manovens
and Mariano Fortuny and opposed Impressionism and the artists associated with
the plein-air technique of the emerging "modernism."

The drama and art critic of Barcelona's lively, independent *Illustración
Artística,* José Yxart, first began contributing to its pages in 1872 when he was a
student at the university. A poet and translator of Schiller, Yxart wrote criticism
for numerous newspapers and belles-lettres journals in a style similar to that of
Gautier and Daudet, including a report of "Les arts en l'exposicíon de Paris"
(1878) for *La Renaixensa.* Yxart's exhaustive coverage of the 1888 Barcelona
exposition appeared in installments in *Illustración Artística* and later in *El Año
Pasado* (1888), a collection of his criticism from that year.

Another member of the group actively engaged in reviving Catalan cultural
life was Salvador Sanpere y Miquel, a journalist, historian, and student of archi-
tecture. When Barcelona's exposition closed, Sanpere y Miquel gave his judgment
of the industrial arts that had been on view. His recommendations of the measures
to be adopted to improve the quality of the Catalan decorative arts followed in a

2. See Oriol Bohigas, "Lluís Domènech y Montaner," in J. M. Richards and Nikolaus Pevsner,
eds., *The Anti-Rationalists* (Toronto, 1980), pp. 71–84. Bohigas writes of this building that "the
volumetric and spatial skeleton . . . , the quality of its material and construction, make it, historically
speaking, one of the most important works of its time in Europe. The use of exposed iron, not only in
the roof arches but even in the facade lintels, is particularly remarkable" (p. 79).

lecture to the Ateneo, a society of intellectuals, artists, and manufacturers that sponsored conferences to encourage the improvement of the arts. *La Renaixensa* published the lecture in 1889.

Outside Barcelona little attention was given to the exhibition. Besides Spain, only France, Belgium, and Germany were represented in it, and in the opinion of the critics, the painters, including even the Spanish artists, of the greatest genius and renown had preferred to send their work to universal expositions in Europe's major art centers. Of the art magazines only the *Gazette des Beaux-Arts* published a report; it was written by its director, Alfred de Lostalot. Familiar to his readers for authoritative reviews of decorative arts, de Lostalot found nothing notable in the paintings or sculptures; he too felt that not one of Europe's, or even Spain's, best artists was represented. He commented that Spanish architects had obviously delved with profit into the French publications on Islamic architecture, noted the influence of France and Germany, and remarked on the few distinctive or original qualities of the Spanish decorative arts displayed. It was the taste and ingenuity that the Spanish exhibitors showed in the arrangement of their products and the restrained sobriety of Spanish decoration of objects that elicited his most favorable comments.

Barcelona's invitation to other nations to send exhibits had coincided with offers from other places—Melbourne celebrating Australia's centennial, Glasgow providing a "Scottish show" to express national pride in its industrial success, the Belgian government soliciting applied-art objects to show from June 1888 to May 1889 in Brussels, and the French government celebrating the centennial of the French Revolution in 1789. As a result of all these competing attractions, the European press covered only the opening ceremonies, which were held in the presence of the queen regent, the well-behaved, two-year-old Alfonso XIII, the duke and duchess of Edinburgh, Prince Rupert of Bavaria, and lesser nobility.

Although Barcelona's exposition received little outside attention, it nevertheless attracted 2,240,000 visitors before it closed its doors, and provided concrete evidence of the continuing strength of the revival of the arts in Catalonia which would do much to establish its importance as a creative center. Through this artistic renaissance Spain would make important contributions to contemporary European art and to the devleopment of the abstract and international art forms of the twentieth century.

In Search of a National Architecture
LLUÍS DOMÈNECH Y MONTANER

The last word in every conversation today about architecture, the basic question of any criticism, returns inevitably to a central idea—the idea of a modern, national architecture.

And whenever this question comes up we have to ask ourselves: can we today

really have a truly national architecture? Will we be able to have one in the near future?

As much as in any other human creation, the architectural monument requires the energy of a productive idea, a moral milieu in which to grow, and the materials available for its formation. The artist, who functions as a more or less perfect instrument of the idea, must reconcile architectural form to this idea and to these moral and physical resources.

Whenever an organizing idea dominates a people, whenever a new civilization asserts itself, a new artistic epoch is born. [. . .]

Only those societies that are without firm convictions or fixed ideas and fluctuate between today's beliefs and those of yesterday and have no faith in tomorrow are unable to write their history in durable monuments. Since their ideas are transitory, so are the monuments they create. [. . .]

In times of transition, when ideas unceasingly struggle amid discordant notes of universal passion, it is impossible to find the grand harmony that is reflected in every period of great architecture.

If modern civilization were not consumed by internal struggles, and if the public could guide the artist with its opinions and approval, undoubtedly modern civilization would give birth to a new architectural period; and it will in time, though at the slow, measured pace that artistic development takes. Never before have there been so many ingredients to foster it. The ideas of justice and emancipation initiated by Christianity have finally entered the collective spirit of governments, in some cases in practice, in others in aspirations not yet attained. The questions of form, rather than of ideas, produce the constant struggle that consumes the vital energies of modern society. Every kind of thinker agrees that these ideas create requirements in the running of civilized nations and the construction of buildings to satisfy them. [. . .]

Everything points to the dawn of a new era in architecture, but we must confess that we still lack a public with taste and firm ideas, we lack a public that has been taught decorative drawing in school or has learned art appreciation. A public with an artistic sensibility would be able to guide modern artists thoughtfully, just as the Greeks in the Athenian agora guided their architects.

Today's architect finds himself in the midst of our complicated modern civilization, with an endless supply of artistic needs and materials, and with infinite means to satisfy them. At times, however, for lack of instruction during his formative years, and at other times for lack of sufficient talent to apply the knowledge he has acquired, the modern artist feels more like a slave to his materials than their master. Only after a certain period of time (which is difficult to determine) will he be able to unite in his creations all the materials civilization gives him daily. At that moment, the artist must cast off all his ties with the stale and ignorant preoccupations of academic training; furthermore, he must not seek to show off a facile type of imagination the public would know how to appreciate in its simplest works. Modern architecture, daughter and heiress of all past periods, will then rise above all her predecessors, bejeweled with treasures inherited from them, along with those acquired from industry and science.

But an architecture acquired in this way will be, like all others before it, the art of a generation; it can express a civilization but not a nation. In a word, given present conditions in our modern society, architecture cannot conserve a truly national character. The nation's own spirit can modify the general modern type, can constitute a school, but it will not meet the conditions needed for a distinct art, that is to say, with its own system of construction and its own ornamental system. The continuous expansion of knowledge beyond its frontiers, the powerful force of assimilation in modern education, the similarities in the organization of countries will defeat every effort to create a national architecture. Roman art was not Roman because it originated in Rome, but because it represented Roman civilization. If a new architecture is created in any particular country which fulfills the requirements of that moment, it will soon spread to those other civilized countries that profess similar ideas and have similar resources. It would soon become a modern architecture, but not a national one.

It is true that the secular character of a people, artistic traditions, and climate can make the buildings of two countries, which otherwise seem to share common ideas, vary profoundly. These variations on the same architectural idea may become visible in countries with a character, a climate, and traditions that are clearly defined and different from each other. But in the case of the peoples that make up the Spanish nation, not even those variations common to all in modern art will make it possible for a single architectural style to be completely achieved.

What are our common artistic traditions? What is our common character? What is the physical milieu we may consider national?

Neither the same history nor the same language nor equal laws, customs, or tastes have shaped the diverse Spanish character. The most varied climate, a terrain different in its topography, formation, and nature make up the different regions of Spain and, as one might expect, an artistic tradition has emerged that is predominantly Arabic in the south, Romanesque in the north, Gothic in the lands of the ancient crown of Aragon, the old center of Spain, and Renaissance in the towns that owe their vitality to the centralizing power of the houses of Austria and Bourbon.

From these artistic elements it is difficult to form an architectonic unity that would be more Spanish than any other national style and would still be equally pleasing to all of us. [. . .]

In addition to a combination of external circumstances, when we look among artists and even more among critics to see if we can define a modern and a national architecture, we can detect four tendencies emerging.

The first and most ancient of them, not only here but throughout Europe, is the one that proudly proclaims itself as classical or Greco-Roman. Our generation knows Greek art and the wise construction and architectural structures of the Romans much too well to allow such a name to be given to pseudoarchitecture. The majestic Doric column, the elegant Ionic column, the rich, gracious Corinthian column [were all functional]: they were rounded at their bases because they served as isolated supports for porticoes where crowds had to circulate; they

were light and slightly elevated because they supported only a simple roof; and they were firmly planted on a base suitable for its purpose. In pseudoclassical architecture columns lose their functional character and can even be found in front of facades, like cardboard castles piled on top of each other. The form of the column no longer corresponds to any kind of requirement or function in construction, and sometimes they become flattened below the capitals, in the form of pilasters, against all canons of Greek good taste. Through the facade, one can see balconies and windows that interrupt the verticals without any order or harmony, as if the temple had been converted into rental housing. [. . .]

But why should I bother to repeat what has already been popularized so thoroughly in volumes by Viollet-le-Duc, Boutmy, and so many others? Architecture has been completely betrayed by all those people who without conscience destroyed the excellent achievements of the Middle Ages and copied form without understanding classical feeling. It is today a corpse, or better, a disfigured mummy, lacking the life or purpose of classical architecture. Nevertheless, something of it still remains from those who practiced it in other times and those who presume to be informed—the ones who are continually lamenting the past but do not trouble themselves to correct the present, much less try to predict the future.

Another school, eclectic though respectable, pretends to preserve classical traditions by applying them to buildings to which they are naturally adapted in order to give them life. This school, like the previous one, is not precisely national, but at least it stems from the study of ancient classical art or art of the Middle Ages. Its principal center is German. For it, a cemetery must be Egyptian or something like it, a museum must be Greek, a parliament house must be Roman, a convent Byzantine or Romanesque, a church Gothic, a university Renaissance, and a theater half-Roman, half-Baroque, for a style with some variations. We do concede that this school is based upon some knowledge, but we do not believe we must support it. Ancient forms do not go well with our current needs nor our techniques of construction, and as a result the followers of this eclectic school frequently find themselves compelled to violate their knowledge of tradition and purpose. They must hide the modern means that they employ, such as girders and steel columns, which are hard to disguise when they respond to a genuine need and, in any case, deserve to be seen. We also consider it very sad for this generation, because when it is called to judgment by the next, all of its monuments may be rejected for the lack of any particular form.

Finally, so far as we are concerned, there are two other trends that have very respectable origins, for they attempt to continue the traditions of the Middle Ages that were unfortunately interrupted by the Renaissance. The first of these two schools prefers Romanesque monuments and pointed arches and, as a consequence of patriotic pride, it favors the school of Aragon, which is well represented in Catalonia. The second looks to Arabic architecture or its modifications, generally known as *mudejar,* of which there are important and numerous examples in Toledo. If three or four centuries had not gone by since those two styles were arrested in their course, and if we could have remained isolated from movements

in Europe, we believe they might have developed into two distinct national architectural styles: one that would possibly have been appropriate for central and southern Spain, the other more adaptable to the eastern part of our nation. Perhaps the two could have united and forced the creation of a third architectural style, but frankly both reason and emotion lead us to believe that any route taken in that direction would not lead us to a brilliant era in modern architecture. We have enthusiastically devoted hours and days to the study of monuments in each of these two styles in Toledo, and on each of those days, returning to our inn through the mists of the Tagus River beside the Alcazar,[1] we reflected on what we had studied, and our admiration for what had been done increased anew, as did our disillusionment over what we still had to accomplish. We found [architectural] composition elastic, as it were; much can be extracted from both styles—one cannot deny that—and a single edifice will illustrate that point. The new Arsenal of Vienna[2] stems from identical traditions and is, in our opinion, perfectly composed. But neither this nor any other attempt to build with the elements of those two styles is sufficient to satisfy the requirements of our own times.

How can we support the great hall of a theater, for instance, if we submit it to the proportions of Arabic or Gothic art in which the vertical preponderates? How can we obey the new and eminently rational laws of economics and construction, which today force us to accept iron with its new mechanically determined forms? How can we follow the forms that in great halls are dictated by the laws of acoustics and optics if, at the same time, we have to subject them to forms that were never meant for those purposes? We would never finish if we tried to indicate all the difficulties in practice that militate against using the old form and oblige us to search for new ones. If we want our architecture to appear as Gothic or *mudejar* we will have to dress it up with four or five elements taken from that period, and that will only emphasize still further the poverty of our invention.

Why not devote ourselves honestly to our mission? Why not create—since we cannot form—a new architecture? Let us be inspired by patriotic tradition, so long as it does not lead us to betray the knowledge we either already have or may yet acquire.

Let us accept the principles of architecture that have been taught to us by all previous ages, for we need them all for good guidance. Let us allow decorative forms to be determined by structure, as was done in the classical period. Let us discern in Eastern architecture the "why" of its imposing majesty, in the predominance of horizontal lines and great smooth or lightly worked surfaces which contrast with solidity and the strong Egyptian line. Let us uphold the treasure of taste from the Greek temple. Let us study the secrets of grandeur of Roman construction, the idealization of materials in Christian temples, and the system of multiple ornamentation in Arab decoration, which is clear and orderly at various distances. Finally, let us learn from the grace of Renaissance drawing and from so many other bits of knowledge. If we study without copying we might learn from the art of all previous generations, and after stringently testing all of these principles, we could then openly apply them to the forms that new experiences and

requirements impose upon us, enriching them and giving them expression with the ornamental treasures that the monuments of all times and nature offer us. In a word, let us assiduously venerate and study the past. Let us search with firm conviction for what it is we have to do today, and let us have the faith and the courage to accomplish it.

We might be told that this is simply another kind of eclecticism. If to extract its principles from all good doctrines (and since they are good they cannot be contradictory) is to be eclectic; if to assimilate them as the plant draws air, water, and land to itself (the elements that are needed to live a healthy life) is to be eclectic; if to believe that all generations have left us something good to learn and to want to study and apply it is to fall into that error, we declare ourselves convicted of eclecticism.

We know well that for those artists who wish to follow these principles, this is not the easy road to triumph, nor is the steady work required the road to profit for today or glory for tomorrow. To accomplish our goals is not the work of two or even three generations; and even when our goals are realized, what each artist of today has done will merely be one more drop in the sea of past ideas.

Translated from Lluís Domènech y Montaner, "En busca de una arquitectura nacional," *La Renaixensa*, 1878, as reprinted in Lluís Domènech y Montaner, *Cuadernos de Arquitectura* (Barcelona, 1963), pp. 52–53.

 1. The Alcazar, a palace built in 1540, is a true Spanish type of the Renaissance, with the simple ashlar masonry of its walls and the accentuation of the principal entrance and windows.

 2. Arsenal of Vienna: commissioned in 1848 and completed in 1855 from designs from Eduard van der Null and his partner August Siccard von Siccardsburg.

The Plan of the Exposition: Its Principal Buildings
FRANCESCO MIQUEL I BADIA

[. . .] Of a totally different character from the fine arts, science, and agriculture buildings examined thus far is the edifice destined to be a restaurant, which is located in front of the principal entrance to the Palace of Fine Arts in one of the oldest corners of the park. The building was designed and, until recently, its construction was directed by the architect Lluís Domènech y Montaner, who has given eloquent proof of his superior knowledge of techniques of construction, as he did in the Grand International Hotel. Today it is difficult to judge the restaurant building with any certainty, for as it is now, the effects of lightness and elegance intended by the architect have not been achieved. Instead, its immense surfaces are reminiscent of a feudal castle, somewhere between Christian and Arabic design—architectural elements are drawn from the Poblet [monastery] and the Lonja de Valencia and mixed with typically Moorish arches and windows. Will the heavy and melancholy effects it presents today disappear when the windows, arches, and surfaces are decorated as they were intended to be by the young

architect and designer of the plan? Will not the combinations of glazed tiles break the sameness and monotony of the surface, and result in a building that seems lighter, more slender and picturesque, and ultimately more appealing both to sight and to the soul? The restaurant will have to be completely finished, both in construction and decoration, before these questions can be answered, and that is very far from being the case now, since without a doubt the work in the park has been the most subject to delay. Whoever examines this brick structure with care must admit that Mr. Domènech is a skillful master in the use of brickwork, for he has solved some basic problems of construction in the halls, stairways, and various other places—or at least so it appears—by employing arches in a way that satisfies both engineering and aesthetics, or shall we say both for solidity and for the beauty of the building. When it is finished it may well turn into a building appropriate not only as a restaurant but also for a more artistic purpose, such as a museum of archaeology or antiquities.[1] The ancient Gateway of Hal in Brussels served that function until a few years ago, and now it houses arms and armor, tapestries and embroideries, furniture, ceramics, and jewels of past centuries in a building not quite so suitable as the one we are discussing. [. . .]

Leaving the two pavilions adjoining the entrance to the park, where a construction system has been followed comparable to that adopted for the Palace of Industry, we arrive at a very important part of the concourse. The design of Mr. Serrano Casanova that was chosen for the [Palace of Industry] turned out to be, more or less, a reproduction of the ellipse of 1867 in the Champ-de-Mars in Paris. The radii in the semi-ellipse or fan and in the general plan of the palace form spacious and elegant naves that vary according to how they are placed. The corridors or sections are occupied by each of the exhibiting nations; if the various products were placed according to specific classifications by following the concentric rings of the semi-ellipse, one would be able to see (as in Paris in 1867) the same product [in each of the different nations' exhibits.] This kind of arrangement has been done in only a very rudimentary way in some of the sections. In others, including the Spanish section, a picturesque effect has been preferred to a rather logical and rigorous organization of products, which is very much in keeping with the idea in vogue today that the attention of the visitor to expositions must be attracted by ostentatious and theatrical installations. Not even this technique has succeeded in producing any especially brilliant installations, because to a greater or lesser degree the same difficulties that were encountered in Paris in 1867 presented themselves, because of a total absence of architectural lineage.

The galleries of the Palace of Industry give the impression of a makeshift market, or dock sheds in which luxury merchandise in fancy wrappings has been stored. Art is absent: the installations and therefore the manufactured products on exhibition lack an appropriate background that would show off their shapes, allow their colors to glow, and highlight their quality, especially among luxury items. A spacious central gallery [in the palace] offers a moment of visual relief; it was designed and built by the architect Jaime Gusta, to whom we also owe the four towers that relieve the monotony of the line of the semicircle at either end.

However, faults in planning from the beginning have caused a pervasive air of indecision that is noticeable throughout the entire Palace of Industry.

Translated from Francesco Miquel i Badia, "Plano general de la exposición universal," *Diario de Barcelona*, October 2, 1888, pp. 122–23.
 1. This building today houses the Zoological Museum.

The Industrial Arts
SALVADOR SANPERE Y MIQUEL

[. . .] I would like to speak for a moment about the regrettable consequences of an anti-artistic tendency in the arts, which is modern industry's ability to imitate the luxurious. . . . Because the luxurious always appeals to even the simplest or most pious souls—which is why the modern evangelical priest dresses in a lace gown and brocade vestment—the highest artistic aspiration of our time always concentrates on items of luxury. One example of this: everyone has rightly admired the vase made by the Masriera brothers[1] at the exposition, and undeniably in this object the sumptuous goes hand in hand with the artistic. When the sumptuous is applied or shows itself in works like this vase, we can say that art is behaving like beautiful women who enhance their beauty with all the things that are capable of kindling an ardent fire in man's soul; but when the sumptuous is applied to works destined for everyone, including the poor and the disinherited, art makes a bad job of it, and industry is committing a sin.

Thanks to the means that science (physics and chemistry) has put at the disposal of the artist, today it is possible for the Masriera brothers to make reproductions of their beautiful vase at a price far below that of the original. Now many whose desire to possess the vase would have been for them only the wildest dream can have a reproduction that might almost be taken for the original. . . . Another example, not so sumptuous it is true, is a room lined with tapestries. This was once so luxurious a practice that it was prohibitive for even the grandest families. Nevertheless today what was denied to them has become possible for us, for all we need to do is go up to the store of La España Industrial and buy tapestries at so much a yard. But what, ladies and gentlemen, will be the result if we all buy cotton tapestries? [. . .]

In some fortunate countries there are men, corporations, institutions, and governments that concern themselves with the needs of art and industry by encouraging them to further progress and to make a contribution to the moral development of the people. They search, in an already time-honored tradition, for ways to keep the industrial arts within bounds and to protect families from the false needs that begin by debasing the character of objects and end in total prostitution of design. I could quote from some of the programs of the Union Centrale des Beaux-Arts Appliqués à l'Industrie in Paris, today's Musée des Arts Décoratifs, where in 1860 prizes were already being offered to artists and indus-

trialists for furnishings that were both economic and artistic; for it is right and necessary to furnish the poor man's house in an artistic way and to dress him well for the sake of the moral effect that art engenders in all those who cultivate, love, or caress it—just as it is criminal, antisocial, and inhuman to estrange the poor from art or to provide them with a false art. [. . .]

There is no country more industrial or mercantile than England, I trust you will agree. England was the first nation to hold a universal exposition . . . the one that was for European industry what the Revolution of 1789 (which will be commemorated in Paris this year by all men of good will) was for European people.

The English did not invent the idea of expositions. It originated when the French, convinced that they were incapable of conquering England's titanic struggle against their Revolution, thought that they could at least find revenge in annihilating England's industrial power. [. . .] [But] England was the first country to hold a universal exposition—in 1870—where the products exhibited were identified by the name of the manufacturer or craftsman. While France worried about socialism along with many other slogans . . . England, a country that likes to get to the bottom of things, went to the heart of the matter and found it worthwhile. [. . .]

I will tell you later what England did to regenerate its artistic industries; let it suffice now to say that two men working together were able to bring about the marvel . . . and they were Henry Cole and Prince Albert, Queen Victoria's husband. That is why there are monuments to both in Kensington—Cole inside the [Victoria and Albert] museum, and the prince in the Albert Memorial in [Hyde] Park—each in his own place. Cole presided over the work; the prince presided over the public. Cole and Albert agreed on the plan for the series of projects that were intended to inform and educate not only the public but also artists and industrialists. [. . .]

Now perhaps you will understand why all English institutions dealing with applied art and industry revolve around the South Kensington museum, for everywhere the center is the museum. This is true in Austria, Berlin, Württemberg, and Paris.

A museum educates the public and instructs the artist, a double function that must never be ignored . . . we do not want to be forced to repeat what Henry Cole said to the parliamentary commission appointed to investigate the vast expenditure the English government was laying out to protect industry by encouraging instruction in the arts. The economists in the House of Commons did not understand the value of public instruction through museums, so Cole told them in colorful Shakespearean language that "it was not merely a matter of bread and cheese."

A people who want to cultivate art and its applications need at least what the soldier who goes to war needs, namely, weapons; weapons can only be found in arsenals, and the arsenals of industry are the museums. [. . .]

Is it not remarkable that industrial production, in spite of its shortcomings,

has done as well as it has considering the lack of guidance? Our artists do not know when or how to train themselves, or how to realize their dreams, because we deny them the museums that are their libraries; we deny our workers the knowledge of what skillful hands can do, because we do not provide them with examples in museums. [. . .]

Today, considering what we have all seen and learned, it would be unforgivable to continue our passive attitudes toward industry.

It is unthinkable that our public, who bought up appealing products from Japan without understanding why they preferred them, will not be more demanding in the future. Those who expressed the attitude that artistic-industrial decoration should be based on the expression of essential line and form and that colors must not be applied in half-tones or shades of the same color but in contrasting ones, will demand greater simplicity in industrial design and more color in their products. Those who were enthusiastic about Hungary's products, so full of the character of a rejuvenated nation, and those of Russia, a nation still in formation—those who have felt patriotic ardor—will demand that our industry reflect more of the character of our own history, for our past is no less glorious, no less typical or characteristic than that of Russia or Hungary. Those who emptied (not once but several times) the display cases of Salviati, Candiani, and the Italian ceramicists were showing that they understood the beauty of form and color in all its romantic variety, just as those who crowded in front of the classical works of Danish ceramics said that they understood the immense enchantment of the ideal in art. All of those people will demand greater variety of forms, greater vitality and ideas, from our industry as well. Those who were so ecstatic over the Austrian section—because they were faced with so much good taste and distinction and did not know what to prefer since everything was so very good—learned of the pleasures to be found in artistic design and what it is to enjoy the charms of a life and society as artistic as the Viennese is; they will demand that our industry fulfill those same aspirations. Those who in the German section were fascinated by historic objects reflecting the glories not only of today's imperial Germany but of the times when our own Charles I reigned there will tell our industry that even without invention there are always historic styles to be revived.

Those who in France and in Belgium, its undisciplined daughter, have understood the full range of art and have admired how everyone (without questioning style) seems capable of furnishing a living room with a Renaissance sofa or with Pompadour or Du Barry hassocks will understand that art is not just an historic form that needs restoration, but something that is and emerges every day. They will demand that our industry produce works of genius, not necessarily classical or romantic, but works that satisfy the artistic aspirations of the human soul, because it recognizes beauty wherever it is—whether in the Athenian Parthenon by Iktinos or the Barcelona cathedral by Roquer, Gual, and Escuder, or in the Roman palaces of Bramante.

But what will happen, gentlemen, if we do not provide our industrialists with the tools for satisfying these genuine aspirations? What if we do not give our

designers the tools to react to them, nor our workers the means to obtain the skill that will be demanded of them?

Gentlemen: one does not desire what one does not know. Today our public knows, and therefore what it demands we must supply, and if we cannot supply it from our own store, we must look for it elsewhere. May God save our national production!

Translated from Salvador Sanpere y Miquel, "Les artes industriales," twenty-first lecture of the Ateneo, Barcelona, as published in *La Renaixensa*, 1889.
 1. The Masriera brothers, Federico and Francisco, were noted jewelers and artists who established a firm of cabinetmakers in 1878. Their products were displayed at many of the universal expositions.

Correspondence from Barcelona: The International Exposition
ALFRED DE LOSTALOT

[. . .] But it is time to enter the exposition; the walk can be beautiful enough, if works of art of particular interest are not required. The location was well chosen. The buildings rise on the vast grounds of the ancient Citadel, close by the station for the trains that connect Barcelona to the French frontier; four of the ancient buildings have been preserved, including the church. The Palace of Industry, which is not to be temporary—being the monument almost all cities holding a grand exposition deem it an honor to preserve—is constructed according to a very ingenious plan. Imagine a vast fan whose ribs, by tricks of construction, correspond to the interior divisions into galleries; the architect has skillfully corrected the disagreeable effect of perspective that the funnel-like galleries would otherwise have presented.

The Palace of Fine Arts has a vast rotunda, around whose center, which is taken up by a handsome concert hall equipped with a large organ, the exhibition rooms have been disposed; on the first floor, painting; on the ground floor, sculpture with an archaeological section still under construction at the time of our visit, and a hall in which several important pieces from the Madrid armory are displayed.

Scattered throughout the park are pretty pavilions, some intended for serious exhibits of national work, others—these are the most numerous—for cafes and other amusements.

Germany has not gone to much expense; its luxury industries have stayed away. [. . .]

To render homage to the queen, who is an Austrian archduchess, Austria-Hungary has made an effort: it occupies but does not fill two segments of the building's fan. A beautiful exhibition of china from Pest and those unavoidable chairs of twisted wood, which one now finds deposited in all the big cities of Europe, can be seen there. [. . .]

In the Italian section, which ought to have been more important since they had only to cross the Mediterranean, there are only festoons and curlicues. It seems that all industry takes Salviati as its model: products of wood, of metal, or of clay are dug, twisted, whipsawed, and painted in gaudy colors like the glassware of Murano. This exuberance makes the decorative sobriety of similar objects made in Spain singularly valuable; one need look no further for comparison.

The United States will have a handsome hall, but we saw it only in preparation. It is painted from top to bottom in a vivid blue pricked with white stars; on one side, in front of a gigantic map of the United States, a figure of Liberty is set up accompanied by two other statues of women, of which one brandishes chains and the other holds a book—without doubt the past and the present. At the other end, *Liberty Lighting the World* by Bartholdi.[1] As to exhibited objects, we saw only all-purpose agricultural machines and a bus from Philadelphia.

In conclusion, the site, the buildings, and the gardens of the exposition are worthy of the great city that has assumed the responsibility for this enterprise: it is exhibitors and especially visitors who are lacking. To the foreigner, Barcelona seems far away; and the approaching great Parisian exposition, the tournament of 1889, explains many of the abstentions as well. Besides, there are too many universal expositions: it is only natural that commerce and industry should draw back from the great expense they involve. And it must be admitted that Spain itself has shown little readiness to assist a city whose prosperity it envies and who on so many occasions has made it only too obvious that it could get along well enough without the rest of the country—a rather risky assertion, incidentally, for if it is true that Catalonia works for all Spain, it is Spain itself that collects the fruits of that work: the producer should not scorn the consumer. The executive council of the exposition has also committed all sorts of blunders; with its stinginess it has alienated the press, whose cooperation is indispensable. All these reasons, and perhaps others of which I know nothing, explain the air of uncertainty that hovers over the outcome of this costly enterprise. [. . .]

I will have little to say about the industrial part of the exposition; the decorative arts are rather poorly represented, and the way they are understood in Spain, it seems to me, differs little from how they are practiced in other countries: the influence of France and Germany is evident. As to original products, Spain still seems to produce them, but we saw none at the exposition. I shall pass over in silence the fabrics from Majorca and the textiles from Cordova, where gold apparently plays an important role. The Balearic Islands produce objects in silver filigree of no special distinction, unless it is their relative cheapness, but we did note some beautiful pieces of hammered white metal. In Cartagena, finally, they make good glass; the exhibit of Valavino has as a facade a large gate copied from the Alhambra[2] and made of porcelain tiles. The objects of engraved and enameled bronze have made Zuloaga's reputation: he has found imitators, especially in the state arsenals where arms and cannons are manufactured.

One thing should not be passed over in silence, and that is the ingenuity the Spanish exhibitors have shown in displaying their merchandise. The pyramids of

cotton, the bags of flour, of chocolates, of tobacco, and of preserves, fountains of thread on bobbins decorated with dolphins from which escape cascades of hemp and of flax; most of these improvised monuments are laid out with taste and a pleasing inventiveness. The section for wines also has its discoveries in picturesque arrangement. [. . .]

After Spain, it is France that occupies the most space in the Palace of Industry, and the quality of its products is unrivaled. Juxtaposing the porcelains of Sèvres, the tapestries from the Gobelins, the jewelry of Christofle, the church ornaments of Biais, the pianos of Erard and Herz, the furniture of Krieger, etc., gives a good idea of our national industry. I need say nothing more.

Translated from Alfred de Lostalot, "Correspondance de Barcelone: L'Exposition Internationale," *Gazette des Beaux-Arts*, ser. 2, vol. 38 (1888):244–48.

1. The reference is to a replica at the Barcelona exposition of Frédéric Auguste Bartholdi's Statue of Liberty in New York Harbor.

2. For a familiar literary description, see Washington Irving, *The Alhambra*, 2 vols. (Philadelphia, 1832).

1889: Paris

Following the sudden resignation in 1879 of General Maurice MacMahon, duke of Magenta, the office of president of the French Republic was filled by a competent but colorless politician named Jules Grévy. When his seven-year term ended he was reelected in 1885, but was forced to resign in December 1887 because of the scandalous behavior of his son-in-law. The Chamber of Deputies then quickly chose the engineer Sadi Carnot to succeed him, but the existence of the Third Republic was still threatened by the popularity of General Georges E. Boulanger, favored by monarchists and conservative republicans, until national elections held in 1889 restored a measure of stability. None of these political crises, however, interfered with the activities of Adolph Alphand, an engineer and the minister of public works who had been named director general of works and assigned the task of organizing a universal exposition to celebrate the centennial of the Revolution of 1789.

From the beginning France regarded the exposition as a national celebration in which other nations would be invited to participate as guests. It was to be financed in part by the government and in part by a committee of bankers who raised money by selling entrance coupons (*bons*) in advance through a lottery. Even though the 32,350,000 tickets they sold ensured the exposition's solvency, it proved to be somewhat less than international in its participation, owing to the nature of the event being celebrated. Britain refused to participate and provided no government sponsorship; an unofficial British exhibit was managed by the Society of Arts. Other countries resorted to similar unofficial arrangements. Germany, Sweden, Turkey, and Montenegro did not accept the invitation. As a result, France's 34,000 exhibitors outnumbered by 6,000 those representing the entire rest of the world.

Nonetheless, thanks to the genius and brilliance of the French engineers Gustave Eiffel and Victor Contamin, the exposition was memorable. Eiffel had received authorization to build a tower for the exposition in January 1887 and had immediately begun to sink foundations of masonry and cement into the Champ-de-Mars to support the four uprights of iron that would first curve and then gradually straighten to form a single shaft topped by a lantern 300 meters above the ground. The tallest structure of iron latticework in the world and the

first monumental sculpture in iron was completed on March 28, 1889, a month before the exposition opened (figs. 19–20).

Before the audacious Eiffel Tower had even reached its astonishing height a vehement protest arose:

> . . . This tower dominating Paris, like a gigantic and black factory chimney, crushing with its barbarous mass Notre Dame, the Sainte Chapelle, the Tour St. Jacques, the Louvre, the dome of the Invalides, the Arc de Triomphe; all our monuments humiliated, all our architecture shrunken, and disappearing affrighted in this bewildering dream. And during twenty years we shall see, stretching over the entire city, still thrilling with the genius of so many centuries, we shall see stretching out like a black blot, the odious shadow of the odious column built up of riveted iron plates.[1]

To this diatribe, signed by writers, painters, sculptors, architects, and enthusiastic lovers of beauty, the novelist Joris K. Huysmans added his voice in the essay "Le Fer" (Iron), which he included in a collection entitled *Certains* (1889). In it he reversed the tolerant and approving position he had taken toward contemporary construction that utilized iron in his review of the 1881 Salon.[2] English-reading visitors crowding into Paris for the exposition would more likely have purchased the popular *Messenger*,[3] however, and it lauded the tower; the French public also vociferously defended it. But the majority of visitors were no doubt too busy examining the machines and the goods they produced to worry about any aesthetic effects Eiffel's construction might have on the Paris skyline.

After the Eiffel Tower, the centennial exposition's most noteworthy structure was the engineer Victor Contamin's Galerie des Machines, a building of which the *Messenger* also approved.[4] It was a bold work, covering the widest space ever roofed by a single span, with trusses 115 meters wide and rising to a height of 48 meters with no intermediate support (figs. 21–22). An immense adjoining central dome served as the main entrance for the millions who crowded into its vast space filled with myriad products, mostly of French design and manufacture.

On either side of the Champ-de-Mars were two galleries that ran toward the Seine and "were greatly admired for their domes covered with glazed pale-blue tiles, and for the dignified simplicity and structural sincerity of their main entrances." The one on the west was devoted to exhibits of sundry manufactures; the one on the east, the Palais des Beaux-Arts, was built to house the fine arts and the *arts libéraux* (i.e., education) exhibits (plan 4). Both were designed by Jean-Camille Formigé. After the exposition closed, the Palais des Beaux-Arts was used

1. "The Eiffel Tower: IV," *Engineering* 47 (May 3, 1889), not paginated.

2. On the use of iron as a building material, see Elizabeth Gilmore Holt, *The Art of All Nations*, pp. 54–74, and "Semper on Iron," in Wolfgang Herrmann, *Gottfried Semper: In Search of Architecture* (Cambridge, Mass., 1985), pp. 174–83.

3. *Galignani's Messenger*, founded by Giovanni A. Galignani in 1814, was published by his two sons until 1884 and then by another concern until 1904.

4. *Galignani's Messenger*, July 1889.

for the "New Salon," an exhibition set up in opposition to the "Old," or academic, Salons. It was supervised by the Société Nationale des Beaux-Arts, organized in 1891; its jurors admitted innovative art and, unlike the Old Salon, permitted the inclusion of objets d'art.

The Machinery Hall
AUTHOR UNKNOWN

If the Eiffel Tower was an unexpected surprise, a triumph of originality and of daring skill, the machinery hall was found to be only one degree less marvelous; and this because the progress of modern architecture and of the science of engineering had, from one decade to another, led us up to this superb realization of the unexplored possibilities of both. Never before, in the opinion of engineers of all countries who have visited it, has a building, proportionately to its vast dimensions, been constructed with such a wondrous combination of solidity, lightness, and grace, the general effect being enhanced by the flood of light freely admitted to all parts of the palace. The Government is therefore to be most heartily congratulated, on national and artistic grounds alike, upon the initiative which it has taken to permanently preserve this magnificent building, together with those set apart to the fine and liberal arts, in addition to the grand central dome.

The machinery hall is, indeed, the most prodigious outgrowth of the joint ingenuity and skill of architect and engineer. To bring under one roof all the machinery that was to be exhibited was a problem which almost defied solution. The task, however, was happily surmounted by the cooperation of M. Dutert, the eminent architect, and MM. Contamin,[1] Charton, and Pierron, engineers. M. Dutert, who conceived the entire plan of the work, tracing it out even to its minutest features, superintended the decorative details. Taking up this vast conception of an artist, M. Contamin stamped upon it the hall-mark of science by calculating the efforts of the materials, estimating their resistance, and insuring the due solidity and equilibrium of the whole structure. He it was who superintended the operation of fitting together the ribs and girders and general framework resting upon the solid squares of masonry constituting the foundations. The palace is 420 meters in length, and 115 in width, covering a superficial area of 48,335 square meters, or about 11½ English acres. . . . There is sufficient "free play" at the top of the arching girders to allow of the slight displacement that takes place under the action of heat and cold. The only points of support are, in fact, at the base of the girders and where these latter meet each other in the center of the roof; but these chief ribs, be it noted, are connected by longitudinal girders, the whole framework being otherwise strengthened, on each side of the building, on the most approved principles. The method which was followed enabled the constructors to carry out their plans with the minimum of materials commensurate with necessary strength and artistic effect; and the entire cost of the palace

(7,514,095 francs, of which 5,398,307 francs was for ironwork alone) was correspondingly lessened. Over the summit of the roof is a narrow gallery for workmen.

Each of the arched girders running up the sides of the building consists of two ribs, an inner and outer one, solidly bound together, above and below, crosswise, one regular square alternating with an elongated one, the only real point of support being, as we have said, in the masonry at the base, inasmuch as the girders meet each other lightly, with a sort of elastic touch at the apex above. The total weight of material over the grand nave is only 7,400 tons, a little more than the mass of iron used in the construction of the Eiffel tower. On either side of the machinery hall is a gallery 15 meters in width, to which access is obtained by broad staircases, as also by lifts. . . . Had steel been used, the framework would have been much lighter than it is, but the idea of resorting to it was abandoned on the two-fold ground of expense and the necessity of hastening the execution of the work. Those who believed that iron was ill adapted to the requirements of art as applied to industry have been agreeably surprised by the happy results achieved by M. Dutert and the engineers who so ably cooperated with him in this veritable palace of wonders.

The internal decorations, under the glass roof arching downwards toward the sides, are most effective, the chief tone being a rosy yellow giving rise to some curious effects of the sun's rays. Thus, toward evening, all the panes over the right side of the nave assume a rosy tint, whilst those opposite are of a light-green hue, the contrast suggesting that between rubies and emeralds. Ten large panels and one hundred and twenty-four smaller ones have been painted by MM. Alfred Rube, Philippe Chaperon, and Marcel Jambon; the former representing the arms and commercial or other attributes of the leading capitals of the world (Berlin, of course, excepted), and the latter the escutcheons, etc., of the minor cities and towns, including all the *chefs-lieux* [county towns] of French departments. Over the chief entrance in the Avenue de Labourdonnais, is a large rose window in different colors. The ornamentations on the outside are exceedingly striking. The vast arch over the porch is decorated with a foliated design showing between the leaves various implements of labor. On the lintel is the inscription "Palais des Machines," in decorative faience, the groundwork being an olive branch. This is supported by two groups 10 meters in height. The first, by M. Barrias, represents electricity, and is composed of two female figures. One of these, by a finger touch, sends an electric flash through the globe, whilst the other, resting in a recumbent position on a cloud, stretches forth her hand to her companion; they symbolize the two opposite currents. The second group, by M. Chapu, shows a female figure personifying steam, and a workman clasping her in his arms. A colored window above sets forth the arms of the various powers taking part in the exhibition. In the center of the gable at the opposite end are some colored panes depicting the battle of Bouvines, and facing the Ecole Militaire is a window dedicated to the "Chariot of the Sun."

Those who enter the machinery hall from the general industries gallery pass through a central vestibule which from its rich decoration, may be regarded as a sort of *salon d'honneur*. Here is a handsome cupola covered with colored panes

and mosaics, the former showing the leading agricultural products of the country, such as flax, hemp, wheat, and maize. The painted pendentives represent the arts, sciences, letters, and commerce. The numerous other allegorical subjects ornamenting the vestibule have been greatly admired. At the foot of the handsome staircase leading to the gallery are two splendid bronze figures, each bearing a cluster of twenty incandescent lamps.

Such, in brief, is the general outline of the building itself. It may be urged that the Palais des Machines affords evidence that a fresh era in architecture has been inaugurated, that *ceci tuera cela,* and that the age of stone is to be succeeded by the age of iron. We do not think so. It is true that the engineers are just now triumphant in many directions. The chief of the state [Sadi Carnot] is an engineer; an engineer, M. de Freycinet, is minister of war; M. [Adolph] Alphand, another engineer, was one of the organizing directors of the Universal Exhibition; and the name of the engineer, Eiffel, has become something more than a household word. With respect to the architectural question, however, it is evident that engineers can dictate to architects only in the case of immense buildings whose distinctive character is, after all, that of use rather than ornament. Those, however, who look at the interior of this machinery hall for the first time can not form an estimate of its imposing dimensions; its architectural lines do not draw the attention upwards, and so its roof appears lower than that of the smallest Gothic cathedral. Nobody, at a glance, would imagine that he stood in the highest covered building in the world.

The motive power is distributed by means of four shafts extending from one end of the building to the other, the total force actually at work being equal to 2,600 horse power, although 5,640 horse power may be developed if necessary. This is more than double the power placed at the disposal of exhibitors in 1878. In 1855 the figure stood at 350 and in 1867 at 638. There has, therefore, been a remarkable progression. Visitors may watch the machinery in movement from two traveling cranes, or *ponts roulants,* as they are more correctly described in French, which move to and fro on rails at some height above the shafts. The bird's-eye view thus obtained proved so startling to an Annamite the other day that he turned suddenly pale, or pale yellow, on glancing down at the iron monsters which to his untutored and superstitious gaze seemed to be harboring destructive designs upon the passing crowds, and he looked as though he were ready at a moment's notice to prostrate himself at the feet of some modern Moloch! [. . .]

The general arrangement of the exhibits may be described in a few words. As the visitor passes through the palace from the Avenue de Suffren to the Avenue de Labourdonnais, he finds that the first half on his right is devoted to those relating to civil engineering, the ceramic arts, cabinet-making, mechanisms of various kinds, electricity, agriculture, mining, and metallurgy, printing, and paper-making; and the other half, on the left, to railway material, and spinning, weaving, and iron working machinery, etc., and the special places set apart to Switzerland, Belgium, the United States, and England. Between the machinery hall and the general industries gallery is a court in which electrical apparatus of all kinds may

be seen in full working order at night. It constitutes one of the most novel and attractive features of the exhibition. The focus of one great lamp consists of a cluster of 15,000 incandescent lights.

From *Galignani's Messenger*, July 1889, as quoted in William Watson, "Reports of Commissioners and Experts: William Watson, Civil Engineering, Public Words, and Architecture," *Reports of the United States Commissioners to the Universal Exposition of 1889 at Paris* 3 (Washington, D.C., Government Printing Office, 1891): 833–35.
 1. Victor Contamin, first a student and then a professor at the Ecole Centrale, where he specialized in railroad construction. He published *Cours de résistance appliquée* in 1873. The engineer for materials at the Companie des Chemins de Fer du Nord, he was named general director of works for the 1889 exposition. With the collaboration of the architect Charles Dutert, Contamin put his theories and practical experience to good use in the design and construction of the Hall of Machines.

Iron

JORIS K. HUYSMANS

In architecture, the situation is now this.

The architects build absurd monuments whose parts, borrowed from all ages, constitute in their ensemble the most servile parodies that one could see.

It's a hash of platitude and pastiche; contemporary art is summed up in the miserable potpourri of the Opéra of [Charles] Garnier, and in the incoherent palace of the Trocadéro which, seen from afar, resembles, with its enormous rotunda and spindly minarets with little gold steeples, the belly of a dropsical woman lying with her head down and raising in the air two meager legs clad in mesh stockings and golden slippers.

One fact is certain: the age has produced no architect and is characterized by no style. After the Roman, the Gothic, the Renaissance, architecture crawls, discovers yet again new combinations of stones, fattens in the awkward pomposities of Louis XIV, thins in the Rococo, and dies of anemia when the Revolution is born.

Another undoubted fact is that stone, considered until now the fundamental material of building, has foundered, drained by repetition; it can no longer lend itself to undiscoverable innovations, which would moreover be nothing but borrowings better parodied or more adroitly patched together from older forms.

The supreme beauty of the religious ages created that magnificent, almost superhuman art, the Gothic; the epoch of utilitarian ribaldry in which we live has nothing left to demand of the stone that stratified, in a sense, the religious transports and prayers, but our period may yet incarnate itself in buildings that symbolize its activity and its sadness, its cunning and its money, in works sullen and hard, in any case, new.

And the material is here named, it is iron.

Since the reign of Louis Philippe [1830–48], iron structure has been at-

tempted many times, but an architect of talent is lacking; no new form has been discovered; the metal remains part of a whole, linked to stone, a subordinate agent, incapable of creating by itself a monument that is not a railway station or a greenhouse, a monument that aesthetic criticism may cite.

The best applications have until now been confined to the interiors of buildings, such as the reading room of the Bibliothèque Nationale and the interior of the Hippodrome: iron's role is thus practical and limited, purely internal.

This was the state of architecture when the exposition of 1889 was resolved upon.

It is interesting to see if, in the palace of the exposition and in the Eiffel Tower, iron-making has come out of its gropings, and, with the aid of majolica and tiles, has finally invented a new style.

To judge the architecture of the palace impartially it is necessary to keep repeating to oneself, at each start, that these temporary buildings have been erected to satisfy the taste of provincial shopkeepers and showy adventurers lured out of their native territory by our advertising.

From this point of view, the architects have fully attained their goal; they have made a transatlantic art, an art for the Americans and the Kanakas [South Sea Islanders].

Indeed, how can these two squat, low domes otherwise be described, whose surface is crackled like Japanese ashtrays, varnished with turquoise enamel, set off with gold; these long galleries edged by cast-iron verandas, with columns stuffed with hollow tiles and metal painted in sky blue; above all how can one describe the third cupola surmounted by a spirit in gold, the cupola that crowns the monumental entrance, worked with massive sculptures, larded with statues and heads, emblazoned with the municipal coats-of-arms? One would say it was half of a pear, the end in the air, or a giant diving apparatus, enameled, perforated with glass, laminated with gold, dappled with azure, and glazed with brown. And nestled throughout, around the galleries, in the creases of the oriflammes, are nude spirits, brandishing wands and palm branches; or there are chubby children, bunches of chicory the color of pewter, trinkets for the noses of savages, again mixed with municipal coats-of-arms surmounted by painted crowns with gilded crenellations.

It is the triumph of mosaic, of faience, of enameled brick, of iron painted in buttered chocolate and blue; it is the affirmation of the most ardent polychromy; it is heavy and gaudy, emphatic and shabby; it evokes in a different medium the theater painting of Makart, so popular at Hamburg, with its redundant pomp of brothels!

With one stroke, it must be admitted, the stonecutters' bad taste is surpassed; but it must be repeated also, these temporary constructions are marvelously suited to the soul of the crowds that fill them. In the evening, when its location becomes monstrous and charming with its agreed-upon truce to the exasperating daily cares, its good-humored atmosphere of the casino, its shallow gaiety, the central dome, lighted from within, has the air of a night lamp ornamented with imitation

stained-glass windows of painted paper, but the irritating excesses of its decorations are stilled despite the strings of glimmering lights that run along the cupola, the dry and strident luster of its bronzes, and its gold is extinguished, and one dreams, before this monumental entry and the gallery it commands, of a church consecrated to the cult of money, sanctified by an altar whose steps are being climbed to the sound of steam organs by the richest man in the world, the American pope, Jay Gould, who celebrates the yellow mass, and in front of the kneeling crowd, to the repeated peals of electric bells, raises the host, the bank check, detached from a checkbook!

In front of this temple rises the famous tower about which the entire universe has become delirious.

All the dithyrambs have raged. The tower has not, as one feared, drawn lightning, but rather the most redoubtable commonplaces: "Triumphal arch of industry, tower of Babel, Vulcan, Cyclops, of a metal spider, iron lace." In a touching unanimity, without doubt acquired, the entire press, flat on its stomach, exalts the genius of M. Eiffel.

And yet his tower resembles a factory chimney under construction, a carcass that waits to be filled with cut stone or bricks. One cannot imagine that this *infundibuliforme* lattice is finished, that this solitary suppository riddled with holes will remain as it is.

This appearance of scaffolding, this interrupted air, assigned to a building which is now complete, reveals an absolute lack of artistic sense. What to think, moreover, of the ironmaker who has had his work daubed with the Barbedienne bronze which makes it look as if it had been soaked in the cold juices of a roast? It is in effect the color of veal "Bellevue" in restaurants; it's the aspic beneath which appears, as on the first level of the tower, the disgusting tint of yellow fat.

The Eiffel Tower is truly of a disconcerting ugliness, and it is not even enormous! Seen from below, it does not seem to attain the height cited for it. One must find points of comparison, but imagine, stacked up one on top of the other, the Panthéon, the Invalides, the Vendôme column, and Notre Dame, and you cannot persuade yourself that the belvedere of the tower is as tall as the height attained by this fanciful pile. Seen from afar, it is even worse. It does not even surpass the top of the monuments named. From the Esplanade des Invalides, for example, the tower barely doubles a six-story house; from the Quai d'Orléans, one perceives it at the same time as the tiny and delicate tower of Saint Severin, and their height appears the same.

From close up, from afar, from the center of Paris, from the depths of the suburbs, the effect is identical. The emptiness of this cage diminishes it; the lathing and the meshwork make of this trophy of iron a horrible bird cage.

Finally, drawn or engraved, the tower is poor. And what could this flask, wickered in painted straw, corked by its campanile as if by a cork armed with a dropper, be next to the forceful constructions dreamed of by Piranesi, or even the monuments invented by the English [John] Martin?

Whichever way one turns this work lies. It is 300 meters tall and appears one hundred; it is finished and appears barely begun.

In default of a form of art perhaps difficult to find with these trellises, which are only accumulated piles of bridge work, it was necessary at least to fabricate something gigantic, to suggest to us the sensation of the enormous; it was necessary for this tower to be immense, that it should spring to insane heights, that it should pierce through space, that it should stand over 2,000 meters with its dome, like an astonishing milestone in the turbulent route of the clouds.

That was unrealizable: thus what good is it to erect on a hollow pedestal an empty obelisk? It will no doubt seduce the high livers, but it will not disappear with them at the same time as will the galleries of the exposition, as will the blue cupolas whose enameled ironwork will be sold by the pound.

If, ignoring for the moment the ensemble, one concentrates on the detail, one remains surprised by the coarseness of each piece. One says to oneself that antique ironworkers nevertheless created some powerful works, that the art of the old forgers of the sixteenth century is not completely lost, that certain modern artists have also modeled in iron, that they have twisted it into snouts of animals, into women, into men's faces; one says to oneself that they have also cultivated in the hothouse of the forges the iron flora in Antwerp,[1] for example, where the columns of the Bourse are at their summit enlaced by creeping vines and stalks that twist, fuse, bloom in the air in agile flowers whose metallic sheafs lighten, make vaporous in a way, the ceiling of the heraldic room.

Here nothing; no ornament, however timid, no caprice, no vestige of art. On entering the tower, one finds oneself in front of a chaos of beams, intercrossed, riveted by bolts, hammered by nails. One can dream only of props supporting an invisible building that is beginning to crumble. One can only shrug one's shoulders in front of this glory of iron rails and slabs, in front of this apotheosis of the pier of the viaduct, the platform of the bridge!

Finally, one must ask oneself, what is the fundamental purpose for the existence of this tower? If one considers it alone, isolated from other buildings, divided from the palace it precedes, it makes no sense; it is absurd. If, on the other hand, one observes it as being part of a whole, as belonging to the ensemble of constructions built on the Champ-de-Mars, one may conjecture that it is the tower of a new church in which are celebrated, as I said above, the divine services of the High Bank. It would then be the bell tower, separated, as in the cathedral of Utrecht, from the crossing and the apse by a vast square.

In this case, its material of a safe, its color of a stew, its structure of a factory stack, its form of an oil well, its skeleton of a great dredge capable of extracting the auriferous mud of stock exchanges, are explained. It will be the spire of Our Lady of the Barter, a spire deprived of bells, but armed with a cannon that announces the beginning and end of services, that calls the faithful to the masses of finance, the vespers of speculation, a cannon that sounds with its showers of powder the liturgical feast days of Capital!

It will be, like the gallery of the monumental dome that it completes, the emblem of an age dominated by the passion for gain; but the unconscious architect who built it was unable to find the fierce and cunning style, the demoniacal character, that this parable demands. Really this pylon of gratings would make

hated the metal that allows itself to be shaped into such works, if its incomparable force did not radiate in the prodigious vessel of the Palais des Machines.

The interior of this palace is indeed superb. Imagine a colossal gallery, wider than one has ever seen, higher than the most elevated nave, a gallery shooting forth on springing arches, describing a broken semicircle like an exorbitant ogive whose dizzying points meet under the infinite sky of glass; and in this formidable space, in all this void, shrunk, become almost dwarfed, are the enormous machines, unfortunately too banal, whose pistons seem ribald, whose wheels fly.

The form of this room is borrowed from Gothic art, but it has burst forth, enlarged, playful, impossible to produce with stone, original, the bases of its great arches like calyxes.

In the evening, when the Edison lamps light up, the gallery stretches out again and becomes limitless; the beacon set in the center thus appears as only a frill of glass dotted with light; stars twinkle, puncture the crystal whose facets burn with the blue flames of sulfur, the reds of vine branches, the lavender and orange of gas, the green of the torches of catafalques; the electrician points his lens, shoots forth pencils of luminous dust which break in a sheet of water under the glass sky. Streams of precious stones seem to flow in a ray of the moon, and the glimmerings of the prism appear, parading around the room in a procession; automatic, ordered, they pass slowly over the length of the walls, now unformed or similar to light washes of color, now spreading into tulips of blue, growing into tufts of unknown vegetation of flames!

The sovereign grandeur of this palace becomes magical; one recognizes that from the point of view of art, this gallery constitutes the most admirable effort that metallurgy has ever attempted.

Only, I must repeat again, that as at the Hippodrome, as at the Bibliothèque Nationale,[2] this effect is all internal. The Palais des Machines is grandiose as a nave, as the interior of a building, but it is nothing as an exterior, as a facade seen from outside.

Architecture has thus not taken a new step in this route. For lack of a man of genius, iron is still incapable of creating an entirely personal work, a true work.

Translated from Joris K. Huysmans, "Le Fer," in *Certains* (Paris, 1889), pp. 401–10.

1. In Antwerp the National Bank building was designed in Flemish Renaissance style by Henri Beyaert (1824–94) in 1875–80.

2. Designed by Henri Labrouste; see Holt, *The Art of All Nations* (New York, 1981), p. 58.

1893: Chicago

An international exposition to commemorate the four hundredth anniversary of the discovery of America by Christopher Columbus was proposed by the United States Congress in 1888, and four cities—New York, Chicago, Washington, D.C., and St. Louis—competed for the privilege of hosting it. After the businessmen of Chicago demonstrated their commitment by forming a World's Columbian Exposition Corporation and pledging $5 million to the cause, a congressional vote awarded the honor to that city. President Benjamin Harrison signed a bill on April 25, 1890, that provided for "an international Exhibition of arts, industries, manufactures and the products of the soil, mine and sea," and responsibility for implementing the act was assigned to the World's Columbian Commission.

The commission's 108 members included two commissioners from each state and territory; Thomas W. Palmer of Michigan was its president. It was authorized to invite the nations of the world to join in the celebration, by sending their exhibits to Chicago and their navies to a gala review in New York Harbor in April 1893. In addition, the act called for the appointment of a Board of Lady Managers, 117 delegates strong, also to include two delegates from each state and territory. The dedication ceremony was set for October 11, 1892; the formal opening for May 1, 1893. This meant that the Chicago corporation of civic leaders and financiers who began by securing the exposition and now acted as agents for the commission had two years in which to convert a swampy shore at Lake Michigan south of Chicago, partially developed as Jackson Park, into fairgrounds four times the size of the Paris exposition in 1889.

The corporation assigned the supervision of the plan and construction to Daniel H. Burnham and John W. Root, whose firm had gained renown from its design of the Monadnock Building among others, as consulting architects. To make the effort nationwide they in turn, with national commission approval, established a commission of ten architects—three from New York City, one from Boston, one from Kansas City, and five from Chicago. Richard Morris Hunt, president of the American Institute of Architects, was chosen as chairman, and Louis Sullivan as secretary. Augustus Saint-Gaudens was assigned responsibility for the sculpture, Francis D. Millet for the color decoration and paintings; Charles Atwood was named designer-in-chief. After the sudden death of John Root in

June 1891, Burnham formed the company G. H. Burnham and Co., and was named chief of construction for the fair.

The country's foremost landscape architect and the designer of Jackson Park twenty years earlier, Frederick Law Olmsted of Boston, effected, with the assistance of Henry Codman, the conversion of the undeveloped land, mostly sandhills and swamps, into a system of islands placed in lagoons and canals filled with water from Lake Michigan, which could then be merged with the already developed Jackson Park. Olmsted's plan determined the topography for the buildings, which were then designed to fit on their assigned site. The unity that resulted from this procedure was further strengthened by setting a standard cornice height of sixty feet and establishing white as the regulation color for the buildings. Although the latter measure ensured the appropriateness of naming it the "White City," it was not rigidly enforced: in the end, the color decoration of the buildings elicited as much critical comment as any other aspect of the exposition.

Visitors would arrive either by railroad at a western entrance or by boat at the main portal. The eastern entrance, an immense Grecian peristyle colonnade, was joined by a gate that admitted lake water to fill the Grand Basin (fig. 23), continued the Court of Honor. It was meant to be the focal point of the exposition. In the middle of the 500-foot-long, 150-foot-high peristyle entrance to the Grand Basin, with its 85 allegorical figures, was a triumphal arch 20 feet higher, topped by the Columbus Quadriga. The 14-foot-tall figure of Columbus standing in a chariot drawn by four horses led by two maidens was the creation of Daniel Chester French and the animal sculptor E. C. Potter. Below, in front of the towering peristyle, French placed in the water at the rim of the Grand Basin his majestic 65-foot-tall statue of the Republic. The peristyle and the statue determined the gigantic proportions for the buildings, the statues, paintings, and decorative details. Facing the statue of the Republic, the grandiose Columbian Fountain (fig. 24), the apotheosis of Liberty designed by Frederick W. MacMonnies, stood in the western end of the Grand Basin in front of the Administration Building, a magnificent structure in the center of the Court of Honor.

The Grand Basin lay between the Agriculture Building on the south and the Manufactures and Liberal Arts Building, the largest exposition building ever erected (1,687 feet by 787 feet), on the north. The water of the basin flowed into the North Canal and along the west facade of that enormous building to fill a lagoon surrounding a wooded island and the North Pond, a reflecting pool for the Fine Arts Palace. The rest of the principal buildings were arranged along the winding waterway to the north and the southern canal and pond (plan 5).

The Fine Arts Palace, which had to be fireproof, was built to be a permanent structure; the rest were temporary, their skeletons of iron and wood covered by a skin of staff, a version of the stuccolike substance that had already been used in Paris. W. D. Richardson, the general superintendent of the buildings, had seen it there and had studied the use of stucco in Portugal and Brazil. He strengthened the plaster by mixing it with sisal and hemp and made his own version of sufficient

strength and durability for molding over the frames constructed both for the buildings and statues, a method that permitted rapid construction.

The exposition's dedication ceremony took place only a few days behind schedule, on October 21, 1892, in the immense and still vacant Manufactures and Liberal Arts Building. Escorted by cavalry and artillery units, the officials entered the building, in which over 100,000 persons had assembled in "Columbia Avenue," the 380-foot-wide central aisle. The roof's 382-foot-long trusses were 202 feet above. The address of welcome by the mayor of Chicago was followed by the poet Harriet Monroe,[1] who read her "Columbian Ode." A chorus of 5,000 voices, accompanied by an orchestra and military band, joined her to sing the portion:

> Lo, clan on clan,
> The embattled nations gather to be one
> Clasp hands as brothers on Columbia's shield,
> Upraise her banner to the shining sun.
> Along her sacred shore
> One heart, one son, one dream—
> Man shall be free for evermore,
> And love shall be law supreme.
> Over the wide unknown
> Far to the shores of Ind.
>
> From the past to the future we sail:
> We slip from the leash of kings.
> Hail, spirit of freedom—hail!

Eight months later, right on schedule, on May 1, 1893, half a million people crowded into the grounds to witness the exposition's official opening ceremony with speeches and music, and to watch President Grover Cleveland press the button that started up the generators and brought the entire exposition to life. The wheels turned; the draperies fell away from the colossal gilded statue of the Republic; the flags unfurled to applause and to the playing of "America."

To the nine official categories used in Paris in 1878, the commission had added three—Fisheries, Transportation, and Women. A building was allotted to each category, and the design of each building to a member of the architectural committee. According to the *Report on the Committee on Awards* written by the architect Henry Van Brunt, the buildings were developed "in an architectural collaboration sufficiently close and intimate to eliminate from each building any personal element of idiosyncrasy which might interfere with the harmony of the

1. Harriet Monroe (1861?–1936), author, editor, and poet, and the biographer of the innovative architect John W. Root, her brother-in-law, whose sudden death in January 1891 had left his partner Burnham in sole charge of the exposition's construction. In 1912 she founded *Poetry: A Magazine of Verse*, notable for the experimental poets—Ezra Pound was a foreign correspondent—it introduced.

exposition as a whole, [though] . . . this process of elimination was not carried so far as to secure the necessary harmony of feeling by a monotonous uniformity which would have been tedious and unimaginative."[2] An effort was made within the restrictions of the building code to identify the category the building housed by using allegories, symbols, and representations.

Only two of the official buildings, Fisheries and Transportation, did not follow the classical style. The other major buildings were distinguished only by their variations on the classical formula as taught at the Ecole des Beaux-Arts, where "classical" meant elements from ancient Greece and Rome filtered through French adaptations. For the Fisheries Building, the Chicago architect Henry I. Cobb selected the Romanesque architecture of southern France, with its red glazed Spanish tiled roofs and pointed turrets, to create a rectangular central structure—the aquarium—with a polygonal wing at each end. The surface ornament was composed of casts of starfish, seahorses, crabs, and other creatures of the sea, and a lobster pot was adapted to form a capital.

For Transportation, large spaces were needed in which to install entire railroad trains and displays of ancient and modern means of transportation over land and sea, and no previous architectural style lent itself to this purpose. The Transportation Building (fig. 25), designed by Dankmar Adler and Louis Sullivan, was huge: its final dimensions were 960 feet long by 256 feet wide with 72-foot-wide bays. It was an interesting and bold experiment executed in sharp contrast in both color and form to the Beaux-Arts style of the other buildings of the White City. Facing eastward over the lagoon, its wall of regularly recurring large glazed arches was interrupted midway by a projecting square pavilion that rose above the broad overhang of a flat roof. A novel, striking scheme of polychrome decoration was applied to the wall. A light color tone free of decoration at the ground line was gradually intensified and ornamented until the spandrels were reached. Each alternate spandrel was filled with conventionalized white-robed, winged figures on a background of gold leaf. The effect was brilliant. A grandiose arch of the central pavilion was flanked on either side by a decorated panel to represent ancient transportation on one side and modern on the other. The arch, or Golden Gateway, as it was soon called, was a series of receding concentric arches treated with aluminum covered with gold lacquer, which was cheaper than gold leaf and when weathered had a richer tone. The Transportation Building's decoration illustrated ideas Sullivan had expressed in an essay, "Ornament in Architecture," published in the *Engineering Magazine* in 1892:

> I take it as self-evident that a building, quite devoid of ornament, may convey a noble and dignified sentiment by virtue of mass and proportion. . . . I believe, as I have said, that an excellent and beautiful building may be designed that shall bear no ornament whatever; but I believe just as firmly that a decorated struc-

2. Henry Van Brunt, "Architecture of the World's Columbian Exposition," *Report of the Committee on Awards* (U.S. Government Printing Office: Washington, 1894), p. 9.

ture, harmoniously conceived, well considered, cannot be stripped of its system of ornament without destroying its individuality. . . .

It must be manifest that an ornamental design will be more beautiful if it seems a part of the surface or substance that receives it than if it looks "stuck on," so to speak. A little observation will lead one to see that in the former case there exists a peculiar sympathy between the ornament and the structure, which is absent in the latter. Both structure and ornament obviously benefit by this sympathy; each enhancing the value of the other. And this, I take it, is the preparatory basis of what may be called an organic system of ornamentation.

The ornament, as a matter of fact, is applied in the sense of being cut in or cut on, or otherwise done; yet it should appear, when completed, as though by the outworking of some beneficent agency it had come forth from the very substance of the material and was there by the same right that a flower appears amid the leaves of its parent plant.

Here by this method we make a species of contact, and the spirit that animates the mass is free to flow into the ornament—they are no longer two things but one thing.[3]

Richard Morris Hunt adapted the French Renaissance style for the magnificent Administration Building. Formed of four pavilions, divided into two stories surmounted by a central gilded dome 120 feet in diameter and rising 250 feet above the Court of Honor, the Administration Building dominated the entire exposition. Twenty-one allegorical groups of sculpture that crowded the four angles of each pavilion symbolized the four elements; emblematic groups flanked the four entrances, and seven single statues were used in the interior. All were provided by the Viennese-born sculptor Karl Bitter. The heroic-sized statue of Columbus holding high the standard of Castile and Aragon placed at the western entrance had been assigned to Louis Saint-Gaudens, but was executed by Mary Lawrence, a pupil of his brother Augustus.

Although the category Women was assigned a separate building, as it had been at the 1876 Centennial Exposition in Philadelphia, it was not used for displays of goods produced exclusively by women. The Board of Lady Managers had been authorized to appoint one or more members to award committees for exhibits produced in whole or in part by female labor, and since in practice that turned out to include most of them, the board had decided that no separate exhibit of work done by women was needed. Shortly before the opening, it had also been decided that the exhibitions of products by women should be judged by the same criteria as those governing any product in that classification. Women could therefore simply enter their products in any category that they wished, for recognition of work they had done in textiles, dairying, or any other area, on a common level with men. The products of their labor, whether displayed in the Women's Building or elsewhere, would also be shown, like those of men, under their own names,

3. Louis H. Sullivan, *Kindergarten Chats* [revised, 1918] *and Other Writings* (New York, 1947), pp. 187–89.

a practice begun by some British manufacturers at the 1878 Paris exposition. The Women's Building exhibition was itself used to provide a picture of women throughout the world in their roles as breadwinners and decorative artists.

When a favorable site overlooking the lagoon and funds for the building were secured, Sophia G. Hayden of Boston, an 1890 graduate of MIT, won the competition with her design of a building in the style of an Italian Renaissance villa.[4] Mrs. Bertha Honoré Palmer, wife of the Chicago merchant and real estate developer Potter Palmer, elected president of the Board of Lady Managers, exercised her genius for organization, her tact, diplomacy, stamina, and charm, all of which equaled her beauty and wealth, to put the show together. Queen Victoria, the Empress of Japan, and the Queen of Thailand were among the women who sponsored exhibitions from their countries. Where religion and custom prevented official participation by women—as it did in some Muslim cultures—they simply sent their exhibits unofficially. Altogether the work of women from twenty-three countries was represented.

The exposition's northernmost structure, designed by Charles B. Atwood, was the neoclassical Fine Arts Palace, located so that its Ionic southern facade would be reflected in the North Pond. Designed to be a permanent structure, it was built of gray stone. Because of the limited space and the problems of transportation, only fifteen countries were officially represented in it; the attractive market for art in the United States might have encouraged countries to send works of better quality if those problems could have been overcome. As it was, neither European nor American critics found the exhibit noteworthy. The selections had been made by committees of artists under the supervision of the government-appointed art commissioner. Fortunately, the European school was augmented by two hundred paintings borrowed from private collectors and museums, including most notably the Impressionists from Mrs. Potter Palmer's own collection.

The 1,075 contemporary American paintings selected by juries of artists located in various parts of the country and Americans in the principal art centers of Europe, and the retrospective exhibit of American art assembled to show its development were of interest to European critics. Wilhelm Bode (1845–1929), the distinguished director of the Kaiser Wilhelm Museum, Berlin, and a noted connoisseur, found "the American section in the Art Building not only the most comprehensive but on the average the best. . . . The exhibition showed an art developed in every tendency, which possesses all the excellence of youth, freshness, naivete, and self-confidence."

4. Others involved with the building were Enid Yandell of Louisville, Kentucky, and Alice Rideout of California, who did the sculpted decorations. Artists contributing to the painted decorations were Mary Fairchild MacMonnies, Mary Cassatt, Dora Wheeler Keith, Rosina Emmett Sherwood, Lydia Emmett, Lucia Fairchild, Amanda Brewster Sewall, Agnes Pitman, and Ida J. Burgess. A Miss Sears of Boston designed the stained-glass window of the building. The list of painters exhibited in it included Anna Elizabeth Klumpke, Enilda Q. Loomis, Katherine A. Carl, M. H. Carlisle, H. Roe, Louise Jopling-Rowe, Elodie Lavilette, Louise Abbema, Jenny Villebessey, Euphemie Murchiton, Maximilienne Guyon, I. Buchet, a Miss or Mrs. Leftwich-Dodge, Lilly Devereaux Blake, Lilly I. Jackson, Florence Mackubin, M. Kinkead, and L. M. Stewart.

The exposition was instrumental in furthering progressive tendencies among architects and critics, one of whom was Montgomery Schuyler, a news reporter and literary reviewer for the *New York World* from 1863 to 1885, with a special interest in architecture. Schuyler found time in 1874 to serve on the *New York Sketch-Book of Architecture* and then left the *World* to devote full time to architectural criticism. Influenced by Richardson and Leopold Eidlitz, a Czech-born exponent of the Gothic Revival, Schuyler's critical writings reflected the growing uncertainty evident in American architecture as the American progressive tendency of "organicism" was confronted with the increasing influence of the Beaux-Arts formalism that emanated from successful New York architectural firms. Schuyler's essay on the exposition, regarded as a masterpiece of criticism, correctly recognized that the exposition was not a model for serious architecture ("It is what you will, so long as you will not take it for an American city of the nineteenth century"), but was appropriate for the illusionary festive stage set of a "fair." It reflected the changing character of the international exposition as it increased in size, complexity, and pretentiousness, and no longer served to demonstrate a single theme with an educational purpose.

The buildings assigned to individual nations of the world and states of the Union gained significance at the Chicago fair at the expense of those devoted to the various exhibition categories, a trend that had been evident in the universal expositions since the Crystal Palace. Instead of all the entrants in a category being under a single roof many countries and American states and territories chose to show their products in individual buildings built of local materials and furnished with native products, directing attention to the objects and the room or space in which they were arranged (see figs. 30–32). The diversity in the structural plan added to the general attractiveness of the American state buildings (figs. 26a–e) and made them of special interest to foreign visitors. In these furnished houses, Europeans could note the differences between American homes and their own in the general disposition of space and the arrangement of furnishings. From his own observations of the state buildings and from his stays in private houses in Chicago, Boston, and New York, Bode wrote an appraisal of American decorative arts for the *Kunstgewerbeblatt*.[5]

An alternative to European and American notions of space and furnishings was supplied by the Hō-ō-den, or Phoenix Hall, a replica erected by the Japanese

5. Wilhelm Bode, "Moderne Kunst in den Vereinigten Staaten von Amerika. Eindrücke von einem Besuche der Weltausstellung zu Chicago," *Kunstgewerbeblatt* N.S. 5 (1893–94): 113. The thirty structures erected by the forty-four states, six territories, and one federal district represented an astonishing variety of styles. In several instances, the building materials available in a state determined the choice of style—a Swiss chalet from Utah's timber, a Pompeiian villa from Vermont marbles. A majority were designated "colonial"—north, south, or Spanish; others were described as "gothic," or "renaissance." The style of ten buildings was undefined. Seventeen were designed by architects, one woman among them. Jean Loughborough, Mrs. Frank M. Douglas, selected "the French rococo style as appropriate because the state, Arkansas, was first settled by the French" (Rand McNally & Co., *A Week at the Fair: Illustrations, Exhibits and Wonders of the World's Columbian Exposition with Maps and Diagrams* [Chicago, 1893], chap. 7, pp. 201–30.

government of one of Japan's most ancient wooden temples (figs. 27–29). Each of its three rooms was furnished according to its traditional use by Professor Kakudzo Okakura. Visitors were allowed to enter the rooms, not just peer into them from a roped-off corridor, and this may well have provided the opportunity for the young architect Frank Lloyd Wright, who was already practicing in Chicago at the time, to experience the space, note the crossed-axial plan, the accented horizontals, the extended roofs, and the frame construction, all ideas he was later to develop in his own architectural forms.

Okakura had been a pupil of Ernest Fenollosa, an amateur painter from Boston who had been named professor of political economy and philosophy at the Imperial University in Tokyo in 1878, and had assisted him in his pioneering attempt to compile charts of Japanese art and in his search for examples of traditional Japanese art. Both had been named imperial commissioners to advise on the establishment of a national art museum and the Tokyo Academy of Art. They were the co-managers of the academy when it opened in 1886. In this role they had been able to arrest the westernization of Japanese art that had begun in the 1870s and had succeeded in directing it to a style "thoroughly Japanese in its materials, technique, and subject matter," yet with sufficient "Western realism to make it contemporary."[6] Now, seven years later, Okakura was able for the first time to exhibit the new art in which traditional brush techniques were combined with Western realism in drawing, chiaroscuro, and perspective. The catalogue that he wrote provided visitors with the manual necessary for them to gain an understanding of the nature of Japanese art.

Fenollosa had returned to the United States in 1890 to accept a position as curator of Oriental art at the Boston Museum of Fine Arts. In a review for the *Century Magazine,* he used the exposition to give a brief account of Japanese artists turning from imitation of Western art to an art based on Japanese traditions, but open to Western ideas. In so doing, he directed attention to the Japanese exhibition:

> The significance of the Japanese department of the World's Fair at Chicago lies in the fact that here for the first time has the policy of self-development in modern Oriental art an opportunity of justifying itself by results, however immature. By its promoters were the Government plans for this exhibition drafted and superintended; by its professors and pupils were the most important of the detached works and all of the decorations executed; and through its influence has the prevailing character of native and original design been throughout stimulated. It is well understood by the authorities that Japan's future position in the world's art cannot be established by throwing away her special gifts of pure and delicate design, in the quixotic desire to compete with France and America in the field of realistic oil-painting. Neither can she fall back listlessly upon the fame of her past achievements. She must grapple with living problems. She assumes that in her art courses sap enough for new possibilities. While at Vienna, at Paris, and at Philadelphia her triumphs were largely in her loan collections of antiques and

6. Michael Sullivan, *The Meeting of Eastern and Western Art* (London, 1973), pp. 121–24.

in modern replicas, at Chicago for the first time has she deliberately dared to be original, and to ask the world's favor for her contemporary art on its own merits.[7]

For Japanese unable to visit the exposition, an artist from Kyoto, Beisen Kubota, who had studied in Paris, found time during his employment at the exposition by the Japanese commissioners to copy art objects in various displays he saw. His sketches were published in 1894 in Tokyo in a three-part catalogue of the exposition illustrated with watercolored wood engravings.[8] Kubota's interests led him to concentrate on European realistic landscape and everyday genre-scene painters: Karl Hartmann, F. Dregger, B. Liljefors, Oreste da Molin, and Jean Millet. For the catalogue he copied two paintings by Millet, *Summer* (painted for Feydeau) and *The Man with a Hoe* (fig. 33). Of the latter he wrote:

> Millet's painting depicts a laborer. The painting is an allegorical work for which he worked and studied hard to reach the point where he is recognized by the world as the greatest master of painting. At the beginning, however, even his painting of the laborer was considered as an ordinary painting of realism. This painting is owned by a person in San Francisco. It is shown at this exhibition by his special favor. The painting is priceless and it is such a privilege for all of us to see this valuable painting in person at this exhibition.

On October 30, one hundred thousand persons once again gathered on "Columbia Avenue" in the vast Manufactures and Liberal Arts Building, this time to applaud the medal winners. In the intervening six months twenty-seven million people had entered the gates of the White City to come and go amid its dazzling brilliance. On November 1 its gates were closed. By December 1 only the Fine Arts Palace, of all its gleaming buildings, still stood beside the lagoon on the shore of Lake Michigan. In what form would reminiscence shape the colossal experience of the White City's architecture? An Englishman, William T. Stead, wrote, "Never before have I realized the effect which could be produced by architecture. The Court of Honor, with its palaces surrounding the great fountain, the slender columns of the peristyle, now unhappily destroyed by fire, and the golden dome of the Administration Building, formed a picture the like of which the world has not seen before."[9] The French psychological novelist, Paul Bourget, whose journal of his trip to the United States, *Outre Mer,* was published in 1894, wrote: "The White City of Jackson Park, with its palatial monuments of human achievement lacking only in stability, standing as the gates of a city still incomplete, is not an

7. Ernest Francisco Fenollosa, "Contemporary Japanese Art with Examples from the Chicago Exhibit," *Century Magazine* 46 (1893): 580.

8. Beisen Kubota, *Kakuryu sekai hakuran-kai bijitsu-hin ghafu* (World's Columbian Exposition: A Collection of Art Objects Copied by Beisen Kubota), 3 vols. (Tokyo, 1893–94); chiefly color illustrations in portfolio. Kubota, together with Kono Bairei, started the Kyoto Prefectural School of Painting in 1880 and the Kyoto Bijutsu Kyokai in 1890.

9. William T. Stead, "My First Visit to America," *Review of Reviews* (English ed.) 9 (Jan.–June 1894): 414–17, as reprinted in *As Others See Chicago,* ed. Bessie L. Pierce (Chicago, 1933), pp. 356–57.

apotheosis, it is a hope. It is not an end, it is a commencement." Then he went on
to ask:

> But what form shall this civilization take? Shall it be a mere copy of things
> European? The national conscience rebels against this thought. . . . Emerson
> understood this when he wrote: "Why need we copy the Doric or the Gothic
> model? Beauty, convenience, grandeur of thought are as near to us as to any."
>
> That is the promise the White City leaves. Coming after so many others,
> this exposition is indisputable evidence that the off-shoots of antiquarianism
> transplanted here by three centuries of immigration will, when given leisure,
> blossom in this virgin soil, into beautiful flowers. These enormous, splendid
> palaces of a day, simply and ingeniously constructed, reared with Aladdin-like
> magic by the shores of this free inland sea, and announcing, as they do, the birth
> of a new art, do not realize the absolute originality of Emerson's dream, but they
> prove that the merely colossal, unaccompanied by grace and symmetry, can no
> longer satisfy the taste of their builders. To the innumerable spectators, gathered
> from the four corners of their stupendous country, those buildings have given,
> one might say, an indelible object lesson.[10]

The sixty-five-year-old Henry Adams, who had been "drifting in the dead-
water of the fin-de-siècle," left the silver-gold-standard debate in Washington and
also journeyed to Chicago to study the exposition. There he "lingered long among
the dynamos, for they were new, and they gave to history a new phase." When he
came upon a new machine, he asked, "Did it pull or did it push? Was it a screw or
a thrust? Did it flow or vibrate? Was it a wire or a mathematical line. . . ?" He
expected answers and received none. "Chicago asked in 1893 for the first time the
question whether the American people knew where they were driving to. On
reflecting sufficiently deeply, under the shadow of Richard Hunt's architecture, he
decided that the American people probably knew no more than he did; . . . Chi-
cago was the first expression of American thought as a unity; one must start
there."[11]

The Transportation Building
DANKMAR ADLER AND LOUIS SULLIVAN

Not the least interesting feature of the Transportation Building is the beautiful
scheme of polychrome decoration to be applied to its exterior. To treat the
building externally in many colors was the original thought of the architects in the
first conception of their design. The architecture of the building, therefore, has
been carefully prepared throughout with reference to the ultimate application of
color, and many large plain surfaces have been left to receive the final polychrome
treatment. The ornamental designs for this work in color are of great and intricate

10. Paul Bourget, "A Farewell to the White City," *Cosmopolitan*, 1893, pp. 135–37. Bourget
was a member of Mallarmé's circle and associated with the *Revue Wagnérienne*.
 11. Henry Adams, *The Education of Henry Adams* (Boston, 1918), pp. 342–43.

delicacy; the patterns, interweaving with each other, produce an effect almost as fine as that of embroidery. As regards the colors themselves, they comprise nearly the whole galaxy, there being not less than thirty different shades of color employed. These, however, are so delicately and softly blended and so nicely balanced against each other that the final effect suggests not so much many colors as a single beautiful painting.

Landscape artists practically use polychrome to a great extent in the rendering of their paintings, for on close observation it is easy for even the uninitiated to see that the color changes almost every one-quarter square inch, and the beauty and effectiveness and truthfulness of a landscape painting depend very largely upon the extent to which the artist has softened and blended many colors into each other.

As in a landscape painting one will find spots of high sunlight and brilliant colors balanced by cool shadows and low tones, so in the Transportation Building there are parts in which the color is worked to a high pitch of intensity and others in which the coloring is soft, cool, and quiet.

The general scheme of color treatment starts with a delicate light-red tone for the base of the building. This is kept entirely simple and free from ornament in order to serve as a base for the more elaborate work above. The culmination of high color effect will be found in the spandrels between the main arches. Here the work is carried to a high pitch of intensity of color, and reliance is placed on the main cornice of the building, which is very simply treated, to act as a balancing and quieting effect in the general composition. In the center of the spandrels is placed a beautiful winged figure representing the idea of transportation. This figure is painted in light colors and will have a background of gold-leaf.

The color scheme of the building as a whole, of course, culminates in the great golden doorway. This entire entrance, 100 feet wide and 70 feet high, which is incrusted over its entire surface with delicate designs in relief, is covered throughout its entire extent with gold, and colors in small quantities are worked in between the designs and reliefs so as to give the whole a wonderfully effective aspect.

From Dankmar Adler and Louis Sullivan, "The Transportation Building," in *A Week at the Fair* (Chicago, 1893), pp. 47–48.

Colour Decoration at the Chicago Exhibition
UNSIGNED

Perhaps the most satisfactory thing in connexion with the colour decoration at the Chicago Exhibition lies in the fact that the exhibits are all on the buildings and in the places for which they were designed, and they are all executed by American artists acting in concord with the architects of the buildings, and under the supreme control of Mr. F. D. Millet, the Director of Colour, who is himself, besides

being a painter of no ordinary merit, a capable decorative artist, as his work on the buildings shows. . . . It was fortunate, too, that the buildings seem in most cases to have been designed for colour treatment. They are laid out on Renaissance lines, with their chief points emphasised by pavilions containing domes or tympani eminently suitable for such treatment, or which have colonnades whose inner wall lends itself admirably to colour treatment, which, while placed in these positions is sufficiently protected from the weather, and also acts as a background for the architectural features in front of it. Decorative art was exhibited to a large extent at the late Paris Exhibition [1889], as in the Central Hall of the Fine Arts Building, by contributions sent by various artists, but it had this great drawback, that it was sent as an oil picture might be sent to a picture show, and could not form part of the building which it was intended to decorate. [. . .]

It is fortunate that the American decorative artists have risen to the occasion, and have shown that they are able to cope with problems of decorative art so as to be in harmony with the architecture which it adorns, and it is needless to say that henceforth decorative art as an aid to architectural effect should take its stand along with sculpture and the other allied arts, and that American decorative artists should be a factor in American art.

Mr. Millet seems to have been fortunate in surrounding himself with a band of men who have had some considerable training in France and Belgium, and who besides have been employed in America on certain modern buildings in which the employment of decorative art has been seriously undertaken. [. . .]

. . . The Manufactures Building, by Mr. [George Browne] Post, of New York, seemed to lend itself admirably to the purpose of colour decoration in its accepted usage. At well-defined points in the covered ambulatory which encircles the building, and which is just about a mile in length, are eight domes, two on each façade; and eight semi-circular tympani, two at each angle, which lend themselves specially to the treatment of subjects dealing with manufactures and liberal arts. Eight artists have been employed on these, and it is not too much to say that, although one at least of the designs is crude in its conception and badly executed from a decorative point of view, the rest are well-conceived and well-executed. [. . .]

The Transportation Building, by Messrs. Adler & Sullivan, which we have reserved for the last, is by far the most important piece of colour decoration at the Exhibition. The building has been described, and it has been shown how, from the very first, the building was designed for a great colour scheme. Mr. Sullivan has some original ideas on the question of colour, one of these being that on the principle that you cannot have too much of a good thing, that, therefore, you cannot have too much colour.

It has been shown that beyond the great projecting cornice and the Golden Gateway there are no architectural "features" of any kind, the walls being just left with the plain plaster surface. No less than forty tints of colours have been used in the façade, which consists of a series of semi-circular arches, the lower portion occupied by two columns, with Byzantine-like foliage, supporting a beam treated

in colour with flat surface. The general scheme of the façade is a series of geometrical figures, simple in the first instance, such as circles, in which other figures are interwoven of different colours, so that the original figure is almost lost, the whole producing an effect akin to embroidery. The main arches are enclosed by a band of dark red, which is the strongest colour in the scheme, and the smaller figures are worked down from this colour, which serves as a base. Above the piers of every other opening is a large figure, 14 ft. high, of a woman holding a screen in front between her hands, with the name of some famous inventor in regard to Transportation. The idea of Mr. Sullivan in these stiff and almost archaic figures was to get the idea of motion expressed without movement of the body, and for this reason the figures, which are all similar, have large outspread wings of white colour, which detaches them somewhat from the main colour scheme. The figures are painted on canvas, and afterwards applied to the façade. Mr. Sullivan, it may be mentioned, is an enthusiastic botanist, and all his system of sculptured and coloured work is derived from a study of practical botany. [. . .]

As a purely colour scheme, thought out and designed from its very commencement for polychromatic decoration, this building is as important, and perhaps more so, as any erected in recent years. Of course such a scheme of colour was impossible in the main court, where the architects wisely determined to leave the surfaces plain white, from motives of symmetry and general effect, but, as the Transportation building is placed away from the main court, and in front of the picturesque wooded island, it could not interfere with the surrounding architecture, and praise is due to Messrs. Adler & Sullivan for the thoroughness with which they have treated the building as a colour problem. It must have required a considerable amount of boldness even for an American architect to have thrown aside the usual architectural forms and accepted methods, and to have designed a building from the very commencement with reference to the application of colour, and not, as is usual in such cases, to apply it as an afterthought. It may be interesting, as showing that the executive spared no money in the realisation of the scheme, that the contract price for the colour work alone was 5,000£. sterling, and its real cost must have exceeded that sum.

From what we have said it will be seen that colour decoration has received more attention from architects and decorators at the Columbian Exhibition than any previous one, and, as we have before mentioned, here we have the actual work executed and occupying the place it was designed for, and where it can fairly be judged on its merits, which it is impossible to do with isolated schemes shown in a picture gallery. That an American school of colour decoration will naturally grow out of this seems but the natural result, especially in a country possessing rich citizens, who are not unwilling to expend large sums in the adornment of their houses, their churches, and their public buildings.

From "Colour Decoration at the Chicago Exhibition," *The Builder*, August 26, 1893, pp. 151–52.

The Hō-ō-den (Phoenix Hall)

KAKUDZO OKAKURA

Japan, the Land of the Rising Sun, has been from ancient times considered the birthplace of the Hō-ō (or Phoenix). The United States of America, her neighbor and warm friend, has organized an Exhibition which for magnitude and magnificence exceeds anything the world has ever before seen, and which is accompanied by all those tokens of success that are believed to follow the advent of the Hō-ō. [. . .]

The Hō-ō-den, or Phoenix Hall, which has been erected by the Imperial Japanese Commission, and will be presented to the city of Chicago at the close of the Exhibition, derives its name from its representation of the fabulous bird. This bird, to use a figure of speech, has flown swiftly over the wide Pacific Ocean bringing with it works of art from its native land, which though comparatively insignificant, may, it is hoped, in some degree contribute to the beauty of the World's Fair. [. . .]

The Hō-ō-den now exhibited is substantially a replica of the edifice at Uji, somewhat smaller in size and modified to adapt it for secular use.

In order to understand Japanese decorative art some idea of its history is essential. It may be divided into three periods ranging from A.D. 629 to 1550. The first is called the Tempei period and lasted till 805 A.D. About a century before this time Buddhism was introduced into Japan from China, and the influence of Chinese art soon began to make itself felt, driving out that purity and simplicity which were distinctively Japanese. The art of this period also shows traces of Indian, Greek and other Western schools.

The second, or Fujiwara, period dates from A.D. 880 to 1150, an era in which the arts of refinement reached a high state of cultivation. The liberal patronage of the powerful Fujiwara family brought about a renaissance of pure Japanese taste. This reaction finally left its indelible mark not on art alone, but on the manners, customs and literature of the time.

The third period is A.D. 1350–1550 during the sway of the Ashikaga Shō-guns, who also did much by their enlightened patronage to foster and develop art. Once more the influence of the Chinese school made its appearance, an influence which has not been eradicated to this day. The *cha-no-yu* (tea ceremonies) and other aesthetic practices belong to this period and show the part played by Buddhism in restoring a tranquil state of mind to the people, so long disturbed by the internecine strife of the days preceding the establishment of the Ashikaga dynasty. In every phase of art the development of that time is marked by greater minuteness and elaboration of detail. But it is to the first of these periods, when the country was shut out from all contact with foreign ideas, that the student will find the source of whatever is original in the art of the people.

The left wing of the Hō-ō-den here erected is constructed in accordance with the principal architectural features of the Fujiwara epoch, specially copied from the Phoenix Hall at Uji, and from the apartments of the Imperial Palace at Kyoto. The floor is high and the pillars round instead of square as they were usually made

at a later period. In buildings of this period the ceilings (*gotenjo*) were often partitioned out into segments filled with reliefs depicting flowers, birds or other objects. The sliding doors being a later invention, protection to the room is afforded by means of vertical shutters (*shitomi*) hung with bronze or iron hooks in the day-time to admit light; and let down at night. A folding door is attached to one side of the room. The room itself is modeled after the apartment of a courtier of high rank. The walls during the Fujiwara period were invariably decorated with paintings; later with white mortar or paper with small printed patterns. The *tokonoma,* or recess for hanging pictures, etc., not yet having been introduced, the walls or sliding paper doors (*shoji*) were elaborately ornamented with paintings of various kinds. In later times, the *ramma,* or ventilating panels near the ceiling of the room, were often beautifully carved, but during the Fujiwara period they were generally covered with paper and ornamented with paintings. In passages leading outside or to other rooms, *misu,* a sort of window or door shade made of fine split bamboo was suspended. This *misu* is easily raised or dropped by means of a hook.
[. . .]

The square or rectangular spaces in the walls were reserved for poems, which took the place of criticisms upon the pictures.

The pictures above the *nageshi* or horizontal beam, are *kinkwa-cho* by [Kose Shoseki] . . . , being patterns much used for palace decorations during the period under notice. The room is that occupied by the master of the house, and is always the center of the whole building, with drawing rooms, bed rooms, and servants' quarters surrounding it.

The aristocracy of those days had nothing to do beyond attending to the ordinary social amenities of their position. They were occupied with the exchange of visits; musical and poetical gatherings, and other amusements. Naturally, too, in a somewhat over refined age, dressing was an important function for both ladies and gentlemen, and was especially elaborate and picturesque on ceremonial occasions.

The right wing of the Hō-ō-den is in the style of the Ashikaga period, when Japan emerging from the civil wars of the two preceding dynasties, began a new art-life under the influence of Zen-Buddhism and the teachings of the Chinese philosophers of the Sung dynasty. As a characteristic representation of the art of this epoch, the interior reproduces, with but slight changes, a room in Gin-kaku-ji (Silver Pavilion), a famous villa near Kyoto, built by the Shogun Ashikaga Yoshi-masa in 1479, and after his death converted into a monastery, or priests' residence.

The style of this period showed greater elaboration of details, and was less gaudy in tone than the preceding. Simplicity of treatment is apparent, but it only affects the surface; internally much care and finish characterizes the work. The exterior of this wing corresponds to that of the left wing; within, it is peculiar to the Ashikaga times. Its division of rooms, pillars, accommodation for seats, *tokonoma,* etc., all typify that age.

The two rooms represent the library and tea room. The library was originally the model of a reading-room which formed part of the suite of rooms of a

Buddhist temple, the *tokonoma* being derived from a dais used for placing offerings to the gods, where a picture of Buddha together with an incense burner was always suspended. [. . .]

The library was used as a reception room, or place where the master of the household read, studied, or occupied himself in Buddhistic meditation. All the appurtenances laid out have these objects in view.

The *kakemono*, or hanging picture . . . , is a study by the old master, Sesshu (A.D. 1421–1527), probably the greatest Japanese artist of the Chinese school of painting.

The tea room is used for performing the *cha-no-yu* (tea ceremonies), where all the appliances are specially noted for their simplicity of taste. The painting is by Professor Kawabata, as is also that on the small paper screen in the attached library.

The arrangement of utensils on the *daisu* is that which precedes the act of lighting the fire for the tea ceremony.

[The central hall] represents the style in vogue during the Tokugawa dynasty of Shōguns, a period extending from the beginning of the seventeenth century down to the restoration when the present Emperor came into power in 1868. The art of that time did not differ materially from that which flourished in the days of the Ashikagas. It shows, however, decided progress in many respects, owing to the peace and general prosperity enjoyed by the country for nearly three hundred years. The hall is a replica of a room in the old castle of Yedo (Tokyo). [. . .]

The buildings of the Hō-ō-den are built of unpainted wood, and the principles of Japanese construction and proportion are wholly adopted. The roofs are covered with sheet copper according to the Japanese method.

The work of interior decoration was undertaken by the Tokyo Art Academy, and the furniture and art works in the exhibition are selected by the Imperial Museum. All represent the three epochs to which they belong. The principal design of the buildings was made by Masamichi Kuru, the Government Architect of Japan, and the builders are Okur & Co., who have sent a number of their workmen to Chicago.

From Kakudzo Okakura, *The Hō-ō-den (Phoenix Hall): An Illustrated Description of the Buildings Erected by the Japanese Government at the World's Columbian Exposition, Jackson Park, Chicago* (Tokyo, 1893), pp. 9–40.

Modern Art in the United States of America: Impressions Following a Visit to the Universal Exposition in Chicago
WILHELM BODE

Architecture and the Decorative Arts and Crafts [. . .] Certainly one cannot speak of an American style in architecture in the sense that one can speak of a Greek, Gothic, or Rococo style. But the most French of the French can just as little hope to discover a French style in the modern buildings of France. Even though we

must honor the French for copying the different styles of their past with special faithfulness and good taste, and for knowing how to adapt them to modern requirements, nevertheless wherever they deviate from their past styles, wherever they attempt to create something new, they are just as deficient in style as every other nation today. Indeed, I must confess that in my opinion celebrated structures such as the Opéra in Paris, particularly its interior, as well as the gallery of French masters in the Louvre, and similar pieces of architecture claiming to be independent, appear to lag far behind when compared with some modest structures in England, and even more compared with those in America. The majority of visitors to the [Columbian Exposition] will be most deeply impressed by the overwhelming effect of the buildings' layout, architecture, and color, and by the fact that the newest buildings in the United States in general reveal a pronounced American character, high technical perfection, and good taste. For me personally, the greatest surprise that the unfortunately all-too-short journey through the eastern states of North America gave me was the impression of the modern buildings, both in their architecture and in their furnishings. [. . .]

The modern American house is built entirely from the inside out, and not only satisfies the separate individual requirements but most of all, in full measure, the characteristic habits and needs of the Americans. That these are distinct and clearly defined is the great advantage domestic architecture in the United States has over our German architecture. [. . .]

In the floor plan of the American house one can still recognize its descent from the English town house, just as the tradition that even in the largest cities every family has its own house goes back to old English custom. Because of that, the front [of the house] is narrow but high; the "hall" with its staricase forms the center from which the living rooms are usually accessible. The hall, therefore, is customarily planned to be as spacious as possible and is comfortably furnished; thanks to the clever disposition of the staircase (comfortable, but modest in form and with a graceful banister) it produces a charming and picturesque effect. Beyond the hall and its installations, the living rooms open up through wide, sliding doors, almost half the width of the wall; they are usually left open, so that from the hallway one has a view into the different rooms. The rooms are not especially lofty—by our standards, rather low; they are not overfilled with furniture, and the walls and ceilings are light in color. The furnishings, too, strive for a comfortable, friendly effect rather than one of splendor. The country house has the character of a summer dwelling; therefore the floor plan and furnishings are essentially different from those of the town house. It is completely detached, is built lightly and modestly, usually of wood and covered with wooden shingles, and is surrounded by a spacious veranda that offers fresh air and protection against the sun at any time of day.

Neither the town house nor the country house is designed palatially in America; even multimillionaires prefer a comfortable bourgeois existence to a princely appearance. On the other hand, they see to it that their places of business are all the more colossal and magnificent; not only the size of the building but also its uniqueness, superior materials, and artistic design are important for advertise-

ment. In American cities, the large department stores, the grand offices of the newspapers and journals, the hotels, theaters, concert halls, warehouses—even mission halls—are usually more striking than public buildings, which up until now have been erected only sporadically, and with monumental style a secondary consideration. [. . .]

American taste is expressed with even greater purity and individuality in the artistic decoration of the home and in the applied arts than it is in architecture. This exposition fails to do it justice. Anyone who with an open mind and open eyes has looked around among the art lovers of Chicago and in the western towns must have brought back quite an extraordinary impression from over there. While in Europe, and particularly here in Germany, it is still generally accepted that even the most commonplace, mass-produced products are good enough for America, we learned there to our amazement and humiliation that even our best works, when compared to those of the Americans, all too often had to be considered as run-of-the-mill; the misunderstood and generally not even successful imitations of old forms appeared unintelligible and banal beside the unique and imaginative creations of American industrial art. If people here—even those who recognize these good qualities—try to console themselves with the thought that "over there, too, one cooks with water"; that only some branches of industrial art are cultivated there at all; that the vast majority of products are still imported from Europe, and that those outstanding accomplishments are due to only a few great artists—this, then, in my opinion, is a deceptive consolation. The Americans have only just begun, and they will expand their artistic appreciation into new areas as the years go by. What they import unfortunately usually falls into the category of "cheap and nasty," and the Americans are justly proud of the fact that they do not concern themselves with such wares, for whose manufacture labor over there is in any case too expensive. If one studies the situation more closely, that dependence of handicrafts on individual, outstanding masters, who have even virtually monopolized certain branches, proves to be precisely one of its advantages in America.

The English are certainly justified in emphasizing that applied art in the United States has been derived from English handicrafts. Indeed, one can even grant that some branches are still dependent on them, just as, on the other hand, they borrow from France the classical models for "stylish" furnishings in the style of Louis XV and Louis XVI, etc. But it is most erroneous to attempt to represent American handicrafts as a colonial branch of English art: in America, wherever a serious attempt is made to develop handicrafts in an artistic manner, it happens in its own, genuinely American way, based on American customs and experience. All kinds of American handicrafts have a common characteristic, which makes them immediately recognizable as such; each one has its special peculiarities, which are just as nationalistic as the circumstances from which they sprang. And just that makes American products so charming and original; precisely because of this, the Americans can count with confidence on a fruitful and unique development of their handicrafts, whereas in Europe one old style after another is being imitated,

which from the start prevents, or quickly suppresses, every free development based on needs.

What advantages do skilled crafts have in the United States, and what is the basis of their rapid development and flowering? These are the questions that suggested themselves to us, children of the Old World, over and over again at the exposition. At the same time we didactic Germans, with our thirst for learning, immediately asked ourselves a third question: what can we learn from American applied arts and take for our own use? To this last question I would like to say straight off that the best thing we could learn from the Americans in this respect would be to try to imitate them as little as possible; to guard ourselves against everything passed on and everything foreign that we have already made our own in the fine and applied arts, without any consideration as to whether or not it suits us to graft an American style onto our own art.

We recognize most clearly how important this limitation is if we trace the conditions under which American applied arts have successfully developed, [that is,] the formation and maturing of independent national requirements. When our craftsmen point to the advantages the Americans have over us, thanks to excellent materials of the most varied kind and also partly to their lower cost, they are of course correct. The numerous kinds of fine woods, the excellent gems, semi-precious stones and metals, the various kinds of fine leather, etc., are most advantageous for the building and applied-arts trades over there. But Russia, for instance, also enjoys this advantage and nevertheless does not make use of it, any more than the United States did a few decades ago. Over there, only after one knew exactly what was wanted, and how one wanted it, did the natural resources become known and exploited. The slow settlement of North America and the very gradual development from the most primitive colonial conditions during the previous century and the beginning of this one meant that the building and furnishing of houses were limited to a few necessities; precisely for this reason they could be perfected all the more keenly and individualistically. In addition, the scarcity of older models (a modest number of English-Dutch works of the previous century) inevitably had a propitious influence in that direction. At first these needs were satisfied in the simplest manner; with increasing wealth around the middle of our century, technical craftsmanship and the use of good materials began to be valued; and when a need for artistic perfection gradually asserted itself, American handicraft was already fully possessed of technical perfection in various fields, a state that we in Germany, except for a very few branches, are still far from achieving.

These are the incalculable advantages which handicraft in the United States has over ours, and which gave it a head start that can be overtaken only with great difficulty, because the character and customs of a nation can be formed only slowly, if indeed they are ever clearly expressed at all. The present rapid development, in part already so brilliant, is still based on various important factors, such as the circumstance that the immense territory, including the major cities of Canada, has almost identical needs, and receives all of its artistic products from

the art centers in the east. What would at first glance appear to be a disadvantage, namely the truly American concentration of certain branches of arts and crafts (and particularly the most important ones) in the hands of a very few persons, is a positive influence. For these outstanding artists, who have worked their way up in handicrafts from very small beginnings, create in their studios a great school, which is directed far more strictly and impartially than is possible in academies and art schools. They have extensive knowledge of the needs and receptivity of their market, and because of numerous and large commissions are in a position to offer much more than almost all of the large arts-and-crafts businesses even of Paris and London, not to mention Germany.

American arts and crafts bear a close relationship to architecture, particularly since they developed as building crafts or else as the decoration and finishing of architecture, especially the private residence. Only in connection with architecture does the significance, the superiority, of American arts and crafts become totally clear to us. It has a very individual character; in a certain sense it already has its own style as well—not in the sense of the older arts and crafts, since we do not find here a thoroughly formed language of style, any more than we do in American architecture—but the endeavor to fit the form to the requirement, to shape it according to its purpose, which is a common feature of American handicrafts. In any case, it is one of the most essential demands of style, even if not yet a real style. Because American furniture is so "practical," because their silverware and ironwork, etc., are so functional, they appear to us to be beautiful, therefore they are beautiful.

Another advantage, common to all branches of American arts and crafts, is the delicate sense of color expressed therein. For an American, harmonious and rich color effect is one of the principal requisites for the artistic decoration of the interior of his home; all furnishings have to contribute to this, and it thereby acquires a part of its character. Nevertheless, decoration avoids bright coloring as much as it does colorlessness and monotony. After all, as I have already emphasized, the most pervasive characteristic of American art is its avoidance of all exaggeration. The elegant outlines and restrained curves in the Americans' furniture are as striking to us Germans as are the delicate color effects of their walls and ceilings, the matching colors of their decorations. Their superiority becomes most apparent when they are faced with the task of giving artistic expression to totally new requirements. American electric light fixtures and their installation, the decoration of elevators, the use and treatment of colored glass for various purposes are completely new and original, even by comparison with established art; it is precisely here that the American sense of function and color effect, as well as imagination, manifests itself most brilliantly. At the same time in Europe such modern demands arising from new discoveries have found only unsatisfactory solutions, modeled after older, inappropriate art forms.

Among the diverse and characteristic branches of handicrafts that have developed in America, cabinetmaking is probably the most important in age and significance. After all, it profited from developments in construction, as well as

from the need of the American to furnish his home as practically and comfortably as possible. In its proportions, its outlines, and its color effect (from the excellent, varied types of wood), the paneling of the walls, an old custom derived from the colonial blockhouses, like the doors, window soffits, banisters, etc., is of an elegance and its technical treatment is of a perfection that stands up to comparison with Japanese and Chinese woodwork. The furniture is particularly striking in its originality. Certain types of furniture, such as wardrobes, tables, and chests of drawers, which we continue to use and manufacture out of old tradition although they serve our present-day needs inadequately, have been almost completely banished from his home by the American. Instead he has one or more special rooms with built-in cupboards that meet all his requirements. The living rooms are all furnished with different groups of seating arrangements around small or larger tables, which the American likes to have as varied as possible. At no other time, and in no other country, has the body been so assured of proper support in every position, to induce agreeable relaxation. Comfort is the first requirement for every American chair, from the desk chair to the rocker; it governs both construction and form, which according to its purpose is as varied as it is original. Like the rocking chair, the more important chairs used by the married couple at either end of the dining table are a specifically American invention, though admittedly derived from old French and Italian traditions. The tables and all kinds of smaller pieces of furniture that make such an essential contribution to the comfort of American life are equally original.

Along with the wall paneling, the remaining wall and ceiling decoration of the modern American home has a completely original character. The rooms are always light, but planned with a delicate, varied color scheme (with the exception of those rooms that have been given light, white, or whitish polished stucco walls, and from which all curtains and other dust catchers have been excluded for hygienic reasons). The color effect is always strongest in the "hall." In the more expensive new private houses, as well as in the large hotels, in addition to the wood paneling there is apt to be a wall covering of colored marble or of splendid semiprecious stones, above which the wall is covered with gold mosaic, which not infrequently also serves as ceiling decoration. The combination of the large, usually dark-colored, splendid stone chimney, the staircase with its marble steps and delicate wood or marble banisters, the colored-glass windows, and colorful light fixtures lends this room, particularly when lit at night, a surprisingly brilliant impression, such as we in Europe are not accustomed to, even in a splendid public building. Nowadays the living-room walls customarily consist of a light-colored stucco covering with elegant small flat patterns, above which a wide frieze runs right up to the ceiling. The latter is either also made of stucco and then regularly decorated with a modest pattern like the wall, or (in simpler homes) covered with a modest wallpaper of a small starlike or flowery scatter pattern. The use of wallpaper or tapestry wall covering is far less common in the modern American home than it is in Europe. Where they do appear, the rule is for light tones and flowery patterns in pure or subdued colors. The fireplace also determines the color

tone in the reception rooms; it is built of the most unusual stones and is frequently of a substantial size, especially in the dining room.

Evening is the time of day during which the American makes the most use of, and truly enjoys, his house, because from early morning on he is occupied away from home in his office. Because of this, the interior decoration of rooms is primarily oriented to the evening, and the question of illumination and lighting fixtures plays a most important role. In most American cities electric light now predominates, and in some others it has already completely replaced gas. The newer buildings, particularly those that lay claim to artistic perfection, are probably without exception illuminated by electricity, and indeed with incandescent lamps. In the construction, form, and color effect of the latter, Americans have proved their practical sense just as brilliantly as their taste and their imagination. In Europe, almost without exception, we are led astray by the tradition of old light fixtures for gas and candles, which are contrary to the nature of incandescent light; we have adapted or redesigned chandeliers, wall lamps, or table lamps. In America, the character of incandescent light was correctly grasped right from the beginning, and as a result the lamps were constructed and shaped in the most varied and imaginative—often even fantastic—ways. The American has accomplished the task of supplying full-strength, gentle, and uniform light to all parts of the room, while at the same time protecting the eye against glare, in the most productive and versatile ways. As a rule, small lamps are installed, individually or in small groups, usually in the stucco decoration of the ceiling and in the door lintels, which are somewhat recessed so that the lights are not immediately visible. Sometimes they form the flowers in the rosettes of the stucco ornamentation; hang from the ceiling as fruit, as sheaves, as beads, as small baskets; sometimes they are positioned behind hovering birds or large butterflies, or hidden in the bodies of flying dragons; sit behind the leaves of a branch made of bronze and glass, or behind a shieldlike glass decoration on the walls. In the recent splendid buildings in New York and Chicago, one of the most important goals is ever to be new, and always completely unique, in devising the placement and fixtures for electrical lights, and through them to enhance as much as possible the rich, colorful effect of the rooms. This is achieved occasionally in a fantastic manner (especially in some of the new luxury hotels), but as a rule also with great taste and extraordinary effectiveness.

Glass plays the most important role in the decoration of fixtures for electrical light and in its shading. As a rule, in simple designs the glass shade is made out of thick cut glass, with deeply cut geometric patterns that greatly diffuse and amplify the light; often, particularly with more opulent decorations, an opaque, opalescent glass is used to tone down the light: a completely original invention of the American art industry, and completely original in its application. The windows and decorations made from such opalescent glass attracted more attention from the visitors at the exposition than all other products of American art handicrafts, although only one firm exhibited them in a satisfactory manner. Its production, form, color, and application are something that is totally new and unique. The

artists who have invented this branch of art and have brought it to its finest flowering—foremost is the painter John La Farge, and after him Louis Tiffany—are fascinated by the effect of color, probably largely through antique glasses that have acquired in the earth that splendid opalescent color which makes them so sought after by American collectors. The color effects of the marble and alabaster panes of antique windows have also influenced their imagination, just as they found their models for the mosaic-like technique of the execution in the small Arabian glass windows. But all of these things only provided the impetus. What we are looking at here is, in its nature, an entirely new type of art; for stylish treatment and splendor of color, our century has nothing to put beside it.

After a series of more or less imperfect attempts, the earliest of which dates back only sixteen years, a very definite technique has evolved. The very original and artistic glass used is translucent but not transparent, thick and strangely undulating and twisted, similar to a solidified lava stream. According to its intended purpose, the most diverse color effects are sought. Sometimes sheets of agate, Oriental alabaster, golden-colored marble, onyx, or something similar are imitated; their splendor and luminosity are even exceeded wherever possible. Such pieces are preferably used as larger panes for skylights, for windows that provide light but no view, and similar purposes. Sometimes the glass panes are stronger and richer in color, resembling precious and semiprecious stones, or competing with the most magnificent flowers, the most splendidly colored butterflies and birds: small pieces, which are assembled into mosaic-like pictures, ornaments, or geometric patterns, are cut from such sheets. Thanks to the perfected production of the glass, colored and shaded in the most diverse ways; to the extraordinary technical skill used in its selection and cutting; to the combination and mounting of the pieces in a lead or wire frame, during which every small unevenness in the surface and every nuance in color is taken into consideration, artists like La Farge and Louis C. Tiffany have managed to produce, purely in mosaic technique, glass pictures that have the delicacy of oil paintings and a wholly unexpected splendor of color (except for the execution of fleshy parts in representations of the human figure)—almost entirely without the aid of painting. The less they strive to compete with modern oil painting, the more they owe to the technique and ornamental importance of mosaic, the more tasteful and elegant is the effect. These mosaic windows find the most varied uses in America: as church windows, on landings, as skylights, for windows looking out onto courtyards or onto rooms that need to be concealed, and for similar purposes. In particular they contribute to the rich, colorful effect of American interiors, in which this colored glass is also used in the most varied ways: as lampshades, for hanging lamps and electric light fixtures, for the creation of mosaics on walls and ceilings, etc.

To the best of my knowledge, the first examples of these American glass windows publicly exhibited in Europe were in the Paris exposition of 1889. Another American branch of industrial art, goldsmithing, became known to us much earlier—at the 1878 exposition—and in much wider circles. Its founder and most prominent representative, the elder [Charles] Tiffany, has already had

his store in Paris and London for more than a decade. The superiority of the Americans' work in jewelry and in gold and silver, as with their stained glass, lies primarily in the tasteful treatment of the material and in the fine color effect. The jewelry of a Tiffany or a Gorham is more modest in form, but more delicate and richer in color (the selection of colored precious stones is almost the rule in America) and more choice and unusual in its setting than are the works of the most famous Parisian goldsmiths. Their gold and silver works are based completely on the chase technique—and therefore without firm architectural structure—and are richly decorated with foliage or fantastic animal shapes. In the common wares (which all too often are German imports!) such as sports trophies, etc., a disturbing excess of intricate foliage and even a Baroque treatment of form easily asserts itself; in the finer works that lay claim to artistic development, we admire the imaginative inventiveness, the tastefulness of the setting of the stones, the skill in niello engraving and in the shading of the silver, in which the Americans are proud to recognize themselves as successors to the Japanese. The cheapness of silver facilitates the mounting in silver of all kinds of everyday objects made of the most varied materials; for example, the finer glasswares, usually of strong cut glass, of robust form and with striking decoration; also products of fine leather from the most diverse animal skins: snakes, lizards, crocodiles, etc., the treatment and shading of which are very charming; the framing of earthen vessels, particularly the deep-brownish Rookwood ware,[1] to which hazily sketched drawings in tones of dull gold are applied with fantastic effect.

Every other metal used for artistic décor is customarily handled with the same feeling for style. Brass, which the American prefers to use for railings, doorknobs, and hinges, is worked and polished to be consistent with its substance, and not—as with us in Germany—burdened with eye-catching ornamentation in a deceitful imitation of bronze, or treated like cast zinc. In the most recent buildings, the use of bronze is preferred: in the form of gilt bronze when used in conjunction with a Louis XVI or Empire-style décor; more often ungilded, wherever bronze takes the place of brass, and then toned down with a fine patina to harmonize with the color of individual rooms or furnishings. In the use of brass, as with bronze technique, the Americans reveal themselves as apt students of the Japanese, without imitating them. Steel, too, is treated in a most original way; as a result, not the astragal (as in the German Renaissance) but the hoop iron—simpler and nearer in style to the smithy technique—provides the leitmotiv for the way it is handled.[2] The wrought-iron works of the Americans, strikingly simple and modest by comparison with the magnificent German works of the Renaissance and Rococo, make a very favorable showing through the variety of motifs, their skillful subordination to architecture, and the practical application of this bold and technically highly successful work. As powerful as is the wrought-iron work in conjunction with exterior architecture, equally delicate is the trelliswork in the interior, particularly in the elevators, whose normal decoration of lightly turned and beaten iron rods and wires creates a varied and charming design.

This survey of skilled crafts in the United States can only be brief and somewhat fragmentary, since it is based only on a short visit to America. [...]

Translated from Wilhelm Bode, "Moderne Kunst in den Vereinigten Staaten von Amerika. Eindrücke von einem Besuche der Weltausstellung zu Chicago. II. Die Architektur und das Kunsthandwerk," *Kunstgewerbeblatt,* N.S. 5 (1893–94):113–21; 137–46.

1. The Rookwood Pottery was founded by Maria Longworth Nichols (Mrs. Storer), Clara Newton, and Mary Louise McLaughlin in 1883 in Cincinnati, and was active until 1967. Its products received a gold medal at the 1889 Paris exposition.

2. *Astragal* and *hoop iron* are the technical terms for the thin strips in which the steel or iron to be worked is received.

Last Words about the World's Fair
MONTGOMERY SCHUYLER

Whether the cloud-capped towers and the gorgeous palaces of the World's Fair are to dissolve, now that the insubstantial pageant of the Fair itself has faded, and to leave not a rack behind, is a question that is reported to agitate Chicago. There is much to be said, doubtless, on both sides of it. While it is still unsettled seems to be a good time to consider the architecture which it is proposed to preserve for yet awhile longer, in order to determine, so far as may be, what influence the display at Chicago is likely to have upon the development of American architecture, and how far that influence is likely to be good and how far to be bad. That it is likely to be in any degree bad is a proposition that may be startling and seem ungracious, but there is no reason why it should. . . . Absolutely without influence such a display can hardly be. The promiscuous practitioner of architecture in America, or in any other modern country, is not of an analytical turn of mind. When things please him, he is not apt to inquire into the reasons why they please him, and to act accordingly. He is more apt to reproduce them as he finds them, so far as this is mechanically possible. For this process our time affords facilities unprecedented in history. Photographs are available of everything striking or memorable that has been built in the world, and that survives even in ruins. [...]

Doubtless the influence of the most admired group of buildings ever erected in this country, the public buildings at Washington not excepted, must be great. What it is likely to be has been expressed by Mr. [Daniel] Burnham, the Director of Works of the Columbian Exposition, in some remarks, published in a Chicago newspaper, which crystallize into a lucid and specific form a general hazy expectation, and which may well serve us for a text:

> The influence of the Exposition on architecture will be to inspire a reversion toward the pure ideal of the ancients. We have been in an inventive period, and have had rather contempt for the classics. Men evolved new ideas and imagined they could start a new school without much reference to the past. But action and reaction are equal, and the exterior and obvious result will be that men will strive to do classic architecture. In this effort there will be many failures. It

requires long and fine training to design on classic lines. The simpler the ex-
pression of true art the more difficult it is to obtain.

The intellectual reflex of the Exposition will be shown in a demand for
better architecture, and designers will be obliged to abandon their incoherent
originalities and study the ancient masters of building. There is shown so much
of fine architecture here that people have seen and appreciated this. It will be
unavailing hereafter to say that great classic forms are undesirable. The people
have the vision before them here, and words cannot efface it.

Doubtless the architecture of the Exposition will inspire a great many classic
buildings, which will be better or worse done according to the training of the
designers, but it is not likely that any of these will even dimly recall, and quite
impossible that they should equal the architectural triumph of the Fair. The
influence of the Exposition, so far as it leads to direct imitation, seems to us an
unhopeful rather than a hopeful sign, not a promise so much as a threat. Such an
imitation will so ignore the conditions that have made the architectural success of
the Fair that it is worth while to try to discern and to state these conditions, and
that is the purpose of this paper.

In the first place the success is first of all a success of unity, a triumph of
ensemble. The whole is better than any of its parts and greater than all its parts,
and its effect is one and indivisible. We are speaking now of the Court of Honor,
which alone it is proposed to preserve, and which forms an architectural whole.[1]
The proposal to remove the largest building of the group, that of Manufactures,
and to set it up by itself in a permanent form on the lake front in Chicago, though
the proposition was not made by an architect, is an excellent illustration how easy
it is to mistake the significance of the architecture and the causes of its success. It is
a masterpiece of misappreciation. The landscape plan of the Fair, with the great
basin, open at one end to the lake and cut midway by canals, may be said to have
generated the architecture of the Court of Honor. Any group of educated archi-
tects who had assembled to consider the problem presented by the plan must have
taken much the same course that was in fact taken. The solution of the problem
presented by the plan was in outline given by the plan. That the treatment of the
border of this symmetrical basin should be symmetrical, that the confronting
buildings should balance each other, these were requirements obviously in the
interest of unity and a general unity was obviously the result to be sought and the
best result that could be attained. The conditions of this unity were all that it was
necessary to stipulate for. Variety enough had been secured by the selection of an
individual designer for each of the great buildings, and the danger was that this
variety would be excessive, that it would degenerate into a miscellany. Against
this danger it was necessary to guard if the buildings should appear as the work of
collaborators rather than of competitors, and it was guarded against by two very
simple but quite sufficient conditions. One was that there should be a uniform
cornice-line of sixty feet, the other that the architecture should be classic. The first
requirement, keeping a virtually continuous sky-line all around the Court of
Honor, and preventing that line from becoming an irregular serration, was so

plainly necessary that it is not necessary to spend any words in justifying it. The second may seem more disputable, but in reality it was almost as much a matter of course as the first. Uniformity in size is no more necessary to unity than uniformity in treatment, and classic architecture was more eligible than any other for many tolerably obvious reasons. There are perhaps no effects attained in the exhibition that could not have been attained in other architecture. The obvious effect of the "magnitude, succession, and uniformity," which the aestheticians describe as the conditions of the "artificial infinite" has been sought and attained in the treatment of the great buildings. Interminable, or for aesthetic purposes, infinite series is the source of the impressiveness of the largest of the buildings, of the long colonnades of Machinery Hall, and the still longer arcades of the Manufactures building. The unusual, in the case of the latter building the unprecedented, length at the disposal of the designer made this the most easy and obvious method of making a great impression. [. . .]

As we say, this is an effect by no means peculiar to classic architecture. It may be found in the flank of a Gothic cathedral as well as in the flank of a peripteral Greek temple. One of the most familiar illustrations of it is the front of the cloth-hall of Ypres, and the most conspicuous illustration of it in the World's Fair is the side of the Manufactures building. [. . .]

Nevertheless, the choice of classic architecture was almost as distinctly imposed upon the associated architects as the choice of a uniform cornice line. In the first place, the study of classic architecture is a usual, almost an invariable part of the professional training of the architects of our time. It is an indispensable part, wherever that training is administered academically, and most of all at Paris, of which the influence upon our own architecture is manifestly increasing and is at present dominant. Most of the architects of the World's Fair are of Parisian training, and those of them who are not have felt the influence of that contemporary school of architecture which is most highly organized and possesses the longest and the most powerful tradition. Presumably, all of them were familiar with the decorative use of "the orders" and knew what a module meant. What most of them had already practiced in academic exercises and studies, they were now for the first time permitted to project into actual execution. [. . .]

That would be one good reason for the adoption of a given style—that all the persons concerned knew how to work in it. Another is that the classic forms, although originally developed from the conditions of masonic structure, have long since, and perhaps ever since they became "orders," been losing touch with their origin, until now they have become simply forms, which can be used without a suggestion of any real structure or any particular material. We know them in wood and metal, as well as in stone. They may be used, as they are used in Jackson Park, as a decorative envelope of any construction whatever without exciting in most observers any sense of incongruity, much less any sense of meanness such as is at once aroused by the sight of "carpenter's Gothic." A four-foot column, apparently of marble, may have aroused such a sentiment during the process of construction, when it might have been seen without a base and supported upon

little sticks, with its apparent weight thus emphatically denied. Such a sentiment may have been aroused again in the closing days of the Fair, when it was no longer thought necessary to repair defects as fast as they showed themselves, and where the apparent masonry disclosed in places the lath-backing. [. . .] The alternative to the use of classic architecture was the development in a few months of an architecture of plaster, or "staff." For this there are no precedents completely available in the world, while the world is full of precedents for the employment of the orders, and precedents which do not imply that the orders are real and efficient constructions, as indeed they have never been since the Romans began to use columnar architecture as the decoration of an arched construction.

It is not to be supposed for a moment that the architects of the Fair would have attained anything like the success they did attain, if instead of working in a style with which all of them were presumably familiar, they had undertaken the Herculean task of creating a style out of these novel conditions. In fact the architects of the Court of Honor might "point with pride" to the result of such efforts as were made in that direction by other architects as a sufficient justification for their own course, if such a justification were needed.

The landscape-plan is the key to the pictorial success of the Fair as a whole, and, as we say, it generated the architecture of the watercourt by supplying indications which sensitive architects had no choice but to follow. In no point was the skill of Mr. Olmsted and his associate more conspicuous than in the transition from the symmetrical and stately treatment of the basin to the irregular winding of the lagoon. As the basin indicated a bordering of formal and symmetrical architecture so the lagoon indicated and invited a picturesque and irregular architecture. Of the associated architects, those who most conspicuously availed themselves of this invitation were the designers of the Fisheries and of the Transportation building. The success of the former is not disputed nor disputable. The plan was determined by the requirements of the building and worked out very naturally into the central mass, the connecting arcades and the terminal pavilions, of which the form suggested the treatment of Romanesque baptisteries, and may very possibly have determined the style of the building. There was ample scope left for the inventiveness of the designer in the detail conventionalized so happily and successfully from marine motives, and the success of this detail of itself vindicates the author's choice of a style and passes a conclusive criticism upon the choice of classic architecture for his purpose. [. . .]

The Transportation building bears still stronger testimony to the same effect, since, while everybody finds it interesting and suggestive, nobody ventures to say that it is distinctly and, on the whole, successful. It is the most ambitious of all the great buildings, for it is nothing less than an attempt to create a plaster architecture. Even the Fisheries building, free as it is in design, bears no reference in its design to its material. It is not a building of staff but a simulacrum of a building in masonry. In the Transportation building alone has it been undertaken architecturally to treat the material of which all the buildings are composed. To comprehend the ambitiousness of the attempt one has only to bear in mind that there is

no such thing as an exterior architecture of plaster in the world. The "half-timbered" constructions of Europe and the adobe of our own continent do not carry us very far. The Saracens, indeed, attained an interior architecture of plaster, and this architecture comprises all the precedents that were available for the architects of the Transportation building. The outsides of those Saracenic buildings of which the interiors are most admired are not only of masonry, but some of them are little more than dead walls. One cannot fail to respect the courage and sincerity with which the architects of the Transportation building tackled their task, even though we find in the result a justification for the architects who have forborne the attempt. It was here a perfectly legitimate attempt, since the Transportation building does not form part of an architectural group, and a separate and distinctive treatment was not a grievance to the spectator, nor to the architects of any other buildings, though it was rather curiously resented by some of these. That it is a plaster building is entirely evident, as evident in a photograph as in the fact. It cannot be called an "incoherent originality," for its departures from convention are evidently the result of a studious analysis. A plaster wall is especially in need of protection by an ample cornice, and the ample cornice is provided. But the mouldings that are appropriate to masonry are meaningless in plaster, and the wall is a dead expanse, that would be entirely devoid of interest if left alone. Whether it could not profitably have been enlivened in the Saracenic manner by patterns stamped in relief—a treatment especially adapted to the material—is a question that the designers might perhaps profitably have entertained. But at any rate they determined to enliven the expanse only with color, and the color treatment is not successful. The most pretentious and perhaps the most successful feature of it—the famous Golden Doorway—suffers from being an isolated fragment, entirely unrelated to the general scheme, and its admirable detail does not for this reason excite the admiration it deserves. The moulded ornament in this, however, is less successful than the moulded ornament elsewhere in the building which is charged with an astonishing spirit and inventiveness and which is, moreover, unmistakably moulded ornament, neither imitative of nor imitable by the work of the chisel. There is certainly no better detail than this in the Fair grounds, but it also loses much of the effect to which it is entitled by its surroundings, and especially by its association with the queerest sculpture that is to be seen on the grounds, and that is saying a great deal. The comparative failure of the color-decoration is very pardonable in so difficult and so unprecedented an essay, but it entails the comparative failure of the design of which it is an integral part, quite independently of other defects in that design.

But, perhaps, the strongest proof of the good judgment of the architects of the Court of Honor is that the effect of unity is not disturbed by those buildings that are in themselves the least successful. [. . .]

There have been critics who insist that comprehensive as it is, the epithet "classic" is not comprehensive enough to take in all the architecture of the Court of Honor. [. . .] But the great advantage of adopting a uniform treatment, even when the uniformity is so very general as is denoted by the term classic, and even

when the term has been so loosely interpreted, as it has been by some of the associated designers in Jackson Park, is that the less successful designs do not hinder an appreciation of the more successful, nor disturb the general sense of unity in an extensive scheme, which is so much more valuable and impressive than the merits of the best of the designs taken singly. Our enjoyment of the Administration building or of the Agricultural building might be very seriously marred by the juxtaposition of buildings equally good unrelated in scale or in manner, while it is not marred by the actual surroundings. The scheme, of a group of monumental buildings, does not depend for its effectiveness upon the equal excellence, or even, as we cannot help seeing, upon the positive excellence of all the parts that go to make it up. It is a scheme and it has been carried out not only in the huge buildings of unequal merit that we have been considering, but in all the accessories of a monumental composition. [. . .] It has been carried out too in the sculptural adornment, not only of the building but of the grounds, while in the sculpture it is even more evident to the wayfaring man than in the architecture that the effect of the whole does not depend upon the excellence of the parts, and that sculpture that will not bear an analytic inspection may contribute, almost as effectively as sculpture that will, to the decoration of a great pleasance and the entertainment of a holiday crowd. The condition upon which the effectiveness of the whole depends is that there shall be a whole, that there shall be a general plan to the execution of which every architect and every sculptor and every decorator concerned shall contribute. That condition has been fulfilled in the architecture of the Exposition, at least in the architecture of the "Court of Honor," which is what everybody means when he speaks of the architecture of the Exposition, and it is by the fulfillment of this condition that the success of the Fair has been attained. That success is, first of all, a success of unity.

Next after unity, as a source and explanation of the unique impression made by the World's Fair buildings, comes magnitude. It may even be questioned whether it should not come first in an endeavor to account for that impression. If it be put second, it is only because unity, from an artistic point of view, is an achievement, while magnitude from that point of view, is merely an advantage. The buildings are impressive by their size, and this impressiveness is enhanced by their number. Mere bigness is the easiest, speaking aesthetically, though practically it may be the most difficult to attain, of all the means to an effect. It constitutes an opportunity, and one's judgment upon the result, as a work of art, depends upon the skill with which the opportunity has been embraced and employed. But bigness tells all the same, and the critical observer can no more emancipate himself from the effect of it than the uncritical, though he is the better able to allow for it. In this country mere bigness counts for more than anywhere else, and in Chicago, it counts for more, perhaps, than it counts for elsewhere in this country. [. . .] If one asks why [the] Manufactures building [is the best], the civic patriot has his answer ready: "Because it is the biggest thing on earth," as indeed it is, having not much less than twice the area of the Great Pyramid, the

type of erections that are effective by sheer magnitude. The Great Pyramid appeals to the imagination by its antiquity and its mystery as well as to the senses by its magnitude, but it would be impossible to erect anything whatever of the size of the Manufactures building or even of the Great Pyramid that would not forbid apathy in its presence. . . . To quote the aestheticians again, succession and uniformity are as essential as magnitude to the "artificial infinite," and it is necessary to it that there should be a repetition, an interminable repetition of the unit, the incessant application of the module. It is an effect quite independent of the style. [. . .]

The devices by which these inordinate dimensions are brought home to the comprehension of the spectator are various, but they consist, in most cases, at least of a plinth and a parapet in which the height of a man is recalled, as in an architectural drawing the draughtsman puts in a human figure "to give the scale." While the Fair was in progress the moving crowds supplied the scale, but this was given also by all the architectural appurtenances, the parapets of the bridges and the railings of the wharves, so that the magnitude of the buildings was everywhere forced upon the sense. To give scale is also the chief contribution to the effect of a general survey that is made by the accessory and decorative sculpture of the buildings and of the grounds. In this respect, and without reference to their merits strictly as sculpture, the statuary that surmounts the piers and cupolas of the Agricultural building and that with which the angles of the Administration building bristle are particularly fortunate. On the other hand the figures of the peristyle were unfortunate, being too big and insistent for their architectural function of mere finials.

There is still another cause for the success of the World's Fair buildings, a cause that contributes more to the effect of them, perhaps, than both the causes we have already set down put together. . . . The success of the architecture at the World's Fair is not only a success of unity, and a success of magnitude. It is also and very eminently a success of illusion.

What the World's Fair buildings have first of all to tell us, and what they tell equally to a casual glimpse and to a prolonged survey is that they are examples not of work-a-day building, but of holiday building, that the purpose of their erection is festal and temporary, in a word that the display is a display and a triumph of occasional architecture. As Mr. Burnham well described it, it is a "vision" of beauty that he and his co-workers have presented to us, and the description implies, what our recollections confirm, that it is an illusion that has here been provided for our delight. It was the task of the architects to provide the stage-setting for an unexampled spectacle. They have realized in plaster that gives us the illusion of monumental masonry a painter's dream of Roman architecture. In Turner's fantasias we have its prototype much more nearly than in any actual erection that has ever been seen in the world before. It is the province and privilege of the painter to see visions and of the poet to dream dreams. They are unhampered by material considerations of structure of material or of cost. [. . .]

The poet's or the painter's spell or the spell of the architect of an "unsubstan-

tial pageant" cannot be wrought upon the spectator who refuses to take the wonder-worker's point of view and instead of yielding himself to the influence of the spectacle insists upon analyzing its parts and exposing its incongruities. There would be a want of sense as well as a want of imagination in pursuing this course and criticising a passing show as a permanent and serious piece of building. [. . .]

It is essential to the illusion of a fairy city that it should not be an American city of the nineteenth century. It is a seaport on the coast of Bohemia, it is the capital of No Man's Land. It is what you will, so long as you will not take it for an American city of the nineteenth century, nor its architecture for the actual or the possible or even the ideal architecture of such a city. To fall into this confusion was to lose a great part of its charm, that part which consisted in the illusion that the White City was ten thousand miles and a thousand years away from the City of Chicago, and in oblivion of the reality that the two were contiguous and contemporaneous. Those of us who think that architecture is the correlation of structure and function, that if it is to be real and living and progressive, its forms must be the results of material and construction, sometimes find ourselves reproached with our admiration for these palaces in which this belief is so conspicuously ignored and set at naught. But there is no inconsistency in entertaining at the same time a hearty admiration for the Fair and its builders and the hope of an architecture which in form and detail shall be so widely different from it as superficially to have nothing in common with it. Arcadian architecture is one thing and American architecture is another. The value of unity, the value of magnitude are common to the two, but for the value of illusion in the one there must be substituted in the other, if it is to come to its fruition, the value of reality. [. . .] Who that has seen the originals would care to have his recollection disturbed, under pretense of having it revived, by a miniature plaza, with a little Administration building at one end, flanked by a little Manufactures building and a little Machinery Hall? Above all, who would care to have the buildings reproduced without the atmosphere of illusion that enveloped them at Jackson Park and vulgarized by being brought into the light of common day? "This same truth is a naked and open daylight that doth not show the masques and mummeries and triumphs of the world half so stately and daintily as candle lights."

It was a common remark among visitors who saw the Fair for the first time that nothing they had read or seen pictured had given them an idea of it, or prepared them for what they saw. The impression thus expressed is the impression we have been trying to analyze, of which the sources seem to be unity, magnitude and illusion, and the greatest of these is illusion. To reproduce or to imitate the buildings deprived of these irreproducible and inimitable advantages, would be an impossible task, and if it were possible it would not be desirable. For the art of architecture is not to produce illusions or imitations, but realities, organisms like those of nature. It is in the "naked and open daylight" that our architects must work, and they can only be diverted from their task of production by reproduction. It is not theirs to realize the dreams of painters, but to do such work as future painters may delight to dream of and to draw. If they work for their purposes as

well as the classic builders wrought for theirs, then when they, in their turn, have become remote and mythical and classic, their work may become the material of an illusion, "such stuff as dreams are made of." But its very fitness for this purpose will depend upon its remoteness from current needs and current ideas, upon its irrelevancy to what will then be contemporary life.

From Montgomery Schuyler, "Last Words about the World's Fair," *Architectural Record,* January–March 1894, pp. 271–301.

 1. The only building that was finally left standing was the Palace of Fine Arts, which had been planned as a permanent structure. It served as the temporary home of the Field Museum until 1920. Today it houses the Museum of Science.

1900: Paris

When the Chicago exposition was being organized in 1889, political instability in Europe had seemed to make it unlikely that another exposition could be held on the Continent in the near future. But the renewal of the Triple Alliance between Germany, Austria-Hungary, and Italy for twelve years in 1891 and the Dual Alliance formed between France and Russia in 1893 reestablished political stability, and the French government, spurred by the rumor that merchants and industrialists in Germany were planning to take the initiative, was emboldened to propose in 1895 that a universal exposition be held in Paris in 1900. France had been shaken internally by government involvement in the financial scandals of the Panama Canal Corporation and internationally condemned by the case of Captain Dreyfus, court-martialed on false evidence. French moderate republicans were therefore eager for a project that would rally all the elements of the population at home and improve France's tarnished image abroad. France was also determined to maintain its position of economic leadership in the face of considerable international competition.

By 1890 the industrial power and wealth of all the European nations had grown extraordinarily, thanks to technical discoveries and inventions, the markets opened up by colonial expansion and reached by improved transportation, and the tariff protection each country had given its manufactured goods. The enthusiasm with which France's proposal was greeted from abroad therefore reflected economic competition among nations rather than the spirit of competitive enterprise between individual manufacturing firms that had marked earlier expositions.

Five years proved to be too little time for preparation, and when the exposition, entitled the Great Festival of Progress, opened on April 14, 1900, the grounds were far from finished; the first-day crowd made its way through the confusion of construction sites. The inaugural ceremony of this ninth international exposition (and the fifth to be held in Paris) took place in the Salle des Fêtes, a magnificent amphitheater built within the Galerie des Machines, which, together with the Eiffel Tower, had been the showpiece of French engineering at the centennial exposition in 1889. It was decorated for the occasion to recall the theaters of the Second Empire and to hide from view the 150-meter-long girders which the audacious engineers had used to hold up what was at that time the

longest indoor span in the world. Many in the opulent setting might have mused that the exposition to herald the dawn of a new era more accurately harked back to that of Napoleon III, thereby confirming the judgment of the ecclesiastical authority in Rome that the year 1900 belonged, not to the coming twentieth century, but to the nineteenth just ending.

Flanked by distinguished guests, the diplomatic corps, and the ministers of the government, President of the Republic Emile Loubet welcomed the representatives of the nations. They were to participate in two distinct expositions—one contemporaneous and one retrospective—to demonstrate the evolutionary stages by which the current capacity and conditions in the arts and sciences had been attained. The Minister of Commerce and Industry, who headed the department responsible for planning the arena for the friendly contest, expressed the government's gratitude for the cooperation it had received from all nations in realizing the plan, before beginning the official review of the exposition. In front of the Galerie des Machines stood the Palais de l'Electricité and the magnificent Château d'Eau, an elaborate, picturesque grotto portal in staff used as an imposing fountain display. Illuminated at night it produced a gorgeous effect in its dazzle and variety.

The various segments of the exposition grounds were strung along the embankments of the Seine and connected by bridges: the Pont d'Iéna joined the Champ-de-Mars to the park placed below the Trocadéro, which was filled with exotic houses representing the colonies of the European powers; the Pont de l'Alma connected the Rue des Nations to the display called Old Paris (plan 6). The old Pont des Invalides and the new Pont Alexandre III (fig. 36), designed by the engineers Résal and Alby, linked the Esplanade des Invalides (fig. 37) to the two splendid permanent buildings, the Grand Palais and the Petit Palais, placed on either side of the avenue Alexandre III, which ran between the Seine and the Champs Elysées to create a splendid new vista (plan 7; fig. 34). The view from the Hôtel des Invalides to the Champs Elysées had previously been blocked by the now demolished Palais de l'Industrie, erected for the universal exposition of 1855 and subsequently used for horse shows, skating, and the annual Salons. The Grand Palais was to house a decennial international art exhibition (1890–1900) and a retrospective centennial show and then to replace the demolished building as the permanent exhibition hall for the Salons. The Petit Palais would have a historical exhibition of the decorative arts assembled from provincial museums, churches, and private collections, arranged by Roger Marx and Emile Molinier, and then become the art museum for the city of Paris.

The chief architect for the Grand Palais, Henri Deglane (since 1890 *chef d'atelier* of the Ecole des Beaux-Arts) and his associates, Louvet and Thomas, followed strict Beaux-Arts precepts in carrying out the program prescribed by the government, with the result that both the Grand Palais and the Petit Palais were the epitome of proper Beaux-Arts style. The plans had called for a hippodrome (fig. 48) for the horse shows and galleries for the Salon painting and sculpture exhibitions. The space was divided as required, and then the building was de-

signed. Deglane had won a Prix de Rome in 1881 for his ability to organize rapidly and clearly the internal spaces that had to be functionally related to one another and then to unite them into an organic and pleasing whole. His design for the Grand Palais called for a sheath of stone over an audacious iron and glass structure decorated to make the edifice readily recognizable as a museum. The design, which included startling sculptural groups on the corners, was described as "contemporary Baroque."

The permanent function of the Petit Palais as a museum for the city simplified the task of its architect, Charles-Louis Girault, another Prix de Rome winner (in 1880). Also designed in Baroque style, it was regarded by some architectural critics, among them H. S. Stratham, editor of *The Builder,* as "one of the most beautiful of modern times." John P. Coolidge, Jr., writing in the American *Architectural Review,* agreed:

> The smaller Art Palace from M. Girault's design combines the dignity of a palace with the amenity of an exposition hall, and has better studied and more refined detail than seems called for in temporary structures adorned with "staff." Furthermore, there is an intimate though indefinable connection between the structural material of the building and its decoration. The steel and glass galleries are not concealed by the stonework but framed in it. The plan is the plan of a composite structure partly of metal. Altogether the building is probably the most beautiful building of its class in the world.[1]

The formal dedication of these new buildings and their exhibits was delayed until May 1. President Loubet once again did the honors, this time entering the "city within the city" from the Place de la Concorde by the Porte de la Concorde (fig. 35) a gigantic ornate arch designed by René Binet with elements taken from Indo-Chinese, Mexican, and European architecture. It was surmounted by Moreau-Vautier's sensational statue, *La Parisienne,* clad in a jeweled peacock-blue tight skirt and blouse.

Reflecting the by now customary emphasis of the exposition on nationality, the space allocated to each participating country was as usual arranged and decorated to accent what was perceived to be its national character. This practice, combined with the general theme of illustrating the achievements of man and the progress of society since 1800, was what gave the show, especially its architecture, its retrospective character. Once again architects rather than engineers had been given the upper hand; they were assigned the major responsibility for both the overall plan and the individual buildings. In 1900 the engineer's contribution was restricted almost entirely to the Pont Alexandre III. Along the Quai d'Orsay, between the Pont de l'Alma and the Pont des Invalides, was the Rue des Nations, the twenty-four pavilions of the principal foreign nations (fig. 38). Although each building was supposed to illustrate its country's "typical" architecture, most of them were designed, if not wholly by French architects, at least with their as-

1. John P. Coolidge, Jr., "The Characteristic Architecture of the Nineteenth Century," *Architectural Review* (July 1900): 79–82.

sistance. That for Romania was by Jean-Camille Formigé, that for Greece by Lucien Magne. The American national pavilion was a joint effort by Charles A. Coolidge and the French architect Morin-Goustiaux, who had been appointed to superintend its construction and assist in adapting it to its site, which was eighty feet wide and about equally deep, on the river. It was flanked by the buildings for Austria and Turkey, the latter also designed by a French architect, in this case René du Buisson. One of the exceptions to this French domination was the Finnish pavilion, the sole creation of a native Finn, Eliel Saarinen (fig. 39).

The square site for the American building required a tall, narrow structure. For it they used a modification of the Administration Building at the Chicago exposition. In classic style, with pilasters similar to those of the White House, it was surmounted with a dome and cupola and supplemented in front with a high portico that sheltered Daniel Chester French's equestrian statue of George Washington.

On the embankment opposite the Rue des Nations were the quaint buildings of Old Paris with vine- and flower-covered walls, ancient roofs, and porches. The City of Paris building in Third Empire style and the brilliantly designed glass-and-iron horticultural buildings by August Gautier separated Old Paris from the Grand and Petit Palais.

The classification of exhibits had grown increasingly complicated since the establishment of the original four groups for the London exposition in 1851. Increased to six in 1871, nine in 1889, and twelve in 1893, by 1900 eighteen groups were subdivided into 120 classes (likened by one writer to the genus and species of science).[2] Among the new additions were the military, a group with six classes, and "social economy with space devoted to what concerns the laboring classes and the amelioration of their condition."[3]

Each group was placed in long sheds transformed into ornate edifices by an overlay of elaborately decorated staff. The two on the Champ-de-Mars contained on the west three groups: transportation (group VI), chemical industries (XIV), a new group, and electricity (V), another new group, which had been elevated from a class "largely due to the example set by Chicago in 1893, where . . . a special building was given up to [it]."[4] On the east were two groups—mines (group XI), and textiles and clothing (group XIII). The space assigned to a group and its classes was then divided up among the participating nations for their displays. This arrangement facilitated the internal jurors' task and challenged each nation to devise a distinctive area that would attract attention.

A part of the exposition was placed at nearby Vincennes and connected by rail and boats on the Seine with the Champ-de-Mars and the Esplanade des Invalides. At Vincennes were arranged the exhibits of motorized power, railways, and automobiles (groups IV and VI) (figs. 46–47). The sports competitions,

2. Theodore Stanton, "The International Exhibition of 1900," *Century Magazine* (Dec. 1895): 314*n*1.
3. Ibid., p. 314.
4. Ibid.

which had been expanded to include the Olympic Games, were held there as well.[5]

Just to the south of the Pont Alexandre III on either side of the Esplanade des Invalides were the fantastic palaces created out of staff, so dazzling to the crowds. Some were laden with allegorical sculptural groups, others with decorative motifs derived from plant life which lent them a "modern note." They housed groups XII and XV, which embraced many classes of consumer goods. In group XII were the fixed decoration and furniture for private dwellings and public buildings (classes 66 to 75). Making these a separate group was necessary because of the attention being bestowed both on interior décor and on the exterior decoration of buildings to give them an original, varied appearance (see fig. 41). The houses and furnishings of the various American states at the Chicago exposition had caught the foreign critics' attention. As the use of color became fashionable, importance was "given to decorative ceramics [ceramic tile had become popular for use on both monuments and houses], to facings in colored wood, in imitative material or even in metal; also to the search for new lines to agree more or less with the harmony in the colors; and finally to find old processes of color decoration and to discover new ones."[6] The objects exhibited were the work both of artists and of mass production, the latter often imitating the inventions of art.

The commercial exhibit in class 72 included ceramic ware, faience, stoneware (*grès*), and fireproof construction materials; it was supplemented by an exhibit put together by the Union Centrale des Arts Décoratifs and displayed in an eighteenth-century-style pavilion, designed as a folly by the architect, sculptor, and ceramicist George Hoentsched. It included a comprehensive retrospective exhibition, and a notable contemporary display to show the new path that manufacturer and decorator Theodore Deck had opened by the decoration of his ware. Influenced by the Japanese, he and others had turned from tradition to fantasy. Their success had created a renaissance in ceramics that had attracted to it painters like Félix Bracquemond, Jules Cazin, and Paul Gauguin.

Group XV, with classes 92 to 100—cutlery, jewelry, artworks in bronze, cast iron, and wrought iron—were on display in the spaces assigned to manufacturers in the Esplanade palaces. The manufacturers of France were on the west side. Germany, Switzerland, England, the United States, Austria, and Japan competed for attention on the east. These "decorative arts" were designed for a world market that had long accepted fashion as being whatever the French designers said it was. The beautiful articles that observed traditional styles and tastes displayed by Russia, Turkey, Greece, and others conformed little to fashion in themselves, but often became a source and inspiration for fashionable Parisian designs. While these products were for the most part displayed in the vast halls in marketplace

5. The second renewal of the modern Olympic Games was played here for the first time outside Greece.

6. César Daly, quoted in Peter Collins, *Changing Ideals in Modern Architecture, 1750–1950* (London, 1965), p. 120, from the *Revue générale de l'architecture*, which was founded by Daly in 1840 and ceased publication at his death in 1888.

fashion, some exhibitors took the alternate route of turning their assigned space into modern model rooms in which all furnishings, pictures, light fixtures, paintings, and sculpture were combined in a unified whole. To this extent the fine arts were allowed to merge with the applied arts, but the traditional separation between them was maintained in the organization of the exposition.

Contributing to the renaissance of the arts in group XII was the room installed and furnished by the artists' colony of Mathildenhöhe, under the patronage of the grand duke of Hesse in Darmstadt, and the separate pavilions built by dealers in the Esplanade. S. Bing had installed a seven-room Art-Nouveau house furnished by the designer-artists Edward Colonna,[7] Eugène Gaillard, and Georges de Feure (figs. 42–43). The German critic and art historian Julius Meier-Graefe, who had opened his Maison Moderne in Paris in 1897, also had a pavilion at the Esplanade, as did the architect-designer Hector Guimard.

The decennial exhibition in the Grand Palais housed part of group XII and was divided among classes 7 (paintings, cartoons, illustrations), 8 (engraving and lithography), 9 (sculpture and engravings on metals and gems), and 10 (architecture). Each country's jury had chosen the works admitted to a class, but the awards for the class were decided by an international jury. On an upper floor hung the retrospective exhibition of French fine art (1800–99) selected by Roger Marx, who did not include any works that had been shown at the similar retrospective in 1889.

In class 7, the attention of the perceptive Austrian art historian Richard Muther and other critics was especially attracted to paintings by Japanese artists executed to conform to the standards set by the European jury:

> In the upper story of the Grand Palais, we walk from the French into the Japanese rooms and scarcely note any difference because for the first time Japan is wearing European dress. Two rooms with silk paintings remind us what an influence the East exercises on the development of art in Europe. The main room shows how European art developed in Japan has become the standard in Japan. The speed of this reversal has been rapid. All that is to be learned in Paris the Japanese have acquired with the finger nimbleness of a juggler. In thick gilt frames, large oil paintings, constructed according to all the rules of our textbooks on perspective, are hanging: young girls who, as in a Bastien-Lepage, dream on the edge of a meadow and permit the sun's rays to play about them; net menders who, as in a Liebermann, stand on a lonely sand dune; laborers who, as in a Meunier, go wearily home; sailors who, as in a Kroyer, look out over the sea at evening; landscapes that are light in all the colors of the Scots or as in a Cazin fade in the evening twilight. There are very skilled, very fine paintings. Kuroda Seiki, Nakagawa Hachiro, Okada Saburosuke, Wada Eisaku, Watanabe Shinya, Yoshida Hiroshi, the names of the masters sound very Japanese. They are placed on the paintings, not in Japanese, but in elegant Latin letters. In morning coat and the most modern ties, the artists present

7. Edward Colonna later worked in Dayton, Ohio, designing the interiors of railroad cars and Pullman sleepers.

themselves in their self-portraits. The old Japanese costumes, the old jewelry that they paint, have for them the ethnographic and archaeological interest that the Altenburger or Niesbacher folk customs have for us. The paintings could come from Hohenberger, Mortimer Menpes, or another European Japanese painter. The general Europeanizing of the country has been followed by art.

So the difference between modern Japan and the adjoining American galleries is not great. One will find himself transported to the Wild West as little as one found himself in the Land of the Rising Sun.[8]

Before judging class 10, a dispute arose among the jurors regarding the eligibility of the American architecture on two grounds: one was whether the problem of fireproofing its tall buildings had been successfully solved—for safety was a stipulation for admission to the class—and the other was whether the United States could be said to have a national architecture at all. Some of its work was found to be too French and thereby lacking in a proper national spirit. The ocean between them had led the jury to expect something unexpected and non-European. But the general consensus was more on the side of the official American view "that among all the foreign sections, the work of our [American] section showed a distinctly greater tendency toward being modern in style and in touch with the spirit of the times. While almost all the work in the other foreign sections was archaeological in character, our architects seemed to solve rationally the problems of this age with a more careful study of the conditions in which we live."[9] The reaction of American architects could be found in the numerous periodicals that catered to buildings and designers in the country's rapidly growing cities. Of the national "houses of representation," the *Inland Architect* of Chicago found the Italian building "the most conspicuous architectural success of the Exhibition." An early report by an anonymous reviewer was given in *The American Architect and Building News.*

The founder of France's first-class architectural periodical, *Revue générale de l'architecture,* César Daly, had written prophetically in 1853 that "eclecticism would not create a new art, but would be a useful transition from revivalism to the new architecture of the future."[10] Those words could now be applied to the service rendered by exposition architecture. *La Construction moderne,* a weekly, provided exhaustive coverage, as did two German-language periodicals, the *Allgemeine Bauzeitung* in Vienna and the Berlin *Architekturwelt.* The latter pointed out that the exposition's administrative buildings sought a fantastic style; the rest had reconstructed "ancient"—that is, national—styles.

The periodicals that in the intervals between expositions were devoted solely to the fine arts and the history of art expanded their reports to cover architecture and the decorative arts more fully. The *Zeitschrift für bildende Kunst* secured an

8. Richard Muther, "Die oberen Säle," in *Aufsatz über bildende Kunst* (Vienna, 1914), 1:320–21. Muther's important history of nineteenth-century European art appeared in 1890.

9. *Report of the Commissioner General of the U.S. to the International Universal Exposition,* Paris, 1900 (Washington, D.C.: Government Printing Office, 1901), 2:75.

10. César Daly, quoted in Collins, *Changing Ideals in Modern Architecture* (cited above, n. 6).

excellent report by a young Berliner, Walther Gensel, later well known for his essays in the illustrated series *Künstler Monographien*. He regarded the Pont Alexandre III as the most noteworthy structure erected in connection with the exposition.

The fine-arts periodicals had also begun to recognize decorative artifacts as an art form. *The Studio* of London assigned to the French critic Gabriel Mourey the task of describing the new art in Bing's Art-Nouveau house and Meier-Graefe's pavilion. Other *Studio* critics covered the new style as it was used in the buildings scattered in the parks of the ephemeral city, including Le Pavillon Bleu (fig. 44), a restaurant on the Cours-la-Reine, and a theater, designed by Henri Sauvage and literally wrapped in a curtain of staff, which was shared by the American dancer Loie Fuller and "the Japanese Bernhardt," Mme. Sadda Yakko, who brought popular Japanese prints to life. Some of the restaurants were also described by "A. Barthelemy," the pseudonymous national director of fine arts, whose real name was Antonin Proust. Under this pseudonym he was a frequent contributor to the *Gazette des beaux-arts,* but this time he wrote for *L'Art et décoration,* a new periodical.

The Herculean task of judging the exhibits in 120 classes, undertaken by jurors from forty countries, had been completed by August 18, when the formal presentation of awards was made at a spectacle in the Salle des Fêtes, with scenic effects devised and directed by the head of the national theaters and a *marche héroïque* composed by Saint-Saëns. Ten thousand persons arose and remained standing while the president, members of the cabinet, commissioner general, and the heads of the eighteen groups passed between a double line of soldiers to take their places in the president's tribune. After the procession of the flags and banners of the foreign commissioners general and the French groups had passed, and a hymn to "La Patrie" had been offered by an orchestra and double choir, President Loubet expressed the gratitude of the Republic to all who had "taken part in this peaceful contest where there are, so to speak, no victims. The palaces which contain the many noble works, the numerous curious and useful products that were offered for the admiration and instruction of the people, will close, . . . [but] the soul of this ephemeral organization will continue long after the destruction of the grand buildings which now enclose them."[11] The exposition actually closed on November 10, a week behind schedule, to allow the president of Transvaal, South Africa, Paul Kruger, the defeated Boer leader, to be accorded an official reception.

The exposition had been presented as an occasion that marked the end of one century and the dawn of the next, an opportunity to evaluate past achievements and predict future ones. The establishment press surveyed the past with satisfaction and looked to the future with discreet confidence. The avant-garde, consistently restless within the restraints of convention and critical of the past, advocated greater audacity. Its evaluation of the exposition was found in the numerous

11. *Report of the Commissioner General* (cited above, n. 9).

"little magazines" that had grown up in Paris since the passing of the freedom-of-the-press act in 1881. One was the *Mercure de France*, launched in 1889 by Alfred Vallette with the collaboration of associates in the art world. It strove to equal the fame of its seventeenth-century namesake, Europe's first belles-lettres journal. The staff solicited manuscripts and reviews from like-minded liberal political advocates and Symbolist writers. Because of the journal's close relationship to literary and art circles in Brussels, Emile Verhaeren, a Belgian poet esteemed throughout Europe, was chosen by Rémy de Gourmont, the art editor, to summarize his reactions to the exposition when its gates had closed.

The press concluded its coverage with remarks to the effect that much of the original character of the universal exposition had been lost. The enthusiasm of 1851 had been replaced by cool calculation and had converted the exposition into a trade fair. In 1851 every producer could hope by exhibiting his wares to win a place in the world market, and each strove to do so. Governments were little involved in the arrangements. But with the end of free trade, protective tariffs encouraged exhibits that were a form of national representation. Each country aspired to show its artistic and technical achievements to the best advantage, requiring that exhibitors be limited to a few who produced the country's outstanding wares. Many firms were reluctant to fill this representational role for the national prestige of their country. Therefore governments, with their ministries of commerce, came to be regarded as the instigators and the ones responsible for the ever-increasing expense. Still it was generally agreed that the periodic effort called for by these competitions among the world's master designers had encouraged the development of the applied arts. The forty-eight million visitors who streamed to the 1900 exposition learned from, and were stimulated by, the comparisons set before them. Although the cherished dream of 1851 had not been achieved, it was at a universal exposition as nowhere else that peaceful exchange and competition among nations could be encouraged.

A glance at the buildings themselves could indicate as well as anything the successive changes in taste and fashion that events had wrought in the course of the nineteenth century. The splendid iron and glass architecture of earlier expositions was nowhere to be seen. The audacious springing girders of the 1889 Galerie des Machines were encased in plaster and concealed from admiring eyes; within was a theater in a Napoleon III style that Beaux-Arts professors had manufactured to serve as a "national architecture" by synthesizing elements from France's architectural past. Except for the two horticulture halls, the buildings were covered with sculptural allegory and liberally decorated. Since two of these buildings, the Grand Palais and the Petit Palais, and the Pont Alexandre III were permanent structures, the perpetuation of this eclectic Beaux-Arts style was assured, and it remained an unchallenged national style at least until the First World War. Only two structures avoided the synthetic "national" styles that seemed to be demanded by the times and which were exemplified by the pavilions lined up along the Rue des Nations. At one extreme, the United States, admitting it had no

national style of its own, aside perhaps from the skyscraper, accepted defeat and took its inspiration from the French Beaux-Arts. At the other extreme—the only building in the exposition to excite universal praise—was Eliel Saarinen's Finnish pavilion which stood out from the rest, clean in line and Finnish in spirit but uncontaminated by historicism.

Emile Zola, an early and avid photographer, paid fifty centimes for his camera and received the necessary permissions to photograph at will from the exhibitors (see fig. 40). Asked for an opinion of the exposition by the *Revue des revues* to print in its illustrated supplement *La Grande Revue de l'Exposition*, in which was a column called "Notre enquête sur l'Exposition de 1900" devoted to the reactions of distinguished men, he wrote: "In two lines, I am unable to give an opinion of universal expositions from the point of view of their economic, political, and social utility, for the good reason that I do not know anything about the subject. Universal expositions amuse and interest me as an ordinary spectator. And that is all I can say about them. Emile Zola."[12]

The Impression of Architecture
RICHARD MUTHER

[. . .] The world expositions have rendered important services which we acknowledge with gratitude. When the first locomotive raced through the country it was inviting and easy for industrialists and artists quickly to become acquainted with products from the entire globe at one central point. Today the products of foreign countries are essentially known. On any specific items the professional can inform himself at special exhibitions. At world expositions the material is so incoherently displayed that the head begins to spin. The new and emerging also cannot be shown, just as the general department store cannot carry special products. The Paris world exposition is the final proof. Compared to the previous one [1889] it is more comprehensive, but it is neither more instructive nor of higher quality. Indeed one gains the impression that people felt the senselessness of the undertaking and completed the project without any enthusiasm just because it had been planned.

The impression we gain of the architecture is altogether disappointing. The connection between the individual parts of the exposition is difficult to discern; the buildings seem to be strewn haphazardly over the huge area. There is one shining exception: the view of the fine arts-buildings, the Pont Alexandre, and the dome of the Invalides. What a spectacular vista would have been achieved if the main entrance had been put there! Instead the monumental gate has been erected

12. The *Grand Revue de l'Exposition* was published in fifteen numbers from November 1899 to October 10–25, 1900. Zola's opinion appeared in no. 5 (Jan. 1900), p. 55.

close to the Place de la Concorde, and prosaic metal grilles built at the avenue des Champs Elysées. At the main entrance there is no life, and the row of buildings at the Pont Alexandre lacks any termination. Zola wrote in *L'Oeuvre* how "he [Lantier, a painter and the main character of the novel] required a formula for a new architecture that would have something powerful and strong, something simple and great. That something is adumbrated in the powerful elegance of the iron trusses in our railway stations and our market halls. With some refinement it could be raised to beauty; it could proclaim the greatness of our achievements." At the world exposition of 1889, the Galerie des Machines and the Eiffel Tower served as precursors of this new architecture. What emerged there has come to full fruition. The organism of a machine, the slender hull of a ship, the powerful arches of a railway station, and the construction of a bicycle all become beautiful when purpose and material are integrated into a new design. The France of 1900 was able to display such an art of building, without stuck-on ornamentation, without hollow pomp, great because of its honesty, and imposing because of its simplicity. All that once was, became one in a last exhilarating orgy.

The two glass palaces of the horticulture exhibition are the only buildings in which the materials are authentic and pure, the only ones whose functional character reveals an impressive beauty. Aside from these, the exposition reflects the varied trends of the nineteenth century instead of striving for a unified style. They clung especially to the Napoleonic period and returned to the gaudy architecture of the Second Empire in order to achieve startling effects. In the fine-arts buildings this was done with some taste. Although everything is based on Garnier's treasury of form,[1] and the facade was not worth being executed in mosaic, at least there was some attempt at dignity and overall elegance. Then, however, begins the swindle; shoddy work in stucco and all kinds of surrogates appear. The buildings feed on the Napoleonic period, but they do not even begin to achieve the level of creditable imitation. The details, which are delicate in the fine-arts buildings, are ostentatious and clumsy in the buildings on the Esplanade des Invalides. Whatever appears to be representative of the Napoleonic style is here insipid confectionery and limp tapestry. Any sensitivity for the intrinsic character of the material is lacking. Pictures are used as supports, and curtains are nailed on painted canvas. Slender pillars are topped in mockery by stupid capitals with Baroque cornices. Ornaments are not painted on walls, but on paper glued to the wall. Iron bridges are painted gold or are disguised as bridges built in stone. The debacle of bad taste is so enormous that the remains of the [expositions] of 1878 and 1889 stand out like the ruins of a better time in an art-poor present.

After the Napoleonic style has been thoroughly savored, a new box of building blocks is opened and a piece of the Middle Ages emerges. Quaint alleys, a few narrow, gabled houses, some costumed soldiers with plumed hats and halberds are to represent the Old Paris at the world exposition: this is the kind of play that we enjoyed in Germany at parties featuring Renaissance costumes. The same nostalgic taste turns the Rue des Nations into a stylistic travesty. As you know, the

exposition is not organized by country, but by various themes—thus education, art, printing, engineering, electricity, transportation, agriculture, hunting, hygiene, military arts—I shudder as I write these words—are arbitrarily presented as established groups.

Once the achievements of the individual nations were split up, it became necessary to create another focus for each country. Thus the idea of representative houses [*puissances étrangères*] was born. This might have been appropriate had they served representational purposes, had they contained reception rooms for members of the reigning families who might visit the exposition. Had the Austrians, for example, reproduced the rooms of the Hofburg, or the Germans rooms from the Potsdam palaces. Germany followed the original plan, at least in part. The Kaiser sent French paintings that Frederick the Great had acquired—a courtesy of the kind he often displays in order to gain the favor of the French. No one else wished to be "representational," and used the buildings for mundane purposes. A course on the cotton industry and shoe manufacturing is offered in one, on pisciculture, distilled spirits, and lace manufacture in another. The Austrian hall contains the post-and-telegraph exhibition; a bit of art is tucked in for which no space could be found elsewhere. The most insipid aspect of all this was the requirement that every country build in a "historical style." This would be appropriate for nations such as Spain and Greece, whose importance is based on their past, but it is not for modern nations where new requirements produce new forms and styles every day. As a result every country searched for a "native" style and finally built in a way a tourist might imagine the style of that particular country to be.

Italy presents in playful manner a kind of St. Mark's Cathedral; England chose the hall of an English country house, and Belgium a copy of the town hall of Brussels. Hungary displays the same building that had been exhibited at the Millennium at Pest. Germany tops the tasteless with a beer hall built like a Renaissance house, the kind that symbolizes the South German spirit at the Spree [in Berlin] . [. . .] Austria, of course, builds in the style of the Baroque. One cannot, however, deny that the effect of the building is noble, yet the architect cannot take credit for this effect. Because the Kaiserlich-Königlich Rat [Imperial Royal Counselor] [Ludwig] Baumann, whom insiders refer to as the Austrian factotum, cannot produce anything of significance, as his Viennese restaurant demonstrates, the compliments for this representational house should go not to him but to Fischer von Erlach, from whose rich drawing board copyists have been gathering crumbs for centuries. What a pity! What would stand there, had a man like Otto Wagner been in charge? The requirement for a historical style certainly does not exclude artistic and free expression. Other countries, England and Hungary, for example, created beautiful and genuine works within their traditions, or they ignored the requirement. The Finnish house [by Eliel Saarinen] is especially saucy and amusing, with its novel skylight and silhouette. The best building of the whole complex is the representative house of Sweden. Here is no hollow pomp, no

shallow imitation. The straightforward style in wood is impressive in its simplicity and dignity. Everything develops harmoniously and logically from the character of the material. The Swedes and the Finns appear to be the pioneers of a young and triumphant beauty.

Translated from Richard Muther, "Der architektonische Eindruck," in *Aufsatz über bildende Kunst* (Vienna, 1914), 1:291–97. Perhaps first published in the Viennese newspaper *Die Zeit* in 1900.
1. Charles Garnier, *Nouvel Opéra de Paris* (1874).

French Art in the Year 1900

WALTHER GENSEL

[. . .] Much has already been written and much debated about the Grand Palais and the Petit Palais of the Champs Elysées. Although they are by no means flawless masterpieces, neither are all the criticisms leveled against them entirely justified. The criticism most frequently heard is that instead of offering something new, they cling completely to traditional forms. But in Paris one must reckon with what already exists; one cannot afford to be as modern as in Chicago. The two palaces had to reconcile the noisily elegant bustle of the Champs Elysées with the severe mansard roof—in other words, to be both Parisian and classically respectable. The Petit Palais meets the former requirement, and the Grand Palais tends more toward the latter. [. . .]

When in 1889 the Eiffel Tower and the Galerie des Machines emerged as the new wonders of the world, the phrase "iron style" was on everybody's lips. Thereafter enthusiasm for it waned considerably as people came to realize that, while architectural beauty is based primarily on the effect of surface treatment, iron provides no surfaces and therefore one can speak only to a limited degree of an aesthetic of iron. Nevertheless, one might have expected that the experiments made in the art palaces of 1889 would be repeated within the exposition buildings themselves—which basically should be nothing more than aesthetically pleasing shelters, and indeed are only halls of iron and glass—as well as in their exteriors, and thus in this special area results would be productive. But since then the architects have managed only to find a new god in "staff," which they use to glue a facade onto an iron frame covered with glass; it has not the least thing to do with the internal structure. Almost all of this year's exhibition halls are built of this "staff." There is one brilliant exception, however, and that is the horticulture palaces of the architect [August] Gautier. They are the most graceful glass buildings that I know, and together they form probably the most charming picture in the whole exposition. From the bank of the Seine, a thirty-meter-high set of steps leads to a square decorated with flower beds, flagpoles, and sculptures. Behind it we glimpse the rectangular building for the exhibition of designs and industrial equipment; to the right and left rise large greenhouses, each of which is a rec-

tangular eighteen-meter-high hall—with semicircular recess and flanked by elegant pillars on the long side—with which a dome-shaped palm house is connected. The iron sections are partly pale green, partly white with light green latticework, and everywhere decorated with large or small pink flowers. Gold is very sparingly applied here and there. One can imagine what a charming, springlike picture results. Nowhere is ornamentation overdone and nowhere lacking. Above all the proportions are so successful that an overall harmonious effect is achieved.

As regards the internal iron construction of the buildings, the Palace of Engineering and Transportation, by the architect Hermant, should be singled out for praise. His pillars consist of bundles of iron rods that spread out at the top like palm leaves. These curved rods are connected at regular intervals by horizontal bars, the upper ones of which support single or connected arches. It is hard to describe these, the more so because I lack the technical terms. In any case the strongest impression of lightness and elegance is achieved, while at the same time we are reminded of twigs and branches along a forest path. However, the system of interconnected supports is so complicated that a certain uneasiness is created. Nevertheless, one needs only compare the iron skeleton of this palace with the ungainly Palace of Yarns and Textiles over the way [on the Esplanade des Invalides], which is reminiscent of railroad trades, to rank this effort highly.

The new Pont Alexandre also belongs among the new iron constructions. It is of course considerably less astonishing than the Eiffel Tower and is scarcely noticed by the general public, but it is hardly a less important technical masterpiece. Because it is located scarcely two hundred meters from the Pont des Invalides, it could not be built on pilings lest shipping be obstructed, but had to be built as a single 107-meter-wide span across the Seine. This gigantic arch had at the same time to be built as low as possible so that the view of the Esplanade would not be blocked out, and as high over the river as possible to permit the passage of steamers under it. All these conditions have been brilliantly met by engineers Résal and Alby. They have created the ideal modern bridge, a broad, safe, and convenient highway that limits neither view nor shipping. On the other hand, its architectural ornamentation has aroused great criticism. The pompous style of Louis XIV that is suggested in the ornamentation does not suit the modern ironwork, and the four powerful corner columns, with their gilded groups of winged horses, the gigantic statues, and the mighty lions on which the best sculptors of France have worked are almost reminiscent of fortifications for a medieval bridge. According to the master builder these columns were needed to mark the course of the river on the broad street to the Invalides. All in all, the Pont Alexandre is a highly distinctive piece of modern architecture.

Translated from Walther Gensel, "Die französische Kunst im Jahre 1900. I. Die Architektur," *Zeitschrift für bildende Kunst* 9 (1900):206–27.

The Exposition: A Few General Figures, the Foreign Pavilions
UNSIGNED

"It is too big, and there are too many things to see!" [. . .]

In the first place, conceive that the enclosure of the Exposition contains, in Paris alone, an area of about 110 hectares, while at Vincennes there is occupied a space of almost equal size, which raises the round figure to the very pretty total of 220 hectares which must be passed over once by whosoever desires to neglect nothing. [. . .]

Now let us enter the Exposition anywhere, and draw our first impression at hazard. At the time I am writing this article the Exposition has been open for two months, and with some few exceptions everything is finished. [. . .]

When comparing the buildings erected by the French with those erected by foreign architects, the mind is drawn to one thing. The foreigners have more often than not made reconstructions of ancient monuments, exactly reproduced or ingeniously reduced and combined. The French architects, on the other hand, in their administrative buildings, have rather sought a fantastic style; if not always a new one, one not recalling, at any rate, any given classic monument. They have sought to be decorators rather than architects, and, through inspiring themselves only through their own ingenuity, some of them have achieved really charming results. Such has been the case this year with M. Paulin, architect of the Château d'Eau, and M. Hénard, author of that delicious silhouette, rich in filigree-work and light, which crowns and encloses the Château d'Eau.

Seeking novelty, the French architects, in constructions so hastily studied, must, of course, expose themselves to severe criticism, and some have not been spared. They have "treated their architecture like confectioners and pastry-makers"; they have been accused of bad taste and compared to their disadvantage with the marvellous architecture of the foreign pavilions. This manner of judging is unjust. The artist who seeks can more easily deceive himself than he who reproduces a given work already built and of known repute: he deserves, at least, the respect due to an effort. This is the case with the French architects, who, in spite of some errors, due to an excess of imagination, have given proof of ingenuity, intelligence, elegance and a charming fancy. And then, it must be said, the task is not easy. At this moment we are passing through a period of transition, which brings it about that in all the arts we find ourselves face to face with several opposing manifestations; some do not try to depart from the dry and routine-bound paths of classic art, others are too eager to get out of them and so fall into eccentricity. The most reasonable, desiring to preserve a just medium, have not yet altogether cast off the academic formulas, nor have they known how to apply the principles of their classic education to the accomplishment of the new problems which they impose on themselves. Consequently, we arrive at a lack of equilibrium, an absence of cohesion between the parts of a building, in a word, at "*hors d'échelles*" which are often shocking.

We shall find the proof of this theory in the Grand Palais des Beaux Arts, on

the Champs-Elysées. The main façade on the avenue is composed of a grand central portico, with, on the right and left, colonnades of fine appearance, excellent proportion, and decorated with a very beautiful frieze by M. Edouard Fournier, executed in mosaic. This very classic façade, which does not include any new element of construction, conceals an immense interior nave, composed of iron trusses of great span, of great height, and crowned by a circular dome, also in iron, the entire roof being glazed. Here there are new elements of construction; the materials suggest new forms incompatible with the classic lines of the façade. So, while from a distance regarding the general effect of the palace, the observer is troubled, without quite knowing how to account for it, by the effect of this mass of glass crushing the façade and having with it no apparent relationship in style or epoch.

This injurious effect of glazed domes over façades of classic architecture is one of the rare bits of criticism which, although in a much less degree, can be aimed at the Petit Palais des Beaux Arts, by M. Girault. Here there is still something to seek, something not yet found. The shrewdest have, wherever possible, concealed their glass windows behind attics, balustrades and decorative pediments. Up to the present time this is the most satisfactory solution, and with this treatment the architects of the palaces on the Esplanade des Invalides and the Champ-de-Mars content themselves.

The great effort is shown in the study of decoration, and from this point-of-view the palaces of MM. Larche and Nachon, on the Esplanade des Invalides, [are] particularly interesting. These two architects have laid the realm of Flora under contribution for the decoration of their façades—a rich realm and an elegant, ransacked with artistic perception, and its spoils arranged with grace and fancy; all ending in lending a modern note to the architectural lines, themselves well composed. Here is really a step towards an interesting modern style.

The foreign architects are less fantastic, but the pavilions which they have built on the banks of the Seine are amongst the jewels of the Exposition, because of the picturesqueness of their silhouettes and the architectonic construction of the buildings themselves.

One of the buildings most remarked is the Belgian building, a reproduction of the Hôtel de Ville at Audenarde (1525–1530), dominated by a superb openwork belfry rising to a height of 40 meters, and crowned by a statue in red copper representing a warrior of the Middle Ages bearing the arms of the city on his banner. In the interior, a monumental staircase leads to the first story, where the principal room represents the grand hall of the Hôtel de Ville, with its lofty mantelpiece decorated with sculpture and Gothic statues. The walls are decorated with paintings representing the arms of the principal cities of Belgium and of the different trade-guilds. Magnificent and very ancient Flemish tapestries ornament the panels and aid in giving to this room a very interesting local coloring. On the same floor, a second room reproduces the sheriff's hall, and it also is decorated with ancient tapestries.

This entire series of palaces is very much like a retrospective exhibition of

foreign architecture. Thus Germany initiates us into the polychromy of her Renaissance façades of the sixteenth century: nothing is more curious than these grand allegorical paintings representing the four elements of nature in lively and crude colors. A picturesque belfry, scintillating with gilding and bearing a large clock and chimes, dominates the palace, the building being an artistic as well as a learned work. It is Herr Radke, architect, who has decorated all the works in the German section, much remarked for their richness and good taste. [. . .]

Several of the foreign buildings on the banks of the Seine contain very little in the way of exhibits. They are in some sort reception-rooms, national products being exhibited in the palaces of the Invalides or the Champ-de-Mars, in the sections corresponding to the different kinds of industry.

The United States pavilion, a very important one and in Classic style, contains no exhibits properly so-called, and it must be confessed that, for most, it seems a little empty when its size is considered. The entire interior, in fact, is consecrated to reading-rooms, reception-rooms and offices. [. . .]

The façade is impressive because of its large dimensions. It is preceded by a monumental portico, a kind of grand triumpal arch, of the Corinthian order, supporting a superb quadriga representing "Labor, on the car of Progress." Under the arcade which faces the Seine is found an equestrian statue of Washington. On the lateral façades, which rule with the lines of the portico, are detached *avant-corps* crowned with pediments. Above soars a dome resting upon a series of elegant arcades, and upon its summit an enormous eagle spreads its golden wings. The entire structure is of wood and staff. The style is Classic, of good proportion, and carefully studied by the architects, Coolidge and Morin-Goustiaux; but the neighborhood of the palaces of Italy and Austria, both of them very picturesque and very rich in sculpture and decorations, makes its academic and somewhat severe air all the more pronounced. This imposing piece of architecture should have had a greater isolation to be appreciated at its real worth.

Now here I am at the end of my ordinary space, and what I said at the start strikes me still more. How many things there are to see! And, in the impossibility of satisfying the curiosity, how many things must be sacrificed! Never mind; if the bill of fare of the banquet be too copious, all the dishes are savory. [. . .]

Unsigned, from "The Exposition: A Few General Figures, the Foreign Pavilions," *American Architect and Building News*, July 14, 1900, pp. 13–15.

The New Architecture at the Exposition

A. BARTHÉLEMY (ANTONIN PROUST)

Elsewhere I once wrote, "It may be fashionable to say that the nineteenth century has been absolutely sterile in architectural matters, limiting itself to copying the legacy of earlier centuries. But, despite that generally accepted opinion, the exposition reveals a knowledge and originality on the part of architects that forbid

pessimism." I will not retract this, although a highly respected architect said to me recently that—apart from the Petit Palais, which he judged to be an exquisite work, certain details of the Grand Palais, the Pont Alexandre III, the horticultural greenhouses, and the Château d'Eau with the Palais de l'Electricité—from the Place de la Concorde to the Trocadéro he saw only a regrettable expenditure of "staff." [. . .]

I am therefore not inclined to resign myself to pessimism. If the present exposition seems to me commendable for the strong collaboration it has brought about among painters, sculptors, and architects, I praise it for showing through certain buildings, which I will cite, the advantages that architecture can derive from the renaissance of decorative art, which is one of the most characteristic and happy trends as this century draws to a close. In this respect I must above all congratulate M. Dulong for having given us the Pavillon Bleu.

One can be witty in architecture, and there is plenty of esprit in the Pavillon Bleu, a pleasing advantage gained from the coloring indicated by the very name of the restaurant, and a most original and agreeable taste in the rational lines that emphasize the purpose of its construction. Thus it is that the whole pavilion is enveloped in great curves, which constitute a sort of frame for it, and its general silhouette immediately acquires a very lively and unexpected interest. Placed at the edge of the pool in one of the loveliest corners of the Champ-de-Mars, the Pavillon Bleu rises up with great elegance, very fittingly crowned by a terrace covered with a large awning. For the painted decoration—portions of friezes running along both the interior and the exterior—as well as for the furnishings and electric lighting fixtures, M. René Dulong has benefited from the collaboration of M. Serrurier. [. . .] The principles of simplicity and logic inherent in these diverse works is thus apparent. The restrained flower motifs, generally done with a stencil, create attractive borders on the walls and contribute to the general color effect. The wrought-iron chandeliers with sinuous stems, enhanced by embossed copper, support the lamps, inspired like the wall friezes by dainty, bell-shaped flowers, and these great lines of metal spreading extensively across the ceiling contribute considerably to the decoration of the rooms.

The transom windows, the open wooden paneling of the galleries, the solidly buttressed furniture, which are again the hallmark of Serrurier's work, create the very special ensemble of these restaurant rooms, light and comfortable, in which all details, even down to the new pattern for the chinaware, have been selected with care, and in which the obvious construction in wood pleasantly accentuates the somewhat rustic and ephemeral character of the building.

M. Dulong has most successfully broken away from the usual ostentation of the present cafe style; he has created an ensemble of good taste, of discreet, assured harmony, in which the blues and the yellows balance each other perfectly; having thus found a legitimate, original, and restrained formula for a truly modern restaurant, the result is excellent. [. . .]

I was not surprised when they told me that the foreign members of the jury for architecture had above all concentrated on examining the exhibition projects

for the trends that we have tried to bring to light here. The German restaurant, the Hungarian bakery, the Viennese restaurant indeed bear witness to the achievement of foreigners in a direction that architecture has every interest in following, for nothing could be more productive than a close union between architecture and all those artists who can help it produce a monument worthy of our civilization. By monument, one should not understand an object which by its dimensions and its intent to serve the public interest imposes itself on our attention. A private residence or a restaurant can merit this title by a judicious use of materials and a careful observance of aesthetic principles just as much as by well-conceived decoration.

In this regard the German restaurant built on the embankment of the Seine below the German imperial pavilion merits serious attention. Its interest lies in its being conceived in a truly modern manner while still maintaining a very marked German flavor. [. . .] [It] is the work of the Berlin architect M. [Bruno] Möhring, who has undertaken the decoration of the rooms with a great deal of variety. The main room is kept to a harmony of white and old gold, at once rich and simple, by leaving the walls white in the area above the wainscoting and decorating the ceiling only with a painted foliage motif. The principal ornamentation, representing foliage gilded in bronze gold, designed and sculptured in a strongly architectonic way, is found in the open arcades. The bay through which one enters is thus framed in an arbor of gold foliage, and the same framework is found on the walls surrounding the large mirrors. This ornamentation is used at the same time for lighting, and electric bulbs are scattered among the recesses in the sculptured foliage. The effect is very interesting. [. . .]

Nearby M. Neukomm has constructed the Viennese restaurant, not lacking in individual character. The side doors placed at an angle, the large glass windows, and the positioning of the terrace denote a very individualistic, well-thought-out, calculated boldness. [. . .]

Private initiative has at times been happy in its inspiration and contributes greatly to the real interest of the exposition. Its memory and the lessons to be learned from it will remain profitable.

One might add that at the last moment still other buildings will be revealed, which until now have been covered with canvas, pending their tardy completion; but the pleasure of having inaugurations is among the things that one likes to see continued at the exposition, because they stimulate the curiosity of the visitors strolling by. We might regret that when it came to the official buildings, innovations were not sought with greater enthusiasm and that certain foreign governments have instead preferred to offer us replicas of some existing architectural jewel of their country; assuredly the architecture of an exposition should insofar as possible indicate a very precise stage in civilization and artistic direction. At least, in the midst of academic exercises, we are agreeably surprised when we discover some youthfulness of inspiration, some accents of freedom and personality, as for example in the central section of the Palais des Industries Etrangères at

the Esplanade des Invalides, where the facade is enlivened by floral motifs framing the doors and replacing the antique capitals with a great deal of verve and sense of surprise.

But if similar discoveries are too rare in the official portions of the exposition, it is even more surprising not to see the imagination of architects being given freer rein in the thousand diverse structures built only for our distraction and pleasure. That is not to say, of course, that it was necessary to turn all the manor houses upside down and to scramble architecture and good sense, which, frankly, in many cases seems to be the distinguishing mark of novelty. But the exposition buildings, light and ephemeral, can really have their own casualness and style. A large number of entrepreneurs obstinately think that trellises and garlands in the most Louis XV style will always have the greatest cachet. Something else should have been tried. A short walk in the rue de Paris permits one to see, at the theater Auteurs Gais, how much a temporary fair booth can gain architecturally from care and stylishness in its construction, as well as from the collaboration of painters, since the panels by M. Bellery-Desfontaines, whose imaginativeness in no way weakens the strength of their design, constitute the principal ornament of the facade. In any case, painted decoration is a subject for further discussion.

The theater dedicated to Loïe Fuller, which is by the architect Henri Sauvage, reveals a very curious type of construction: all the lines are inspired by the long folds of floating drapery which have made the dancer famous. And this necessary plasticity in the contours, which would be condemned in a stone building, in which one should feel the resistance of the material, is acceptable in a pavilion where the building material of staff plays such an important role. M. Sauvage is certainly one of those who tried the hardest to take advantage of the special conditions of the building's construction and even to emphasize its fragile and whimsical character. Less happy is his marionette theater, built on the opposite side of the Seine, where the decoration over the framework is carried a little too far.

This construction of wood brings us to the ticket booths, which form an integral part of the architecture of the exposition, multiplied as they are along its entire perimeter. As one enters or leaves, it would be unfair not to pay attention and give due praise to them. Their construction is really well thought out and successful, and one might have wished to see the same spirit of enterprise and modernity applied everywhere in keeping with the proportions of the various buildings.

Translated from A. Barthélemy (the pseudonym used by Antonin Proust), "L'Architecture nouvelle à l'exposition," *Gazette des Beaux-Arts*, ser. 3, vol. 24 (July 1900):12–20.

Round the Exhibition
I. The House of the "Art Nouveau Bing"

GABRIEL MOUREY

[. . .] The house of the "Art Nouveau Bing" stands in the left-hand part of the Esplanade des Invalides, in the midst of the Breton village. The contrast between the calvaries, the granite churches, the ancient buildings and the modernity of this facade, adorned with a frieze of orchids in relief, and with its walls adorned by Georges de Feure's panels, representing Architecture, Sculpture and Ceramics, is quite fascinating.

This little edifice contains, in my opinion, the most delightful, the most nearly perfect, things in the whole decorative art exhibition. Here, it seems to me, is to be seen the triumphant result of the endeavour, on the part of a little group of artists, to attain as nearly as may be the absolute ideal of novel decoration. The artists in question are MM. Georges de Feure, E. Colonna and E. Gaillard; and their instigator, their head, is M. S. Bing.

The house of the "Art Nouveau Bing" consists of six apartments—a vestibule, a dining-room, a drawing-room, a dressing-room, a bedroom and a boudoir.

M. Gaillard is responsible for the vestibule. A mosaic of bold design, strictly appropriate to the shape and the arrangement of the room, covers the floor; the walls are hung with draperies in bold pink, and are decorated with a frieze *au pochoir*. A huge piece of furniture in polished walnut, with looking-glasses tier above tier, flanked by clothes-pegs right and left, fills the base of the apartment, the pattern of the mosaic marking its place.

The walls of the dining-room, which is also M. Gaillard's work, are covered to a third of their height with a panelled wainscoting in polished walnut, with copper appliqué, surmounted by a powerful piece of painted decoration by M. José-Maria Sert, running all round the woodwork. This decoration is, indeed, overpowering, considering the size and the height of the room; but the work itself, with its grey and black tones, slightly relieved by touches of dull yellow, is quite beautiful, however imperfectly it may be adapted to its surroundings. The rest of the furniture—a large sideboard, with four doors, a cupboard, a table, chairs and armchairs—is designed strongly, yet with grace. The ornamentation is but slight, and where it is employed one feels that it has been well and appropriately distributed.

From the dining-room we pass into the drawing-room, furnished by M. E. Colonna. It is really a drawing-room—a French *salon* in the fullest sense of the word, the room in which we receive our guests, not the *pièce* where we live; yet one longs to live there, so fascinating, so comfortable is its appearance. The walls are covered by a sort of plush of a delicate green tone, while the furniture, the woodwork of the doors and the window fittings are of orange wood, the yellows

and the greens producing a charming effect. M. Colonna has a delightful sense of harmony, and his lines are charming in their supple grace. Altogether, the room is quite beautiful, and full of interest in all its details.

The dressing-room, designed by M. G. de Feure, has an atmosphere of enchantment. Everything is deliciously feminine—the curtains, of Japanese silk, the woodwork of ash, intermingled with a figured silk of grey-blue, grey-mauve and grey-green, revealing the subtlest tones and showing like a field of flowers under the moonlight. And all the rest is in keeping, the effect being altogether charming.

Next comes the bedroom, by M. E. Gaillard, wherein we find a large bed of simple form, with a lovely coverlet of mignonette-green silk, embroidered with rich and harmonious trimmings, a huge wardrobe, a table, chairs and *fauteuils*. The high qualities shown in the furnishings of the dining-room are again apparent here; but in this room everything is soft, delicate and caressing, without, however, any eccentricity or weakness. And in these days, when extravagance and over-elaboration are common, these are points deserving of unreserved appreciation.

A semicircular passage leads from the bedroom to the boudoir, the external partition being filled with glasswork by M. de Feure. There are four panels, with flowers and curious female figures, the outlines being of simple lead-work. The glass, it should be said, is coloured glass and not painted. The tones are splendid, but in no way gaudy, a fine effect being attained by subtle combinations melting into the rarest harmonies. The chief novelty consists in this—that the parts of the wall enclosing the windows have been painted in a violet-blue tone with red *motifs*.

M. de Feure also designed the boudoir itself, which I have no hesitation in saying, is the thing that pleases me most; and, without disparagement of M. de Feure's collaborators, I should declare this to be the pick of the entire building. Here, to my mind, is expressed absolutely in its perfection the fanciful, novel, independent, graceful spirit which pervades the whole exhibition. Fully to appreciate the value of this work one must bear in mind the object aimed at by M. Bing, and carried out by M. de Feure. It is simply this: to revive the tradition of the graceful French furniture of the eighteenth century, adapt it to modern requirements, make it conformable to our present ideas of comfort—give it, in fact, the impress of the age. Obviously, there were many and serious difficulties to be overcome ere this result was achieved; but that success has been attained no one can dispute, for the Boudoir de l'Art Nouveau Bing constitutes one of the first examples of *style* produced by the renaissance of decorative art in France.

All the woodwork in the furniture of this room is gilded, and everything has its distinct individuality. The chairs are covered with silk embroidery; the walls are hung with brocade; while the fireplace of white marble is designed in the form of stalks, which support the mantelpiece. Around the hearth is a strip of opaline, framed in repoussé brass. In a large bay, and ornamented with a bordering of pale-coloured glass, is a little divan covered with a brocade similar to that on the walls. On the floor are silken carpets here and there, and in one corner stands a screen, a

perfect gem of art. All the rest is equally beautiful, and one cannot praise too highly the artist who has contrived to combine so many materials into this perfectly harmonious *ensemble*. It all seems specially devised as a background for Helleu's female figures, for assuredly no setting could be found better suited to his delightfully graceful subjects.

Such, briefly, is the display of the "Art Nouveau Bing," one of the most perfect pieces of combined decorative art-work in the whole Exhibition. It does the highest honour alike to the creative artists and to him who inspired them.

From Gabriel Mourey, "Round the Exhibition. I. The House of the 'Art Nouveau Bing,'" *The International Studio* 11 (1900):164–80.

Round the Exhibition
III. German Decorative Art
GABRIEL MOUREY

[. . .] On the first floor is the "Salle de la Colonie des Artistes de Darmstadt," which demands special notice, as it is one of the most charming and most perfect examples of decorative art in the entire section.

As the readers of *The Studio* are well aware, the modern decorative art movement is flourishing greatly in the Grand Duchy of Hesse, thanks to the cultured initiative of the Grand Duke and the Grand Duchess, and if proof of this were needed, it might be found in this exhibition by the artists of Darmstadt. That sense of depression which, as I have already said, appears to me to pervade the interior (of the hunting room) decorated by Mr. [Richard] Riemerschmied, makes itself felt in nearly all the departments of the German exhibition: for the style is gloomy and austere—almost sepulchral. Here, however, among the Darmstadt artists, everything is bright and joyous, full of happy fancy and true elegance. Not a single detail but bears the imprint of a rare understanding of measure and proportion. All the cabinet maker's work is of grey-tinted wood, varnished; the marqueterie ornamentation is quite simple in color and form alike; the hinges, locks, and drawer-handles are in copper. The effect of all this with the bevelled glass of the cabinets, the bright tints of the wall-hangings and the embroidered chair-coverings, the stove with its gleaming earthenware panels and brass-work, and the thousand-and-one rare and beautiful knick-knacks, disposed here and there in the happiest manner is absolutely exquisite. In order to do justice to all concerned in this delightful achievement I will give the names of those who have collaborated with Professor Jos. M. Olbrich, who planned the entire scheme. M. Peter Behrens did the woodcarving and several designs for bindings; M. Rudolf Bosselt, the sculptor, designed the clock-dial; the glass-work, the carpets, and some of the enamels are the production of Professor Hans Christiansen; M. Paul Bürck, the painter, is responsible for the hangings and the applied embroideries,

while M. Louis Kuppenheim contributed enamels. His special exhibition of gold-smiths' work, displayed elsewhere, is exceedingly interesting.

From Gabriel Mourey, "Round the Exhibition. III. German Decorative Art," *The International Studio* 12 (1900–01):49–51.

Chronicle of the Exposition
EMILE VERHAEREN

Closing Time! This cry, a daily commonplace for some months, on Monday, November 12, assumed a painful and sinister significance. It proclaimed the final and irrevocable end of a city, glorified by all, to which the whole universe had flocked. Already for many evenings the great brilliantly lit tower—all black and gold—has seemed to represent a gigantic catafalque. It appeared as an omen, looking into the night. It was frightening. It seemed to say, even in moments of joyfulness, that it flashed its signals of mourning far and wide to announce ap-proaching death, a cold and fateful death, piercing the heart with [its message of] the day of the month of the dead. [. . .]

The universal exposition of 1900 ended its life with all of its vigor intact. To the last day, the last hour, the faithful crowds continued to be attentive. It did not die a lingering death, forsaken by all.

Misfortunes, catastrophes, and conflagrations had been predicted for it. None of these ominous predictions marred the exposition. It was saddened by some nearly fatal accidents, but it was spared the wide swathes of Fate's scythe, which some people had hoped for, perhaps prayed for. Threatened by a thousand dangers, it attracted the greatest multitude of human beings ever set in motion to reach a symbol. In comparison with its 50,000,000 visitors, what do invasions, the marchings of armies, the hundred-year-old fairs of Germany and Russia, the pilgrimages to Rome or Mecca, amount to? What neither necessities nor business interests, nor wars, trade, or religion, could stimulate, the modern spirit, except for a few rare attempts in the periods from 1867 to 1878 and from 1878 to 1889, has brought about at last. On some Sundays the crowds crossing the bridges of the Invalides and the Champ-de-Mars were as thick as the migrations of schools of fish to the ocean straits. Their force, like that of forests, plains, or the sea, was intoxicating. One feared and loved them as a new element, that of our time and certainly tomorrow's. Even larger crowds, they say, were hoped for. But there are some people who would not admit to being satisfied even if the equilibrium of the earth had been disturbed by the mobs crowding into Paris.

For the exposition of 1900, more so than for its predecessors, autumn pro-vided an admirable funeral. Even before September the palaces, with their flaking gilt domes, stained, unpolished columns, and monotonously colored walls, had lost the new, raw, appearance of merchandise from a bazaar which might have been unpacked by a giant and set up in rows along the river. The avenues were

illuminated by marvelous golden-brown foliage, the waterfalls here and there turned green, and mosses appeared. In the October dawns, the Seine unwrapped herself from her mists in a setting of minarets and pagodas, whose marvelous absurdity, reminiscent of the landscapes of dreams and of fairy tales, astonished everyone. The evening light of a sunset full of molten metal, their coppers and bronzes veiled in billows of smoke, evoked the monstrous works of the Cyclops, builders of strange and incongruous monuments, for some vast future race, which would encompass all races and the whole history of the world. Thebes, Rome, Byzantium, Lahore, Venice, Moscow were gathered together in Paris, pressing around her palaces, crowding her triumphal ways to pay homage to her. All the famous cities were represented, witnesses to the colossal, many-faceted beauty of this hour of the century, the finest of the centuries of man.

It would be difficult to assess the impressions that the different peoples took back from their journey. What do they think, those cunning and disdainful Chinese, those complicated, smiling Japanese, those Hindus, those Persians, those Malaysians, and those negroes? What are the Europeans' opinions of themselves, as they think of Africa, America, and Asia? What do the other nations think of the French nation? The information on these questions that we get from the press tends to be unreliable because of the random interviews which are the natural tricks of the reporter's trade.

But the question can be precisely stated, if we ask ourselves what the artists continued to admire during these six months of curiosity and investigation. Each one, in magazines or newspapers, has given some scraps of opinion, quickly stitched together by the editor of some gossip column. They were hasty and necessarily incomplete. Even so, from them one can come to the conclusion that they have been attracted and surprised, especially by the industrial innovations of a Lalique, the silken and embroidered marvels of the Japanese, the miracles of the Parisian cutters and fashion designers, the glazes and enamels of modern potters, the replica of an Indo-Chinese temple, the archaeological collections of the Petit Palais, the Ingres, the Daumiers and the Corots, the Fantins, the Monets, the Renoirs, and the Regameys and the Trutats, as well, of the centennial exhibit, and above all, by the dramatic power—artless, ingenuous, simple but complex, realistic, and synthetic, in a word contradictory and yet unified—of the great and talented actress, Sada Yacco.

As to the new ambitions, which certainly must have sprung up [in the artists' consciousness] as they saw assembled before them the thousand samples from the thousand civilizations of this world—can any be more urgent than the desire to travel? The infinite variety of beauty, no longer Greek, Italian, Flemish, or French, but human, must have penetrated their eyes, their ears, their sense of touch; must have entered into their hearts and souls, to the point that it will be the whole universe, rather than their own country, that will fill their thoughts from now on. A strictly local artist is less and less understood. He becomes an oddity, like a trinket. There is no place for him in the crisscrossing flights of ideas, whose wings carry them over the world like rays of light.

The Oriental countries, the lands of Africa, the old civilizations of Asia Minor, and the new Americas, so far away, now lie open so that from them art as well as science will reap its profit and be reborn.

All beauty is not found in any one place: not only in Athens as many people claim. It also reigns supreme in India, in China, in Japan. It matures in New York and in the huge warehouses of San Francisco; it renews itself like all thought, and since thought is everywhere, so is beauty revealed everywhere.

The artist must strive mightily to discover beauty in no matter what corner of the world. His talent, which has become sluggish in his own country, will awaken, become active, and he will be dazzled to find beauty on the other side of the earth. It is by chance that the finest lives are brought to light. More than anyone else, an artist needs a shock, a thunderbolt, or, at the very least, a spark. He must see all things as if for the first time, and as if no one had ever seen them before; perceive them artlessly, analyze them little, and divine their depths. He must absorb them into his genius, in a special atmosphere, to make them broader, transform them, and make them fruitful.

The ardent flame of enthusiasm creates masterpieces in the very soul of the traveler. There is nothing better in this world than to remember of an evening, even in the most commonplace inn, the marvels—things and people—encountered along the road in an unknown country. The sincerest and warmest soul-searching and the most glowing and shining poems must have been born and developed in this way. More and more, in tomorrow's literature, when there will no longer be a thinker who will not make a tour of the whole planet to shape his mind and spirit, this beauty—once European, later worldwide—will become the only beauty worthy of rapture and conquest.

I know all the petty and perfectly reasonable objections that can be made to such a theory. They are not important. They are irrelevant. The huge thrust of inevitable forces will blow them away like wisps of straw. When one thinks how happily two entirely different arts—Japanese and French—have influenced each other and merged in painting, one need not fear the most extraordinary alloys. Our own philosophical ideas have also been united at two different times to those of India; and for nineteen hundred years we have lived according to a Bible that comes to us from the East.

Certain religious writers place the unity of Man at the beginning of time; it is in the future that it will come about. Finance, science, philosophy, art will inevitably work together to make it a reality—slowly in days gone by, swiftly today.

Translated from Emile Verhaeren, "Chronique de l'Exposition," *Mercure de France* 36 (December 1900):780–85.

1902: *Turin*

Turin, whose straight streets and squares betray its origins as a Roman settlement, sits on the banks of the Po River as it enters the beautiful Val d'Aosta, the gateway to the Petit and Grand St. Bernard passes that lead to France and Switzerland and have always been routes for invaders and traders. The capital first of the kingdom of Savoy and then, until 1865, of Northern Italy (when Italy's capital was moved, first to Florence, and in 1870 to Rome, after the Papal States were incorporated into the kingdom of Italy), Turin still remained a royal residence after Italian unification and retained its vigorous community of writers, artists, architects, and patrons of the arts backed by its university, its museums, and a thriving industrial community. In 1857, a Società Promotrice di Belle Arti had been founded there, similar to those established in Milan in 1822 and Florence in 1847. Like the Kunstvereine in Germany and Austria, the Italian societies financed annual exhibits by membership dues and a lottery system. Interest in the arts was encouraged by the journals they published: first the *Gemme d'Arte Italiana,* an illustrated magazine affiliated with the Società, in 1846; then *Mondo Illustrate–Giornale Universale* in 1861, whose format, lively style, and many wood-engraved illustrations resembled the French *Magazin Pittoresque;* followed by *L'Album* in 1863, *L'Emporium* in 1895, and *L'Arte Decorativa Moderna* in 1902, devoted to the decorative arts.

In Italy the initiative to improve design had come from the industrial centers of Bologna, Milan—which had held decorative arts exhibitions in 1894, 1898, and 1899—and Turin. Turin organized its first decorative-arts show in 1898, and even before the Paris exposition of 1900 the city's artists' society, the Circolo degli Artisti, had drawn up a formal proposal to hold a universal exposition of modern decorative art in 1901. The Turin organizers were headed by Enrico Thovez, a well-known critic, director of the gallery of modern art in Turin, poet, painter, and one of the founders of *L'Arte Decorativa Moderna,* and Luca Beltrami, who had founded the journal *La Lettera,* which introduced the phrase *stile Liberty* (the English word was used because the reference was to the style associated with Liberty's, the well-known shop in London) to designate the style of the new century in Italy, the equivalent expression to New Art or Studio Art in England,

Art Nouveau in France, and Jugendstil in Germany.[1] They had the assistance of an international committee, whose honorary president was Walter Crane of England; its other members, selected from the participating countries, included pioneers of the movement such as F. H. Newbery of the Glasgow School of Art and Charles Rennie Mackintosh for Scotland.

The exposition was to demonstrate that a modern art had been achieved that adapted form and decoration to the requirements of consumers and the dwellings they inhabited. The committee "agreed that the time had come for proving to outsiders the fact that the evolution of a modern style so eagerly longed for, and pronounced by so many worthy souls to be an impossibility, had not only become an accomplished fact, but had already won the victory over the cold and lifeless repetition of the academic motives of a day gone by; they agreed that the time had come for that modern style to receive the stamp of official recognition."[2] Support for the exposition was offered from groups in other countries who had themselves already sponsored exhibitions of New Art. In Brussels Le Libre Esthétique had displayed Gustave Serurier-Bovy's *chambre complète d'ouvrier* in its first exposition in 1894; the "House of Secession"[3] provided a gallery for the avant-garde artists in Vienna; and the Freie Vereinigung Darmstadter Künstler held its first exhibition in 1898 in which outside artists Emile Gallé, Otto Eckmann, and H. E. Berlepsch-Valendas were invited to show their work. Particularly strong support was given to the latter group by the Grand Duke Ernst Ludwig of Hesse-Darmstadt, a son-in-law of Queen Victoria. He expanded the local artists' union by establishing a colony for architects, master craftsmen, artists, painters, and sculptors at Mathildenhöhe.[4] Whatever the protestations of these new art groups regarding the bettering of the working class, however, their products were all designed for a clientele with sophisticated tastes and considerable money to spend.

The Turin committee's proposal for the scope and organization of its exposition set up a procedure that would ensure the tasteful display of all the objects: "[It] was to be in its entirety and in its component parts, a genuinely artistic exposition, and not at all an assemblage of products of ordinary manufacture."[5]

1. See Eleonora Bairati, Rossana Bossaglia, and Mario Rosei, "Liberty italiano e modernismo internazionale," *L'Italia liberty: Arredamento e arti decorative* (Milan, 1973); and Rossana Bossaglia, *Il Liberty in Italia*, Saggi di Arte e di Letteratura (Milan, 1968), chap. 5, pp. 74–105.

2. Enrico Thovez, "The First International Exhibition of Modern Decorative Art in Turin," *The International Studio* 17 (1902):45.

3. In 1897 an organization of young Viennese artists, the Vereinigung bildender Künstler Oesterreichs, formed a group they designated "Secession," which published the journal *Ver Sacrum* and developed the forms that came to be known as Jugendstil.

4. Mathildenhöhe was not a school, but a "free creative community" in which the concept of the *Gesamtkunstwerk* (complete artwork), the result of teamwork, could find expression. It also had a studio for students and a factory for the manufacture of furniture. The colony and its products were on view at an exhibition called "A Document of German Art" (Ein Dokument deutscher Kunst) on May 15, 1901.

5. Alfredo Melani, "L'Art Nouveau at Turin," *Architectural Record*, 1902, p. 586.

Sections would be devoted to the modern house, to its furnishings and decoration, and finally to the street on which it stood. This last section would have three subdivisions: drafts of buildings and details; plans of streets, squares, garden areas, bridges, malls, etc.; and finally exterior decoration of the house, models of grainings, door knockers, and so forth. Altogether there were twenty-two subdivisions, including ceramics; painted and sculptural decoration; glass; mosaic; wall coverings, both paper and textile; gold and other metalwork; furniture; graphic and various other arts.

Each country's entries had to be approved by its own national committee or jury. France's jury was made up of the artists Gérôme, Roty, Gallé, Gardet, Besnard, Lalique, and the sculptor Dampt. The German entries, selected by the German Kunstgewerbe-Vereine (arts-and-crafts associations) were subsidized with funds from the state; the Hungarian Kunstgewerbe-Vereine performed the same service for that nation. Initiative for an English exhibit was assumed by the Arts and Crafts Exhibition Society of London and by individual industries and arts, since neither official representation nor subsidy was forthcoming for "merely decorative art." Austria's exhibit was chosen by its national Kunstgewerbe-Vereine. The United States committee was headed by the director of the Metropolitan Museum of Art, Louis di Cesnola. Sweden, Denmark, the Netherlands, Belgium, and Japan also sent exhibits.

Only works that demonstrated artistic innovation as defined in the program would be accepted. In the words of the official program, "We have decided that at our Exposition only original works shall be admitted, and such as represent an effort towards an aesthetic renaissance of form, excluding all objects that are mere reproductions of existing styles or are produced by industrial manufacture not inspired by any artistic sense."[6] The regulation applied also to photography, which was to be placed in a special building.[7]

The competition to design the exposition buildings for the site in Turin's Valentino Park bordering on the Po River specified a plan that would include the buildings and gardens already there and, in addition, provide an entrance gate, a main building, and a 4,000-seat theater of glass. The Italian architect Raimondo d'Aronco won. He had already gained recognition for his design for a building in the public garden of Venice where an exhibition of fine arts was held in 1887, and had then gone on to become architect-in-chief for an industrial and agricultural exposition in 1893 in Constantinople, where he designed buildings in both the "modern" and the "national" style. After that he stayed on as architect to the Turkish sultan. Unhampered by the French Beaux-Arts tradition, d'Aronco designed for the principal building at Turin an immense rotunda from which radiated the long halls required for the various installations (plan 8; figs 49–50). The functional skeleton structures were covered in the decorative style that had been

6. Thovez (cited above, n. 2), p. 45.
7. The photography exhibition was placed in a building whose facade simulated a camera (fig. 58).

developed by the group around the Viennese Otto Wagner, whose particular preoccupation was the interrelationship between modern life and architecture. His book *Moderne Architektur* (1895) and his antihistorical, quasi-symbolic decoration for architecture were d'Aronco's inspirations.

Most countries installed rooms, complete with furnishings, in the section of the hall allotted to them, the method the organizers favored, but Austria refused to have its exhibits half-hidden in the main building and instead chose to erect a separate pavilion at its own expense. This villa was the work of the architect-designer Ludwig Baumann, also identified with the Austrian section of the 1900 Paris exposition. It was furnished in the modern style by various decorator-designers active in Vienna. Baumann wished that others had done likewise—"how instructive it would have been for the whole world had England had her own villa, appointed and furnished by Englishmen"—but W. Fred (Alfred Weschler) in reviewing it for the *Studio,* found that the Austrians had succeeded in producing neither an advantageous nor a complete impression of its artistic manufacturers or of its artists. Unfortunately most of the distinguished talents—Otto Wagner, Josef Hoffman, and other members of the Vienna Secession that had led the way to the Austrian-German modern decorative-art movement known as Jugendstil—had refused to contribute to it.

The United States was represented in the decorative arts by Tiffany and Company with the support of J. P. Morgan, and in photography by thirty prominent American amateur photographers, with the support of the duke of Abruzzi. The sixty prints shown were selected by Alfred Stieglitz.[8] France's principal representations were from the Paris dealers: S. Bing's "Art Nouveau" room; Julius Meier-Graefe's modern décors; and Charles Plumet and Tony Selmersheim's room of French designers.

Even though Crane had presided over the organizing committee, England's participation, with no official help, was necessarily limited. Crane filled two of its three allotted rooms with an exhibition of his work that had been touring some European cities; the Arts and Crafts Exhibition Society, of which Crane was a founder in 1896 and the president in 1902, occupied the third.

M. P. Verneuil, editor of *L'Art et Décoration,*[9] reviewed the exhibition for the *Magazine of Art.* The latter also brought to its readers Walter Crane's "general impressions" of the exposition, a "veritable museum of modern decorative art." *The Studio* and its offshoot *The International Studio* assigned a group of critics to cover the exhibition.[10] Its review was introduced by the secretary and organizer of the exposition Enrico Thovez. The reviewer for the English section,

8. "Society News," *American Amateur Photographer* 14 (1902):573–74.

9. The first of France's periodicals devoted principally to the decorative arts, the *Revue des Arts Décoratifs,* had merged with *L'Art* to become *L'Art et Décoration.*

10. The *Studio* report began in July 1902 and continued in subsequent issues until January 1903. Many of these reports also appeared in the *International Studio,* including reports on the Austrian section (A. S. Levetus); the Dutch section (Enrico Thovez); the English section (F. H. Newbery), and an uncredited review of the Scottish section. See figs. 56, 59, and 60.

F. H. Newbery, commented that until he had seen this exhibition he had had no idea of the extent of Crane's versatility either as a book illustrator or in other media:

> Here is a man who was a pioneer in England thirty years ago, and, in his own line of work, is as alive to-day as ever he was. . . . But, with all this, there comes the impression that the Crane of twenty years ago is the Crane of to-day, and though he was a pioneer few workers have followed in his steps; nor is there, either in England or elsewhere, any widely spread movement which owes either its birth or growth to his influence. . . . There is in Crane's work a certain want of conviction and a lack of relation to Nature, which appear to have arrested all progress above a certain plane.[11]

The Turin exposition displayed the culmination of fifty years of effort to involve the socially minded architect-craftsman and the artist-designer in the planning of contemporary dwellings and the design of consumer goods. The exhibition space reflected the devotion of the New Art to the principle of unified design both in its interiors (figs. 51–57, 59–60) (based on the English house) and in its public rooms, restaurants, and cafes. Proportions, space, and colors were in harmony with each other as well as with the function or use of the room. The awards, given by an international jury headed by Albert Besnard, the French mural painter, designer, and art dealer, and including the Belgian critic Fierens-Gevaert, Grand Duke Ernst Ludwig of Darmstadt-Hesse, and others, went not to the manufacturers, as was the practice at the universal industrial expositions, but to the artists. Two Austrians, the Austrian villa's Baumann and Joseph Olbrich received the first and second prizes respectively. The American photographic show chosen by Stieglitz was awarded five grand prizes, two gold medals, four silver medals, and eight diplomas of merit.[12]

The exposition had given evidence of the changes that had taken place in every branch of the decorative and industrial arts and of the rationalization of the living space in which household objects would be used, but it also made obvious the failure of the movement's original purpose to improve the taste and the living quarters of the worker and the middle classes. The principal effort of the ten years between 1893 and 1902 had clearly been directed toward refining the taste and meeting the requirements of the new patrons of art, the prosperous bourgeoisie. It also showed that in each industrialized country local practices had been altered to accommodate a spreading cosmopolitanism that would eventually obliterate in both architecture and consumer goods the national traits that were rooted in historical styles. An "international style" related solely to the needs of contemporary life in an industrialized era was already in the making, and as the twentieth century advanced, it would affect the design and quality of consumer goods and the decoration of both private and public space for all classes of society.

11. F. H. Newbery, "The English Section," *International Studio* 17 (1902):251–59.

12. Other countries who displayed objects in the exposition were Germany, Switzerland, Denmark, Sweden, Japan, Belgium, England, The Netherlands, France, Hungary, and Spain.

L'Art Nouveau at Turin: An Account of the Exposition
ALFREDO MELANI

Turin is the first city in the world to assemble, at an international exposition, the products of various countries in the field of the New Art. Thus it has come to pass that Italy, so long indifferent to the modern aesthetic movement, will give the world a spectacle fit to win a pardon for its former apathy. [. . .]

As early as in 1899 Venice conceived the idea of adding to one of its expositions of fine arts a section for modern decorative art in order to gauge the importance of the efforts which aimed at giving to our times an independent style; but our country, absolutely unprepared for this noble task, was not represented, and the Venice galleries were filled mostly with work from Scotland.

The failure was disastrous, and two years later the "Famiglia Artistica" of Milan, undertook the same task; limited, however to Italian products. About that time, in January, 1901, the "Circolo degli Artisti" in Turin, took the initiative for an International Exposition of Modern Decorative Art, and this initiative met with a sympathetic response among the cultured classes and the people generally in Turin. [. . .]

In general, industrial expositions are bazaars, where one finds by chance now and then something worthy of interest and of study. The Turin Exposition, on the contrary, was to be, in its entirety and in its component parts, a genuinely artistic exposition, and not at all an assemblage of products of ordinary manufacture. In this respect the program of the Central Committee was very precise, and among other points it contained the following, which I give here translated:

"In order to avoid a useless repetition of the ordinary industrial expositions, we have decided that at our Exposition only original works shall be admitted, and such as represent an effort towards an aesthetic renaissance of Form, excluding all objects that are mere reproductions of existing styles or are produced by industrial manufacture not inspired by any artistic sense; leaving, however, at the same time to the exhibitors within the limits of this program the greatest freedom in expression and tendencies."

We may, indeed, say that these are few words, but good ones. And it is exceedingly interesting to see how the program, whose essential condition I have just given you, was conceived. It was decided at Turin to have an exposition of a new kind, and even the data of the program had to be in harmony with this meritorious purpose: Thus, instead of presenting to visitors a series of detached objects, dwelling-rooms (*degli ambienti*) were demanded, completely furnished, and we shall see hereafter that not only rooms are exhibited, but complete apartments, decorated, and furnished, rich in plaster and painting. Divided into three classes, the program laid down the following three principal subjects: The modern dwelling in its decorative elements; the modern room in its decorative ensemble; the house and street in their decorative organism. Each class is divided into categories embracing everything relating to modern decorative art intended for the embellishment of house and street. [. . .]

At our Exposition there are represented France, Holland, North America, Hungary, Switzerland, Sweden, Germany, Austria, Belgium, not to speak of England and Scotland, which, together with the United States, occupy one of the most conspicuous places. Nor will I say much of Japan, which exhibits in a special gallery; for the Japanese work, though very curious and suggestive, has been found everywhere for several years past.

The competition for the Palace was won from among eleven competitors by one of our architects, Mr. Raimondo D'Aronco,[1] at present in the service of the Sultan, at Constantinople. This D'Aronco, still a young man, has been always distinguished by the independence of his ideas, and his work has a character which discloses a vivacious and original imagination. Being in this sense more scene painter than architect, he changed as time passed, and in his designs for the Exposition he shows that his mind, although still quick and alert, has capitulated somewhat. In one word, those who know the architecture of the Vienna secessionists, of that school which has its centre in the capital of Austria, notice that D'Aronco as the architect of the Exposition Palace, has been carried along by his liking for Austrian architecture. Having said so much, we must recognize that the Palace has rather a grand aspect and that the interior of the central pavilion or rotunda is painted in a fanciful fashion. Color, and gold in particular, have been made use of rather extensively in the Palace by our architect. The sides of the pavilion have been more admired than the pavilion itself. I consider this opinion sound, because I think that the Palace is more impressive on its south and east sides, where the lines are less quiet and more expressive, than in its façade.

Aside from its secessionist inspiration, the principal entrance of the Exposition is a fine piece of architecture, which forms a special structure composed of two piles of brickwork and an iron gate. The two brick piles are yellow. Scroll railings in green form the bases for roofs above, which throw a majestic shade over the two brick piles. The latter have received from their architect a large frieze, high up, of sombre coloring, and other details making an ensemble of a brilliancy difficult to define. [. . .]

Mr. D'Aronco erected also almost all the other pavilions for the Exposition. Everywhere he showed his pictorial tendencies, very appropriate, especially for such ephemeral structures as these are, and if he had forgotten his infatuation for the secession, his work would have been a more pronounced success. [. . .]

Austria alone among all the countries represented at Turin has erected a pavilion at her own expense. I mean to say, she built after the design of the architect L. Von Baumann, a small villa, which is decorated and furnished in a manner that, though not in any way extraordinary, yet attracts the attention of the public. Here Austria has made an exhibit of her own. When approaching the building we find on the right France, on the left England. North America is almost opposite England and close to Germany and Hungary.

Italy has naturally the first place at the Exposition, so far as space occupied is concerned. Two large galleries in front of the Rotunda are decorated in mauve tones in soft relief on a background of white, touched here and there with gold.

These two large galleries are filled in great part with isolated furniture, the complement of the furniture that distinguishes rooms and apartments. These are in a place called "*degli ambienti*" (interiors), which opens on the upper part of one of the two galleries. (I say two galleries, because the decoration makes this division; structurally, this is only one vast gallery.)

Besides the furniture, we find here exhibited ironwork, ceramics and embroideries, and we must say that Italy, though she has made an effort at emancipation from her artistic past, has fallen far short of making an important contribution to the aesthetic movement before us. This was to be expected; artists do not spring up over night, and a designer's proposal to turn out New Art, is not equivalent to the actual performance. Led astray by the old way of eclectic teaching, we have made the apprentices design in every style. Our industrial artists produce in great part the New Art in the same fashion as they used to produce work in the Renaissance or Louis XV style. Thus, before we can have objects sincerely representing our epoch, we must form aesthetic consciences; we must begin by teaching what Art is; we must tell our designers that Art lives in the soul of the poet, not in the mind of those who change their style with the same facility as I, who to-day write with a steel pen, and may use to-morrow a goose quill.

The Exposition of the Italians makes upon every free and modern mind exactly the impression I have just described. It is a pity, for Italy possesses the talent and the courage, but we shall have to be content for the present, in the line of New Art, with the products of artist manufacturers, if I may call them, who really are but craftsmen. Even among those artists who have a certain reputation there are some who yield to this dangerous opportunistic tendency, which reminds one of an old roué who colors his beard and hair in order to counterfeit youth. Here is a striking example:

In 1898 there was founded at Bologna, by a group of local artists, together with some persons who took an interest in the advancement of decorative art, a society, the "Æmilia Ars" Society. (The archaic form of its name by itself inspires very little hope.) Their principal aim was to improve, from the points of view of art and of practical usefulness, the products of the decorative industries and arts, especially in so far as the furniture and decoration of houses is concerned, and also to increase by this means the business of artists, laborers, and studios. [. . .] The aim of the organization is to produce either imitations of the antique or "New Art," but this "New Art" of the "Æmilia Ars," as we see it at the Turin Exposition, is in general nothing but an assemblage of ancient ideas, and I would say, of modern ones, if the floral decoration as it is applied by the artists of our society, were something novel!

Well, this Society, which, from the moral point of view, receives compliments from all sides, and which, from the point of view of Art, is far from representing a rich source of aesthetic activity in the modern sense, gives you the character of our New Art and explains to you by what confused tendencies we are diverted, and how much we in Italy lack faith in an independent artistic future.

However, we may wish that the manufacturers of furniture, bronzes, lace,

and silverware were all like those of the "Æmilia Ars," the majesty of Art, at least, should be respected. But to compare with the artists at the head of the Bologna Society we have at Turin ordinary manufacturers who work in "New Art" for the sake of profit exclusively, taking an idea here, stealing one there, following the ways of the English, of the Belgians, of Van de Velde, or Walter Crane, or William Morris, in fact, even Olbrich, who though now triumphing at Turin, was unknown until recently to our craftsmen.

In short, the artists in wood among us who design furniture as artists, with a genuinely sincere love for the modern aesthetic movement, are small in number. Personally, I know but three, and three or four are all who are making an impression at the exposition of Turin, namely: C. Bugatti, E. Quarti, G. Cometti and A. Issel; two from Milan, one from Turin, and one from Genoa.

Mr. Bugatti is the most individual of the four, and the first in Italy to design furniture outside of the eternal Renaissance and Louis XV. So we are here in the presence of a real artist, a bizarre mind, who impregnates his art with a touch of Orientalism without knowing it. For I, who know Mr. Bugatti, can assure you that among the many things which he does not know, one is certainly the Orient. Cairo, Granada and Toledo are places whose geographical existence even is perhaps unknown to Mr. Bugatti; and he has never been to Rome, nor to Florence or Venice, nor even opened a book or studied photographs regarding the countries of the Orient. He is so truly an artist, our Mr. Bugatti, that if somebody should tell him that his work resembles something that already exists, he would destroy his model with an Olympic indifference. This shows that the Milan artist is guided in his visions, which are of an aristocratic fashion, by his instinct alone, and even if his tendency be toward the Orient, his art is genuine Bugatti art.

In order properly to appreciate our artist, you have to know him. Even in Italy, even in Milan, where Mr. Bugatti appears always in most eccentric costume, there are many persons who do not believe in Bugatti's sincerity. But what proves that we have not to do with a sham is, in the first place, the genius of the artist, and then his utterly insufficient instruction. The exhibit of Mr. Bugatti at Turin is one of the richest, so far as furniture is concerned. Two dwelling-rooms, a drawing-room and a bedroom form as it were the ends of a file of furniture, different in purpose and design, representing chairs and desks, chests of drawers and card tables, writing tables and closets, arm-chairs and book-cases, cornices, châtelaines for ladies in pressed leather. The whole is connected by an ideal thread, and even where the line seems to you to be broken or the idea exaggerated, everywhere you find the trace of this thread, which shows you that the artist is always himself, exalted by the same vision, rich with the same inspiration.

Two styles, however, are found in the composition of the Bugatti furniture; the first is more loaded and less delicate than the second, which is the newer and the one principally exhibited at Turin. I am sorry that I cannot send you a photograph of the drawing-room, which has a character absolutely unique. It should be the joy, as we say here, of some fastidious and wealthy American.

Fashioned in wood covered with parchment and painted with pink flowers and geometrical foliage, it is a vision rather than a room, fit to be from the scene of one of Edgar Poe's fantastic novels. The fantastic elements predominate always in the furniture of Mr. Bugatti. The purpose it is intended to serve and even the nature of the material are sometimes almost lost sight of, the artist being carried away by his idea to please the eye. Thus, the furniture in the second style of Bugatti—which, however, is a logical consequence of his preceding manner—is covered with parchment, and the soft tone of this skin is carefully preserved and almost put into relief by a red-and-green floral decoration. The latter has nothing English about it; sometimes it is a flowering branch, often a fashioned frieze. This *discrete* coloring is accompanied by metallic tones of certain discs, richly chased, which almost always form the constructive and decorative complement of the Bugatti furniture. [. . .]

Richness is a matter of course with almost all of our cabinetmakers as soon as they aim at artistic furniture. This is due to the fact that we are at the end of a period when artistic furniture was made exclusively for the wealthy. Museum furniture and atavistic habits do not help to broaden us in our taste. [. . .]

From Alfredo Melani, "L'Art Nouveau at Turin: An Account of the Exposition," *Architectural Record*, 1902, pp. 585–99.
 1. In the original the name was misspelled D'Avonco; it has been corrected here throughout.

Modern Decorative Art at Turin: General Impressions
WALTER CRANE

There is a certain appropriateness in the idea that Turin—one of the chief portals of Italy, so long the mother or tutelary deity of European art, especially of decorative art—should be the first to summon the nations of Europe in a friendly spirit of artistic emulation and rivalry to show their prowess in the arts of design.

Turin sounds the trumpet to proclaim this *carrousel* of artists, even as the trumpets, presided over by the Duke d'Aosta at the brilliant scene at the Teatro Regio the other evening, called the cavaliers forth to their musical and fanciful evolutions before the King. It is somewhat remarkable, too, to note that the different nationalities—the different artists that ride to this tourney under their national banners, as it were—bring also their racial symbols and personal characteristics with them. Although gathered under the broad and comprehensive pavilion of modern decorative art, "Arte Moderna," "l'Art Nouveau," or whatever we like to term it, these racial, local, and personal distinctions assert themselves. The language and its forms may be universal, but the dialect and the accent differ in each country.

At a superficial glance, indeed, it might almost be supposed that the decorative art of modern Europe had but *one* designer and *one* origin, seeing how

constantly certain motives occur and recur—in architectural design, in furniture, in textiles, in metal-work and jewellery, in pottery and glass, and in surface decoration.

The exhibition buildings themselves are instances of this.

One might deduce the symbols of an aesthetic language of line and form from certain recurring elements. Yet the elements which contribute to the effect of the *ensemble* are extremely mixed and remotely derived. One cannot resist the conclusion that in the later phases of modern decorative art we have the results of modern intercommunication of ideas, of the constant intermingling, through modern commerce, travel, colonisation, scientific discovery, and historic research, fused together, as it were, in the imaginative brain of the artist, and produced in the strange and weird combinations of line we see around us on every side.

The results, too, show the influence of the restlessness of modern life, and the dislocation of artistic and constructive tradition constantly taking place owing to new discoveries and inventions, new materials and new uses, new demands to meet new necessities.

One cannot hope that such influences create anything approaching an ideal atmosphere for mature and beautiful art. Art, as both the exponent and the creature of modern conditions, shows, indeed, plainly enough the effects of the conditions of its inception. Artificial stimulus has had a similar effect upon its growth as that of heat in the forcing house upon plants. The stems become extravagantly drawn out and attenuated; the plant itself is sacrificed to its flower; its leaves are pale and anaemic.

A prevalent motive in the new art is a long-drawn-out, irregular spiral stem, often multiplied, and varied with "kinks" and elbows, and terminating in formal rows of disks or floral forms. There is a resemblance to certain parasitic climbing plants in this treatment, and such resemblance is perhaps quite as real as superficial, and may be the result of analogous conditions.

There appears to be a law of evolution working in the arts of design quite as inevitably as in the natural world. Certain germinal motives, derived from forms in nature or art, are combined by the fancy of the designer. A conflict for pre-eminence, a struggle for existence, takes place in the mind of the artist, as his hand records the stages of the evolution of his design, either on paper or in some plastic material. In view of his ultimate purpose—the use and destiny of the design—certain lines, certain forms, prevail over others as the most fitting; the design sheds inessentials and takes final shape. It may closely follow the principle of its inception, or it may, passing through a multitude of complex stages, finally be evolved in some very different shape; but in either case its development proceeds much as the development of a plant from its seed germ to its full completion and flower, always strictly adapted to its environment.

I would not say that forms of design, say, surface-design, are always so strictly adapted, and one must always, of course, allow room for individual caprice and wilful extravagance and the desire for originality. The limits, howev-

er, of even these apparently spontaneous impulses are more restricted than might be supposed. Efforts to be new and original sometimes lead to results curiously similar in form to work of former epochs, where the constructive principle in design has been obscured. For instance, I noted in more than one new art restaurant building in the Parc Valentino, near the Exhibition buildings, that which, in its general masses and distribution of ornament, in its absence of rectangles or verticals, or constructive feeling, curiously recalled buildings of the late eighteenth century, or what would be called in Hungary "Maria Therese" types. Extremes meet, and our twentieth century new art touches, in its least consciously artistic form, the rococo decorative confectionery of the palaces of the eighteenth century.

These are, in truth, I venture to think, two principles at work in this modern development of decorative art—a principle on the one hand of health, of life and growth, and on the other of decomposition and decay. The first tends in the direction of restraint of ornament and simplicity of construction in architecture, furniture, and the decorative accessories of life. In the crafts of design it maintains the principle of the adherence to the limitations, as well as the capabilities, of the material, and the control of use, while not rejecting new material, new methods, or new uses should they fall within its province, and be capable of being assimilated and harmonised. The second principle rather tends to follow a fashion whithersoever it may lead; to adopt forms and lines for the sake of the forms and lines, irrespective of their adaptation to particular materials and uses; to gather from every kind without giving time to digest and assimilate; to imitate superficial or artificial mannerisms in all sorts of ways; to use material simply to display material and skill of hand, without thought of the harmonising sense of beauty. The choice of woods, for instance, in some recent French marqueterie work, to express different textures and surfaces, such as rippling water, the coats of animals, etc., is marvellous, and the dexterity of the workmanship so great as to give almost an independent interest to the work. But if we ask if the decoration is appropriate to its purpose: Does it help the expression of the object so adorned? does it fall into its place as decorative pattern in the scheme of a room?—we cannot find any satisfactory answer. Then, too, if we are content to regard it as pictorial work, and judge such work by pictorial standards and from the pictorial point of view, it fails because, by the very nature of the material, inlaid wood cannot compete in pictorial effect with a painter's work, because the craftsman is necessarily debarred from the use and expression of certain values and atmospheric effects strictly belonging to pictorial art and its methods and upon which rest its chief value and power to appeal to the eye.

Such work may astonish by its skill and imitativeness, but it is neither satisfactory as pictorial work nor as decoration, whereas the same materials, used in a strictly decorative or flat pattern motive, would display the quality of the wood equally well, while producing a reposeful and appropriate decoration, and an object in a room it would be possible to live with.

To go through the Exhibition at Turin and rigidly apply this latter test—

whether one could live with any given exhibit—would be a process of such severe elimination that there might be some doubt about getting enough decorative art to furnish one's house withal!

Even here, however, one must allow for race, climate, and habit. An Englishman's choice would not be a Frenchman's or a German's or an Italian's. But if each proceeded on the same principle, the results would certainly be characteristic and interesting.

The danger of so wide a field of choice as lies open to the modern designer is no doubt that the climatic and racial elements of different countries have a tendency to become confused and to be applied inappropriately. This is a sort of danger, too, which is probably fostered by such exhibitions as this at Turin. At the same time, it may have also its beneficial side in enabling artists of different nationality to compare their work in a way impossible by any other means. The imitator may find new ideas and new methods to imitate, but the man of invention may be stimulated, not to go and do likewise, but, as is often the result of stimulating suggestive work, something quite different.

Where there is life there must be movement. The use of such international exhibitions is that we get a kind of water-mark in the arts of design. It is at least a record of united but independent effort. The waters of human accomplishment in the arts may possibly recede, or on the other hand, they may advance and reach higher levels. The record, meanwhile, is something: it marks an epoch. The record, too, of an exhibition limited as this at Turin is to the arts of design and handicraft, is far more striking than previous international exhibitions—those huge fairs and markets of the mixed industries of all nations.

In the state of design and handicraft of decorative art of any given age or people we have the truest key to their standard of civilisation, so that from this point of view alone such an exhibition must be full of significance to the thoughtful observer. Even the most rapid glance at the different sections will bring out the characteristic notes of the different races and countries. Incomplete as many of them still were at the time of the opening, one could not but receive strong impressions.

The boldness, the richness, the resource, the variety, fantasy, and redundancy of detail, the thoroughness, perhaps even the heaviness, of the German section, were manifest; the reserve, the homely quaintness, the domesticity, the solidity, the completeness, the soundness of the Dutch; the smartness, the ingenuity, the mechanical perfection, the adaptability of means to commercial ends of the American section; the dramatic *chic,* technical skill, and rather florid and unrestrained experimental expression in design of the French; the great technical accomplishment of the Belgians, very much on French lines in all kinds of design, were equally noticeable, but with less definite artistic aim or controlling taste.

The Hungarian quickness in adopting the forms and methods of expression of the New Art, and their extraordinary resource and technique in most of the arts and crafts—more especially in the pottery of Izolnay—were remarkable. No less characteristic, though practically the expression of a single group or school, was

the Scottish section, in the austerity and simplicity of its *ensemble,* not albeit unmixed in its details with certain imported elements from Japan and the East.

The Austrian was perhaps more determinedly "New Art" both in its building and in its show, and therefore less characteristic than most, except as coming from Vienna, the home of the Secessionists.

And, as the gay and varied coloured envelope enclosing all these diverse communications from the nations of Europe—the Italian: brilliant, dramatic, of extraordinary technical skill in all materials, but careless of observing the limits of balanced expression in such materials; intent upon *tour de force,* arresting the attention in whatsoever material; fantastic, scenic, dazzling.

The Italian mind seems to have taken up the elements of the New Art decoration, and to have dramatised them, so to speak, for the rest of the world. The scheme of decoration in the interior of the dome of the Exhibition is an admirable illustration of this, for there we have nearly all the elements combined in a remarkable scenic and effective whole.

And what of England amidst all this glitter and show?

A modest white-washed gallery, with cartoons in black frames, coloured plaster, wallpapers, textiles, brass and copper, colour-prints and photographs; some simple furniture; a choice Arras tapestry of William Morris's on the white wall; a few cases of choice books and MSS.; jewellery, glass, and metal; the show of the Arts and Crafts Exhibition Society, founded in 1888, wherein some may discover the original modest germs of the exuberant tree of New Art motives, so amply illustrated in the other sections of the Exhibition. These, with a collection of the works of the present writer, endeavour (without Government support) to maintain the honour of Old England in this friendly artistic congress of nations.

From Walter Crane, "Modern Decorative Art at Turin: General Impressions," *Magazine of Art,* 1902, pp. 488–93.

The "New Art" and the So-Called "Liberty Style"
ALFREDO MELANI

New Art, new style, modern style, Liberty style, floral style; let us count the ways by which this new aesthetic movement is singled out!

Let us settle once and for all that one designation of these is false, derived from an error; the term Liberty style is false, rising from the happenstance that a London merchant named Liberty opened some luxurious shops selling industrial-artistic items of modern design. This merchant, whose views, I do not deny, are wide-ranging and who has a fine-honed perception, has opened no fewer than two shops, on Regent Street in London and in Paris near the Opéra, and has given his name to the concern "Liberty & Co.," which aims to popularize objects of modern taste, not always doing it honor. And since shopkeepers have more ways and needs to advertise themselves it so happened that the term "Liberty" com-

monly referred to the art that Mr. Liberty did not create but sells; for this reason the name of the merchant concealed the name of the artists who were the authors of the work welcomed and housed by Liberty & Co. in the London and Paris shops. The whole thing could combine wonderfully because the term *liberty,* which also means *freedom* in Italian, corresponds to the essence of "New Art," which seeks free intellects not yoked to old-fashioned styles. Therefore there is no such thing as Liberty style—if the term is used—in the minds of those who adopt it—to designate the objects for sale at Liberty & Co.; there is no such thing as "Liberty Style," a designation current in Italy, and almost unknown abroad, at least among those who have an accurate conception of Art Nouveau. From this designation arose the auxiliary labels, like Liberty textiles, Liberty colours, which, since they arose from a mistake, we will not adopt, either now or in the future.

New Art requires consciences that are free, artists who think and who warm themselves by beauty's blaze. Therefore it puts copyists to flight and welcomes those souls who are trusting and strong. One has to be strong to resist, and it is necessary, nowadays, to resist: to resist the inroads of the opposition, who strive to defeat us on every front. Nor do I deny that there are men of worth among our adversaries, for there are. And I have heard New Art decried for being limited and narrow in its aspirations and for harboring the germs of decadence. The floral! they say to us, why always the floral? It is as ancient as the world. Agreed. It is not necessary to go far afield. The Duomo at Milan is full of leaves and flowers, but it is not New Art; and this, the Gothic feeling for flowers and leaves, is not the modern taste, neither this nor that. I can understand that Ruskin, the "ethereal Ruskin," as Carlyle called him, did feel the poetry of flowers and championed it; I am aware that William Morris designed splendid floral compositions; but that is a personal event, not New Art, or rather, not all of New Art. Even you readers also love and draw flowers, and for this?

Gentlemen, New Art is not all floral; as a matter of fact, van de Velde, one of the apostles of modern beauty, does what is the contrary of floral, the linear; and the French, those bizarre wits, with a very effective turn of phrase, described the the new style of the Belgian van de Velde, also cultivated in Germany and Austria, as *l'art à coups de fouet,* whiplash art. Think of a whip when it cracks; it produces agitated, sinewy, serpentine lines: the lines of van de Velde's art.

So, I have made clear to you, two forms of New Art: the floral and the linear. You find me another one, and I will be happy to express my satisfaction.

This, finally, will show you that New Art, which is based on freedom, welcomes all artists who build their productions on their own personalities.

A German artist studies insects with the help of a microscope in order to provide art with new elements, which were actually adopted for the manufacture of textiles. There are those who believe that this is the way that leads to degeneration, and that it is a symptom of the degeneration of New Art. They are mistaken. Every artist may turn to the part he likes the best, and he will be praised if he turns to his own sources by a spontaneous and natural impulse. Artists must *feel,* if I may put it that way, rather than *see* form: the artists who see are the ones who copy; those who feel are the creators.

New Art wants to live by creations. It is true that not everyone can create, but I am speaking about artists, not about those who practice art solely for a livelihood. Truth has said to us through the voice of Tolstoy[1] that professional men are the plague of all disciplines. Perhaps it is possible to practice bookkeeping without a lofty spirit of individuality, but not art. And do not bring up the objection that all of that is idealism, is poetry. I will reply to you: art that represents feeling and thought, and represents it with sincerity, is poetry; and New Art is poetic and places itself in the opposite camp from the prose of old art, which is a rehash of ancient things.

Translated from Alfred Melani, "L'arte nuova e il cosidetto stile Liberty," *L'Arte decorativa moderna*, 1902, p. 53, as reprinted in Paola Barocchi, *Testimonianze e polemiche figurative in Italia: Dal Divisioni al Novecento* (Florence, 1974), pp. 157–59.

1. Count Leo Tolstoy (1828–1910) was known for his influential essays, as well as his novels. An uncensored edition of *What is Art?* (1897) was available in many translations.

The Scottish Section
UNSIGNED

[. . .] If a piece of work is to be done well, give its control into the hands of one man. This is an axiom that applies to other than affairs artistic. And it is upon this principle that the design and decoration of that part of the Turin Exhibition called the Scottish Section has been worked. The delegate for Scotland, appointed by the Turin Committee, is Mr. F. H. Newbery of the Glasgow School of Art, and the architect is Mr. Charles R. Mackintosh of Glasgow. Mr. Mackintosh has had some experience in work of this nature, notably the design and decoration of the room which, two years ago, Mr. Mackintosh and Margaret Macdonald Mackintosh were invited by the artists of the Vienna Secession to deal with. And the experience gained there has been turned to account in Turin. Large, lofty, and barn-like galleries, designed and carried out by the architect of the Exhibition, Signor D'Aronco, entirely on the lines of the ordinary picture saloon, with windows whose light glared into every corner, have been ordered into a sequence of studied and interdependent proportions; and the veiled daylight looks into rooms whose simple tones and harmonies afford a welcome relief to an eye tired with the glare of an Italian sun.

Rarely has such unpromising material been more happily or successfully dealt with, and it is not a matter of wonder that the section is receiving much interested attention, nor that the verdict passed upon the work is one that adds solidly to the already rapidly-growing reputation of Mr. Mackintosh. [. . .] From the first, the architect decided that the rooms without any exhibits should be in themselves and for themselves matter for exhibition. Containing nothing, they yet should be material for study, and the exhibits should be added enrichments, and should by treatment fall into the general scheme. The spectator on entering was to be struck by the fact that here was something novel and complete in its

general *ensemble,* and was to be insensibly led on to examine in detail the work of its parts and the matter exposed for exhibition. [. . .]

The section consists of three rooms leading the one into the other, and lighted entirely from the sides by large windows, whose sills are eight feet from the ground. This gives an unbroken wall space for hanging. The first room is white, silver, and rose; the second toned white and grey gold, enlivened on one wall by a frieze of pink and green; while the other and largest room is golden purple and white. All wall spaces above the window-sill line, and all ceilings, have been whitewashed and the woodwork throughout painted white. A feeling of quiet repose, of coolness and of freshness, pervades the rooms; and in the work there is a reserve which recalls the temperament of the nation to which the architect belongs. A happy feature is the treatment of the electric fittings. No artificial light is to be allowed in the section, but the lamps are there. Pendent from the tops of the tall mast-like poles, or hanging from the ceiling, each on its cord of flexible wire, they give the effect of falling streams as of a white rain, while little lamps, hanging bare and without reflectors, look like drops of water. And the contents of the rooms are, on the whole, as worthy of attention as are the rooms that contain them, though there is a distinct falling off in some of the exhibits shown in the general section. Scotland, however, is a small country, and art life asserts itself only in the large cities; and as one of these, the capital, is conspicuous by its absence, the burden falls upon the shoulders of the art workers of Glasgow. The first room on entering is occupied with the work of the architect and of his wife, Margaret Macdonald Mackintosh. Short screens, projecting into the room at right angles to the walls, indicate a division into two parts, and one of these parts has been treated as, and is called, "A Rose Boudoir" (fig. 59). Framed into the wall at each end are two panels painted in gesso by Margaret Mackintosh. Their colour schemes are of pearly lightness, pale rose, pink, green, and blue. The subjects are decorative treatments of the figure, the forms being marked, and the surfaces led over into slight lines of coloured gesso, and broken by spots of colour. Set out on the floor are various articles of furniture, notably a black wood writing cabinet by Charles R. Mackintosh; with panels of painted gesso and of silver by Margaret Macdonald Mackintosh; chairs and a table of white wood inlaid with ivory, and a chair in black and purple (fig. 60). A needlework panel by Margaret Macdonald Mackintosh (lent by Herr Emil Blumenfelt, of Berlin) hangs on the long wall; and this is balanced by a silver repoussé panel, also by the same artist, loaned by Miss Cranston, whose tea-rooms, designed by Mr. Mackintosh, are reckoned by some of the pilgrims to Glasgow as one of the sights of the city. Running the whole length of the boudoir is a row of silvered electric lamps, ornamented with pendants of framed pot metal, and this note is echoed elsewhere on the walls of the room by lights of a bowl-shaped form, similarly decorated.

The other part of the room serves by its simple treatment as a foil to the boudoir. A few drawings well placed, and two or three sheets from a book dealing with Mr. Mackintosh's work (one of a series on "The Masters of Interior Decoration," by Koch, of Darmstadt), comprise the exhibits in this half. This first room is

the "*clou*" of the Scottish Section, and it is an epitome of the work of an architect and of an art-worker, labouring together as co-partners in the same scheme, and to whom the "House Beautiful" is an edifice built and adorned by the one handiwork, and standing as an expression of thought in art. The second room has been treated in much the same manner as the first, already described; that is, separated into two parts by structures which mark without dividing. The more important half contains the joint work of J. Herbert McNair and Frances McNair. Though partaking of the same character as the work of the Mackintoshes, there is yet in everything a personal note, which distinguishes it from theirs and other novelties and differing treatments of the same theme, creates new interest, and arouses fresh attention. The McNairs' room is a writing chamber. The floor is covered in part with a felt carpet, having a border of appliqué roses in a scheme of pink and black, and filling the other part is a baby's crawling-rug on which the young mind creeps through art to a quaint knowledge of Natural History. Upon these textiles are placed pieces of furniture almost entirely of black wood. A settle with glazed and curtained sides invites to rest, and the luxury is enhanced by a cushion embroidered with a charming treatment of little birds in nests. The dainty craft of these fittings proclaims the woman's hand, while the sturdy structure of the chair itself attests to the work of the man. A revolving bookcase, showing how treatment can make an artistic possession out of a commercial need; and a writing cabinet with chair to match, and a table and chairs *en suite* complete the furnishings of the floor. On the walls are panels, two painted and two in silver. Man and wife are equally responsible for their production. The painted panels treat of legends of the snowdrop and of the swallows respectively, the former by Frances McNair and the latter by J. Herbert McNair, while the silver panels, each treatments of a single figure, contain much novel matter. On the broad plane of the silver sheet the figures are repoussé in low relief, and these are traced with silver wire designed in curved forms strung with beads and coloured stones, through which the figures are seen. It is a delightful piece of playful fancy, quite novel in treatment and rich in possibilities. Four leaded glass panels by J. Herbert McNair, now pasted on the wall and forming the central part of the frieze, were for a window shown on the plan. The absence of this window is the fault of the authorities, and the glass loses all its true qualities. Two show cases contain—one, *objets d'art* by the McNairs, and the other enamels by Miss Lily Day. Both cases are very good. This second room demonstrates how the same *motif* in the hands of differing artists, becomes like a new thing, and the utmost credit is due to the McNairs for this object lesson, showing in what manner the necessities and beauties of life can be brought together in one harmonious whole. From a baby's crawling-rug to a silver figure panel is a far cry. The one room contains them, and to united brains working through helping hands we owe the beauty of both. [. . .]

Some people, though of small stature, are said to carry themselves with a dignity far beyond their inches, and something of this sort must be said about the Scottish Section of the Turin Show. The little there is, is good, and the interest evoked carries the visitor beyond the question of mere quantity. But this exhibi-

tion shows that Scotland is possessed of a body of art workers who are executing sound and thoughtful work, and are winning for themselves a place among those with whom decorative art is at once the highest and the truest expression of man's worship of the beautiful.

From (unsigned), "The Scottish Section," *International Studio* 17 (1902):91–103.

The Dutch Section
ENRICO THOVEZ

It would be very difficult to define the tendencies of decorative art in Holland with the aid only of the examples shown at the Turin Exhibition. It may, indeed, be said that in the quest for new forms of decoration the Dutch are more hostile than any other people to the naturalistic tendency which, with its combination of medi-aeval and Japanese feeling, forms the fundamental principle of modern decorative art in France, Belgium, Italy, and a considerable portion of Germany, Austria, and Hungary. With very few exceptions, a pronounced tendency will everywhere be found for geometrical forms, combined with certain decorative elements culled from the barbaric art of the savage races of the remote East. The section organised under the able superintendence of Mr. E. von Saher, chief professor of the school of decorative art at Haarlem, Mr. Karl Sluyterman, and Mr. Philip Zilcken, the well-known painter and etcher, includes examples of every variety of art, and, as a matter of course, ceramic work occupies a very important place. The grand entrance-hall is completely filled with it, and it is no doubt the most attractive portion of the Dutch exhibits.

The Royal Rozenburg Manufactory of porcelain and pottery of the Hague (artists: J. Jurriaan Kok, de Ruyter, Hartgring, Schelling, Sterken, Brouwer, van der Welt, van Rossem, and L. Smit) deserves to be noticed first, not only on account of the importance of its exhibits, but also because of the decorative tendencies which link it intimately with the modern naturalistic movement. [. . .]

There are four completely furnished rooms in the Dutch section:—a Dining-room, exhibited by Binnenhuis, of Amsterdam, another by J. S. Hillen, of the same city, a Hall, by John Uiterwijk, of the Hague, and a Bedroom by the firm of Onder S. Maarten, of Zaltbommel.

The leading characteristic of all the furniture in these rooms is the geo-metrical simplicity of its design, and the almost complete absence of carving or of naturalistic ornament of any kind. Indeed, scarcely so much as a few geometric marquetry decorations relieve the surface of the unvarnished wood.

The best furniture of these few representative rooms is, perhaps, that by Binnenhuis. This dining-room, in light walnut wood, with the ebony bolts, inlaid ivory, and yellow metal fittings as its only structural decorations, was designed partly by Mr. Van der Bosch and partly by Mr. H. Berlage, and executed by Mr.

W. Gieben. The furniture is good and appropriate; the effect of the whole thoroughly harmonious.

If possible, the dining-room of J. S. Hillen, of Amsterdam is even more simple. It is in dark oak, with fittings of red copper, and was entirely designed by Mr. H. P. Berlage. The furniture is put together with bolts, which can be taken in and out, a striking proof of their perfect construction.

The Hall exhibited by the Arts and Crafts firm of John Uiterwijk & Co., of Apeldorn, near the Hague, has a good deal more originality about it than the dining-rooms just described. This well-known house, directed by M. Uiterwijk, in collaboration with the architect, Christian Wegerif, who designs the furniture, and Madame Wegerif Gravestein, who superintends the Batik workshops, produces all kinds of work for private houses, metal fittings, furniture, textile fabrics, engravings, &c. The Hall under notice is of teak, inlaid with ebony and ivory. It has a grand chimney-piece, of conical form, with four massive beams as supports, which give to it a primitive appearance, not without charm. Plaques in red and blue enamel are skilfully introduced in the fireplace, and a copper frieze is adorned with very cleverly executed dwarf dogs, whilst four large panels, looking rather empty in spite of the paintings representing the Dawn, the Day, the Evening and the Night, by Frans Stankart, decorate the walls.

The furniture, of rigidly geometric design, is decorated with inlaid ebony and ivory; recalling, in severe symmetry of style, certain ornaments of the Polynesian races, and also certain Oriental details occasionally turned to account by Olbrich. [. . .]

The most noteworthy of the exhibits are without doubt the magnificent screens and the grand polyptych, with several panels, from the firm of Van Wisselingh, on which are represented various animals, such as roe-deer, peacocks, cranes, storks, fish, &c., admirably drawn by Mr. Dysselhoff, printed by the Batik process, and finished off with remarkably clever silk embroideries by Mme. Dysselhoff. [. . .]

Among the numerous Posters we must note especially those of Toorop (who, in the one designed for the Society for the Emancipation of Woman, combines the Javanese style with something of the feeling of Khnopff).

From Enrico Thovez, "The Dutch Section," *International Studio* 17 (1902):204–12.

The English Section
F. H. NEWBERY

[. . .] To Walter Crane methods and mediums offer neither let nor hindrance, either in the choice of his subjects or the manner of their expression. The hand obeys the thought in that wonderfully unconscious way that is the gift of the few; and the worker, though critical of the process, is always confident as to the consummation.

But herein lie the methods of mannerism and the fear for the hieroglyphic; and, although it is quite possible that mannerism may become a precious quality, there is, wherever natural form is employed, an appeal back to Nature itself. And there is in Crane's work a certain want of conviction and a lack of relation to Nature, which appear to have arrested all progress above a certain plane. The convincing realism of Aubrey Beardsley, linked with an expression in line and value, as personal as it was precious, revolutionised in a few years all our preconceived notions of the possibilities of black-and-white drawing; and Laurence Housman, Ricketts and Shannon, not to mention others, are names that stand for an art whose possibilities are limited only by the artist's power to use Nature. And Nicholson and Pryde have taken work a stage farther and shown the potentialities of printed colour. With Crane, however, we are back to a point analogous to that period when Egypt, speaking through art, limned for us the history of the country on the walls of the tombs of her kings. He is the heritor of the primitive artist, making for a fraternity of race and creed, and with whom language is a line, speech a drawing, and eloquence the expression of an idea in terms of colour and composition blended to make a literary tale. [. . .]

Means may defeat ends, and education may better be helped by a quality of work instead of a quantity in output. For art is not a matter of quantity, and there are economical laws which tell against overproduction, even in art. Moreover, it is so difficult to do even one thing well, that the all-round man carries with him his own limitations. To design books for babies, and illustrate operas for those of equally tender years; to illuminate the poet, and decorate the page of the mediaeval romanticist or modern versifier; to interpret Spenser, and put into line the lore of the fairy tale; to design the wall-paper, and make a pattern for the carpet; to model in gesso; to paint in water-colours and handle oil-colours, is to sum up a very big task. And Crane has essayed all these. Is there a masque? Crane designs the dresses, arranges the tableaux, and times the dances. Does a lowly deed of heroism require a chronicler, in order that art through time may tell the story? Crane limns the incident, and form and colour combine to transmit the story. Religion building the house of God claims the same artistic hand to enrich the light streaming through its painted windows. The student is bidden to turn to those books where Crane resolves line into language, and endeavours to trace back to a conscious basis.

The history of book decoration finds in him an historian; and to all this may be added other labours, which speak of his unselfishness and disinterested devotion to the social welfare of his fellow man. But there is a danger in all this—the danger that a man working in art may have no time to study that art itself! And so the conventional must perforce be accepted, and the supply yield to the demand. Turin points the moral. Here are two large galleries hung about with a collection of Crane's work, that has made a tour of some of the mid-European cities, and has come into Turin to form part of the English section. And this exhibition is as unrelated to its purpose as ever was an exhibition of the Royal Academy. Drawings, paintings, designs, sketches, modelled panels, executed work, elbow each other on the walls, without either sequence or meaning. Carpets are nailed up

where tapestries usually find a place, while the floor is destitute of their employment. The leaded design for stained glass avoids the material for which it was intended, and the decorative panel hangs apart from its place. Where is the art in all this? What of the architecture which is the root and basis of all things artistic? What of the house for which all these objects were made, or of the room that, decorated by them, was further to be enriched of them?

But it might be urged, "Is it possible to make rooms in an exhibition, and to show objects in their right and proper relation?" The answer is that what has been done in the Scottish section by Mackintosh, and by twenty architects who have decorated the forty rooms of the German section, was possible in the English section. Olbrich, of Darmstadt, makes three rooms upon a given space. Each is a related and relatable structure, each has its proper plenishings and decorations in perfect *ensemble,* and it is only by such work and through such means that decorative art can ever hope to have a place or make progress. And it is because these things are neglected that the English section is the exhibition of a collection of work, arranged without idea and without scheme, instead of being a selection of art work, related by beauty and through utility to its purpose. Crane's show, with half the work, well chosen and wholly related to its purpose, would have doubly gained and been wholly educative. And by no one is this better understood than by Crane himself. The exhibition in the third room is in perfect sympathy with the arrangement in the two Crane rooms; except that there is, if anything, a less sense of order and an utter absence of the axiom that the care for the setting of an object should be in direct ratio to the value of the object itself. [. . .]

The exhibition is an exhibition of the Arts and Crafts Society, London. And the great dead complete the tale. Morris and Burne-Jones were members, but death surely prevented the further subscription; and it is, perhaps, a fact not very widely known that Ford Madox Brown, while he lived, was a member. Why is not Aubrey Beardsley represented? And then, although membership appears automatically to demand representation, it is not altogether a secret that Commerce and the Arts and Crafts are not considered bosom friends, and there are foremost places given to examples of art work that do not carry with them the associations of the studio.

Or, again and even here, as stated above, Crane is a sinner, although he sins in the good company of the keepers of the tapestry court of the Victoria and Albert Museum—the place for carpets designed for floor coverings should be on the floor, that men may see utility abiding with beauty; and cartoons for stained glass are unnecessary and altogether insufficient to represent the art of the glass mosaicist and painter. The photograph of the house that the builder has builded may be permissible, because it shows the root of the matter, and this is in some cases helped out by the model of the house that the man would build. But the photograph of the detail is best confined to the trade catalogue; for handicraft is apparent only by the presence of the cunning work, and men gaze lovingly even upon the candlestick where brains have guided the hand, whereas they turn away from the picture of the thing that is because the picture painter does it so much better. The wall paper may be good and beautiful in itself; but the proof of its

artistic fitness lies in its use, and the sample is better relegated to the merchant who sells. For the room is more to be preferred than the covering of its walls, and the unrelated brings us back to the picture again. It is not enough that men see the apparent, for the right education is to present the actual; and a chair or a table gains in preciousness by being shown as part of our daily surroundings. Otherwise the draper's shop window becomes the acme of excellence in arrangement, and the customer sees and is tempted. It has been said, and perhaps truly, that the English are a nation of shopkeepers. But at any rate commerce should not be allowed to preach where she should pray.

But when all is said and done, and every censure passed that criticism can call for, the exhibition of the Arts and Crafts Society contains work where beauty of design, coupled with excellence of workmanship, makes for all that is best. For there are English architects who have grasped the fact that an exterior, however beautiful, is at the best but a part of the whole, and that a man may leave the outside of his house for the admiration of his neighbors, but adorn the inside for his own delectation. And the pity is that in many cases the plenishings for the "house beautiful" have, in Turin, been treated as are the contents of most museums, where, owing to the exigencies of space, the artist is often less catered for than the archaeologist.

But the glass case is a wonderful preservative, and generally speaking, the work arranged in the cases shows evidence of loving and careful placing. Thus the jewellery and metal work sent by C. R. Ashbee and other workers are seen at their best, and very delightful work it is. The bookbindings and decorations likewise receive just and proper treatment, and the excellence, alike of design and craftsmanship, testifies to the great advance that has been made in the past few years, in the treatment of books. [. . .]

The impression that remains after a careful inspection of the section is that it contains individual works that are among the finest of their kind, and are proofs of the existence of a healthy, virile art craftsmanship that must in the near future make a strong appeal for public acceptance. And had the works exhibited been treated less like pictures and related more to daily use and environment, the English section would have made one of the best.

From F. H. Newbery, "The English Section," *International Studio* 17 (1902):251–59.

The Austrian Section

W. FRED [ALFRED WESCHLER]

Austria, like many other countries, has not succeeded here in producing an advantageous or even true impression of her arts and artistic manufactures. Many causes have contributed to this result. In the first place, the time that had elapsed since the Paris Exhibition [1900] was too short to allow of any new efforts; and in the second place, in consequence of the epidemic of exhibitions in Germany and

Austria within the last few years, the careful execution of artistic products, which formerly was almost always praiseworthy, has given way to hasty and careless work. [. . .]

A special reason for the failure as concerns works of art lay in the fact that the Viennese Secessionists, among whom must be reckoned most of the distinguished talents of Austria—as Otto Wagner, Josef Hoffmann, Koloman Moser, L. Bauer, and others—refused on personal grounds to take any part in the Turin Exhibition. In the same way almost all the schools of applied art in Vienna refused to exhibit, and this abstention, when we consider the remarkable activity of the youthful talent which is trained in these schools, leaves a conspicuous blank. The readers of *The Studio* are familiar, through many articles, with the tendencies of these artists—amounting, in fact, to a distinct "Modern Austrian" style.

Austria was so exceptionally lucky as not to find herself obliged to display her products in the great bazaar-like central hall of the Turin Exhibition; she was able to arrange them in two small buildings erected by the architect Herr [Ludwig] Baumann. The opportunity was not altogether judiciously used. One of the buildings, a sort of kiosk with a circular vestibule and a white plaster façade—not untastefully decorated with black and yellow, the symbolical national colours— showed some affinity with the Viennese Secessionist style of white stucco villas with an irregular façade, and produced a not very satisfactory architectural effect of triviality, with which we are familiar from other examples, without revealing any strong artistic feeling. Some mural paintings by Josef Engelhart which decorate the entrance are, however, worthy of remark. In this kiosk are to be seen examples of the industrial arts of Austria, most of which have already been shown in Paris, and recently also in London; while the second building should have formed a little separate world of its own, since it was intended to represent a little villa, after the model of the exhibition of the artistic colony of Darmstadt, completely furnished and fitted with *objets d'art;* it thus really offered an opportunity of showing the visitors to the Turin Exhibition what the young school of applied art in Austria could do. But I cannot but admit that, though in these two buildings there is some very good work, especially some carefully executed cabinet work and some tasteful effects of colour arrangement, and a certain quiet tone of homely elegance, the subtle element which makes a true work of art is wholly wanting: the impress, namely, of a distinctive artistic individuality.

The villa is designed very much after the English plan, and here again the façade shows a quite singular treatment in its line and architecture, so we must be content to believe that comfort was consulted in the matter of taste. A large hall, designed by Herr Baumann and very well carried out by J. W. Müller, of Vienna, is the central feature of the interior, and out of it open a suite of rooms and a dining room on the ground floor. A dinner lift is, however, wholly lacking, as are many other conveniences for a large household; and such an omission, to say nothing of the absence of a kitchen and of the modern arrangements of domestic offices, is a serious defect in this building. The first floor is designed for bedrooms, but here again we find nothing new, either in their plan or in the details of the arrangements and furniture—little of any artistic merit. Finally, we can but wonder what

there is in any way characteristic in the villa to make it an example of modern decorative art. The decoration of the interior is quite pleasing, but in all respects insignificant. [. . .] [A] reception room, by Jacob and Josef Kohn, of Vienna, displays the application of the modern invention of bent wood, which has for many years been an Austrian specialty, though it is only lately that artists have hit on the idea that the process by which any curve can be given to wood is particularly applicable to the modern taste for "line." In this room, too, we note with pleasure a remarkably good coloured window by Koloman Moser, who unfortunately, with this exception, has kept aloof with the other Secessionists.

On the first floor we find a bedroom decorated by Baron Krauss, whose work is already known to the readers of *The Studio,* and another by the architect, Baurath Baumann. What chiefly strikes us in this house, besides the absence of any kind of study or workroom, is the lack of character and individuality in any of the rooms. It is quite impossible to picture to oneself what sort of men and women would inhabit this completely furnished abode; consequently the very first law of modern comfort and taste—that the dwelling and the inhabitants should harmonise—is neglected, since these rooms are exhibition rooms and nothing more. And it must be said that the much abused exhibition of the Darmstadt *coterie* of artists, which was carried out on the same principles, fulfilled its purpose far better. [. . .]

It is to be regretted that Austrian industrial art, which is generally so highly praiseworthy, and is making a name for itself all the world over, has not in the present instance done itself more justice.

From W. Fred (pseudonym of Alfred Weschler), "The Austrian Section," *International Studio* 18 (1902–03):130–34.

The Italian Section
W. FRED [ALFRED WESCHLER]

The idea of an International Exhibition on Italian soil was at first startling, for in the Exhibitions of recent years, and especially in Paris in 1900, Italian applied art had made no such display as might induce high hopes of its success. It may, however, have been the feeling that Italy had a large blank to fill that led to an exceptional effort on the part of a few patriotic lovers of art. They could not indeed be blind to the danger of the superiority of foreign contributions, both in quantity and quality; but they understood that such a public competition would prove the best spur to the torpid industries of their native land, fettered as they have been by the enfeebled survival of once great traditions. For, since the period of noble and homogeneous decorative art in Italy—the XVth and XVIth centuries—not only has there been a stagnation of artistic crafts but also, and more recently, such changes in social life and habits, and in the general conditions of existence, as seem to have undermined the very demand for such work. It is no

mere tourist's exaggerated view to say that Italians live in the streets, and so feel but little of that desire for the graces of domestic life which influences northern nations. Still, it can be seen that the organisers of the Turin exhibition have done their utmost to arouse the demand, and we cannot doubt that they will succeed with a race so instinctively artistic as the Italians; not perhaps immediately, nor till original design has taken the place of imitations of foreign work.

As yet, in fact, we too plainly see that Italy has no modern native school of industrial art; we find a confusion and mixture of styles, and a craving for novelty, out of all proportion to the gift of inventiveness, especially in constructive design, which is subordinated to frittered detail and gaudy colouring, to produce the "modern" appearance which we find in England, Austria, and Belgium. Italian drawing-rooms are furnished with every variety of work which can be comprehended under the designation of "New Style." Thus, we see furniture of plain design, suggesting English influence, decorated with coloured marqueterie in the manner of E. Gallé; or pieces of light scroll work, in the early Dutch style, mixed up with female figures of pre-Raphaelite affectation—all the medley which ensues when art is applied to craft with no sense of purpose, but solely for the sake of novelty, however eccentric it may be. [. . .]

Of the complete rooms, decorated and furnished throughout, in the Turin Exhibition, I can praise but few. A young lady's bedroom, by Moretti, is simple, bright, and pleasing in colour. The *Famiglia Artistica* of Milan have made a more serious attempt to provide for the requirements of the middle-class, by showing some furnished rooms of suitable style and price for daily uses, in which the treatment is simple and the colouring restricted to a key of green, blue or red. One excellent room is priced at 680 lire (£30).

Those decorated by Issel are adapted to a more fastidious taste and deeper purse. Here we have a nursery, intended no doubt to train the youthful mind in decorative art. The wood in its natural colour is carved with conventionalised flowers. A dining room by the same firm shows a rich but heavy use of wood carving, well executed, and the breakfast room is ingenious and pleasing; the treatment of marine subjects is even poetical.

The most important Italian industry is pottery of many kinds. It has been carried on very continuously since the time of the della Robbias. The constant demand of foreign purchasers has kept up the production of more or less good work of the kind, and the fine old shapes have been perennially reproduced. In Italy, as in other countries, the coarser kind of earthenware lends itself best to the modern taste for effective colour in pottery; the lustres originally produced by the village potter, so far as his means of firing them allowed, are now applied to artistic pieces in the town factories. Conte Vincento Giustiniani was the first to check inartistic copying and encourage original design and colouring. Capital examples of his ware were exhibited at the Paris 1900 Exhibition, and attempts are now being made to adapt earthenware plaques and panels, with plain or iridescent glazes, to the decoration of interiors; for instance, large pictured panels, as well as decorative tiles for larders and bathrooms. The old-established factory

of the Ginori, in Florence, has followed the example of its younger rival; a very good bathroom and a variety of dinner services were exhibited by them, of which the simplicity and taste, the rich colour and fine glaze were extremely attractive. Of other *objets d'art* I found few worthy of remark, excepting a case of jewellery, French in its inspiration, by Musi of Turin.

This brief notice cannot, of course, do full justice to the Italian section of the Exhibition. The whole effect of it was that of a huge bazaar, rather than an exhibition of artistic work. Nevertheless, it seems certain that the Exhibition generally, though of no very high order, will have left its mark on Italian industry.

From W. Fred (pseudonym of Alfred Weschler), "The Italian Section," *International Studio* 18 (1902–03):273–79.

The German Section
UNSIGNED

Germany has certainly taken a very prominent position in the Exhibition at Turin, thanks to the liberal subsidy of the Imperial Government and the generous contributions of the Confederated States, amounting to some 120,000 francs. The Committee, presided over by the architect, H. E. von Berlepsch-Valendas, of Munich, has collected a very representative series of examples of the new departure in decorative art, recently inaugurated in Germany, and although that country does not enjoy, as does Austria, a separate building, its exhibits are shown in a gallery designed expressly for them by Mr. von Berlepsch-Valendas, which is in itself a practical illustration of the decorative work recently done by German architects. Truth to tell, beautiful and effective as is the general design of the accomplished Munich architect, with its characteristic sloping roofs, courts, etc., the details added by his collaborators do not in every instance do justice to the progress made of late years in Germany. There are points open to criticism in the work of Mr. Behrens, of Darmstadt, for instance, who designed the Hall; of Mr. H. Billing, who is responsible for the chief room of the section; of Mr. Kuhke, who decorated the Lecture Hall; and of Mr. Kreis, who designed the ceramic decorations, executed by the house of Villeroy and Bock, for the Saxon Section.

Peter Behrens' Hall, with its heavy arches and vaulting, is only relieved by the fountain in the centre, with the noble, but somewhat stiff, winged figures so characteristic of their author. The great Hall of Herr Billing is not altogether satisfactory from an architectural point of view, and is somewhat lacking in originality; while the Saxon Room, the ornaments of which, by the way, were designed by Karl Gross, though there is a good deal that is clever about it, is not entirely harmonious.

Germany was especially well prepared to take her true place in the modern decorative movement, for her artists were thoroughly imbued with the spirit most

closely in touch with modern requirements; and although it is too soon to speak of a modern German style—for German designers are still much influenced by those of France, England, and Austria—there are tokens that the evolution of such a style is only a question of time.

The influence of the ingenious, but somewhat irritating, style of Van de Velde is here seen in the Prussian-Room in the work of Bruno B. Pankok, whilst a reflection of that of Plumet will be noted in the exhibits of Bruno Paul. To set against this, the visitor will be reminded at every turn of Viennese work or, rather, of that of one Viennese designer—Olbrich. A notable instance of this is a Room evidently inspired by Olbrich's celebrated Reception Hall at Darmstadt—in fact, little more than a copy of it—of scarcely any interest except to those who have not seen the original. The change of national character is of course more noticeable in ornament than in architecture. In the decoration of furniture German artists are disposed to neglect the naturalism employed by their ancestors, in favour of the geometric patterns of Van de Velde and other designers like him.

To this, however, Mr. Berlepsch-Valendas is an exception. The three rooms in the Turin Exhibition do not perhaps give a just idea of his ability, but some of the ornaments of the ceiling, the painted friezes and the decorations of the mantel-piece in the Bavarian Antechamber are full of individual character.

German designers of decoration are just now divided into two parties, those who follow Olbrich and those who think there is no one like Behrens; but although these two artists of Darmstadt are rivals, their work is really not unlike. In Germany Behrens is considered the modern German master par excellence, but this is a mistake. His style it is true, is thoroughly Viennese, with some flare of Viennese imagination left out; but it is Olbrich who is the real leader, the real impersonation of modern tendencies, and whatever individual opinion may be as to his art as a whole, he is the very prince of modern decorators, the most powerful and prolific of them all. It is impossible to help admiring his style, and it must always be remembered that it is his very own, and that he knows how to turn it to account with a verve, an irresistible logic, such as is indeed rare amongst those who devote themselves to decorative art. No one has known as he has how to combine simplicity with lavishness in decoration, and on certain occasions he has approached perfection. He has, indeed, become almost a classic master: there is something Greek about him, and he has borrowed from the Greeks many of his decorative motives. There really is very little of the German in him, and it is almost painful to watch the efforts of his fellow countrymen to follow his steps.

Olbrich exhibited three rooms at Turin. [. . .] For my part, I think there was more freshness, more *élan*, about his early work than there is in these later more classical productions.

With regard to Behrens, it is just the very reverse. He has lately made a very distinct advance, and that simply because he has approached Olbrich more nearly. [. . .] Much may yet be expected of Behrens; for though he has not yet shown a great amount of versatility in his work, he is a sound, sincere, earnest, and thoroughly reliable worker. [. . .]

Other noteworthy exhibits are those of the society known as the "Vereinigte Werkstätten für Kunst im Handwerk" of Munich, under the direction of the painter F. A. O. Kruger, with whom the artists, Bruno Paul, Bernard Pankok, and Hermann Obrist, are the able collaborators; and the designs executed after the drawings of Bruno Paul, Pankok, and Friedrich Adler, by the "Königliche Lehr- und Versuchwerkstätte" of Stuttgart, also under the direction of Kruger, who is now Professor of Art in the Government Schools of the same town. [. . .]

The "Vereinigte Werkstätten," or Associated Manufactures of Munich, which were the first to espouse the cause of modern decorative art in Munich, complete their show with a number of interesting bronzes, jewels, etc., with some fine pieces of porcelain designed by Theodore Schmutz-Baudiss, which are undoubtedly so far the best modern examples of German work of the kind. [. . .]

To sum up, Germany is taking a very important place in the modern art movement, though so far her actual position cannot be very distinctly defined. She is to a great extent under the influence of Olbrich which checks her instinctive leaning towards naturalism; and whilst awaiting further developments, we congratulate her on the position she has taken in the first International Exhibition of Decorative Art.

From (unsigned), "The German Section," *International Studio* 18 (1902–03):188–97.

The Belgian Section
ENRICO THOVEZ

Though the Belgian Section was less in extent and numbered fewer exhibitors than some others, for instance Austria and Germany, it was as well arranged and one of the most distinguished in effect. The committee, of which M. H. Fierens Gevaert, a well-known man of letters and art critic, was chairman, gave the display a stamp of the Belgian style by achieving harmony in the various rooms, by exhibiting the work of artists only, and on the condition that the designer's name, and not the manufacturer's, should be attached.

The entrance was through a stucco portico with a vaulted arch, supported by two pillars, decorated with masks and scroll work; within was a vestibule with two stairways, leading to a large room, designed by M. Horta. In the narrow space between the two stairs was a little bookroom, where modern books, illustrated by Belgian artists, were displayed. The portico and bookroom were designed by Leon Gevaerts, the architect, and plainly showed the influence of the Brussels architect, M. Horta. His large salon was very rich in colour, the woodwork red, the walls hung with gold-coloured silk, and, taking it altogether, it gave a very good impression of this artist's individual style. He also exhibited, in a flat glass-case, various photographs of his more famous buildings—the Hotel Solway, the Hotel van Eetvede, the People's Palace, and others. In the corners were two complete sets of

furniture in light-coloured wood, ash and sycamore, well executed and elegant, in M. Horta's peculiar undulating style. On the walls were two large allegorical panels in body colour on canvas, by M. Fabray, vigorous in movement and modelling, and very decorative in effect. Their ruddy key of colour harmonised well with the red tones of the room.

To right and left of the corridor, on leaving this salon, were two smaller rooms, a dining-room and a study, designed by M. Georges Hobé, of Brussels. They were simple and practical, well arranged, with no such striving after originality as often leads to extravagance in modern decorative work; the plain furniture, devoid of mouldings and scrolls, was certainly among the best in the exhibition. One of the rooms was embellished by a painted frieze by M. Wytsman, representing the town and environs of Bruges, a very pleasingly decorative work, in subdued tones and clear-cut outlines.

The next room was dedicated to the use of the artists of Ghent. The furniture, designed by the architect, M. Oscar van de Voorde, was more Viennese than Flemish in taste, but less capricious and brilliant, massive in outline, with a free use of brass mounts. The glass cases contained leather work of all kinds, stamped and tinted, really beautiful work, by Mme. Voortman, of Ghent; bronzes and plaster casts by M. Georges Minne, remarkable for their expression; pottery by Laigneul; drawings and etchings, by Dondelet and others, were on the tables and walls.

Next to the Ghent room was a studio for an artist, designed by M. Léon Sneyers, a pupil of the late M. Hankar and of Adolphe Crespin. This was the most original room in the Belgian section, showing a healthy and inventive modern spirit. Still, while the furniture, the staircase and the door were commendable for sound, plain design and happy details, very unlike M. Horta's sinuous inventions, the green linen panels embroidered with flowers well conventionalised by M. Crespin, were perhaps a trifle fatiguing to the eye. Some posters by Crespin, and superb lithographs by Khnopff, some masks by Isidor de Rudder, and bronzes by Victor Rousseau adorned the studio. In the five next rooms were collected the architectural drawings and bronzes, and M. Wolfers's various work, with the educational exhibition from the schools. While the photographs of buildings erected by Hankar and other architects showed the visitor the progress of their art in modern Belgium, the room devoted to the graphic arts rejoiced the eye; here were the charming postcards by Henry Meunier and Lynen, the interesting designs and *ex libris,* by Khnopff, the little bronzes by Paul Dubois and Georges Morun, and, above all, the wonderful posters by Henry Cassiers, marvels of decorative design and brilliant but harmonious colouring. But particularly worthy of notice was the embroidery on two large panels by Mme. de Rudder, from designs by her husband. These large compositions, *Spring* and *Summer,* in a style suggestive of Botticelli, were in exquisite taste as to colour, and the needlewoman's skill was simply astonishing; she had achieved what had always been thought possible only to the Japanese. M. and Mme. Rudder have not wasted the ten years devoted to this wonderful work. [. . .]

The last room contained the work of pupils in the industrial schools, and it

was satisfactory to see that the modern style has found its way into their training, with very good results. Though we had to lament the absence of M. Van de Velde, fully occupied in Germany, we had, on the whole, a fairly representative show of Belgian Art. This was partly the result of the interest taken in the matter by M. Horta; he it was who studied the plan of the section and arranged the colouring, besides contributing his co-operation.

From Enrico Thovez, "The Belgian Section," *International Studio* 18 (1902–03):279–82.

Artistic Photography
O.B.

The Origins of This Exhibition It is well known that for many years outside of Italy, rather than in Italy itself, thanks to the efforts of deserving associations supported by rich amateurs, periodic exhibitions of artistic photography have been held to combat the vulgarity of what is usually produced and to push photographers to the study of art, to elevate culture, and to refine the taste of the public.

As soon as the idea of the exhibition of modern decorative art had taken shape in Turin, it was a natural consequence that the plan of adding a photography exhibition to it should be born: an exhibition which, as the rules establish, would include "only those works in an original form whose qualities demonstrate a conspicuous propensity to be a work of art rather than of technical perfection."

To launch the project, a special commission was formed with the duke of Abruzzi as its honorary president and the able photographic amateur Cavalier Edoardo Balbo-Bertone of Sambuy as the active president, director, planner, and, indeed, soul of the whole enterprise.[1]

The exhibition is located in a special building which one enters by a curious door, framed by two enormous simulated gilded cameras. It is an international show, and the works displayed consist of 1357 pictures and 7 stereographs.

Knowing this, let us go through the numerous rooms of this exhibition, which is a worthy, useful, and educational addition to the exhibitions of decorative and fine arts.

Italy Let us start with Italy and make it *"ab Jove principium."* Cavalier Edoardo of Sambuy shows some of his splendid portraits (among them the portrait of the sculptor Calandra), Mount Cervino and other alpine landscapes, and also some delicate mythological and historical compositions, executed with the artistic use of models, such as *The Satyr and the Nymph, Introduction to Peace, Odalisque,* and *Medieval Page.* One of the best collections in the show is from Gatti Casazza of Ferrara: it consists of fifty or so small photographs illustrating Lake Como and its environs—boats, fishermen, waves, forests, sunsets, pastures, and villas. Guido Rey, the well-known alpine climber, does not offer us any of his many

alpine photographs, but some of his excellent small genre pictures, Dutch costumes, and portraits in the manner of Van Dyck. The painter Grosso also gives us matchless portraits, among which are those of the artists Bistolfi, Reduzzi, Girardi, and Delleani. Vittorio Selva, already famous in Italy and abroad for his alpine photographs, exhibits for the first time panoramas of the Himalayas. I will also mention the good seascapes by Prince Barbiano di Belgioioso d'Este, a Milanese; country views and animal pictures (all carbon prints, in rather dark tones but perfectly executed) by Dr. C. Schiaparelli of Turin; the photographs that could easily be taken for etchings, by E. Quirico of Turin; the portraits by Cominetti, also of Turin; from Verona, Cadavini's landscapes, which remind one of lithographs, this time with details of the river Adige and Lake Garda; a triptych, *Prayer at Evensong,* by Dante Badino; the curious and slightly contrived *Struggles of Early Man* by E. Garrone; scenes of the Ligurian coast by Traverso of Genoa; two snowfalls by Boetto of Turin; landscapes full of melancholic poetry by Ernesto Forma of Turin; those by the Florentine sculptor Vannucchi; the heads, the clouds, and the charming *Congress* (of dogs) by Treves of Turin; the landscapes by Enrico Assarelli; those by Nathan of Florence. [. . .]

The Italian exhibitors are almost all amateurs, but there is no shortage of professionals worthy of mention. [. . .]

Among the book illustrations (a very wide field for practitioners of artistic photography), those for a novel by Balzac are worthy of notice, achieved by a young lady as able as she is anonymous.

Other European Countries Whereas in Italy almost all the exhibitors are amateurs, those from Germany, on the other hand, are all professionals, and the 114 works presented by them are listed in a catalogue with a foreword by G. M. Emmerich, director of the School of Practical Photography in Munich. In the show (underwritten by the governments of Bavaria and Württemberg), one notices that, while it is full of excellent qualities, there are not a few works that come too close to painting and oleography. [. . .]

One of the best galleries is that of France. This is due to the Photo-Club of Paris. [. . .]

Switzerland has little, and not very much that is good. Among the works sent by the Photograph Club of Geneva, I made note of the photographs by Revilliod.

From Spain, Canovas y Valeio (former director of the photographic exhibition in Madrid) was able to send only his own work, among which a few portraits in the style of Velázquez are noteworthy.

The contribution of Sweden and Norway (amateurs and professionals) was collected by Rooswel, the director of a photographic magazine in Stockholm. One notices in it some good portraits of the members of that royal family.

The same may be said of Denmark, whose exhibition is due to the efforts of Ranuzzi-Segni, secretary of the embassy at Copenhagen.

Many pretty and attractive things, if not of the best, are to be seen in the Belgian section: portraits, seascapes, villages, woodlands, fishing scenes, and snow. [. . .]

In Holland, not many things can be pointed out which really relate to the concept of the exhibition. [. . .]

What the Photo-Club of Hungary submitted was not all good. [. . .]

United States and Japan One of the most noteworthy sections is that of the United States; this is certainly not because of the sumptuous interiors of the mansions owned by millionaires and billionaires, nor for the photograph of the interiors of the Switt Company offices (which is believed to be the largest photograph in the world done directly from a contact print), but really for the marvelous portraits, for the night scenes, for the small genre pictures by Stiglitz [sic], Trigley,[2] and other well-known amateurs.

And here we finally come to Japan, with its landscapes and costumes, in which we are aware of a great artistic feeling, offered by two photographers, Tumamura [sic][3] and Ogawa[4] with his work on gold and silver lacquer,[5] a method invented by him.

It is to be hoped that this international exhibition of art photography may teach many things, not only to our own amateurs, but also to professional photographers, too often so slovenly, so dull, clumsy, primitive, and wanting in good taste as far as posing their sitters for their portraits is concerned, and lacking common sense in their choice of subject and the angles from which they take their landscapes.

Photography is, at the same time, applied art and applied science. May this exhibition persuade many photographers to become artists as well as technicians, not only salesmen of goods by the dozen, but also gifted creators of true works of art.

Translated from O. B., "Fotografía artistica," *Corriere della sera*, May 13–14, 1902, p. 130, from the text reproduced in *Torino 1902: Polemiche in Italia sull'Arte Nuova,* ed. Francesca R. Fratini (Turin, 1971), pp. 293–94.

1. The name of Cavalier Sambuy is mentioned especially in connection with international photographic exhibitions of the time in numerous photographic journals.

2. As Stieglitz's name has been misspelled here, this name may also be in error. The reference might be to Stieglitz's fellow American photographer and associate editor of *Camera Notes,* Joseph T. Keiley, or to Keighley, the English photographer.

3. K. Tamamura, a late-nineteenth-century Japanese art and fashion photographer who in the 1890s specialized in hand-tinted views of Japan and its people. See Jed Perl, "Japan: Photographs, 1854–1905," *Art in America* 68 (Feb. 1980):35–37; and Clark Worswick, ed., *Japan: Photographs, 1854–1905* (New York, 1979), p. 124.

4. Isshin Ogawa, also referred to as K., or Kazuma, or Kazunao Ogawa, was the most successful society photographer in the decade 1880–90, and was known for his art and fashion photographs in the collotype process. Perl (cited above, n. 3) reports that Ogawa came to the United States in 1883 for eighteen months. He published a great deal and seemed to have served the same patriarchal role in his country that Stieglitz played in the United States. See also Worswick (cited above, n. 3), p. 136.

5. In "A Century of Japanese Photography," organized by the Japan Photographers Association (New York, 1980), lacquer-and-gold covers of Meiji-dynasty (1868–1912) photographic albums are mentioned, which contained tinted prints of famous scenes and beauties. As fashion photographers, Ogawa or Tamamura may have been credited with inventing such album-cover decorations; it is unlikely that such a technique would have been used on the prints themselves.

PART TWO

State-Sponsored Fine Arts Exhibitions

France was the first nation officially to sponsor an exhibition of the fine arts when, in 1633, the royal household organized a display of paintings, sculpture, architectural work, and engravings executed by the members of the Académie Royale de Peinture et de Sculpture to familiarize the court with its work. Its purpose was to display works that exemplified the aesthetic criteria required for executing pictures, statues, and ornaments suitable for glorifying the monarch as a symbol of the state. As Louis XIV later declared, "L'état, c'est moi!," and the Academy's responsibility was to ensure that the techniques employed and the types represented were worthy of proving that claim. The shows were held annually for the king to review and, beginning in 1725, were displayed in the Galerie d'Apollon and the Salon Carré in the Louvre. From the name of the latter, they came to be known simply as "the Salon," and for the next two hundred years that word was synonymous with exhibitions of art approved by the state and controlled by its Academy. It was not until 1791 that the Academy's hold on the Salon was broken when the French Revolutionary Assembly officially decreed that "all artists, French or foreign, whether members of the Academy or not, will be admitted to exhibit their work on an equal basis in that part of the Louvre assigned for the purpose."

From its inception, the Salon was the steppingstone for French artists to lucrative state commissions and awards and for foreign artists to recognition and patronage. For that reason, through the Salon the Academy came to dictate "taste" in art throughout Europe. As other nations aped the French model and founded their own academies, held exhibitions to foster and maintain uniform standards of taste, and provide acceptable conventions for the representation of state figures and national historic events, the standard required for admission by the Salon jury was adopted by other academies as well and thus set the rules for correct technique and style on the entire continent.

The conception of the fine arts that the academies had established began to

change when the London exhibition of 1851 placed sculpture with raw materials, machinery, mechanical inventions, and manufactures, and except for the preparation of colors by mechanical means, excluded painting altogether as a medium not capable of improvement. Until then the sister arts of painting and sculpture had been inseparable. By splitting them apart and regarding sculpture as an "industrial art," the London exposition provided the precedent for showing works of art that involved mechanical processes and paved the way for the establishment of the decorative arts as a legitimate artistic category worthy of serious consideration.[1]

After the revolution of 1848, the Salon was no longer held in the Louvre, and it did not have a permanent location until after the exhibition of 1855. When the nations of the world were invited by Napoleon III to send their agricultural, industrial, and art products to Paris for a second universal exposition, the objects exhibited under the fine arts classification were placed in a temporary building beside the Seine embankment, but the permanent Palais de l'Industrie, that "crystal palace hidden in an envelope of stone" designed by Viel and Desjardins for the agricultural and industrial section, was made available for the Salon in 1857. After that time, whenever there was a universal exposition in Paris, the Salon was held within the scope of the exposition, but it was always kept as an event distinct from the expositions' fine arts section.

In contrast to the regular Paris Salons, where artists competed without regard for nationality before a French jury, the regulations for the universal exposition required that the works be chosen by each country's jury and that those chosen and sent be exhibited together by country just as industrial and agricultural products were displayed. In that way they could then easily be judged by the international jury as a single nation's team effort in the academically established classes of painting, sculpture, architecture, and engraving.

At least at first the procedures established for the fine arts exhibits at the universal expositions had no direct effect on the regularly scheduled Salons in Paris, but in the course of the century the social and industrial developments that they represented had their effect on the established official art that the academies perpetuated. In 1863 the emperor Napoleon III responded to protests over the enormous number of works rejected by the jury by instructing Count Nieuwerkerke, the Minister of Fine Arts, to hang all rejected work that was not withdrawn by its artist at the southern end of the Palais de l'Industrie. Thus two Salons were instituted, only one of which represented official taste. Both were managed by the state, however, and both were hung in the Palais de l'Industrie, one at either end, with the sculpture placed below them in a simulated garden on ground level. In 1874 a group of these Refusés turned their backs on the Salon altogether and exhibited their work in the rooms of the popular photographer Nadar at 35 boulevard des Capucines. They were given the name "Impressionists" by the art critic of the satirical *Le Charivari*, Louis Leroy.

In the same year the Third Republic assigned responsibility for the Salons to a

1. Holt, *Triumph of Art*, pp. 233, 323.

Conseil Supérieur des Beaux-Arts, a group similar to the seventeenth-century academicians. In 1878 the government followed this council's suggestion and assigned the management of the annual Salon to a committee of the Société des Artistes Français. The 1881 Salon was managed by that group. In the spring of 1881 an even more significant change in the relation of government to Salon was made, which was to take effect in 1882. The council would in the future leave all the arrangements, organization, and management of the yearly Salon to the artists themselves. The Ministry of Fine Arts would lend the Palais de l'Industrie and provide a subsidy of 16,000 francs every year for the expense of management. The jury would be composed of seventy-two members elected by those artists in the five traditional categories whose work had been admitted in the past. The conditions of admission, classification, and arrangement of the works of art would be decided by a general meeting of the Société's jury as a whole. In addition to the annual Salon, an exhibition would be held every four years, the entire direction of which would be assumed by the state. "The new scheme seems likely to give satisfaction to the artists, whose interests are thus in their own hands, while the state exhibition held every four years will afford the means to judge of the advancement of art during each quadrennial period."[2] In 1883 the society was constituted by decree as "an establishment of public utility," with power to regulate the annual Salons.

After 1890, a group split off from the society and, calling itself the Société Nationale des Artistes des Beaux-Arts, organized a competing Salon. For several years there were again two Salons: the "Old Salon," juried by the Société des Artistes Français, was on view at the Palais de l'Industrie on the Champs Elysées; the "New Salon," arranged by the Société Nationale, was displayed in the Palais des Beaux-Arts designed by Jean Formigé and built on the Champ-de-Mars for the universal exposition of 1889. When these two Salons were joined together at the 1900 universal exposition after the demolition of the Palais de l'Industrie in 1898, it spelled the end of the Salon as the synonym for all that was officially acceptable in the world of art.

Elsewhere in Europe fine arts exhibitions also remained, until the 1880s, adjuncts of the established state academies of painting and sculpture, under the control of their professors and of artists who had been trained in, and remained loyal to, the academic curriculum. The only exception was England, where the academy was from its inception a private organization. For that reason, English art was apt to be an anomaly on the international art scene. On the one hand, because it was beholden to the semiofficial, semiprivate Royal Academy, it was inclined to reflect the taste of the establishment, but because, on the other hand, it had no official state apparatus behind it, the Royal Academy could not count on government support or subsidy in sending representation to international exhibitions.

The Royal Academy was founded in 1768 when the Incorporated Society of

2. "Art Notes," *Magazine of Art,* 1881, p. xv.

Artists of Great Britain applied for and was granted a royal authorization to exhibit works of art. King George III took the society under his protection, and it was renamed the Royal Academy of Arts in London for the Purpose of Cultivating and Improving the Arts of Painting, Sculpture, and Architecture. The royal authorization is still renewed annually. Its Instrument of Foundation consisted of rules for the management of its school and a list of the forty charter academicians.

Although it had "Royal" in its name and always enjoyed royal patronage, it managed to avoid direct governmental control. In its school, instruction was free, and except for a brief period of royal subvention professors were therefore unpaid. Revenues sufficient to finance running expenses and its artists' pension fund had to be obtained from the sale of the catalogue and tickets of admission to its annual exhibitions, which thereby represented the business proposition central to the Academy's survival and political independence. These exhibitions, opened each May by the king, showed "artists of distinguished merit" chosen by the selection committee and were the social event of the season. At first the king also provided rooms for the school and for the annual exhibition in Somerset House, but by 1780, admission and catalogue sales were sufficient to finance the exhibition, the costs of running the school, and the pension fund. When the National Gallery was built by the government in 1836, the Academy received an allotment of free space there, but in 1859, again using its own funds, it built Burlington House as its permanent home on a site granted by the government.

In 1805 a competing organization, the British Institution of Art, was formed by wealthy patrons and artists to support artists outside the Royal Academy's small group of forty members, twenty associates, and six associate engravers. Every winter the British Institution exhibited the work of contemporary artists, including some academicians unwilling to send their creations to the Academy's selection committee. Each summer, when the Academy show was on display, the British Institution showed Old Masters lent from private collections, until the National Gallery assumed that function in 1836. When the British Institution ceased to exist in 1867, the Royal Academy resurrected the idea, but reversed the sequence. In what came to be known as the Winter Exhibition, a loan exhibition of Old Masters and the work of recently deceased academicians were shown; in the Summer Exhibition the work of incumbent academicians and other artists was displayed.

By the end of the eighteenth century there were official academies in every country on the continent, and all of them staged exhibitions. Although the Salon in Paris continued to command the most influence and attention, all officially sponsored exhibitions were covered by the press, for the public was avid for information on what was accepted taste in art, and whatever was on view at an official show that the majority of the critics liked was thereupon accepted as "good taste" and made its creator an "acceptable" artist in the European art market. For this reason it was essential to the artists that their work be shown in them. Even works innovative in technique or subject might occasionally be admitted by a jury. Though they rarely received awards, nonconformist artists con-

tinued to submit works, hoping for some mention in the establishment press that would carry their name beyond the often ephemeral liberal or avant-garde journals to a more general audience and a more lucrative market. To this extent, then, academic exhibitions gave some modest encouragement to deviations from the current taste, even as they dictated what that taste was to be.

The art exhibitions that from 1855 continued to be held as the fine arts section within the framework of the universal expositions also served to keep the artist before the buying public and the consumer abreast of both national and international trends in the art world, and it was not long before it was realized that the fine arts section need not wait for the organization of an entire universal exposition to be held at all—it could easily be organized separately and still constitute an event distinct from the Salons and other regularly scheduled exhibitions by the national academies. Among the first to act on this realization was the kingdom of Bavaria. In cooperation with the artists' association in its capital Munich, where the Glaspalast, authorized by King Maximilian and built in 1854 for an industrial exposition, offered the only structure in the German principalities of suitable size and form to accommodate a large exhibition, it held the first government-endorsed exhibition devoted entirely to the fine arts in 1869.

Central Europe had become wealthy, thanks to the exploitation of its natural resources and the export of its agricultural products, and its prosperity had enhanced the importance of Munich and Vienna—the capitals of Bavaria and Austria-Hungary respectively—as cultural centers and markets for art. When in 1888 Wilhelm II of Prussia succeeded his father as emperor of the German Empire that had been formed following the French defeat in the Franco-Prussian war of 1870, he forced the resignation of Chancellor Bismarck and determined to extend Germany's influence worldwide and make Berlin, already the imperial capital, a cultural center as well. Munich strove equally hard to retain its position as the cultural center in the face of this competition, and as part of that effort scheduled international exhibitions of the fine arts to follow the international fine arts exhibition of 1869. Similarly Vienna sought to retain the importance it had acquired in organizing the 1873 universal exposition. Further south, Venice, a mecca for all lovers of art and freed from Austrian domination since 1870, eagerly asserted its artistic identity with the recently constituted kingdom of Italy and invited its monarchs King Umberto and Queen Margherita to inaugurate both the city's first biennial international fine arts exhibition and a national fine arts exhibition.

Thus by the end of the nineteenth century a fairly predictable schedule of fine arts exhibitions had been set for Europe. The procedure established for the fine arts exhibition at the universal exposition in Paris in 1855 continued to be used for these international exhibitions—that is, the art admitted was selected by a jury from the artist's own country, and the winning works were displayed together as a national group, but submitted to an international jury for award. The Salon, with the exception of the Salon of 1880, when the work of foreign artists was also displayed by national group, continued to be organized in the traditional art

classifications, and, whether foreign or French, to be judged by a jury of French nationals. Entries in any one of the five categories were hung together regardless of national origin.

The extent to which outside nations actually participated in the international shows that followed the Bavarian initiative varied according to the location of the exhibition, the occasion being celebrated, the subsidies the host country was willing to provide for exhibitors, and how sales commissions were handled. As both sales and admissions played a significant part in the financing of these exhibitions, it was essential for them to attract well-known artists and to encourage each nation to install a large and attractive gallery. For that reason they encouraged the participation of established artists over controversial or unknown ones because they were the most likely to have work available, to be associated with a local dealer, and to attract a paying public. Established artists were also the most likely to have contact with the state bureaucratic apparatus that supervised the art schools and to be represented on the juries of their own national exhibitions.

Just as the universal expositions raised questions about what constituted nationality, especially in architecture, so the international fine arts exhibitions raised questions about national identity as it pertained to the fine arts: What constituted nationality in painting? Was a "national" painting simply one that reflected what foreigners thought a nation ought to look like—ice scenes from Norway, canals from Holland, mountains from Switzerland? Paradoxically, such questions were being raised just when industry, commerce, and markets, combined with the exhibitions themselves, were pushing art in the direction of an international style. To keep the public, patrons, and connoisseurs informed, the established art and belles-lettres journals and the art, drama, and music critics of the daily press gave increasing coverage to art events in foreign centers and especially to the international shows. Affiliated as they were with the establishment, whose administrative apparatus facilitated the arrangements required to mount an international fine arts exhibition, the critics reflected its judgment of the developments shown by each assemblage of collected works. Together with the exhibitions themselves, they too had the ultimate effect of eroding the concept of a purely national art and replacing it with gradually accepted and uniform international notions of "taste," which were academic in both technique and subject matter. At the same time, the practice of inviting an innovative artist or group to join an exhibition did much to counteract the stagnation of art brought about by the bureaucratic apparatus needed to stage such exhibitions, which had at its service the schools and academies controlled by the government, art associations with close governmental affiliations, and the press.

Although on the surface the art world was apparently secure and organized by the late nineteenth century, and its aesthetic notions of technique and taste firmly entrenched through this apparatus of officially sponsored academies, institutions, and exhibitions, in fact the system was breaking apart through pressures from nonconformist artists and organizations. By the late 1880s many

processes and techniques used in the production of sculpture, painting, graphic art, and architecture since the sixteenth century had been replaced by newly invented technology and machines. The architect had a variety of new materials and devices supplied by the engineer and the metallurgist. The painter no longer ground his colors, and he grouped them using the chromatic studies of the physicist. The artist joined the psychologist in his probing and interpreting of man's inner world; the sculptor no longer carved or cast his own statues; the graphic artist used power presses, photographs replaced sketches, and the photographer joined the ranks of the artists, as did the makers of furniture, jewelry, ceramics, glass, and other decorative objets d'art.

By the 1890s official support had been divided in France, as manifested by the two Salons, and in both Austria and Germany it was challenged by vigorous artists' associations. Groups of artists, musicians, and writers using unorthodox idioms and techniques had turned their backs on the establishment exhibitions and had begun to arrange their own exhibition facilities, either in special buildings, such as those in Berlin, Munich, Vienna, and Milan, or in the gallery of an art dealer, or even in the editorial offices of a journal. Explanatory promotional journals were financed by the dissidents to supplement or correct any coverage the group might receive in the establishment press. The academy's authority was challenged, and the old structure of the world of art and letters was crumbling. In 1886 the literary and art community in Paris had been challenged by a manifesto by Jean Moréas, a spokesman for the Symbolists, followers of the poet Stephen Mallarmé, who were to be found in groups with names like Hydropaths, Hirsutes, Chat Noir, and Zutist. The writer Paul Bourget described for the outsider the reality that went on within the individual. At the same time, Charles Henry, a French scientific aestheticist, collaborated with the painter Georges Seurat to establish a version of reality by observing the rules he had formulated to achieve a balance in color analogous to those which established harmony in music.

As the number of independent artists' groups increased, so did the number of exhibitions, for artists still had to be shown to gain access to the market. In 1887, 64 exhibitions were held in Paris alone, sponsored by a variety of artists' organizations, 27 in London, and numerous others in Berlin, Vienna, and other European centers. They were reviewed by the national press, but unlike the establishment shows, they generally received brief and cursory foreign coverage.

In the course of the nineteenth century, the academies, which had started as institutions for enhancing—through officially recognized symbols and styles—the king and the church as the embodiments of the state and of moral values had become simply a means of providing the citizenry with images that it could associate with popular notions of national glory and the critical notions of acceptable taste. By the end of the century, the combination of an increasingly prosperous bourgeoisie, a self-conscious nationalism, and growing secularism, and the corresponding decline in the authority of church and monarchy had undermined the authority of official art and led to opposition movements that splintered all the arts in ways that would become increasingly apparent in the years to follow.

1875: London

In no criticism was the tendency to fit art into the critic's own view of life more evident than in the writings of John Ruskin. His "Notes on Some of the Principal Pictures Exhibited in the Rooms of the Royal Academy and the Society of Painters in Water-Colors" and his notes on the annual exhibitions from 1855 to 1859 and in 1875, which he published at his own expense and sold to the public for a shilling, ran through several editions. They differed in some respects from art criticism elsewhere, however, in large measure reflecting the relatively loose relationship in Britain between the government and the Royal Academy compared to what prevailed on the Continent. In England, by midcentury, many different voluntary societies and associations were playing their important roles in shaping public attitudes, so it was natural that an Englishman like Ruskin would be convinced that he could reform those attitudes of his society toward the arts and their place in English life, especially as he had the means to finance the social programs he was confident would accomplish that goal.

When Ruskin began his *Academy Notes* in 1855, he selected at random works from the several general classifications in the exhibition to illustrate the statements he had earlier made in his books. The first volume of *Modern Painters,* written in 1843 when he was twenty-four years old, included a defense of J. M. W. Turner based on an explanation of the artist's technique. Other volumes followed in 1846, in 1856 (when he endorsed the Pre-Raphaelite painters' "adherence to the simplicity of nature" as practiced by Italian and Northern painters before the sixteenth century), and in 1860. At the same time, Ruskin expanded on the ideas he set down in *The Seven Lamps of Architecture* (1849) and in the early volumes of *Modern Painters* in the three volumes he entitled *The Stones of Venice* (1851–53). In them he sought to demonstrate that ethical and moral qualities in builders and workmen were essential to excellence in architecture. He insisted that art in all its forms was a product of society and therefore reflected its moral character: "Every principle of painting which I have stated is traced to some vital or spiritual fact." In his mind, architecture expressed a people's morality, national aspirations, and social habits, and his ideas and observations were somewhat haphazardly injected into this underlying theme. That theme also led Ruskin to put great emphasis on the critic's role as arbiter and judge of the fitness of work, in strong contrast to the "art for art's sake" espoused by contemporary French writers.

Both Ruskin and the French critics agreed, however, that the artist had a right to freedom of expression, though only insofar as his work was a result of communion with nature's forms.

Taught in his own upbringing that "even the most instinctive inclinations . . . are governable" and that "it is a kind of duty to direct them rightly," and firmly persuaded that he knew the right and wrong ways of liking, Ruskin early saw it as his duty to defend the Pre-Raphaelite Brotherhood painters at the 1850 Academy exhibition by showing that they, just as the artists of the fifteenth century, had experienced a direct, mystical communion with nature. In 1855 he began his first *Academy Notes* with the remark that twenty years of studying the principles of art had given him the right to speak on the subject, but that he would limit himself "to pointing out simple facts with respect to each picture, leaving to the reader the power of verifying such statements for himself. No criticism is of any value which does not enable the spectator, in his own person, to understand, or to detect, the alleged merit or unworthiness of the picture; and the true work of a critic is not to make his hearer believe him, but to agree with him."[1]

Ruskin had a superb command of language, and he addressed his readers with the same directness and assurance that a teacher or preacher would show toward his class or congregation. His artistic sensibility—he was himself a fine draftsman and graphic artist—saved him from pedantry; he had discarded the "rules" of drawing for the principle of love: "If [a thing] be not drawn for love of it, it will never be right, and if it be drawn for love of it, it will never be wrong, love's misrepresentation being truer than the most mathematical presentation."[2]

Ruskin's claim that the source of artistic expression was "the mystic communion with nature," and not the application of prescribed rules, encouraged artists to break loose from the shackles of tradition, especially between 1850 and 1860, when the aphorisms on art and nature scattered throughout his essays and books were turned into slogans and mottoes. After 1860 Ruskin's calculated, if quixotic, career teaching drawing in workingmen's colleges, his public lectures, and his financial support to any enterprise that would bring art to the masses and educate everyone to its social and moral value fired reformers both in England and on the continent.

By the time Ruskin wrote the *Notes* for the Royal Academy in 1875, his influence on artists and the public was widespread; it would continue unabated for the remainder of the century. It was decisive in the transitional period of the later nineteenth century when his persistent defense and fervent support of the arts and their role in the life of the masses did much to encourage, within romanticism, a direction in favor of beauty of color and of line and away from the rigid formulas of classicism and historicism. The Austrian art historian Richard

1. Quoted from John Ruskin, *Notes on Some Principal Pictures Exhibited in the Rooms of the Royal Academy, 1855,* "Preface," E. T. Cook and A. Wedderburn, eds., *The Works of John Ruskin* (New York, 1904), vol. 14, *Academy Notes 1855–1888,* p. 5.

2. John Ruskin, *Modern Painters,* vol. 4 (London, 1860), pt. 4, chap. 6; *Stones of Venice,* vol. 3 (London, 1853), sec. 2.

Muther closed his obituary of Ruskin with the sentence: "Among those who had opened the way into the art world for the worker, Ruskin would be named first."[3] Marcel Proust wrote,

> The work of Ruskin is universal. He searched for truth, he found beauty even in chronological charts and in the laws of society. . . . He will have been one of those geniuses whom even those of us who received at our birth the gift of the fairies need in order to be initiated into the knowledge and the love of a new aspect of Beauty. . . . Dead, he continues to give us light like those dead stars whose light is still streaming toward us. It can be said of him what he said of Turner at his death: "It is through these eyes forever closed in the depths of the tomb that generations yet unborn will see nature."[4]

Notes on Some of the Principal Pictures Exhibited in the Rooms of the Royal Academy, 1875

JOHN RUSKIN

Preface It is now just twenty years since I wrote the first number of the *Notes,* and fifteen since they were discontinued. I have no intention of renewing the series, unless occasionally, should accident detain me in London during the spring. But this year, for many reasons, it seemed to me imperatively proper to say as much as is here said.

And that the temper of the saying may not, so far as I can prevent it, be mistaken, I will venture to ask my reader to hear, and trust that he will believe, thus much concerning myself. Among various minor, but collectively sufficient, reasons for the cessation of these *Notes,* one of the chief was the exclamation of a young artist, moving in good society,—authentically, I doubt not, reported to me,— "D—— the fellow! why doesn't he back his friends?" The general want in the English mind of any abstract conception of justice, and the substitution for it of the idea of fidelity to a party, as the first virtue of public action, had never struck me so vividly before; and thenceforward it seemed to me useless, so far as artists were concerned, to continue criticism which they would esteem dishonourable unless it was false.

But fortune has so sternly reversed her wheel during these recent years, that I

3. Richard Muther, "Ruskin: January 1900," in *Aufsätze über bildende Kunst* (Berlin, 1914) 2:116–24.

4. Marcel Proust, "John Ruskin," *Gazette des Beaux-Arts,* April 1900, p. 310; idem, August 1900, pp. 145–46. In 1889 Proust became discouraged with the progress of his novel *À la recherche du temps perdu* and, setting it aside, took up a study of Ruskin which occupied him for four years. He was in the midst of translating Ruskin's *Bible of Amiens* when news of Ruskin's death arrived. See Philip Kolb, *Marcel Proust: Correspondance,* vol. 2, 1896–1901 (Paris, 1976), pp. x, 387ff.; Proust's enthusiasm for Ruskin's work was inspired in part by Robert de la Sizeranne's two books, *Ruskin et la religion de la beauté* (1897) and *La peinture anglaise contemporaine* (Paris, 1895).

am more likely now to be accused of malice than of equity; and I am therefore at the pains to beg the honest reader to believe that, having perhaps as much pleasure as other people both in backing my friends and fronting my enemies, I have never used, and shall never use, my power of criticism to such end; but that I write now, and have always written, so far as I am able, what may show that there is a fixed criterion of separation between right art and wrong; that no opinion, no time, and no circumstances can ever in one jot change this relation of their Good and Evil; and that it would be pleasant for the British public to recognize the one, and wise in them to eschew the other.

Herne Hill, *May 23rd*, 1875

Notes, Etc. Before looking at any single picture, let us understand the scope and character of the Exhibition as a whole. The Royal Academy of England, in its annual publication, is now nothing more than a large coloured *Illustrated Times* folded in saloons,—the splendidest May number of the "Graphic," shall we call it? That is to say, it is a certain quantity of pleasant, but imperfect, "illustration" of passing events mixed with as much gossip of the past, and tattle of the future, as may be probably agreeable to a populace supremely ignorant of the one, and reckless of the other.

Supremely ignorant, I say;—ignorant, that is, on the lofty ground of their supremacy in useless knowledge. . . .

And I am conscious of, and deeply regret, the inevitable warp which my own lately exclusive training under the elder schools gives to my estimate of this current art of the day; and submissively bear the blame due to my sullen refusal of what good is offered me in the railroad station, because I cannot find in it what I found in the Ducal Palace. And I may be permitted to say this much, in the outset, in apology for myself, that I determined on writing this number of *Academy Notes* simply because I was so much delighted with Mr. Leslie's School, Mr. Leighton's Little Fatima, Mr. Hook's Hearts of Oak, and Mr. Couldery's Kittens, that I thought I should be able to write an entirely good-humoured, and therefore, in all likelihood, practically useful, sketch of the socially pleasant qualities of modern English painting, which were not enough acknowledged in my former essays.

As I set myself to the work, and examined more important pictures, my humor changed, though, much against my will. Not more reluctantly the son of Beor [cf. Num. 24] found his utterances become benedictory, than I mine—the reverse. But the need of speaking, if not the service (for too often we can help least where need is most), is assuredly greater than if I could have spoken smooth things without ruffling anywhere the calm of praise.

Popular or classic, temporary or eternal, all good art is more or less didactic. My artist adversaries rage at me for saying so; but the gayest of them cannot help being momentarily grave, nor the emptiest-headed occasionally instructive: and whatever work any of them do that is indeed honourable to themselves, is also intellectually helpful, no less than entertaining, to others. And it will be the surest way of estimating the intrinsic value of the art of this year, if we proceed to

examine it in the several provinces which its didactic functions occupy; and collect the sum of its teaching on the subjects—which will, I think, sufficiently embrace its efforts in every kind—of Theology, History, Biography, Natural History, Landscape, and as the end of all, Policy.

218. *Rachel and her Flock. (F. Goodall, R.A.)* This is one of the pictures which, with such others as Holman Hunt's Scapegoat, Millais's Dove Returning to the Ark, etc., the public owe primarily to the leading genius of Dante Rossetti, the founder, and for some years the vital force, of the Pre-Raphaelite school. He was the first assertor in painting, as I believe I was myself in art literature (Goldsmith and Molière having given the first general statements of it), of the great distinctive principle of that school—that things should be painted as they probably did look and happen, and not as, by rules of art developed under Raphael, Correggio, and Michael Angelo, they might be supposed gracefully, deliciously, or sublimely to have happened.

The adoption of this principle by good and great men produces the grandest art possible in the world; the adoption of it by vile and foolish men, very vile and foolish art; yet not so entirely nugatory as imitations of Raphael or Correggio would be by persons of the same calibre. An intermediate and large class of pictures have been produced by painters of average powers; mostly of considerable value, but which fall again into two classes, according to the belief of the artists in the truth, and understanding of the dignity of the subjects they endeavour to illustrate, or their opposite degree of incredulity, and materialistic vulgarism of interpretation.

The picture before us belongs to the higher class, but is not a fine example of it. We cannot tell from it whether Mr. Goodall believes Rachel to have wept over Ramah from her throne in heaven; but at least we gather from it some suggestion of what she must have looked like when she was no more than a Syrian shepherdess.

That she was a very beautiful shepherdess, so that her lover thought years of waiting but as days, for the love he bore to her, Mr. Goodall has scarcely succeeded in representing. And on the whole he would have measured his powers more reasonably in contenting himself with painting a Yorkshire shepherdess instead of a Syrian one. Like everybody except myself, he has been in the East. If that is the appearance of the new moon in the East, I am well enough content to guide, and guile, the lunacies of my declining years by the light of the old Western one.

Natural History There ought to be a separate room in our Academy for the exhibition of the magnificent work in scientific drawing and engraving, done, at present, almost without public notice, for the illustrations of great European works on Palaeontology, Zoology, and Botany. The feeling, on the part of our artists, that an idle landscape sketch, or a clever caricature, may be admitted into their rooms as "artistic"; and that work which the entire energy of early life must

be given to learn, and of late life to execute, is to be excluded, merely because it is thoroughly true and useful, is I hope likely to yield, some day, to the scientific enthusiasm which has prevailed often where it should have been resisted, and may surely therefore conquer, in time, where it has honourable claims.

There is nothing of the kind, however, to be seen here hitherto; but I may direct attention under this head, rather than that of landscape, to the exquisite skill of delineation with which Mr. Cooke has finished the group of palm trees in his wonderful study of sunset at Denderah (443). The sacrifice of colour in shadow for the sake of brilliancy in light, essentially a principle of Holland as opposed to Venice, is in great degree redeemed in this picture by the extreme care with which the relations of light are observed on the terms conceded: but surely, from so low sunset, the eastern slopes of the mountains on the left could not have been reached by so many rays?

To this division of our subject also must be referred Mr. Brett's Spires and Steeples of the Channel Islands, but with less praise; for since the days when I first endeavoured to direct the attention of a careless public to his conscientious painting of the Stonebreaker and Woodcutter, he has gained nothing—rather, I fear, lost, in subtlety of execution, and necessitates the decline of his future power by persistently covering too large canvas. There is no occasion that a geological study should also be a geological map; and even his earlier picture, which I am honoured in possessing, of the Val d'Aosta, would have been more precious to me if it had been only of half the Val d'Aosta.

The extreme distance here, however, beyond the promontory, is without any question the best bit of sea and atmosphere in the rooms. The paint on the water surface in the bay is too loaded, but laid with extreme science in alternations of colour.

At a still lower level, though deserving some position in the Natural History class for its essential, though rude, and apparently motiveless, veracity, must be placed 'The Fringe of the Moor' [by J. E. Millais].

But why one should paint the fringe of the moor, rather than the breadth of it, merely for the privilege of carrying an ugly wooden fence all across the foreground, I must leave modern sentimentalists and naturalists to explain. Vestiges of the painter's former power of seeing true colour remain in the iridescent distance, but now only disgrace the gentle hillsides with their coarseness of harlequinade; and the daubed sky—daubed without patience even to give unity of direction to the bristle marks—seems to have been wrought in obtrusive directness of insult to every master, principle, and feeling, reverenced or experienced, in the schools of noble art, from its nativity to this hour.

And, closing the equivocal group of works in which Naturalism prevails unjustly over art, I am obliged to rank Mr. Leighton's interesting study of man in his Oriental function of scarecrow (symmetrically antithetic to his British one of game-preserver) [*Eastern Slinger Scaring Birds in the Harvest-Time: Moonrise*], (398). It is, I do not doubt, anatomically correct; and, with the addition of the corn, the poppies, and the moon, becomes semi-artistic, so that I feel much

compunction in depressing it into the Natural History class; and the more, because it partly forfeits its claim even to such position, but obscuring in twilight its really valuable delineation of the body, and disturbing our minds, in the process of scientific investigation, by sensational effects of after-glow, and lunar effulgence, which are disadvantageous, not to the scientific observer only, but to less learned spectators. For when simple and superstitious persons like myself, greatly susceptible to the influence of low stage-lamps and pink sidelights, first catch sight of the striding figure from the other side of the room, and take it, perhaps, for the angel with his right foot on the sea and his left foot on the earth, swearing there shall be Time no longer [Rev. 10:5–6]; or for Achilles alighting from one of his lance-cast-long leaps of the shore of Scamander [*Iliad* 21. 251]; and find, on near approach, that all this grand straddling, and turning down of the gas, mean, practically, only a lad shying stones at sparrows, we are but too likely to pass on petulantly, without taking note of what is really interesting in this Eastern custom and skill— skill which I would recommend with all my heart to the imitation of the British game-preserver aforesaid, when the glorious end of Preservation is to be accomplished in Battue. Good slinging would involve more healthy and graceful muscular action than even the finest shooting; and might, if we fully followed the Eastern example, be most usefully practised in other periods of the year, and districts of England, than those now consecrated to the sports of our aristocracy. I cannot imagine a more edifying spectacle than a British landlord in the middle of his farmer's cornfield, occupied in this entirely patriotic method of Protection.

The remainder of the pictures which I have to notice as belonging to the domain of Natural History, are of indubitable, though unpretending, merit. They represent indeed pure Zoology in its highest function of Animal Biography, which scientific persons will one day find requires much more learned investigation of its laws than the Thanatography which is at present their exclusive occupation and entertainment. [. . .]

Landscape The distinction between Natural-Historic painting of scenery and true Landscape, is that the one represents objects as a Government Surveyor does, for the sake of a good account of the things themselves, without emotion, or definite purpose of expression. Landscape painting shows the relation between Nature and man; and, in fine work, a particular tone of thought in the painter's mind respecting what he represents.

I endeavoured, thirty years ago, in *Modern Painters*, to explain this difference briefly by saying that, in Natural History painting, the artist was only the spectator's horse; but, in Landscape painting, his friend.

The worst of such friendliness, however, is that a conceited painter may at last leave Nature out of the question altogether, and talk of himself only; and then there is nothing for it but to go back to the Government Surveyor. Mr. Brett, in his coast scene above noticed [*Spires and Steeples of the Channel Islands*], gives us things, without thoughts; and the fuliginous moralists above noticed, thoughts— such as they are—without things: by all means let us rather have the geographical synopsis.

265. *[The Deserted Garden by J. E. Millais]* [. . .] Little thought I, when I wrote the first line of *Modern Painters*, that a day would come when I should have to say of a modern picture what I must say of this. When I began my book, Wilkie was yet living; and though spoiled by his Spanish ambition, the master's hand was yet unpalsied, nor had lost its skill of practice in its pride. Turner was in his main colour-strength, and the dark room of the Academy had, every year, its four or five painted windows, bright as the jewel casements of Aladdin's palace, and soft as a kingfisher's wings. Mulready was at the crowning summit of his laborious skill; and the "Burchell and Sophia in the Hayfield," and the "Choosing of the Wedding Dress," remain in my mind as standards of English effort in rivalship with the best masters of Holland. Constable's clumsy hand was honest, and his flickering sunshine fair. Stanfield, sea-bred, knew what a ship was, and loved it; knew what rocks and waves were, and wrought out their strength and sway with steadiest will. David Roberts, though utterly destitute of imagination, and incapable of colour, was at least a practised draughtsman in his own field of architectural decoration; loved his Burgos or Seville cathedral fronts as a woman loves lace; and drew the details of Egyptian hieroglyphs with dutiful patience, not to show his own skill, but to keep witness of the antiquity he had the wisdom to reverence; while, not a hundred yards from the Academy portico, in the room of the Old Water-Colour, Lewis was doing work which surpassed, in execution, everything extant since Carpaccio; and Copley, Fielding, Robson, Cox, and Prout were every one of them, according to their strength, doing true things with loving minds.

The like of these last-named men, in simplicity and tenderness of natural feeling, expressing itself with disciplined (though often narrow) skill, does not, so far as I can see, now exist in the ranks of art-labourers; and even of men doing their absolute best according to their knowledge, it would be difficult to find many among the most renowned exhibitors of London and Paris;—while here, full on the line, with highest Academic name, and hailed by explosive applause from the whole nation, here is—I cannot use strength of words enough to tell you what it is, unless you will first ascertain for yourselves what it is *not*.

Get what good you can of it, or anything else in the rooms to-day; but to-morrow, or when next you mean to come to the Academy, go first for half an hour into the National Gallery, and look closely and thoroughly at the painting of the soldier's helmet and crimson plume in [Giovanni] Bellini's "Peter Martyr"; at the horse-bridle in the large, nameless Venetian picture of the Madonna and kneeling Knight; at the herbage in the foreground of Mantegna's "Madonna"; and at Titian's columbines and vine in the "Bacchus and Ariadne." All these are examples of true painter's work in minor detail; unsurpassable, but not, by patience and modesty, inimitable. There was once a day when the painter of this (*soi-disant*) landscape promised to do work as good. If, coming straight from that to this, you like this best, be properly thankful for the blessings of modern science and art, and for all the good guidance of Kensington and Messrs. Agnew.[1] But if you think that the four-petalled rose, the sprinkle of hips looking like ill-drawn heather, the sun-dial looking like an ill-drawn fountain, the dirty birch tree, and the rest—whatever it is meant for—of the inarticulate brown scrabble, are not

likely to efface in the eyes of future generations the fame of Venice and Etruria, you have always the heroic consolation given you in the exclamation of the *Spectator:* "If we must choose between a Titian and a Lancashire cotton-mill, give us the cotton-mill".[2]

Literally, here you have your cotton-mill employed in its own special Art-produce. Here you have, what was once the bone and sinew of a great painter, ground and carded down into black-podded broom-twigs. That is what has come to pass upon him; that, *his* finding on his "ruinous walk" over the diabolic Tom Tiddler's ground of Manchester and Salford. Threshed under the mammon flail into threads and dust, and shoddy-fodder for fools; making manifest yet, with what ragged remnant of painter's life is in him, the results of mechanical English labour on English land. Not here the garden of the sluggard, green with rank weeds; not here the garden of the Deserted Village, overgrown with ungathered balm; not here the noble scenery of a virgin country, where the falcon floats and the wild goat plays;—but here the withering pleasance of a fallen race, who have sold their hearths for money, and their glory for a morsel of bread.

Policy We finally inquire what our British artists have to say to us on the subject of good Government, and its necessary results—what triumph they express in the British Constitution and its present achievements.

In old times all great artistic nations were pictorially talkative, chiefly, next to religion, on the subject of Government. Venice, Florence, and Siena did little else than expound, in figures and mythic types, the nature of civic dignity, statesmanly duty, and senatorial or soldierly honour; and record, year by year, the events conducive to their fame.

I have not exhaustively overlooked the Academy; but, except Miss [Elizabeth] Thompson's study of a battle fought just "sixty years since" [*The Twenty-Eighth Regiment at Quatre Bras*]—I find no English record of any important military or naval achievement; and the only exhibition of the mode in which Britannia at present rules the waves is Mr. Cooke's *Devastation* being reviewed; —somewhat sable and lugubrious as a national spectacle, dubious as a national triumph, and to myself, neither in colour nor sentiment enjoyable, as the picture of *Victorys* and *Téméraires* one used to see in days of simpler warfare. And of political achievement there seems still less consciousness or regard in the British artist; . . .

The verdict of existing British Art on existing British Policy is therefore, if I understand it rightly, that we have none; but, in the battle of life, have arrived at declaration of an universal *sauve qui peut*—or explicitly, to all men, Do as you like, and get what you can. Something other than this may, however, be gathered, it seems to me, from the two records given us of the war—so unwise, and yet so loyal—of sixty years ago.

613. La Charge des Cuirassiers Français à Waterloo *[Félix Emmanuel H. Philippoteau]* This carefully-studied and most skilful battle piece is but too likely to be

overlooked in the confused rush to Miss Thompson's more attractive composition. And of all in the Academy, this is the picture which an English man, of right feeling, would least wish to overlook. I remember no so impartial and faithful representation of an historical battle. I know no war painting by the artists of any great race, however modest, in which the object has not hitherto been definitely—self-laudation. But here is a piece of true war history, of which it is not possible to say, by observance of any traceable bias, whether a Frenchman or Englishman painted it. Such a picture is more honourable to France than the taking of the Malakoff. . . . Of course, all that need be said of it, on this side, must have been said twenty times over in the journals; and it remains only for me to make my tardy genuflexion, on the trampled corn, before this Pallas of Pall Mall, and to murmur my poor words of warning to her, that she remember in her day of triumph how it came to pass that Atalanta[3] was stayed, and Camilla slain.

Camilla-like the work is—chiefly in its refinement, a quality I had not in the least expected, for the cleverest women almost always show their weakness in endeavors to be dashing. But actually, here, what I suppose few people would think of looking at, the sky is the most tenderly painted, and with the truest outlines of cloud, of all in the exhibition; and the terrific piece of gallant wrath and ruin on the extreme right, where the cuirassier is catching round the neck of his horse as he falls, and the convulsed fallen horse just seen through the smoke below, is wrought, through all the truth of its frantic passion, with gradations of colour and shade which I have not seen the like of since Turner's death.

I place there two paintings under the head of "Policy" because it seems to me that, especially before the *Quatre Bras*, one might wisely consider with Mr. Carlyle, and with oneself, what was the "net upshot" and meaning of our modern form of the industry of war.[4] Why should these wild and well-meaning young Irish lads have been brought, at great expense, all the way to Four Arms, merely to knock equally wild and well-meaning young French lads out of their saddles into their graves; and take delight in doing so? And why should English and French squires at the head of their regiments have, practically, no other object in life than deceiving these poor boys, and an infinite mob besides of such others, to their destruction? [. . .]

From "Notes on Some of the Principal Pictures Exhibited in the Rooms of the Royal Academy, 1875," L. T. Cook and A. Wedderburn, eds., *The Works of John Ruskin*, vol. 14, *Academy Notes, 1855–1888* (London, 1904): pp. 261–310. For explanations of references in Ruskin's review, see the notes supplied there.

1. The art dealer Thomas Agnew, with his sons William and Thomas, had a gallery at 39 Bond Street.

2. The "exclamation" occurs in a review of Ruskin's Oxford lectures on art, August 6, 1870.

3. The story of Atalanta, who picked up the golden balls, was stayed in her course, and thereby won by a suitor, is mentioned by Ruskin in *Val d'Arno*, sec. 19.

4. See Thomas Carlyle's *Sartor Resartus*, bk. 2, chap. 8: "What, speaking in quite unofficial language, is the net purpose and upshot of war?"

1876: Paris

To accommodate the demand for information on events in Paris, the fashion capital of the world, Whitelaw Reid, the owner of the *New York Tribune,* first retained the services of Arsène Houssaye. Long an influential and successful figure in France, he was director of the Comédie-Française from 1849 to 1856, owner of *L'Artiste* after 1843, director of the *Revue du XIXᵉ Siècle,* and critic for many periodicals. In 1884 he became president of the influential Société des Gens de Lettres, whose "Tuesday evenings" were attended by Zola. But his arrangement with Reid did not last long. To avoid having to translate Houssaye's "Paris Letter," Reid terminated the agreement and hired in his stead Henry James, Jr., at twenty dollars in gold per "letter" beginning on October 25, 1875. The thirty-two-year-old James, who with his brother William had spent much of his childhood in Europe, was a good choice. After attending Harvard College, where his closest friend was the painter John La Farge, James had studied painting with William Morris Hunt. Finding that he lacked a painter's talent, yet having gained an insight into the limitations set by the painter's media, he turned to develop his skill as a writer. He would find a way to draw his characters, as a painter did, from a "fixed point of view," but using words and phrases instead of paint and brush. He was familiar from boyhood with the museums and exhibitions at the New York Gallery of Fine Arts, the American Art-Union, and the National Academy of Design, as well as the contemporary German and French paintings to be seen at the dealers Goupil and the Düsseldorf galleries. He had also seen examples of European contemporary sculpture at the 1853 New York City Crystal Palace World Exposition. His taste had been further molded by a European grand tour planned by Harvard University's president, Charles Eliot Norton, which began in England with letters of introduction to John Ruskin, Dante G. Rossetti, and William Morris. Then, schooled by Ruskin on how to see art, he went on to Switzerland and Italy.

James's career as an art critic began in Boston with eight reports for the *Atlantic Monthly* on the "Fine Arts in Boston" (1872); in them the romantic associational aesthetic of Ruskin is still evident. They also qualified James for the job of Paris correspondent for the *New York Tribune.* In his first letter from Paris he described the theatrical shows, a new play, and the new opera house. The first

art show he visited and which, he said, should have been announced as "The Works of M. Barye, or the plastic beauty of ferocity," demonstrated his ability to bring the reader into the presence of an art object.

The Salon of 1876 opened on May 5, the first to be managed by the Conseil Supérieur des Beaux-Arts since it had been assigned responsibility for the Salons under the Third Republic (the government continued to retain control over the Ecole des Beaux-Arts, the purchase of works for the national galleries and the Prix de Rome, the Prix du Salon, and other fine-arts awards). Before it opened James had already written about several of the artists to be on display there whose names would be familiar to *Tribune* readers. He found Meissonier's *Battle of Friedland*, already purchased by an American, "a thing of parts rather than an interesting whole . . . an idea is conspicuous by its absence in Meissonier's pictures." He was more enthusiastic about the two Delacroix paintings, *Sardanapalus*, which "indicates the dawning of a great imagination," and the *Entombment of Christ*, "the only modern religious picture I have seen that seemed to me painted in good faith," and whose roughness or sketch quality in the technique he could therefore excuse. He had found the paintings of the group of Impressionists at the dealer Durand-Ruel interesting; the Salon made him "think better than ever of all the good old rules which decree that beauty is beauty and ugliness, ugliness, and warn us off from the sophistications of satiety." He was averse to making a virtue of technique, and liked his art to have "an element of magic, of independence, of fancy," while the Impressionists made both subject and treatment a "moral" question, for they "are partisans of unadorned reality and absolute foes of arrangement, embellishment, selection . . . [and of] the artist's allowing himself . . . to be preoccupied with the idea of the beautiful." But for James a picture also had to have some relation to life.

James's reaction to the sculpture he saw in Paris was probably influenced by what others were writing at the time. He may well have been familiar with Charles Perkins' books, *Tuscan Sculptors* (1864) and *Italian Sculpture* (1868), volumes which would have prepared him for qualities of monumentality and grandeur in the Dubois statues he saw at the Salon of 1876. Lacking such schooling for contemporary sculpture, he wrote in his column dated December 6, 1875, "Every visitor to Paris has gazed at it [Carpeaux's *La Danse*, a decorative sculptural group at the Opéra] in mingled admiration and perplexity."

> . . . They are the most modern things in all sculpture. That undressed lady and gentleman who, as distinguished from the unconsciously naked heroes and heroines of Greek art, are the subjects of modern sculpture, have reached in Carpeaux's hands their most curious development. In this ferocious winter weather of Paris, behind their clear glass plates, they make the passer shiver; their poor, lean, individualized bodies are pitifully real. And to make the matter worse, they are always smiling—smiling that fixed, painful smile of hilarious statues. The smile in marble was Carpeaux's specialty. Those who have seen it have not forgotten the magnificent tipsy laugh of the figures in the dancing

group on the front of the Opéra; you seem to hear it, as you pass, above the uproar of the street.[1]

James then concluded, "If to seize and imprison in clay or marble the look of life and motion is the finest part of an artist's skill, he was a very great artist."

Six weeks after James's letters on the Salon of 1876 appeared, he requested an increase in salary. Reid instead replied with some criticism of his own. James should make his letters more "newsy," for newspaper readers like "brevity, variety, and topics of wide interest," while what he was sending in was "magazine rather than newspaper work." In response James terminated his connection with the *Tribune* and left Paris for London, where the literary quality of his writing could find a more congenial setting. His critical essays on art were soon appearing in the *Fortnightly Review* and similar magazines, where he described himself as "an honest and intelligent mediator between painters and the public," who dealt "with painters and paintings as literary critics deal with authors and books."

Art in France: The Salon of 1876

HENRY JAMES

Paris, May 5. I find no difficulty today in deciding what to write about; for chroniclers and talkers there is only one possible subject. The Salon—the 93rd in the history of the institution—opened a few days since, and all the scribblers are mending their pens. I have paid three visits to the Palais de l'Industrie (in which the exhibition is held), and I have, I believe—from my own point of view—separated the sheep from the goats, and earned the right to attempt some coherent discourse. It seems at first as if coherency in one's impressions would be slow to arrive; the first effect of so vast an array of pictures, pervaded by a high average of cleverness, is most bewildering and confounding. The Salon this year is very large; there are, exclusive of drawings and cartoons and without making mention of sculpture, 2,005 pictures. The regulation enacted during the present year, in virtue of which an artist has a right to exhibit but two works, has not had the effect of reducing the exhibition numerically; it contains upward of a hundred pictures more than that of 1875. It is, moreover, not of exceptional brilliancy; the number of works which make landmarks in its long-drawn extent is not large. It is hardly more than a fair average Salon—though it must be added that it may be only this and yet leave a lively impression of cleverness upon the Anglo-Saxon visitors.

Amid such a chaos of productions it is hard to know how to measure conflicting claims or what to speak of first. The easiest course is perhaps to let simple size take precedence, and to dismiss at once what are called the "machines" of the exhibition. Large pictures in France are usually spoken of as *de la peinture de*

1. Henry James, "Art in France: The Salon of 1875," *New York Tribune*, December 25, 1875, pp. 1–2.

style; a properly constituted Salon must have a certain number of them; they are a sort of propitiatory offering to the "high-toned" Muse. This year there are a great many such offerings, but in each of these quality and quantity are to my sense more than ever divorced. For simple brute size a colossal canvas by Gustave Doré carries off the palm—a canvas presenting to us M. Doré's "Christ's Entrance into Jerusalem." I do not see what old memories of admiration for Gustave Doré's genius in the days when he treated it with common humanity should avail to make an even very amiable critic hesitate to speak of this as a rather shameless performance. M. Doré treats his genius now as you wouldn't treat a tough and patient old cab-horse; I know of few spectacles more painful in the annals of art. Imagine a colored print from the supplement of an illustrated paper magnified a thousand-fold and made to cover almost a whole side of a great hall, and you have M. Doré's sacred picture. A vast, garish crowd is sprawling on its knees over a mass of palm-boughs, in front of a pasteboard colonnade, through one of the arches of which a figure which a school-boy might have daubed, advances on an ass. There is no color—or worse than none—no drawing, no expression, no feeling, no remotest hint of detail; nothing but an immense mechanical facility, from which every vestige of charm and imagination has departed. But it is really very naïf on my part to be so explicit. There is an immense Jeanne d'Arc by M. Montchabron, bounding over agglomerated corpses, brandishing her sword and heroically screaming; I don't know what sustained the artist through the execution of this very spacious work—it was not the force of talent. There is a great canvas representing "Harmony", for a governmental ceiling by M. Bin, full of elegant muses and foreshortened lute players; (M. Bin's picture, which is meant to be above one's head, horizontally, is hung against the wall, and the spectator in consequence is made to feel as if he, tipsily, had lost his proper standpoint—an imputation which he resents by not admiring the picture as much, perhaps, as he ought to do). There is a brilliant and elegant group from Ariosto by M. Joseph Blanc—the deliverance of Angelica from the sea-monster—the most agreeable, to my mind, of the big pictures. It is a kind of picture which leaves us cold, but it is very good of its kind—painted in a high, light tone, full of pinks and light blues and other elegant tints, but with a great deal of skill of arrangement and refinement of taste. It is the only one of the "tableaux de style" which seems to me to possess much style. Style is what M. Temarte, who paints in quite a different tone, and affects intense browns and powerful shadows, has aimed at in his "Orestes and the Furies". He has only half hit it, I think, but he has missed it with a good deal of vigor and picturesqueness.

The striking picture of the year and the one, probably, to which nineteen-twentieths of the visitors to the Salon attribute most talent, is a great subject by M. Sylvestre—a "Locusta trying the effects of poisons before Nero." As a subject the thing is detestable, inasmuch as it allows almost no chance for beauty; but as an accomplished and picturesque piece of painting of the younger, larger and richer Academic sort, combining a good deal of reality with a good deal of arrangement, it is a remarkable success. I suppose the picture is marked for the medal of

honour—or at least for the first medal in painting. Nero is seated, leaning forward, with his elbow on the back of his chair and his hand over his mouth, watching the contortions of a slave who, extended on the pavement, is expiring in agony before him. Beside him, and nearer the spectator is seated the horrible Locusta, descanting upon the properties of her dose, her face turned toward him and her arm, with a strangely familiar gesture, lying across his knee—the movement of the outstretched hand meanwhile giving point to her explanation. She is a gaunt, swarthy gypsy, half naked, and with the profile of a murderess. Nero is both listening and watching, and the grave, intent, inquisitive depravity of his dark, fat, youthful face is very cleverly rendered. The portentous familiarity, the sinister "chattiness" of this precious couple is indeed in a high degree effective. But the strong point of the picture is the figure of the victim of their interesting experiment—the slave who is writhing in a horrible spasm upon the polished marble pavement. This is a strong drawing and strong painting, and it does great honor to the young artist. The man is a magnificent fellow, in his prime, with a fair beard and a yellow head-cloth, and he stretches out his arms with an agonized movement which is at once very real and very noble. Into this figure, indeed, the painter has introduced a certain element of beauty—it has great breadth and yet much detail, great solidity and yet not a little elegance. It is, in a word, very intelligent. But there is something vulgar in the way the picture is lighted, something coarse in its tone, something in the effect it produces that falls below the talent that has been expended upon it. M. Sylvestre is not a painter who sets you dreaming about his future. The same subject has been treated by another artist, M. Aublet, with inferior, although with noticeable skill. M. Aublet gives us three or four poisoned slaves, wriggling over the pavement in different attitudes; the effect is slightly grotesque—they suggest toads hopping out after a shower. This simple jest is not heartless, inasmuch as M. Aublet's slaves do not produce a lively impression of reality. His picture is flanked on each side by an equally huge and much less clever scene of torture—one, a so-called "Diversion of a Courtesan"— a lady reclining on a gigantic couch and watching a slave bleed to death at her feet (I recommend the subject), the other "Clytemnestra and Agamemnon", reeking with blood and mediocrity. It is a charming trio, and it is a great pity it should not be seen by those critics in Berlin who affirm that French art is chiefly remarkable for its cruelty.

If M. Sylvestre's picture is the most impressive in the Salon, I have no doubt that the most popular will be the contribution of M. Detaille, the admirable military painter. It is indeed, already, of all the pictures, the most closely surrounded, and it has a good right to its honors. It is called "En Reconnaissance", and represents a battalion of chasseurs coming into a village street in which a cavalry fight has just taken place and scattered its trophies over the ground. A squad of sharpshooters is preceding the rest of the troop and advancing cautiously along the crooked, blood-stained lane. They have paused and are scanning the lay of the land in front of them—the leader checking them with a backward movement of his hand, while he listens to an urchin who has come up to speak to him—

a patriot of thirteen, in blouse and muffler, doing his boyish best to be useful, and give damaging information. This boy, with his light, small body, so well indicated beneath his thin blouse, his cold red face, his hand in his pocket, his scanty trousers, is the great success of the picture; in the gesture with which he points, eagerly and modestly, down the street there is something singularly vivid and true. On the right, in the foreground, a Prussian lancer and his horse have lately tumbled head foremost; though they are not yet cold they are pitifully and awkwardly dead. A couple of the sharpshooters are glancing down at them as they pass, with different expressions—"It served him right" in one case; "It's a bad business at best" in the other. These men are all admirably studied. On the left a gendarme, badly wounded, has collapsed against a garden wall, through the open gate of which a man, peeping out, is trying to drag him in. In the rear, through the gray snowy air, the rest of the chasseurs are coming up. The picture is remarkably perfect and complete—a page torn straight from unpublished history. The variety and vividness of the types, the expressiveness of the scene, without a touch of exaggeration or grimace, the dismal chill of the weather, the sense of possible bullets in the air, the full man-size of the little figures, the clean, consummate brilliancy of the painting, make it a work of which nothing but good is to be said.

The picture which will appeal most strongly to the inner circle of observers—those who enjoy a first-class method more than an entertaining story—is unquestionably the much noticed, the already famous "Intérieur d'Atelier" of M. Munkácsy. It divides with one other work, to my sense, the claim of being the most masterly piece of painting in the Salon. The other work is a portrait, of which I will presently speak. Meanwhile M. Munkácsy, who is a Hungarian, with a Parisian reputation already established, comes so near the absolute of solid and superb painting that it little matters how we settle the question of pre-eminence. I do not know when I have seen a piece of artistic work of any kind which struck me as having so purely masculine a quality. M. Munkácsy's painting is strong as a rich barytone voice is strong—in the same personal and closely characteristic way. Imagine the barytone voice admirably educated and master of every secret and mystery of vocalism, and the analogy is complete. M. Munkácsy belongs to the school of painters for whom a "subject" is simply any handsome object whatsoever—anything materially paintable. He does not resort to history or mythology for his themes, and it doubtless seems as absurd to him that you should have to look at a picture with one eye on a literary paragraph in a catalogue, as that you should listen to a song with one ear applied to a tube into which a spoken explanation should be injected. His subject here is simply a handsome woman in a blue velvet dress sitting in profile before an easel on which stands a small landscape, and of a man (the painter himself) lounging against a table between her and the easel. The lady is bent forward, her hands are pressed together in her lap, she is looking intently and appreciatively before her; the artist, who is in light drab garments, presents his full face, but turns it slightly askance, and eyes his work more critically. There is nothing here very new and strange, and yet the picture is admirably full and rich. It is composed in what I believe painters call an extremely

low key—it is an extraordinary harmony of the deepest tones, unrelieved by a touch of light color or by more than a gleam of highlight. And yet in spite of the sort of unctuous brown cavern of which the studio seems at first to consist, you presently perceive that there is nothing cheap or brutal in the artist's dusky accumulations of color, that everything is defined, harmonized, and made to play a part. The painting has incomparable breadth and freedom, and yet all its rich, bold brush work has been admirably wrought, and as it were melted together. There are almost no sensible lines anywhere, and yet there is no sensible evasion of line; it is rare to see a picture in which draughtsmanship is so enveloped and muffled in color. There is plenty of detail, and yet it is all detail in such warm, fluid juxtaposition that you are conscious of it only through your general impression of richness. The heads are admirable—full of solidity and relief; the only complaint to be made of them is that they are painted too much in the same tone and on the same level as the inanimate parts of the picture. A little more rosiness, a little infusion of light, would not have spoiled them. The blue velvet dress of the lady is, however, the great triumph. It is one of the most interesting pieces of frippery that I have seen in many a day, and the way it is painted is a sort of résumé of the manner of the whole picture. It is the work of a man who stands completely outside of it and its superficial appeals, and has, regarding its texture and tone, a vision, a judgment, and a conviction of his own. This second solution, as the apothecaries say, of blue velvet a trifle faded and worn, has a peculiar charm. I meant to add a word about the magnificent portrait of M. Wallon, the late Minister of Public Instruction, by M. Bastien-Lepage—the gem, to my mind, of the exhibition. But I shall be obliged, with your permission, to devote another letter to the Salon, and I defer my remarks. I shall not be sorry, on the ground of not having yet committed myself to utterance about it, to go and look at the picture again.

From Henry James, "Art in France: The Salon of 1876," *New York Tribune*, May 27, 1876. See figures 61–65.

1879: Munich

The Münchener Künstler Genossenschaft or MKG, chartered in 1861 and given the art exhibition building (Kunstausstellungsgebäude) in the Königsplatz for its exhibits, enjoyed official status. Encouraged by a subsidy from Ludwig II and in cooperation with the Akademie für bildende Kunst, it held an international fine arts exhibition in 1869, a type of show that would become increasingly common in the last quarter of the century. Although it had competition from another international show held concurrently in Brussels, for political reasons both the English and the French lent their support to the Munich one, and that ensured its success. The enterprising MKG then announced a schedule of similar shows to be held at ten-year intervals. Transportation and insurance for an entry would be paid round trip if it was accepted, one way if rejected. If an exhibited work was sold, the sponsors would take a twenty-percent commission.

Ten years later the second MKG show was held on schedule, and the French critic and novelist Edmond Duranty, who, along with Jules Castagnary, Philippe Burty, and Théodore Duret, numbered among the frequenters of the Café Guerbois, the favorite meeting place of the Impressionists, went to Munich to appraise it. In 1856, Duranty and Champfleury (Jules Fleury-Husson) had founded the important, though short-lived, journal *Réalisme* to support Courbet's innovative technique and subject matter, and since then Duranty had continued to write art criticism. He took particular note of the work of the non-French artists on display both at the Salons and at the 1878 universal exposition in Paris. Now, in one of the last criticisms he was to write, Duranty warned his French readers against indifference to what was happening in Munich. Of the 1879 international exhibition, he wrote, "There are . . . a great many very strong talents and more than one very original artist: much is being attempted seriously and with vigor."

Munich and the German Exhibition
EDMOND DURANTY

My dear director and friend: Munich is really a city of painters; it teems with art dealers and, not content with the Glaspalast[1] exhibition, the societies of artists maintain two other exhibitions, the first one under the arcades of the palace

garden [Hofgarten] and the second in the Greek temple that faces the Glyptothek, so that this city has a great deal to keep an art critic busy.

There are two Munichs, the old and the new. The old one is full of a dizzy Rococo, through which an attempt has been made to revive something of the Middle Ages; the second is a city created by erudition of intimidating scope.

I believe that one must empathize with the joys that Erudition experienced at the end of the eighteenth century and the beginning to the nineteenth when she felt that she began to see her way clearly into history and archaeology, that she understood both the meaning and the forms of antiquity, the Middle Ages and the Renaissance. Of course the times in which Erudition lived, the eighteenth and nineteenth centuries, having nothing that was archaic, therefore did not count and merited no attention. She wished to profit from her knowledge, to display to herself the riches she possessed, and she decreed that she would build a city, where, from Phidias to Michelangelo, she would recreate an example of all the things that previous ages had created. Erudition met a young prince, attractive in face and manner, an artist and a poet, bright-eyed, with a pretty moustache and small beard. It was King Ludwig. They fell in love with each other, and from their union sprang the new Munich, Greek, Pompeiian, Byzantine, Gothic, Florentine, and English, where, in front of the Athenian propylaea, the Oriental basilicas, the fourteenth-century palaces, trams and cabs go by, and kiosks for newspapers stand among other kiosks destined for less intellectual uses.

You will forgive me, won't you, for being carried away by fairy tales and allegories in this environment of symbolism, allegory, and philosophy in fresco and sculpture. [. . .]

Nowadays if one goes into the international exhibition one must recognize that this great movement [to resurrect Erudition] remained a dead letter. It has not engendered anything. Art has even found shelter in this *palace of glass,* a construction of a modern engineer building for modern needs with new materials. This is significant, even though the encounter was involuntary.

There is perhaps one painter in this exhibition [. . .] who has drenched himself in the coloring of the Piloty school, which alienates him from the tradition of 1820. That is Mr. [Anselm] Feuerbach, who has a great reputation in Germany.

There is not a trace left of any influence of the ideas and the systems of thirty years ago. The only remaining presences are the historical and coloristic school of Piloty, and realism, which encroaches on the Piloty school from every side; realism, from simple fresh landscape studies up to the boldest eccentricities and explorations possible. This is what stands out clearly from the exhibition [see fig. 66].

Kaulbach, not the 1830 Kaulbach but the 1860 one, has followed Piloty's regime of color and form. Piloty has become the king of painting in a third of Europe.

For many people Piloty and his school are realists because of the exactitude of their costumes and accessories and because they represent actual, solemn, or anecdotal events but not ideas, symbols, or theories.

North Germany is more realist than the south: but everywhere it seems clear to me that the landscape painters, without its having been noticed, have played a large part in the advance of realism.

Going out into the country, living in villages, it is they who have brought figure painters to the peasants, have made them familiar with their picturesque costumes and customs. Isolated for the most part, face to face with nature, the landscape painters obey her, trying to be truthful; returning to town, they encourage the feeling and the study of truth among the figure painters. On the other hand, the figure painters live much more in the museums and tend to borrow their coloration from the paintings they see there. Rottmann, the great landscape painter, who on one hand follows Corot in the tidiness of his notations but on the other is inspired by Turner in his enthusiasm for certain sky effects, has had more influence on the painting of his country and a more effective influence than any of the artists of the 1820 movement. Landscape painting has always seemed to me to have been sustained with some vitality in German art of the nineteenth century. Rottmann brought to it decisiveness, clarity, and direction.

Portraiture, also, has always been a great school of truth and power in painting. In 1820 it was despised; since then people have begun to believe in it again; it has been a channel by which life, vigor, harmony, and expressive feeling have flowed once more through art. In the south, the great works of M. Lenbach [see fig. 67] and of M. Canon have steered many young men toward study, and today one notices a definite élan among the portraitists.

Most of the genre painters do local paintings, and their minds pivot around the bedizened bodices of peasant girls or the variegated waistcoats of the peasants of different districts where the old costumes are preserved. The Tyrol is the place that absorbs the largest number of artists. This group has ties both to Düsseldorf, under the leadership of Knaus and Vautier, and to the Piloty school, from which it partially originated.

The realism of the frock coat, city realism, which is, on the whole, the most decisive, has fewer adherents but is already gaining ground. Pawnshops, auctions, taverns, workmen loading carts, couples at the piano, are seen here and there. This tendency comes mainly from the north. M. [Adolf] Menzel leads the way with his admirable *Factory*. M. Paul Meyerheim, whose talent has greatly grown, follows closely with his large painting of an equestrienne about to mount her horse while her children play with a dog on the steps. There is strength and freshness in this painting which reminds one of both Courbet and M. Carolus Duran.

Religious painting is a very odd case into which realism has introduced itself in a most surprising way. You will remember that just last year [1878] at the universal exposition, people were struck by the beautiful *Last Supper* of M. de Gebhard, in which Christ and his apostles were unmistakably German professors and students. You know that M. Menzel, in 1851, drew a famous lithograph of *Christ among the Doctors*, composed with modern Jewish characters in accurate attitudes. Today I see at the exhibition a sort of copy of this lithograph, only now it is a large canvas painted in the Makart manner by M. R. Zimmermann: a little

further on, in another large painting, M. Liebermann has represented the same subject with a dreadful little street urchin who is arguing with opera-glass salesmen, whose relaxed attitudes suggest they are perfectly at home—a very curious work, quite remarkable for the boldness and daring of the actual *painting,* but deliberately exaggerated to compel the public's attention. In another room, a votive painting shows a gentleman and lady in modern dress kneeling in front of the Virgin, all of them on a gold background. Elsewhere M. [Hans] Thoma, in a *Flight into Egypt,* composed in a mood of grave, meditative peacefulness, has placed a wholesome family of his friends dressed in a close approximation of their everyday clothes, reminding us on both counts of M. Cazin in Paris. I could cite still other examples of the spirit that induces the artists to take up in this way the conceptions of their fifteenth-century ancestors, when those naively mixed the common people, who were their contemporaries, with the saints, the angels, and other divine personages.

Finally, realism has made its way into fantasy and poetry. That man of strange arts named M. [Arnold] Böcklin has shown a very fantastical *Battle of the Centaurs* in which everything is completely realistic, as in a scene drawn from nature, and the Centaurs have the faces of old ragpickers. M. Trübner, who sent a *Battle of the Centaurs and the Lapiths,* follows suit. In his dreadful *Infanticide,* where the color, the atmosphere, the place, the gestures, the physiognomy, make for such a gloomy and painful general effect, M. Gabriel Max has painted a newborn child, covered with blood, with all the minute details of his deformity. M. Thoma, already mentioned, in painting the *Holy Family at Rest,* has imagined a scene of common people in the country, with their donkey, and has set it in a landscape that is a marvel of simplicity, of truth and impressiveness, and has little cherubs emerging from the water and offering them who knows what gifts.

The larger part of the exhibition consists of the Piloty school, and together with its branches, it ends by constituting fully half. Everyone in Munich, whether a direct student or a fellow artist, has been influenced by the Piloty studio. Add to them those gifted with initiative who have wanted to vary the *central* formula, not to mention the unconscious derivations that have also arisen.

These ramifications are quite numerous. There is the Makart branch, which reddens yellows, piles up fabrics and figures, seeks rich strong tones, and often becomes mixed in muddy shadows. Keller and Zimmermann are part of that branch. [. . .]

I place in a separate series but still together, although there is a good deal of difference between them—or rather, because the variations on the same original theme causes some of them to draw quite far apart from the others—Messrs. Feuerbach, Lenbach, Lindenschmidt, Gabriel Max, Leibl, Böcklin, and Trübner. M. Leibl, who formerly, like Lenbach, produced Rembrandt imitations, now devotes himself to those figures in full light of which he gave us an example at the Salon of 1878 and in which he seems to recall the German, Flemish, and French schools of the sixteenth century. He has also sent some wonderful drawings. He will become an overwhelming painter. M. Lindenschmidt has a charming sketch

that is reminiscent of Bonington; like M. Lenbach, he used to make Rembrandt-like or Correggio-like attempts that resembled those of Ricard. Lenbach exhibits portraits of von Moltke, of Bismarck, and heads of children, in that manner of masterly coloring—subtle, singular, and sometimes disagreeable—and with that sharp, penetrating, *searching* drawing, which gives such an accent to his work. M. Feuerbach, M. Max, M. Trübner put chocolate into their browns, and they have a heavy pasty tone in their ochers and umbers, a fault that is nearly universal in German painting. M. Böcklin also shows this heaviness. Apart from this, each goes his own way. The *Battle of Titans,* a huge ceiling by M. Feuerbach, and his dark, sculptural *Medea* show strength and spaciousness, but one feels the tension, the heaviness, the lack of spontaneity. The *Romeo and Juliet* of M. Trübner has lovely tones and also that indescribable heaviness. This artist has painted a fine portrait of a man with a luminous face and lively tonality, very frank and lifelike. M. Max is less of a *painter* than either of the preceding. Sometimes he is also closer to the straight Piloty formula, with highlights of a dull, yellowish white, but a lofty feeling of tenderness or sadness dominates his work and stamps it with a moving unity. As for Böcklin, he is further from the Piloty method: his powerful spirit, his deep-toned harmony, which makes one think of a tremendous bass-baritone, his strokes of thick, unpolished light through the strong, dark tones, seem to me to derive from the *Saint Andrew* of Ribera, which can be seen in the Alte Pinakothek. At first sight M. Thoma follows quite another impulse than Böcklin; he is completely original, and his paintings are perhaps the ones that stand out the most in the whole exhibition; he is set apart by his supple scale of grays, blues, and greens, so soft, so self-contained, so steady, with such a definite harmony: by his spirits, by peaceful, grave, naive sentiment. Fantastic conceptions, a dreamy poetry—expressed with entire truthfulness—subtle brushstrokes, infinite delicacy, as in his *Clouds,* all consisting of a flight of small sprites, at once precise and airy, floating over crags of a vigorous greenish black, and as though lifted by the wings of a great eagle of intense execution: all these prompt me to rediscover in him a musical inspiration for his painting, analogous to that which animates Böcklin. They are symphonic painters. [. . .]

Imitating the old Dutchmen is quite obvious in many of the painters, for instance, in the landscapes of M. Fedderson, M. Her, M. Hertel, M. Kubinzky, M. Neubert, in M. Tubbecke's *Skaters* in Weimar and in M. von Bochmann, who has painted a delicious painting of peaceful intimacy of a Dutch village. One sees here how a consummate artist subordinates the picturesque role of the costumes to the general impression of the picture, while the Tyroleans, in contrast, even the most intellectual ones, let it be seen that costume is their first concern.

In paintings of interiors one also finds the mark of contemplation before the Dutch. [. . .]

The Piloty school also has sprung from the Dutch, but it has thrown itself into russet tones because it has misunderstood Rembrandt, that very dangerous magician; and all the artists who are veering to the grays threaten and encroach upon it. Some painters hold themselves between the manner of M. Knaus and that of the

Tyroleans; for instance, M. Michaël, with his Italian school manner, paints unctuously but with slightly reddish color.

The landscape painters are very numerous; we were not able at the universal exposition [1878] to assess the importance of their role. They are divided quite sharply into two categories, which does not prevent some of them from joining both camps. Some of them go out to the country with black, dramatic ideas and seem to see in the landscape only a kind of infernal vestibule. Starting from their black base they throw themselves into somber colors mixed with bursts of sunsets. [. . .] Others are sensitive observers, accurate, who take nature in the quietness of her simplicity; [. . .] the sharpest, the finest, the most delicate perhaps is M. Heffner. [. . .]

A great success greets *Andreas Hofer* by M. Defregger who, up till now dedicated to small pictures, has suddenly seized his large brush and taken on a large canvas. This work interested me from one angle only, the analogy between the treatment of the Tyrolean characters crowding around the hero and the workmanship of some of the figures of the huge decoration with which Piloty has decorated one of the halls to the Hôtel de Ville. This decoration constitutes an addition to the exhibition. I have not yet seen anything better in the work of Piloty. The blacks there are beautiful; the figures in the foreground are solidly placed; the halftones have softened and become transparent. The backgrounds, on the other hand, are always lost in a dull light and weakness.

One realizes that the *Living Torches* of M. Siemiradzky was a soft and inferior application of the master's method; a master who not only stages his compositions much better, but handles them with much more assurance and gives the impression of a consummate orchestra conductor.

Now this will be my conclusion: there are yonder a great many very strong talents and more than one very original artist; much is being attempted seriously and with vigor; leaving aside the Munich school, which fails in its attempts at lightness or transparency, people are obsessed with strong colors; the whole lacks freshness; the Piloty school has reached its apogee, and twenty-five years from now it will have disappeared; the current of truth and nature is rising up; and finally, we would need our Parisian indifference to anything that is happening beyond our doorstep to think that the Munich exhibition is not interesting. [. . .]

Translated from Edmond Duranty, "Munich et l'exposition allemande," *Gazette des Beaux-Arts,* ser. 2, vol. 20 (November 1879):454–61.
 1. Eugen Roth, *Der Glaspalast in München: Glanz und Ende, 1854–1931* (Munich, 1971).

1879–81: *Paris*

In 1879 the Salon opened in the Palais de l'Industrie only a few months after the 1878 exposition displays had been cleared away. Jules Lafitte, owner of *Le Voltaire,* a journal he hoped would take the place of *Le Bien Public,* a republican journal with bourgeois subscribers, hired Joris K. Huysmans to review it, at the suggestion of Emile Zola. The twenty-nine-year-old Huysmans, a clerk in the Ministry of the Interior, had already reviewed the Salon of 1876 for the monthly *République des Lettres.* In the same year he had also published at his own expense a novel, *Marthe,* modeled on Flaubert's *Madame Bovary* (1857) and Edmond and Jules de Goncourt's *Germinie Lacerteux* (1857). Before it was confiscated by the police he had presented a copy to Zola. Now Huysmans' second novel, *Les Soeurs Vatar,* was ready for the press; in it "[I] set down what I see, what I feel, what I have lived, writing it as well as I am able, *et voilà tout.*" His associates were artists like himself, whose work was "ugly and superb, outrageous and yet exquisite, like the Folies Bergère."

In Huysmans' first letter on the 1879 Salon he summarily dismissed the Beaux-Arts painters as mediocre. Many subscribers violently objected, and only the strong support of Zola prevented Huysmans from being fired. Undaunted, he continued his censure of the Salon as a triumph of the conventional, the commonplace, and the commercial, and allied himself with Jules Castagnary, who had codified the principles of Naturalism in his 1863 Salon review. Huysmans noted that in "modern" or "contemporary" painting, "a model can serve indifferently to personify great ladies and common girls." He extended the name "Impressionist" to include the Naturalists by stating, "[The Naturalists] go more deeply into the individual character they are portraying, and if they wonderfully express his outward appearance, they also know how to make him give off the odor of the soil to which he belongs."[1]

The Salon of 1880 was the last for which the French government assumed complete responsibility, as it had since the time of Louis XIV. A committee of ninety, elected by all the artists who had exhibited in the Salon, constituted a temporary organization, the Société des Artistes Français pour l'Exposition des

1. Arthur Symons, "Huysmans as a Symbolist," in *The Symbolist Movement in Literature* (London, 1899), p. 142.

Beaux Arts, until the permanent society was established in 1883. This society controlled the Salon until 1891, when innovative artists seceded to form the Société Nationale des Artistes Français and held their own annual Salon in the Palais des Beaux-Arts on the Champ-de-Mars. In additional to the twenty-six enormous rooms in the Palais de l'Industrie set aside for the Salon, four more large rooms were annexed to handle an additional thousand pictures (plan 9; fig. 72). Fine sixteenth-century tapestries adorned the stairways and vestibules.

In 1880 Zola himself took the place of his protégé Huysmans as the reviewer of the Salon for *Le Voltaire*. He had been an unknown journalist when he wrote his first Salon criticism in 1866, with its praise of Manet that had provoked a violent reaction in established art circles, but by 1880 he was a well-known novelist. In the interval he had devoted himself to writing the saga of a Second-Empire family, the Rougon-Macquarts, which was supposed to serve as a scientific study of heredity. Begun in 1868, it had at first attracted little attention, but when the story of an alcoholic, *L'Assommier,* appeared in 1877 it became a bestseller. The sensation of the winter of 1879 was its sequel, *Nana,* the ninth volume in the saga and a detailed description of the life of a Parisian courtesan. Zola was now recognized as the leader of the naturalistic school, the continuer of the methods of Flaubert and the Goncourts, and he attracted a group of young writers to his circle, among them Paul Alexis and Guy de Maupassant, in addition to Huysmans.

Lafitte was pleased to have the famous Zola's name appear in the pages of *Le Voltaire* in place of young Huysmans, but Zola devoted little space in his Salon criticism to what was actually on view. Having first sidetracked to point out the futility of administrative changes made to satisfy the exhibitors, he offered an explanation of the term *impressionist* as it applied to painting. He compared his own technique in writing to "impressionism" in painting, and the public agreed that they were comparable: Zola's novels were viewed by many as as great an assault on decency as Manet's painting *Olympia* had been when it was seen in the Salon in 1865. As an "independent," Zola transgressed the rules governing literary aesthetics, just as the Impressionist painters transgressed the rules of aesthetics laid down by the Ecole des Beaux-Arts and the French Academy.

Zola's definitions of Impressionism and Impressionists had been gleaned from discussions with his associates, the painters Manet, Pissarro, Degas, Renoir, his school companion Cézanne, and their defenders among the journalists. In defining Realism, Edmond Duranty had distinguished between artists who used an innovative manner of painting from those whose realism lay in their choice of subject matter. Zola's defense of the Impressionist painters made the same distinction, and it was a defense as well of his own method of studying minutely, recording accurately (as in any natural science), and even employing the argot of the working class when writing about it. This method was his "careful brushstroke." In *The Experimental Novel* (1880), a collection of essays (five of which had been published in the 1870s in translations in *Le Messager de l'Europe* in St. Petersburg), Zola explained his procedure by stating that as in life, so in art, the

subject matter should have no finale: it was a fragment, analogous to the painter's sketch. Zola worked up a "finished" novel from his notebook sketches. But because the artist-character Lantier in his novel *L'Oeuvre* (1886) described the method as fruitless, and because it was a method Cézanne, Manet, and other painters thought they also used, they took the novel as a criticism of their work and broke with Zola. Because an artist's final work, if executed by this method, did not fit the current definition of a work of art as "a faithful copy of life transfixed by beauty," Zola's writing also stirred up controversies such as whether the depiction of the ugly was any more realistic than the depiction of the good and the beautiful; whether a portrait photograph was the reality; whether the truth of a man could be given only in a portrait by a great artist. As an art critic, Zola felt that art's growth and change from epoch to epoch made it impossible to find a set formula by which to judge a work of art, a stance which put him in direct conflict with the academicians. For the contemporary epoch, the methods of natural science were the measure: "What was seen was realism, as life without arrangement, an impression."

A few months after submitting the 1880 Salon review, Zola fell out with Lafitte and began instead to supply a weekly review for the very conservative *Le Figaro,* but he gave that up the next year to complete the Rougon-Macquart saga. In every volume of his novels, however, detailed descriptions of the arts, architecture, painting, and sculpture, past and contemporary, could still be found, and because he was the most widely read European novelist of the time, his influence as an art critic and determiner of taste continued. Everywhere his books were as attacked by the supporters of the status quo as they were praised by advocates of social change and the avant-garde. His naturalism aroused hostility and approval in equal measure among literary and art critics, and his novels were a major factor in making Realism acceptable and bringing about changes in popular taste in both art and literature.

When Zola chose to write the Salon review in 1880 for Lafitte, Huysmans reviewed it in four installments for *La Reforme,* with which the Zola group collaborated after *La République* folded. The Salon had been arranged on a new principle. Instead of the alphabetical order used for twenty years, artists not French by birth were placed as foreigners in five separate rooms, as they would have been in an international exhibition, and were assigned one wall of the Salon Carré, the court of honor. The work of foreigners trained in Paris hung alongside works sent by their compatriots from abroad. The native French works were divided into three classes: *hors concours,* or works by artists who, because of medals already received, no longer competed for them; works received but exempt from being submitted to the jury; and the 2,448 pictures admitted by the jury.

Huysmans again disdained such favorites of the establishment as Bonnat, Carolus-Duran, and Dagnan-Bouveret. It was Manet, included in this Salon, whom he recognized as the artist who "pushed modern art in a new direction."

He found extraordinary a young artist, Gustave Moreau. Moreau had first come to the attention of critics at the 1876 Salon with his *L'Apparition,* whose style Huysmans found analogous to that of Flaubert and the Goncourts in writing.

In his Salon review of 1881, Huysmans ended with a résumé of contemporary architecture (see part 1, above), a quotation from Zola's novel *Ventre de Paris* (The Belly of Paris; 1873), and the statement that architecture "has been able to create a new art with entirely new materials," this notwithstanding that in 1879 Benoit E. Loviet, a pensionnaire in Rome, received a first prize for his restoration of the Lysicrates monument in Athens. The emphasis on architecture was unusual, for from the beginning the Salon critics had concentrated their attention on the two classes of major interest, painting and sculpture [fig. 80]. Although Charles Landon, the first to publish an account of the Salon, had included architecture in his innovative illustrated *Annales des Salons* (1801), in the first half of the nineteenth century a *salonnier* rarely followed his example, and the class was hung in the Louvre in rooms apart from the paintings. When the Salon moved to the Palais de l'Industrie in 1857, paintings were hung in the open gallery or balcony that surrounded the "garden" on the ground floor where the sculpture was placed, and architectural drawings and models were relegated to a deserted corner room, where they shared space with the graphic arts and drawings along the outer walls behind the sculpture garden—this despite the fact that at this time architectural studies in France were exceptionally well organized.

That a prize could be given for a Greek restoration was less surprising. Every architect began his career at the Ecole des Beaux-Arts in the architectural section, classical in its instruction. At the Ecole de Rome, often referred to as the Academy of Rome, study was directed to monuments of antiquity, and students were obliged to make careful drawings of Roman monuments. Training geared toward preparation for government service was the responsibility of the Ecole Spéciale d'Architecture. Its responsibility was to teach the design and maintenance (in 1837 a Commission for the Conservation of Historic Monuments had been established to save the monuments of France from destruction by imperfect restoration) of civil buildings, historical monuments, diocesan edifices, and public works in the city of Paris.

Since the beginning of the nineteenth century, drawings of monuments from Italy, Sicily, and Greece as well as projects for contemporary theaters, banks, churches, and commemorative monuments [figs. 78–79] had been eligible for entry to the Salon. Although little consideration was given to the location and hanging of the architectural drawings, many were of interest not only as technical studies but as sketches from nature. At the end of the eighteenth century the use of watercolor achieved a compromise between geometrical conventionality and picturesque truth, so that "in the charm of their color [architectural drawings] could well stand comparison with work exhibited elsewhere in the Salon, and whose chief aim was to fill the eye."[2] But the public seemed to have little interest in this art, despite its relevance to science, industry, and society's own current requirements.

2. E. F. S. Pattison, "The Paris Salon," *The Academy,* May 22, 1880, pp. 389–90.

Huysmans was an unlikely architectural critic, being foremost a novelist—or so it seems until one reflects on the contents of his novels, which, like those of Zola, took place in Paris amid the destruction of the old and the construction of the new. Between 1853 and 1869 Paris was transformed by Napoleon III and the prefect of the Seine, the engineer Georges-Eugène Haussmann. Broad boulevards and straight avenues were cut through a tangle of streets, providing views of the splendid buildings that had been built throughout its history. The demolition task was assigned to engineers, who were trained at the Ecole Polytechnique, not at the Ecole des Beaux-Arts. It was left to the Beaux-Arts graduates to design and erect buildings of new materials to meet the requirements of Paris's swelling population. F. Léonce Reynaud was responsible for the Gare d'Austerlitz (1843–47) and the Gare du Nord (1845); Victor Baltard's iron and glass Halles Centrales were set in 1853 beside the fifteenth-century church of St.-Eustache. Gustave Eiffel designed the department store Bon Marché in 1876. The engineer's technically audacious Galerie des Machines for the expositions of 1867, 1878, and 1889 rose in front of Jacques-Ange Gabriel's elegant Ecole Militaire of 1752. In Huysmans' *En ménage* (1881) the characters walk by the construction site of the Hôtel de Ville (gutted by fire during the Commune uprising in 1871), which was being rebuilt with an iron interior frame and covered with French Renaissance façades. Cyprien, a painter in the novel, expresses his irritation with people who "rave about the apse of Notre Dame and the rood screen of Saint-Etienne du Mont! So what! the Gare du Nord and the new hippodrome, don't they exist?"[3]

The Salon report for 1881 was the last that Huysmans wrote. The Impressionists, or "independents," as he called them, with whom he was closely associated, had dispersed, thus preventing the formation of a united front against increasingly frequent attacks by academic art circles. Perhaps that is why he saw 1882 as the opportune time to republish together in *L'Art moderne* the defense of the group found in his Salon reports of 1879, 1880, and 1881, and in his exhibition reviews of 1880, 1881, and 1882. Adding an appendix with observations on some artists not seen in 1882, and mentioning others, he gave the collection to the publisher Charpentier, who brought it out in 1883. Art circles took note of the volume's appearance, but the fickle public that had reacted strongly to the criticisms when they first appeared in the press did not. Only current events held its attention. Six years later, in 1889, Huysmans brought together *Certains*, miscellaneous notes and analyses of contemporary artists, to complete the series published in *L'Art moderne*. In one of these, he reversed his attitude, expressed in the review of Salon of 1881, to the iron-age architecture.[4]

By 1882 Huysmans, as he wrote to Zola, had "embarked on a wild gloomy fantasy, something crazy, but at the same time realistic." His "fantasy," *A Rebours* (Against the Grain), appeared in 1884. Its hero, Des Esseintes, after a sojourn in the country, returned to engulf himself in the "world of human mediocrity" in a Paris already transformed from the old to the new, whose inhabitants

3. See Joris K. Huysmans, *En ménage* (Paris, 1881), p. 401.
4. "Le Fer," *Certains* (Paris, 1889), see section 1, 1889: Paris, pp. 74–78.

had been startled by the strange structures erected for the universal exposition of 1878, had seen them razed, and now watched the erection of still more exotic buildings and bizarre structures to house the noisy machines and show the goods from the world's four corners at yet another exposition. Huysmans and his associates sought "to preserve the veracity of the document, the precision of detail, the fibrous and nervous language of Realism, but it was equally essential to trace a parallel pathway in the air and to grapple with the within and the after, to create, in a word, a spiritual Naturalism." He fulminated against the Eiffel Tower, for he, no more than many of his contemporaries, could envision the reconciliation of materials which would give rise to architecture and monumental sculpture in the next century. He therefore praised those who fled the horror of their surroundings to other times and other places.

The Salon of 1879

JORIS K. HUYSMANS

I. Except for the paintings by Herkomer, Fantin-Latour, and Manet, the landscapes by Guillemet and de Yon, a seascape by Mesdag (fig. 77), several paintings by Raffaëlli, Bartholomé, and some others, I do not find anything that, from the point of view of modern art, is really interesting and really new in the canvases that are unrolled on the walls of the 1879 exhibition.

Apart from the few artists I have just mentioned, the others continue peacefully in their little routine. This exhibition is exactly like the exhibitions of preceding years. It is neither worse nor better. The mediocrity of the people who have attended the Ecole des Beaux-Arts remains fixed.

The present exhibition proves once more that all of these painters can be divided into two groups: those who are competing again for a prize and those who, because they will not receive one, are simply trying to sell their products in the best possible way.

The first group is still singing the deplorable refrains that you have already heard. Out of preference they choose subjects taken from religious history or ancient history, and they constantly talk about "being refined," as if this quality derived from the subject itself and not from the way in which a subject is treated.

Most of them have had no education and have neither seen nor read anything, except about "being distinguished." For them it is simply a question of not making things real and true to life. And, oh, this other expression: *le grand art!* They have their mouths full of it, the poor things! Tell them that the subject of a great work could be furnished by the modern as well as the ancient and they are stupefied and indignant. Then, is great art the painted blinds they put into gold frames; the Ecce Homos, the Assumptions of the Virgins dressed up in pink and blue like butterflies? Is great art the Eternal Fathers with white beards, the Brutuses made to order, the Venuses made to measure, and the stuff they paint at the

Batignolles on a cold day? That's great art? Come on now! It's industrial art, at the most! And at the rate it's going, industrial art will soon be the only art we will have to study when we are in search of truth and life.

Such are the painters who follow the tradition of the Beaux-Arts—and they really work hard at it. Let us now look at the others. They no longer pay any attention to the basic principles of the school. They have put aside all the worthless old stuff which does not sell at all, and to earn money they do their best to flatter public taste with their niceties and their cute tricks. They produce sugar babies with care, dress silk dolls in tin, give a mother who has lost a son a log wrapped in diapers to rock, put a gun into the hands of a youngster still wet behind the ears, and they decorate the whole thing with titles of this kind: "The First Troubles," "Sorrow," "The One-Year Volunteer," "May I Come In?" "Reverie." It is useless to add that these painters are no more refined than the others and that, if they are beginning to make fun of great art, they, too, claim only to be working in what is distinguished.

So, without fear of being wrong, we can lay down the following axiom: the less education a painter has had, the more he wants to create great art or sentimental paintings. A painter raised with workers will never portray workers, but people in evening dress whom he does not know. It certainly cannot be denied that the ideal is a very beautiful thing!

This is how far we have come in the year of grace 1879, when the naturalist movement has tried to destroy all the old conventions and all the old formulas. While romanticism is dying, the painting allowed in the Champs Elysées market of oils continues calmly to survive, closes its eyes before everything that goes on in the street, and remains indifferent or hostile to any endeavors that are made. In painting, as well as in poetry, we are still in the Parnassus period.[1] It's all fiddle-faddle and tricks and nothing else.

Ah, but these spoilsports, the independents—so spurned and decried—are more interesting. I do not deny at all that among these people there are some who do not know their work well enough. Take a man of great talent like M. Degas; take even his pupil, Miss Mary Cassatt, and see whether the works of these artists are not more interesting, more curious, more distinguished than all these jingling things that are hanging on the line in the interminable galleries of the exhibition.

I find that they have a real concern for contemporary life, and M. Degas, on whom I must dwell a little—for his work will serve me many times as a point of comparison when I come to the modern paintings of the exhibition—is certainly among the painters who have followed the naturalist movement, which is determined in painting by the impressionists and by Manet—the one who has remained the most original and the most daring. He was one of the first to attack feminine elegance and vulgarity; one of the first to dare to try to portray artificial lights and the flare of footlights, before which low-class concert hall singers in décolleté are bawling out their songs or dancers dressed in gauze are frolicking and pirouetting. Here there is no creamy smooth skin, no goldbeater's skin, no skin like watered silk. It is real flesh in rustling silk—made-up skin from the

theater and the alcove, just as it is when seen up close—grainy and rough—or when seen from a distance—with its sickly glow. M. Degas is a past master at the art of rendering what I would willingly call "the civilized flesh tint."

If people who are not used to this sort of painting are startled, it matters little. Their slippers are not in their place, but they will wear them wherever they may be found. They will finally understand that the painting techniques of the old Flemish school, excellent for rendering the peaceful interiors in which good fat mothers smiled, are powerless to render the upholstered interiors of our day and the exquisite Parisian women with their matte complexions, painted lips, and swinging hips, moving in rustling armor of satin and silk! Of course, I personally admire the Jan Steens and the Ostades, the Terburgs [Terborch] and the Metzus, and I have a great deal of enthusiasm for certain Rembrandts; but that certainly does not prevent me from declaring that today something else must be found. Those masters painted the people of their time with the techniques of their time. It's over and done with—now it's up to others! While waiting for the appearance and the take-over of a man of genius who has mastered all the curious elements of impressionist painting, I cannot give too much praise to the attempts of the independents who are contributing a new method and a hint of singular, true art, and who are distilling the essence of their time, just as the Dutch naturalists expressed that of theirs. In new times, new techniques. It's a simple question of common sense.

Is it now necessary to add that the official exhibition has, less than the independents' exhibition,[2] expressed the real essence of contemporary life? The first glance is gloomy. How many canvases and how much wood used so wastefully! All of this pretentiously colored material does not create a clear picture. Of the 3,040 paintings listed in the catalogue, there are not one hundred that are worth examining closely. The rest are certainly not as good as the industrial posters which are displayed on walls in the streets and on lamp posts on the boulevards. These *tableautins* portray images of Parisian life, ballet exercises, clown acts, English pantomimes, and behind-the-scenes activity at race tracks and circuses.

Personally, I would prefer to see the rooms of the exhibition decorated with color prints by Chéret or those wonderful Japanese prints that are worth one franc each rather than to see them cluttered with such an accumulation of sad things. Let us have art which throbs and lives for God, and to the wastepaper basket with all the cardboard goddesses and all the churchiness of time gone by! To the wastepaper basket with all this overpolished stuff à la Cabanel and à la Gérôme!

Thank God we are beginning to unlearn respect for conventional glories! We no longer bow down before reputations hallowed by interest or stupidity and, instead of all the Coutures and Signols in the world, we prefer the beginner who has finally seen the wonderful scenes of the drawing rooms and the streets and who tries to portray them. These attempts themselves interest us, for they are the preludes to a new art. But, unfortunately, it is not a matter of new art at the moment, since the canvases piled up in the Palais de l'Industrie are the same as the

ones found there ten years ago. They are like old clothes handed down from father to son—lengthened or shortened according to size.

So, without further discussion, we come to the works themselves. [. . .] Let us first look at the yards of painted fabric designed to cover yellow chapel walls or to decorate provincial museums, town halls in large towns, or drawing rooms in subprefectures. In other words, let us begin by visiting what my contemporaries call historical painting. [. . .]

III. Painters will always surprise me. The way in which they understand the nude in the open air stupefies me. They stand or lay a woman down under the trees, in the sun, and they paint her skin as if she were lying on a white sheet in a warm room, or as if she were standing against a background of wallpaper. Now then, what about the play of light which filters through the branches of the trees? The way that most of their nude figures are posed, they should have hearts and spearheads formed by the shadows of the leaves on their skin. And what about the air and the reflection of everything surrounding them, as well as the vibrations of the ground? Is all that completely nonexistent?

I know that we see few nude women lying under trees. It's an instructive sight forbidden by the police, but it *is* possible. If it is never offered to many painters—which I can well imagine—why then do they dare to portray it? That seems as scandalous to me as a painter who would never go outside and yet would haphazardly compose a landscape in his studio. I shall go even further. The nude, as painters understand it, does not exist. We are nude only at certain moments, under certain conditions, in certain jobs. Being nude is a provisional state, and that's all.

To take an example from older painters, I challenge anyone to show me a nude woman by Rembrandt who is not simply undressed and who will not put back on her clothes as soon as she no longer has a reason to be undressed. It is true that if an artist only likes to paint chimerical beings such as centaurs, fauns, and nymphs, it is completely useless for him to observe anything whatsoever. In the background he can—or, better, he should—paint a wallpaper landscape and a spun-glass brook. That would be less out of tune. What is a real setting for a conventional subject? Let's at least be logical. Boucher was, with his theatrical landscapes and his lively actresses dressed as Venus and Diane. Or, if you think that nudity is not an unusual condition, then paint me some nymphs such as they might have been, in a real landscape: paint me some farm girls, tanned and brown in all kinds of weather. No girl has a pale or slightly pink complexion and a body molded in pink and white when she strolls without a veil in clearings and in the woods.

Since nature and truth do not exist for mythologist painters, by accepting their theories for a minute, let's see how they have accomplished the task they have undertaken.

Unfortunately, I must begin with the work of M. Bouguereau. M. Gérôme had already renovated Wilhem [A. Willem van] Mieris' cold ivory. M.

Bouguereau did worse. In agreement with M. Cabanel, he invented light, airy painting. It's not even porcelain anymore; it's overpolished and flaccid. I do not know what it is—it's something like soft octopus meat. The *Birth of Venus* [. . .] is of unspeakably poor quality (fig. 69). The composition is perfectly ordinary. A naked woman on a shell, in the center. All around, other women frolicking in well-known poses. The faces are banal, like mannequins rotating in hairdressers' windows, but the bodies and legs are even more distressing. Take the Venus— from head to toe, it's completely unreal. There are no muscles, no nerves, no blood. The knees buckle, as if they had no joints. It's a wonder that the poor thing can stand up—a few pinpricks and she would fall down. The color is horrible, and so is the drawing. It's as if it had been made as a design for a pillbox. The artist's hand worked all by itself, mechanically making the outline of the body. It makes me shout with rage to think that this painter, in the hierarchy of mediocrity, is a master and the head of a school, and that if we don't watch out, this school will easily become the absolute negation of art! [. . .]

V. We have finally come to the modern painters. First of all, allow me to quote an unpublished document on contemporary life. Afterward we will be able to get right down to the subject.

A few years ago a foreign artist was walking through the rooms of an official exhibition of paintings with M. de Neuville when he met Fromentin. M. de Neuville left, and the two friends began to talk about "modernism."

The listener took down the following interesting conversation.

"Your modernity bores me," cried Fromentin. "We must certainly paint our time, I know, but as part of its material aspects, it is necessary to render decorations and people and, especially, customs and feelings, before clothing and accessories. These things play only a secondary role. I will never be convinced that a woman in a blue dress reading a letter, a woman in a pink dress looking at a fan, or a girl in a white dress looking up at the sky to see if it is raining are very interesting aspects of modern life. [. . .] Ten photographs from an album could provide us with the same amount of modernity, especially as the woman, the young lady, and the girl *are not* caught in the act, but have been brought to the studio at five francs a sitting to dress up in these dresses and represent modern life. It's just as if I myself had taken the date merchant from the rue de Rivoli, put a Turkish pipe in his hands, and painted Algeria according to this Tunisian Jew. It's as stupid as that! Where is modern life in all these paintings, which Worth might have painted had he had an artist's temperament?"

"Ah! life, life! The world is there, laughing, shouting, suffering, enjoying itself—and no one portrays it! I used to be contemplative, and I went to the Orient, to those large calm countries with their primitive life. *If I had my life to live over, I might live it in another way,* but I have rendered the aspects, the passions, and the last grandeurs of a race that was disappearing, and it still belongs to my century. I have not spent my life painting dully." Then, after a few minutes of silence, Fromentin continued, "I don't mean that it's necessary to have

a lot of spirit, but it is necessary to capture the spirit of things, which is enormous and which springs from all of nature, just as water flows from a fountain. But look how stupid these modern painters are! I was at one's place a week ago. In comes a young girl, twenty years old, with a bratty kid who was born in the Reine Blanche district. She was as pretty as anything, but rather coarse looking, with plenty of lampblack under her eyes! Superb for a 'clairvoyant.' The painter made her wash her face, shoved the kid into a corner, threw a beautiful velvet dress on the slattern, put a trinket in her hands and the little wench—so pretty to paint as a wench—became a lady looking at a Chinese curio! Modernity, my young friend, modernity! He should have taken a real lady if he wanted to paint a lady!"

I have practically nothing to add to the preceding observations. No, the modern painter is not only an excellent "couturier," as are, unfortunately, most of those who, on a pretext of modernity, wrap up their models in different silks. No, the contemporary is not created by praising a model who can serve indifferently to personify great ladies and common girls. It is especially from this point of view that the talented impressionists are, in my opinion, superior to the painters who show their works in official exhibitions. They go more deeply into the individual character they are portraying, and if they wonderfully express his outward appearance, they also know how to make him give off the odor of the soil to which he belongs. The girl is the girl, and the woman of the world is the woman of the world. For this reason they have no need to portray, as the late Marchal did, Penelope and Phrynis, one sewing in a modest gray dress and the other displaying her breasts in a black velvet dress cut much too low. A talented man would have shown both of them dressed by a well-known couturier, and the two different races would have been recognized even if they were both wearing identical clothes.

Take, for example, a painting by M. Degas and see whether he is simply an excellent modiste and whether, aside from his skill in rendering materials, he does not know how to throw you at the feet of a creature whose face, figure, and gestures speak and tell you what she is. He portrays ballet dancers. They are all real dancers and they all have a different way of practicing their act. Each one's individuality is evident. The nervousness of the girl who instinctively does pirouettes and who will become an artist is apparent in the midst of all these feminine athletes who are supposed to earn their living thanks only to their legs. Such as it is and, especially, such as it will be, impressionist art gives proof of very close observation and profound analysis of the individual temperaments on stage. Besides that, it has a surprisingly exact way of seeing color and a scorn for conventions used for centuries to render light effects; it goes out in search of the open air, the true tone, life in motion, the wide brushstroke technique, shadows made by complementary colors, and the simple overall picture. All of these are tendencies of the art of which M. Manet, who is now showing at the yearly exhibition, has been one of the most eager promoters.

This year two of M. Manet's paintings have been accepted. The first, entitled *In the Greenhouse,* shows a woman seated on a green bench listening to a man

who is leaning on the back of the bench. There are tall plants all around and some red flowers on the left. The woman, a little awkward and dreamy, is wearing a dress which seems very hastily made—yes, do go to see it!—and which is superbly rendered. The man is bareheaded, with some rays of light playing on his forehead that from time to time touch his hands—which have been hastily sketched—as they are holding a cigar. In this pose of casual conversation, this figure is really beautiful: she is flirtatious and lively. The air moves and the people stand out wonderfully from the surrounding green background. This is a very attractive modern work—a victory over the conventionalism of sunlight never before observed in nature.

His other painting, *Boating*, is just as curious (fig. 71). The very blue water still exasperates many people. Doesn't water have that shade? But of course it does, at certain times, just as it has green and gray tones and scabious, chamois, and slate reflections at other times. We must simply be more observant. This is precisely one of the great mistakes of contemporary landscape painters who, because they have preconceived notions of how to look at a river, do not create the necessary harmony that nature always creates between the river, the reflection of the sky, the location of the riverbanks, the hour of the day, and the season, which all exist at the time they are painting. Thank God M. Manet has never had these prejudices which are so stupidly maintained in the schools! In short, he paints nature as it is and as he sees it. His woman in blue seated in a boat partly cut off by the house, as in certain Japanese plates, is well posed in the bright light, and she and the boatman dressed in white stand out emphatically against the bright blue water. These are paintings which few in this dull exhibition can match.

Let us now go on to the work of M. Gervex. He escaped from the shop of that overfamous Beaux-Arts pastry cook, M. Cabanel. Although the concoctions he has created and the pies he brings to town are like the ones his chef makes, M. Gervex turned in his apron as soon as possible, and he has begun to knead the dough in his own way.

Of the young painters, M. Gervex certainly inspired the most hope. His paintings revealed undeniable talent. I need not remind you of his autopsy [*Dr. Péan at the Saint Louis Hospital*] which is so perfectly observed, nor his *Mass at Trinity Church* and his *Rolla*. I like his *Home from the Ball*, for example, much less, but it's still one of the least bad paintings hung on the hooks of this rag temple. This is how the scene is set up: a man in evening dress is leaning forward in his chair. He has just berated a woman, who is crying with her face in her hands, with all the angry words which are centuries old and which have never had any other effect than to show her the power she has over the man and the abuse she can make of these words. The man nervously takes off his glove. His anger shows up completely in this gesture. The idea was ingenious, but the woman's prearranged attitude spoils the whole thing and the lamplight on the clothes and faces is inaccurate. The painting shown by Mr. Gregory in 1878 in the English section portrayed a similar subject, but it was much more original, much more true. [. . .]

VI. M. Bastien-Lepage is a tremendously skilled painter, and he has his art completely at his fingertips. The *October Season* is a good repetition of his last year's painting. M. Lepage has portrayed his peasant woman again, but instead of showing her in a full-face pose, he shows her profile as she is filling a bag of potatoes. As usual, the painting's good qualities are wonderful, but although I recognize this artist's true ability, I cannot find in his work that intensity which belongs to the masters. It's skillfully arranged, it almost seems to be painted without effort, it's swaggering enough to be called daring, but in spite of everything I detect the affection of sham treatment, a step forward which has been interrupted and then skillfully halted in order not to displease the public. M. Lepage is a rebellious wiseman. He's the platonic pole of the Beaux-Arts.

With the *October Season,* as well as with *Hay,* M. Lepage's evident ambition was to be simple and great. Millet haunted him. Of course I do not blame him, for Millet was a great artist. However, the wonderfully real aspect of Millet's peasants in the countryside does not come through in Lepage's work.

In a word, M. Lepage seems to be pretending to be too innocent and naive. I have no doubt that he is sincerely moved by the poor people he portrays, but his feelings simply do not come across to us. Millet was a frank artist. After him Mr. Breton had already begun to play the role of "the good peasant of painting." M. Lepage has gone further, and now he is playing the role to the fullest.

To be perfectly truthful, this year's painting shows some strange weaknesses. The modeling is impersonal, and the atmosphere is not so vibrant. The peasant's hands are not the hands of a woman who works with the soil—they are like the hands of my maid who dusts as little as possible and hardly manages to wash the dishes. The public will undoubtedly be grateful to M. Lepage for burking the truth in this way and for prettying up the people he paints. In my opinion, it's very polite, well-bred painting, disguised by a clever fellow. [. . .]

Another painter, who is really modern and also a powerful artist, is M. Raffaëlli. This year his two paintings are absolutely excellent. The first depicts the ragpickers' return. It's twilight. In one of those melancholy landscapes seen around the poor part of Paris, factory chimneys are belching great puffs of soot into the pale sky. Three ragpickers are coming home with their dogs. Two of them, with their wicker baskets on their backs and their canes in hand, are dragging painfully along. The third is walking ahead, bent beneath the weight of a sack.

I have seen few paintings in the exhibition that have impressed me in such a distressing and charming way. M. Raffaëlli has evoked for me the sad charm of rickety shanties and thin poplars lining those unending roads which go on as far as the sky when they leave the ramparts. When I was faced by these poor things as they walked along so wearily in this marvelous and terrible landscape, all the anguish of these old suburbs rose up before me. Finally, here is a work that is really beautiful and really great!

The other painting portrays two old men whose hands are swollen, chapped,

and dirty from such overburdening work. They are walking arm in arm, coming slowly toward us. They are dressed in rags and have sheepskin hats on their heads. Their faces are swarthy and covered with bushy gray beards, and their still-lively eyes sparkle brightly. Look at them—they move, they are alive. It took courage to portray them in that way, just as they are, without embellishing or cleaning them up—two old men worn with misery, whose only pleasure must now be the bottle.

I thus recommend these two canvases as examples of resistant, bold painting done by a man of unquestionable talent. Of course, they have been placed high up, while other horrible smudges and abominable butcher-shop blinds and hunts going on under castle keeps clutter up the best places and the staircases. M. Raffaëlli has received neither prize nor any honorable mention, but so much the better, because that increases our hatred of the selection committees and the Ecole des Beaux-Arts. With any more injustices like that—so many prizes given to manufacturers of old burlesque saints, Jeromes at five francs a pose, wooden Christs implored by lead militia soldiers, mediocre historical paintings such as the Girondins—and with the newspapers that consent to forge ahead, we will soon manage to demolish those dispensaries that distribute commissions and assistance every year only to the artisans who have best attained the goal of great French art: to make everything unlifelike and not at all true! [. . .]

IX. In my opinion, patriotism is a negative quality in art. I am well aware that the masses dance excitedly when they hear a concert blaring "Revenge" or "France, My Love," and that many people swoon when they hear M. Deroulède's sentimental songs, but these people are just simpletons who are ready to cross all these patriotic bridges which make the poet-engineers who construct them say, "Here are some good souls!" Patriotism, as I understand it, would consist of creating some real works.

With their wonderful paintings, Delacroix and Millet have been of more service to France than all the generals and statesmen. They have glorified and exalted France, while Vernet, Pils, Yvon, and other military painters who have celebrated her victories have disparaged and debased her with their bad paintings. That's my frank opinion. In his "Aesthetic Curiosities," on the subject of military painting, Baudelaire wrote, "I hate this kind of painting, just as I hate the army, armed force, and everything that drags noisy weapons into a peaceful place." I shall go no further—from the point of view of art. The army exists and consequently has the right to be represented like all other classes in society. But, for example, I wish that it were not always portrayed so melodramatically and whiningly. I wish that it could be depicted simply, just as it is. M. Guillaume Régamey at least tried, and sometimes he succeeded in doing so.

The battle scenes shown at this year's exhibition are all, without exception, of very poor quality. M. Detaille, the public's favorite, shows us an *Episode of the Battle of Champigny* (fig. 70). All of his figures are spanking clean and placed in poses which had never been seen at that time. It's a row of dolls arranged by a man who is used to this sort of thing. I bet that M. Detaille took from his sketchbook

two or three poses that he copied from a magazine or drew in a field and set the whole thing up as a battle for the edification of amateurs. You can't smell the gun powder in this painting—only strong glue and freshly ironed rags used to dress these puppets up as soldiers!

M. Detaille's painting is certainly not very meaty, but it's no worse than those by Messrs. Médard, Castellani, and Couturier, and it's certainly as good as the one by M. Berne-Bellecoeur, who still insists on being mediocre. One single painting, by M. Reverchon, is exquisite. It depicts a pioneer showing the sky to a sniper who is on his knees, close to death. This painting is one of the best ways I know to overcome ill humor, and I recommend it to people who have trouble laughing. This time they will burst into wonderful gales of laughter. For people who might not have time to visit the exhibition, I also recommend the audacious and very charming attempt of a Left Bank tinsmith: a battle between lead soldiers on an artificial battlefield made of sawdust, near a river made of a piece of mirror. It gives a good first impression, and the arrangement and grouping are very well done. The lead fortress, armed with cannons spewing cotton smoke, is quite remarkable and very true. If it were shown at the exhibition this year, it would certainly win out over all the large canvases painted by M. Castellani and company. [. . .]

XI. I have often been amazed at the gap in art made by the impressionists and by Flaubert, Zola, and the Goncourts. They revealed the naturalist school to the public. Art was shaken from top to bottom and freed from the official bonds of the schools.

Today we can clearly see the evolution in literature and painting. We can also imagine how modern architecture will be. The monuments are there. The architects and the engineers who built the Gare du Nord, Les Halles, the Villette livestock market, and the new Hippodrome created a new art which is as exalted as the old art—a completely contemporary art appropriate to the needs of our time, an art which, transformed from top to bottom, almost does away with stone, wood, and raw materials furnished by the earth in order to borrow the power and lightness of cast iron from the factories and the ironworks.

In line with all this art produced as a result of the terrible life in big cities, let us now consider the Eglise de la Trinité as a wonderful specimen of the age which created it. All the sickeningly elegant art of the Second Empire is here. The cathedral erected by the believers is dead. Notre Dame no longer has a raison d'être. The skepticism and the refined corruption of modern times have constructed La Trinité, that smoking-room church, that praying-bench sofa where smells of ilang-ilang and moss rose are mixed with incense fumes, where the holy-water basin smells of the perfumed Dresden china which is dipped into it—that church of tasteful religion where people have reserved places on certain days, that stylish boudoir where M. Droz's ladies flirt while praying and hope for mystic luncheons, that Notre Dame of Champaka, in front of which people get out of their carriages as if they were getting out at the theater door.

I have mentioned these monuments because they are the most characteristic of the century. I purposely did not mention the Opéra because it is only a patchwork of all styles which belongs to every period, with its staircase taken from Piranesi, its bulk which is so painfully joined together, and all its ill-fitting parts put together like the pieces of a puzzle. Especially from the point of view of exterior arrangement, it has nothing to do with the new art, of which there are two kinds: one is morbidly distinguished and corrupt and the other is powerful and grandiose, enclosing the superb grandeur of machines in its large frame or sheltering the tremendous swell of buyers or the rapturous circus multitude from its enormous but airy vessels, which are light as feathers.

Music has also made some progress. Thus, of the arts, only poetry and sculpture have remained stationary. Poetry is dying—that is certain. As great as Victor Hugo was and as skillful and artistic as Leconte de Lisle is, they are losing, and will lose in a short time, all their influence over the new class of poets. It will certainly not be because of Musset that poetry will get out of the ditch where it is floundering. Unless a man of genius is born, I cannot see what will become of this art that Flaubert called an art of amusement. I can see even less clearly the direction that other art called sculpture is taking.

Such as it is today, it's the most dreadful ankylosis imaginable.

It's about time to retire the old cliché which is brought out regularly every year: "Sculpture is the glory of France." Painting hardly makes any progress at all, but sculpture . . . ! No, a thousand times, no! I certainly detest with all my might most of the paintings shown at the annual exhibition. I hate the painting by Bonnat and company. I hate these mystifications of great art and the cowardice of the public and the press who believe that the moon is made of green cheese. But if it is possible, I hate even more the mystification called contemporary sculpture.

There are only two possibilities—either sculpture can adapt itself to modern life or it cannot. If it can, it should try to depict modern subjects, and we will know what to expect. If it can't—well, it's perfectly useless to reexhaust all the subjects which were better treated in past centuries. It's better for these sculptors to be simple decorators than to clutter the art exhibition with their products! Everyone will be happier for it—the sculptors, to begin with, for there will soon be a general cry of indignation against the solemn buffoonery of their marbles, and the public even more so, because it will no longer be bothered by this stonework, and it will be more at ease looking at the incomparable marvels of the floral exhibition.

I have no intention now of reviewing one by one all these strange busts lolling on their pedestals which immediately bring to my mind the idea of eyeglasses and tasseled caps. I will look even less closely at the "wash-basin" sculpture whose fantastic chef-d'oeuvre, a child emerging from a cabbage, is shamelessly displayed in the glassed-in garden. The author of this horrible thing doesn't even have the courage to defend it. He hasn't put this statuette in the zinc salad bowl designed for it, and until now he hasn't dared to put the stream of water in the kid's navel, which would liven up and refresh the cardboard castle where the families who buy these things strut about for several months of the summer.

Because of the atrocious scarcity of artists, I find no difficulty in admitting that the selection committee was right to give M. de Saint-Marceaux a prize. His *Genius* is an excellent piece of intrigue which, in comparison with everything surrounding it, may be straightforwardly qualified as a virile, bold work (fig. 68). While we're at it, we must now mention a curious wax statue by M. Ringel, the works of Miss Sarah Bernhardt, which are part of the hydraulic sculpture mentioned above, and a good bust by M. Carrier-Belleuse. And what else? Nothing— unless, to show that the sculptors' spirit is equal to, if not better than, the painters', I point out the *Christmas Stocking*, a child crying because he finds coal in his stocking instead of toys. It's delicate and very French in spirit, as you can see, and it sustains the note sounded by Messrs. Koch, Lobrichon, and other so-called painters.

I shall now sum up, for it is time to close. The present exhibition is, like those of preceding years, the bold negation of modern art as we conceive it. In painting as well as in sculpture, it is the insolent triumph of skilled conventionalism. [. . .]³

I must reproach myself for a minute for the indulgence I have shown in reviewing most of the paintings by the young official modernists because, for lack of talent, they almost covered up their desire to get rid of the ball and chain the school had tied to their ankles. None of them has had the strength to break out of the irons. From Cabanel to Gérôme, from Gérôme to Bouguereau, from Bouguereau to Meissonier, we came down to Firmin-Girard, Toulmouche, and Vibert.

We have come to the last rung on the ladder. The cesspool gives off whiffs of its foul odor. If it is possible to descend even lower still, I ardently hope that they will, for then the end of these Mardi Gras festivals will be near.

Translated from J. K. Huysmans, "Le Salon de 1879," *Le Voltaire*, May 17, 1879, as reprinted in *L'Art moderne* (Paris, 1883).

1. The author is referring to the Parnassian school of French poets, whose first collected works were published in 1866.

2. [Huysmans:] Once and for all I should like to explain what I mean by the generic terms I am obligated to use in these articles. In spite of the systematic injustice and narrow-mindedness of putting people with individual talent and different opinions into the same category, I could not divide the impressionist painters, such as Messrs. Pissarro, Claude Monet, Sisley, Guillaumin, Gauguin, Cézanne, and Miss Morisot, and all the artists who are called independents, such as M. Degas, Miss Cassatt, and Messrs. Raffaëlli, Caillebotte, and Zandomeneghi into two different groups. My reasons for not making this distinction are the following: first of all, if I had done this, I would necessarily have left something out, because points of comparison between the two groups were lacking as a result of the absence of certain impressionist painters who did not exhibit their works during the three-year period of these exhibitions [1879–81]; and, second, I would have had to consider very minute details and open myself to the danger of possible errors if I had tried to place artists like M. Renoir in one group or the other. He abandoned the impressionist formula and then afterward took it up again. I could not classify M. Forain, either, because he got off the track marked out by M. Manet, and now he is following in the direction of M. Degas.

Nevertheless, I had to separate these painters from the official painters. Thus, I made no distinction between the known, comprehensible, commonly used names of impressionists, intransigents, or independents. This choice alone allowed me to stay within the tight limits I had marked out for myself: I simply wanted to show the parallel movement of the independents' exhibitions and the official exhibitions of recent years, and to bring to light the artistic consequences that have resulted

from this parallelism. [The fourth exhibition of the Impressionists, with fifteen participants, was held at 28 avenue de l'Opéra, April 10–May 1.]

3. [Huysmans:] I have forgotten something. I passed over in silence the plates on which some poor porcelain designers in long black aprons have copied paintings by Messrs. Chaplin and Compte-Calix. On the whole this omission is better, because it would be unseemly to spoil with a sarcastic laugh the glorious pleasure experienced by fathers, husbands, or lovers when they see the work of their loved ones hung with white numbers on one of the walls of the exhibition.

Naturalism at the Salon [1880]

EMILE ZOLA

I. This year the opening of the Salon has singularly agitated the artistic world. During the twenty years that I have followed the exhibitions, I have noticed that there is no one more difficult to satisfy than painters and sculptors. Soon I will try to determine the reasons behind their nervousness.

In the meantime, here are the facts. The undersecretary of state for the fine arts, M. Turquet, aided by his employees, has ambitiously desired to link his name with some reforms. This is a characteristic trait of every new administrator who, believing he holds the artistic glory of France in his hands, finds himself in the grip of an extraordinary attack of zeal. He immediately dreams of endowing us with great men, and he has the odd hope of creating them to order. Therefore, M. Turquet has come in his turn to modify the organization of the Salon. He has concentrated above all on the classification of the works exhibited. Before him, paintings were hung in series in the galleries merely in alphabetical order; he, being a man of order, has created four categories: the artists *hors concours,* the artists who have a right to be exempt from being juried, the artists who do not have that right, and last, the foreign artists. At first glance, this seems innocent: there are four groups, logically established, and it seems to be an excellent measure. Ah, well! you cannot imagine the turmoil that M. Turquet's classification has caused. No one likes it, all the painters are protesting, the studios are in a state of revolution.

The painters *hors concours,* those who can receive only the grand medal of honor or the cross, have come out the best; for despite their small number, they have been given almost as many galleries as the exempt artists, which has permitted them to hang all their paintings at eye level in a single row. The question of good or bad placement is a question of primary importance in the Salon. Every artist dreams of being at eye level and in the middle of a panel. However, the *hors concours* have still not declared themselves satisfied. A fact that should have been anticipated has made them ill at ease in their isolation. There are among them artists démodés, who had their successes around 1840 and who today send abominable canvases to the Salon, in front of which the jury is supposed to bow. When these canvases are lost in the mass of paintings exhibited they are almost unnoticeable. But today they are set apart, very much in view with plenty of

elbowroom; crushed by the nearness of the greats of the present hour, they appear, in their lamentable mediocrity, to be very nearly comical. Certainly one does not find among the nonexempt, among the untalented students whose masters' influence gains them entrance every year, painters so devoid of all original qualities, which has given rise to the accurate saying that the worst paintings in the Salon hang in the *hors concours* gallery. Some of this was expected, but the result truly exceeds the anticipation. This is perhaps one of the most useful consequences of the classification invented by M. Turquet. In the future, if the jury is continued, all works should be submitted to it, for it is ridiculous to say that a painter who was recognized in 1840 has received through this a diploma of eternal talent. Can you imagine the astonishment of the public, placed in front of grotesque works presented to it as the flower of the French school? The *hors concours* artists who are in fashion today are therefore very annoyed at being in the neighborhood of these outmoded painters who remind them that, lacking originality, there is only premature aging. It is the ragpicker in tatters standing in the path of a girl dressed in silk whose carriage splashes her with mud.

As regards the exempts and nonexempts, they are furious with an administration that has packed them into the galleries, that has hung their paintings up to the cornices, when the *hors concours* are given so much room. [. . .]

And that is not all. Here now are the foreign artists with their complaint. These articles claim that when they come to exhibit in France, it is to be placed with French artists and not to be set off by themselves as is done at the universal expositions. I would say that this complaint seems to be valid. A foremost consideration with many foreign artists is to compare themselves with French artists, and they regard it as an honor to be placed among them. If they are segregated, it is as though they were left at home. Moreover, it must be said that most of them are mediocre, and the public neglects the galleries into which they have been stuffed. In this passion for dividing and classifying everything, why not exhibit on one side painters born in Paris, and on the other painters born in the provinces?

For these reasons M. Turquet's reforms have been badly received. They accomplish nothing useful; they have simply made the weakening of certain *hors concours* painters visible, which their friends should have prevented from happening. I see no advantage in groups that disorient the public used to an alphabetical order; to find a particular canvas this year a real effort is necessary, a pursuit through a deluge of paintings. However, if the entire scheme of classification is not particularly happy, it is not a disaster either. It is an experiment without serious consequences which does not seem to be successful, that is all.

If I have spoken at length of this, it is above all to show how difficult it is to please artists; and this brings me back to my starting point. The situation of our painters and sculptors must be clearly seen. All the difficulties stem from the fact they have, or believe themselves to have, need of the administration. It is taken as a principle that the state alone can make the arts live, because it distributes commissions; in effect it is the state which, almost alone, buys statues and decorative paintings for public buildings. From this comes the fundamental idea of admin-

istrative intervention. The whole skein unwinds as a result: the Ecole des Beaux-
Arts for the general instruction of artists, then the Ecole de Rome to place proven
talents in a hothouse, then the rewards and the commissions that support good
students to the end. This guardianship takes the artists from the cradle to the
grave. Naturally such customs, such an education and existence, have had over
the years an influence on the way our painters and sculptors exist. Compare them
for a minute to writers, for whom the state does nothing, and you will feel their
dependence, their abasement in front of bureaucrats, their continual need for
being supported, encouraged, bought. Bit by bit they have formed a conviction:
the state owes them everything—the lessons that teach them, the Salons that show
off their works, the medals, and the money that pay them. From this come their
demands of the administration, their fury when it does not satisfy them, the
continual embarrassment in which they place the state in imposing on it the
difficult problem of pleasing them all, both those who have talent and those who
do not.

Such are the facts. The situation between the administration and the artists
resembles that which inevitably occurs between ill-mated couples. There are argu-
ments; one does everything possible, goes to every length, the other is never
satisfied. [. . .]

It would form a curious history if one were to list the efforts that the admin-
istration, driven every year to extremes, has undertaken during the past twenty
years to please artists. Starting only in 1863, the year of the first Salon des Refusés,
the state began upsetting the regulations, first evicting the Institute,[1] then piece by
piece giving to the artists themselves the right to elect the jury. Thus it started
down the fatal slope of concessions, like any absolute power conquered by liber-
alism. And the worst is that today it has still not satisfied anyone; there are always,
among its administrators, its exhibitors, or its *refusés*, malcontents who insist on
new reforms, who demand further advances along the path of liberty.

Isn't this a curious situation? Let us study for a minute the singular effect of
state protection. Just now I was depicting a small band of artists existing under the
guardianship of the administration from the Ecole des Beaux-Arts to the Institute,
and coming to be unable to do without this guardianship, regarding it as its right.
This is the reason that even the most independent artists of talent almost always
remain servile men, crouched on their knees before a bureaucrat. This is the
reason why those who proclaim their emancipation the loudest are not the
quietest when it comes to blaming the administration for every one of their
failures. [. . .]

Many painters come and complain to me: "This is an indignity, you should
write this, you should write that!" I smile, I try to make them understand that
those questions do not reflect on their talent. The Salons, whether they are orga-
nized well or poorly, remain at this point the best way for a painter to become
known. Undoubtedly there are disturbances to self-esteem, all the difficulties and
all the wounds of the battle of art, but what does it matter; it is sufficient to paint
great works, and even if they are refused for ten years and badly placed for

another ten, they will always finish by having the success that they deserve. This is what must be said. Obstacles deflect only the mediocre. It is to be noted also that the artists who complain the most are the least talented. They dream that the administration owes them talent, and they are furious with it when success does not come. So much for the weak, who fall to earth crushed by the strong: it is the law of life. When one is young it is possible to dream of administrative reforms; one can believe that just measures will make of art a happy and rapid road. But when one has grown old in its production, when one has recognized human stupidity and the necessity of battle, one loses interest, more or less reasonably, in all these regulations. And believing only in work, one says to oneself, best is to have a great deal of talent and to make use of the means that one has available in order to show it in public. The rest does not matter to strong men, and only strong men exist.

However, simply out of curiosity one may ask where the frightened administration is going in the midst of the ever-growing demands that carry it away. In former times the Institute was the only master. It was the body that accepted and paid for paintings; the administration was there only to furnish the space and deal with financial questions. The situation was therefore very tidy. The Institute had a body of doctrine and applied it logically. It might show itself narrow in its judgments, but nevertheless it had a well-defined line of conduct that gave to the Salons an absolute significance. Certainly the classical despotism of the Institute is not to be mourned, but it must be said that the mess began the day the administration dispossessed the Institute and gave its role to elected juries. The democratic evolution has continued from then on; we are moving toward universal suffrage. I do not wish to go on at length here, to study the advantages and the inconveniences of the new regulations. It is sufficient to observe that the Salons are becoming more and more crowded bazaars. Inevitably the day will come when the doors will be flung open to every work that offers itself. This year, for example, it is difficult to see what might have been refused. It is a deluge, a flood—7,289 paintings, drawings, or statues are exhibited, when in earlier times the Institute accepted at most a few hundred. You can see how far down the road we have come. Naturally there are no more rules, no dogma that decides whether or not works will be accepted. We are in a state of anarchy, and that is excellent: but we are also in a state of masters protecting their students in the fickleness of cronyism, which is bad. The jury that accepted sentimental turpitudes from young *pensionnaires* still refuses certain carefully conceived works by innovative artists of real value. Therefore I see only one possible end, and not far distant: the dissolution of the jury, all the works exhibited only through the intermediary of the administration. I repeat, the old Salons are dead, we are inevitably coming to a warehouse, a general store of paintings, kept open at the expense of the state. It is certain that even that will not be enough to satisfy everyone, because there will always be the question of the more or less advantageous places. But at least that will be a logical scheme of organization; one must either have dogma, the Institute, or else complete liberty, the warehouse open to all procedures.

Here I am being logical, without being unaware of how much the word "warehouse" will annoy artists. As soon as everyone can enter, there will no longer be any prestige in exhibiting. Also, there are awards which will have to be done away with. It will be the end of a world. No more abasement—the artists will have to carry the heavy burden of their regained liberty. That is what makes me believe that the future is still pregnant with new regulations and new quarrels. Actuality marches on, men devour each other; but this does not prevent great painters from being born. And that is what must be repeated as we conclude this: talent accommodates itself to the administrative organization as it finds it, and it is talent all the same.

II. [. . .] Now I come to the influence the impressionists have on our French school. This influence is considerable. I use the word *impressionist* here because a label is necessary to designate the group of young artists who, following Courbet and our great landscapists, have devoted themselves to the study of nature; otherwise this term seems to me a narrow one and does not mean a great deal. Courbet was a master craftsman who left imperishable works, where nature is recreated with extraordinary power. But the movement has continued after him, as it continues in literature after Stendhal, Balzac, and Flaubert. Artists have come who, certainly without having Courbet's sureness and beauty of execution, have enlarged the formula by making a more profound study of light and freeing themselves increasingly from academic formulas. Actually, as a craftsman Courbet is a magnificent classic painter who remains in the larger tradition of Titian, Veronese, and Rembrandt. The true revolutionaries of form appear with M. Edouard Manet, with the impressionists Messrs. Claude Monet, Renoir, Pissarro, Guillaumin. They propose to leave the studio where painters have immured themselves for so many centuries and go out and paint in the open air, a simple act whose consequences are considerable. In the open air the light is no longer uniform, and from this come infinite effects which diversify and radically transform the appearance of objects and persons. This study of light in its thousand fragmentations and recombinations is what has been called more or less accurately *impressionism,* because a painting becomes from then on the impression of a moment experienced in nature. The wits of the press have gone on from there to caricature the impressionist painter as seizing impressions on the wing with four unformed strokes of a brush; and it must be admitted that these attacks have unhappily been justified by certain artists who content themselves with too rudimentary sketches. In my opinion, nature should be caught according to the impression of a minute; only this moment must be fixed forever on the canvas by carefully studied brushwork. When all is said, no solid achievement is possible without a great deal of work. In addition, notice that evolution is the same in painting as it is in literature, as I mentioned a minute ago. Since the beginning of the century, painters have been turning to nature by very noticeable stages. Today our young artists have taken another step toward truth in wanting to bathe their subjects in the true light of the sun and not in the false light of the studio. It is like the chemist or the

physician who returns to the sources in placing himself where he can observe the actual phenomena. From the moment one wishes to paint life, one can but take life in its entirety. In painting this means the necessity of open air, of light studied in its causes and effects. This appears simple to state, but the difficulties begin with the execution. Painters have sworn for a long time that it is impossible to paint in the open air, or even with a ray of sunlight in the studio, because of the reflections and continual changes in the light. Many still continue to shrug their shoulders in front of the impressionists' attempts. One must be a painter in truth to understand all that must be overcome, if one wishes to accept nature with its diffuse light and its continual variation of colors. Most certainly it is easier to tame light, to bend it by the aid of shades and curtains so as to obtain fixed effects; only then one remains purely in the field of convention, in an ordered nature, in academic "pouced drawing."[2] What stupefaction for the public when certain canvases painted in the open air at definite hours are placed before it. It remains gaping before blue grass, violet earth, red tree, rolling waters of all shades of the spectrum. However, the artist was conscientious; he did, perhaps, in reaction, exaggerate a little some of the new colors his eye observed. But the basic observation is absolutely true: nature has never had the simplified and purely conventionalized notation given it by academic tradition. From this comes the laughter of the crowd faced with impressionistic paintings, despite the good faith and very honest efforts of the young painters. They are treated like jokers, like charlatans, contemptuous of the public, who advertise their works to the sound of a bass drum, when on the contrary, they are strict and dedicated observers. People do not seem to know that the majority of the crusaders are poor men who die of want, misery, and exhaustion. These martyrs for their beliefs make odd jokers.

Here, then, is what the impressionist painters have to bring: a closer research into the causes and effects of light, influencing outline as well as color. They have accurately been charged with having been inspired by those Japanese prints which are so interesting and are today in everyone's hands. These prints should be examined here to show what this clear and refined art of the Far East has taught us Occidentals whose ancient civilization prides itself on being all-knowing. It is certain that our dark painting, our academic bituminous painting, found itself surprised and took up studying again when faced with those limpid horizons, those beautiful vibrant areas of the Japanese watercolorists. There was a simplicity of means and an intensity of effect which struck our young artists and led them into a path of painting drenched by light and air, which all new talented arrivals of today follow. I do not speak of the Japanese art of exquisite detail, of their refined and accurate drawing, of all their naturalistic fantasy, which ranges from direct observation to the strangest extremes. I would like to add, however, that if the influence of Japanese style has been excellent in extricating us from traditional bitumen and showing us the blond gaieties of nature, a sought-after imitation of an art which is neither of our race nor of our surroundings would finish by being no more than an unbearable fashion. Japanese style is good, but it must not be used everywhere or art will become a bauble. Our strength is not

there. We cannot accept as the last word in our creation this willfully overnaive simplification, this fascination with flat colors, this refinement of the line and colored *tâche*.[3] All this does not come to life, and we should make things come alive. [. . .]

Translated from Emile Zola, "Le Naturalisme au Salon," *Le Voltaire*, June 18–22, 1880, as reprinted in F. W. J. Hemmings and R. J. Niess, eds., *Emile Zola, "Salons" (Société de Publications Romanes et Françaises 63)* (Geneva, 1959), pp. 233–43.

 1. In 1863 Napoleon III signed a decree that transferred the Ecole des Beaux-Arts from the Institut de France, under whose direction it had been since 1793, when the Académie Royale had been abolished and replaced by the institute, to the Superior Council of Instruction.

 2. Zola is here referring to one method of transferring a composition from a drawing to canvas. First small holes are pricked along the drawing's outlines and then a powder (*pouce*) is forced through these perforations. The result is a reproduction of the original composition in the form of small dots on the new surface.

 3. *Tâche*, literally a blob or splotch of color.

The Official Salon of 1880

JORIS K. HUYSMANS

II. M. Gustave Moreau is a unique and extraordinary artist. He's a mystic who is shut away in the middle of Paris, in a cell which even the noise of contemporary life pounding furiously at the doors of the cloister cannot penetrate. Engulfed in ecstasy, he sees the dazzling, enchanting fantasies and the bloody apotheoses of other ages.

He was obsessed by Mantegna and da Vinci, whose troubling princesses reappear in his mysterious black and blue landscapes. Then he became enchanted by the hieratic Indian arts and by the two schools of Italian art and Hindu art. He was finally spurred on by Delacroix's feverish colors and brought forth his own art, a new, personal art whose alarming flavor is quite disconcerting at first.

Indeed, his canvases do not quite seem to belong to the realm of painting as such. In addition to the extreme importance M. Gustave Moreau attaches to archaeology in his work, the methods he uses to make his dreams visible seem to have been borrowed from old German engraving techniques, from ceramics and jewelry making. There is a little of everything in his painting—mosaic, black enamel, Alençon lace, patient embroidery of former times, as well as the colored print of old missals and barbarous watercolors from the ancient Orient.

It is even more complex and more indefinable than that. The single analogy that might exist between these works and the ones he has created up until now can only be found in literature. When you look at his paintings, you have a sensation almost like the one you feel when you read certain strange and charming poems from *Les Fleurs du Mal* by Charles Baudelaire, such as "Le Rêve," which is dedicated to [the painter] Constantin Guys.

M. Moreau's style might even be closer to the Goncourt's wrought-work

language. If it is possible to imagine that Gustave Flaubert's admirable, definitive *Tentation* were written by the authors of *Manette Salomon,* then perhaps we would have an accurate point of comparison with M. Moreau's delightfully refined art.

The *Salomé* that he showed in 1878 lived a strange, superhuman life. The canvases he is showing this year are no less singular, no less exquisite. One portrays Helen [of Troy] standing up straight, highlighted against a terrible horizon spattered with sulfur and streaked with blood; she is wearing a dress encrusted with precious stones like a shrine. Like the queen of spades in cards she holds a large flower in her hand. She is walking, and her eyes are wide open and staring fixedly, in a cataleptic state. Piles of dead bodies pierced with arrows are lying at her feet and, in her august, blonde beauty, she stands over the carnage, majestic and superb like Salammbô[1] appearing to the mercenaries, and quite like an evil goddess who unwittingly poisons everything that comes near her or everything she sees and touches.

The other canvas shows us Galatea naked in a grotto, being spied upon by Polyphemus' enormous face. With this painting especially, all the magnetism of this visionary's brush bursts forth. The grotto is a huge jewel box where the light falls from a lapis lazuli sky and a strange mineral flora sends out its fantastic shoots and intersperses the delicate laces of its unbelievable leaves. Coral branches, silver boughs, and tawny, filigree sea-stars spring forth at the same time as do green stems bearing both fantastical and real flowers in the cavern, which is illuminated by precious stones and which contains the inimitable, radiant jewel—the white body and pink lips and breasts of Galatea, sleeping soundly with her cheek against her long pale tresses.

Whether or not you like these fairy scenes hatched in the mind of an opium smoker, you must admit that M. Moreau is a great artist and that, today, he stands far above the banal mob of historical painters.

However, they are all great artists, if I may believe the clichés brought out regularly every year at this time. The painter of *Honorius*[2]—which shows a swarthy kid, wearing a red mask and a crown, who is the sort of street urchin we have seen in the streets of Paris playing hopscotch on the sidewalk or crawling on his knees between the legs of clients on cafe terraces to pick up cigar butts and used pipe tobacco—is a "great" artist. M. Puvis de Chavannes is an even "greater" artist, but his jesting has perhaps gone on too long. He works in the realm of the "sublime," which is a specialty like the one adopted by M. Dubuffe, who works in the realm of the "pretty." M. Puvis de Chavannes puts people in awkward poses and arranges them clumsily in groups. He does not trouble himself to find exact tones, and his figures and the surroundings where they display their heavy ankyloses have no resemblance whatsoever to truth and life. Criticism sees all of this as primitive naiveté, a fresco, a decorative machine—as sublime, great art à la Bornier and I don't know what else!

On the other hand, I willingly recognize the complete success of the attempt made by M. Cazin. In his work there is no affectation of simplicity, which shocked me so much in M. de Chavannes's painting. In his gentle and melancholy land-

scapes covered with blossoming yellow broom plants and green pine needles, the true simplicity of the figures gives them real grandeur. With subjects that have been treated over and over for centuries, M. Cazin has found a way to create very original, very bold painting. To keep nothing back, the titles of his paintings lie, for his characters are hardly biblical. Hagar, the Egyptian chambermaid, and her son, Ishmael, are in the artist's painting two modern figures, and M. Cazin has not portrayed their abandonment in the desert, which was described in chapter 21 of Genesis, but instead the anguish of a poor distraught peasant woman who is sobbing, her face in her hands, as the child holds out his arms to embrace her. *Ishmael* [fig. 74] is thus a contemporary work, and the emotion we feel when we see it comes precisely from the fact that these are not legendary characters whose misadventures mean very little to us, but from the fact that this is a terrible scene from real life, portrayed frankly and sincerely by a true artist. The *Tobias* is conceived and painted in the same way as the portrait of Ishmael—without effort or trickery, in charming pearl gray and pale yellow tones.

As for the other canvases that belong to the category of historical painting— what good is it to speak of them? As soon as I have mentioned M. Monchablon's comical portrait of *Victor Hugo* standing on a rock in the midst of a storm, pulling his polytechnic-school cloak around his shoulders, and M. Bonnat's portrait of *Job* [fig. 75], I have certainly touched the bottom of the barrel and taken out the best there is to take.

This *Job* is the spitting image of the late Celica, the rat man who used to work on the Place des Invalides. It is true that this artist himself looked exactly like all those old models who went from one studio to another, from Vaugirard to Clichy and from Clichy to the Batignolles. Judging by the considerable number of paintings in which their bearded faces appear, this work seems to have paid off for these good fellows this year. Among other things I point out the old dotard who appears as the main figure in M. Cormon's very mediocre *Cain*.

To come back to Job, the old man is painted kneeling on two mats of straw, in a joyous transport which must very well have earned him his five francs an hour. The trompe-l'oeil technique has never been used so immoderately. I have never before seen this plasterer called Bonnat produce such laborious, strained painting with his heavy trowel. It is painted wrinkle by wrinkle and wart by wart on the eternal blackish background, which plays down the pale color of the sad flesh lit up by violet candlelight. And what can I say about the portrait of *M. Grévy,* who is posed like a broomstick against a gloomy background lit up from above, no doubt, by a sash window which lets pale bluish glimmers falls on M. Grévy's face and on his hands, affectedly touched up with a thousand elaborate details. This is a most illiterate portrait, a stereotype if there ever was one; it's the product of a foreman's manual dexterity and careful work, and that's all.

This opinion may also be applied to the canvases by M. Carolus-Duran, although he adds something extra to his paintings—some rather curious, athletic work. He's the man in the circus who lifts barbells in response to the cheering of the crowd. Or, rather, he's the clown who parodies the strong men after they have

finished their tricks; he, too, juggles with barbells which look real, although they are only made of empty cardboard. After the blue child of preceding years, this time we have a child in red, pretentiously posed in scarlet clothes, against a purple background. The exercise is red on red. The clever feat is performed, but what is it worth, with this doll-like figure which is not at all alive and this riot of colors which will fade in a year? [. . .]

M. Goeneutte's painting is also artificial modernism and elegantly painted and arranged contemporary life. The same is true for *An Accident* by M. Dagnan-Bouveret [fig. 76]. A child has cut his hand and there's enough blood to fill a wash basin! How pale his face is! What a melodrama, what a dramatic scene! After the photographer's studio comes the cut finger and after the smile, the tears! It's a success all the way down the line. [. . .] Women get dizzy when they see this red washbasin and these bloodstained bandages. But it's not blood that should stream from this pale little doll's finger—it should be pretty yellow stuffing! Truth imperiously demanded this sacrifice, but, as usual, M. Dagnan refused to make it. He's a good partner for Messrs. Bastien-Lepage and Gervex. From now on, we shall have to reckon with him, for, like Bastien-Lepage and Gervex, he seems determined to monopolize the public's affection by any means possible.

I cannot be too insistent about the fact that these canvases show no signs whatsoever of artistic temperament and endeavor. They are the exact opposite of modernism. The independents are decidedly the only ones who have really dared portray contemporary life.[3] Whether they paint dancers, like M. Degas, poor people, like M. Raffaëlli, middle-class people, like M. Caillebotte, young girls, like M. Manet, or the goings-on at the Folies-Bergère, like M. Forain, they are the only ones who have given a special, clear picture of the world they wanted to paint.

For reasons that are unknown to me, M. Manet shows his paintings at the official exhibition. And, for other reasons that are even more unknown to me, he generally has one painting out of two on sentry duty, in the foreground of the gallery. It is very strange that they have decided to find a decent place for an artist whose work advocates insurrection and that they have tended to sweep the piteous plasterings of the old art sicknurses into the corner! However, the selection committee has managed this year to put an exquisite painting by this artist, *At Old Lathuile's,* on the third floor, while a less exquisite portrait by the same artist—the portrait of M. Antonin Proust, which is interesting in its execution, but empty and full of defects—has somehow been hung on the ground floor. Unfortunately, I find with this portrait that the face seems to be lit up from the inside like a night-light, and the suede gloves have been inflated, but there is no flesh inside them. On the other hand, in the *Old Lathuile,* the young man and woman are superb, and this bright, lively canvas is surprising, for it actually sparkles when compared to the rancidity of all the official paintings around it. This is the modernity of which I was speaking! In the open air, in true daylight, some people are having lunch. The woman, with an affected expression on her face, is so alive, and the attitude of the young man, who is terribly eager because of this bit of good or, rather, bad luck, is very expressive and accurate! They chatter on, and we

know very well what kind of inevitable, wonderful platitudes they are telling each other in this tête-à-tête, as they sit before their goblets of champagne. They are being watched by the waiter, who is getting ready to give the signal, from the back of the garden, announcing the arrival of a foul, black champagne in a dirty coffeepot. This is life rendered without affectation, just as it really is. Precisely because of this genuine quality, this is a bold piece of work which is unique, in this copious exhibition, from the point of view of modern painting.

Other equally audacious paintings have also been displayed by M. Manet in a private exhibition.

One, *The Dressing Scene,* portrays a woman who looks exactly like a prostitute; she is wearing a low-cut dress, and a wisp of hair from her chignon is falling over the V of her breasts as she attaches a garter to her blue stocking. One of M. Manet's most constant preoccupations has been to envelop his characters in the atmosphere of the milieu to which they belong.

His work is pure and free from the pipe juice and all the old stuff that have dirtied up canvases for such a long time. Beneath its blustering appearance, it often has a caressing touch. The drawing is concise but staggering, like a bouquet of bright spots in a silver and blond painting.

In this exhibition there are also several portraits done in pastels; for the most part, the tones are very subtle, but it must also be said that they seem lifeless and hollow. Although Manet has many good qualities, they are not all completely developed. Of all the impressionists, he has been of very great help to the present movement by adding a new revelation—the experiment in the open air—to the realism that Courbet implanted, especially in the choice of subjects. On the whole, Courbet used the usual formulas, which he embellished with abuses of the palette knife, to treat subjects which were less conventional, less approved, and sometimes even sillier than the subjects treated by others, but Manet overthrew all the theories and all the customs and pushed modern art in a new direction.

The parallel stops here. In spite of his old-fashionedness and his ignorance of values, Courbet was a skillful artist.[4] Manet was not at all strong enough to impose his ideas with a powerful work. After the trouble he had disentangling himself from the imitations of Velásquez, Goya, Theotokopoulos [El Greco], and many others, he wavered and rambled. He pointed out the direction to follow and then himself remained stationary, at a halt before the albums from Japan, struggling with the stutterings of his drawing and fighting against the freshness of the sketches he spoiled by working on them so much. All in all, M. Manet has now been outdistanced by most of the painters who could formerly, and rightly, consider him as a master.

Since we have spent so much time walking outside the state warehouses, let us now stroll past the exhibition of M. de Nittis' works in the art galleries.

In 1879 M. de Nittis had a great success with his views of London grouped at the Champ-de-Mars in the Italian section. Indeed, a few of his canvases were worthy of being extolled. Impressions of districts drenched in fog, bridges crossing dreary rivers lashed by rain and immersed in mist were all spiritedly rendered.

Here on the avenue de l'Opéra, a whole series of pastels is going to attract and charm us with its amusing ragout of vivid colors.

Only the *Tuileries* [fig. 82] is unrecognizable. The obelisk and the Arc de Triomphe look as though they were I don't know how many leagues away from the Carrousel. It seems that this landscape was seen from a tower or from up in a balloon. Add to that some sly deceits: M. de Nittis removes a pond that bothers him, and on the quay the sidewalk seems narrow to him, so he widens it; the Esplanade des Invalides seems short to him, so he makes it a third longer.

On the other hand, he has done a truly enticing panel entitled *Woman in White behind a Venetian Blind*. A Parisian Japanese woman in a wrapper is holding a red fan and looking at you with a smile on her face, while the shutters of the Venetian blind crisscross her face with alternate rays of light and shadow.

In short, M. de Nittis has talent. In art, he is between M. Degas and M. Gervex—he is neither official, nor independent, but right in the middle. He's a charming, whimsical painter, a gracious, delicate storyteller. [. . .]

Now we have only to go back to the Champs Elysées and wander briefly through the galleries of black and white work.

If, as I have already said, the poverty of the innumerable panels smeared with colored oil paint is beyond all measure, what can I say now of the mass of wood engravings, sketches, lithographs, and etchings? In the office where this heap of stuff has accumulated, there is a radiant apotheosis, an enchanting assumption of worthless plates.

First of all, the exhibitors from these groups may be divided into two classes.

There are those who use any technique whatsoever to reproduce paintings for so-called artistic magazines,

And there are those who work for editors as illustrators of books.

The first category is hardly worth considering. For the most part, the people who belong to it are skillful workmen. They diligently copy the landscape, the still life, or the human scene which has been entrusted to them and, according to the number of years of apprenticeship they have done, they can interpret a painting by Rembrandt just as well or badly as a linen drapery by Lobrichon.

It's manual dexterity and that's all. Since Jacquemart's death, M. Léopold Flameng has rightly been considered one of the most skilled foremen in this factory.

The second category works exclusively in the style of the eighteenth century. I shall concern myself more especially with it.

All of them slavishly carry out the orders of the booksellers who in turn are only submitting to the platitudes of public taste. Today, in order to please this mob of buyers who shop for so-called luxury books because they are prestigious or in vogue, they have to bring out all the affectations of the last century, stamp chamois paper and artificial purfling with elzevirs,[5] connect up all kinds of little rosettes and tailpieces—doves cooing inside decorated letters, cupids brandishing torches and sticking out their bottoms, volutes, chicories, shells and twists printed in black, blood red and bister—and sew the whole thing up in a pillbox cover

whose sides are plastered with those gaudy labels so dear to candy manufacturers in France! [. . .]

Translated from J. K. Huysmans, "Le Salon officiel en 1880," *La Reforme*, May 15, June 1–15, July 1, 1880, as reprinted in *L'Art moderne* (Paris, 1883), pp. 143–86.

 1. *Salammbô*, Flaubert's famous novel of 1832.

 2. Jean-Paul Laurens, who specialized in historical subject matter such as the fifth-century Roman emperor Flavius Honorious.

 3. The fifth group exhibition of eighteen Independents was held at 10 rue des Pyramides, April 1–30.

 4. [Huysmans:] Since these lines were written, I have had the opportunity to see Gustave Courbet's almost complete works again. What a disappointment! The canvases deemed worthy of being compared to certain indelible works in the Louvre had become incoherent signboards! The allegory of *The Studio* seems to me like a terrifying blunder imagined by an uneducated man and painted by an old workman. And what can I say about the seas of marble and the skies of iron of the *Young Ladies of the Seine*—this group of water nymphs which is arranged in such a banal way and painted in such a heavy style? And, finally, what can I say about these two practically naked women in *The Awakening*, which is as cold and lifeless as works by Gérard, whose distressing memory it evokes? With Courbet, we simply come back to the most exasperating old habits in painting. In my opinion the talent of this man is a perfect myth, which has been perpetrated by all the critics and approved by M. Antonin Proust [director of fine arts, who wrote criticism under the pseudonym A. Barthélemy; see part 1, Paris 1900].

 5. A decorative border of a book ornamented with a particular style of type invented by the Elzevir family of Leiden in the seventeenth century. Huysmans is here deriding his contemporaries' passion for collecting fine editions.

The Official Salon of 1881

JORIS K. HUYSMANS

. . . Let us now put aside the elegies and all these masculine niceties and take up the purely democratic or patriotic works. Let us walk by the *Bastille* by M. F. Flameng, who is still painting subjects recommended by M. Turquet and who is still carving his little crystal figures and painting the flesh of his figurines and the copper of his drums in the same tones, and then let us stop before M. Cazin's *Holiday Memory*.

Let us try to understand, if possible, this strange enigma. The cupola of the Panthéon, delineated by jets of gas, stands out against a steel-blue sky decorated with the inscription "Concordia." Three figures are perched on a scaffolding. One has a rifleman's casque on his head and a bathrobe over his naked body; another is seated, wearing a white dress; and a third, who is standing, is offering a golden bough to the other two. Do you understand?—No. M. Cazin seems to have suspected that his canvas is incomprehensible, so, in golden letters, below a rocket describing a parabola in the sky, and above the rifleman, he has written "Virtus," and above the woman with the bough "Labor," and above the seated woman "Scientia." Do you understand better now?—No, of course not. Well, I don't either! Let's see . . . Work is giving a bough to Virtue, with the full approval of Science—and all of that is called Harmony. It's the symbol of virtuous, peaceful

France—it's virtue resulting from the coupling of harmony and work; it's the personification of the century which is, so they say, a century of science; it's peace obtained through work and thanks to the courage of the army, symbolized by the casque. If not, what is it, then? And what does the symbol of this noisy, useless celebration have to do with this obscure abstraction? However I look at this subject, it seems ridiculous and vague, but what is even worse, M. Cazin, who is a man of talent, has completely foundered. Let's just say it—his painting is frankly very bad. The figures are weak and frozen in their poses; the drawing is heavy, the colors frail, the tones obstructed, the lighting comes from I don't know where and seems borrowed from Schalken's candle.[1] However, this is where the painting of ideas, sentiments, and so-called profound subjects can lead!

In his *Country Fair* in the Louvre, Rubens did not do this kind of painting. Nor did Brouwer or Ostade. In their canvases people urinate and vomit, and in a canvas by Brueghel the Elder in Haarlem, as well as in an etching by Rembrandt, they go even farther—they perform the act that is considered to be the most repulsive of all by well-bred people. And, yet, it's admirable painting—painting which is grander and bolder than M. Cazin's! These people reek of the soil of their homeland, and they cheat and drink without thinking subtle, profound thoughts. Yet they are painted with a superb style that neither the Laurens, the Chavannes, nor the Cazins will ever attain, in spite of all the recipes they have learned for creating great art.

Jordaens' woman wiping a child, Terburg's [Terborch] gallant offering money to a girl, Jan Steen's drunkard hanging on unsteadily to the jacket of another drunkard, in the Van der Hoop Museum, are all works of great style. While they are exact, almost photographic reproductions of nature, they nevertheless have the stamp of a particular accent which is determined by the personal temperament of each one of these painters. On the other hand, the *Mignon* and the *Faust* by Ary Scheffer and the religiosities of M. Flandrin are heavy language written without any style, because neither of these two men had a palette that belonged to him alone or an original way of seeing things.

It is thus quite useless for a painter to try out the ways of exalting painting that are used in the schools. It is useless to choose subjects that are supposed to be loftier than others, for subjects are nothing by themselves. Everything depends on the way in which they are treated. Moreover, there are none so licentious or sordid that they do not become purified by the fires of art.

As for the meditations and the thought they suggest, don't you think, to choose a modern example, that the canvases by Messrs. Degas and Caillebotte are more full of food for thought than all of M. Cazin's machinations? The life of a whole class of society parades by us in their paintings, and we are free to reconstruct the life of each one of these figures—their actions and gestures, in bed, in the street, at table—whereas we can only be haunted by incoherent fantasies when we see the puppets M. Cazin arranges so wretchedly. I ask you, how can we be interested in these dolls and their troubles? How can we be touched by these mythologies that he applies to modern life? Like a virus that does not abate, the

original stupidity of painters has reappeared and invaded the brain of a man who had nevertheless been vaccinated by M. Lecoq de Boisbaudran, the only master whose teaching did not decrease the intelligence or increase the ineptitude of those pupils who had the opportunity to learn their art under his direction.

Since we have spent so much time looking at the rebuses and the myths of painting, let us now look at a strange panel by M. de Chavannes: *The Poor Fisherman*. A roughly sketched figure is fishing from a boat; on the shore a child is rolling in the yellow flowers next to a woman. What does this title mean? How is this man a wretched or lucky fisherman? Where and when is this scene taking place? I do not know. It's a crepuscular painting, like an old fresco eaten away by moonglow, drowned by torrents of rain. It's painted in whitish lilac, lettuce green dipped in milk, and very pale gray; it's dry and hard and, as usual, pretentiously naive and stiff.

I shrug my shoulders before this canvas and feel irritated at this mimicry of biblical grandeur, which is obtained by sacrificing the colors to the engraving of the contours, whose angles stand out with affectedly primitive awkwardness. However, I also feel pity and indulgence, for this is the work of a stray sheep, who is also a sincere artist who scorns the public's infatuations and, unlike other painters, refuses to become involved in the cesspools of fashion. In spite of the feeling of revolt that rises up in me when I stand before this kind of painting, I cannot prevent myself from being a little attracted by it when I am far from it.

I cannot say the same thing for M. Blanc's *The Triumph of Clovis*, for example. On a gold background we see Messrs. Gambetta, Clemenceau, and their leader Lockroy, who is crowned by a halo, and also the profile of M. Coquelin, who is dressed as a martyr.[2] This fresco—apparently, it is called a fresco—is an inferior work which, at the very most, is worthy of appearing in an exhibition of Swiss paintings.

Moreover, we will be spared nothing this time. Another monstrosity is being displayed: *Carnot's Office*, a democratic, patriotic still life.[3] Two or three years ago, after a comical circular preaching against the intrusion of republican ideas into painting went around, Duranty began the rumor that the still life was also going to become democratic and, in an affected tone of voice, he predicted that the day would come when someone would paint the office of an influential republican. Everyone laughed and shouted hurrah. Well, it's been done now—the buffoonery Duranty foresaw does exist. It was committed by M. Delanoy and purchased by [the minister] M. Turquet.

What about Robespierre's *thomas* [chamberpot] and Marat's bidet? And, supposing that a new form of government comes to power, when will someone paint Louis-Philippe's umbrella, Napoleon's sounding rod, and Chambord's hernial pincushions?

We haven't spent too much time before the atrocious wretchedness of these canvases. We had to, unfortunately, for if the 1881 exhibition is perhaps more comical than those of preceding years, it's because art has been invaded by militarism and politics.

Now let us carry on to the painting by people who have the reputation of being "modern" in the eyes of the public.

Messrs. Bastien-Lepage and Gervex are in the lead.

The first of these painters is exhibiting a beggar holding out his hand and having a door closed in his face. M. Lepage has stopped strumming on M. Breton's rustic guitar; this time he spares us his rapturous model of potatoes and hay, for which I am grateful to him. Unlike most of his colleagues, he is trying to change. He goes from here to there, imitating Holbein's portrait of the Prince of Wales or approximating Van der Werf and Mieris' portrait of Mr. Wolff. But, with all this movement, is he finding his own personal accent? Has he gotten rid of his old faults, his affected touch, the lack of air in his canvases, and his pretenses of rags borrowed from theater cloakrooms? Certainly not, but he has at least kept his light touch and the technical knowledge of his art, which, unfortunately, M. Gervex lacks. It's sad to say, but this artist doesn't even know how to paint anymore. His *Civil Wedding* might have been signed by Sonthonax, the astonishing man who paints the signs for circus tents. There's no drawing, no color, nothing. M. Gervex is finished—and I am sincerely sorry, for, after his first works, I was one of those who stood by him and believed in him.

This is decidedly a bad year, for M. Manet is collapsing, too. Like a tart, slightly sour wine which has a unique, pure taste, this artist's painting was pleasing and heady. Now it is sophisticated—full of china fuchsia and stripped of its tannin and flowers. His *Portrait of Rochefort,* created according to semiofficial methods, does not hold together. The flesh looks like cheese pecked at by a magpie's beak, and the hair looks like gray smoke. They have no intensity, no life. The nervous sensitivity of this peculiar face has not been understood by M. Manet. I really don't know what to say about his *Pertuiset,* who is kneeling and aiming his gun into the gallery, where he undoubtedly sees some wild animals, while the yellowish figure of a lion is stretched out behind him in the trees. This sideburned hunter, who seems to be killing rabbits in the woods of Cucufa [Kufra], is in a childish pose, and the execution of this canvas is no better than that of the wretched daubings that surround it. To single himself out from the others, M. Manet has smeared the soil in his painting with violet. This novelty is not very interesting and much too facile.

It grieves me very much to have to judge M. Manet so severely, but considering that I have been perfectly sincere throughout this series of exhibitions, I owe it to myself not to lie and not to hide my feelings about the works exhibited by this painter because of party spirit.

I am in a hurry to look at the richer, larger canvases, so I am going to rush through my review of the portraits we are looking at now. I think that it is quite useless to repeat what I have been saying for two years now about certain painters—namely, that, in M. Bonnat's heavy portraits, drippings of phosphorus stand out conspicuously on the foreheads and prominent noses, jumbled with colors of wine dregs and dry brown which become feebler from the top to the bottom of the frame; that M. Carolus-Duran is like a quick, noisy pianist; that M. Boldini's way

of playing is more nervous, and his virtuosity more expressive; and that M. Laurens has borrowed the lusterless, discontented aspect of his portraits of women from Ingres, that old Saint Anthony who exorcises vivid colors. Fortunately, the Fantin-Latours are nearby to make up for all of them. He has an appreciably accurate way of looking at things and a definite colorist's personality, for with brown, black, and gray colors, he is a thousand times more coloristic than all the Boldinis and Durans. Indeed, an artist is not a colorist just because he slaps down some harmonious bright oranges and blues, greens and reds, violets and yellows, or because he finds it pleasing to set reds next to reds or blues next to blues. Velásquez, who worked dull browns sometimes brightened up by tender hints of sulfur yellow and pink into a silver scale, is just as much a great colorist as Rubens, who used full reds, powerful blues, and almost pure whites and blacks. Each of these masters was able to combine his colors in skillful, exact relationships and was able to bring them out in weak or strong, but always unusual, combinations. M. Fantin-Latour has the gift of color, but this year his paintings are the same ones as last year. It's always the same woman posing in the same room. This painter is much too persevering in his immobility.

I shall not direct this same reproach at M. Renoir. Since his balls at the Moulin de la Galette, his landscape, his nooks and crannies of Paris, and his jugglers in a circus, he has produced many varied portraits. The ones shown at the present exhibition are charming, especially the one of a little girl seated in a profile pose and painted with such a choice of colors that it is necessary to go back to the old painters of the English school to find another one like it. M. Renoir is curiously taken by reflections of sunlight on the velvety texture of the skin and by the play of light rays running over hair and fabrics. He has bathed his figures in real light, and you must see the wonderful nuances and the delicate irisations that appear on his canvases! His paintings are certainly among the most savory in the exhibition. [. . .]

Before leaving the painting galleries, we have only to speak about M. Baudry and Mr. Alma-Tadema.

M. Baudry has been commissioned to paint the ceiling in one of the rooms of the Court of Appeals. It is called *Glorification of the Law* [fig. 81]. The painter's idea is neither very adventurous nor very new. It's the eternal decorative ceiling: there is a figure seated at the top of the steps of a temple, women flying overhead, and others crouched near a lion; the whole thing is adorned by a flag and a judge with an aquiline nose and a red robe taking his wig off to Law. However, since it is a matter of convention that these vast scenes are all cast in the same mold, it must be admitted that M. Baudry's figures are elegant and well posed, even though they are based on a single all-purpose model. It's a clear, harmonious scene full of imitations of old Italian masters, but in spite of everything it is superior to the other ceilings prepared by artisans entrusted with similar tasks.

On the Way to the Temple of Ceres, by Mr. Alma-Tadema, takes up less space and is certainly more interesting and more original [fig. 73].

The case of this artist is really astounding. There is no need to recall the works

he exhibited in 1878 at the Champ-de-Mars: *The Audience with Agrippa, The Intimate Feast, After the Dance,* and some panels produced with the delicate skill of the artist and archaeologist. Mr. Tadema's art certainly hasn't Gustave Moreau's mysterious, exquisite style, but it does have a unique touch and a heady quality which combines milk-white colors with Naples yellows and coppery greens and mixes bursts of magnificent reds with the pale and tender assonance of the other hues, as in the field of hedges and poppies blooming in the sunlight in his *Roman Garden.*

When I see these canvases, I cannot help thinking of Gautier's *Avatar,* in which Balthasar Charbonneau, that strange miracle worker, sends his soul to travel far back into past centuries while his empty body remains motionless on a mat. What strange faculty, what psychic phenomenon has allowed Mr. Tadema to remove himself from his time in this way and to depict ancient subjects as if he could see them with his own eyes? I admit that I don't understand and, with a troubled mind, I admire the talent of this man who must feel quite out of his element in the London fog.

On the Way to the Temple of Ceres is a repetition of his other canvases, so I shall not dwell on it. However, since it has brought the artist's name to my attention, I shall take advantage of this opportunity to talk about the works of two of his pupils, two English draftsmen, Mr. Walter Crane and Miss Kate Greenaway, who have created some gems for the New Year's children's albums. As the English and Japanese albums are the only works of art left for us to contemplate in France after the closing of the independents' exhibition,[4] the parenthetical remark I am about to make does seem to have a raison d'être.

Mr. Walter Crane's works are published by George Routledge and Son of London and have been imported to France by Hachette. His children's albums for the New Year may be divided into three groups. The first is fancifully adapted to the translation of fairy tales; the second is purely humoristic, with a few explanatory stories; and the third is modern and tries to express certain characteristics of intimate life.

In the fairy tales there is a unique conception of feminine beauty—a straight nose which seems to be part of a very low forehead, eyes with very large pupils like those of Juno, a small, slightly indented mouth, a very small chin, a high waist, large hips, very long arms, and strong hands with slender fingers. This is the model of Greek beauty, but what is strange is that this woman appears in these sketchbooks in many different costumes and belongs to every age—to the Greek empire period in certain plates from *The Hind in the Wood* and *Sleeping Beauty;* to the Middle Ages in *Valentine and Orson;* to the Renaissance period in *Bindweed* and others; and to the age of Louis XVI in the second plate from *Beauty and the Beast.* It takes nothing more than a barely noticeable deviation of the slightly turned-up nose, and this sculptural figure becomes different; she still has the artist's inalterable touch, but now she is as charming and graceful as one of Marivaux's[5] maidservants chattering on with a London accent. Or, as in *Ali Baba,* she is a Roman with regular features, but she is no longer rigid—she has become supple, and she brings

partly animated, partly sullen Pompeiian elegance into the amusing atmosphere of this Persian fantasy.

Here is another curious fact that I have observed:

In contemporary paintings in France, the painter neglects the composition and seems only to be illustrating an anecdote for a picture book, but in the albums we are discussing, Crane composes true paintings. Each leaf in his books is a small painting: Princess Formosa, who is seated before a pond, in *The Frog Prince,* and Princess Belle Etoile, in the album of the same name, who finds her brothers buried under the enchanted mountain, might very well be careful, stylized canvases at the annual exhibitions. I could mention many other pages of these picture books, signed with the monogram of a crane in a capital C, which are more deserving of a frame than all these lost remnants of canvas hung every May in golden wood all along the galleries of the Palais de l'Industrie.

In this series, however, the only thing is that the memory of Alma-Tadema is always present. Whether he dresses his figures in brocade dresses, disguises them as Japanese, as in *Aladdin,* or keeps them in Empire-style costumes, Crane cannot escape from the influence of his teacher. Even if he uses a wider, more varied scale of colors, if he goes toward harsher tones, more ferocious oranges and greens that are almost black, they are so intense, or if he uses little of Tadema's ash-colored range of hues, his drawing is still not free of the most flagrant imitations. He has the same way of posing his figures, drawing them in motion, foreshortening and muscling them under their clothes with a few brushstrokes, and making their silhouettes stand out in old poses. Even the archaeological preoccupation that makes him match the whole interior with his figure's costumes in *Bluebeard* or copy Japanese decorative swans and flowers in *Aladdin* reminds us of the minute care Alma-Tadema takes to place his figures in the environments where they can breathe and live.

An interesting parallel could now be drawn between the dissimilar ways in which M. Doré[6] and Mr. Crane understand the realm of the fantastic. The comparison is quite easy to make, because both of these artists have illustrated certain tales by Perrault, such as *Bluebeard* and *Little Red Riding Hood.* Doré is more whimsical, more dramatic, more far-fetched, while Crane is less discordant and more simple; he stays very close to the truth and always creates a real atmosphere, even in a fairy land; as in *Bluebeard,* he always seems to find a Sister Anne in a tower overlooking the countryside, which has the grandeur of style unattainable by M. Doré. If you also consider the ethnological interest that makes these picture books a delight for artists, and if you tip the scales in favor of M. Doré for his amusing country phantasmagorias, the play of light as in a theater, and the transposition of the art of decoration to these drawings, you will have the most dissimilar qualities and interpretations of Perrault's tales.

Basically, one is very English, and he works solely for the children of his country, whose minds are already mature and whose need for reality is more developed than that of our children. The other is very French and works solely for our children, whose imaginations are more wavering and credulous, with no

desire for rationality, with no attachment to the daily routine of family life. Complete differences of race and education show up in the way these tales have been interpreted.

However, Mr. Tadema's unquestionable influence does decrease and disappear. In his purely humoristic and modern work, Mr. Crane has gotten away from this influence. A very particular kind of humor is revealed in his two figures of old women: in *The Yellow Dwarf*, there is a monstrous one in a scarlet dress and a scarlet bonnet, with viperine, witchlike hair and enormous eyes rolling about above her nose, which separates the bottomless depths of her horrible mouth from her long, pointed chin—she is the Desert Fairy and she is accompanied by two gigantic, strutting turkeys; and, in the *Princess Belle Etoile*, there is an old witch who is twisting herself up in a comical position.

He has developed this touch of humor especially in three albums. One depicts the months, and it's a gem of crazy caricatures. January is personified by a sort of Russian general who is absurdly decked out in the most baroque fur clothes; he takes off his cocked hat in a salute, walks on snowshoes, and squints through his monocle, while his little groom, a solemnly penitent godsend, is offering packages of goodies to adorable little girls who are so dumbfounded that they hardly dare to touch such nice things. August is incarnated by a sailor whose hair blazes like the sun. September is a joyous waiter showing some dusty bottles with unspeakable delight, and he is followed by two gentlemen, one fat and one thin, who are wonderfully lifelike. It is impossible to describe and explain this book—its sense of humor is not translatable. I can only refer it to the reader, even though I believe that it has not been translated into French by the Hachette publishing house. In any case, its title is *King Luckieboy's [Party]* [fig. 83].

Another album tells the story of the daily life of a family of pigs [*This Little Pig Went to Market*]. The father, who has his neck squeezed into a Prud'homme collar, his eyes shaded by the smoked lenses of his glasses, his body tightly covered by a pistachio green jacket, his bottom bulging out of his lemon-yellow-and-white striped trousers in which there is a small hole so his corkscrew tail can wiggle, and his feet molded into top boots, takes part in all the intimate scenes of English life. With his hat perched cavalierly on his head and a jovial, satisfied look on his face, he goes to the market and then comes back with his baskets filled. Following along behind him is one of his sons, a young boar who is dressed in red and wears a tasseled pastry cook's hat on his head. In this plate, the father's enormous bottom fills the sky, and its roundness shelters the whining child, who is holding on with one hand to the tail of the pistachio green jacket and, with the other, rubbing his eyes in the grumbling, ill-tempered way so natural to kids. Once he has come home, the father gives dinner to the four little pigs seated in a row around the table. As he cuts up the meat, they all fall into peaceful contemplation; the young pigs clasp their hands together and look on very seriously. One is so enticed that his eyes are crossed, and the others puff out their little bellies, point their ears, and voluptuously freshen the bibs they have tied around their necks to cover their clothes.

What is priceless about these plates is the expression and the spirituality of these figures, the skillfully rendered looks in their eyes, and the reality of their poses. They have a flavor that is unknown in France; they give off a distinct smell of the soil and far surpass the heavy, insipid jestings by [the caricaturist] Grandville, that Paul de Kock[7] of drawing, who coarsely disguises human feelings and passions in animal skins and snouts! [. . .]

The third category, in which Mr. Crane treats modernity, contains the essential details of life in London. On one page we see an apple merchant squeezed into her chair, coloring her pipe. On another there's the half of a house, a bright vestibule where, through an open door, we glimpse the whole right side of a cavalry soldier in fatigues who is flirting with a maid, while a row of amazing, threatening bells are ringing in the air. On still another, there's a kitchen where some servants are standing drying plates and cups, and a pantry where others are kneeling to draw hot water from the furnaces heated by a red-and-blue coal flame. And on still another page, we see the dining room and its large window, which opens out into the gardens where the whole family—father, mother, and children—is seated; it's a gay picture showing all the insignificant details of English living, including the different correct or incorrect ways in which children hold their cups and spoons. [. . .]

It is in these . . . albums that Mr. Crane's personality has become confirmed. As I said above, in his series of fairy tales the derivation is too obvious. I could even add that Alma-Tadema and also Mr. Crane's grandfather, the Belgian painter Leys, show themselves also in the artificial naiveté in certain albums such as the *Liseron*. But the traces of this inheritance die out in the recent volumes. Here nature is consulted directly with entire frankness. Incidentally, these qualities of exact notation and indisputable veracity, common to the majority of talented draftsmen from across the Channel, have made the *Graphic* and the *Illustrated London News,* magazines without rival in the illustrated press of two worlds. Mr. Crane needed only to let himself be carried along by the movement of English modern art in his scenes of contemporary life, but in his *King Luckieboy's [Party],* in his *Fairy Ship,* in several of his alphabet primers, and in the drawings with which he has ornamented music books, he has been able to put forth a humor, a wittiness, a sophisticated fantasy that make these works unique in art.

Miss Greenaway's only album [to date], *Under the Window* [figs. 84–85], has been translated into French with the title *La Lanterne magique*. This artist has been lucky enough to succeed with her first attempt, and her album has now become almost famous in certain circles in Paris.

Miss Kate Greenaway has drunk from the same spring as Mr. Crane. Strong traces of Alma-Tadema appear in many of her plates, as well as undeniable memories of the albums of Hokusai, but over this skillfully compounded mixture floats an affectionate distinction, a smiling delicacy, a witty spirituality that mark her work with a delectable graceful femininity. It must also be said that only women can paint childhood. Mr. Crane catches childhood in its most active and

naive attitudes, but his watercolors lack the tender love, the maternal fervor, that I find in Miss Greenaway's. You may leaf through these pages at random, the one where the little girls are playing at battledore and shuttlecock, the one where in a Nuremberg landscape a delectable moppet stands mute and ashamed before a comic-opera king of joined, painted wood, or that other one in which a big girl holds a toddler in her arms, and that last one in which five young ladies look at you, their hands hidden in their muffs, their bodies smothered in green fur-trimmed pelisses, to assure yourself of the character and the sex of their author. Indeed, no male would dress a child in this manner. He would not arrange their hair under that large cap, nor give them that petulant easiness and that pretty apron and dress which are shaped to the slightest movements of their bodies and which respond to the slightest movement even though they do remain motionless for a few seconds. The decoration of this album is very artfully done, and so is the layout of the pages. There is a never-ending variety of ornamental motifs; they are inspired by fruits, flowers, household utensils, and the usual troop of domestic animals. And, to add to all this diversity, the size of the frames of the pictures changes on every page of the book. On one page sunflower stalks are growing in one corner; on another, spearlike reeds rise up from the bottom of the page, which shows a picture of a bridge and a stream; on still another, there are baskets of tulips in abundance beneath the picture of a well-kept, clean little house. Then the usual harmony of the pages is disturbed and we have hoop races scurrying around the texts of the stories; as tailpieces, the painter has used the teacups of the characters in the story, and as decorative designs at the ends of chapters, she has drawn shuttlecocks which pass through the lines of text, to the great delight of the children who are waving their rackets at the bottom of the page.

In addition to this album Miss Greenaway has presented us with some small illustrated notebooks, books given to English children on their birthdays, and some thin little books bedecked with insignificant chromolithographs. The symbol of her talent, in my opinion, is to be found on the first page of *Under the Window:* in a sort of Greek frame there's a picture of a Japanese vase full of pink tea roses. A fresh, sweet, delicate smell of flowers is emitted by this bouquet, which is done in the style of Tadema and Hokusai.

A third draftsman, Mr. [Randolph] Caldecott, has painted some collections in color for children. He is influenced not by Alma-Tadema, but by the greatest— and least known in France—English caricaturist, Thomas Rowlandson. However, Mr. Caldecott's *John Gilpin* was inspired by Cruikshank's *John Gilpin;*[8] but I must add that that artist was also directly influenced, in this fantasy at least, by Rowlandson. Here we have the wonderfully jovial, terribly gay interpretation of the story of the man who is carried away on his horse. It breaks away and gallops at full speed across fields and through villages. The man drops the stirrups and loses his tie and wig in a flock of geese, which take off in a flurry under the feet of his horse, which is chased by a pack of dogs. Finally, a whole group of his friends manage to catch up with him and, after this wild escapade, take him home where

he collapses, exhausted, in the arms of his wife. This story has something Flemish about it, something of the resounding echo of Jan Steen's hearty laugh which shook windows and slammed doors.

Rowlandson added a cold, very English scoff to this overflowing laughter. He left Hogarth with the moralistic, utilitarian ideas which were later taken up by Cruikshank; after several tries, he abandoned his political subjects to James Gillray, and he began to do incomparable satires of customs, etching and hand coloring them. The whole series of *Doctor Syntax, The Misery of Human Life,* and *The New Dance of Death* proves how personal an artist was this man whose plates, which used to be discarded as rubbish, now get very good prices at auction.[9]

Unfortunately, we have very little information about his life. All we know is that he was born in July 1756 in the Old Jewry district of London. He lost his parents, came to Paris, received an inheritance from his aunt, but lost it all on women and gaming. He returned to London, continued going on sprees, lived a fast life, and only worked when it was absolutely necessary. He died on April 22, 1827, in the most abject poverty. In addition to his political caricatures, he left some illustrations for books and some studies of manners and customs—a series of jolly plates that are pure masterpieces of obscene ingenuity. [. . .]

Like Rowlandson, Mr. Caldecott is given to making fun of obesity and rickets. Like Rowlandson, he draws potbellied people galloping over hill and dale, in his *Three Jovial Huntsmen.* However, if he has not yet come to the monstrosities of old age in women, he still has never been able to draw the elegance of their youthful pleasures as well as Rowlandson.

In spite of everything, Mr. Caldecott is not just a carbon copy of Rowlandson. In a few albums on which I am going to dwell, he has shaken off his master's influence and put in something of his own style. [. . .] Mr. Caldecott really achieves the rank of a great artist who owes nothing to his predecessors in *The Babes in the Wood,* in which a man and his wife are dying as their two children play with puppets on the edge of the bed. If the faces of the doctors did not look like caricatures, this would be a real masterpiece. [. . .] [Caldecott] describes [the parents' death] to us on several pages and spares us none of the horror and agony of dying. He shows us the mother embracing her little boy at the very last moment and, even more than Mr. Crane and Miss Greenaway, he has the gift of breathing life into his characters. Everything else seems stiff and formal next to his thrashing, squalling figures; it's as if life itself had been caught in the act. And what a landscape painter he is! In his book entitled *The House That Jack Built,* look at the way the ramshackle houses are buried deep in the tall forests bordered by fields and flowerbeds stretching out under cloudy skies. Look at the sun rising over the countryside as a rooster crows and a smiling man opens his window. [. . .]

And Mr. Caldecott paints animals just as well as he paints landscapes. In one of his collections a rat gnawing on some sacks of barley is chased and eaten up by a cat, which in turn, is cornered by a dog, which is ripped open by a cow. He captures the whole scene with a few decisive, ingenious strokes of his brush.

Further on, he gives us an extremely exact picture of a kitten in a typically feline position, curled up in the hand of a man who is caressing it. [. . .]

Plates of this kind are unfortunately rare in Caldecott's work. In his other picture books, the caricaturist's joyful openness is amusing, but this type of bantering, funny drawing does not fit in with his style, and if certain sketches, such as the one of a baby who is being bathed in a tub, do not show Rowlandson's influence, they do seem to have been drawn by one of the Japanese artists.

These chromolithographs are magnificent, like those in Miss Greenaway's *Under the Window*. None of them gives the impression of a watercolor painting because they are all so delicate and pale. The art of colored pictures, which is so primitive in France that it should be confined exclusively to industry, has reached full perfection in England. When he looked at these plates, Mr. Chéret, who, in addition to his original talent, is our most expert chromolithographer, sighed and said, "We have no workmen who are capable of printing these plates." It is true that the ones about which I have just spoken are wonderfully soft and mellow. They were done by a printer called Evens [Evans], and they are very much better than Crane's, whose tones are still discordant and rough.

In short, the picture book for the New Year is so slighted in France that the makers of children's toys hand it over to some workmen or other whose wallpaper designs bitterly remind me of the naive and sometimes gay pictures of Epinal[10] with their bold slashes of Prussian blue, leek green, deep red, and yellow-orange; but it has become a true work of art in England, thanks to the talent of these three artists, although I do not include in this statement the more or less successful imitations of Miss Greenaway's *Under the Window* which have recently been published in London.

Although the sources they have borrowed from are known to us, Crane, Miss Greenaway, and Caldecott each have a personal touch, a different disposition, and a similar nervous temperament which is very balanced in Crane, dominated by mixed blood in Caldecott, and slightly anemic in Miss Greenaway.

Without trying to compare their works, it can nevertheless be stated that, when they are as popular in Paris as they are on the other side of the Channel, artists will give their preference to Crane,[11] whose talent is more varied, fuller and more versatile; women and admirers of pretty, tender things will be more attracted by the delicate gems of Miss Greenaway's work; whereas the general public will choose Caldecott because it is captivated by his comical warmth and his hearty laugh.

Translated from Joris K. Huysmans, "Le Salon officiel de 1881," *La Revue littéraire et artistique*, November 1881, as reprinted in J. K. Huysmans, *L'Art moderne* (Paris, 1883), pp. 187–235. For the second part of this article, see part 1, "1878:Paris."

1. Huysmans is referring to Godfried Schalken (1643–1706), a Dutch genre and portrait painter who frequently used the effect of candlelight in his paintings.

2. Léon Gambetta (1832–82), statesman; Georges Clemenceau (1841–1929), statesman, journalist, editor, and premier of France; and Eduoard Lockroy (1840–1913), journalist and deputy of France. Benoit Constant Coquelin (1841–99) was a celebrated actor and member of the Comédie-Française.

3. (Marie Français) Sadi Carnot (1837–94), president of the Republic from 1887 until his assassination by an Italian anarchist in 1894.

4. The sixth independents' exhibition, with thirteen painters exhibiting, was held at 35 boulevard des Capucines in the spring of 1881.

5. Pierre Carlet de Chamblain de Marivaux (1688–1753), dramatist and novelist.

6. [Huysmans:] Another French artist, M. Odilon Redon, has recently asserted himself as a painter of the realm of the fantastic. He has brought the nightmare into art. If you take a macabre atmosphere and add some somnambulistic figures who have been badly frightened and who look vaguely like Gustave Moreau's figures, perhaps you will have an idea of this unique artist's strange talent.

7. Paul de Kock, French novelist and dramatist.

8. George Cruikshank, whose illustrations are found in William Cowper's *Diverting History of John Gilpin*, published in 1828.

9. [Huysmans:] I must point out a very strange discovery. In its composition and in the arrangement of the subject, one of Rowlandson's plates looks exactly like a famous panel by the illustrious M. Vibert, *The Painter's Rest*, exhibited in 1875. Rowlandson's plate is called *Comforts of the Bath*, published on January 6, 1798, by S. B. Fores, 50 Piccadilly, corner of Sackville Street.

10. Epinal, a city in France that was the publishing center of popular colored prints.

11. [Huysmans:] Moreover, Mr. Crane has not confined himself to the illustration of albums and books. As a painter, he has also had much success in England. Unfortunately, his works have not crossed the Channel, and it is not possible for us to study them. Let us simply say that he was among the Pre-Raphaelites, which explains his concern for archaeological accuracy and exact details.

1881: Milan

In 1831 a spirited and determined group of young literati, artists, and political visionaries banded together as Giovine Italia (Young Italy) to realize a land freed from foreign domination and governed by citizens loyal to a constitutional monarchy. King Victor Emmanuel of Savoy shared the aims of their *Risorgimento,* and in 1859, the governing officials of the Austrian Empire were driven from Lombardy and other northern provinces by French and Piedmontese troops. By 1861, the king and Garibaldi's red-shirted liberals had united almost the entire peninsula, though Venetia remained in Austrian hands until the War of 1866, and under Napoleon III's protection the Pope held on to Rome and some of the papal states until the defeat of France by Prussia in 1870. By the end of 1870 both Venetia and the rest of the papal states had been annexed and, though the Pope did not concede his loss of temporal power until much later, the Italians moved the capital to Rome. The conservative monarchical party was defeated by the liberal party in 1876, thanks to a papal decree in 1874 that had restrained conservative Catholics from participating in elections or parliaments, and liberalizing measures—a compulsory-education law of 1877 was one—were passed with little opposition.

Under the patronage of King Umberto I, a committee of Milanese municipal officials, industrialists, and representatives of cultural groups invited all Italians to participate in an exhibition in 1881 that would celebrate both twenty-two years of North Italian independence and eleven years of national unity. It would also demonstrate the economic, industrial, and cultural advances of the new nation, evident in all regions since its first national industrial and fine arts exhibition in Florence in 1861. Its planners were aware of the realignment of political power that had followed France's defeat at the hands of the Prussians ten years earlier. The Italians, especially those of the rapidly developing north and central regions, felt the need to demonstrate their progress to the outside world as well as to reinforce awareness at home that Italy was in fact a viable political, economic, and cultural entity. That an exhibition could have that effect and that this one was successful in achieving it were both amply verified in an article that appeared in the September 1881 issue of *The Builder:*

> [The Milan exhibition] has proved a surprise to the Italians, a surprise from the fact of the activity shown in Italy of branches of industry believed alone to exist

245

and be capable of development in other countries. From this point of view a sensible progress has been marked by the Milan Exhibition. Italy, whose industrial activity has till now been considered, not alone by the world at large but by itself, to be chiefly in artistic productions, in which old traditions, taste, and aesthetic sentiment have had more to do than the practical,—industries such as that of the silk-weaver, the glass-blower, the mosaic worker, the furniture producer, the wood-inlayer, and such like, now has shown an ability to compete successfully in the manufacture of those more mechanical contrivances and aids to industry for which, till recently, they had to rely on foreign countries. . . . Young Italy, and especially Northern Italy,—is growing apace, and among the nations of Europe is rapidly obtaining its place. . . .[1]

Milan's public gardens, with the adjoining Villa Royal and park, provided an ideal site for the enormous wooden building that was planned to house the exhibits. Dispersed around the main building would be the numerous smaller structures in diverse styles that had become customary at such expositions, and which an English critic in 1878 had christened "follies." That the main building was wooden was unexpected: Milan had made a substantial contribution to the iron-and-glass constructions that had been identified with universal expositions since the Crystal Palace. Guiseppe Menghone had built the Galleria Vittorio Emmanuele in 1865–67, and this, the most imposing structure of its kind in Europe, connected the Piazza del Duomo with the Piazza della Scala.

When the exhibition opened on May 5, the liberal newspaper *Il Secolo* commented:

> The facade of our Industrial Exhibition building, together with its architecture, signifies hope. Its architect Ceruti chose the style of the Risorgimento, which after [a period of] artistic barbarity, re-fuses both taste and beauty in the harmony of correct lines and in the name of rebirth. From the manner of the exhibition's palace, we expect a new resurgence of the *patria,* and a majestic day for the people in the arts, from the noblest to the most humble and communal.[2]

For the first time in Milan, a fine arts exhibit was not held in the Palazzo di Brera, the seat of the Accademia di Belle Arti founded in 1776 by order of Maria Theresa of Austria. Instead it was arranged in the Palazzo del Senato near the public gardens. For the occasion the corridors that led to the painting and sculpture galleries were hung with splendid ancient tapestries from the Duomo, the cathedral of Como, and the royal collection. Architectural projects, drawings, and watercolors were arranged in rooms on the second floor. The event proved so profitable—296,000 visitors paid the lira admission charge—that the city was left with enough money both to cover the exhibition's cost and to inspire an energetic committee to collect additional funds and construct a permanent building for Milan's Società per l'Esposizione Permanente di Belle Arti. When it opened in 1886, it provided a center for cultural events, just as the artists' unions being established at about the same time did for Munich, Berlin, and Vienna.

1. *The Builder,* September 17, 1881, p. 353.
2. *Il Secolo,* May 6, 1881.

At the fine arts exhibition, two catalogues were offered for sale, one without illustrations, which cost one lira and sold 29,700 copies, and a second, illustrated in the French style by either a lithograph or a sketch by the artist of the work on view, which cost three lire and sold 2,700 copies [see fig. 86]. The foreword to both versions was written by Federico Mylius, vice-president of the executive committee for the exhibition and president of the Società per l'Esposizione. In it he stated:

> From the day when an exhibition of Italian industry was announced for 1881 by a valiant group of our fellow citizens, from that day when a thousand voices of approval and support arose among us, art could no longer remain inactive in a corner like the Cinderella of the family, neither woman nor queen: from art radiates the pure light by which every object and every piece of work requires the attraction of a smile.
>
> It was therefore an obligation to open to art a field in which to show itself, to persuade it to intervene, to place itself alongside the useful effort of industry; teaching, supplying, and leading it forward toward perfection by determining a harmony between visible forms of the ideal and those applied forms which mark the supreme periods of the civilization of a people and summarize its spirit.
>
> Let us not forget that art had its origin in industries. . . . It is this link that this exhibition wishes to remember and to bring to life. . . .
>
> There is sufficient evidence to recall its upward movement, that when the constricting chains of the Middle Ages were split asunder there arose from Italy's soil, consecrated with the name of Renaissance, the forms of art that miraculously aroused the entire West with a light not yet extinguished. We can see how it spread from above, reaching through workshops of the goldsmiths, the cabinetmakers, and the most lowly laborers for life; how it insinuated itself among the needles of high embroideries and the looms for splendid tapestries and descended happily to labor on behalf of the ceramicists' and the glass-blowers' art.
>
> Our country, more than any other, has need of these gatherings. It was divided for too long not to feel their great importance, indeed the necessity for them. . . . We can consider that the ancient schools . . . which divided Italy, as did its foreign domination, can well be considered eliminated, while the major features that ensure the variety in unity are retained. What is important is the desire to have it respected as well as encouraged.
>
> Interest in Italian national exhibitions can only increase significantly if the artist does not yield to a natural inclination to base his personal direction on local style, and if the observer who considers and judges the expositions does so from his own perspective when he views it. . . . Thus this feast of ours, if it is a citizen's feast, is above all a feast of industry enlightened by art.[3]

At the entrance to the fine arts exhibition stood two statuary groups by Diego Arti, a twenty-year-old sculptor from Bologna. One depicted a lioness tearing open the body of a prostrate gladiator in the arena; of it a contemporary critic declared that, "while the lioness's expression might inspire fear, that of the man

3. *Esposizione Nazionale di Milano, 1881* (Museo di Milano, 1881), p. 15.

would provoke laughter." In the other group, *An African Kiss,* a lioness caresses a superb aged lion. These animals had obviously not been observed in the wild, but in the seraglio of their cage. The second group was purchased at the exhibition by a collector for ten thousand lire.

Contemporary sculpture was displayed in a central court. A group of statues in gesso, *The Favorites of the Romans,* stood nearby. Many of the works shown were well traveled by that time, having represented Italy in universal expositions and national exhibitions both in Europe and overseas. National exhibitions circulated according to a fixed schedule between Rome, Naples, Turin, Florence, and Milan, so critics had to search among them to find the few pieces that were new. Towering over the 1,722 statues by 740 sculptors was the colossal equestrian statue of Napoleon III made by the Milanese sculptor Francesco Barzaghi.

The sculpture section was linked to the industrial exposition building by a passage through an immense block of marble brought from one of the large marble quarries at Serravezza in the Apuan Alps south of Genoa. It now waited for art to turn it into statues infused with life, and was thus meant to symbolize the wondrous marriage between the industrial arts that had brought it there and the fine arts that would transform it.[4]

The Prince Umberto Prize was awarded to the Venetian sculptor Eugenio Marsili for *The Supplicant (La Vocazione).* The Roman sculptor Giacomo Ginotti's *The Vanquished Incendarian,* a heroine of the 1870 Commune in Paris, won the admiration of the public: "He had no need for recourse to revolutionary attributes to express a revolutionary subject."[5]

Contemporary Italian painting was identified by the name of the principal city in a region from which its creator came—only in exhibitions abroad was the appellation "Italian" yet in use for art originating on the peninsula. The revolutions that had permitted the formation of a nation had been municipal and regional revolutions, and each region, with its principal city, clung to its identity. Painting was reviewed not as a national oeuvre but as a set of contributions from Tuscany, Lombardy, Venetia, and so forth. In the official publication, *Esposizione Nazionale di Milano* in the article "Al Palazzo di Belle Arti," the reviewer Luigi Chirtani discussed the qualities identified with each: the Milan school continued to be robust with vigorous colorists, for example; its landscape painters Filippo Carcano and Gignous and the marine painter Mose Bianchi of Monza were particularly worthy of mention. Not on his list—nor any other— was Pietro Bouvier's *Daddy Understands,* purchased at the exhibition by Tiffany & Co. for twenty thousand lire.

The art of the capital, Rome, still remained the most diverse, as it was executed mainly to sell to a broad range of tourists. Southern Italy's representation was poor, but Francesco Michetti from the Abruzzi, a friend of the young

4. Ibid., p. 54.
5. Ibid., p. 60.

poet Gabriele d'Annunzio, attracted attention by his demand for a single gallery with walls tinted blue in which to show his thirty-four large watercolors.

A review of the fine arts exhibition appeared in Italy's foremost quarterly, the liberal *Nuova Antologia,* published in Florence. It was written by Camillo Boito, a frequent contributor who was son of a successful miniature portraitist in Venice and brother of Arrigo Boito, the poet-composer. Camillo had studied architecture with Pietro Selvatico in Venice, interrupting his studies with visits to Poland, his mother's homeland. Appointed instructor in contemporary architecture at the Academy, Boito had lived in Venice, except for trips to Florence and Rome, until he fled from the Austrian police and arrived in Milan in 1859. Already respected for the fresh approach to art found in his articles, which also appeared in the *Spettatore* and *Crepuscolo,* Boito was named a professor of architecture at the Brera Academy in 1860. As Italians sought to shed their regional provincialism, Boito became an important figure in the art circles that were turning away from romantic history painting and classicism in architecture.

Boito was also a significant figure in the search for a style in architecture that would correspond to the country's culture and satisfy its nationalistic ambitions. For it he chose Lombard Gothic, a style common to all regions of Italy, and one that he considered as truly representative of Italian culture as Tudor was of English. He defended and explained his idea in an essay entitled "L'Architettura della Nuova Italia," which appeared in the *Nuova Antologia.* In 1862 he served as one of the judges for the cathedral facade competition held in Florence and provided a review of the painting and sculpture on view there for the *Nuova Antologia.*[6] The writer-politician Ferdinando Martini, recently named Minister of Education, who had launched the newspaper *Fanfulla* in Rome and its weekly supplement *Fanfulla della Domenica* in 1879, asked the Roman painter Nino [Giovanni] Costa to review the exhibit.

Indicative of the growing rift throughout Europe between state-sponsored fine arts institutions and artists was an exhibit entitled "The Indisposition of the Fine Arts," on view nearby in the former studio of a sculptor. It had been arranged by the Famiglia Artistica, whose members—artists, businessmen, and critics—came from a circle united by a common interest in art and a common desire to bring together the various branches of the arts and their related industries. The paintings and sculptures on view were not just avant-garde, but nonsense—almost Dada-Surrealistic—pieces with titles that were parodies, puns, and jokes. "A Bach Fugue" showed silkworms in a woodland bosk, and in a parody by Roberto Fontana of Delaroche's *The Stern Father,* a Cromwell family portrait, the father's eyes moved mechanically. A catalogue, *Libro d'oro,* and the exhibits themselves were available for sale. Famiglia Artistica members led guided tours, and 40,000 visitors enjoyed the show.

6. *Nuova Antologia* 20 (September 1873): 28–49. See Elizabeth Gilmore Holt, *The Art of All Nations* (New York, 1981), pp. 554–55.

Letters to the Artists
GIOVANNI COSTA

Dear Friends and Colleagues,

By no means all our painting is represented at Milan; few Neapolitans have exhibited, practically all the Romans and Tuscans are missing; the mass of official historical painters is absent. Because of this lack I am unable to arrive at criteria regarding the activities of Italian painting, and must limit myself solely to giving you my impressions and opinions on the works of some of the best-known artists.

In the first room, up to number 35, there is little of interest; there are works by Borsari whose drawing is careful, and by Domenico Bologna whose paintings are of sound quality. From 35 to 68 there are lined up in battle order thirty-four studies from nature or cartoons, framed with great care and in part already sold by Francesco Paolo Michetti. These studies are in watercolor on gray paper with pastel: there are small heads painted in oil on smooth transparent paper and glued on the two layers of paint: there is also painting on the very wide black frames, painting on the glass which covers the cartoon, and painting over the paint which covers the glass. Are these studies from nature?

It is a great shame that a young man so gifted by nature does not know how to be simpler, as is due to the understanding of his own strength, and does not at least have some respect for the general public.

Number 35 depicts a young shepherdess lying face down on a flowery meadow horizontally in the direction of the painting, exactly as done by Alma-Tadema. I do not blame Michetti for having derived this composition from another artist. In fact it would be praiseworthy if he, who has made a life-size figure, had depicted and developed this pose better than had his original model: this would have been quite possible. This figure, conceived with the maximum of realism, is not immersed in the flowers with which the field is filled and has no weight. It is true that those flowers seem to be tied by a florist, gathered in bunches, and inserted in black holes on the surface. The right arm of this figure, the only part of the body which indicates motion, is neither found nor rendered. The shift that covers the shoulders bears no relation in color, position, or light with the shift that covers the legs. Furthermore those feet, whose material is impossible to determine, are horrible, without draftsmanship, without bones. Nor was it a happy idea to place the profile of that lamb at a short distance, opposite and against the profile of the woman, in an attempt to obtain a vulgar and tasteless contrast.

This large cartoon does not stand up to examination; it is brilliant in color but it is not true, it is not real, it is not drawn or arranged with decorum, and is below the talent of the painter. Number 36 depicts a young peasant girl passing shyly along a country lane, while some of her fellow peasants lying in a meadow observing her make uncomplimentary comments about her, each according to his age and character. This, for me, is one of the best compositions Michetti has created to date and one of the happiest paintings of the Milan exhibition. In it there reigns the greatest harmony between the figures and the landscape. The line

and the movement of the heads are well thought out; it has variety and good expression. The figure of the woman standing out against the sky is very graceful, although it reflects too much Japanese influence in outline and color. The idea of placing the judging peasants lying like animals on the grass, leaving the woman who may be guilty standing alone, is subtle, noble, and human, while the line of the ground is proper and necessary. Above the heads of the men a dramatic movement of clouds unfolds, while on the head of the woman is a heavy, nebulous, violet-colored veil. This is not a study from nature, but an unfinished composition of great interest, a true work of art. And now one would ask Michetti why, instead of finishing his precious little woman and giving her at least one small foot, he goes and paints on the glass which covers the pictures? Why does he not paint the feet of those *ciocari*[1] who move forward? The *ciocie* is a graceful and very picturesque footgear in the way it protects the foot and outlines the leg, binding it with strips of cloth.

I take into consideration all Michetti's life-size studies of heads from nature. In them the way the artist makes clear the light and time of day in which they were done is very remarkable. All these heads, although they often lack a bone structure and a whole, are nevertheless full of character. Head number 50 is the most remarkable for the expression given by the light of the setting sun. It seems as if the look of the woman and the rays of the dying orb come together, giving each other an enchanting farewell. All Michetti's heads exude a feeling of joy and good health, and looking at them one breathes the good sea air with which they are surrounded.

The first and the second could be two picturesque illustrations for stories from children's books, those books which are so well produced by artists in England and which I could wish that the Italians would make for our children. In number 42 we see some sheep following a little girl. This picture is very successful on account of the light which illuminates it. Moreover, the heads of the sheep are beautiful in their draftsmanship, color, and movement.

But the contrasts of colors in the painting are exaggerated: imagine that in the midst of the sheep, which as I have said are illuminated by the most beautiful light, is a violet-colored sheep contrasting with a piece of bright green meadow on the opposite side of the canvas. The maiden is not in proportion with the heads of the sheep in regard to the ground that would be at the base if the frame did not cut it off. This picture shows the good training Filippo Palizzi imparted to Michetti in depicting animals. Number 44 shows a row of sails at sea. It is a childish, impudent, coarse work, which is not fit to be hung even in the room of the child of a hairdresser. In number 45 we see a peasant girl gathering flowers. A short distance behind, a peasant follows her, making certain amorous gestures so expressive that he seems to make a bunch of both the flowers and the flower girl. This painting is a masterpiece of tenderness. In number 47 Michetti gives us an excellent picture which we could call a dialogue of love under the great ceiling of the sky. The figure of the man is strong, resolute, and noble; the figure and expression of the maiden is not very well defined, although it is expansive in its action. It is this contrast

which forms the beauty and interest of the picture. The relationship between the figures and the background is perfect, and the church standing on the hill between the two lovers is most significant. The work numbered 48 is of a tree with a background of sea and sky. Michetti, in exhibiting this study, could not care less about the public, and the public, as was evident to me, does not care a rap about him. Number 51 has a masterpiece of a frame. Everything fails in this landscape painting, and one quite understands that Michetti does not have the power of certain French artists of the past to paint a subject as simple as the one he has chosen. Number 52 is a delightful conception. How well Michetti has combined the blossoming tree, the sky, the sea, the music, the woman, and love! A beautiful woman sits on a hill with the sea in the background: behind the hill a man appears, his right foot pointing forward, playing a musical instrument. The woman has her hands crossed on her legs, her head is relaxed on her shoulder; she is inebriated. Behind the man we see the blue sea, and against the sky there is a delicate tree covered with flowers representing the joy of the very beautiful day. One cannot put a group of two figures better, as regards the idea, the figures, and the color over an enchanting background. But this painting is nothing less than half as much too long, and I would like to see eliminated an episode of turkeys going past a tree on the opposite side from the group of lovers. What does this cartoon lack which would make it a work of art? It lacks the fact that the author does not know where his painting is; and why does he not know it? Because number 52 is a translation, made in the Abruzzi, of a Japanese composition. In number 56 our artist has explained very well the happy slumber of the youth who lies on his back under the trees. He has even untied the red band which is twisted around his legs in order to enable his blood to circulate in his veins and to breathe. He is asleep and snores; he is not dead. And how piquant are those small heads of the little women who move behind the sleeping man, laughing madly. How the light smiles on those little heads full of good humour! In this picture, in which sleep and life are so well interpreted, I would only desire a piece of horizon in the background to complete the painting in line and appearance. In cartoon number 57 our artist perhaps has tried to make a "return from church" a festive day. Along the country road we see children, men, and women merrily walking along: the effect is just and proper. The expression of the heads is very well observed and rendered in the various characteristics, the movement of each individual well characterized, in contrast with the linear movement of the background and of the trees. This work reveals a very great talent and very good taste. A girl sings and sings in the sixty-fourth cartoon as she leads home turkeys along a rugged terrain enriched with flowering spring trees, insufficiently indicated. This is a pleasant, small picture; nevertheless, I would like the area of the sky diminished by a good half from the top of the frame downward. In the sixty-fifth cartoon three young brides walk forward along a country road, followed by their three respective husbands. Here Michetti, with great shrewdness, has known how to couple the wife with a suitable husband, as regards both physique and moral character: he has partnered the man who gets on with the woman who smiles, well-being with well-being, the pensive

woman with the man assailed by doubts. The artist has achieved this concept with the expressions of the faces, with the demeanour and the gait of each individual. This composition does honor to Michetti because I believe that it is derived from something he has actually seen. Number 66 depicts a very simple composition. A peasant woman walks forward toward the spectator with her hands one above the other on her breast. A sturdy peasant follows her. This picture shows all the fine qualities of Michetti when he knows how to be simple. It has fine characteristics, a composition of great taste, the gait of the figures is properly related, and the harmonious background brings out the figures. Yet in this picture one understands what difficulties face the young painter when he is obliged to draw the feet: the woman walks along a road which is as smooth as the deck of a ship; there is no excuse this time, the feet should have been depicted. What has the young artist from the Abruzzi done to get out of this quandary? He has painted a branch of a cherry tree on the glass where the woman's foot is situated.

Now that I have finished as regards Michetti, I can only repeat what I said last year, that this artist has the most precious, the finest, and, at the same time the most corrupt artistic organization. He is too greedy and cunning. This year he seems to be saying to the great Italian public, "You do not want to know anything more about art, but I want to take hold of you by force to show you my ability. I swing on the trapeze to show you the artistic shrewdness of the whole world, and my artistry is not for you but only for my taste." For me, Michetti, whom I do not know at all personally, is a healthy young man, very talented, well organized artistically, a real thief of nature, but too much taken up with stealing the craft of his fellow men. He is one of those plants which grow spontaneously on old buildings—ethereal, light, and happy against the sky.

Translated from Giovanni Costa, "Lettere agli Artisti (Francesco Paolo Michetti)," *Fanfulla della Domenica* 3, no. 25, June 19, 1881.
1. *Ciocari* are the peasants from the *ciocaria*, a mountain region southeast of Rome, who wore a type of cloth legging known as *ciocie*.

Art at the National Exhibition in Milan

CAMILLO BOITO

There are in Milan exhibitions of fine arts and of industry next to each other. For the first, the exhibitors should have considered only beauty; for the second, not all, but the major part, should have considered use, utility, and beauty together. From one point of view, this time the industrial art is the more attractive, more agreeable than the pure art. The latter is by necessity below the level of the national art exhibition at Turin which closed a few months ago and in which Italian artists were able to present works carefully and thoughtfully considered. On the other hand, the industrial arts have not had the opportunity to exhibit their product to Italian viewers for a long time.

Furthermore, in some of the industries in which both design and color can more or less find the opportunity to express their beauty, one can now discover a new clarity of intention, a spirit of true sensitivity and sure progress, while in the painting and sculpture, which almost always lack a sound knowledge of ends and means, the works, even the beautiful ones, appear to be the efforts of a truly skillful and lively, but unsure and inconsistent, ability.

One might add that the beauties of the past, in which Italy is so very rich, useful as they are to the art industry, are more of a hindrance than a help to the arts, which today more than ever have the purpose, partly sincere and partly painfully affected, renewing a perennial intimate contemplation of nature.

I. "*Brera*[1]—Market of Fine Arts and of Sciences," wrote Fosculo[2] in an unfinished essay. The fine arts exhibition was not held at the Brera, but in the two large courtyards of the building known as the Helvetic College of the Senate, which are connected to the sheds for railway carriages, for the agricultural machines, for the artificial stone blocks, and concrete, and other such categories of the industrial exhibition. Nor was the exhibition opened and directed by the Academy of Fine Arts, as it usually is, but by the Permanent Society for Art Exhibitions, which is itself occupied more with the material advantage of mediocre artists or with the sale of minor works of good artists than with the elevated nobility of truly great art.

The exhibition has, in fact, a distinctly commercial character. *Brera* market indeed! One undoubtedly observes some beautiful things, but on the whole one is reminded of a workshop. Already from too many canvases and from too many marble statues our ears have heard ten times over the cry—"Gentlemen, buy us. We are for sale!"—We agree that the artist must be recompensed; that he actually has the right, if he can, to become a millionaire, as sometimes happens outside Italy. But while he conceives and carries out his work, he must be fired with the sacred flame of art, he must have no other thought save that of beauty, passionately loved and intensely experienced according to his own spirit; on the other hand, the public must be respected. Not every little thing that issues from the imaginative brain and able hands of the artist can be offered to the inquisitive public or to the purse of the wealthy patron without impairing the decorum of the artist himself. Not all the studies, even if conscientiously carried out, to complete a work of art can then be exhibited without a trace of covetousness as genuine works of art. The concept of the dignity of art is gradually waning in the soul of the artist, who, relying on his own genius and on his own fame, considers everything to be legitimate, while in the mind of the beholder the painting or the sculpture, instead of appearing to be the result of a serious, sincere, and elevated study of nature and of an ideal, now seems to be the product of an ingenious caprice.

Michetti, admirable painter though he is, able to catch from reality the most delicate and subtle graces, inspired, nimble, abundant, filled with light and elegance, has fallen into this very error. Few of the thirty-four paintings included by

him in the Milan exhibition serve to enhance his reputation. Those studies of heads nearly all round, swollen, without a trace of inner expression, all alike and insipid; those pictures of male and female peasants, and their progeny, children who come toward you smiling; those rural idylls, the infant in swaddling clothes among the chicks; that woman stretched face down on the ground; that blue sea with the white sails all in a very long row; that flaming water; those flowers and those four toads—all of them have something superficial, something light and vacuous. The forms, the colors, the expressions are seen from the exterior, not from the inside or the heart. They are seen by a mind which does not take the trouble to ponder over what it sees, by a heart satisfied by a fleeting impression. Of course, this fleeting impression is substantiated with a surprising and inimitable skill.

Here and there the painter of the *Dead Children* and of other stupendous canvases can, however, be found. Among the thirty-four paintings all executed in tempera or watercolor and protected with glass, there is one, not very large, in which are depicted five peasants sitting on the grass. They are looking at a young woman with varying expressions of curiosity, scorn, and derision. Although her gait is majestic, she bows her head in shame. The sky is cloudy and threatening: it is conceived and carried out with extraordinary vigor. The admirable main theme is then followed by large dots shining in gold on the edge of the glass which add nothing to the impression one receives from this work. In fact, to a certain extent, it lessens its seriousness and its poetic character.

Michetti has it in his head to make the frame part of the picture. The frame and the picture must belong to each other. Here the head of a woman is garlanded with flowers which are not painted on the canvas, but on the glass which serves to protect it. The flowers of the field where she walks, picking a flower here and there, a country Mathilda (often in these country maidens of Michetti one finds an affected gracefulness), continue on the glass even beyond the actual painting on the canvas. Here, as in other frames, appear hundreds of extravagances: slimy snails, lizards, musical fragments, odd figures, crosses, stars, and so forth.

The artist, in all truth, is a master and can do what he wants. If he feels like indulging in such oddities, let him go ahead. But the critic has all the same the right to make two observations: the frame was invented in order to isolate the painting from its surroundings, and that is why they are gilded; and caprice is enjoyed so long as it is spontaneous, expedient, extempore, out of the ordinary, but it becomes tiresome when it turns into a habit. Michetti is so rich in originality that he has no need to have recourse to such tricks in order to maintain a hold on his audience. His widest public looks at the works of his brush, even if those works are, like the major portions of these thirty-four paintings, merely sketches tossed off; impressions recalled for his own use and artistic exercises to keep for himself in his studio and to gather the praises of his friends. The result is that artists and cultured people become suspicious, murmuring under their breath, "Oh look, now he plays the fool just to take us in"—and soon feel more inclined to malice than to benevolence.

II. At Turin in the beautiful and noble national exhibition of last year, Michetti and Favretto, both painters of familiar genre themes, were united in prizes and praises, and yet are utterly unlike both in their way of interpreting nature and in their artistic inclination. The difference this year has increased, and the reason for this seems to us clear: the works of both are less well thought out and less good than the ones that were seen in the spacious halls of the Turin exhibition, and the diversity, in general, is less in the value of the works of art than in their defects. [. . .]

Translated from Camillo Boito, "L'Arte all'Esposizione Nazionale di Milano," *La Nuova Antologia.*
 1. The noted picture gallery and academy, in the Palazzo di Brera, was established in 1776.
 2. Ugo Foscolo (1778–1827), active in the Risorgimento movement, was a noted writer and classical scholar.

1881–82: London

In 1881 the accounts in the press of the Royal Academy's annual exhibition and the social events that traditionally accompanied its opening were pushed to the back pages by the death of Disraeli, Lord Beaconsfield, on April 19 and by the casualty lists from the war in the Transvaal that had broken out the previous year. But that did not mean that the Royal Academy had lost its accustomed place in England's art world. Before the opening of its annual exhibition of works by living artists on the first Monday in May, it was traditionally host at an anniversary dinner whose guest list was drawn from the ranks of royalty and aristocracy. At this banquet in Burlington House in 1881, Sir Frederick (later Lord) Leighton, the Academy's president since 1878 and regarded, with Sir John Everett Millais who would succeed him in the post, as England's foremost painter, "above criticism or debate," sat in the host's chair. After the principal speakers—among them the Prince of Wales, Mr. William Gladstone (who had succeeded Disraeli as Prime Minister in 1880), and the poet Matthew Arnold (one of Her Majesty's inspectors of schools)—had finished, Leighton gave a summary of the revision and extension of the Academy's scheme of education. It included the institution of new prizes to encourage the study of special branches of art and the remodeling of the north end of Burlington House, scheduled for completion the following year, which would provide additional gallery space with a skylight. But in 1881 the 895 oil paintings, 230 watercolors, 100 drawings, 135 sculptures, and 338 architectural projects selected by the hanging committee, that "awful tribunal," from the more than 7,000 works submitted, still had to be placed in the space available. That meant that not all the 895 oil paintings could be hung "on the line"—that is, at viewer's eye level;[1] some had to be "skyed" or "floored"—hung either too near the ceiling or too near the floor to be properly viewed.

The Royal Academy's social prestige made its annual exhibition an important arbiter of the establishment's taste in the fine arts. The show had, however, always been accompanied by various other exhibits put on by artists and dealers, and these served to provide variety. They were also reviewed by the press (see fig. 87) and generally enjoyed an even-handed criticism, if one excepts the *Fors*

1. A narrow ledge was on the wall, 8′8″ above the floor; the line was lowered to eight feet in 1859. Pictures hung "on the line" had the tops of their frames near this ledge.

Clavigera, a small magazine written by John Ruskin and sold through its printer (who paid Ruskin 10 percent of the ten-pence price). It was there that Ruskin published his vehement criticism of James A. McNeill Whistler's *Nocturne in Black and Gold: The Falling Rocket* in 1877. Whistler found the review libelous, brought charges, and won the suit, but was ruined by the court costs and the assertion by Edward Burne-Jones at the trial that his paintings were mere "sketches." If they were not finished work, they were not worth the price he asked, and the statement therefore deterred potential customers from visiting his studio on Sundays, the customary viewing day for popular painters in London. To recoup his losses, Whistler accepted a commission by a firm called the Fine Art Society of London to execute a set of etched views of Venice, a city always popular with the English, and left for Italy.

The Royal Academy's monopoly on the art world had first been challenged in 1877 by Sir Coutts Lindsay, a painter and gentleman of great wealth who, at the urging of friends, had built an art dealers' gallery, a handsome establishment called the Grosvenor, where paintings and statues could be seen throughout the year (plan 10). Its major annual exhibition opened in May to coincide with the Royal Academy opening, and dissenters could be found at the Grosvenor alongside some recently elected Royal Academy associates and academicians who chose to be shown there. The gallery came to play in the English-speaking world something of the role the Salon des Refusés, on display in the west end of the Palais de l'Industrie in 1863, 1864, and 1874, played in France. It was at the Grosvenor, for example, that Ruskin viewed Whistler's offending *Nocturne.* After its establishment the Royal Academy show attracted less attention than the works hung at the Burlington, but the press still always found space to mention the works the academy itself bought from the show with the Chantry Fund, the bequest the sculptor Francis Chantry had left for the purchase of works created by contemporary artists residing in England, and the choice of purchases continued to have great influence on the art market.

In 1881 the English press found little to interest them at either show. The widely circulated *Illustrated London News* called what was on view at Burlington House

> a heterogeneous assemblage of works by men more or less self taught . . . there is no impulsion forward, because there is no mass to give momentum in a given direction. . . . Where space is notoriously and confessedly insufficient to represent the general body of British artists, the Academicians and Associates still maintain the right of each to eight of the best places and this though they can only hang a few hundred out of the thousands of pictures annually offered. The number of paintings at the French *Salon* is this year greatly reduced: yet they must still be in the Champs Elysées as three or four with us, not withstanding that the painters, *hors concours,* and the greatest artists of France are only allowed to show two works each. Experience proves that a committee of selection and hanging composed of artists alone (it matters little who they are) is a narrow, prejudiced, fallible tribunal. . . . Where and when we are to look for

reform in the national administration of art matters it is hard to say.[2] [See also fig. 90.]

Both Leighton and Millais had paintings in Burlington House and in the Grosvenor Gallery as well, but Burne-Jones was absent from the latter, an omission especially noted by the press, for the idea of founding that gallery was attached to his and Whistler's names. A painting by Whistler was on view for the first time since he had won his suit against Ruskin in 1878, but it aroused little comment in England. As the *Illustrated London News* mentioned, "Mr. Whistler has a whole-length of Miss Alexander, primarily an 'arrangement' in white, black and grey in a greenish gold frame. It is reminiscent of Velásquez, but with this difference in principle, to go no further, that the minor key does not serve to foil clear natural color in the flesh."[3]

Whistler received more attention in French art journals, however, for his *White Girl* (or *Symphony in White, No. 1*) had made his name in France. When it was rejected by the Royal Academy in 1862, it had been shown in the Salon des Refusés instead, and Whistler himself had become a striking figure on the boulevards. Added to that fascination was the general gossip identifying him with the character of John Sibley in George du Maurier's popular novel *Trilby,* until Whistler protested to Harper's, its American publisher, and forced du Maurier to change the name of the character to Bald Anthony and eliminate all resemblance to the painter. Whistler was also associated with the Impressionists, and he joined them and their supporters at the Café Guerbois whenever he was in Paris. His art was especially appreciated among its habitués, the writers and critics Edmond Duranty, Emile Zola, and Théodore Duret.

Duret in particular sought—as had Théophile Thoré before him—to explain to the public what the painters were about, and especially how, in reaction to contemporary life, they were using new techniques to record an ever-changing world. Duret's association with art had begun at the age of twenty when he saw a show of Millais's paintings during a visit to London. He had met Manet when they were both in Madrid in 1866, and it was on their return that he first began to frequent the Café Guerbois. In 1863 he published *Lettres sur les élections* and founded with three others the anti-imperialist newspaper *La Tribune,* which had Zola on its staff. In 1870 he incurred the wrath of the *Electeur libre*'s owner when he wrote an enthusiastic review of Manet's two Salon paintings, *The Music Lesson* and *Portrait of Eva Gonzales.* In 1871 he traveled with the banker Henri Cernuschi to China and Japan, where they arrived in the wake of the overthrow of the regional shoguns that heralded the consolidation of political power in the person of the emperor. *Voyage en Asie,* an account of these travels, appeared in the same year. Cernuschi, an Italian liberal and a political emigré, returned to his exile in France with a notable collection of Japanese art, which he later bequeathed along with his house to the city of Paris, and both travelers joined the

2. *Illustrated London News,* May 1, 1881, p. 426.
3. Ibid., May 7, 1881, p. 459.

circle of collectors, dealers, and artists who had been captivated by Japanese art. In 1878 Duret published *Les Peintres impressionnistes*, with biographical information and explanatory comments for the five leaders of this group, Monet, Sisley, Pissarro, Renoir, and Morisot. He closed with the prophecy that they would be the painters of the future.

In 1881 Duret was selected to cover both the Royal Academy and the Grosvenor exhibitions for the *Gazette des Beaux-Arts* by its editor, Charles Ephrussi.[4] He preceded his report by an article "English Artists: James Whistler," illustrated by one of Whistler's etchings.[5] Whistler's single painting at the Grosvenor provided Duret with an opportunity further to explain his manner of painting and his position in the English school, which he found analogous to that of the Impressionists in France. Duret clearly found his London assignment congenial, and he returned again in 1882 and 1883 to review the exhibitions. In 1883 Whistler painted him standing before a gray background in a black evening suit, holding a pink domino cape for a masquerade (fig. 92). The portrait was shown in the 1885 Salon with the title *Arrangement in Flesh-Colour and Black*. In the same year Duret published *Critique d'avant-garde*, a series of studies on the Impressionists whose work (like that of artists in other small groups in Europe) was based on a visual perception of the world obedient to the chromatic principles established by current studies and a method of rendering relationships of objects in space learned from the Japanese. Duret's *Life of Whistler*—an artist whose paintings and etchings were to exert increasing influence on European art as they circulated among the various European exhibitions at the end of the century—appeared in 1904, one year after the painter's death. In 1922 the eighty-two-year-old Duret was to look back over the vast array of artists he had known and wonder, "In truth, was it really I who was there?"[6]

The Royal Academy and the Grosvenor Gallery Exhibitions, 1881

THÉODORE DURET

In London there are two exhibitions that correspond to our Salon. One is controlled by the official society of well-known painters, the Royal Academy, a sort of guardian institute of the tradition and respectability of art. The other, at the Grosvenor Gallery, owes its existence to Sir Coutts Lindsay, a wealthy amateur and artist who, having contributed millions for the construction of an appropriate building, himself organizes the annual exhibition assisted by a group of men of taste. The result of this situation is that the terror which haunts certain French

4. *Gazette des Beaux-Arts*, ser. 2, vol. 23 (June 1881): 549–56.
5. Ibid. (April 1881): 365–69.
6. *Bulletin de la vie artistique*, January 15, 1922, pp. 31–33.

painters, that of being refused by the Salon and thereby having their careers snuffed out, is unknown to English artists.

There is no independent English painter refused by the Royal Academy who is not assured of being promptly invited to exhibit at the Grosvenor Gallery, always concerned with appealing to the curiosity of the public by showing new work.

Each exhibition has its palace: the Royal Academy in Piccadilly, the Grosvenor Gallery in Bond Street. The elegantly decorated salons are vast, though not quite so vast as to make one think of unadorned markets or warehouses. One has the sensation of being in distinguished surroundings, designed to be museums. Since the two exhibitions are equally popular with the public, well-known artists are accustomed to sharing between the two the works they wish to exhibit each year. Therefore both must be visited before one can form an opinion of a popular artist.

Classical art, dedicated to the preservation of art forms derived from antiquity via the Italian Renaissance, particularly in the painting of nudes, is cultivated by Sir Frederick Leighton, president of the Royal Academy, and Mr. [Edward] Poynter. These two painters hold a position in the English school comparable to that held in France by Messrs. Cabanel and Bouguereau. One could ask exactly where classical art stands and what it represents in France and in England, but this would raise questions that would lead us too far afield. We will confine ourselves to discussing the offerings of its principal representatives in England. Sir Frederick Leighton is a cultivated, intelligent man of the world who seeks to impregnate the old traditional forms with a new spirit. This year he is showing at the Academy seven pictures, two of which are *Elisha Raising the Son of the Shunamite* [fig. 91] and *Idyll.* The latter seems to us the most important of them all. An idyll calls for an amorous group, and it is here in this picture: a shepherd, seen from the back, is charming with the music of his pipes two young nymphs stretched out on the grass beside him. The figures, instead of being traditionally placed in a grove or in some secluded and shady setting, are facing a vast beach, traversed by a stream. In the background the sea completes the picture. It is an ingenious idea, which allows the painter to do something new and original in treating a subject difficult to rejuvenate. However, of all of Mr. Leighton's canvases we really prefer the portrait of Mrs. Stephen Ralli. We may not be dealing with the Bible and mythology, but we are better off in the realm of living human nature. This portrait is painted in a sober range of colors, in the best of taste. The subject is standing, wearing a simple black dress. The head and figure stand out well against the background, and the portrait emanates a tranquil and pervasive charm, which makes this portrait one of the best things of his that we have seen.

Mr. Poynter is a classicist, sustained by his choice of subjects. In recent years he has shown canvases entitled *A Visit to Aesculapius* and *Nausicaa and Companions Playing Ball.* This year he has sent to the Royal Academy a painting whose subject is also drawn from antiquity, *Helen,* a half-length figure adorned with jewels obviously copied from those discovered by Mr. [Heinrich] Schliemann.

Behind her is the palace of Troy in flames. It is painted according to conventional precepts, but it is absolutely cold and lifeless. The real Helen must have been more animated to have been the cause of Paris's infatuation and the events that followed.

I believe English critics and art lovers would agree that Messrs. [J. E.] Millais and [G. F.] Watts are the two English painters who have shown the most strength and talent in seeking to establish a personal style of their own. Mr. Millais in these last years has, in the eyes of the public, been accorded the highest standing among the painters of the English school. He has become the object of a veritable infatuation. One can understand the cause of this interest: he has behind him a considerable oeuvre, the result of sheer perseverance. This work extends from historical and genre painting to portraits and landscapes. His technique and individual touch give evidence of a vigorous hand, that of a man capable of vision and daring. Millais is certainly an artist of uncommon merit, but the exaggerated admiration of the public goes beyond all limits when it seeks to rank him above all others and to make of him a great master. The essence of Mr. Millais's work is of an inferior nature; it is like a historical novel. Mr. Millais does not paint men of his own time, so he leaves no lasting work which would interpret the English character of the nineteenth century; he lacks the wings to soar; he does not know how to idealize forms and create human beings. He has simply taken a stroll through history, looking for pictorial events to put onto canvas, decking out his subjects in costumes of all ages and all countries. I do not see in the numerous portraits he has painted, with many doubtful successes, any general character such as that left by the body of work of Reynolds and Gainsborough, who have made the eighteenth century so alive for us. Let us then award Mr. Millais a distinguished place among the English painters of this century—that would be only just—but let us stop there.

Mr. Millais, in his early Pre-Raphaelite style and when he was beginning to leave it, painted the most daring and perhaps the most powerful pictures in all his work. In *Autumn Leaves, The Vale of Rest, Christ in the House of His Parents,* there is a mordant strength in the execution and expression which to me does not seem to be present in his recent work.

The canvases shown at the Grosvenor Gallery do not enhance his reputation. We see no fewer than eight portraits, all almost alike: standing figures against a neutral background. One senses work done in haste with the least possible inner reflection. There is no harmony of tone or color, modeling is often lacking, and the figures do not stand out from the background. This comes close to mere mass production.[. . .]

Besides the portraits, Mr. Millais has sent to each of the exhibitions a little girl: *Cinderella* to the Royal Academy, *Soft, Melting Eyes* to the Grosvenor. These little girls are part of a family he is launching in the world. Reproduced in engravings, they are destined to join *Cherry Ripe,* published last year in the *Graphic,* which has reputedly sold more than 400,000 copies. Once it becomes a question of pleasing the entire universe through the medium of an illustrated paper, it is

naturally necessary to keep to a certain motif. The little girls of Mr. Millais pout, assume coquettish poses, deck themselves out in all sorts of frills. This is all very well in chromolithography, but in oil and on canvas it is affected and smacks of eyelash fluttering.[. . .] (When one recalls Mr. Millais's early canvases, bold and vigorous, and compares them to what he shows us nowadays, one is tempted to say to him, "Give us, as before, those paintings in which you sought only to please yourself, and forget about currying favor with the public.")

Mr. Watts has gained a special place for himself in the art world by his portraits. In these he paints boldly, according to a simplified design, giving his whole attention to expressing the human figure, omitting details and accessories. However, Mr. Watts, so well endowed in some respects, seems not to have found an individual style or color range which would allow him to spread paint on canvas in a spontaneous way. In tracing the development of his work one perceives that he has been constantly struggling for a method of execution that would be exclusively his own. While his bold and simple design has remained constant, as a birthright, his painting and color procedures have varied considerably and reveal the traces of borrowings either from the procedures of the old Italian school or from those favored by the modern English school.

With Mr. Whistler we find ourselves in the midst of a raging controversy. To find something analogous to the opposition he has encountered we must turn to France and recall the hostility that arose in the time of Delacroix and that has cropped up again today against M. Manet and the impressionists. Mr. Whistler, however, is not a man to be intimidated by attacks upon him. He has fought terrible battles with the critics and has never made the slightest concession to public taste. On the contrary, he has gone his own way, developing with all his abilities his own personal style. If artists are judged according to the degree of originality and inventiveness of their work, one must rank Mr. Whistler at the very top of the English school of painting. In England it was Mr. Whistler who first banished lampblack, burnt sienna, chocolate brown, deep and opaque shadows from painting, substituting delicate coloring and the juxtaposition of harmonious color tones. To an eye as acute as his, color has a charm of its own, quite aside from the tracing of lines and the realization of the subject. He can communicate to us the sensations he himself perceives.

This year at the Grosvenor we see one of his portraits, that of a young woman, *Miss Alexander*. The model is standing, elegant and feminine, three-quarters turned toward the viewer, holding in her left hand, along the length of her figure, a gray felt hat. The picture, painted in delicate tones, presents a most harmonious combination of blacks and tender gray-green. It is fresh and translucent and has a range of color tones undiscovered by any other painter.

Mr. Whistler goes straight ahead. One can well attack him and even question the merit of parts of his work, but everyone in his heart recognizes quality, and the number of etchers and painters already inspired by him are legion. Mr. Albert Moore, for example, has devoted himself entirely to painting that is fresh and delicate in tone [see fig. 88].[. . .]

Two artists are missing in this year's exhibitions, Messrs. Dante Rossetti and Burne-Jones, which leaves an entire aspect of English art represented only by understudies. Mr. Rossetti is one of the most curious figures in the art world that this century has produced. It was he who brought creativeness and originality to the Pre-Raphaelite cult, which originated in England around 1848. He was the first to go back to the Italians before Raphael for inspiration. He revived the tall, slender, lean bodies of the primitives, enveloping them in draperies designed in the mode of the fifteenth century. It is obviously a literary conception, one that would not have occurred to a pure painter whose eyes see only life around him.

These attempts to make a connection with a bygone past are absolutely contrary to my own tastes and my ideas about art. So naturally I have approached the evaluation of Mr. Rossetti's work in a less than favorable spirit. But in good faith, whatever one may think of the methods and procedures of this man, it is impossible not to be impressed by his originality. Mr. Rossetti was born in England of Italian parents, and surely this Latin heritage, budding and flowering in English surroundings, gave birth to an art absolutely sui generis. The tall women, the sirens, whom he puts on canvas, with their accentuated features, heavy hair, and deep, intense eyes, are vigorous and full of vitality. They are strange and mysterious, and one finds them moving and striking.

Mr. Rossetti has proved his strength not only by his own work but by the students and imitators inspired by him and by the stimulus provided by him which has spread into the various branches of English art. For years he has exhibited nothing to the public, and it is now Mr. Burne-Jones, chief among his disciples, who receives the incense and homage in the temple of the faithful. The distance between Mr. Rossetti and Mr. Burne-Jones, however, is great. Mr. Burne-Jones did not invent the types he paints, and by himself would never have discovered the path he has followed. In spite of this, it would be unjust to deny him the title of artist. His creations, svelte in form, are endowed with a certain melancholy charm, though taken as a whole his work lacks vitality and variety; the subjects are all of the same conventional type, lacking life, and their bodies are so emaciated that they have practically no fleshy substance. Upon seeing these anemic figures with yellowed faces, one is inclined to believe they have just come from the hospital, recovering from some serious illness. [. . .]

Certain branches of English art are not represented in the exhibitions at either the Royal Academy or the Grosvenor Gallery, or are seen there only in fragmentary manner. For example, water colors, produced by a great many artists, are divided into two large societies, each of which has its exhibitions in different places. Nor would one find in the two large exhibitions the illustrators who, in the realm of illustrated books and journals, have mined colorful and original lodes. Such are Messrs. [Randolph] Caldecott, Walter Crane, and Miss Kate Greenaway. Finally, there is one man whose work is not to be seen in any exhibition, who belongs to no society, but who is unique. In any discussion of English art Mr. Charles Keene of *Punch* must be included. I do not know whether

Mr. Keene has ever worked in oils. All his work, except for a few etchings, consists of pen-and-ink drawings. But what drawings!—full of talent, local color, vitality, and clear-cut individuality. This is great art, living art, which has its roots in the depths of human nature. If you would observe the way the English behave, the way they move about, breathing *à l'anglaise,* captured from life by a pure-blooded Englishman who owes no debt to ancient Greece or Italy, subscribe to *Punch* and look at the drawings signed with an interlaced *C* and *K.*

Translated from Théodore Duret, "Expositions de la Royal Academy et de la Grosvenor Gallery," *Gazette des Beaux-Arts,* ser. 2, vol. 23 (June 1881): 549–56.

The Royal Academy and the Grosvenor Gallery Exhibitions, 1882

THÉODORE DURET

This year's exhibition at the Royal Academy is not very interesting. The well-known painters are for the most part showing works of secondary importance, or at least inferior to those they showed last year. Those exhibited by the honorable president of the Academy, Sir Frederick Leighton, are uninspired. [. . .]

In my opinion, among the members or associates of the Academy, Mr. [William] Orchardson and Mr. [Hubert] Herkomer are the only ones whose works show any evidence of a developing talent. Mr. Orchardson exhibits a portrait of a woman, *Mrs. Robertson.* The subject, life-size, in a black velvet gown, is seated on a chaise-longue, in an interior setting. It is an unaffected and personal painting, done with taste, and very English.

Mr. Herkomer, who received a first-class medal at the universal exposition in Paris in 1878, has found himself since then very much in the English public eye. Consequently, he has felt obligated to paint in high style and in the grand manner. This does not seem to me to have been successful; last year he exhibited canvases in which, under the pretext of style, the linear tension and the attempt at effect were not altogether pleasing to the eye [see fig. 89]. This year, his work is two sided: in one painting we see the attempt at elegance, as in the portrait of the Rev. W. Thompson, master of Trinity College, paid for by subscription. This formal style is apparent, an enormous amount of it. That is to say, in order to achieve the effect of an epic personality and an heroic countenance, the Rev. Thompson (who is surely a respectable churchman and probably the best of men) is represented with a grim face, clenched hand gripping the arm of his chair, looking as if he were longing to eat alive the adolescents of his college. This is typical of portraits paid for by subscription! On the other hand, Mr. Herkomer's portrait of W. Wynne is quite naturally drawn; no subscription, not a public personage, and consequently no attempt at showy style. In this very intimate portrait, unaffected and natural,

one rediscovers the Herkomer who has not been seen for a long time, the Herkomer whose picture of Chelsea pensioners, *The Last Muster,* had such a success in Paris.

Let us proceed to the young painters. Mr. L. Wyllie is exhibiting a *View of the Port of London.* The special atmosphere that envelops the Thames, a mixture of smoke and fog, has here been vividly reproduced, and the two steamboats in the center of the painting are well portrayed, both in the water and against the sky. But why does Wyllie lessen the effect of his picture and diminish its value as an ensemble by including minute details and tiny tableaux? In the same way Mr. [Alexander] Reid spoils his picture *Homeless and Homewards,* in which there is real painting quality, by the multiplicity of details and accessories, thus producing ensemble without any effect. This year, among the works of the young painters, Mr. John White's *Gold and Silver* shows a broad landscape, luminous and full of atmosphere. Gold is represented by fields of ripe wheat, traversed by a road; silver by the sparkling sea in the background. This painting is the best landscape in the Royal Academy exhibition, and if Mr. White develops his talent by continuing to paint in the same loose, natural, and translucent manner, he will certainly become first among the young painters of the English School.

As for the exhibition at the Grosvenor Gallery this year, it is excellent.[. . .] Never could Sir Coutts Lindsay and his aides have better shown that they are men of taste and discrimination than by the collection of interesting works they have assembled this year. In the two galleries of the Grosvenor we find examples of all those English artists who, whether for their recognized talent, their originality, or their search for new effects, deserve the privilege of exposure to the attention of the public. I know of nothing more satisfying than such an intelligent choice of exhibits, sparing us those dreadful journeys along the kilometers of mediocre canvases such as one is obliged to make at the Royal Academy and at the Paris Salon.

Painters who are members of the Royal Academy, who owe to this distinction the privilege of showing at Burlington House as many as eight paintings, usually hung in the best places, nonetheless have taken advantage of exhibiting at the Grosvenor. I notice also that they are accustomed to choosing for the Grosvenor, considered to be a much-frequented spot, not only their most pretentious canvases, designed to attract crowds, but pieces of true artistic distinction, intended to be seen by an elite company of viewers.

Last year Mr. Millais showed at the Grosvenor his best portrait, *Mrs. Perugini.* It was a loosely constructed work of high quality, the work of an artist painted for an artist and happily distinguishable from the portraits he turns out by the dozens for rich clients satisfied by mediocrity who have neither taste nor artistic judgment. Mr. Millais has nothing in this year's exhibition that can compare with the portrait of Mrs. Perugini or of Mrs. Jopling. However, the two works shown, the portrait of Mrs. G. Whilley and *The Children of Mrs. Barrett,* show evidence of his search for refinement which did not appear to so great a degree in the pictures he sent to the Royal Academy.

Mr. Holl, together with Messrs. Watts and Millais, is the portrait painter most in vogue. In my opinion there are altogether too many portraits in the English exhibitions. Undoubtedly catering to the vanity of those who have themselves painted, desirous at any price to appear before the public, has led [English] artists to exhibit this multitude of monotonous portraits, so fatiguing to the viewer. Why can they not limit themselves to the best ones? Their reputations could only be enhanced. Why, for instance, does not Mr. Holl confine himself to sending to the Grosvenor only the portrait of *Mrs. Gardnez* [sic] which is full of vitality, beautifully modeled, and strongly designed, a true masterpiece, unusually successful?

There are two artists, Messrs. Burne-Jones and Whistler, who do not belong to the Academy and exhibit only at the Grosvenor and are thus "children of the house." Here are two painters at opposite poles of art, as different from each other as two men can be, and whose simultaneous presence at the Grosvenor could not better express the intelligent and eclectic spirit which presides over the organization of the gallery's exhibitions.

Mr. Burne-Jones appears to be a survivor of a bygone world. As time goes on, the art that he cultivates becomes more and more foreign to the preoccupations of artists who continue to develop and to attain greater heights. Mr. Burne-Jones carries on the artistic movement which, under the leadership of Mr. Dante Rossetti, around 1848, endeavored to reproduce in modern England forms typical of the Italian primitive painters. Mr. Burne-Jones is a latecomer in the Pre-Raphaelite line. He is not a true innovator, for he has adopted the forms and style created by his predecessor, Mr. Rossetti. In most of its manifestations his art is morbid and sickly. The figures he paints are strictly conventional and could not be otherwise, for it is impossible to imagine that an Englishman of the nineteenth century could possibly put himself inside the skin of an ancient Italian, as he would have to do to bring to life again the forms and style of fifteenth-century Italy. I could go on and on in my critical appraisal of the work of Mr. Burne-Jones,[1] for his attempts to resuscitate a distant past are completely contrary to my tastes and to my ideas of art. However, while my mind is crowded with these objections to his work, I do see something uncommon emerging from his paintings—a certain melancholy, a poetic note, manifestations of imagination. Mr. Burne-Jones impresses me as being more of a poet than a painter. He is in any case a man of conviction who faithfully follows the course he has laid out for himself, never stooping to curry favor with the public. For this he deserves respect.

Mr. Whistler is certainly the artist who has gone farthest from the conventional roads which circumscribe England. His art has a flavor and individuality all its own. For a long time he has been engaged in a battle in England similar to that which occurred in France at the time of Courbet and which is still being fought over Manet and the impressionists. So Mr. Whistler shares the fate of all truly creative artists.

This year he is showing at the Grosvenor both seascapes and feminine figures

that use in their composition, as is his custom, the language of musical compositions. He presents us with a nocturne in black and gold, another in blue and silver, a color harmony in rose and flesh tones[2]. . . and another harmonious composition in black and red. At ten paces before the two nocturnes what impression do I receive? The one in black and gold presents a square black surface I can stare at for as long as I like without seeing anything in it. I can understand the critics and men of letters who claim that Mr. Whistler's nocturnes are such vague expanses of color that there is nothing the eye can perceive. They are partially right. Mr. Whistler attempted to paint black night, really an impossible achievement, as black night cannot be seen. But the other nocturne, the one in blue and silver, shows a vast expanse of water, illuminated by a sort of twilight moonlight, whose limits are lost in the far distance. The effect is translucent and profound and creates a penetrating impression. And I realize that the artists, critics, and art lovers who claim that Mr. Whistler's nocturnes are admirable are also right.

The two harmonies in color, rose and flesh tones, black and red, are figures of standing women, unencumbered by accessories, supple, graceful and ravishing, whose effect is obtained by the clarity and delicacy of tones.

When an artist deserts the path of tradition and brings a personal note to his art, instead of being appreciated for the originality of his work, he is rejected because he disregards the forms of his predecessors. Critics are nearly always right about the imperfections they perceive in works they condemn. All the faults found in Corot, Courbet, and Delacroix really exist in their work just as much today when they are so much admired as yesterday when they were scorned. There are no perfect artists, and what the critics find lacking in Whistler's work probably is lacking. But Whistler has his own manner of painting and his own way of seeing nature, delicately and surely. Everything he does bears the cachet of his personality. Whether he uses the burin of the etcher or the brush of the painter, he gives life and soul to the scenes of nature and the people he portrays. I concede his faults without in any way changing the opinion that leads me to recognize in him a great, a very great, artist.

Translated from Théodore Duret, "Expositions de la Royal Academy et de la Grosvenor Gallery," *Gazette des Beaux-Arts*, ser. 2, vol. 25 (May 1882):617–20.

1. In the 1882 exhibition Burne-Jones showed nine paintings. *The Tree of Forgiveness* was regarded as the masterpiece.

2. Whistler's painting was titled *Harmony in Flesh-Colour and Pink: Mrs. H. B. Meux.*

1882–83: Rome

One of the early acts of the Italian state after its capital had been moved from the provisionary seat in Florence to Rome in 1871 was to reassert the Italian presence in the mainstream of European culture and the arts by inviting nations to participate in an exhibition at which artists from the Kingdom of Naples and the Two Sicilies, the Duchy of Parma, the Duchy of Tuscany, the Papal States, Milan, and Venice would be seen for the first time in the ancient capital as Italians.

In 1871 Italian troops had seized Rome by force and declared the eternal city the permanent seat of government for the newly constituted nation, thus leaving the papacy in a politically anomalous position that continued until 1929, when the Lateran Treaty recognized the Vatican as an independent state. Victor Emmanuel II of Savoy-Sardinia took up residence as king of Italy in a palace built by a pope in 1574 on the Quirinal, one of the seven hills of ancient Rome. An adjacent building which had housed the administrative offices for the Papal States became the Ministry of the Exterior; the Senate met in the fifteenth-century Palazzo Madama, long occupied by the grand dukes of Tuscany; and the Chamber of Deputies was convened in a palace of a Ludovisi prince begun by Bernini and furnished for the papal tribunal by Carlo Fontana. A court of justice was erected on the fields along the Tiber near the Castello San Angelo, and the Via Nazionale was cut through the city to connect the railway station and the Baths of Diocletian to the Piazza Venezia, the Via Vittorio Emmanuele, and the Corso. Along this broad avenue rose a modern hotel, the Banca d'Italia, and the American Episcopal Church of St. Paul designed by the English architect George E. Street and ornamented with a mosaic by Edward Burne-Jones (fig. 94).

The Chamber of Deputies also approved the construction of a Palazzo delle Belle Arti for modern art. Rome had never ceased to be a major international art center, with its numerous national academies and colony of foreign artists, many of whom had gained their reputations at the Paris Salons and the universal expositions. By building a gallery to show contemporary foreign and Italian art, the government hoped both to create its own national salon that would replace the exhibitions of the venerable regional academies and make contemporary art an Italian entity, and to found a national institution to which foreign artists could submit their work. In 1883, to inaugurate the Palazzo, later known as the Galleria Nazionale d'Arte Moderna, the Italians held an international exhibition of con-

269

temporary art, opened by King Umberto I accompanied by the mayors of the Italian cities, representatives from the Senate, the Chamber of Deputies, and the provinces, and other dignitaries of the state. On the first floor of the new building the fine arts were displayed; the applied, or industrial, arts were on the second. But since the exhibition had attracted five thousand artists (of whom only two hundred were foreigners), many objects ended up in temporary buildings on the southern slope of the Quirinal.

The exhibition attracted little attention in the foreign periodicals. The *Art Journal* commented, "Although styled International, this exhibition is hardly so in the strict sense of the term. It is scarcely even National, especially as regards sculpture."[1] The *Gazette des Beaux-Arts* supplement, *Chronique,* remarked only that its readers might be interested in knowing that the Spanish honorary consul in Nice, Ernest Gambart,[2] would be sending some of his finest paintings by Rosa Bonheur, Alma-Tadema, Frère, Dyckmans, and Portaels to the exhibition. The critics who did write about it generally noted that the works displayed showed the same two tendencies found everywhere else, either a sentimental genre romanticism executed for and supported by the tourist trade, or Realism. The latter also tended to fall into two distinct groups. The first, taught at the academies and related to Romanticism, was derived from a technique practiced by a group of artists active in Florence in the 1850s and 1860s known as the Macchiaioli, who painted open-air sketches and then finished their work off in the studio to gain color brilliance. The other, sometimes referred to as the Scuola di Posilippo, from the village near Naples where it was practiced by the Palizzi brothers, Domenico Morelli, and their friends and students, sought by much the same method to achieve a chromatic accuracy that all open-air painters aspired to. The two groups were distinguished more by subject matter than by technique. The Macchiaioli earlier had painted historical or religious romantic themes; the Scuola paintings either followed the Barbizon landscape school and lacked narrative subject altogether, or emulated artists like Courbet and Breton in painting subjects with social implications.

Freed from censorship in the new Italy, newspapers and periodicals prospered, supported by a reading public whose numbers steadily increased, thanks to compulsory elementary education and the requirement that the citizen must be literate to vote. The periodicals *Nuova Antologia* of Florence and *Gazzetta letteraria* of Turin competed with the newspapers like the *Fanfulla* and its supplement *Fanfulla della Domenica,* launched in 1879 under the direction of the writer-politician Ferdinando Martini, who was then Minister of Education. Martini was a Florentine and an early sponsor of the city's Nuova Società Promotrice delle Belle Arti. Among the outstanding Italian writers he attracted was the young poet

1. B. Duffy, "The International Exhibition of Fine Arts in Rome," *Art Journal,* 1883, p. 162.

2. Ernest Gambart, once a favored art dealer of collectors, with galleries in London and Paris, had secured this appointment upon his retirement (*Chronique,* December 23, 1882, p. 308).

1882–83: Rome

One of the early acts of the Italian state after its capital had been moved from the provisionary seat in Florence to Rome in 1871 was to reassert the Italian presence in the mainstream of European culture and the arts by inviting nations to participate in an exhibition at which artists from the Kingdom of Naples and the Two Sicilies, the Duchy of Parma, the Duchy of Tuscany, the Papal States, Milan, and Venice would be seen for the first time in the ancient capital as Italians.

In 1871 Italian troops had seized Rome by force and declared the eternal city the permanent seat of government for the newly constituted nation, thus leaving the papacy in a politically anomalous position that continued until 1929, when the Lateran Treaty recognized the Vatican as an independent state. Victor Emmanuel II of Savoy-Sardinia took up residence as king of Italy in a palace built by a pope in 1574 on the Quirinal, one of the seven hills of ancient Rome. An adjacent building which had housed the administrative offices for the Papal States became the Ministry of the Exterior; the Senate met in the fifteenth-century Palazzo Madama, long occupied by the grand dukes of Tuscany; and the Chamber of Deputies was convened in a palace of a Ludovisi prince begun by Bernini and furnished for the papal tribunal by Carlo Fontana. A court of justice was erected on the fields along the Tiber near the Castello San Angelo, and the Via Nazionale was cut through the city to connect the railway station and the Baths of Diocletian to the Piazza Venezia, the Via Vittorio Emmanuele, and the Corso. Along this broad avenue rose a modern hotel, the Banca d'Italia, and the American Episcopal Church of St. Paul designed by the English architect George E. Street and ornamented with a mosaic by Edward Burne-Jones (fig. 94).

The Chamber of Deputies also approved the construction of a Palazzo delle Belle Arti for modern art. Rome had never ceased to be a major international art center, with its numerous national academies and colony of foreign artists, many of whom had gained their reputations at the Paris Salons and the universal expositions. By building a gallery to show contemporary foreign and Italian art, the government hoped both to create its own national salon that would replace the exhibitions of the venerable regional academies and make contemporary art an Italian entity, and to found a national institution to which foreign artists could submit their work. In 1883, to inaugurate the Palazzo, later known as the Galleria Nazionale d'Arte Moderna, the Italians held an international exhibition of con-

269

temporary art, opened by King Umberto I accompanied by the mayors of the Italian cities, representatives from the Senate, the Chamber of Deputies, and the provinces, and other dignitaries of the state. On the first floor of the new building the fine arts were displayed; the applied, or industrial, arts were on the second. But since the exhibition had attracted five thousand artists (of whom only two hundred were foreigners), many objects ended up in temporary buildings on the southern slope of the Quirinal.

The exhibition attracted little attention in the foreign periodicals. The *Art Journal* commented, "Although styled International, this exhibition is hardly so in the strict sense of the term. It is scarcely even National, especially as regards sculpture."[1] The *Gazette des Beaux-Arts* supplement, *Chronique,* remarked only that its readers might be interested in knowing that the Spanish honorary consul in Nice, Ernest Gambart,[2] would be sending some of his finest paintings by Rosa Bonheur, Alma-Tadema, Frère, Dyckmans, and Portaels to the exhibition. The critics who did write about it generally noted that the works displayed showed the same two tendencies found everywhere else, either a sentimental genre romanticism executed for and supported by the tourist trade, or Realism. The latter also tended to fall into two distinct groups. The first, taught at the academies and related to Romanticism, was derived from a technique practiced by a group of artists active in Florence in the 1850s and 1860s known as the Macchiaioli, who painted open-air sketches and then finished their work off in the studio to gain color brilliance. The other, sometimes referred to as the Scuola di Posilippo, from the village near Naples where it was practiced by the Palizzi brothers, Domenico Morelli, and their friends and students, sought by much the same method to achieve a chromatic accuracy that all open-air painters aspired to. The two groups were distinguished more by subject matter than by technique. The Macchiaioli earlier had painted historical or religious romantic themes; the Scuola paintings either followed the Barbizon landscape school and lacked narrative subject altogether, or emulated artists like Courbet and Breton in painting subjects with social implications.

Freed from censorship in the new Italy, newspapers and periodicals prospered, supported by a reading public whose numbers steadily increased, thanks to compulsory elementary education and the requirement that the citizen must be literate to vote. The periodicals *Nuova Antologia* of Florence and *Gazzetta letteraria* of Turin competed with the newspapers like the *Fanfulla* and its supplement *Fanfulla della Domenica,* launched in 1879 under the direction of the writer-politician Ferdinando Martini, who was then Minister of Education. Martini was a Florentine and an early sponsor of the city's Nuova Società Promotrice delle Belle Arti. Among the outstanding Italian writers he attracted was the young poet

1. B. Duffy, "The International Exhibition of Fine Arts in Rome," *Art Journal,* 1883, p. 162.
2. Ernest Gambart, once a favored art dealer of collectors, with galleries in London and Paris, had secured this appointment upon his retirement (*Chronique,* December 23, 1882, p. 308).

Gabriele d'Annunzio, from Pescara on the Adriatic. He had been a pupil of Giosue Carducci, one of Europe's foremost poets, whose verse was classical in its style and romantic in intensity and themes. D'Annunzio adopted his classical meter and added to it the Realism of Zola and the spiritual Naturalism of Paul Bourget.

D'Annunzio first came to the public's attention through a review of his first book of poems, *Primo Vere*, in the *Fanfulla della Domenica* in 1880, and he was soon publishing his own reviews in both the weekly and the daily *Fanfulla*, for like many young writers he supported himself first as a journalist. His taste, and that of the circles he frequented, was still dominated by the popular, technically brilliant painter Mariano Fortuny, who at the time of his death was head of the Spanish Academy. A foretaste of his literary style can be found in his review of his friend Francesco Michetti's *The Vow*, the picture that caused a sensation at the exhibition (fig. 93). A romantic and a disciple of Nietzsche, d'Annunzio later wrote sensuous, decadent novels that were avidly read both inside and outside Italy. He incorporated his description of *The Vow* almost verbatim in his novel *Il Trionfo della Morte* (the Triumph of Death; 1894).

The approach to criticism of Francesco Netti was diametrically opposed to d'Annunzio's. Netti had learned to paint with the Scuola di Posilippo when the group was first formed and had been represented among the work of the group headed by Morelli that was shown at the first Italian national exposition in Florence in 1861. As the reviewer for Naples' Società Promotrice's third exhibition in 1864, he expressed aesthetic aims that were strongly influenced by the noted literary historian and aesthetician Francesco de Sanctis, who held that the concept of form was identical to the concept of imagination or artistic vision.[3] After painting in Paris for five years, Netti returned to Naples in 1871, and through his writings participated in the discussions relating to the teaching of art, its place in society, and the social conditions art required as the status of his native Neapolitan region shifted from independent kingdom to province in a nation-state. His ideas were set forth in the criticism he wrote for the national exhibition held in Naples in 1877 and in Rome in 1883. In his reviews, published in the Neapolitan papers, in *Arte in Italia* (Turin), and in *Illustrazione Italiana* (Milan), he questioned the worth of the immense historical and battle canvases that were so often used for decoration. The 1883 exhibition in particular provided him with examples to illustrate his aesthetic theory and make clear the difference between the two schools of Italian color Realists: "The painting is rough; it smells of village dirt," he wrote of Michetti's *The Vow*, while of Alma-Tadema's picture he said, "Your imagination is allowed to rest. He does not move you, but he pleases you." Netti also considered the part color played in historical painting and questioned the value of that category unless the painting was "moving."

3. Elizabeth Gilmore Holt, *The Art of All Nations* (New York, 1981), p. 299.

Exhibition of Art

GABRIELE D'ANNUNZIO

I. I often recall, my lady, with a touch of melancholy and nostalgia, the beautiful blaze of December which crackled in your little fireplace, beneath the blue dragons and putti of a majolica bas-relief. Do you remember? We spoke almost always of art, smoking certain thin and yellowish Russian cigarettes, while the aroma of the tea steamed warmly out of porcelain cups. Art, meanwhile, completely surrounded us. Through a flowery Japanese umbrella—peculiar lampshade!—the light blandly spread across the room, finally reaching the Florentine tapestries on the walls and the great vigilant bronze ostriches in the corners. The furniture, in that almost lunar haze, became submerged, losing its form, and a gigantic banana plant threw up abundant green leaves which looked as if they were traversed by a red artery. On the mantel, among small ivories, vases full of fresh flowers, and delicate bamboo fans, a little group of figures in old silver by Barbella[1] stood out from its background of a swatch of garnet-colored velvet: they represented two songstresses of May walking down the slope joined in song. Opposite, the head of a blonde by Cremona smiled in the sweet and diffuse tones of watercolor. A landscape by Vertunni expanded in a profound melancholy of green plains, interrupted by groups of trees isolated by the whiteness of the sky.

Then there were several plates, with narrow-eyed female figures or flying storks, hanging like escutcheons above the mirrors, to which were attached cascades of silken and gold fabrics. From one side hung a swatch of silk on which some unknown disciple of Buddha or Fo had lovingly painted a long branch lively with flowers and amorous birds. [. . .]

As you see, I remember all. [. . .]

And now here I am keeping the promises I made you before leaving. Melancholy promises, my lady.

How instead would I have loved to accompany you through the large and luminous rooms of paintings and statues, carrying on that amusing chatter among the crowds, crinking with slow voluptuousness at each pure spring of art. [. . .]

At first we would have wandered aimlessly, as in a kind of dream, past that fugue of canvases, not analyzing, but being alive to the sensations stirred up in us by each note of color; being content with the infinitely varied fantasy, taking pleasure in it as if it were an indistinctly heard symphony rising softly and growing around us. [. . .]

II. *Landscape Painters* The painting of landscapes seems to flourish in Italy today. From Lojacono, who loves the seas of burning gold of his Sicilian countryside, to Gignous, who prefers the tame autumn greenery of Lombard hills, a whole flock of artists, differing in goals and methods, is inspired by the august poetry of Nature.

I reread yesterday the crystalline alexandrines of [Théophile] Gautier, *À Trois Paysagistes*, of the Salon of 1839.

> Thanks to you—all of you—oh sovereign artists!
> Your pictures, piercing a breach in the wall,
> Are for us like so many open windows
> Through which we behold the great green plains,
> The golden harvest fields, the woods yellowed by autumn,
> The limitless horizons and the infinite skies! . . .

Théophile was then speaking of the austere and penetrating landscapes of Bertin, of the severe delicacies of Aligny, of Corot's sunsets, letting the mood overflow to the full.

Today, in this exhibition, which are the canvases that truly open a breach in the walls? Very few; because the pure and conscientious study of life does not triumph. In most of the pictures the "manner" predominates: there is something dry, something dead, that cold minuteness of execution and that brilliant vacuity, which bring to mind the hangings of a master's "studio," that obvious striving for effect and that artificiality of means which reminds one a little of theater-set designers. The pictures are, as Heine would say, embalmed in moonlight. Even certain extremely well-painted canvases, really strong in their qualities of drawing and color, remain inanimate, because they are lacking in what may be referred to as "ambience." The air does not breathe in them, no sense of time and place stamps them with a particular character; nor is there that lively freshness which reveals an immediate vision and an inspiration. No; the trees, grasses, skies, and waters may be exquisitely crafted, but the painting of landscape must not stop there; it must not be a photograph. In landscapes, I search for something else beyond the simple aspect of things—a significance, a sense of life, the expression of that which a poet has daringly called "the thoughts of nature."

Then, too, some *landscapes* that are generally pleasant and attractive are not a sincere reproduction of reality, but are a surface covered with a certain harmony and attractiveness of intonation. Gignous, for example, who indeed is undoubtedly one of our more accomplished landscape painters, sometimes falls into this error: his painting has great charm, which he uses to excess, and once he has captured those intonations pleasing to the eye, he sometimes begins to daydream and fails to care for or worry about truth. Sweet tones of green and earthen colors, and skies of bright clouds attuned with a felicitous spareness, this is what could be called his dominant *note*. Never a discord.

Now, such pictures are pleasant; the eye rests on them and the soul abandons itself to the reverie. But go back to real life and you will recognize the deception.

The cause of this is, I believe, too assiduous a predilection for certain aspects and certain attitudes of nature. The painter becomes used to seeing things in just that way, under just that light, with just that quality of shadow, and there comes a moment at which, instead of executing from immediate life, he executes from memory, almost, we might say, according to a particular formula.

And of such pictorial formulas, many, even the best, make use, with little respect for art.

Gignous, to be sure, does have here, among several others, two or three landscapes in which a most powerful broadness of technique, a most poetic natural sentiment, a sobriety of color, and a classical simplicity of line are such that one stops in contemplation as if seeing a vision, almost feeling the moistness of the countryside, the pungent odor of the rotting leaves, and the august silences.

The greatest of these pictures is *Autumn,* a succession of green heights under a sky full of white clouds. In the foreground, a thicket of trees floats in the first drowsiness of life; the meadow is still alive, with its bright and brilliant green interrupted by the red-brown of the fallen leaves. A few sheep wander about. The mountains grow distant, as if under a curtain of light vapors; and an almost invisible veil appears to waver over everything and submerges the forms and outlines of the land, which falls asleep in an agony both sad and sweet. There is something of antiquity in this, of that ineffable antique quality that enlivens the copses of Corot; there is that sense which I might call holy, that sense which few landscape painters, and few poets, possess. [. . .]

One of the most beautiful and strongest personalities among the painters is Francesco Lojacono, that Sicilian full of impetuousness, overflowings, and suffocating effusions. He nearly always observes with much sincerity and renders with much correctness, though sometimes abandoning himself to certain affectations, certain feminine graces, certain deliberate effects of technique. He has not yet achieved that full and absolute indifference to the public, to the crowd, which every sound artist must possess; rather, sometimes, he descends to compromise, omitting, attenuating, modifying or positively falsifying that with which life presents him, to oblige vulgar preferences.

Thus he even occasionally falls into mannerism, dazzled by his own palette, deceived by his own brush, violating that pure felicity of vision which he possesses as a natural gift, forgetting himself.

Of this, his little picture of *Saracen Olive Trees* is proof. Here the pictorial qualities are extremely strong, but the shadows and lights are not right, and in certain areas one senses an uncertainty of recollection and almost the embarrassment of one who tells a lie. We see beautiful olive trees, old giants of vegetation rising in spirals like desiccated snakes, too delicately painted, without a rough touch, without a lifelike ruggedness. The sky is of purest deep blue: now, why don't the shadows on the inside of the tree trunk take on something of the color of the sky? And again, why is the shadow inside the basket so warm? And why, in a distance as short as that from the top of the olive tree to the bottom, does the tone of the shadows change?

It is no use: there is nothing but real life. All that which is not honestly drawn from life; all that which is a more or less splendid product of fantasies, reminiscences, preferences, in short, subjectivity; all that which is only a more or less dazzling demonstration or show of bravura, of what we today euphemistically call virtuosity; every exaggeration, every sentimentality, every imposture, all must

be demolished. Only then will art be created, healthy art, great art; then will it be like a religion, like a respected cult; and the Pharisees will be routed.

Certainly Lojacono is not among the Pharisees; if only he suppresses certain excessive technical ambitions, he can produce vigorous paintings like his *Near Vesuvius;* where especially the middle- and background are done with an intelligence so full of the nature of the place, and with such reality of coloring, that the illusion is perfect.

The crater calmly smokes into the blue; and the heights, covered with low vegetation, fade into the bare lava of the foreground, toward the boulders among which a little girl, erect, hands at sides, with a basket of twigs at her feet, looks toward the sun. Behind her are two other small female figures, collecting the dry brush. In this foreground area the brushstroke is too visible.

But the major picture, the picture that is a broader manifestation of the talent and the tendencies of Lojacono as a painter, is *The Unexpected Return.*

The Sicilian May, that golden May, triumphs in an impassioned flowering of rosemary, fennel, wood sorrel, thistles, and poppies. The countryside whitens in the calmness of the afternoon, under a sky spotted here and there with ashen clouds, curving toward a horizon full of lightly violet mists, cut off at the left by the deep blue line of the sea. The groups of figures are enveloped in sunshine. The soldier, arriving unexpectedly, embraces his beloved; a few curious females watch the embrace. Beyond, an old woman and a burly man look into the sun, perhaps to see another soldier arriving. At the rear, there is a melancholy group of two women and a child: the child perhaps asks his mother in mourning when his papa will return. The immense blueness of the sky floods over everything and everyone; it seems that the air, through this enormously broad trail, invades the picture; and a profound sense of the hour of the day dominates the dissolving plain.

Some will find that the sky occupies too large a part of the canvas. But I like the almost immaculate luminosity; it seems to me that all of the scene's poetry lies there, in those two colors of the distance, in that hot gold and that pure ultramarine.

The figures are rather indefinite; they are like a reduction of life, a reduction more refined, more prettified, more stippled, in honor of the buying public. And the effect of distance among the figures is obtained by a mistake, because in that radiant sunlight, in that clarity of atmosphere, the fine powderiness of the haze cannot begin to thicken visibly so close to the front.

The foreground is studied with the happy fondness of an artist who loves the beautiful blond hues of the crops and of those long-stemmed primroses of the woods. Every stem, every leaf, every cluster of flowers is drawn and painted with care; and a gust of vital warmth seems to rise up from amid these intertwinings.

From Lojacono, it is a jump to Bezzi. Bartolomeo Bezzi is the painter of moist and chilly mornings which hover over the houses and over the silence of greenish waters. He has at his command a certain tone of light clear sky, a gray vaporosity, a particularly delicate harmony of colors, and he uses and abuses this in all five of his exhibited works. Never a dissonance, never a wavering chord. He seems like a

kind of crystallization of a type; and among landscape painters, there are many who are so crystallized. Gignous always does autumns; Formis always does autumns and rocky landscapes; Gecconi always does groupings of bare trees; Gostantini always does cool and wet greenery; and so on.

Now this, it seems to me, is a sure sign of poverty of ideas.

Let's look at Bezzi. He shows a calm *Morning* which protects the houses still slumbering in a row on the water; green spots of moss and brownish blotches climb along the walls of the houses. A solitary boat creeps by in the melancholy silence; and the sky takes on a very light beryl hue at the horizon. The coloring is most delicate, everywhere; and there is something noble in the technique, a simple elegance, an almost poetic love.

The impression is rendered with great sobriety, and the atmosphere is all-encompassing. But how different are the impression and atmosphere of *Mills on the Adige*? The lines are different, but the color, technique, and sentiment remain identical.

The largest of the five canvases is *Pescarenico*. The houses lined up along the shore, white and pink, are mirrored in the gray sheet of water against a vague background which must be mountains. The whole execution of the background is vague. The houses somewhat resemble embossed paper. This, in my opinion, is Bezzi's weakest picture: a tinted photograph. [. . .]

One of the greatest landscape painters of the Lombard school, a real master, is Achille Formis. Like Gignous and Boggiani, he loves the last greenery of the fields and the rugged hillsides and the clarities of the skies. He has a felicitously practiced hand, and paints with a certain elegant broadness, without major audacities. He does not, however, possess the warm feeling of nature: his pictures are simply more or less beautiful views, impressions rendered with a cold accuracy of draftsmanship and color, tourist souvenirs. Today, all of this has no importance for art, all of this is useless, signifies no progress, does not open up any road, nor reveal new glimpses and new horizons; all of this is commonplace: we demand something quite different.

Don't artists realize that from a good while back the public has been bored? Don't they realize that the public is fed up with that petty bourgeois art which lacks muscle and blood, which lacks the purity of ideas, which lacks health? Don't they realize the vacuity of this art, which is content with a harmony of colors, of line, of relationships, sacrificing life to gracefulness, or effect, petrifying itself in formalisms, in types, in deliberate attitudes?

We demand something quite different, we demand something truly young, truly new. We are tired of that solidity which is heaviness, of that purity which is coldness, of that realism which is ugliness, of that imagination which is overexcitement or hysteria, of that dramaticism which is theatricality.

May the innumerable throng of painters be decimated; may all the washouts, all the tradesmen, all the taxidermists be exiled. The few elect shall be admitted to the cult of art; the others shall be turned away as scoundrels.

Every powerful manifestation of a painter's personality shall be accepted—

accepted with all its defects, with all the exuberance which emanates from true value. For it must not be assumed that we ask perfection of a work of art.

Can we discover purity of design in Delacroix, can we discover in him realistic coloring? Can we find the charm of beauty in the works of Courbet? or find in those of Corot variety in the type of subjects, or correct perspective in the planes? or in those of Watteau robustness and boldness? or in those of Meissonier the trace of an impression? Certainly not.

Can we find in Goya disciplined workmanship and elegance in composition? in Rembrandt lucidity of atmosphere? solidity in Van Dyck's portraits? enchantments and transparencies of atmosphere in the canvases of Spagnoletto [Ribera]? dazzling color in those of Velásquez? Sober restraint in those of Tintoretto? Certainly not.

But all these painters have made their own mark on art, with unique insights and accomplishments.

Now originality is precisely what we demand, we cannot allow uncertainty, tentativeness, insignificant productions, mediocrity. We here, for example, accept Michetti and reject Cammarano, accept Nono and reject Cortese. Just so. [. . .]

III. *Edoardo Dalbono* Among all those gray landscapes of autumn and those dark seascapes, the canvases of Dalbono radiate with the joyous luminosity of waters and skies, vibrate like a peal of song or of laughter, breathe like the lively freshness of youth. They are idylls of the sea, idylls of clouds, they are poetry, the great resplendent poetry of the Gulf, loved and felt and dreamed by a poet. All the enchantments and illusions of color, all the graces of line smile at you; the most fleeting transparencies of water, the noblest virginities of the sky, the weirdest flashes of light, the most fickle lusters, the most sonorous harmonies of colors tempt you. You are there before them and you seem to be dreaming; you experience some indeterminate fear that affects you like the charm of sirens, or like the perturbation you feel when you see a woman who will be your undoing. At first, you do not understand: are they fantasies of an artist drunk with sunshine, or real impressions sincerely reproduced? You do not understand, you have never swum in the seas of Vico, Capri, Sorrento, where the waters seem to dye you a deep blue or encrust you with malachite, where you never know whether there is sand or a void beneath your feet, where from every side you are assaulted and terrified by mirages and dazzled by unknown shapes which are the reflections of far-off reefs. You do not know the bottom of the Neapolitan sea covered with emerald green, where the currents of mineral-laden waters lavish marvelous iridescences, where the living shells project the resplendence of crystals and metals, where each thread of seaweed plays a thousand tricky, glittering, and unexpected games. The clashing accents of red kerchiefs, of green awnings on the white-, yellow-, and pink-tinted houses, which stand out on a ground of sky blue, offend you, pain you.

So the canvases of Dalbono naturally cannot please you; this sort of painting, this searching for certain particular effects, this lively manifestation of an artistic personality full of all the southern nervousness and excitability, that idealism of

vision and that transcendental love for optical illusions and mirages, seem morbid, of course.

But they are not. I really wish to settle the question. Some accuse Dalbono's painting of falseness, because he prefers those special characteristics and aspects, because he prefers those special effects of sunshine and those watery transparencies. This accusation is wrongfully made; it is not just. There is a great difference, I think, between falseness and transcendence. Falseness is failed harmony, provoking pastiche, impure mixing of colors; but it is not transcendence, the search for a given quality. Now for some, Dalbono is false because he does not love grayish hues, because he does not always paint dying trees under pearly skies, because he does not put four fingers' worth of paint on the canvas. It would seem then that he, a Neapolitan, is not permitted to depict the joyous and luminous countryside of Naples. That is what is wrong.

When we say transparency, fusion, liquidity, we must realize that beneath these facile words lies the long and painful study of the artist who paints sky and sea.

We will always be able to find many solid paintings, and will often find many solid seas and skies, and even solid flowers, because pictorial "solidity" has had such a development since 1830 that it has come to seem desirable not merely to use solid tones, but to make a bas-relief of colors on the canvas. We had reached the point of mixing in sand and dirt; and tree trunks and stones have been so painted that in robustness and solidity they were not second to the real thing.

Now in such a small reproduction of nature as a picture is, the abuse of this solidity became so unbearable that finally the need was felt to return to painting the canvases instead of besmearing them. This needs much toil.

And in that period, in which everything came to us from France—through the Corots and Daubignys and Troyons—even the artists of the south of Italy, following that direction, threw themselves into painting stagnant waters, groups of trees, and so on, all in gray hues which were called "distinguished" hues. Now, if it is true that in countries where nature is of such character, artists should select their harmonies from this key, it is not fair to ask that a Neapolitan, a Sicilian, a southerner in one word, should achieve being "distinguished" by destroying his coloring and toning down his luminous palette.

A deep blue sky, burning eventides, flowering trees, sails on the green sea lit up by the sun, and exulting reflections in the water did not mean anything in that period. Nature was allowed to be "distinguished" only on cloudy or rainy days, and even then with reservations: it had to be overcast and rainy in the French fashion.

This period has fortunately ended, because many courageous people in one way or another began to act for themselves.

One of Dalbono's first pictures, in which the sense of nature, of our nature, was deepest and most alive, was *The Legend of the Sirens*: a marine background, full of that freshness and that almost mysterious intimacy found in certain coves, against which three white nude women writhed voluptuously in sight of some beached boats.

The painting at first gave rise to heated discussions, seemed the work of either a fool or a drunkard, was thought improbable, manneristic, false, and who knows what else. Afterward, little by little, the *Sirens* began to conquer and fascinate us, so great was the sense of life, so sincere the youthful feeling in that bewitched nook of the sea.

Thus the young artist advanced along a new road, with the most resplendent joys of color on his palette, with a soul full of all the enchantments of his Naples; and there was a noble profusion of flowers, butterflies, oranges, shiny cloths, and fresh smiles on the bright red mouths of the fisherwomen. In every canvas, in every watercolor, the healthy joyousness of the life of the Gulf vibrated and rang out; as if it were a wave of invading poetry that animated and sometimes transfigured men and things. [. . .]

V. *Alma-Tadema* His is a gemlike sort of painting, something like a rare piece of old silver, something like a jewel covered with chased work, a sculptured and incised ivory, a miraculously carved slab of alabaster; just that. One stands there looking, observing, investigating with the curiosity of an antiquarian who has a passion for relics, miniatures on parchment, slender foliage winding around capitals, fragments of flowery bas-reliefs, ancient cameos; just that. A peculiar effect: looking, observing, investigating, at first one does not think of painting, one does not think of the work of a wise and patient brush. These canvases seem to have an almost glassy hardness, virtually the consistency of gemstones; certain pieces resemble intarsia, certain others, Florentine stone mosaic, still others, enamel. Here and there the coloring takes on an amberlike transparency, that sort of diffuse golden tone with which time has enriched Venetian portraits. One senses that many effects of surface and of quality are obtained by means of very exacting technical processes, mostly glazes. The brush is never visible, nor is the touch; the diversity of materials in the objects that fill these interiors is not rendered through a diversity of brushstrokes, through thickening of the colors, scratchings, hammerings, or speckles—that is to say, by means of all those little expedients of which many painters make use nowadays. No, the strokes are always the same, the appearance of the colored canvas is always that of a miniature on a smooth sheet of ivory. But differences in materials are nonetheless achieved with admirable clarity, achieved through compositions of color: the metals are metals, the marbles, marbles, the woods, woods. All that delicate architectural scrollwork, the sacred paraphernalia and elegant ornaments; all those backgrounds, softly harmonious with their carved walls and receding columns, are studied and executed with an investigative love, with a tireless attention to detail, with an equal care. The artist seems to prefer all those dead things; the inanimate orderliness of statues seems to have him in its spell. A "marble-ishness," so to speak, stiffens even the human figures who appear in that light. Flesh takes on a gemlike transparency, the clothes are without fluidity in their folds, without softness.

Nonetheless, these figures attract: they are types of great refinement, and all have something noble in attitude and expression, though very few are characteristically Roman. The female type beloved of Alma-Tadema has burning red-

gold hair, a diaphanous face full of tranquil grace. Such an ideal of ancient beauty, dreamed up by a Fleming in the misty springs of England, appears almost always in a rose-colored or white tunic; she has the chastity of a Nordic virgin and serene azure blue eyes, sometimes astonished.

Sometimes the flaming hair is attenuated to a delicate blonde, as in the voluptuous woman in *Cabinet of an Amateur*, who, stretched out, lifts her eyes toward the easel and admires.

In *Cabinet* the illumination descends from high windows, with a silvery flow of morning light. There is an intimacy, I would say, both intense and sweet: on the walls, the painted panels create a harmony of opaque colors: they are works of Turpilius, and of Marcus Ludius; a tall muse, their patron, protects the art treasures. To the left, on the easel, stands the picture exposed to admiration; in front of it, a youth with a great black mane, an olive complexion, and white clothing, bends over to look. Beside him one glimpses, half-hidden, the protruding bald skull and intent eye of an old man. To the right a group listens to the amateur reading out loud, perhaps a harmonious Greek ode to love. In the group, all the pale tones Alma-Tadema prefers mingle with shadow: the languid beryl green, the soft blue tending to gray, the deep green with iridescent reflections of red, the gray starred and flowered with white. In the center, luminous, radiant, the blonde woman stands out from the marble background; she raises her eyes from a long papyrus and turns them toward the picture: she is of a light blondness, like a sheaf of corn, even her flesh, even her eyes; the rosy folds voluptuously envelop her. Beneath her, the white mosaic pavement; all around, an air of poetry, an intimate enchantment of art. [. . .]

But the truly Virgilian spring among Tadema's works is *The Idyll of the Proposal*, before which one feels as if whiffs of sea breeze and scents of jeweled trees are wafted over one's face in a twinkling of silver hexameters. It is the voluptuousness of happy leisure, the voluptuousness of youth. The doubtful girl, in the trap of love, has an intent bewilderment in her eyes; it seems as if she were listening to something within herself, the echo of an insidious whisper, a wave of abandon that invades her, an unknown throbbing that perturbs her. She remains perplexed, bending down toward the young man, as if under a spell, with a finger on her lips, with an arm leaning on the marble back of her chair; the roses on her knees emit their scent, her white garments flow, and with their almost warm whiteness her bosom, tied up with strips of amaranth, creates a vague harmony of violet and light touches of yellow. She listens: her hair is like a spot of red gold on the delicate color of the sky.

The young man lies prone on the bench, one hand holding his chin, and turns his eyes toward her, full of inquiring desire; with the other hand he barely touches an edge of her gown, making it tremble.

Around them everything is propitious. There seems to be a lascivious warmth in the air and in emanations from afar; the rosy branches of the auspicious oleander rise behind the marble, flowering in the sun; and the row of hills gradually recedes and in the background the green sea, the divine sea.

This is the idyll. The cameolike rigidities of Tadema are mitigated in the softness of watercolor; there is in this length of paper a sort of melodious fusion of color and brushstroke. One remains before it for a long time, with blandly enjoying eyes, abandoning oneself to fantasies. Little by little it begins to seem that everything there has a soul, everything a voice: the marbles, the flowers, the sky. One feels that under the patient love of that brush every part has assumed a significance, almost a life: observe a hand, a patch of clothing, a portion of the bench, a branch.

It is a unique sort of art, whose fascination lies chiefly in its use of color, in the antique character of its color. Nearly all the tones are half-tones, submerged tones, gentle harmonies. Look at *The Staircase;* to content your eye, to give you a welcome sensation, it is enough to observe that rather sharply drawn figure of a woman who ascends leaning on the banister. She wears a gray gown and over the gown a pale green cloak with white stripes spotted with black: a felicitous combination, nothing else.

Then, too, for us who are accustomed to the broad effects of "spot painting," to disdain carelessness and vagueness of outline, it seems odd, this delicate investigation of all the accessories, this wise Flemish patience which does not neglect any point, which sees everything with the clarity, the inexorable purity of a carving. But unjust are those who consider the canvases of Tadema as merely more or less well-executed archaeological reconstructions. Rather, there are in many of these works an exquisite sense of poetry, a love of pictorial effects, sometimes a friendly artistic wit which is kind enough to certain attitudes and certain expressions cultivated in the modern reality of life. It is a serene and mild sort of painting, of which one ever cherishes the apparition: the tall white virgin, with hair of burning gold, between two columns with marvelously flowered capitals, under a descending silvery light.

Translated from Gabriele d'Annunzio, "Esposizione d'arte," *Fanfulla della Domenica* 5 (January– February 1883).

 1. Constantine Barbella, a sculptor from the Abruzzi in southern Italy, whose female figures were related to the work of such eighteenth-century French sculptors as Claude M. Clodion, was admired by d'Annunzio.

National Exhibition of Rome
FRANCESCO NETTI

It is well known that exhibitions, as they have been until now, are the best place for seeing pictures badly. But they have their good side. The artists receive terrible lessons from them. Many of the artists, on opening day, wander around the rooms, more hurried and agitated than usual, almost pale; one cannot be sure that the night before they have eaten with their heartiest appetite.

To have worked so long in the solitude of the studio, to have watched over,

caressed, protected their work, as if it were a delicate child, and then to find it again, tucked away in the public marketplace, exposed to so many curious and pitiless eyes, pushed and lost in the crowd, turned into a pawn on a huge chessboard of gilt frames, full of other peoples' paintings—what a disappointment! In that close confrontation, actually a collision, where the works of art are face to face, mutually destroying each other, it seems that the good qualities of a work of art are hidden and the bad qualities instantly catch the eye. The exhibitor himself hardly recognizes his work. Then to calm himself he complains of the place that was assigned to him. Sometimes the complaint may be justified, but not always. The truth is that all the works of art lose something of their intensity, even those which because of their exceptional personality stand out from the rest and are [therefore] proclaimed the victors in the struggle. [. . .]

If you stand in the middle of the small octagonal hall at the center of the exhibition of painting and turn to look into the eight rooms that radiate from it, you see at the far end of each one a large painting that attracts your eye.

Whatever one may say, those big paintings really occupy a place of honor and almost give their name to the room where they are. And that is very good. But it is doubtful whether all of them deserve in equal degree that place of honor, especially if one has had a look at the other large paintings in the exhibition. There being such a number of large paintings, the choice was not difficult. There are so many that there are too many, more than there should be. Let me make myself clear: these words are not tantamount to a declaration of war against large paintings; rather, if an artist feels that he needs an ample expression of his powers as a painter, let him use an ample canvas. If the true life size of the objects can add to the feeling of his painting, let him paint large, like Nono. If the actuality of a scene can make a serious, terrible message more moving, let him paint enormously, like Michetti. When he wants to illustrate some interesting historical event, let him paint immensely, like Matejko. In every case, the large painting must be a necessity or a *vision,* not a whim. Unfortunately, many of the large pictures in the exhibition have no other reason for their ample dimensions than the desire to arrest the public's attention. The artists' reasoning seems to be this: "There's going to be a very big exhibition in Rome, so let us paint a very big picture."

As long as one stays within the exhibition, the artist may possibly succeed in advertising himself by his work. Outside the exhibition those pictures, unjustified and unjustifiable in their huge size, would no longer have a purpose or any importance. All in all, they would be left only as decorations of the vast premises. That would be sad. So, looked at from this angle, the Rome exhibition is too much of an exhibition. It is also a danger. Because at this rate the artists' activity will be reduced to a search for what will make the biggest sensation at the exhibition, and not an endeavor to express what they think and what they feel. [. . .]

Let us establish one thing. Does the painting by Michetti, *The Vow,* deserve the uproar and the discussion that go on about it? As far as I'm concerned, I do not

hestitate to answer immediately. My answer is yes: most of the discussion is deserved.

From the very first day I felt attracted to that huge strip of canvas which looms blue in the distance. Was this attraction the result of a curiosity stimulated beforehand and unsatisfied for a long time? It may be. Certainly I was under the spell.

At first I looked at it for a long time: then I continued to walk through the galleries; but after a few turns here, I find myself in front of *The Vow*. I examine it briefly; then I say to myself, "Very well, I'll come back to it when I am obliged to write of it," so I start looking at other paintings, since it is not my intention to write of it now. Why? I cannot say exactly. Perhaps because a chorus of hymns of praise, of newspapers, put Michetti at the start of their art criticisms—while many other paintings had just as much right to engage first the journalists' attention because of the excellence of their work and the immense talent displayed [in them]. This excited a rebellious feeling in me, and a desire to go against the current. Perhaps it was something worse: a kind of spitefulness hidden in the darkest, most wicked corners of ourselves gnaws us when we see everyone's praises raining on the same person. Perhaps it was something else. I would not be able, I repeat, to pinpoint it. What I do know is that my determination or desire to be impartial, my spitefulness notwithstanding, my legs led me, again and again, in spite of myself, back to that painting. [. . .] It was an attraction, an impatience, and finally it became an obsession. It became absolutely necessary to be freed from it, by talking a lot about it. Now I will free myself of it.

It is useless to describe the subject. Open any journal that concerns itself with the exhibition, and you will find it, hacked, minced, broken into little bits, described sometimes admirably, detail by detail. At any rate I can tell you in a few words what it is all about.

It is the feast day of a saint, Saint Pantaleon, if you like. The church is crowded. In order to fulfill a vow, peasants, both men and women, are licking the dirty floor, covered with dust and mud. They are crawling like reptiles—toward the silver bust of the saint, which unnecessarily is set with no pedestal on the altar steps. When they reach the bust, a canon, wearing a brocaded cape, sprinkles them with holy water, while they kiss, with bloody lips, the white metallic face of the saint, as if they were kissing the face of the saint himself, who is in paradise.

I wanted to dwell on the actual subject depicted by Michetti, because one of the "great attractions" of his painting is the subject itself. "But," you say to me, "that's all very well. Now, if you agree, at your convenience, of course, it would not be a bad thing, if you would speak to us a little about painting. What *is* the painting of this particular picture?"

Exactly: I was just about to say that there is no painting in this picture. Let me make myself clear. Until now, Michetti's paintings that are familiar to us have been worked over, polished, lovingly modeled, facile, tender, full of delicate shading, harmonies, sensitive line, very decorative and magical. His courtesans were idealized, white, diaphanous, with rosy fingernails, fabulously dressed, cov-

ered with pearls, earrings, jewels, veils, smiles, dimples, vivacious colors. This is all changed. The change has not been sudden. Nothing is sudden. In other pictures by him, in the studies sent to Milan last year, there was a definite hint of his new and happy transformation.

But here the transformation is complete. Do not believe that, for the time being, he is another painter. He is always the same painter, with the characters he loves, the figures he holds dear, the colors he prefers. Everything that is scattered throughout his other work is concentrated here, but everything is handled with sincerity, with pride. He is independent. Few concessions to the amenities, no flattery of the public. Those peasant women are truly peasants, those men really live in the country. The painting is rough; it smells of village dirt. It is done, so to speak, with the painter's eyes closed, with the one idea of expressing himself truthfully.

It is a determination harshly stated. It is a picture painted as though no one should see it. The well-deserved admiration is directed less to the painting itself than to the spirit of art that forms it.

At first appearance the painting, which is not really completed nor finished, is therefore not attractive, but when one has seen it three, four, five times, one becomes mesmerized and cannot get away from it. Then one becomes part of the scene and stays in the church, suffocated in the midst of that crowd. [. . .]

Searching among the people, I see some that are sad, others austere, others praying with shabby umbrellas under their arms, one peasant woman has come with her basket full of chickens, but all are devoutly earnest. Behind these people I discern more heads, and still more up to the big beam of the cornice.

At last, overcome by the clouds of incense and the heavy atmosphere, I have come out of the church rather bewildered, and have gone away thinking over all the things and people I saw: among which one woman's figure stands out, her head covered by a white veil, her neck and part of her breast hidden by the numerous coils of a massive gold necklace, calm, erect, with level eyes and lips looking into space, motionless, like an ancient idol. [. . .]

Alma-Tadema has three oil paintings and two watercolors—total, five gems. *The Vintage Feast, A Sculptor's Studio, The Cabinet of an Amateur,* Roman subjects full of archaeological curiosities, which have already been shown, in larger dimensions, at Paris in 1877. The ones we have in Rome are very exact replicas, smaller, painted by the artist himself. To describe them in detail would be superfluous. [. . .] Alma-Tadema, a tireless researcher of antiquities, was, if not the first, certainly among the first, to study the antique from the pictorial point of view, reconstructing edifices and every part of an edifice, tracing out the cut of the costumes, restoring characters and persons to life, and becoming himself a part of the public or private life of ancient people. There is no doubt that he has done this better than anyone else. He has discovered the antique genre picture. He has become an authority, and his paintings have an antique quality, which, if not

authentic, at least seems to be what one generally imagines antiquity to have been. Therefore there is a little of everything in his paintings. They are museums. Nothing is lacking, from the great ornamental portals that are in Naples, to the very last object, or statue, or painting, or mosaic or vase, or utensil discovered in Pompeii or Rome, or in the rest of Italy, or in Greece or in Egypt. [. . .] The things represented by Alma-Tadema are stated rather than painted, are said with their own names, minutely described, with such clear expression, that absolutely not a doubt remains. It is speech, rather than painting, and it is everywhere. [. . .]

Rosa Bonheur transports us to a different world. We are in open country, in the middle of a wild forest. A *Herd of Wild Boars* is clambering down a steep slope. In the foreground two of them seem to rush at the spectator: brown, reddish, life-size, with shiny, shaggy bristles, their snouts low to the ground, their backs huge, they trample the bracken, looking for acorns and sniffing the large mushrooms that have sprouted that night.

A little farther on, in a second painting, *The King of the Forest,* a majestic stag, also life-size, stands at guard on four legs, looking with his wide-open eyes, straight in front of him. It is a portrait. Finally, an admirable *Head of an Ass.*

Three paintings worthy of Rosa Bonheur. They do not take us by surprise. They are so natural, so conscientious and right. Not only is there perfect knowledge of animal lore, but there is also a quiet but untamed passion for open country. [. . .] I know that Rosa Bonheur does not have the powerful color of the great *tonisti*—forgive the coined word. What do I care!

There is no painting, at least among those I see around me here, that makes me live, as she makes me live, in the midst of the forest, in that mute luminosity that woodlands, as well as very spacious churches, have in common. If I could (alas for wishes!) have those pictures in my house, I would stay indoors and contemplate them for hours, and then, going out into the streets, I would breathe more freely, as if I were returning from a morning walk through a cool wilderness. [. . .]

The huge painting by Matejko, the largest in the exhibition, is a red, noisy picture. At first sight it looks like a crowd of people half-submerged in a vermilion lake. It seems as if it were painted with blood, during a battle. It is an uproarious din, a great orchestra without a conductor. All the brass players are blowing with distended cheeks into all their instruments, each playing a different tune: all the drums roll continually, incessantly. It is a deafening vibration. One's first reaction is to stop one's ears.

Then one gets used to the din, little by little begins to understand, and at last, in the midst of that agitated performance, ends up by distinguishing what is going on. The blood turns into red velvet and covers the floor and the steps of a great stage; the violent notes become gold and brocades; the sharp tones are transformed into silver and shining steel.

Unfortunately, nothing is in the right place. This is the chief fault of this picture, and it hides consequently some beautiful things. The picture, painted with

the patriotic object of glorifying the history of the ancient kingdom of Poland, represents *The Homage Paid by Albert, Prince of Prussia, to King Sigismund I of Poland.*

First of all I must say that I write the words "historical painting" with great hesitation. There has been so much discussion on this subject, and for so long, that the outcome was plain: no one can understand anything any more.

A historical painting, in the most obvious meaning of the word, should be the representation of an event drawn from history. But where does it end? In ancient or modern times? Which are the truly historical actions? Are the actions of persons not listed in history historical? If there are historical characters, or even portraits, in the picture, how is one to recognize them?

New arguments, new anger, new theories—all come to a single conclusion, which is a general misunderstanding, as mentioned above. The boldest will and do disavow *historical painting*. Perhaps if the question had been left to the artists they would, in the end, have become bored with it, and, locked in their studios, would only have cared to work in their own way. Instead, people who are strangers to the practice of art have become involved in the controversy. Men of great talent, cultivated, often famous, lovers of progress and always motivated by the best intentions, have maintained that painting must be inspired by the heroic deeds of the ancients and portray subjects famous in history or which render the fatherlands illustrious. Only in this way could painting be elevated to its former splendor, and would there be great art in Italy. Because, in case you don't know it, there is also little art.

It was easy to answer these gentlemen. Some people did reply that the nobility of artistic sentiment does not derive from the heroism or the importance of the events which are represented, but that it is due to the sincerity with which art is practiced; that art is great when it is a genuine expression of the artist's soul; and that painting must be first of all painting. We—they went on to say—are not in the same situation as the ancients.

For the ancients it was perhaps necessary to use painting to record the events that were most important to the country. We have books, histories, newspapers, which acquaint us with the facts better than painting could. While the ancients—the first ones, those who saw things simply and clearly—did use painting as language, they felt that it was not always able to say certain things by itself, so, next to the person represented, they would write his name, or let a ribbon of words come out of his mouth. Even now, in order to explain some paintings, the moderns do the same thing in a different way, which is to print half a page of history in the catalogue.

The controversy, although very old, is still just the same. Some of the artists have left history out of their painting; others, either through inner conviction, or believing that the historical picture would win encouragement from higher up, have started to read books, and when they have found a dramatic, or even a curious, episode, they go to work on it and make a picture. Many of these paintings have nothing of history except for the title. Many are outside the pic-

torial field. Only those in which the external forms of the subject are needed to express a personal feeling save themselves.

Certainly I will avoid adding to the confusion in this controversy by further discussion. I only said what I did say in order to explain the point of view from which I will analyze the so-called historical paintings. If that is not enough, I will say it now more clearly. Whether or not the figures the painter puts on his canvases are important in history leaves me neither hot or cold. I do not care what their names are; I do not have to know them. I do not trouble myself about how they are dressed. I will tolerate them in any style and any fashion, even without any clothes, naked. What matters to me is that I should understand very well what the painter wanted to do.

If his painting is true and good, I am happy; if he moves me, I am even happier; if, besides, he has a personality of his own, different from the others, then I am very happy.

Let us take, for instance, the painting by Pio Joris. It is of a boat crossing the muddy waters of a river; it is being attacked by people with bows and arrows, seen in the distance, toward the riverbank, on the right. In the stern a man is standing, giving orders, another one is shooting arrows at the assailants, while the oarsmen are rowing as hard as they can, to try to turn the boat around. In the middle of the boat are two monks in black habits; one is sheltering the other with a shield, under which he hides, pale and frightened. The subject is clear: they are two monks escaping, carrying their treasure, locked in a green velvet box. [. . .] But this is not enough for the artist. He wants us to know that the monk in hiding is a pope, disguised as a Benedictine monk: by dropping his hood, he lets us see the red papal cap that he is wearing. It seems to me, at the very least, quite imprudent that a man who has disguised himself in order not to be recognized and to be safe from peril should keep the insignia of his important position on his person; but this was made necessary by the subject. Otherwise the monk would not be really a pope, and the picture would no longer be historical.

To tell us then that the pope is Eugene IV, to tell us who was with him, and who had helped him escape, shows more clearly than ever the torture which a painter, however able, undergoes in the attempt to force his painting to say more than it is possible for it to say.

Then, the painting itself, in general, does not seem to me to be very deeply felt. [. . .] The gray and rather monotonous color, the inadequate draftsmanship seem to portray the state of mind of a painter who is unenthusiastic about his work. One senses in the picture the translation of a narrative, done slavishly, as though to fulfill a duty.

The greatest excitement is among the artists who are struggling more directly with exterior reality: among those who paint the countryside for the countryside's sake, trees, houses, open waters, and vast skies and figures in spacious surroundings. I do not refer to them as landscapists because they do a little of everything, and since categories of painting no longer exist, their nomenclature needs to be

abolished as well. All of them in different ways of doing and seeing are represented quite completely at the exposition. There are those who paint at a distance, with paintbrushes a yard long, who want the picture to be looked at as a whole. They would drag away by the neck the unlucky man who dared to look at it closely. Then there are those who paint with their nose to the canvas, who would push forward with a punch on the shoulder the ignoramus so bold as to inspect it only from a distance. Luckily, with great foresight, their paintings have been scattered around the rooms and separated from each other. Thus an affray was avoided. Between the two extremes there is a graduated scale.

Milan, in general, inclines to impressionism. The most zealous apostle is Filippo Carcano. When one has looked at Carcano and then immediately goes on to Edoardo Dalbono, it's like making a trip to the antipodes. When you think it over, the abyss that separates them is apparent rather than real. There is a kind of intimate link between the two artists. They are two very distinct characters; they start from diametrically opposed points of view, but meet in the quest for the same result. I do not like parallels very much, so I will only barely indicate where it seems to me the two disparate painters find common ground.

Both of them strive to fix a fleeting impression on the canvas. But Carcano reaches this aim by eliminating all the details that might be harmful to the total effect. Dalbono, on the other hand, does not leave out any of the details, but subdues them to a harmony either observed or preconceived. Neither style of painting is candid and spontaneous, neither is born from a deep, planned observation. But in Dalbono's case this observation is more instinctive and poetical; in Carcano's, more reasoned and realistic.

It is easy to imagine the impassioned discussion that must have preceded Carcano's way of seeing and painting. These debates among artists become interminable and fierce. It is easy to guess Carcano's opinion. He would have said: "If you place yourselves at one end of a city square, or in front of a large space, you will take in everything with your eyes, but you will not distinguish any of the details. You will see that there is a church, with its domes, a belfry, side buildings, etc., but these things will impress themselves on your eyes by their general pictorial mass, not because of their slender columns, drawn one by one, or by their capitals or by mosaics or by any other architectural detail. Well, if you can't distinguish these things, why paint them? By painting them, you betray instant vision. I will give you this vision with color alone, destroying all the minutiae of linear perspective, and will make you see what you would see if you were passing by—without stopping there." So he painted the Piazza San Marco in Venice as a concrete proof of his words.

It was a happy experiment. It is a splendid piece of painting, and the Rome exhibition has corroborated the judgment of the Milan [national] exhibition [1881], where the picture was first displayed. Seen from the distance required because of the huge size of the canvas, everything is there: the domes, the gold, the mosaics, the innumerable slender columns; on the white and absolutely precise pavement, half in the shade and half in sunlight, the black pigeons move and

flutter: each stone and each piece of marble has its special substance, everything. He who has seen the square sees it again; he who never has, believes in it. He stands inside it. Seen close by, nothing is defined; but there is the brushstroke, sonorous, rich, and knowing. Next to this I place *S. Maria delle Salute* in Venice. It has the same qualities, but is less firmly painted. [. . .]

The painting by Dalbono in the exhibition is set apart by a sort of diffused, airy splendor, and differs from the other paintings because of a color scale so special as to be incredible.

Dalbono, a Neapolitan to his very soul, paints Naples almost exclusively, or to be more accurate, the atmosphere of Naples. [. . .] If Naples is the honeymoon dream of young lovers, it is the despair of painters: Naples is unpaintable. [. . .] Dalbono, however, is among painters the one who comes closest, if not to the actual truth, at least to the impression of truth. I am not overlooking the excessive *airiness* of some of his paintings. One step farther and his figures, drenched in light, are no longer bodies; they become ghosts. His painting becomes like an opal, it gleams like mother-of-pearl and the interior of seashells. His transparencies become so thin that they evaporate. Very well! And then? Then these are not mistakes, they are simply the artist's will. He did not want to make things *solid,* and has made them transparent; he did not want to make things *powerful,* and has made them light. What he definitely wanted to do was to make things transparent and light, perhaps he wanted to do even more than this: he wanted to make *what is not there,* if I can express it that way. He does not lack for art; his is an excess of art; he makes use of hyperbole and of superlatives. Why? Because he sees Naples with the poetry of one who from a distance sees it for the first time, because the illusion of that fantastic and misty city still remains with him, because he believes in sirens.

He does have faults, does he not! But not these. What one can criticize in him is the determination to be pleasing at any cost, too much *prettiness,* the shallow preparation of some pieces, like the *Arianna,* and an excessive solicitude for unimportant trifles. [. . .]

Translated from Francesco Netti, "Esposizione Nazionale di Roma," *Arte in Italia* (1883), as reprinted in Francesco Netti, *Critica d'arte* (Bari, 1938), pp. 130–39, 144–48.

1883: Berlin

Berlin, Prussia's capital, had been raised to the status of an imperial city when, after the defeat of France in 1871, the kingdoms of Bavaria and Württemberg were united to the grand duchies of Baden and Hesse and the North German Confederation to form the new Germany. Although in fact a confederation governed by a Bundesrat representing the individual states and a Reichstag representing the electoral districts, it chose to call itself an empire and to elevate its ruler, the erstwhile king of Prussia, to imperial rank. The first emperor, Wilhelm I, had married Augusta, daughter of the grand duke of Saxe-Weimar, in 1829. Raised in a liberal, humanistic court, where French was spoken as often as German, the empress maintained an active artistic circle to whom she voiced her disapproval of the aggressive, suppressive tactics that Chancellor Bismarck adopted to augment the central power of the state.

Developments in the new capital's art circles aroused widespread interest in Europe, and both the daily press and the art journals gave it increasing space because artists and dealers were eager to take the measure of the taste of a market that was bound to expand. The Königliche Preussische Kunstakademie, founded by Frederick the Great in 1786 and patterned after the French Academy, with its biennial exhibitions of paintings, sculpture, and architectural drawings, was responsible for making certain that the art shown there would properly represent the new united Germany. In so doing it had to overcome competition from the more established exhibition in Munich—a difficult task, as the Berlin Academy was still in the grip of the classicism and the predilection for murals that had been maintained by Peter von Cornelius, who had been its director for the twenty-seven years before his death in 1867.

Since neither the Germans nor the Scandinavians had ever had a single national center, artists followed the practice of the *Wanderjahr*, traveling from place to place to study with different masters—after the eighteenth century almost every region had its academy—before settling down. The study center common to most of them continued to be Rome, despite the fact that the first international fine arts section of the 1855 universal exposition and the long-established Salon made Paris the unrivaled center for art studies and the art market in western Europe. For central and eastern Europeans the market center was still Munich, thanks to the patronage of the Bavarian kings and to its large exhibition facility,

the Glaspalast, built in 1854. The Berlin Academy had little success in meeting the challenge of Munich's preeminence: its fifty-fifth exhibition showed artists from Düsseldorf and Munich, but the majority were still from Prussia. Because the exhibition was held in a temporary structure with crowded and badly lighted rooms, other German artists stayed away. It did not attract the progressive artists at all: any show of color came from the pupils of Karl von Piloty's Munich studio school.

In November 1881 the twenty-one-year-old French poet Jules Laforgue arrived in Berlin to take up his duties as French reader to the Empress Augusta. He was assigned rooms in a building next to the royal residence, the Kronprinzen Palast, where, as he wrote to a friend, he looked out onto the Unter den Linden, "the center of lounging and activity. Everything is there: the palaces, the university, the opera house, the royal guardhouse, the academy building, the arsenal, the singing academy, the largest restaurants, the brightest shop windows, with the statue of Frederick the Great placed at their head." His position gave him room and board and 9,000 francs a year, with few demands on his time. He owed it to a slightly older poet, critic, and writer, Paul Bourget, associated with the *Revue Indepen-dante*, whose newspaper column and drama criticism had won him a large following, and to Charles Ephrussi, editor of the *Gazette des Beaux-Arts*. The position would free their protégé to write the poetry that had won him the attention of the Hydropaths, one of several avant-garde circles soon to be grouped together under the general term Symbolists or Decadents, and to supply the *Gazette des Beaux-Arts* with occasional articles.

In the year and a half Laforgue was in Berlin before the fifty-sixth Academy exhibition opened, he gained familiarity with the capital's art circles. The art approved by the court had much in common with French academic painting: anecdotal genre and historical subjects in an academic style that had become international. In the German states it had been encouraged by the academies and circulating exhibitions of the Kunstvereine since the 1850s. The historical paintings contained patriotic themes considered legitimate in the current climate of nationalism.

The leading exponent of "modern" painting based on keen observation, as opposed to academic formulas, and long a target for the academicians' criticism, was Adolf Menzel (see fig. 95). His paintings were inspired by observed reality executed with the colors of the *Freilichtmalerei*, the German equivalent of the open-air or plein-aire school, but they were not in keeping with the color theories currently developed in Paris by the French scientific aesthetician Charles Henry in collaboration with George Seurat, a friend of Laforgue.[1]

When many of Menzel's paintings were displayed at the Nationalgalerie in 1884 to celebrate the fiftieth anniversary of the artist's membership in the Berlin

1. See José A. Arguelles, *Charles Henry and the Formation of a Psychophysical Aesthetic* (Chicago, 1972).

Kunstverein, Laforgue sent an article in appreciation of Menzel's talent to the *Gazette des Beaux-Arts*. He found four of the works especially remarkable, for Menzel had captured on canvas the vibrant atmosphere of the waves of light after the rain, a fugitive impression.

Soon after his arrival in Berlin Laforgue met the artist Max Klinger, who had come there in 1878 when his teacher, Karl Gussow, was called to the Berlin Academy from Karlsruhe. At its 1878 exhibition Klinger had shown two series of pen sketches, *Series upon the Theme of Christ* and *Fantasies upon the Finger of a Glove* (fig. 96), that were startling in their psychological suggestion. In the second he placed reality into an imagined world. Laforgue regarded Klinger as "a sort of genius of the bizarre" and urged him to go to Paris. The artist left in 1883 to work there for three years. Asked to review the Academy exhibition of 1883 for the *Gazette des Beaux-Arts,* Laforgue wrote Klinger that he took the "job seriously, not by reading books and hunting around in old museums, but by trying to see the world clearly and by observing as a simple human being (a prehistoric one, if you like), the Rhine, the sky, fields and crowds and streets. I have studied life far more in the streets. . . . I am convinced that I have the artist's eye; I am hostile to all artistic prejudices and sincerely wish to inform public opinion. If I didn't believe all that, I wouldn't write."[2]

In 1883 Laforgue was attracted by the work of the Swiss Arnold Böcklin, long associated with the Munich school. Using the *freilicht* technique, Böcklin employed color to set the mood of a subject, and at the same time he peopled a realistic landscape with mythological beings to embody the cosmic life force that nature contained. In his own writings Laforgue likewise juxtaposed everyday words and ideas with pretentious ones, the concrete with the abstract, the sublime with the commonplace, so that each was set off by contrast with the other.

Later that year Laforgue accompanied his patron, one Professor Bernstein, to the first exhibition of Impressionist painting in Berlin at the art dealer Fritz Furlitt's gallery. The nucleus of the exhibition consisted of Bernstein's own collection: two Monets, five Manets, a Sisley, a Degas, a Cassatt, a Morisot, and a de Nittis, bought in Paris with Ephrussi's help in 1882. With them were displayed paintings sent by the dealer Durand-Ruel. At the same time Laforgue wrote a draft for an article on Impressionism for the German press, but it was neither translated nor published.

All during his stay at the Prussian royal court, Laforgue continued to write the lyrics that inaugurated *vers libre*. As he described the process to the French Symbolist poet Gustave Kahn, "I forget to rhyme. I forget the number of syllables. I forget to set it in stanzas, the lines themselves being in the margin just like prose. The old regular stanza turns up only when a popular quatrain is needed." It was a literary style related to the painting technique of Seurat, and approved of by Charles Henry, "for the images have the sparkling, mathematical precision of dots of color applied to canvas."[3]

2. David Arkell, *Looking for Laforgue* (New York, 1979), pp. 134–35.
3. William Jay Smith, *Selected Writings of Jules Laforgue* (Florence, 1936), p. 39.

Shortly before leaving Berlin in 1886, Laforgue reviewed an exhibition of special interest to him. It included examples of ancient polychrome sculpture, principally from Persia, polychrome work by the sculptor Reingold Begas and the painter Böcklin, and two wax sculptures by his friend Henri Cross. On his return to Paris, he published, with the assistance of his friends, the poet Kahn and the art critic Téodor de Wyzewa, his free verse lyrics, *Les Complaintes* (1885) and *L'Imitation de Notre Dame la Lune* (1886), before his death from tuberculosis in 1887.

The Berlin Salon

JULES LAFORGUE

When one speaks of art exhibitions in Germany, Munich comes to mind first of all. The annual exhibition in Berlin, officially the Exhibition of the Berlin Royal Academy of Art (this year's being the fifty-sixth), is little known in Paris, if at all. [. . .]

 From the ordinary visitor's point of view, the first impression is very different from that of our Paris Salons. Taking into consideration their relative importance, what is striking at first glance is the absence of that festive atmosphere of crowds to which we are accustomed; the absolute absence of the nudes which at home add shining patches of light in the riot of color present in each hall, those nudes which are the primary concern of our school, and the eternal and only theme of some of our masters; the general dislike for life-size paintings, especially among the moderns; the persistent disdain for the peasant, who is raised to epic heights at home; finally, the timidity of the sculpture, a timidity that is generally found elsewhere in Europe except for France and the Italian marbleworkers.

 A slender official catalogue—950 numbered exhibits including architecture—sparsely illustrated, preceded by a history of the Academy from August 1881 to October 1882, contains the biographies of its most recently deceased members, the prizewinners, the composition of the jury from Berlin and Düsseldorf for the present exhibition. The pieces that are for sale are marked with an "X"; one of them even carries its price. To finish with the details, an engraver, exhibiting a portrait done after one of [Heinrich von] Angeli's works, has quite unashamedly placed on exhibition in the same frame a signed letter from the master congratulating him on the accuracy of his work. I hasten to add that I do not know if this sort of familiarity is customary here. One would believe so in seeing how casually this particular artist exposes himself.

 The Berlin exhibition has only two prizes; the great medal and the small medal. It is two steps from the ideal, but Paris is still further away.

 Ten lines will take care of the sculpture quite adequately.

 From a recognized master, Reingold Begas—gold medal, Paris, 1867—a bust of the princess royal, very freely done, delicately modeled, but too solid, which has a subtle charm. In addition, two sketches in bronze reduced in size, for

the monuments of Alexander and Wilhelm von Humboldt, pleasant to look at in this size and revealing the thumbprint of a master, but which in full scale will scarcely escape the fatal banality of those monuments to allegorical figures. And yet those eternal figures, Science, Duty, Patriotism, etc., could all be rejuvenated.

From [Reingold's] brother, Carl Begas (their father, Carl Begas, very famous in his day, was a student of Gros), there is among other works a very compact bust of a man.

Considering all the Begases together as a family (three out of four are exhibited) I will finish off at once the third, Oscar Begas, even though he is a painter, a member of the Academy, and a medal winner. [He is represented by] an antique idyll, taken from Goethe—insipid, trifling, and insignificant—and by two portraits, one literally painted with a shaving brush, one more worthless than the other, made worse by a basket of peaches from the perfumer's shop. Of course, we also have in Paris the noncompeting artists who surprise the naive each year by their lamentable showings (from every point of view), but I would never have imagined that naiveté in this kind of gamble could go so far.

Three sacred names: [Rudolf] Siemering, a *Luther*—Luther is much in demand this year for the celebration of his four hundredth anniversary—with low bas-reliefs that are an interesting artistic restitution; A. Wolff, a group of animals remarkable only for its dimensions; [Fedor] Encke, a bust of a woman.

Equal or inferior to the other schools of Europe (these comparisons are somewhat philosophical, but the chauvinism that flourishes in every latitude in Europe permeates everything), the German school is obviously still merely exploiting recognized formulas with greater or lesser character and force.

Only two artists strike a slightly unusual note: one of them is already old, the painter Böcklin; the other still young, the etcher Max Klinger. In accordance with their national character, their originality is derived from a literary, not an optical, point of view, and is even less at ease in the craft than the general run of mediocre talents.

Böcklin, born in Basel, having lived mostly in Rome and Florence, and who should be studied mainly in his fifteen old canvases in the Schack gallery at Munich, is one of those personalities who must be accepted as they are or left alone. He is an artist whom one either immediately loves or considers a nightmare, one of those oddities who are deaf to all influences, of whose work ordinary criticisms are as out of place as they are useless. I will not therefore speak of his drawings, which possess neither the classical line nor the vibrant line obtained by a combination of strokes, which are nonexistent, nor of his nudes, which resemble those of a less-than-gifted student. Everything here, secondary to the surprising conceptions, is fantastic color. This color produces its unique effect not by underpainting or the molding of contours but by an artless and audacious use of coloring, fantastically and fully lighted, without visible brushstrokes, without a preliminary sketch, painstaking, polished with a patience which gives to these fantasies an icy air that is accentuated by the calm signature in large gold letters, sometimes placed almost in the center of the painting. The signature is not the

least interesting aspect of a canvas; it often gives an insight into the underlying psychology of the brushstrokes and the technique.

Finally, Böcklin uses his own particular varnish instead of oil. In spite of everything, it is not *painted*, and of all the canvases I have seen by this artist, *Games in the Waves* is most guilty of this fault. His *Champs Elysées*, in the Nationalgalerie in Berlin, with its supernatural light and deep blue of a lowering sky, is better executed, more solid. I am considering here the painter's present style, which is different from his first, as an oddity of construction in painting. If Böcklin can be compared to anyone in France it must be with Gustave Moreau, but he lacks that artist's profound mysticism that is still discreet in effect, like the art of a jeweler. I enjoy unreservedly the *Champs Elysées, Prometheus, Games in the Waves*, but I judge them superior as literary curiosities; to me they cannot be compared as art to Gustave Moreau's *Galatea, Helen, Salômé*, not to mention his marvelous watercolors.

An exact description of his entry in the exhibition will tell more about Böcklin than any technical criticism. *Games in the Waves*, with its narrow band of strange and timeless sky, gives at once a powerful impression of a lonely sea with its blue and green lapping waves cradling their reflections. A small, unattractive but supple mermaid, feet in the air, winged with short fins, is diving beneath the gray-green water. Bewildered, a pursuing centaur stops, his arms stretched out sheepishly, his muscles bulging, his eyes bloodshot, water streaming down his flanks and tail waving, his enormous belly polished like brass, his pounding hooves magnified by the refraction of the water. In the foreground swims a faun, ears pointed, face inflamed by wine, glowing, bursting with lewd joy, his yellow goatee and seaweed hair lightly crowned with white flowers, his back flesh colored, and his chest hairy with the moss that covers stones in still water. He is swimming, drawing along behind him a white mermaid whose fishtail has scales of gold, emerald, and mother-of-pearl, whose silver hair is braided with scarlet seaweed. Her face is twisted into an anguished grimace of voluptuousness, her changeable eyes are of an indescribable green and sapphire. Above, a fleeing mermaid dives backward. In the center, a head like a brass sphere, a fin rippling at the nape of its neck, blows as it emerges from the waves. One sees from here those underwater games. I have already said what I think of the technical aspect of this painting. Having done this, and with no ulterior motive, I have no qualms in enjoying such a work. Craftsmanlike talent is everywhere, but there is only one Böcklin in the world, and the word *genius* exists to be applied to such a phenomenon.

The other highlight of the Salon, the ten etchings by Max Klinger, attracts visitors to the print section, which, however, has nothing else to commend it. This young master is not a newcomer. His prints are already important and could be the occasion for a curious chapter in the plastic aptitudes of this race [i.e., Germans] that is instinctively led to painting not for painting alone but in order to say something. Max Klinger seems to me a poet gone astray, an artist with an all-encompassing imagination, possessed of an eccentric and pessimistic sensitivity,

placed by chance in a studio, and who, driven by his furious independence into the most advanced modern formulas, is in the process of modifying his artistic attitude to a cold and rather uncomplicated eye. Such a nature, whose dominant faculty is literary imagination barely confined to the limits of vision, impatient with all apprenticeship, was bound to try etching, with its magic tricks, its chance bitings, its tricks of black shadows, its reworkings, its effects won by chance from dirty or poorly smoothed copper plates, to that entire cuisine of alchemy in which Rembrandt appears in an apotheosis of clouds of red vapor as the master sorcerer. The strange creator of *The Soul of Apuleius,* of *Eve and the Future,* of *Fantasies upon the Finger of a Glove,* of *Rescue of Some Victim of Ovid,* of the life of centaurs in primitive landscapes and so many nightmares and symbolic riddles that have emerged from the fumes of effervescent copper plates, belongs to the same species as John Martin, Füssli, and William Blake. He appears to me to have been under decisive influences—Alma-Tadema and our naturalistic novelists—while still remaining unforgettably himself. We find him here in a decisive moment of naturalism in *Mother*—three cruel and impersonal scenes of the financial crash within heart-breaking modern surroundings, which are emphasized: the first a little thin, a little awkward, but very sincere; the second solidly constructed; the third whose black effect is too carefully obtained by equal strokes. *Caught in the Act* shows the facade of a villa set among chestnut trees; a raised blind reveals the husband with his still-smoking gun; an enormous vase conceals the lover fallen on the flagstones, of whom only the legs of Cherubino of the comic opera are visible; the wife, hands clasped to her temples, cowers in a corner. It is made up of separate parts, very carefully designed, very decorative, and consequently cold, doubtless intentionally so, a most curious whole. *A Murder,* a desolate scene on a quay on the Spree, the print closed at the top by the arch of an iron scaffold, an effective grouping with a good basic idea, done in excellent detail, free and supple in technique. *Suspicious Actions,* a bit of shady nocturnal business, whose shades of black do not give the desired effect. *In the Forest,* a jacket, a hat, a letter at the foot of a tree, everything indicated by a wash of stains. Finally, *Days of Mars,* three episodes of an uprising treated in a freer manner, with a surer and broader effect. The background of the first, very oddly treated, is a little monotonous in tone; the light part and the parts darkened by the crowd are etched with rather insufficient variety; the second, the most alive of these ten pieces, depicting the last defenders of the barricade at dusk, is brutally and forcefully drawn, with its shadows furiously brought out in the smoke, its kiosk riddled with bullets, its bell tower rising in the heavily washed black sky; in the third, the deportees are being led through a nocturnal countryside by officers on horseback, a lugubrious vision carefully detailed and very impressive, with an unfortunate effect of a rather piteous moonlight. This is the entry that has been a sensation since the opening. I repeat, until now the unforgettable attraction of Klinger's works has been first and foremost literary, and those who know his work only by these *illustrations* will hardly recognize them as his. This naturalistic phase is probably only a passing one; he will have gained from it a livelier insight and a wider and freer point of

view, and will emerge from it better prepared to make use of the personal genius that lies under his prehistoric, pagan, mystical, worldly, humoristic reveries.

If Plockhorst were not a well-known name, I would have forgotten that religious painting was represented in this exhibition. *The Women at the Tomb,* a Signol without interest, and the *Life of Jesus,* a series of fifteen grisailles by Bida for the parishioners. As far as I can see these are still in the style of Flandrin and Overbeck, but with very little of their flair. If there is a country in which the prophet John Ruskin would seem not to have to preach in the desert, it is certainly that inhabited by these men beloved of the Pre-Raphaelite historian Carlyle; but no neophyte has as yet risen. Germany has produced the greatest mystics in history. None of them was a sensual visionary, and the greatest of all, Jakob Böhme, was a good father and a model citizen. It is obvious that Germany has been saved from the influence of eighteenth-century France, thanks only to its eternal well of mysticism, and that, according to a well-known saying, religion is a love of the heart—of reason would be more correct—for the Germans, a love of the head for the French. Whether this is true or not, in the decline of Catholic art we have again taken up and brought to light the human basis for biblical conceptions and golden legends. Offhand I think of *Sainte Geneviève,* of the *Prodigal Son* by Puvis de Chavannes, of Cazin's *Ishmael,* and, though of a different character, of Duez's *Saint Cuthbert.* Moreover, religious painting has generally flourished among the most pagan peoples and at the most pagan moments of the modern age, from the inanities of Bernini to the Spanish atrocities, and has no relationship to pure faith.

Historical painting, dull enough in Germany, and having scarcely produced anything but Delaroche-Piloty images or others, is represented only by a vast canvas by the Hungarian [Wenzel] Brozik, which is considered the most important piece in the Salon and which shows us how the *condemnation of Jan Hus by the Council of Constance* is supposed to have looked. In its bituminous base and in its lighting of a massively pillared church, it recalls the work of Jean-Paul Laurens (without his dramatic and technical precision) and his [Brozik's] fellow countryman Munkácsy. The painter has somewhat restrained his usual prodigality to display here a more or less accurate wardrobe. It is a collection of good facial studies, all alive with the same emotion, too much mixed in, however, with the inevitable faces of lusty monks, shaved and thick-lipped, with inquisitive eyes. The bishop, in white, passionately pronouncing the sentence, is well done. Jan Hus, pale and ascetic in his sackcloth, reminds one a little of Munkácsy's *Christ.* Also, here are the notables of the church, clothed in scarlet, on the left, and the two sumptuously clad dignitaries of Hungary on the right, as well as the richly decorated pillars, obligatory in these decorative pictures as in the *Ambassadors of Ladislas* at the Nationalgalerie in Berlin. To sum up, this is a rather monotonous type of painting with no conviction concerning the subject matter, and monotonously treated, though undeniably skillful in execution.

Few military canvases: the battles of Sadowa and Sedan have not produced a Detaille or a Neuville. The official [painters] Anton von Werner, Franz Adam,

Bleibtreu, and Kolitz, who are not lacking in talent, have shown nothing. *Loigny, December 2, 1870,* by Hünten, a celebrity, is a large canvas—awkwardly and painfully full, heavily painted, cold, and I would add, indifferently painted, grossly stained with chauvinism, if not worse. This is the artist's customary style. He also shows a heavy panorama of Saint-Privat.

A number of portraits. Lenbach, who has signed some very elaborate ones in which sincerity is too often replaced by that warm Rembrandtesque patina which easily misleads one concerning the solidity of a work, is not exhibiting. Only two, by the Belgian Emile Wauters, are at all interesting, and because of their dimensions or because they are foreigners of distinction, share with the Brozik the honor of [placement in] the glassed-in vestibule. A wet beach, a rainy sky, the line of a receding wave with dirty foam, a boy nervously perched on a pony whose form is well-rounded and firm under its gray-brown coat; the boy with an air of determination and daring, in blue velvet, one hand on the reins and the other, holding a soft hat, on the pony's hindquarters; animal and rider have stopped, heads turned toward the observer, while a bulldog watches them, waiting, his master's riding crop in his jaws. Life size; everything is large, clear, lightly done, and, God be thanked, transparent. The dog is beautifully placed, brushed in a handsome tarry color. The pony's head is delicate and charming. As it is a pleasure to discuss such a sincere and candid work, I will say that, if the head of the small rider is well set and full of character, it is overdone, overworked, a too strongly marked oval; it is too prominent in its surroundings and too opaque; not transparent enough or in natural harmony with the rest. When one has the marvelous and simple idea of making a picture out of a portrait, is there not a trace of presumption, under the pretext that the most important thing is the model's face, to paint this face in the stuffiness of the studio, while the rest is taken from impressions gained under the open sky? The second portrait, though not made out of doors, strikes a note that is equally sincere and legitimate. Standing in a corner of a parlor cluttered with a carpet, furniture, draperies, paintings, [is] a woman with a pale and iridescent complexion, in a pose of lassitude, dressed in a blue dressing gown with short transparent sleeves, her right arm stretched along the high back of an armchair, the other falling gracefully, the fingers striking a careless chord on the piano, freely brushed in a rich but bloodless and faded gamut of colors without painful and pedantic undertones, the pale flesh tones in harmony with the faded blue satin and the soft, delicate touches of rose in the pale breast. In spite of this decorative, lavish display, the whole gives a very suggestive impression of intimacy.

Some celebrities: from [Ludwig] Knaus, who is not exhibiting a genre painting, a lady in black, seated, looking like porcelain but with an aspect of expressive individuality, particularly in the face. The background is nothing. From the famous [Gustave] Richter, a student of Léon Cogniet, two female portraits: the one of Countess [von] Dönhof, like unflavored cream, in no way remarkable, but not totally without merit. By [Karl] Gussow, to whom the younger painters are attracted, and who produces good students, three finely painted portraits, reminis-

cent of inferior Jacquets, all of them as though painted with the same appealing cream, fresher and more delicate than nature, complexions the artist might sell in a beauty shop, perfection but not flesh. Furthermore, what are these cold backgrounds, polished like a boot or plastered like a wall, from which these beauties stand out, all sugary and rose, like those on an expensive box of soap? From Anton von Werner, *Pastor Frommel,* a surface likeness perhaps, but a cardboard figure, flatly lit and drowned in oil on an insipid chocolate background. There is also a series of former medal winners who are showing nothing of interest. [. . .]

No nudes. The French school remains the most triumphantly faithful to this eternal theme. Everyone knows this, and one does not hesitate to claim a reputation for it, not without innuendos of modesty.

Let us proceed to the landscapes. In the Nationalgalerie, as in the exhibition and elsewhere, our incurable vanity would give us high cards in certain comparisons. If we are to counter the main reproach, which our neighbors have never ceased taxing us with in art as in everything else, that consummate talent hides a lack of profound faith, conviction, love of truth, and spontaneity (attributing these qualities to themselves by divine right), it will be with that unique school of the great poets of truth, from Troyon to Daubigny, which is in the process of renewing itself in an ever-deeper and evermore refined adoration of our native soil. [Except for being] cited sometimes in reviews, the names that are our pride are absolutely unknown in Germany. Otherwise, to persist in denying the dedication to truth of Rousseau, Millet, Courbet, Corot, and spontaneity in the crisis that has given us, among others, Monet and Sisley, and then to celebrate these virtues "in the most insipid and most awkward painting in Germany," would be trespassing too far upon the domain of native fatuity, which, at least, as everyone knows, is all ours! No, Germany has not yet produced a great landscapist, and sadder still, their museums and exhibitions are tepidly indifferent, deserting their native character, which reminds one of Courbet's words: "Were those people never born in any place?"

One of the most famous, [Eduard] Hildebrandt, a pupil of Isabey who mainly transplanted the romantic fluttering of his master into the landscapes of a picture album where Ziem sends off his fireworks, has not sent anything. Oswald Achenbach, the most popular, exhibits only one example of his unchanging manner, hot, dusty, agreeable, singing the praises of Italy, and that is enough. His brother and teacher, Andreas Achenbach, a tormented and empty romantic, does not show any of his equally well-known and pleasing chromos. [. . .]

From Adolf Menzel, the most famous name in Germany, a marvelous little thing that has been rather silently passed over here, which I definitely prefer to the popular pictures done in his first manner, *Voltaire at Sans-Souci, Frederick Giving a Concert on the Flute,* etc. It is *Memories of Paris, 1868,* with people in summer clothing in a public park under the shade of trees whose foliage has already turned to autumn; a marvel of warmth and freshness, of air, of depth and life in its colors and in its lines, all done from an impression. The only things of Menzel that I know in that lovely, lively mood, which he considers perhaps as a little relaxation

from more serious and more studied works, are his small *Departure of the King for the War of 1870* and his prodigious *A Street in Paris,* at this moment hanging in the international exhibition in Munich. There are still one or two preconceived notions from these two small pictures which should be discarded, and this extraordinary eye should see them clearly. [Franz] Defregger is perhaps as popular as Knaus. Who does not know at least one of his Tyrolean scenes? Here is still another painting destined to feed a lively trade in photographs and engravings. This categorizes it: the faces, the costumes, the details of the poses are wittily depicted, the anecdote is pleasingly and neatly painted, even though in a dull, hard fashion. It is entitled *A Tyrolean of the Salon,* and this title would fit perfectly under a portrait of this artist, who has nothing of interest beyond these subjects, as his other canvas, a group portrait of three small boys, testifies. [. . .]

Then, two of the best canvases in the Salon, two fine Dutch scenes by [Edmund] Harburger, who, with Oberlaender and Schlittgen, makes up that trio on the staff of that curious and sometimes precious newspaper, the *Fliegende Blätter.*[1] [. . .]

From a study of one of our Salons, general and legitimate conclusions can be drawn about the state of contemporary art in France. To attempt something of the sort here would raise a cry of "French superficiality" reinforced by malicious self-conceit. On the one hand, there are artistic centers in Germany, of which the capital is not the most brilliant. On the other hand, even with the help of a thorough knowledge of the Berlin equivalent of the Luxembourg Museum,[2] who would dare to draw conclusions from an exhibition that is unanimously considered to be exceptionally incomplete? It is a fact that the hierarchy of leading artists has contributed in only a mediocre way this year. However, is it not true that Germany, where the artificial artistic culture of a new race is still evident, is not in the first rank in art?

The French and English formulas are not yet at home here; [Mariano] Fortuny, who has thrown dust in everyone's eyes, here throws it to the sparrows. The formulas that are in general usage are the most common, and the most accessible to an inexperienced race who dislike all dilettantism and are not given to art for art's sake. They have other talents and, in spite of their pretensions to cultivate them all with ease, are not gifted with an eye. This eye is essentially frank and cold, transparent, and does not transform what it perceives. It is neither curious nor joyous; in brief, it is not art.

Not having yet digested the present in art, the German school of painting will still have to work very hard for a long time before it can give us an advanced school of painting, or even surprises like those the English school has been giving us for thirty years.

To summarize, Germany has had until now two great masters of drawing, in fact, of painting. To be of consequence, Germany should have to its credit at least some personal visual interpretation of life.

However, if there is here one firm article of faith, confirmed moreover by the most impartial German observers in foreign countries, it is that Germany is

inferior to no other nation in art, while [France has] been suffering for the past decade or so from an intellectual and moral decay. The [German] newspapers, which keep their public informed of the slightest change in our fashions, our traditional monopoly, do not really teach them our great names in art. Except for Meissonier, Detaille, and Neuville, and perhaps Courbet (because of the column incident[3]), as in other days, except for Delaroche and Horace Vernet, this public knows nothing about us. And no more is known in the studios.

This does not prevent our art from being judged with a casualness as imperturbable as it is common and labeled with the crude and hollow tag of "realistic."

What can one say in reply?

P.S. Here is the distribution of prizes at the Salon of Berlin: grand medals to Siemering, Wauters, and the Viennese architect Ferstel, of whose death I have recently been told; small medals to Karl Ludwig, [Albert] Vogel, Max Klinger, Dielitz.

The international exhibition in Munich, only half installed, has just opened.

Translated from Jules Laforgue, "Le Salon de Berlin," *Gazette des Beaux-Arts*, ser. 2, vol. 28 (August 1883):120–81.

1. *Fliegende Blätter* was a humorous satirical weekly published in Munich between 1844 and 1928.

2. The Luxembourg Museum was the museum of French contemporary art. About ten years after an artist's death, his works were transferred to the Louvre or sent to provincial museums.

3. The Vendôme column was erected to commemorate Napoleon's victory over the Russians and Austrians in 1805. It was overthrown by the Communards in 1871 at the instigation of Courbet, and re-erected in 1875.

1888: Munich

Munich enjoyed a strategic position on the crossroads of commerce and had long been a center for eastern European—Hungarian, Czech, and Russian—and for Scandinavian artists. By the 1880s, the first were bringing with them a strain of Naturalism and the influence of Tolstoy (his *Powers of Darkness* appeared in 1886) and Dostoyevsky's psychology. Jan Matejko and Joseph Brandt established studios there in 1867 and attracted to them their Polish countrymen and the Russians. Scandinavian artists had long shown their work in the Munich exhibitions, and they brought ideas to Munich from Christina (Oslo), Stockholm, and Copenhagen. Henrik Isben was often there in the period during which he was writing *The Doll's House* (1879) and *Ghosts* (1881). Zola's novels such as *L'Oeuvre* (1888) were immediately available in translation and received attention in *Die Gesellschaft,* a periodical founded in 1885 to encourage Realism in the arts. The international exhibitions in Munich also enabled Austrian artists to move closer to western Europe, even while they were actively attempting to make Vienna an equally important and vital center.

The third of Munich's international fine arts exhibitions—planned in commemoration of the centennial of the Bavarian King Ludwig I's (1786–1868) birth—followed by only a few months the jubilee exhibition in Vienna that celebrated the forty-year reign of Emperor Franz Josef. It opened in the summer of 1888, with 2,732 contemporary works of art from fifteen countries (see figs. 98–100). Visitors entered the Glaspalast through a specially designed vestibule which induced, according to one critic, an appropriate mood of awe.[1] In addition the Munich decorative-arts society, the Kunstgewerbegesellschaft, contributed an exhibition of work by its members in an immense building that it erected on the banks of the Isar river. So successful did the exhibition prove to be that the Münchener Künstlergenossenschaft or MKG confidently announced that henceforth it would hold one, not every decade as had previously been planned, but every year; it would be called the "Annual Munich Exhibition."

To cover the exhibition the *Gazette des Beaux-Arts* agreed to publish the review of twenty-five-year-old Téodor de Wyzewa. Born a Pole—he early dropped the -ski from the original Wyzewski—Wyzewa was brought up from an

1. See Eugen Roth, *Der Glaspalast in München: Glanz und Ende* (Munich, 1971).

early age in Paris, where he taught briefly in a college before coming to the attention of the literary world through his association with *La Revue Wagnérienne,* a journal started by the playwright Edouard Dujardin in February 1885.[2] The enterprise had been inspired by a group of French Wagner enthusiasts who had attended a performance of *The Ring* in Munich in the summer of 1884, six months after Wagner's death. On their return to Paris they secured financing and the participation of the poet Stephane Mallarmé, Catulle Mendès, Champfleury, Huysmans, and others. The *Revue*'s contributors were also frequenters of Mallarmé's Tuesday gatherings. Baudelaire had opened a path to Symbolism for the new generation of poets and painters with his sonnet "Correspondences," and his essay "Richard Wagner and Tannhäuser" (1861), which recognized Wagner's operas as a synthesis of the arts. Dujardin stated, "The objective of the *Revue Wagnérienne* was not, as some believe, to make propaganda for the works of Wagner, but to penetrate their meaning and make their profound significance known . . . and above all [to comprehend] Wagner as creator of a new art form."[3]

By 1888 the *Revue Wagnérienne* had already ceased publication, but two years before, Dujardin, Wyzewa, Félix Fénéon as editor and Mallarmé as drama critic, had begun yet another journal, this one "a special review of art, of literary, musical, plastic art—that is what the *Revue Indépendante* would like to be."[4] It first appeared November 1, 1886.

None of the ideas that Wyzewa had expressed when he attempted to formulate a Wagnerian aesthetic of *l'art total* in "La Peinture wagnérienne: Salon de 1885," written for the *Revue Wagnérienne,* was repeated in his appraisal of the 2,732 entries from twenty countries arranged in the Glaspalast's ninety rooms. He only noted that the "grand composition historique ou symbolique," which had once been thought to survive indefinitely in the land of Cornelius and Kaulbach, had been laid to rest. Wyzewa found little to praise in Klinger's painting, the artist who had so attracted Wyzewa's friend and associate on the *Revue Indépendante,* the Symbolist poet Jules Laforgue, who had died in 1887. In the painting sections, a tendency toward an increasing Naturalism in subject and in the technique of the plein-aire painters was evident. In sculpture the graceful half-classicist, half-naturalistic treatment of both single figures and groups continued to prevail with one startling exception: *The Gorilla* by the French sculptor Emmanuel Frémiet, which had already created a sensation in the Paris Salon of 1887 (fig. 97). Frémiet's treatment of the subject was straight from Zola's school of Naturalism. Friedrich Pecht, the onetime painter and publisher-editor of the conservative *Kunst für Alle,* included an illustration of *The Gorilla* in his journal and closed his lengthy review of the exhibition with the sculpture section and the French entries:

2. Isabelle de Wyzewa, *La «Revue Wagnérienne»* (Paris, 1934), p. 43.

3. Ibid., pp. 98, 140.

4. Ibid., p. 140.

At the beginning, France was represented only by Falguière's very coquettish but well-executed bust of Diana, a dipped bronze figure, *Luxe* of Aimé Millet, and a pretty *Flute Player* in the antique manner by Fasselot. However, at the very end, we were given a characteristic strengthening of contemporary trends in Frémiet's prize-winning group labeled *A Gorilla Which Has Kidnapped a Negro Woman*, which shows the animal ready to defend his booty against all attackers. This very repulsive scene of the rape of a woman by a beast is undeniably presented with great bravura in the case of the animal and with a vulgar and realistic exactitude in the case of the woman, which makes this nude only the more objectionable. This sort of thing might well happen in Africa, but that admiration for the talent wasted here should be carried so far in our society as to place this group in the location of honor in the vestibule so that it must horrify every woman who enters shows us again what our German overestimation of foreign things can lead to.

Ponder the possibilities that change of taste opens for us when we consider that a century ago the noble figures of Schiller and Goethe, succeeded by the gods and heroes of Cornelius, were followed by the glorification of the proletariat and now even the glorification of bestiality. Do we believe that it is a matter of indifference to our culture if we substitute Zola for Schiller and Frémiet for Cornelius? What finally is left of our national respect?[5]

Ludwig A. Ganghofer showed greater tolerance in his review for *Über Land und Meer,* an illustrated magazine launched in 1878 for German middle-class readers, the counterparts to English subscribers to the *Illustrated London News* and the French who read *L'Illustration.* Ganghofer stated, "The objection to such a subject is only partly valid: according to the same standard, the raccoon could be regarded as a sculptural monstrosity. But the group is not effective as a reality, at least not in the sense of artistic realism. It is effective only on account of the horror of the imagination and because of the gruesomeness of the event. And also on account of its powerfulness."[6]

Trained both as an engineer and in the humanities, Ganghofer was one of a group of writers and artists equally at home in Munich and Vienna. His participation in a popular Volkstum theater group in Munich and the acclaim for his first play made him a successful dramatist, writer, and novelist, first in Vienna, in the decade 1881–91, and then in Munich. He was associated with the von Wolzogen brothers—playwrights, novelists, critics—in founding a literary society, and with the artists Kobell, Stieler, Kaulbach, Defregger, and Stuck. His popular novels of peasant life in the Bavarian woods and mountains gave him prominence in a contemporary pantheistic and nationalistic cult similar to that fostered by the German Romantic movement earlier in the century.

5. Friedrich Pecht, "Die Münchener Ausstellungen," *Kunst für Alle,* Oct. 1, 1888.

6. Ludwig A. Ganghofer, "Die internationale Kunstaustellung im München," *Über Land und Meer,* no. 51 (October, 1888).

The Art Movement in Germany
TÉODOR DE WYZEWA

The exhibition at Munich has been the great artistic event of recent months in Germany. Furthermore, this exhibition will have the importance of being a major landmark.

It achieved what neither the modern museums of Berlin, Munich, and Dresden nor the partial exhibitions of the preceding years were able to do: it has shown clearly the contemporary tendencies of German art. One might even say that this exhibition has marked the death of the large historical or symbolical composition, which one believed would endure forever in the native land of Cornelius and Kaulbach. We know that even today the Neue Pinakothek of Munich and other similar galleries are full of paintings of that type, alternating with alpine landscapes, imitations of Calame. At the Glaspalast only one or two of those compositions were to be found, and those were of an astonishing crudity. Even scenes of the war of 1870 have become rare: the influence of Werner is definitely waning—what am I saying? Werner himself is a convert to genre painting and to *l'impressionisme*. More and more German painters are inspired by Menzel, Knaus, Uhde, or even more by our new painters of French genre.

In the German section what one saw above all was interiors of factories, studios, taverns, cottages; street corners, invalids on park benches, all the stock pieces that Kuehl, Liebermann, etc., seem either to have imported from us, or exported to us, whichever you prefer. The same careful, detailed workmanship, the same effects of *petit plein-aire,* the same colors, feigned fashionable or of an affected roughness.

Unfortunately, the German painters have been able only to add their rather heavy-handed bent of conscience and propriety to this style, which is entirely artificial, and which most of all requires lightness of spirit.

Above this rather homogeneous ensemble some superior work stood out with a particular charm, compensating for the absence of Menzel and the disastrous inadequacy of the retrospective section. We should mention first Franz von Lenbach, who showed about thirty portraits: without doubt, he is one of the most esteemed painters of our time.

In Munich Lenbach's portraits filled an entire gallery. They had just been seen in Berlin and Cologne, but the German public could not tire of admiring their national portrait painter. Even the art press found some unexpected praise for him, going so far as to commend him for being faithful to bituminous backgrounds. Truly the names alone of some of Lenbach's sitters sufficed to invest his entire collection of portraits with special interest. In his double role of imperial chancellor and proprietor of Friedrichsruh, the prince of Bismarck was seen twice; twice also the priest Döllinger, the founder of neo-Catholicism, whose stubborn, sly expression Lenbach has wonderfully depicted. There was Paul Heyse, the Berlin novelist, to represent literature; to represent music, Richard Wagner and

his music director, Hermann Levi, dressed as a Christ; to represent beauty, some charming ladies for whom Lenbach had the graciousness to be more detailed than usual in his painting.

From the artistic point of view, Lenbach's exhibition was no less important. His thirty portraits were thirty masterpieces, masterpieces which for the most part were not very expressive, but were of an extraordinary technical skill and manual dexterity. Nor were there two of those masterpieces that appeared to be the work of the same painter. It could have been designated an exhibition of old masters. An old lady wearing a lace collar was a perfect Hals; a young woman dressed in red resembled a Van Dyck of the first period. One admired Rubens' children, a Spanish woman by Goya, an authentic Ricard, and as one might imagine, some excellent Velásquezes. One could not find anything by Lenbach himself, not a new brushstroke that could be attributed to him, not even an attempt to reconcile two imitations in the same picture. In order to understand this artistic prodigiousness one had to recall the room of the Sedak gallery in Munich, where Lenbach has left his copies of famous paintings of every school. Then only, in front of those miracles of skill and impersonality, could one see how the German painter had been able to divest himself of all original stamp of character and acquire this disconcerting mastery of imitation.

At the Munich exhibition, as at the Paris Salon, the paintings of Uhde stood out from the neighboring pictures. Once again these works have provoked some rather lively debates in the German art press. A good many critics objected to Uhde's profaning of the fine arts by the introduction of misplaced naturalism into them; others applauded him as the restorer of the national art. Is it that Uhde, in his recent paintings, has enjoyed exaggerating the symbolic at the expense of accuracy and picturesque charm?

Certainly his triptych, for example, in spite of its wonderful details, looks more like a piece of philosophical musing à la Wiertz[1] than a piece of painting. The coloring has become dark and unpleasant; the composition is confused. One begins to feel the need of an explanatory booklet. In that I believe there is a national danger, to which, even before M. von Uhde, the highest intellects of his country have succumbed. All, from Dürer to . . . Goethe, have been arrested in the development of their realism by a sort of metaphysical madness causing any work of art which at first appeared destined to be total truth, to lose itself in symbolical reverie.

We must still point out one of the most curious works in this exhibition: the bizarre mythological picture by Klinger, with its frame of polychrome clay;[2] a composition attractive and uncouth, so German in the bad taste of its originality. Liebermann and Kuehl are just the same in Munich as they are in Paris. Next to them a young painter, Dürr, wishes, it seems, to create in Germany a type of Pre-Raphaelite painting, concerned only with lovely forms and harmonious color.[3] *The Virgin Adored by Three Angel Musicians,* in spite of some of its parts being obviously copied from Van Dyck and the Florentines, is, in my opinion, the most interesting work in the exhibition. It is bathed in soft fluid light, delightfully

harmonizing with the languid grace of the poses and the muted, golden colors. It does seem that in Germany, as in France, the fashion of the large composition has waited to disappear from common use before producing its masterpieces.

There is nothing to be said about the foreign part of the Munich exhibition. The French, Russian, and English were represented in a very summary fashion. To compare the merits of the Italian and Spanish schools, to say nothing of the Scandinavian and Dutch, it is advisable to wait for the Paris exposition [of 1889].

Another artistic event has recently taken place in Germany, which in the eyes of some is even more important than the Munich exhibition. For the first time the publication of a complete and thorough history of German art has been undertaken.[4] Sixty years ago Stendhal described the Germans as "a singular people, who admires the Greeks and despises itself." Since then the Germans have done what they could to stop despising themselves. They have erected statues to honor their great men and have listed their names in their schoolbooks. It seemed that their efforts could go no further. In spite of everything, they continued to regard their older painters with good-natured contempt. In Munich, Berlin, Dresden, go to a photographer who sells reproductions of works in the museums; there you find, in ten different formats, the most wretched works of Maratta and the recent ones of Schalken, but you will scarcely see a Dürer, or a Cranach, and if an old German painting is unfortunately anonymous, you will waste your time to look for a photograph. The catalogues so carefully prepared for Italian and Flemish works are extraordinarily insufficient for the Germans. [. . .]

Translated from Téodor de Wyzewa, "Le Mouvement des arts en Allemagne," *Gazette des Beaux-Arts*, ser. 2, vol. 37 (February 1888):164–67.
1. Anton Joseph Wiertz was a highly gifted but eccentric Belgian painter.
2. Max Klinger's *Judgment of Paris* (1887) was set in a frame of bronze and stone.
3. Wilhelm Dürr received a gold medal for his painting.
4. Hermann Knackfuss, *Deutsche Kunstgeschichte*, 2 vols. (Bielefeld and Leipzig, 1888).

1891: Munich

The large number of artists and visitors participating in the third international exhibition (the first had been held in 1869) held by the Münchener Künstlergenossenschaft in 1888 encouraged the MKG to abandon its ten-year schedule and to hold a fine arts exhibition annually, thus converting what had once been a local exhibit into an event not unlike the Paris Salon. The first of these three international fine arts exhibitions was held in 1889. The second, 1890, had been preceded in April by an international exhibition sponsored by the grand duke of Baden-Württemberg in Stuttgart, and in May by an international exhibition in Berlin—the first since the independent German states had been consolidated into the German Empire after the defeat of the French in 1871. The third, 1891, finally opened on October 29, 1891. In spite of all the competition, 2,000 works of art—among them works from fifteen other countries (see figs. 101–04, 107–09)—were displayed in the Glaspalast (plan 11). This was thanks in part to Munich's long service as the major cultural center for Europe's German-speaking region and in part to the energetic efforts of MKG members who, beginning with the international exhibition of 1869, had been visiting art centers in other countries to discover innovative artists and extol the facilities they had available for art displays in Munich. As with the original decennial exhibitions, transportation and insurance were paid both ways for works accepted by the jury, and one way for those rejected.

Alfred Gotthold Meyer reviewed the exhibition in the Glaspalast for the *Zeitschrift für bildende Kunst* in two parts, the first of which he devoted to the work of the Scottish painters, the so-called Glasgow Boys. Their work had first drawn critical attention in their first group show the year before at the Grosvenor Gallery and had been seen by one of the MKG's representatives. It was also noticed by the well-known critic Claude Phillips, who wrote in the *Art Journal*:

> It is difficult to decide whether to place under this subsection [modern genre] or in the category of landscape, a very curious group of works by Scottish painters, which are to a marked degree impressionistic in tendency, but approach the problems of impressionism with a certain originality of aim, if at present with considerably more audacity than success. Mr. Arthur Melville's 'Audrey with Her Goats' is one of the most pretentious and one of the least successful of the series. Instead of "impressing," and irresistibly suggesting what it omits to

represent, it merely puzzles and repels; leaving us, after contemplation, doubtful of what the painter has intended to express, and annoyed at an audacity the only practical result of which is—to use French studio slang—to "épater la bourgeoisie." Much better, if still far from attaining the full pictorial result aimed at, is Mr. James Guthrie's large rustic idyll, 'The Orchard.'[1]

Cosmo Monkhouse of *The Academy*, a widely circulated literary journal noted for its reviews of contemporary literature in history, fine arts, and science, found that the Grosvenor was not "quite denuded of specialty or novelty."

> In Mr. Arthur Melville's 'Audrey and Her Goats,' and Mr. Guthrie's 'The Orchard,' we have two pictures apparently of the same school; and, moreover, both artists seem to have been moved by the same desire to emphasise the contrast between very green grass and very red hair. Mr. Melville is the more daring of the two, for he carried the red hair up into the trees, and sets them on fire, one might almost say. . . . the place for such suggestions is the studio and not the picture gallery. . . .[2]

Of the same group, the anonymous *Times* critic wrote:

> Trained draughtsmanship, combined with a preference for strong and sometimes heavy colour, a tendency to impressionism, a fondness for dark tones relieved by very high lights, are to be noticed in the majority of these pictures, especially in the works of the younger men, who have not yet entirely decided upon their own individual path. There are good and bad among them. . . . All . . . have a certain charm of their own, and show a mastery over the grammar of art, which is at least something. On the other hand, one of the two or three most conspicuous of the Scotch pictures cannot assuredly claim to be successful. It is the 'Audrey and Her Goats' [. . .] of Mr. Arthur Melville, whose clever "impressions" in watercolour have for some few years been a feature of the exhibitions of the Old Society. . . . It is said that this picture is not, as might be supposed, a mere hurried note of an impression reviewed in a moment, but that, on the contrary, it has occupied the artist at intervals for several years. If this is so, it only proves that not even the longest meditation can put right a view of nature which has a twist at the bottom of it.[3]

The twenty-one Scottish painters who made up the group, some of whom had painted in Holland with Mauve, the Meires brothers and Mesdag—the same tutelage that had initiated the career of Vincent van Gogh—aspired to a social realism in their work similar to that of Joseph Israels, the French Barbizon school of painters, especially Jules Bastien-Lepage, combined with the decorative quality of James McNeill Whistler and Japanese prints. At the exhibition in Munich, too, their work was seen as startlingly original, but the technique of color and brush-

1. Claude Phillips, "The Summer Exhibition at Home and Abroad: The Grosvenor," *Art Journal*, 1890, p. 171. The Glasgow Boys exhibited also with the New English Art Club in 1887 and 1888.

2. Cosmo Monkhouse, *The Academy*, May 31, 1880, pp. 378–79.

3. Notes to the *Times*, "The Grosvenor Gallery: First Notice," Monday, May 5, 1890, p. 10.

work they used to capture the freshness of nature was not unlike that defined as Freilicht- or Hellemalerei, the German equivalent of the French plein-aire or open-air style practiced by disciples of Wilhelm Leibl, whose endeavors and choice of subject matter also showed the influence of Jules Bastien-Lepage. To confirm Munich's admiration of the Scots, the Bavarian government purchased several of their paintings out of the Glaspalast, including John Lavery's *Tennis Party*, which had been awarded a gold medal at the Paris 1889 Salon.[4]

In his consideration of the Scottish paintings shown at the Munich salon, Meyer pointed out the variety of solutions to common technical problems found by the painters of the two nationalities. The exhibition of the work of the seven living German painters identified with the Naturalist or Realist school were shown in special galleries set apart from that where the Scottish work was hung. On display there were the paintings of Leibl, whose Naturalism had been strengthened by Courbet's visit to Munich in 1869; Franz Lenbach, long a social leader in the artists' community, who had given up copying masterpieces for the art patron Count Adolph von Schack's gallery to devote himself to painting the psychological portraits so desired by the successful in Austria and Germany; Hans Thoma, from Karlsruhe, who had retained a spontaneous response to nature in spite of training at the Bavarian Academy; two Berliners, Adolph Menzel and Max Liebermann, the exponent at the exhibition of Freilichtmalerei; Max Klinger, painter, graphic artist, sculptor, and creator of provocative "bizarrities," a resident of Leipzig; and the Swiss, Arnold Böcklin, long a popular exhibitor in Munich (see figs. 105–06).

Through the efforts of the critic and aesthetician Konrad Fiedler and the successful Bavarian sculptor Adolf von Hildebrand, a gallery was also made available for a posthumous exhibition of Hans von Marées' paintings and drawings, which were at that time still virtually unknown. Marées (see fig. 111), a north German, went to Italy at the age of twenty-seven in 1864, after some training in Berlin and eight years of study in Munich. Like Lenbach he was supported in his studies in Rome and Florence by copying old masters for Count von Schack.

Even more than his compatriot Anselm Feuerbach and Böcklin, Marées was determined to reject anything that had contemporary or literary relevance. He limited himself to themes derived from the classical and biblical world. Although cut off from Germany, Marées, like his countryman Asmus Jakob Carstens a century earlier, was not without influence among his contemporaries. His studio became a gathering place for young German artists and dilettanti on the grand tour, visiting what Goethe had described as "the land where the lemon trees bloom, where in dark foliage the golden oranges glow" to study the classical art and architecture of the ancient and Renaissance world. But Marées received only a

4. Also purchased were W. Y. MacGregor's *Quarry* and paintings by D. Y. Cameron, J. W. Hamilton, J. Paterson, A. Roche, and E. A. Walton; see Frank Rutter, *Modern Masterpieces* (London, n.d.), pp. 36–64.

single commission for an original work, a series of mural paintings for the Zoological Institute of Naples in 1873. Like his older French contemporary, Puvis de Chavannes, who refused to inject didactic intentions into his murals and paintings, Marées strove for an austere, pictorial decoration. Instead of historical anecdote or dramatic literary episodes, he chose a single word, classical in its connotations, to suggest a theme or subject, and then realized his vision by laboriously eliminating the inconsequential and extraneous details that might relate it to visible reality.

Fiedler had visited Marées' studio in Rome in the winter of 1866–67 and, through watching him work, became interested in the process of creativity. He published the results of his research in *On Judging Works of Visual Art* (1876). In noting the artist's reaction to actuality, Fiedler found that "perceptual experiences alone can lead the artist to artistic configurations" and came to define art as a method as valid as philosophy for arriving at knowledge and truth. Therefore art has its own independent existence in every civilization, since it conforms to each epoch's laws of visibility, rather than those of nature. "The work of art must take the place of nature," Fiedler wrote, "Only then will we cease to want to see art through nature; we would instead submit to art so that it might teach us to see nature." The painter's domain of light, shadow, form, and color, from which he creates his work through the vision of his genius, is unconcerned with logic or rational knowledge derived from the environment.[5]

After Marées' death in 1887 Fiedler set to work describing the evolution of his oeuvre. The result was the privately printed *Hans von Marées: A Tribute to His Memory* (1889),[6] which contained selected statements by the artist pointing out his kinship to the poet, playwright, and novelist Heinrich von Kleist. Fiedler's writings directed some interest to Marées, and he devoted considerable effort to the preservation of his paintings and drawings, which he had returned to Germany, where aside from a small exhibition in 1885 at the gallery of Fritz Gurlitt, the Berlin art dealer, they had remained virtually unknown.[7] The posthumous exhibition of twenty-four oil paintings, two pastels, a dozen drawings, and photographs of the Naples frescoes in the Glaspalast attracted slight attention. In the many reviews of the exhibition the artist's name is mentioned only three or four times. One review appeared in Copenhagen's *Dansk Tils Kueren*; it was an appreciation of Marées' work written by a Danish correspondent after a visit with Fiedler.[8] The *Zeitschrift für bildende Kunst* was the only significant journal to notice Marées' show, in the form of an essay written at Fiedler's request by the twenty-six-year-old Swiss Heinrich Wölfflin.

5. See Elizabeth Gilmore Holt, *From the Classicists to the Impressionists* (New Haven, 1986), pp. 449–68.
6. Conrad Fiedler, *Hans von Marées: A Tribute to His Memory,* afterword by H. Uhde-Bernays (Munich, 1953), p. 54.
7. Two exhibitions of his work were held in Munich in 1908 and 1909, preceded by one at the House of the Secession in Berlin, and some thirty examples of his work were included in the 1909 autumn Salon in Paris.
8. See Julius Meier-Graefe, *Hans von Marées,* 3 vols. (Munich, 1910), 3:306.

Following the example of the historian Jakob Burckhardt, his professor at the University of Basel and the author of many works (among them *The Cicerone: Instruction for Enjoying the Works of Art of Italy* [1885]), Wölfflin had gone to Italy in his early twenties. His studies were from the first concerned with the empathetic reaction to form. By studying how form was seen in various epochs, he hoped to establish art history as a discipline independent of the history of culture, as an autonomous subject with basic principles of style. He published his findings in *Renaissance and Baroque* (1888). In 1889, Wölfflin met Hildebrand, who was working in the studio he had once shared with Marées and Fiedler outside Florence. Hildebrand was also engaged in writing a book, *The Problem of Form* (1893), an attempt to direct attention to laws basic to the concept of form in sculpture. Hildebrand introduced Wölfflin to Fiedler's concepts and Marees' art, and they, too, helped him to develop the analysis of form he used for his art-historical method. It was only natural that Fiedler would then ask him to write an explanatory note for the *Zeitschrift für bildende Kunst* on Marees' art at the posthumous exhibition. Wölfflin also acknowledged that he owed much to Marées' work in *Classic Art* (1898), in which he further developed a theory of style that would be universally applicable to art forms. He refined these concepts into *Principles of Art History* in 1915.

When the 1891 exhibition closed, Fiedler presented most of the Marées pictures to the Bavarian state, but it was not until it was included in the German Centennial exhibition in Berlin in 1906 that the press and critics finally began to take notice of the artist whose paintings, in the judgment of the art historian Richard Muther, had formulated a principle.

The Second Annual Exhibition in Munich, 1891
ALFRED GOTTHOLD MEYER

I. [*The Glasgow Boys*] The second annual exhibition in Munich held what the first had promised; like its predecessor it assumed in its international character the highest aim of all similar enterprises: it gave a general view of the latest phase of development in modern art. [. . .]

The initial general impression of the galleries filled with nearly 1,900 works of art was positive. That favorable impression was reinforced on a closer study. Whatever his taste, no one will have left this exhibition entirely unsatisfied. Beginning with the well-known favorites of the general public, like Robert Haug's *Farewell,* the way led into the dangerous field of the experimenting artists, the originals, the revolutionaries, where the popular applause of the crowd often turns into derision. In this sphere, the foreign nations had the lead this year also, and this time a very strange group of works was prominent, which intrigued public and critics by their originality and source: the works of the "Scotch." When you enter their room you are reminded of Zola's description of the "Salon des

Refusés." Indignation, hardly concealed laughter, but also enthusiastic defense and great praise! Had the Munich artists foreseen or even wished to give their exhibition this particular flavor? Not a few favor this explanation, but the serious and honest efforts which lend an exceptional distinction to the whole enterprise contradict this thesis. Or did one think with Zola, "The public laughs—the public should be educated"? This too is improbable. One must bear in mind that the yearly exhibition in Munich represents, more than other organized events, the point of view of the practicing artist and endeavors to furnish him with new models and examples. From this point of view the whole exhibition should receive the most objective appreciation, and this should be kept in mind when judging its "originalities." It might have been more advisable first to show this still-developing "Painting of Glasgow" only to a circle of experts, but the way chosen also has its advantages, and in any case it is the duty of any conscientious critic to treat without any preconceived opinion a subject that has been so insistently submitted to discussion.

First of all, the paintings and colored sketches should definitely have been shown separately. The latter especially provoked the derision of the public, mostly because their significance as artistic instantaneous pictures was not perceived. That is the only way to look at Henry's *Galloway Landscape* and the *Cinderella*, Hamilton's *Shepherdess*, Hornel's *Goats* and *Under the Hyacinths*. Yes, even the large paintings, Melville's *Audrey with Her Goats* and Guthrie's *Orchard*, appear to be only improvisations merely to fix the picture of a fleeting moment, a passing mood, on canvas. Much is indicated solely by gross spots of color, as in decorations for stage sets. But there are minutely executed details. In the studios of our painters, we often find canvases and wooden panels which to the superficial eye appear to be "meant to serve as a deposit for useless leftover color"—the favored image for the Scottish sketches, but which for the artist are irreplaceable color sketches for a new painting, and for the discerning critic are more interesting than the accomplished painting. From this point of view, even the most doubtful Scottish paintings are valuable. "Dilettantes" are not able to sketch this way, and even most of our best colorists do not reproduce nature with this freshness of approach. The brush that created these sketches was dipped into a richer color scheme than has been used on the Continent in recent decades. These color tones have rightly been compared with a soft, congenial alto, and it has been said that in this Scottish room "everything had been tuned a few tones lower" than in the others. In fact, we have listened here to a melody of a foreign, yet in some ways curiously related, people, often clearer and deeper than in any other international exhibition.

Look at the landscapes! The melancholy of the old Highland poems and Scottish folksongs vibrates in the representation of nature with its warm, golden light, gigantic trees, and lush green. These paintings and colored sketches of Docharty, Dow, Macgregor, Macaulay-Stevenson, Melville, Morton, Paterson, Roche, Walton are not only landscapes but also pictures of impressions and moods. As such they are even more effective when the song of nature in the picture

finds an attentive ear. The little shepherdess who sinks on her knees in Roche's forest, Christie's peasant boys, Walton's *Brother and Sister,* and Henry's little *Girl Collecting Mushrooms,* whose head is so delicately designed by moonlight, are children of true nature poetry. The most outstanding of these pictures, which appear to be illustrations of German fairy tales, is Alexander Roche's charming description of the *Good King Wenceslaus* who brings bread and firewood to his people in the snow-covered forest: so simple and unpretentious and yet so dignified and full of fairy dreams such as even our Moritz von Schwind has hardly created. And even where these Scottish color poets enter the sphere of the strange and fantastic, they may claim an impartial audience. In our exhibitions we encounter so few original ideas that one can only greet Roche's *Kings of Cards,* where the jacks try to conquer the very young queens, as a charming jest, and Henry and Hornel's *Druids* demands consideration owing to the originality of their conception, composition, and technique.

With the pictures mentioned, we have exhausted the number of Scottish works that may be open to discussion. The remaining large paintings are without doubt among the best of this exhibition. The three outstanding masters of this new school, Guthrie, Lavery, and Walton, conserve their national stamp even in those pictures where they leave their homeland and face the tasks of the English society portraitist. Three prize-winning paintings, Guthrie's forceful portrait of Dr. Gardener, Walton's portrait of a young girl, kept in a dark red-brown, and Lavery's *Tennis Park* [sic] surpassed even the major English paintings between which they were shown, by their elementary force and astonishing technique. The same is true of *Miss Loo* by Roche. However, the relationship of the Glasgow painters to the London and Paris schools still requires intensive study. These atmospheric landscapes and genre paintings have their counterparts in the two paintings of the Englishmen Birkenruth and Lloyd—a young shepherd boy up in a gnarled willow tree dreams in the moonlight, and a shepherd family rests in the spring sun on a slope overlooking the sea—painted in a smoother, but no less poetic manner, and to which the landscapes of Muhrnan and Yeend King are also related. One can compare those portraits with the paintings of the Londoner Ouless and the portrait of an old woman painted with a virtuosity reminiscent of Frans Hals by the Parisian Alfred Roll. The strange conception of David Gauld, who stylizes his figures as if they were models for a crude Gobelin weaving, would find congenial admirers among the English adepts of the Pre-Raphaelites. The Scot Lavery follows, in his fanciful pastel, *The Sirens,* the footsteps of the Englishman George Watts in his fine figure, *Hope.* It should be remembered here that one of the most characteristic representatives of the English school, who excells in the description of life on the beach, John Robertson Reid, is a Scotsman by birth.

One can appreciate entirely the values of the Scots indicated here without closing one's eyes to certain inadequacies in the handling of color, or exaggerations in the impressionistic paintings, and a few other extravagances. But if derision and mockery are not justified, the absolute enthusiasm with which some

fanatic apostles praise these works as the heralds of a new age and prophesy their influence on our own works goes too far! One should judge these pictures for what they are: interesting examples of an authentic national school, attractive by their original force and strange charm. Their immediate influence on our own painting is not to be underestimated, but will probably be reduced to its technical aspect. The easy, casual, precise handling of the brush of Guthrie, Lavery, Walton, Henry, and the genial watercolorist Joseph Crawhall sets, indeed, an aim to be followed by our young impressionists.

The Scottish painters were the only ones to form a self-contained national group in the exhibition. Even the contributions of the English and French, although well assembled, do not give the same picture of originality as in the previous year. The reason is that the main characteristics, as last year, are in general already well known. In the English room the leading artist is Hubert Herkomer. His name stands for an artistic principle which in its perfect execution guarantees success. It is illustrated by five exhibited portraits, but it is no longer entirely incontestable! In the much-admired portrait of Lady Eden, the color experiment in white and black is transformed into a light, slightly greenish yellow. Is it the fault of this apparently strangely indifferent tone that this portrait, in spite of its delicacy, leaves us cold, especially next to its vivacious sparkling neighbors, Briton Rivière and Dr. Villiers Stanford? I have the feeling that the creations of this master are now too socially successful. Even in the magnificiently executed view of *Our Village*, with the churchyard under the lime tree where the artist's parents rest, the atmosphere does not seem that of the fresh country air. But perhaps this is a national trait and only perceptible to foreigners? We have a similar feeling in the late Frank Holl's representation of an anxious mother facing the terrors of a *Siege* in a lowly hut, and in Reid's bargemen and fishermen there is something of the same attitude. This aristocratic conception, which shows itself also in the picturesque attitudes, in the predominance of a sometimes cool, often fine silver-gray tone, is certainly an important counteraction to the extremes of the "most modern" realism. [. . .]

II. [*Open-Air Painting*] Right from the start an exhibition in Munich, the bastion of open-air painting, leaves scarcely any doubt as to the artistic creed of the Paris school. But the creed is not a rigid dogma; already it seems to be approaching a second phase of development [in which] significant new directions emerge more distinctly than ever before.

The most radical period of the "new school" may be considered to have passed. The problems of open-air painting—which, coming here from Paris, at once, if only superficially, turned every unusual, self-confidently proclaimed manifesto into a rigid, one-sided interpretation—have now almost overcome the difficulties of their first, most universal phase. To submit a good painting to this exhibition, it is no longer absolutely necessary to depict with skill a landscape or an interior in a cold, uniform daylight, while choosing the least appealing model, the most insignificant event, and the largest possible scale. Numerous works of

this type were rejected, and those that were accepted owed it to their excellent technical merits and, it must be admitted, to the names of their artists. [. . .] Within their circle these paintings, highly valuable as "studies," only served to show that the technical basis of the new school is not yet sufficiently sure of itself always to distinguish correctly a practice piece from a finished work, or rather to distinguish between ends and means. Individual works of importance that are part of the new trend also bore witness to the great significance attributed to technical ability itself; in all of them, however, that basic problem is already refined and modified by nuances.

Conditions and assumptions are clearly becoming more difficult. Scenes from nature are selected that can only be understood and properly appreciated by the most careful observation of the effects of light as a whole and in detail. In this exhibition the wide canvas stood out very noticeably. The most important task appears to be to conjure up the picture of a wide, flat plain, only gently rising or falling. And this problem, long studied by our marine artists, was indeed solved by some with astonishing skill. The Scot John Lavery scored the most brilliant success with his *Tennis Park* [sic]: a wide lawn, surrounded by trees, with numerous small human figures, executed in exemplary fashion both in linear and aerial perspective. Only close study reveals the unusual talent that permits this degree of illusion in so small a painting. Equally worthy of recognition but less attractive in subject matter are the paintings of the Milanese artist Belloni, *Under the Cherry Trees,* and of Walden-Hawkins, *The Orchard.* The problem is solved in a natural way by increasing and sharply accentuating the figurative. Max Liebermann's painting, *Women Mending Nets,* unusually attractive on account of the main figure, Frank Brangwyn's *Rope Walk,* P. Billet's *The Gleaners,* and J. Exter's *Children's Playground* rely on this to achieve a similar effect of perspective in a far larger and more conventional format. The risky task of giving powerful, deep dimensions to a totally bare meadow landscape, minus any staffage, on a wide canvas, is handled by Otto Beininger with great technical ability, but his painting produces a completely monotonous effect, that of a background rather than of a self-contained landscape.

The second nuance that open-air painting has added to the technical problems of its practitioners involves color itself. No longer does one see only open air, but colors, too, and indeed they are once again deeper, friendly colors. A. Aublet's *Among the Blossoms,* already acclaimed in Paris, shows the limits of attainment in this direction. Lawn, park, and the tender figures of young girls gathering roses— everything in rich colors, and at the same time the summer sunshine playing upon the scene and enveloping the whole in a delicate, bluish vapor: such a fitting glorification of that *"bleuissement delicat des feuilles"* [delicate transformation into blue of the leaves]. The study entitled *Autumn Sunshine* by the Belgian Henry Luyten also testifies to the open-air painters' newly awakened delight in color. In the last analysis this method of interpretation is only another attempt to solve the overriding problem of the lesson of diffused light.

It is astonishing to what different paths this problem leads. Indeed, the

world's painters have hardly ever beheld such a diversity of color as in our own days. One sees only local, the other only atmospheric, color tones. Here the whole discussion about color is tuned to a single, basic note; there one is aware of an almost inexhaustible wealth of changing tones. The Parisian Eugène Carrière and the Dutchman Josef Israëls choose to place their naturalistic exaltation of mother love in a twilight that dissolves every line, even every surface, in a gray-brown play of shadows. The Englishman Walter Sickert exhibits a female figure that is actually totally gray-black; the Parisian W. Dannat sets the mood of a portrait with a leaden white background. And in contrast to these "monochrome artists" there is Paul Albert Besnard, the ingenious Parisian leader of all who experiment with color, who earns still fresher laurels here than he did in the Salon. His painting *Naked Woman Warming Herself* received the top medal and indeed brilliantly deserves its success. How much healthy, organic strength is contained in this woman's body, in spite of all outward appearances and an external softness apparently ready to yield to every breath, is made clear by a comparison with the sauntering figures under flowering trees with which the Munich artist M. Kuschel celebrates spring. And how exquisitely is the warming process indicated by color alone, by going from the cool, bluish tone on the woman's neck to the hazy red and yellow which plays around the front of her squatting figure! [. . .]

It appears, however, that the immediate future would belong to the problem developed here by Besnard to the last degree, and tested by [Anders] Zorn and Harrison with great skill. Standing in front of the second important piece by Besnard, *The Vision,* one forgets the clever feat of coloring for the genuine painterly imagination expressed in its plan and execution: if the colors of the flowers and the bright green of the treetops glow in such a strange glitter of light, for a moment one may indeed glimpse in the mind's eye the charming appearance of the play of color of the woman's body. In the third painting, a family portrait, the artist is dealing directly with reality. Here, too, he displays his outstanding gift for color. One who can so recklessly place violet, red, and pink so closely together without giving offense has been endowed with a tremendous sense of color harmony and possesses all its secrets. Only virtuosity and at the same time a quick, daring tempo allow such experiments with color to be carried out effectively and still in a dignified manner. But Nietzsche's words, "That which is hardest to translate from one language to another is the tempo of its style," apply equally to art. In Paris, even non-Parisians can brilliantly succeed in making this bold trait their own, as witness above all Boldini, whose feeling for color is scarcely less daring than that of Besnard. Harrison gives proof of this, admittedly less impressively; he knows how to capture a magic that enchants the senses, in the play of sunlight against a wooded background, where moss-covered trees encircle a fishpond and disrobed beauties delight in the joy of living, on velvet-soft patches of grass. However, in the important piece by Paul Höcker, that bold tempo in which there is an echo of artistic inspiration is already somewhat missing: a long path through a shrubbery, with rays of sunshine penetrating its natural roof; in the foreground, a young nun sits dreaming on a stone bench, gazing ahead. Here

the experiment with color is carried out more academically than with Besnard, but instead, the effect of a rare combination of poetry and truth is heightened. [. . .]

The most important piece among these poetically effective curiosities in color is F[ranz] Stuck's *Lucifer* [fig. 110], completely enveloped in a violet, will-o'-the-wisp shimmer. It is a strange exercise, repulsive to many, or merely "sensational"; the execution is superb. This painting will continue to haunt anyone who has looked for long into the apparently empty eye sockets of this skulking figure. With this piece, the young Munich artist has successfully invaded the field of Klinger, just as with his *Pursuit of the Centaurs* and *Teasing* he followed Böcklin.

Piglhein's magnificent large painting, *Blind*, marks the transition from these regions of freely creative fantasy, newly animated through the awakened pleasure in color, to the firm foundations of nature. Here, too, content and mood are inseparable from the color effects; indeed, one could assume that the whole subject was inspired by the sight of a field of glowing red poppies.

In the multitude of genre paintings, this time scarcely to be taken in at a glance, there is a repetition of the same astonishing phenomenon mentioned earlier, which led impressionism and the open-air concept to a second stage of development. In fact, the term for most of the works of the new school collected here is no longer "open-air painting" but "impressionist painting," and not only impressionist painting in the sense of naked, totally objective truth, which preferably investigates the sad side of life, but of subjective paintings in which the goddess of poetry gradually comes back into her own. [. . .] These artists are—and collectively remain—capable open-air painters, but here they are simultaneously much more—they are poets! And neither more nor less are the most recent and many of the older followers of Bastien-Lepage. In this exhibition they sought to describe country life unpretentiously and as nearly true to nature as was possible, and thereby in very delicate tones to celebrate the poetry of nature, when at morning or evening, or in the afternoon sunshine, man and beast go quietly about their work or briefly rest. [. . .] And for the rest there are the most "modern" artists, who dare to clothe their figures in the sober dress of social convention. What these painters told us this time, using a more or less impressionistic brush, is the equivalent of passages in our best modern short stories, with their subtly nuanced precision of content. In [Joseph] Block's painting *The Prodigal Son*, the "how" and the "what," the purely artistic value and the significance of the content, coincide to an unusual degree. If only for what he has achieved in color, its creator would be assured of recognition for all time. It is truly no easy task to render figure and movement plastically in a garment so aesthetically unattractive as the modern man's suit; in the lighting, to conceal the deliberate artistic intention through the lifelike overall impression; to give animation to black and white through so many delicate gradations, and to paint such articulate heads and hands. But this painting is not only a superbly executed "study," with excellent figures—it depicts the thrilling moment in an act of a famous drama—the name of Ibsen springs instantly to mind: firmly and surely it grips our very lives, as only a master intellect can make it do. One who is *so* gifted at describing the mixture of

embarrassment, boredom, and regret in the mood of such a "prodigal son" listening to his father's reprimand is far more than a modern artist who is "just a painter." [. . .]

True historical painting is noticeably rare. In O. Friedrich's very meritorious and justly acclaimed *Canossa,* and in F. Vele's *Death of St. Wenceslaus* there is more evidence of better training and concentration of available strength than in A. Delug's giant canvas depicting the burial of Alaric. In contrast, Siemiradzki's well-known colossal painting, *Phryne in Eleusis,* has far more of the classical about it than one seems inclined at present to admit. Special attention should be called to a history painting of great strength and still greater technical mastery, *Distribution of Medals of the Legion of Honor by Napoleon I,* by the Italian Aleide Segoni.

Contrary to tradition, compared with paintings of a narrative nature, portraits, landscapes, and seascapes were insignificant. [. . .]

Next to Thaulow's unsurpassed snow paintings and the seascapes of Henry Moore, Harrison, A. von Bartels, and Duez, landscapes apparently worthy of being singled out reflect with singular conformity the same inclination toward poetic refinement that was evident in the genre paintings. Significantly enough, the Munich painters, who in a few hours can turn to the majesty of the Alps for subject matter that is always rewarding, prefer to depict smooth, rolling hills, meadows and fields intersected by canals, idylls of fall or spring, all too characteristic of a region which even nature has treated quite shabbily! But some among them paint these scenes in such a way that frequently one would not wish to exchange their work for a large painting of a glacier or an Italian landscape. Corot is their standard-bearer, but their strength is above all a true Germanic or, better still, Nordic feeling for the simplest form of nature's poetry. The valiant pioneer of this band, Erich Kubierschky, has been honored with official recognition; in addition, the Swedish Eduard Rosenberg deserves special mention. [. . .]

The impressive number of sound works by younger Munich sculptors is noteworthy: portraits, nudes, and classical figures from a good school, and especially a representation of *The Prodigal Son* by Franz Schildhorn, which revealed deep emotion. For vigorous strength, the *Bear Fight,* E. Frémiet's companion piece to his *Gorilla,* is by far the best. [. . .]

Considering the splendid overview provided by the exhibition of the leading art of our day, the retreat of the remaining [conservative] groups, which was anyway to be expected, managed not to prejudice the success of the whole. The Munich Society of Artists has certainly created the most suitable base for the development of its own strength with this "Exhibition of the Year". If it knows how to make it the showplace of such a lively international contest in the future as well, and if the contest continues to be as excellent as it was this year, then this enterprise will become a milestone in the history of our art.

Translated from Alfred Gotthold Meyer, "Die zweite Münchener Jahresausstellung," *Zeitschrift für bildende Kunst,* N.S. vol. 2 (December 1891):71–75; 95–100.

Hans von Marées in the Annual Munich Exhibition
HEINRICH WÖLFFLIN

This year's art exhibition in Munich has set aside a special room for the paintings and drawings of Hans von Marées. To most visitors the name will sound strange and unfamiliar, and the pictures themselves are more likely to increase this sense of strangeness than to dispel it. A world of its own confronts the viewer. Beneath an open sky there stand life-size nude figures, calm, unassuming, of truly antique beauty in their movements and extremely effective through the power of their plasticity. A few slender tree trunks give the indication of a glade: through them one looks out upon a landscape in which a gently undulating terrain is depicted with the simplest of lines. Nothing is unusual about the subject matter, but the whole is such that the viewer feels he has never seen anything like it. One might possibly compare these pictures to good Pompeiian wall paintings, yet the individuality of these contemporary paintings is so strong that the recollection of the former immediately recedes. What is remarkable is the fact that the purest beauty is coupled with ridiculous malformations, the most magnificent movements with partly stunted limbs. Deep rich colors in the background enhance the effect of luminous bodies, but the bodies themselves are morbidly painted over and painted over again so that whole cushions of pigment accumulate on some areas and attract the attention in an unpleasant way. Lingering for a longer time, however, one notices that these disturbing elements vanish more and more before the unique fascination that begins to emanate from the figures. The pictures possess a power to stir the soul so great that one forgets the defects.

It has been said that it is as if one heard beautiful peaceful music—after experiencing such a moment one may be overcome by the feeling that here a high point in art has been attempted and that it certainly is worthwhile to try to penetrate the intentions of this unusual artist. The following is an attempt to give, if not an exhaustive characterization, at least an indication of those points from which access to his art is easiest. [. . .]

Who was Marées? Why has he remained so unknown? The artist, born in 1837 at Elberfeld, did not live in Germany after his twenty-seventh year but was uninterruptedly in Rome. He never contributed to any exhibition. Hardly a single work came out of his studio during his lifetime. Only a few persons had access to the studio where the products of a tireless activity were stacked close together, and his only public work, the frescoes in the library of the Zoological Institute of Naples, was of course not likely to make the name of Marées widely known. Therefore, when in the summer of 1887 he died at the age of fifty, a man who was practically unknown to the world was buried. He himself had not expected such an end. He definitely was not one of those who withdraw into solitude and who want to satisfy only themselves. He wanted to create an impression, not only by satisfying his friends but also by jolting the dull and indifferent everywhere. That he did not exhibit publicly was due only to his conviction that he could not, or not yet, show himself as his artistic intentions demanded. But he did have the need to communi-

cate his convictions to some individuals, to come close to them by letting them partake in his development. He significantly influenced younger artists, painters, and sculptors.

What Marées was he became by dint of hard work, as a self-made man. He began his first studies in Berlin. Then he went to Munich for eight years. In 1864 he moved to Rome. This move was the most important external event in his whole life. All his art is conditioned by the Italian soil. It was here that the "clarification process" began which enabled him to return to the simple, natural way of thinking which he felt to be the most essential possession of an artist. He himself would have considered only the last ten years of his life as years in which he approached maturity. The paintings of this period form the major part of the Munich exhibition as well as of [Konrad] Fiedler's photographic portfolio. (Only the portrait of the sculptor Adolf Hildebrand and the double portrait of the artist himself with Franz von Lenbach belong to an earlier period.) Our judgment of Marées must be based on these works.

Marées' pictures offer nothing interesting as to subject matter. He considered it an unreasonable demand that an artist should seek to obtain the interest of the viewer through what was represented in his painting. Though in his earlier years, he did once, in fact, paint *Schiller's Death*, later he eschewed all such attempts, which he perceived as a great danger in the contemporary world both for the artist and for the viewer. When the attention is attracted by the subject matter, one is wont to take as the essence and substance of the picture something which lies quite outside the realm of art. The nonessential becomes the essential, and the difference between a mere illustration and a work of art disappears. Marées does not offer much to those visitors to the exhibition whose interest in the pictures is aroused by intriguing titles. Even when a caption seems to promise a "story," as in the *Rape of Helen*, a disappointment is in store for the curious. Marées purposely avoids creating strong spiritual relationships between his figures: what he calls the *Rape of Helen* is nothing but a seated woman and a man with his horse standing before her. He seems to have thought that when portraying nude figures emotions should not be expressed. Almost all his human figures have only a physical existence. The artistic interest is fully satisfied by the motifs of simple, quiet standing or sitting or by some restrained movement. An often-repeated motif is that of orange-picking: a youth reaches up to pluck a fruit, an old man bends down toward one which has fallen, a child attempts to catch one which is rolling away. Here and there a horse, "the Homeric companion of man," is included in the image. The nude ephebe rides his horse in the school, the armed warrior comes galloping on a magnificent steed, while a third figure with a lance vanquishes the crawling dragon. In this case the picture is titled *Saint George*. Otherwise all of them could bear the same title: "The Golden Age," or something similar. In later years, when Marées had completely found his own world and had rejected any definite relationship to antique-mythological or medieval-legendary imagery, he liked to name his creations "Hesperidean Images"—he called three standing nude maidens in a shady grove *The Hesperides*.

In paintings of this type Marées believed that he had achieved what he

considered to constitute the primary task of the artist: namely, to help his fellowmen enjoy and take delight in the existing world. Everything that appears to the artist's eyes must, from his earliest age, present itself "in its full abundance, in its value as something inexhaustible." The all-surpassing joy he feels when beholding the perfect forms of nature is the most essential trait of his personality. He opens the eyes of men so that they learn to see the beauty which surrounds them, and each derives new values from nature according to his individuality. Totally pervaded with the beauty of the human figure and the harmony of its natural motion, Marées shunned the representation of what interested his contemporaries. The starting point of all artistic production was, for him, the delight in structural beauty. This led his interest entirely to the normal and the universal. Both in the shape of his figures and in their movements he avoids the particular or the exceptional. There is a deeper connection here: from his earliest days, Marées had attempted to liberate himself from the observation of isolated details and experiences. He willingly absorbed what his eyes could reach, and his friends often marveled at how the liveliest conversations did not keep him from keenly and incessantly observing his surroundings. These impressions, however, were never used directly in his art, but remained as part of the aggregate of images in his mind, where they were to mature into typical forms.

A plastic spirit prevails in Marées' pictures: his vision is always directed to the solid form. No light effects ever appear in his work. Light and shadow serve only to define the position of the body and the correlation of the parts, not to offer an independent attraction of their own. Everything transitory, incidental, or intangible was repugnant to him. (Thus, for example, he despised the procedure by which old and recent painters achieve a more or less accidental pictorial effect through the grain or thread of the canvas.) The preliminaries for his pictures were never coloristic but purely graphic. Marées was a consummate draftsman and in his later years possessed an astounding knowledge of forms. The representation of organic form in all clarity was for him a question of conscience.

A certain archaic element has been found in his pictures: figures may be seated on the ground with their legs parallel to the frame and the upper and lower parts of the body at exactly right angles to each other. But this is not meant as an imitation of the antique style: his aim was merely to achieve the simplest possible image for the sake of clarity and of the emphatic effect of the main lines. The decisive forms and directions are to be easily and surely grasped at a first glance. Sharp turns and foreshortenings are avoided. Marées preferred to draw a horse in straight profile because he thought this gave the clearest image. He used to point to the example of children who, when they try to reproduce the things around them, proceed in exactly the same manner. "And we should all become children again in our way of looking at things." Overlapping to any extent occurs very rarely. All allurements of a picturesque grouping are consciously avoided. The planes follow each other in parallel arrangements. The background must never draw the imagination into the unfathomable. It is kept utterly simple: a few small tree trunks, a stream, the outlines of a hilly landscape are generally all there is. And

yet it is always very attractive and indispensable for the picture. Marées used to say that nothing is so difficult as a good background. Landscape plays merely an accompanying role, but in the manner in which these accompanying lines are related to the main lines of the bodies, the artist develops a unique subtlety. Besides, there is a second purpose to be fulfilled by the background. It is to help achieve a clearer illusion of space. The creation of a strong spatial illusion was a basic quality Marées required of his pictures. With painstaking care he continuously studied the best means to arouse the imagination to this end. His figures are not mere beautiful silhouettes on a flat ground: they are bodies in a space. The composition does not limit itself to a balancing of lines against one another, but requires a harmonious division of masses and a rhythmic play of motion in three dimensions. Here Marées achieved his utmost, and here is the reason why his pictures—in spite of their simple lines, their moderate action, and the absence of that tremulous, undulating, leaping motion which is considered richness in the pictorial sense—give the impression of festive exuberance. He is frugal with his means, but everything produces the strongest effect not because it is ostentatious but because it is in the right place. In a good composition the miracle happens: suddenly all the relations fall into place, everything crystallizes, the scattered parts unite into one whole, pulsating with homogeneous, uniform life. Without this crystallization, without the invisible play of the relationships from one part to another, the most colorful assemblage will appear empty and poor. Marées was tireless in rejecting and renewing until he had assured himself that the form was really clear. In this respect some of his pictures, for example, *The Hesperides,* are absolutely peerless. There is none of the feeling here, which one so often gets when looking at modern paintings, that everything could just as well be entirely different. The composition breathes necessity.

Marées had a high conception of his art. Actually he believed that he could express himself fully and worthily only in murals. Not only did the guarantee of durability of the solid wall surface seem desirable to him, but with murals he could feel assured that his art, which aspired to universality and permanence, would be most effectively protected against all interference. He needed the solemnity of the monumental style. To distill a typical form out of the manifold shapes, to elucidate the order of bodies in space to the point of achieving the impression of necessity, seemed to him the first aim of artistic endeavor. Another reason that drove him to want to paint murals was the desire to see his picture incorporated in an unchangeable and legitimate relationship. Paintings cannot be placed here and there at random; they demand surroundings that harmonize with them, or rather, the disposable space is what determines the picture's composition.

The opportunity to paint a real mural came to Marées in 1873 when he was commissioned to decorate with frescoes a room in the Zoological Institute of Naples. The work was finished rapidly and felicitously, but Marées regretted later that he had not received the commission in his maturer years. When the time came for him to feel completely equal to such a task, a similar opportunity did not again present itself, despite all his waiting and hoping. The artist repeatedly sought to

find compensation in compositions that were meant to be seen together and joined by some architectural links. Thus *Wooing* and *The Hesperides* are the centerpieces of a whole that was to be completed by two side panels and a base. The last page of the Fiedler portfolio shows a vivid illustration, and I must draw attention to it expressly, since the side pictures give the central picture its proper perspective: through them the many vertical lines in the sitting and bending figures achieve balance and harmony.

Marées' pictures were always completely finished before he started to execute the actual painting. But here he could never reach a satisfactory completion. His demands were such that he could not fulfill them with the means at his disposal. His almost passionate feeling for plasticity drove him to demand from a picture that it should convey a total illusion. Instead of desisting at a certain point, he kept working his pictures over until they were ruined. He had perfected a personal technique in tempera, since he hated oils and blamed them for all indistinctness in painting; yet he felt he could not do without them if he was to succeed in endowing his figures with the forceful presence he had in mind. He did not heed advice, and his friends had to watch helplessly the sad spectacle of his most wonderful creations being irretrievably ruined one after the other.

He answered those who reproached him that his pictures were never finished with the paradox that the "finished" pictures of the other artists had not even been begun. What he meant by this is not hard to understand.

Marées always began with the elementary conditions. To concern oneself with the expression of a mood, the spiritual molding of a historical event, or any such thing seemed to him an idle endeavor, as long as one had not yet come to an understanding of the most universal fundamentals of artistic creation. This is where he started his work, and this is where he felt the other artists were not seriously enough involved. Construction seemed to him the most important part of a picture. He reckoned with masses and directions of motion, with relationships between the space and the objects within the space, etc.—and these primary factors have such an impact in his painting that even where the figures are utterly distorted the effect of the picture is still impressive. But where the artist's sense of beauty finds full expression, a rare pleasure is in store for the viewer. A wonderful well-being seems to float from the pictures, pervading all our fibers and imparting a kind of feeling of redemption. Here Marées is on a level with the great in art, and he stands by himself, totally independent and autonomous.

It was a sad fate for him that he could not express the world of his imagination completely, that a gap always remained between what he wanted to achieve and what he was able to achieve. He suffered cruelly from this. Periods of exulting self-confidence alternated with deep depression, finally giving way to a kind of resignation. He believed, however, that people of sensibility would at least sense in his pictures a noble disposition and a certain kinship with the best.

Translated from Heinrich Wölfflin, "Hans von Marées," *Zeitschrift für bildende Kunst*, N.S. vol. 4 (January 1892):73–79.

1894: Vienna

The prosperity, brought by industrialization, that was spreading eastward along the Danube River, the enthusiasm aroused by Austria's universal exposition of 1873,[1] the museums and the school for applied art established between 1860 and 1870, had all helped to open up an art market that was active enough to attract artists from both western and eastern Europe to Vienna. The city's Künstlergenossenschaft, or artists' association, also added its contribution by holding exhibitions, but the close ties it maintained with the Austrian Academy of Fine Arts also made it a bastion of conservatism. Enlarged in 1882, the association's Künstlerhaus held exhibitions, but foreigners were excluded from them so that the Viennese market could be preserved for local artists.

When the association decided to depart from that practice and hold an international exhibition, invitations were sent throughout Europe to governments, artists' associations, and the press. The occasion was the twenty-fifth anniversary of the founding of the Künstlerhaus itself. Archduke Rainer (the director of the universal exposition of 1873) was its patron, and entries had to have been executed within the last ten years. Two works per artist in each category would be admitted, and six gold medals would be awarded: three to foreigners and three to Austrians. The emperor, the city, and the state all promised to buy pictures and sculptures and to sell others through a lottery. Of the 2,000 entries, the vast majority were from either Austria or Hungary, which were considered cohosts; 174 came from Germany, and 400 were sent from other foreign nations.

Until 1894 three painters—August von Pettenkofen, Hans Makart, and Anton Remako—had dominated Austrian art circles, overshadowing the work of the naturalistic landscape painter F. G. Waldmüller with their combination of traditional subject matter and a modern, but not plein-aire, use of color. This was related in technique to that of the Rome-based painters from Russia and Poland, the Spaniard Mariano Fortuny, the French school of Meissonier, the English Alfred Stevens, and the Barbizon painters popular with the Viennese art dealer Charles Sedlmayer. Within the year, however, they were succeeded by the circle of artists led by the painter Gustav Klimt and the architect Otto Wagner. Wagner's motto was "Anything impractical can never be beautiful," and he insisted that

1. Elizabeth Gilmore Holt, *The Art of All Nations* (New York, 1981), pp. 545–72.

modern form be of new materials and in new arrangements that corresponded with "our democratic, self-conscious epoch" and that "technical and scientific achievements must be adapted to the needs of our society."

The academicians Frederick Leighton and Lawrence Alma-Tadema (fig. 112), among others, were seen in Vienna for the first time (the prince of Liechtenstein purchased Alma-Tadema's *Fredegonde*). Also on view were the "Glasgow Boys"—Brown, Cameron, Macaulay-Stevenson—and others who worked out of doors, just as Waldmüller had done thirty years earlier (a habit that resulted in his dismissal from the academy).[2] Novel was the presentation by photographic reproduction of the works of Edward Burne-Jones.

The Swiss-born art and music critic William Ritter reviewed the show for readers of the *Gazette des Beaux-Arts*. He had studied at the University of Vienna with Brückner and Hanslick and was the author of an adaptation of the Siegfried legend, *Sigurd* (1893), with illustrations by Ernst, Mittis, and G. Picard. From him one might therefore have expected sympathy for the avant-garde Viennese artists who gathered at the Cafe Griensteidl, rather than the condescension his review displayed. Perhaps it was simply a reflection of the attitude Parisian art circles assumed toward any international exhibition that was held outside Paris.

A reaction to the English exhibit was contributed by the brilliant twenty-year-old playwright and poet, Hugo von Hofmannsthal,[3] whose playlet in rhymed verse, *Gestern* (1891–92), set in Renaissance Italy, had already attracted attention. It was followed by *Der Tod des Tizian* (1892), which was taken to be a manifesto to German Symbolism. At this same time, Hofmannsthal was contributing to the little magazine *Blätter für die Kunst,* founded in Munich in 1892 by the poet Stefan George as a platform from which to resist Naturalism in literature. In 1893 Hofmannsthal wrote a commentary for the *Deutsche Zeitung* on a then-popular type of publication, the *Musenalmanach,* which came in the form of a folio of prints by prominent artists, and an essay, "Die Malerei in Wien," in the *Neue Revue.* In 1894, for the same journal, he wrote a criticism of an exhibition of Franz Stuck's work, a review of the Vienna exhibition, and—prompted by what he saw at the exhibition—an essay, "Über moderne englische Malerei," signed with the pseudonym Loris, which professed that it was the combining of moral passion and social consciousness with the pursuit of beauty that attracted him to English art.

The Third International Exhibition of Fine Arts . . . in Vienna
WILLIAM RITTER

On March 6 the third international exhibition of painting opened in Vienna. The first two were barely talked about; and if this third one deserves to attract atten-

2. Ibid., p. 193–94.
3. See Michael Hamburger, ed., *Hugo von Hofmannsthal: Poems and Verse Plays* (Princeton, 1961), p. xvi.

tion, it is because of the effort expended by a small brave group of Austrian artists, on a badly prepared terrain with only halfhearted encouragement, rather than because of the number of worthwhile works shown.

This small Austrian pleiad of modern artists, who struggle with all their might to awaken a little artistic taste in their capital and take their cue from Paris and Munich, will doubtless have to do a great deal to raise the sensibility of the Viennese public to that of the Parisian.

As far as painting is concerned, it must be confessed that here we find ourselves very far from Paris or Munich.

Messrs. Bonnat and Carolus-Duran, who came here to represent France at the inaugural ceremony presided over by Archduke Rainer, the official protector of the fine arts in Austria, tried their very best in their amiable speeches to make up for not being able to thank their hosts in German by citing the inevitable formula "art, the universal language," in spite of the fact that actually there is no city in the world where such a language, or rather where the modern expression of this language, is less understood than in Austria.

Except for some rare high-ranking patrons, among whom Count Lanskorowsky-Brzezie and the Marquis Pallavicini must be mentioned, the Austrian aristocracy displays the most lamentable predilection for tinted photography and chromolithography. The only great painter of our time produced by Vienna, Pettenkofen, has never really been appreciated there. As for Makart, it is well known how much the reputation of his rather coarse and theatrical art has gone downhill, and anyone who studies his work nowadays is astounded by the infatuation it once was able to inspire.

The best evidence of the unfortunate taste of the Viennese lies in this fact: if one had not verified this state of affairs, one would not believe the insignificance of the works that were sold. Quite literally, everything that is very bad has been bought: all the paltry and worked-over finicky anecdotes, everything that looks like the top of a snuffbox or a chocolate box, everything that has the conventional shiny character of tinted photography, was grabbed in the first days. The Dutch room, led by Israëls, is full of splendid pieces, spirited watercolors, luminous landscapes, smoky interiors, striking effects of mist, and snowy winter scenes; it is almost always deserted. Finally, a particularly Viennese detail: in order to attract as numerous a public as possible, one day a week, Thursdays, a military band plays the waltzes of Ziehrer and Strauss right in the center of the exhibition.

When one first comes in one is rather annoyed, walking through these small rooms where an exhibition of a very special character could have been organized. A succession of small galleries of modern paintings, where the most beautiful or the most exquisite works by the best of contemporary artists, a faultless selection of their characteristic canvases, could have been grouped. It was this that the Viennese committee hoped for by calling on the governments and not the artists. But the governments have other preoccupations than to engage in such complicated, delicate choices. [. . .] From then on, the invitations were sent out in a quite haphazard way. The artists have absolutely not come to terms with each

other in order to form ensembles that would be somewhat homogeneous, so now each section has a more or less disordered appearance, with unevennesses and gaps, and it is absolutely impossible to derive an exact idea of foreign painting from the Vienna exhibition.

In particular, the contributions from France were awaited with the most impatient curiosity. France is rightly considered to be the discoverer, the initiator, and in a way the pivot from which all the directions of modern art radiate. Certain Austrian artists, whose work is much criticized in their own country, hoped that the French section would vindicate their own ideas and methods in the eyes of their countrymen—well, they were disappointed. [. . .]

The really interesting French paintings are all well known in Paris. Puvis de Chavannes has sent a woman wearing a Phrygian cap, seated under flowering trees on the top of a mountain, a very gentle and very harmonious piece, excellent to see after having seen other works by the master, but which by itself will never explain the work of Puvis de Chavannes, its decorative role, to an interested viewer, one who is just starting his artistic education or who has not traveled in France. (Exhibitions, in order to accomplish their purpose, should also be useful educationally—a point on which the Viennese committee had particularly insisted in order to make theirs a success.) The same is true of the portrait in white satin by Bonnat, the female nude seen from the back by Carolus-Duran, the old monk reading by Jean-Paul Laurens, the finely drawn profile with black and green veils by Agache, the small Muslim burial scene by Gérôme, and the soldiers of 1800 and 1806 of Detaille; they hardly justify the well-deserved fame of these painters, in the eyes of the Austrian public. [. . .]

Anyway, painters of life are always more comprehensible and subject to more reasonable debate than are painters of *idéalité,* who are always the targets of prejudice. Speaking of which, let's say that the majority of the neo-idealists of the Champ-de-Mars [the New Salon] are not taking part in this small Viennese festival: only Madame Demont-Breton contributes a picture of Giotto as a child, inspired by Burne-Jones.

In just ten years Germany, it is well known, has made up a great deal of the time lost by not throwing herself courageously into the path of realism. This and the exact copying of nature endure as the foundation of all artistic study and are always necessary to prepare the advent of "idealist" masters such as Gustave Moreau, Puvis de Chavannes, Burne-Jones, and Böcklin.

Well, if one can in Vienna acquire a pretty fair idea of contemporary German realist painting, the whole of German painting is almost as poorly summarized as the whole of French painting is: it is enough to point out that Böcklin, Franz Stuck, and Klinger do not answer the roll call. Lenbach, who seems to be an understated great-grandson of Van Dyck and Rembrandt rolled into one, has two portraits of the same man, the composer Brüll; again, a Frenchman seeing them this time will never understand how the official painter of Bismarck can have gained his universal reputation.

The best portrait in this section, even ahead of the lady in lilac by Rafael

Schuster-Woldan, even ahead of the lady in red by Fritz von Kaulbach, is the portrait of a slight, blond, smiling, and aristocratic Berlin youth by Ferdinand Schauss, a work of keen observation, and beautifully achieved. But among the great number of landscapes and scenes of real life, it is impossible to determine any new tendencies or to foresee definite personalities. Let us just say that the number of really worthwhile paintings is so great that the overall average of the German section could perhaps be assessed a little more highly than that of the French one, with less brilliant individualities. [. . .]

Austria-Hungary shares in the remarkable progress shown by Germany. [. . .]

There is nothing new in the Scandinavian sections. There are always the beautiful transparent waves, where Niss Thorvald's porpoises are playing, the inevitable fjords and fishing villages by Normann, a magnificent rose-colored flowing stream by Thaulow, and quantities of such real-life scenes, drawn from the life of fishermen on the coast, as the grandmother's birthday party by Hugo Salmson, a masterpiece of interior genre painting, as badly hung as its merit is great.

In Italy one need not linger except in front of the alpine painters, such as Giorgio Belloni and Filippo Carcano, who have all the vigor and swagger that is typically southern, in spite of the crude color and northern vegetation of the mountains. Alessandro Morani paints harvesters in the Pontine marshes, with revived methods of the German and Italian old masters.

Historical painting flourishes mostly in Spain and supplies the two largest canvases in the exhibition. [. . .] The Belgians are very poorly represented. [. . .] England, as well as Holland, is the best represented, and for the same reason. All its painters have certain characteristics in common, and there is a pervading spirit which floats over their work: this is due to their respect for tradition. In this section, as in the Dutch one, one encounters many fewer frankly second-rate paintings than in the others, and the star of the whole exhibition, a major painting, is found there: *Fredegonde* by Alma-Tadema, a painting both archaic and realistic, with a luminous amber coloring, deeply psychological, of a royal distinction, a work full of historical and artistic research, without mannerism or pedantry; painted some time ago, it seems to us to surpass by far even the best among recent works by the same master. Marianne Stokes has painted a salutation of angels in which a blue Holy Virgin sleeps on the straw, lulled by the song of two little angels, clothed in a startling red. The violence of these crude colors does not in any way interfere with the peace and simplicity of this very unusual composition. It is mainly in this section that we should mention a score of portraits, all of them very distinguished: one is a pastel, in slate and iron-gray colors, comfortable and cold, quite Anglican, which M. Stott of Oldham titles *In Front of the Hearth*. It represents a young woman in mourning, seated by her fireplace. With the simplest, even the most bourgeois elements of real life, the English excel in attaining style, in embodying the most unexpected contemporary elements in their tradition, in order to express the mystery and indefinable

qualities which are sometimes present in the simplest interiors and objects. The portraits of Cameron are characteristic of this. [. . .]

There is little to stop us in the sculpture displayed, very sparse and very commonplace. [. . .]

As one paces through the halls with long strides and studies the general traits, such is the international exhibition of Vienna. As I asserted of the French section and also of all the others, except for Holland and England, the whole thing is an accumulation of scattered, jostling works of art with no hierarchy, judgment, or order. Besides, the margin between the best and the worst really could stretch from the museum with the severest standards to the most lowly bazaar: that is too great a space!

As for the Viennese, they believed that they had organized this exhibition as well as possible. They invited wholeheartedly, thinking it was the way to do it, country by country, and did not invite the artists individually. For the guests who did come they fulfilled all their duties: it was not their fault if the foreigners in general responded so poorly to their appeal.

Translated from William Ritter, "Correspondance d'Autriche: La Troisième Exposition interna-tionale des Beaux-Arts et l'Exposition des Arts graphiques à Vienne," *Gazette des Beaux-Arts*, ser. 3, vol. 11 (June 1894):512–20.

About Modern English Painting
LORIS [HUGO VON HOFMANNSTHAL]

Rather surprisingly, the impression one received from the pictures of the English school in the latest international exhibition in our Künstlerhaus was a strong and special one. The surprise grew as one entered the small adjacent room hung with reproductions: about thirty photogravures of an individuality that could not be overlooked, reproductions of the principal works of one Edward Burne-Jones, whom not many knew.[1] The urge to imagine these works in the presumed color-ing of the originals was less strong than it usually is in front of such gray, shadowy images, because imagination and intellect were so busily engaged in absorbing these wonderfully clever lines, this archaic yet subtle suggestive mimicry, this symbolism full of ideas. One saw a world that appeared antique, even mythical, yet at the same time thoroughly Christian, even English; figures with an almost mystic sadness in their yearning eyes, with the naive, doll-like gestures of primitive art epochs, yet involved in allegorical action and suffering of infinite significance. One saw beings whose slender, occasionally hermaphroditic charm had, at first sight, nothing unearthly. One saw them daintily occupied with the trappings and symbols of worldly vanity, reflecting their luminous beauty in living waters, hiding in wild, dreamy rose thickets, or greeting and escorting each other with the graceful gestures of court miniatures. The more attentive glance, however, per-ceived more. These beautiful beings had an intense, though narrowly restricted,

inner life. They were sad and bewildered. At the same time they were very simple, simpler than people are, simple as profound myths, simple as the mythical figure whose dream life and vagaries and metamorphoses each one of us endlessly devises: Psyche, our soul. The deepest function of all imagination, the revelation of the innermost self, the foreboding dream of how one's own soul wanders, incredibly alone, through the unspeakably dismal realms of existence, ignorant of whence it comes and where it goes, shuddering deep down in endless wonder, in longing and sadness—this primitive approach to existence, in which wonder is the first and greatest element, was expressed in all those pictures. Psyche, the androgynous, who has experienced nothing but her own mysterious presence in the world, who looks at us anxiously with unfathomable eyes. It is she who is in these adolescent boys and girls with their naive, almost embarrassed movements, their unaware bodies. She is the yearningly anxious Galatea awakened from her numbness, the pilgrim walking between dreaming ponds toward the House of Idleness, the Circe bending down to the humble enchantress leopard, the enchantress, enchanted herself, uncannily guiltless. These beings have nothing to say to each other, they do each other neither good nor evil; all they know from each other is that they are. The region of drama lies elsewhere, nearer to the surface. Here, in the dusky depths of lonely being, other actors play: the cosmic powers; the masters of dream and death; Pan the god born unripe, cut from the entrails of the earth, not man, not beast, neither male nor female, with wild, flowing hair and awkward, kindly hands and sad eyes; and other divine and wonderful personifications of yearning, threatening, intoxicating, deadly life. Nowhere is the enchantment of allegory carried further than in the work of Burne-Jones. "His essential talent and disposition tend toward personification," Ruskin says of him. "To illustrate the first chapter of Genesis, another would have painted Adam and Eve, but he surely the allegory of a day of Creation."[2] His boldness is such that it even might not be far from him to seek the expression of a Platonic idea in painting, for instance putting into the hands of the six creating angels a transparent basin full of a magic of color that would call forth the image of the Day of the Flowers and Trees, the Day of the Birds and Fishes, the Day of the Waters and Winds.

We see before us an art of subtle cleverness, a mastery of the means of expression that borders on mannerism. The whole has something artificial, at least something cultivated, not quite naturally grown. Indeed the leading school of painting in England these past forty years, of which Burne-Jones is an offshoot, has been trained by great and productive critics through the most seductive and ingenious interpretation of Italian art of the past to bring about an artistic repetition of the Renaissance. This whole art has twined its growth round Dante, Botticelli, and Leonardo like young vines round old stakes.

Immersion in the secret of Dante's art became, most fortunately, the core of the tradition of the English "Pre-Raphaelites." They all derive from Dante. Their first master, Gabriel Rossetti, the son of a Dante scholar, bore the given name of Dante from childhood on, as a symbol, with deeper right than, for instance, Raphael Mengs bore his. Beatrice and the other women with mystic eyes and

slender hands became the subjects of their pictures, besides antiquities, flowers, animals full of a strange symbolism. Finally, the Trecento seemed too simple. The disconcerting beauty of Botticelli's women and the complicated psychology surmised with quivering fascination behind the strange, mocking, and resigned smile of Leonardo's heads were again simultaneously seized by ingenious and creative critics and similarly ingenious artists, and varied in such a way that, despite the artificiality, a captivating series of paintings emerged.

All these painters, more poets than painters, said some things in their manner for which poetry has no means of expression. Though they interpreted more than they created, there was so much essential poetry, so much ingenious mastery and animation of the inanimate in their interpretation! Art is, after all, nature reached by a detour. We call spring water detoured through root and grape, wine, and it is not a bad thing. We are out at sea in the night, far from land, and we long for the murmur of sweet water, for gardens and paths of the earth. Suddenly the wind wafts a delicate sweet and sharp fragrance over us. "Roses!" one of us exclaims, half-asleep, and smiles. But there are no roses for far and wide. The fragrance came from a boat that glided past us in the darkness, a boat of Persian men with a cargo of precious intoxicating oil, the distilled sweet blood of glowing roses that oozes through the cracks and lives in the night air. This is the kind of sweet half-natural intoxication that these English artists have distilled from the blossoms of the Renaissance. Like children sucking the honey from clover blossoms, they suck the delicate essence of spiritual beauty from the gestures of Beatrice, the mysterious smile of the Gioconda.

> We all know the face and hands of the figure, set in its marble chair, in that circle of fantastic rocks, as in some faint light under sea. . . . The presence that rose so strangely beside the waters, is expressive of what in the ways of a thousand years men had come to desire. Hers is the head upon which all "the ends of the world are come," and the eyelids are a little weary. It is a beauty wrought out from within upon the flesh, the deposit, little cell by cell, of strange thoughts and fantastic reveries and exquisite passions. Set it for a moment beside one of those white Greek goddesses or beautiful women of antiquity, and how would they be troubled by this beauty, into which the soul with all its maladies has passed! All the thoughts and experience of the world have etched and moulded there, in that which they have of power to refine and make expressive the outward form, the animalism of Greece, the lust of Rome, the mysticism of the middle age with its spiritual ambition and imaginative loves, the return of the Pagan world, the sins of the Borgias. She is older than the rocks among which she sits; like the vampire, she has been dead many times, and learned the secrets of the grave; and has been a diver in deep seas, and keeps their fallen day about her; and trafficked for strange webs with Eastern merchants; and, as Leda, was the mother of Helen of Troy, and, as Saint Anne, the mother of Mary; and all this has been to her but as the sound of lyres and flutes, and lives only in the delicacy with which it has moulded the changing lineaments, and tinged the eyelids and the hands.[3]

This "beauty wrought out from within upon the flesh," the same that so deeply moved Goethe's mind at the sight of the bold and noble lines of Schiller's skull, this beauty from inner necessity, a spiritualization of the corporeal so consummate that we perceive it as an incarnation of the soul, this highest ennobled individual beauty is what the English Pre-Raphaelites seek. Their idealism is almost the opposite of the classicistic idealism that originated in the abstract perception of beauty (derived from the statues of antiquity) and that among us once bore the name of Winckelmann, but now regrets to bear that of Paul Thumann.[4]

Not without astonishment people have pointed to what is usually called the second phase in Ruskin's spiritual life: the great aesthete's turning away from problems of art and absorbing himself in moral, even active religious thoughts. The turn from intense preoccupation with art toward another lofty, sacerdotal avocation should not be surprising to anybody, all the more so as this English art of psychophysical beauty is ethical through and through. These pictures speak an ennobling language directly, much more directly than do noble music or meditative landscapes. These painted beings educate the soul through the example of their noble bearing. I will try to make this somewhat wooden sentence more understandable and meaningful by returning to Dante's style and the related noble mimicry of Dante's figures. In Dante's countless conversations with the doomed, the penitent, and the blessed, mention is made remarkably often of the men and women with whom he speaks becoming sad, smiling self-consciously, turning fleetingly pale or angry; and often we are not immediately aware of the motive of these emotions. But after some consideration it strikes us with lightning clarity, and we are shaken with awe and wonder at the subtle and inexorably true individual life of these small figures. Their emotion was in most cases caused by some word, some name dropped in the conversation, some chance remark, in which they, highly intelligent and superior as they were, detected an allusion or sensed an analogy with an event that had been ominous in their former moral life.

To sense this analogy, however, an extraordinary degree of a quality that could be called "tact" (in the highest meaning of the word) is needed. This is the basis of the deeply moral impact of the mimicry of Dante's figures, which reveals their inner life: the most spiritual, most energy-laden genius subservient to the most intense moral alertness and the most inflexible striving for truth.

These figures are genuine through and through. They do not compromise with existence, they do not benumb themselves, they do not concern themselves with alien things, they do not forget, their life is not makeshift, nor metaphorical, nor untrue. They have *one* fear, *one* longing, *one* anger: the fear, the longing, the anger essential to their own being. Their speech, their nods, their glances are graceful because they are necessary. He who has ever felt the meaning of these observations, better and clearer than it is presented here, in the *Divina Commedia* and the *Vita Nuova,* will not deny that something similar is attempted in the pictures of Rossetti and Holman Hunt, of Watts and Burne-Jones. For a while,

perhaps, all other art, compared to this, may seem to him insipid and unrefined, if not downright vapid and coarse; and even later, after plunging back with a deep breath of joy into the elementary revelations of genius, the landscapes of Whistler, the human heads of Rembrandt, the music of Mozart, even then will he avow that there are more original ways of serving the Lord, but none nobler and purer.

Translated from Loris (pseudonym of Hugo von Hofmannsthal), "Über moderne englische Malerei," in *Gesammelte Werke,* vol. 1, *Prosa* (Frankfurt, 1950). Originally published in the *Neue Revue,* 1894, pp. 226–33.

 1. The photogravures were the work of the Scottish photographer Thomas Annan. He and his son J. Craig Annan studied in Vienna in 1885.

 2. From John Ruskin, "Mythic Schools of Painting: E. Burne-Jones and G. F. Watts," *The Art of England (The Works of John Ruskin,* vol. 13, ed. E. T. Cook and A. Wedderburn [New York, 1904]). The original (section 39) reads: "Indicating, thus briefly, what, though not always consciously, we mean by Romance, I proceed with our present subject of inquiry, from which I branched at the point where it had been observed that the realistic school could only develop its complete force in representing persons, and could not happily rest in personifications. Nevertheless, we find one of the artists whose close friendship with Rossetti, and fellowship with other members of the Pre-Raphaelite brotherhood, have more or less identified his work with theirs, yet differing from them diametrically in this, that his essential gift and habit of thought is in personification, and that,—for sharp and brief instance,—had both Rossetti and he been set to illustrate the first chapter of Genesis, Rossetti would have painted either Adam or Eve; but Edward Burne-Jones, a Day of Creation.

 "And in this gift, he becomes a painter, neither of Divine History, nor of Divine Natural History, but of Mythology, accepted as such, and understood by its symbolic figures to represent only general truths, or abstract ideas."

 3. The passage is taken from Walter Pater, "Leonardo da Vinci," *The Renaissance.* For the original, see Walter Pater, *The Renaissance: Studies in Art and Poetry,* ed. Donald L. Hill (Berkeley, Calif., 1980), pp. 97–99

 4. Paul Thumann, a painter of historical subjects, genre, and portraits, who became a professor at the art school in Weimar.

1895: Venice

Industrialization also brought prosperity to the northern cities of Italy—Turin, Milan, and Venice—by reviving their importance to Europe's traditional trade routes. Rome, once the *urbe de urbis* that stood above all nation-states, was now only the capital of Italy, while the pope in protest still confined himself to tiny Vatican City. The northern cities were not only Italy's production centers, with schools to train designers for a wide range of consumer goods—textiles, glass, ceramics—but its marketplace as well. Every fine arts academy and every association of artists, designers, manufacturers, and art patrons strove to promote consumer interest in the arts by exhibiting both their fine and their decorative objects. To attract the markets of the rest of Europe they fixed on Renaissance art as their national idiom, because the market required that Italian products conform to the consumers' notions of what "Italian" art should be. At the same time, most artists brilliantly executed eighteenth-century scenes in the accepted academic technique and ignored the subject matter of social realism. The Realism or Naturalism nurtured in the 1860s by nonacademic groups in Naples, Florence, and Milan could be seen only in regional shows or in the international exhibitions held in other countries.

Venice, long a popular tourist attraction, scheduled its exhibitions to alternate with those held by the art associations in Milan and Turin. Adopting the practice current at the time of using exhibitions to celebrate events of national importance, the council of Venice resolved to mark the twenty-fifth wedding anniversary of King Umberto and Queen Margherita by offering the city's first international biennial fine arts exhibition in conjunction with its usual exhibition of national art. The resolution stated the conviction that art was one of the most precious aspects of civilized life, for it expanded the spirit and provided the basis for fraternal solidarity among peoples. In the name of that solidarity, both foreign artists and the foreign press were asked to give their support.

To ensure the exhibition's success, the organizing committee followed the Munich pattern of inviting selected artists and limiting the exhibition's size. The 150 invited foreign artists and the same number of invited Italian artists would be allowed to send only one or two works. Two hundred items would be chosen from the unsolicited work of Italians by a jury of three Venetian painters. Paintings were limited to a maximum height or width of three meters, and sculpture to a

maximum weight of four hundred kilograms. Invited artists would be exempt from jury review and from all transport costs. Such costs for unsolicited work were to be borne by the artist, but the jury would refund the amount to the artist if his work was selected. The committee was to receive a 10 percent commission on all sales.

The first prize of ten thousand lire put up by the municipal council and the second prize of five thousand lire provided by the administrative council would be awarded to the most notable works, regardless of their national origin. The list of eminent international artists as patrons and the promise that all invited work submitted would be on view was meant to guarantee a wide participation and the approval of the venture by Europe's art bureaucracy. As it turned out, however, a number of foreign artists refused the invitation because the dates conflicted with an international exhibition of modern art sponsored by the Hamburg Kunstverein announced for the same time.

For its tribute to King Umberto, Venice placed a single exhibition hall, designed by the painter Mario de Maria, in a tree-filled park with no visible resemblance to what is commonly regarded as a typical Venetian setting. In keeping with the style of the time, the building was a simple shed covered with staff, giving it the eclectic Beaux-Arts classicist appearance required of a fine arts museum. On April 30, 1895, King Umberto and Queen Margherita viewed the first Biennale, with its 516 canvases and 60 sculptures, three-fifths of them by foreign artists, arranged in the building's ten galleries. In spite of the Hamburg competition, there were many familiar names among the painters shown. In addition to those of the patrons—predominantly Pre-Raphaelites, whose work was rarely seen in Italy but was favored by the Neo-Renaissance group led by d'Annunzio—there was Menzel's *Atelier Wall*, work by Whistler, Redon, Thaulow, and Stuck, and sculpture by Troubetzkoy, Tilgner, and Van der Stappen, not to mention Frémiet's *Gorilla*, along with his *Man in the Stone Age* and *Saint George* (see also fig. 113). Scant attention was given to the exhibition by the English and French art journals, however. The most extensive review, which appeared in three installments in the *Zeitschrift für bildende Kunst*'s supplement, *Kunstchronik,* was written by a southern German, August Wolf, and reflected the traditionally close cultural relations between the south German states and Venice.[1] After receiving, as had Marées and Lenbach, a commission to copy masterpieces in Italy for Count von Schack, Wolf had settled in Venice and become a member of the Academy there. For his own paintings he chose scenes of old Venice and mythology.

Venice and its sixteenth-century painters were the symbol of the Neo-Renaissance movement in Rome, though through the influence of d'Annunzio, Botticelli, the "visionary painter" of Walter Pater, was taken as the group's "ideal painter."

1. In 1797 Napoleon had assigned Venezia to Austria, under whose control it remained until 1866, when it was incorporated into a united Italy. Until then, northern Italian artists were shown in exhibitions in Munich, Vienna, and Paris as Austrians.

The circle of liberal writers and painters who belonged to it also contributed to the liberal magazine, *Il Convito* (1895–98), founded and edited by Adolfo de Bosis, one of its members. Their enthusiasm was further encouraged by Robert de la Sizeranne's *La Peinture anglaise contemporaine*, which appeared in 1895. D'Annunzio, by his address, "Ommaggio a Venezia" and essays in *Il Convito*, was able to create a vogue for that city which supplanted that for Rome. *Jorio's Daughter*, painted by his friend Michetti, was seen as a contemporary summation of Botticelli and Leonardo, i.e., of the "Neo-Renaissance" (fig. 114).

The Roman sculptor and painter Giulio Aristide Sartorio (1860–1932), a friend of Michetti and an early member of the circle of Mario Fortuny, head of the Spanish Academy, was also an adherent of the Neo-Renaissance group and opposed to "divisionism" or "impressionism." Shortly after writing the review of the Biennale for *Il Convito,* in which his essay on Rossetti had also appeared, Sartorio went to Weimar to teach at its academy (1895–99) before returning to the Accademia delle Belle Arti in Rome.

An exhaustive report of the first Biennale was provided by the several-hundred-page *L'arte mondiale a Venezia nel 1895,* written by the thirty-year-old Vittorio Pica. Winning a competition held by the popular weekly, the *Fanfulla della Domenica* of Rome, had launched Pica when he was only sixteen on his lifelong career as an art and literary critic. Together with the well-known Italian critic Diego Martelli, he early recognized Impressionism. He was already an advocate of the literary and artistic avant-garde and a promoter of the Macchiaioli.[2] His numerous articles were collected and published in *All'avanguardia: Studi sulla letteratura contemporanea* (1890), and his *L'arte europea a Venezia* appeared simultaneously with the Biennale. In 1910, as secretary-general, a position he held until 1926, he would realize his ambition of establishing the Biennale as a permanent international exhibition center for the avant-garde.

The First International Art Exhibition in Venice
AUGUST WOLF

Let us start our trip through the exhibition with the Italians, who are well represented both in number and in quality. Four full halls surprise one by the brilliance and diversity of the productions as much, in many cases, as by the ceaseless penetrating study of nature down to the smallest detail or, on the other hand, by the great artistic value. Only in a few instances does the Italian art wander into error through misunderstood imitation of northern characteristics.

Let us begin, according to custom, with figure painting. It used to be that the historical presentations were mentioned first. An almost complete absence of historical and religious painting in the Italian section eliminates this requirement.

2. See Elizabeth Gilmore Holt, *The Art of All Nations* (New York, 1981), pp. 335–36.

Among the few in this category, Domenico Morelli should be mentioned first; in a small picture pervaded with light and air he portrays Christ in the wilderness with two attending angels. Also, G. A. [Giulio Aristide] Sartorio, in a fine tondo with life-size figures, similar to S. Botticelli's, presents a very beautiful Christ-child surrounded by praying cherubs. This painter knew how to apply with moving charm the delicate linear execution of his early Renaissance predecessors without losing flesh and blood in the figures. In four additional paintings, some pastels with animated subject matter, figures, or landscapes, this same quality appears with the greatest finesse. Also belonging to religious history is the large picture by the Roman G. Ferrari of a standing Christ with raised outstretched arms, praying in the Garden of Gethsemane. Through a dark, desolate mood, the artist attempts to do justice to the subject. With the exception of this picture, only a woman's full-length portrait by the Piemontese G. Grosso, placed in the middle of the room, will hold everyone entering the first gallery. He has labeled this imposing painting *Woman*. Seen full front, with head raised high, this triumphant, thoroughly modern woman stands before us dressed completely in white satin with some gold. Head, shoulders, torso, and limbs are all on the same axis. Both arms, sheathed in elbow-length gloves, drop down somewhat apart from the body to the sofa, and both, left and right, are lightly supported by the fingertips. The background is white damask in the middle of which is a woven band of yellow silk; against this the thick brown hair of the powerful, vigorous head stands out with striking effect. At the bottom a few scattered roses are strewn. The mastery, especially the boldness, with which everything is presented in the picture, a certain brutality in the subject's expression—the features radiate inexhaustible vitality and strength—as well as the great superiority of color, make the picture unforgettable for anyone who visits the exhibition. Not only among the Italians but in the entire exhibition it is one of the principal pictures.

The conception of "Woman" that we encounter here threatens to be popular, for she is present in several different pictures in the exhibition, though not with such compelling strength. [. . .]

The uninitiated were very curious as to what the frequently mentioned Ettore Tito would bring. In his two exhibited pictures he breaks completely with his early predilection. The painter of the rosy children and maidens which still delighted art lovers some years ago is no longer recognizable. With the strongest determination he searches for other goals, for light, for larger, broader treatment. The public was right to wait to see how the treatment developed. Shaking its head, the public stands in front of his *Fortuna*. She exhausts herself frightfully, painfully pushing her gigantic wheel, and shames the *Woman* placed on the opposite wall. In his *Procession* the great breadth of light mass is very interesting, but is given in a strange manner. Within the frame of the "Procession" there is room for only a few life-size figures, who stride down across a bridge carrying a little so-called St. John in their arms. It is the subject of a most lively controversy. Milesi, as well known in Germany as Ettore Tito, gives with his Rembrandt light and half-life-size figures the interior of one of those miserable local workshops in which rosaries are

produced with gusto. E. V. Blaas pleases wonderfully with a fine life-size Venetian girl who stands on the beach, looking out over the water awaiting "him." She has set down on the ground the two baskets of fruit and flowers carried on the yoke, and she leans on it in a most graceful way. The charm of the figure is naturally a thorn in the eye of the realists. Sharper contrast is unthinkable between this figure and that be-it-ever-so-fine realism of the Tuscan F. Simi, still remembered favorably from the large local national exhibition. (That picture, *Maidens Dancing in the Open,* was bought by the National Gallery in Rome.) This time he named his large picture *The Parzens* (Fates). It is a country scene pervaded with tender realism. A young lad flirts with three spinners. An old peasant rests on the ground from his work. In an extremely delicate figure of a girl whom he names *Bice,* stretched on a settee, the painter tries with endless care to reproduce all effects of mother-of-pearl. The unusual task is solved with genius. In the entire picture there is no deep shadow; with faultless drawing and restrained modeling a truly entracing magic of youthful beauty, of play of light and iris tones, is achieved. [. . .]

Let us now follow the best landscape pictures in these galleries. Three of them demand attention because of their uniqueness. G. Segantini's large picture would certainly attract us by its moving subject if its theme were not truly suffocated by its amazing technique. We see a man bent by sorrow leading a simple wagon with a coffin through high mountain country. A weeping woman with child sits on the coffin. A loyal dog follows the horse-drawn misery. Segantini, a very interesting artist in spite of his peculiarities, had a special exhibit arranged last autumn in Milan (with about ninety items) in which his excellent drawing especially struck one. However, when the artist paints his usually large pictures, the beautiful drawing is buried beneath a myriad parallel lines circumscribing all the forms, which in their roughness resemble colored metal wires, so there are blue, red, black, or yellow stripes. Morelli comes with two pictures, more dotted but equally blue, the colors divided according to their prismatic appearance. One depicts women workers (all seen from the rear) in a rice field, the other a procession. From Bartoluzzi, living in Venice, we see an imposing sunset with high mountain peaks; by Sartorelli, an evening mood along the Riva degli Schiavoni. By the excellent B. Bezzi is shown the Campo Sta. Margherita during the fish market. It is late autumn or winter, everything is wet. The women filing past the wares, the wet shine of the cuttlefish—everything is splendidly reproduced. In the second gallery, we again encounter Bezzi with a landscape of the upper Adige River. The artist has mastered with the greatest skill the transparency of the water and the clarity of air. The Venetian Zexxos has represented the Piazza San Marco on a windy afternoon—the ladies sitting in the Cafe Florian have had to close their colorful parasols. They, along with the waving flags before the church, the people in their Sunday dress, give something uncommonly festive to the whole. Across from us, we see by the same artist a weary farmer plowing with four trudging oxen in order to cope with the heavy soil. Both excellent pictures strikingly show the versatility of the artist.

Silvio Rota, who, beginning with his latest picture, *The Galley Slaves,* has

increasingly cultivated the frightful, the nightmarish, has preferred this time to lead us into the court of an insane asylum. Infinitely desolate is the gray mood of this large picture, in which we can glimpse the unfortunate as types of their particular insanity. The group of a priest and a bitterly weeping man he comforts is of moving beauty. [. . .]

Of truly arresting beauty and veracity is *The Ocean* by Belloni. With no foreground of firm land, we see the majesty of the eternally resurging billows, following them to the far horizon. This beautiful picture, as well as that named above has already been purchased. [. . .]

A large picture by the original Michetti takes up an entire wall of this gallery. The very significant Abruzzese, at home in every saddle, leads us this time to one of the highest ridges of his native mountains, where costumes and ancient customs have been maintained. An entire row of peasants of various ages are enjoying a *dolce far niente* just as a notorious village beauty strides by, who calls forth their sneers, derision, and lust. The variety of the impression upon these raw men of nature is wonderfully reproduced. The woman striding by gives the impression of a photographic snapshot and is by her costume just as interesting as are the racial characteristics of the sinister mountainmen. To this tempera picture, woven together with extraordinary boldness, have been added six highly interesting nearly double-life-size sketches. Who does not know Michetti, and in the picture itself does not admire him simply from a sense of duty, will certainly do so when considering the splendid studies of heads by this very versatile artist.

Finally we enter the fourth gallery, where every hour of the day a dense crowd pushes past the sensational picture of G. Grosso. This remarkable picture, which causes so much talk, should have been rejected on account of its subject matter, although one then has to admit that an exceptional work of an excellent artist would thereby have been withdrawn from admiration. It caused the greatest embarrassment. A special commission formed of men of letters and critics—Panzacchi, Giarosa, Castelnuovo, Fogazzaro, and others—was named. They decided that the picture was not indecent, in no way harmed morals, and should be exhibited. Thus it became the chief attraction of the exhibition and would be the most sought-after sensation even if shown separately.[1]

In a sumptuous church the corpse of a libertine has been exposed in its coffin. As is the custom in Italy, the simple coffin is draped with black velvet richly embroidered with gold and covered with flowers; around it are great candelabra. The repose of the deceased is now disturbed by those women who in life had been in part his victim, and whose victim he himself has now become. The wildest of these priestesses of Venus, completely naked like the other four, rides on the half-opened coffin, and with mocking laughter tosses about the magnificent roses. The others lie on the lid of the coffin, enjoy themselves with devilish gaiety above the pale limbs of their lover. The beautiful back of one is the focus of light for the whole picture. The velvet covering has been torn away, the candelabra have been knocked over. In the folds of the covering cowers an unhappy half-grown girl who does not have the courage to take part in the crazy joy of the others. She con-

stitutes the note of reconciliation in this devilish music. From the interior of the church come still other figures. Everything in the picture, which covers an entire wall, is painted with the greatest mastery. The contrasts in artistic character have an entirely unusual effect. Therefore Grosso preferred to leave the female figures completely naked. Much can be said against it; perhaps a ghostly appearance of the betrayed dead man would have had just as gripping an effect, but never one so artistic as this stark nakedness. Only artistic considerations have given the picture its form. Naturally the local clergy have forbidden their faithful to visit the exhibition, and its press blocked any further discussion or information about the exhibition so long as this picture was not removed. [. . .]

Translated from August Wolf, "Erste internationale Ausstellung in Venedig," *Kunstchronik* N.S. 6 (*Zeitschrift für bildende Kunst*), May 30, 1895, pp. 422–26; July 25, 1895, pp. 487–98; September 19, 1895, pp. 538–39.

1. The Grosso painting was bought by an American syndicate for exhibition in the United States, but unfortunately the warehouse burned at the port before the painting was shipped.

Notes on Francesco Paolo Michetti

GABRIELE D'ANNUNZIO

It has become difficult for an artist to isolate himself. His disdain and his pride are of no avail. With skillful and tireless hands vanity reties around him the bonds he had severed.

But we have one example of total isolation, perhaps unique in our era: Francesco Paolo Michetti, the famous hermit of Francavilla, who early on took for himself Leonardo's words, "Salvatico è quel che si salva" (The untamed one is the one who is saved).

He belongs in fact, to the race of geniuses who are wild, violent, out of touch with the multitude, scornful of community life. A wise and thoughtful spirit, at an early age he came face to face with his own life and realized that any outside allurement was negligible compared to the tumults and whirlwinds stirred up within him by his creative power. As in Goethe's verses, this power filled his whole soul, flowed out continuously to his fingertips, in order to create. And, as in Goethe's lines, from his fingertips there burst forth "an essential shape."

Really, the long and laborious education of this artist, were it to be described, would be one of the most wonderful pages in the history of the human intellect. No painter, neither ancient nor modern, has nourished himself so richly with studies, and no one has mingled his own soul with a greater empathy to the great soul of nature; and no one has enveloped the beauties of the earth with a warmer poetry. Through his constant contemplation, his sight has gradually been transformed to profound, continuous vision. Through his diligent workmanship, his hands have gradually been turned into most obedient instruments, able to surmount any mechanical obstacle, able to solve any material problem of form.

Through his constant meditation, his mind has gradually acquired a power that penetrates and comprehends the very soul of things, in the same way that a strong electric current irradiates metals and reveals their essence by the color of their flame. In his education, he shares with the pure craftsmen of antiquity the free space of light and air. The ancient craftsmen, the Greeks, as Joseph Joubert points out, always saw the object of their art in the open air, that is to say, surrounded by the universe.[1] In the gymnasiums, they could choose for models of physical beauty their great men in their youth, as they could also in other public places choose as models of moral beauty their philosophers and their fathers, the wives, daughters, and mothers of their most illustrious citizens. All the scenes of an emotional nature took place in the open air, weddings and funerals, victories and defeats, proclamations and triumphs, all the fortunes of fatherland and family.

Having always lived in the country, like those early craftsmen, Francesco Paolo Michetti has always had before his eyes the subjects of his art in the conditions in which he wishes to study them. He has always seen man in the open air in his varying attitudes and expressions. He was, therefore, able to observe and to reproduce the varying scenes of an emotional nature in the actual place where they happened; he has always been able to observe his models animated by their individual feelings, in the midst of the universal animation of things surrounding them.

Herein lies his preeminence and that of the ancients. Like the antique works of art, his seem to be designed not to be shown in a museum but, to borrow Joubert's phrase, "à être placées au milieu du monde" to be placed in the midst of the world.

No other painter has observed "what *is*" more than he; no one has trained a clearer, more unerring eye on things. Never has a keener curiosity for truth been joined to a more burning love of beauty. Knowing that to obtain beauty it is necessary to dwell long on truth, he has accumulated an incredible wealth of exact notes, has analyzed the pageant of things in all of its elements in order to discover the hidden relationships, has tried to detect the secret of creation by exerting analysis. By dint of studying the procedures by which nature builds and reveals her forms and by following the same procedures, he has succeeded in producing the forms that correspond to the feelings of the human soul. In a word, he has succeeded in continuing the work of nature, in expressing with more clarity and vigor that which she expresses vaguely.

Now, as far as technique is concerned, although instinctively he links himself to the admirable forerunners of the Renaissance, he has not followed the example of any one master; he has never accepted anything from anyone. He himself opened and sounded out his way; he has run the course by virtue of his own strength without other help. He who sees his goal with his own eyes, even if he never reaches it, is superior in power and nobility to one who reaches it by the suggestions of others.

From the beginning, as free from habit as from authority, he placed himself directly in front of nature. His virginal spirit had such power of youthfulness that

he restored youth to whatever he looked upon. There was in him that childlike innocence that Lord Bacon[2] speaks of, that sovereign innocence "without which it is no easier to enter the kingdom of Truth, than the Kingdom of Heaven." He always looked at things as though he saw them for the first time, simple, innocent, amazed. For the first time he discovered their hidden poetry, which he revealed without disturbing it. His sympathy went out to the most humble of creatures. In every life there was for him a sacred mystery that must be adored. In the pictures of that first period, he studied animals in their infancy, the grace of suckling calves and lambs, the tremulous fragility of baby chicks just hatched, and the idylls of child shepherds among shrubs laden with buds and the shyness of tender leaves and the gentle sweetness of new blossoms. From that time on he knew how to enclose within the precise lines of form the infinity of confused, dark sensations, the depths of subconscious life, the soul that knows not itself and contains a limitless world.

But as he climbed the slopes of youth, a sort of panicked intoxication invaded him. The flames of intelligence burst forth from his brain in sudden flashes that dazzled and astonished even the boldest spirits. Unconcerned with measure, he had to express his thought with a single vehement rectilinear thrust, the strength of which he himself could neither estimate nor control. He felt and represented with an unlimited power the blind, irresistible whirlwind that lifts up inert matter and arranges it in ever-differing shapes in the sunlight. His marvelous eye was adept at picking out all the lines, the colors, all the aspects of nature herself, the most lasting and the most fugitive; while his hand, freer and swifter than any other craftsman's ever was, was ready to fix them on canvas with an unalterable stroke.

Almost all the huge collection of studies in the convent of Santa Maria Maggiore at Francavilla belongs to this period. This collection has been neglected for a long time and has been exposed to the perils that threaten the pastels' delicacy. It has finally been set in order in glass cases—a matchless treasure which represents the most lively and original artistic achievement of this century.

What an admirable page in the history of the human intellect would be, I repeat, the exact description of the natural process through which the intemperate lyric painter of the *Corpus Domini* arrived at the austerity and the simplicity of today!

This process of choice, begun with the *Morticelli,* continued in *The Vow,* and maintained without pause during ten years of deepest concentration, has been fulfilled in the *Jorio's Daughter.* Francesco Paolo Michetti is poised to conquer the highest peak of art. Not only is he the most powerful and most felicitous artistic personality to appear in this century, but his is the keenest intellect that has penetrated into the whole spirit of modern art.

Writers who are concerned about style in the practice of writing are familiar with the ineffable anguish which I would name the "Search for the Absolute"— that is to say, the search for the unique, unchangeable, perfect, deathless turn of phrase.

To render a thought exactly there can be but one expression, the "seule qui

convient" (the only one that suits), of which La Bruyère speaks.[3] And a thought which is exactly expressed is a thought which already existed, I will say *pre-formed,* in the dark depths of the language. Drawn out by the writer, it *continues* to exist in the consciousness of man. Therefore the greatest writer is the one who can uncover, unwrap, and extract many of those ideal pre-formations. The four volumes of the *Collected Letters of Gustave Flaubert* are full of the groans and roars that his painful toil wrung from that persistent, sublime slave.

A similar search is pursued by Francesco Paolo Michetti in draftsmanship and color.

Among all the various pictorial representations of any real object only one is the true one, the proper one, the absolute. Given certain principles, certain rules, certain laws, a thing of nature can be represented by art in only one way. The visible appearance of an object is composed of a mystery of innumerable lines, among which the artist must know how to pick out and determine the fundamental ones. Drawing does not consist of simply seeing "what is there," but rather of extracting from the complex reality of things what deserves to be pointed out, what gives "character" to a particular form, to that particular aspect of truth. Drawing consists, above all, in choice. So it is that it is not only the eye and not only the hand that make a good draftsman, but truly the intellect, for selection is one of the highest acts of the mind.

Thus art is the representation of what a discerning analyst boldly calls "thought obscured by nature." Art is the simplification of the lines. The great artist is a simplifier.

Having established this principle, completely obvious like all principles that are born from the essence of things, it is also evident that a work of art cannot be something arbitrary. A work of art, if it is perfectly conceived and executed according to a given principle, comes into the world, not as an artifact, but as a living organism equal to the other living organisms, and it continues to live in the consciousness of mankind, an everlasting subject for study, like life itself.

Now Francesco Paolo Michetti, in tireless pursuit of this rare, supernal ideal, has reached the ultimate peak in his own art, where every doubt has disappeared, and the well-trained, invigorated activities are balanced into a full, overpowering harmony. He has left behind everything that is superfluous and useless. Having understood everything, he is at peace with himself. The language that is now at his command is equal to the greatness of his inner dreams. His intellect is on a par with his sensibility. He can reveal his whole soul and can really create life.

But this last period, recently marked by *Jorio's Daughter,* a work of the greatest significance, in which all the details converge to express the central character, had already begun at the time when the great artist was painting the portraits of King Umberto and Queen Margherita, works that remain almost unknown, unappreciated even by the knowledgeable, yet that are sufficient to evidence clearly what I have stated above: that this artist had attained his highest, purest expression.

Eugène Fromentin,[4] the author of *Maîtres d'autrefois* [*The Masters of Past*

Times], hammers insistently on this thought: the intellectual and moral worth of a painter is expressed more in the quality and manner of the painting than in the subject matter painted. The subject matter is accessory and secondary. The temperament, the spiritual bent, the greater or lesser quantity of intelligence, of awareness, of goodness, are more patent in the painting itself than in the choice of the subject that was painted. Fromentin even goes so far as to state that it is possible to tell whether the author is a spiritualist or a materialist by looking at the painting of a tree, or any other detached fragment.

The theory of the painter-critic, though it seems paradoxical, is absolutely valid, and in our case, we can also test it.

At the time that Michetti, by then almost entirely renewed, painted the portraits of the king and queen of Italy (truly historical statements, certainly comparable in beauty to *Francis I* by Titian, *Julius II* by Raphael, the *Admiral Pareja* of Velásquez, the *William Waram* of Hans Holbein), it seemed that he had gone out of his field, indeed out of his genre, as people commonly say. Some critics were dubious before that sort of unexpected interlude between *The Vow* and *Jorio's Daughter* to come. Without pausing in front of that king and that queen, who were lost in the sad and gay rustic multitude, they waited for the next work of art to mark the beginning of a new period.

In fact, the new, the brightest, period actually began with these portraits. The subject was irrelevant, had been provided by pure chance, was secondary, negligible; but the quality of painting was new, unparalleled, supreme, utterly pure.

And so, in the studies of heads, exhibited in Rome in the spring of 1893, analyzing the human physiognomy with a subtlety and a depth worthy of da Vinci, the master searched for, found, was able to draw out the *type;* among the apparent lines, he knew how to see the hidden ones, those that Amiel[5] calls "the invisible groups." Some of these heads are marvels of psychological insight and workmanship. Never, I think, has the stroke of a brush reached such a degree of strength and clarity, and never has technique reached such a degree of simplification. Here every stroke has an exact value, sure, absolute, immutable, indispensable; every stroke instills into the canvas a breath, a heartbeat of the life that the painter, shall I say, has drunk through the pupils of his eyes, contemplated in his mind, and then analyzed and recomposed with an inner, almost creative, operation. Here it really seems that the artist has been able to trace, without ever breaking it, that ideal line of life and beauty, which continuously unfolds itself in our minds, but which no hand has been able to reproduce without interruption. The eyes as they look have the illusion of an almost perfect continuity in which drawing and color melt into each other, generating, I might say, a visible music, infinitely delightful. All the charm of this painting comes from its mystery. The wisdom of the master is concealed within it. There are no traces of the brush, only the appearance of life.

Jorio's Daughter, that huge canvas which last autumn at Venice—wonderful to relate!—obtained a favorable vote from intelligentsia and ordinary people alike, is, as I said before, a work of the greatest significance ever "for the greater

development given to the greater power." So overwhelming is the sincerity of this manifestation that weak or false spirits received a rude shock from it, almost a violent blow. Never has the nature of man revealed itself through the instrument of art with an energy and with more genuine and more straightforward simplicity. Never did color take on such a clear and high moral value. Here is a work of art before which free spirits have stood still with inexpressible emotion, recognizing in it the power of that supreme virtue which they themselves seek to extract from their own substance in order to refine it and make it the splendor of their lives.

Meanwhile, bathed in the constant warmth of meditation, there ripens the body of his work, into which the master wants to concentrate the essential energies of his spirit, now that he finally knows them all and is wholly in possession of them, having brought them methodically to the highest possible level of intensity. "To reveal while concentrating"—these four words point out the endeavor of modern art.

About two hundred canvases are now ready; they have received the first thrust of the idea, the basic tones and lines of the picture. In some of them the technical refinement is so advanced that the colored surface gives my eye the sensation of a living substance. In others the moral value of a single line and a single color is so strong that it communicates to me the whole emotion that created it, excluding the secondary elements. In others one mark placed with instantaneous accuracy seems to spread its influence over a confusion of brush-strokes and load them with its own suggestive force, multiplied. In others a few energetic strokes, through their dynamic expression, reproduce movement with miraculous truth.

Here is our whole race, represented in the broad lines of its physical and of its moral structure: the exuberant ancient race of the Abruzzi, so vigorous, so grave, so harmonious, around its mother mountain, from which the poetry of legends and the waters of melted snow flow in inexhaustible rivers to the Adriatic Sea. Here are the eternal images of the joys and sorrows of our folk under the sky they pray to with savage faith and over the earth they have tilled with centuries-old patience. Here at dawn, along the peaceful sea pass the vast flocks of sheep led by shepherds as solemn and stately as patriarchs, images resembling primeval migrations. Here, along fields of flowering flax, along fields of ripening wheat, wedding, religious, and funeral processions wind their way. Here men on fire with unquenchable longing follow in droves the beautiful, powerful woman, from whose body emanates an unknown enchantment; and they fight each other with scythes, among the gigantic sheaves of corn in a blood-colored sunset light that turns their shadows even blacker and more tragic on the razed earth. Here are fanatical crowds, with bare torsoes, their arms wound about with snakes, or with baskets of corn on their heads, or with garlands of roses and clematis, following after their idols, crying out, stupefied by the monotony of their cries. Here is the maiden with red hair, which binds her brow like a fiery diadem, closed in her deep unawareness, who, leading the cow heavy with calf to spring pastures, carries in

her fist a leafy wand from which trickles the intermittent sap. Here the languid maiden, freed from a charm of love after having seen the face of death, goes to fulfill a vow, accompanied by her family bearing the waxen gift; and the frail white ghost in the midst of beautiful fruitful women, in the midst of bronzed muscular farmers, passes almost airborne in the midday light, under the pitiless blue, along the harvest fields, tall, golden, infinite. Every drama and every idyll, all the images of the joys and sorrows of our people, are here as in a visible poem. And in each one of these beings the artist allows us glimpses of a soul without limit, the mystery of confused sensations, the profundity of life unknown, the wonders of the dream involuntarily inherited.

So, beyond the exploration of forms (pushed, as we have seen, to the highest degree of intensity), psychological exploration is what places the painter of *The Vow* above all the contemporary painters, at unattainable heights.

Certainly, da Vinci would call him his son.

The thoughtful Quattrocentisto, whom his own contemporaries named Prometheus and Hermes, a passionate and tireless investigator of mysteries, the keenest psychologist, to whom we owe perhaps the most subtle analyses of the human physiognomy, constantly immersed in studying and searching out the most arduous difficulties and the most occult secrets; the artist who discovered a law of nature while drawing a leafy branch; the scientist who, while studying water, found in the swirling liquid the movement of soft tresses of hair and the lines of a feminine smile—to me, he seems to be the heavenly intellectual father of the painter who in *The Vow* painted the woman in black and the tragic old man kissing the saint; the artist who in *Jorio's Daughter* has expressed with such terrible insight the diversity of laughter and irony on the faces of the recumbent men; the painter who has drawn all the flowers of spring, seeking the secret of their structure in the conditions of their existence, with the precision of a botanist and the tenderness of a dreamer; finally, the artist who, reconciling what seems irreconcilable, always with a happy effort, embracing and blending the two limits of every antithesis, has not placed the ideal outside reality, but has given it as a fulcrum the laws of life.

Translated from Gabriele d'Annunzio, "Nota su Francesco Paolo Michetti," *Il Convito*, 3 vols., ed. Adolfo de Bosis (Rome, 1895–98), vol. 2, bk. 9, pp. 583–92.

1. Joseph Joubert, French moralist noted for his *Pensées, essais, maximes et correspondance*, 2 vols. (Paris, 1842).

2. The reference is to Francis Bacon, the English philosopher and statesman.

3. Jean de La Bruyère, French essayist and moralist, whose *Les Caractères de Théophraste traduits du grec, avec les caractères et les moeurs de ce siècle* (Paris, 1688), contained fanciful portraits of his contemporaries at the French court.

4. Eugène Fromentin, successful painter of Algerian scenes and author of accounts of his travels there. *Les Maîtres d'autrefois* (1876) was an early study of the Netherlandish school of painting.

5. Henri F. Amiel, Swiss poet and philosopher.

On the Sculpture at the First Biennale

GIULIO ARISTIDE SARTORIO

Sculpture at Venice is represented inadequately, which as a matter of fact has been the case at all the exhibitions, except perhaps for those in Paris, where vanity and encouragement on a large scale favor its cultivation. Cultivation indeed, because this artificially stimulated "galvanized" art no longer has any place in our daily life! The Luxembourg Museum has a huge hall full of sculptures, and the garden is also filled with them; but all those works of art, piled on top of each other, large or small, of marble or bronze, produce an inexpressible feeling of tedium. It is the effort of those artists, rather than the spontaneity, that is echoed in the spectator.

This kind of sculpture is an art that can be stimulated and found in every country, for, even if we concede that sculptors like [Jean] Gérôme, [Eugène] Guillaume, [Jean A.] Falguière, [Henri] Chapu [. . .] are artists of uncommon worth, in England identical results are found in the work of [Frederick] Leighton, Thomas Brock, W. H. Thornycroft, Hilary Bates. If money ran more freely into the hands of Italian artists and we were to ask them firmly what was the intention in their style, we would also have, perhaps, a more radiant flowering of sculpture because, in addition to our marble quarries and our wonderful human race, we have the natural bent and the tradition of looking at sculpture in the open air. The statuette by [Domenico] Trentacoste in Venice is a palpable proof of that.

The obvious incongruity begins from the moment that this art (which is ruled academically), because of being outside everyday life claims to be part of it, and so we have those monstrous paperweights that encumber the public squares of Paris, London, Berlin, Milan, and Rome.

Is a sculpture exposed to cold, dust, and smoke from engines, a sculpture whose subject wears top hat and frock coat, logically possible? I shall always remember with irresistible mirth, at the vortex of city traffic in London, a statue of a seated gentleman exposed in evening dress, hatless, already black as a chimney sweep, collecting and bearing the weight of some tons of dirt.

When Tiberius, overcome with admiration, confiscated the *Apoxyomenos* of Lysippus—exhibited in front of the Baths of Agrippa—the populace rose up so violently to reclaim it that the tyrant had to yield and give it back; but today, for the sake of Christian charity, a public subscription ought to be started for the benefit of these poor wretches exposed to the harshnesses of public squares! To think that [Leon] Gambetta, on the Place du Carousel, will harangue the people for centuries; to think that so many generals and so many soldiers, with truly beautiful gestures, and lacerated throats, are forced into an eternal torment and fight a hyperbolic enemy to no purpose; this is unheard-of cruelty.

Modern sculpture is struggling at this inevitable crossroads: if it attempts to return to a primitive art after the relaxation caused by the abuse of realism, it necessarily becomes academic; if it follows the pictorial spirit of the period, it is no longer even a reflection of sculpture. It was so that Hadrian, who was a learned

archaeologist, having taken the most ancient art from Greece, stimulated and protected a renaissance. After Hadrian, a genuine attempt to return to the sources of sculpture was never made until the period of Canova and Thorvaldsen, with results not too unlike the Antonine ones.

The impressionist movement in sculpture is absolutely a vain illusion, and even if it were logical it would lead us to a perfect *panottico* [360-degree view], in the same way as, if historical painting were logical it would find a suitable field in the painting of panoramas. Let the Musée Grévin [Wax Museum] and the Panorama of Imperial Rome at Munich bear witness.

To be sure, it would be a fine outcome if we were to catch up with the examples of realism by the Quattrocentisti, but impressionist sculpture goes on its way so independently of every criterion that one cannot understand what it wants. At the very least, going all the way back to the Quattrocentisti, to the portraitists of imperial Rome, or to the sculptors of Memphis, although a step backward, would be a step in some direction.

At its birth sculpture was a merely imitative art and took the place of painting, which had not yet progressed into the laws of perspective. The wooden statues of the Memphis school are of such *instant* naturalism that in comparison impressionism is a childish art. Simultaneously with their wooden statues the Memphis sculptors produced those wonderful stucco bas-reliefs, which are the most ancient and effectual beginning of the intimate pictorial sense. [. . .]

Byzantine art, an antisculptural art, closed into hieratic forms in the early periods, which led irremediably to its death, and it was this school that provided the models which were modified according to various attitudes until the twelfth century.

From then on, the unconstrained Gothic sculpture began in France, with its independent characteristics, varied, animated, pictorial. It should be pointed out that nearly all Gothic sculpture is clothed, even in the Last Judgments—for example, the one over the portal of Notre Dame in Paris.

The Pisan sculptural movement had a more classical development when it was inspired by the classic Roman sculpture, which was, as we have seen, an importation of Greek decadence. The pompous Roman architecture, polychromed, gilded, overloaded, could not tolerate a straightforward, plain sense of sculpture; even the Greek orders, when applied to the arch, appeared poverty-stricken, and an order richer than the noble and flowery Corinthian was sought in the composite capital.

In one building the [Italian] statues could increase or decrease, be gilded, be painted, change the form of effigy, and the building would not lose a thing! And I will say no more; the Italian temperament has always kept this feeling for decoration, which makes it use statues as ornamental objects rather than as essential elements of a building, and the museums are proof of that. The Medicis caused antique sculptures in their collections to be so scraped and polished that many noble fragments were damaged. In the making of museums the real guidance has

always been the sense of a hall, nobly decorated with restorations, adaptations, rearrangements, sometimes incredibly successful. Who, for instance, would believe that the head of the Vatican *Sacrificer* does not belong to the body?

But if the reader is able to imagine a Roman building, or a Renaissance or Gothic one, bare of its sculptures, I do not believe that he could as easily imagine the Parthenon or the temples of Aegina and Olympia with blind façades; as a Byzantine or Romanesque church would be inconceivable without mosaics decorating the apse, the fifteenth-century hall with no frescoes, or the Gothic cathedral without stained glass windows. [. . .]

The question of sculpture reaches on every side the identical conclusion: that sculpture is deprived of its organic ties with architecture when it depends on architecture modern in its aims; it becomes tedious, and it becomes absolutely necessary that sculpture be academic. After the evolution of pictorial sentiment had taken place, sculpture did not find in its nature an element of independent life, being less quick and less emotionally moving than painting, which gives sensations that are complete and at times sculptural.

The time of the wonderful Baroque portraits will come, the time of the magnificent fountains will come, but the great sense, the lofty subject matter, will be enclosed within the orbit of the great mural decorations. And if, speaking of antiquity, the Parthenon and Phidias are the names which spontaneously rise to the lips; to speak of another philosophically masculine and sculptural manifestation, Michelangelo and his Sistine Chapel come to mind.

When the reader who has been following me now reads the titles of the sculptures shown in Venice, he will have a kind of cold shower: *Union beyond Life, The Beach, Modesty, Dark Struggle, The Beauty of Death, Interval, Maternal Instinct, Homesickness, Labor, The Meeting of Opposites, Poor Little Girl, At the Forge, Two Orphans, The First Cigar Stub, From the Veio Mine, At the Beach, The Grafting, He Who Sleeps Catches No Fish, The Whirlwind, In the Pillory, The Tears, I'll Drink It, Little Mother, Back Stage, The Disinherited, True Life Impression!* [. . .]

When sculpture has reached such a pitch of slavish, superficial imitation, do we still want to call it sculpture?

Translated from Giulio Aristide Sartorio, "Sulla i Biennale: Sulla scultura," *Il Convito*, 3 vols., ed. Adolfo de Bosis (Rome, 1895–98), vol. 2, bk. 9, pp. CI–CVI.

European Art at Venice
VITTORIO PICA

II. *The Pre-Raphaelites* The room that attracts the public more than any other is the one where the work of the English painters is hung, and this is only natural and right because they set before us a wholly original view of nature and humanity:

they reveal to us a conception of aesthetics that is completely new and characteristic of the Anglo-Saxon race. The pictures that are the first to be sought out by the visitor with eager curiosity are those which have been so much discussed, and alternately despised and exalted, painted by the Pre-Raphaelites. [. . .]

The Pre-Raphaelites—to repeat the word of the learned art historian Ernest Chesneau—assigned to their art the aim of active moralizing. They proposed to reach this aim each in his own way. The historical painter represented scenes characterized, as minutely as possible, by precision and accuracy. The landscape painter faithfully reproduced the smallest details, particular to the site preselected by the artist and provided by nature. In both cases they faced a system of microscopic analysis pushed to the most extreme consequences. By following this system of analysis, they claimed that they attained, that they espoused, truth, the beginning and end of all morality.

And, according to what Robert de la Sizeranne maintains in his fine book on contemporary English painting [*La Peinture anglaise contemporaine*, 1895], two essential qualities are to be found in every Pre-Raphaelite canvas: the expressive originality of the attitudes and the raw vivacity of the brushwork. Now it is well to remind my readers, so that they themselves may comprehend the enthusiastic admiration for the frescoes in Pisa of the initiators of this new pictorial formula, that the psychological intensity of expression in attitudes and gestures is the crowning glory of Giotto and the Giotteschi, whose painting is still so faulty in perspective, in the anatomy of the human body, and likewise so little pleasing to the eye. On the other hand, Rossetti, Hunt, Millais, and their followers, placing dry color on the white canvas, without the substratum of bitumen and warm colors dear to academic painters, and working on their paintings bit by bit without finally going over them in order to fuse the tones and harmonize the whole, were only reviving the technique of Benozzo Gozzoli and the other fresco painters of the fifteenth century.

Of course, when the English Pre-Raphaelites returned to the pure and ingenuous inspiration of the Italian painters before Raphael, they had not the least intention of giving up the technical progress made by art after the Quattrocentisti. Indeed we are very far from finding in the Pre-Raphaelites' canvases the dried-up figures of the Giotteschi, or the gentle incorporeal angels of Fra Angelico: for, even under the soft, richly pleated dresses of the spiritual Pre-Raphaelite maidens, one may guess the presence of the slender but fleshly roundness of beautiful feminine forms.

On the other hand, one perceives in the poses and gestures of the figures in the Pre-Raphaelite pictures something that is exquisite without being precious, revealing the refined tendencies of an aristocratic yet totally modern art. In fact they strive to replace, as much as they can, the vulgar and traditional gestures of the art academy that are learned at art school, and not from the direct observation of nature, by the unusual, unhackneyed, individual gesture which perhaps is not the most spontaneous but is certainly the most elegant and the most expressive.

Finally, in the principal works of Rossetti, Holman Hunt, and Burne-Jones,

as well as in those of Madox Brown, who was in a way their forerunner, and above all and almost to an excessive degree in those of Watts, who even if he cannot exactly be considered one of the Pre-Raphaelites, yet has a pictorial technique and ideals of art quite akin to theirs, in all of these there appears an assiduous preoccupation to speak to the soul rather than to the eye of the beholder, to make use of history, of myths, of symbolism, even of the landscape to inspire noble sentiments in him. Their moralistic obsession, and, in a completely coarse way, their barbarically violent use of color, which often offends our sophisticated Latin eye, demonstrates the deeply English character of Pre-Raphaelitism, so much so that it would be useless and harmful, even absurd, to attempt to acclimatize it in its entirety in our country.

But certainly the lofty idealism of the Pre-Raphaelites and the careful workmanship of their canvases cannot but offer useful opportunities for study and meditation to our painters, who too often work in a routine manner, relinquishing any original inquiry, and make no attempt outside the well-beaten paths of tradition, and also to those who usually do not trouble themselves to think before putting a brush to canvas.

Of the initial Pre-Raphaelite triad, since Rossetti has been dead for several years and Millais several years ago gave up his youthful theories of art, only Holman Hunt remains active today. We have in the Venice show a large and important canvas by him, though not one of his most characteristic. It does not reflect that ideal of Christian art which caused him at twenty-seven to leave for Palestine and to remain there for several years in order to paint biblical scenes as they probably did happen, with types of men and women and landscapes observed and taken from life in the Holy Land: as later, imitating him, the Hungarian Munkácsy and the Frenchman Tissot did.

The painting that Holman Hunt sent to Venice is entitled *May Morning on Magdalen Tower*. It represents an episode of academic life, quite thoroughly English. At Magdalen College, at Oxford, an ancient floral ceremony takes place every year on the first morning in May. The warden, the professors, and the scholars climb up into the Gothic tower of the college to sing a hymn, with their faces turned to the east, at the very instant the sun rises.

This is how Holman Hunt has represented the curious scene, which is not lacking in a certain noble poetry, but which causes an involuntary smile to flutter on the lips of the skeptical Latins that we are. The carved slender pilasters of the Gothic tower are drawn against the dawning springtime sky, dappled with little red-violet clouds, and streaked by flights of birds which pass, singing, a troop of rosy, chubby, laughing children and youths clad in white robes on the platform of the tower. Behind them come the warden and the professors of the college walking at a slower pace, also clothed in snowy tunics and singing the hymn in praise of spring. The scene is glorified by the gold from the barely risen sun and made even lovelier by the profusion of flowers strewn on the ground and garlanding the robes of the children.

The scrupulous patience of the brushwork, with which the varied expressions of all those childish faces are portrayed, is incredible. In their harmonious joy they bring to mind the memory of the two groups of angels of Benozzo Gozzoli's frescoes in the Palazzo Riccardi in Florence. In the portrayal of the noble, austere faces of the professors, we also find the same patient, scrupulous brushwork. This is seen particularly in the minutely detailed execution of the flowers, which could have been studied petal by petal, fiber by fiber, by a botanist. That actually is one of the fundamental characteristics of Pre-Raphaelite painting. Another common characteristic of contemporary English painting is to represent only regular and beautiful faces. They may indeed be brightened by a faint smile, may indeed be clouded by a veil of melancholy, as often happens in the canvases of Rossetti and Burne-Jones, but they are never deformed by a too-noisy gaiety or a too-violent expression of grief. It is Ruskin who warns, "By exaggerating the exterior signs of passion, far from demonstrating the force of that passion, you will only show the weakness of your hero."

Do look at, and pay special individual attention to, each one of the children and adolescents that people Hunt's picture, and you will not find even one who is ugly, or bears on his face the imprint of some disease which might already be afflicting the youthful physique.

Surely this painting of Holman Hunt's interests us. It may even provoke our admiration, but that does not make us love it or excite the aesthetic empathy which, moreover, is the greatest reward for an artist. No, indeed. The reason for this lies not only in the excessively garish, cold, unharmonious coloring and in the slick miniature-like execution, which cannot help but be unpleasant in such a huge canvas, but principally in the fact that the scene so realistically and scrupulously depicted in every detail, in every accessory, is lifeless in its entirety.

Although true in each authentic part, it is false as a whole because in natural sunlight the outlines of bodies or of objects lose their precision; the hues, with changing reflections, melt and are blurred; the tiny details of structure become faint and often disappear.

On the other hand, *The Bride of Lebanon*, a painting by Burne-Jones, makes an entirely pleasing impression on us. The Lebanese bride, dressed in a soft bluish tunic, makes her way along a dry rivulet, between two rows of flowering lily stems.

How is it possible to describe the exquisite grace and the soft languor of this young woman's body, whose form, as is Burne-Jones's wont (and also that of Watteau in the last century and several Florentine sculptors in the fourteenth and fifteenth centuries), is slightly lengthened and changed to accentuate its elegant slenderness?

How is it possible to describe the ineffable expression of the deep blue eyes, with their vague, pensive look, of the lips, which are the color of faded roses, of the head, slightly leaning to one shoulder with the weight of dreams?

How is it possible to describe the eloquent movements of the little white

hands?—one droops wearily alongside her body, the other twists her auburn hair into a necklace around her rather long neck, which is like those of Botticelli's lissome creatures.

To complete the picture, behind her appear angelic figures. Their heads stand out against the green of the trees and are surrounded by wide green airy scrolls— of their light fluttering garments—of two greens, one light and the other darker, nearly blue.

In the conception and execution of this canvas, Burne-Jones has as always proved himself to be a poet as well as a painter.

Another most lovely picture is one painted by another Pre-Raphaelite, a late follower, William Blake Richmond, which bears the title *Venus's Bath*. Against the background of an idealized, misty landscape and beside a malachite pool, with rose petals floating on its pellucid waters, rises a blonde Venus in all the delicate nudity of her rosy body.

But she has none of the shapely opulence of the classical Cyprian. She seems to be a lissome and elegant daughter of the north. After all, in such guise she has already appeared to us in the famous painting by Sandro Botticelli, the glory of the Uffizi Museum. With a dainty, graceful gesture she still holds against her body the last bit of drapery, which has only just revealed the enchanting secret of her forms, while three handmaidens form a circle around her, helping her disrobe. [. . .]

VI. *The German Painters* Munich, Vienna, and Berlin are the three most important centers of German painting; for this reason, anyone who wishes to acquire a thorough knowledge of it should study its three manifestations separately and then compare one to another and thus find out what their affinities and dissimilarities are. But it is very difficult, if not impossible, to do this here in Venice, where the founders of the different schools either are absent, as in the case of Böcklin, Munkácsy, Passini, and Knaus, or, like the venerable Menzel, have sent work of quite secondary importance. Here in Venice only a small Austrian phalanx has arrived, bringing work that with three or four exceptions is rather mediocre. We must be content then to contemplate the pictorial production of the Bavarian, Viennese, and Prussian painters, in terms of the German characteristics they have in common [fig. 115].

Strolling around the two galleries where it is exhibited, we are often struck with admiration for one painting or another, but the exhibition on the whole fails to give us the joyful aesthetic satisfaction or the pleasant surprise we felt in the English, Scandinavian, and Dutch galleries. How can this be so? Simply because the correct, patient, conscientious Germans make us breathe again the rather heavy air of art academies. It is because the scholarly resources of their painting, exceptions notwithstanding, seem to us to owe more to art school than to a loving study of nature; at the same time the painting appears to us more often made to interest the mind or touch the heart than to gladden the eye with festive color harmonies. Be aware that if it is directed to the mind and heart, it is not done, as is the painting of the Pre-Raphaelites and Watts, in order to speak a noble and poetic

language or, like that of the Frenchman Gustave Moreau, to suggest magnificent rich visions, but to flatter the low, coarse sensibilities to which sentimental novelists and playwrights usually address themselves. [. . .]

One of the most challenging and most discussed painters of this section, the Berliner Max Liebermann, particularly deserves our attention: having been, while still very young, a disciple of Munkácsy, he was completely transformed by the influence of the Dutchman Israels and of the more daring French painters, so as to become a realist in his search for subjects and an impressionist in the technique of his paintings.

In addition to a pastel portrait of the famous playwright Gerhard Hauptmann, drawn with firm competence but perhaps a little too bleak in color, Liebermann has sent two small canvases, *In the Haarlem Marketplace* and *Country Beer Garden*. When seen close up, they seem to consist only of streaks and spots of different colors, but looked at from a suitable distance they manage to bring out—in a truly wonderful way—in the one the swarming crowd of vendors and buyers around the rosy piglets which are being marketed in a tree-shaded corner of Haarlem and, in the other, the good-natured quiet of the peaceful groups of drinkers gathered under the wide awning of the beer garden. In each canvas the sun that either pours down from the tops of the leafy trees or creeps in sideways under the awning has such dazzling intensity as to give almost the sensation of real light.

Well, these canvases by an acknowledged master of the brush usually provoke the laughter of the three types into which the inevitable and instinctive enemies of every artistic innovation are divided: the *foolish,* who furiously repel any attempt not instantly clear to them, any experiment that is beyond the reach of their thoroughly commonplace intellectual activity; the *frivolous,* who, while not lacking some intelligence and taste, dislike every patient attempt at a new initiative and cannot resist the contagious temptation of making, at the expense of something that they cannot and do not wish to understand, witticisms that are facile and vulgar but sure of success; finally, the *presumptuous,* the most dangerous category of all, because it consists of artists and men of letters deeply convinced that they possess the only true and insuperable aesthetic, outside of which there is no salvation, and to draw away from it one must be, according to them, either inept or mad.

In spite of the stupid abuse of the foolish, the pseudo-witticisms of the frivolous, the disdainful and contemptuous shrugs of the presumptuous before the canvases of Liebermann—as formerly in front of those by Besnard, Segantini, Previati, and Pellizza—there is also never lacking a small group of ardent admirers or artists. They, even though they have some reservations, find these experiments by the impressionists and the foreign pointillists, like the experiments by the Tuscan Macchiaioli and the Lombard divisionists, much, much more interesting, in spite of all their inevitable errors, with all their inevitable exaggerations, than the frozen academic attention to detail, the learned virtuosity, the musty charm, which are the only inheritance of the correct, popular painters.

Art, in all its forms, is a continuous and untiring *becoming*. It is because of this that we will never show enough tenderness, never enough admiration, for the innovators, either those who pay with a long series of bitter experiences for a tardy ray of glory, or those who go from one mistake to another to prepare the way for those who will triumph tomorrow. In their dedication to a lofty ideal of art, which shines brightly in their minds but which, alas, they have not been able to embody, they appear grotesque to us, while they truly are the suffering, unknown martyrs of art.

Another Berlin painter, who in the latter part of his career, after having for many years imitated the painter Menzel in a whole series of historical canvases, has resolutely crossed over to the ranks of the impressionists is Franz Skarbina. Particularly notable in Venice is a delicious little painting entitled *Two Sisters,* elegantly but not excessively impressionist. It shows us two graceful maidens, stepping into the half-light of their rustic little house, while the reflection of the sunlit countryside, sifted through the window and the door, ajar, sprinkles their faces and their dresses with little greenish luminous spots.

Three painters who are particularly famous in Germany are Menzel, Uhde, and Lenbach, and all three are represented in Venice. Of the first, eighty years old today, who has been painting for no less than sixty years, and who is the illustrious founder of the German school of painting as Munkácsy is of the Austro-Hungarian, there is only a small canvas. It depicts a dividing wall in his studio covered with death masks, half-torsos, plaster casts of hands, a canvas with exceptional knowledge of drawing and chiaroscuro, but it cannot give us even a remote idea of this wonderful artist, who, in two justly famous paintings, *The Workshop* and *Modern Cyclops,* has depicted with eloquent modern efficiency, and with a rare depth of observation, the crowd of workmen, who, in the midst of black scrolls of smoke and ruddy reflections from the furnaces, are tossed in a whirlwind of activity, as though they were athletes, with accentuated muscles and strangely rounded eyes.

The large painting with life-size figures by Franz von Uhde, *The Sermon on the Mount,* which shows us Christ seated in open country and speaking to an attentive crowd of peasants of our times, immediately reveals to us the art program of the noble Saxon artist.

By representing the gentle Nazarene in the midst of a modern crowd, he wishes to express the permanence of the evangelical ideal in the midst of the vicissitudes of custom and race.

I will not try to emphasize how questionable and artificial this attempt at mystical painting is. It is very different, in spite of an apparent resemblance, from that by Holman Hunt, and James Tissot in France, which is inspired by a feeling that must be respected and by historical and topographical accuracy. To this pseudoreligious style of painting the able and subtle French painter Jean Béraud added, with great success, a flavor of worldly, slightly grotesque elegance. In his painting *The Magdalen among the Pharisees,* Jesus, surrounded by gentlemen in black evening suits, lifts up a modern Magdalen, clothed in an evening dress, who

has prostrated herself at his feet. I will only point out that even if the figures of the Nazarene and the women and children do not lack a certain expressive competence, Uhde's canvas, on the whole, seems hard in drawing and not very agreeable in color.

I cannot deny the rare virtuosity of Lenbach, generally proclaimed the prince of German portraitists, which is reaffirmed once more by the four portraits here in Venice. Among them, the one of the elderly American philosopher Emerson almost gives the illusion that the sparkling little eyes wink behind his glasses and that the lips smile mischievously in his white beard. But it seems to me that Lenbach lingers too much on the exterior, and very little of the soul shines through in the faces that he fixes with such technical mastery on the canvas. As to the workmanship, I must confess to little sympathy for the shiny reddish brown varnish that he spreads over all his portraits. [. . .]

VII. The French Painters Should a person who had never left Italy wish to make a comprehensive survey of today's French painting, he would commit a very serious error if he were to limit himself to a scrutiny, however careful and detailed, of the thirty or so canvases that represent it so incompletely and so poorly at the Venice exhibition. Anyone who might have stepped into the Luxembourg Museum, the Panthéon, the Hôtel de Ville, or anyone who might have visited a couple of the annual Paris Salons or above all some of the special exhibitions of this or that artist or this or that group of French painters, or even some of the modern private galleries, cannot fail to recognize that in our times, in no other country in the world, is the alluring art of the brush more brilliant, more varied, or bolder than in France. This explains why from every part of Europe and America artists crowd into Paris in order to learn, to become aware of the most interesting innovations in painting, and to exhibit there whenever possible their most characteristic works.

It is really deplorable that a whole series of causes, great and small—among which, alas, we cannot exclude that muffled ill feeling between the two sister countries which the tedious, vicious rabble of politicians for several years has enjoyed fomenting and exacerbating—has prevented our artists and the public from being able to admire and judge visually, and not only from hearsay, the most original and innovative examples of today's French painting.

Among the fourteen French exhibitors, certainly, there are not wanting some very famous ones, but unfortunately they have sent only work already well known or of secondary importance. They reserve their more recent or interesting work for one of the two Paris Salons, or for the universal exposition at Berlin, which opened at the same time as this one in Venice.

Here we have, first among them, the septuagenarian Puvis de Chavannes, rightly esteemed as one of the most illustrious masters of painting in Europe. But it is not by looking at the pastel, primarily a decorative piece, or even at the masterly sanguine crayon drawing he sent to Venice, that one can have any idea of the noble poetry of his painting, of the archaic simplicity of the composition, the soft

pallor of the color, the bewitching, evocative drawing, put together so masterfully. An art in love with allegories and symbols needs vast expanses of walls to decorate in order to express the grandeur, at once austere and ingenuous, of its conceptions.

Why, for heaven's sake, did this distinguished painter not send to Venice some of the large cartoons for the admirable frescoes with which he has ennobled so many walls in the public buildings of Paris, Lyons, Amiens, and Rouen? Among others I remember as a magical, radiant vision [the fresco] of colossal proportions that he showed four years ago in the Salon of the Champ-de-Mars, an allegory of summer which was to decorate one of the largest interior walls of the Hôtel de Ville in Paris. [. . .]

In its austere simplicity of design, and in the overall faded tones, that vast composition admirably expressed all the glorious poetry of summer, as well as the intimate association of transitory human life with the permanent and ever-renewed life of nature.

A painter of a totally different character is Alfred Roll. He has always shown a marked inclination to represent modern life as manifested by the tumult of rioting, noisy crowds, either in the panic of a terrible disaster as in the *Toulon Flood,* or in the boisterous rejoicing of a public fête, as in the *July 14, 1880,* or *Centenary of 1889 at Versailles,* or finally, the exasperation present in a threatening revolt, as in the *Miners' Strike.* Vigorously painted by a keen observer of real life, his pictures are always interesting, even when he cannot resist the urge to attract the attention of the public by placing in the foreground a whole series of portraits of well-known Paris personalities or, still worse, by drawing conventional figures and melodramatic groups of utterly vulgar sentimentality.

Besides a portrait of Admiral Krantz, Roll has sent to Venice a picture, to which he has given the title *Workers of the Land,* that is certainly not one of his best works. Between the hedgerows of a country path and under the subdued light of the rising moon, a shabbily dressed young mother presses to her breast her fair-haired baby. Behind her a bearded workman bends his eyes to the ground with a grim look of pain and desperate thought. The man's face is not devoid of psychological effectiveness. The group of the mother and little child does not lack for sorrowful tenderness, but the whole tonal harmony of the picture is too pale. The figures do not have enough emphasis. The intimate tragedy of that outcast soul raging at his misfortunes, who perhaps tomorrow will be pushed by the lack of work and the cruel sufferings imposed by hunger on his wife and little son, to steal or avenge himself with dynamite against an uncaring society—[all this] entirely escapes the spectator or, at the very least, fails to move or touch him. Thus this painting proves once again that for art in general, and for the plastic arts above all, humanitarianism, patriotism, and other similar most worthy sentiments are almost always negative qualities. I am well aware that someone will not fail, in order to contradict me, to remind me of Israels' paintings, the *Proximus Tuus* of D'Orsi, and *The Heir* by that great artist from the Abruzzi, Patini; but is my contradictor really sure that the merit of these works lies in the preselected subject, and not,

rather, in the accomplished workmanship and the powerful vision of truth that their authors, in a flash of genius, have had?

Two French painters who on the contrary command everyone's sympathy in this exhibition are Dagnan-Bouveret and Carolus-Duran. As far as the first one is concerned, he imitated Bastien-Lepage for several years and has been, like him, a realist to the end—"un sage insurgé," as Huysmans called him, adding maliciously, "C'est le Polonais platonique des Beaux-Arts." In 1887, after a trip to Brittany, Dagnan-Bouveret turned to mystical painting, painting dreamy feminine figures in the profound contained ecstasy of prayer or ascetic meditation.

The Madonna in Venice belongs to this second manner, and even if it may appear somewhat contrived, no one will deny the infinite spell cast by the dreaming blue eyes in that image of a sweet young woman, dressed and hooded all in white, who cradles her rosy baby in her arms, walking under a green pergola from the top of which golden drops of sunlight rain on the tender little group. [. . .]

Translated from Vittorio Pica, *L'Arte europea a Venezia* (Naples, 1895), pp. 19, 24–33, 72–73, 84–91, 94–97, 98–101.

1895–97: Paris

When the Old Salon opened on April 30, 1895 in the Palais de l'Industrie, the sunshine and the spirit of spring drew an enormous crowd of well-dressed people. The first day was "varnishing day," the time set aside for the painters to touch up their canvases, and many were willing to pay the five francs admission to look down through the shrubs and statuary into the great central area and watch artists like Bouguereau, Alfred Stevens, Courtois, and Aman-Jean at work. Mingling with them was the dancer Loïe Fuller "in a costume that was a fantasy of spring violets," and Mlle. Clara de Merode, the reigning beauty, "in vernal greens with a suggestion of daffodils in the yellow satin. . . ."[1] An English visitor stated that at least 3,000 of the 5,000 objects on view could be dismissed without great injustice, for the Salon was a triumph of the conventional, "accomplished, orthodox and sincere in every way."[2]

Paris looked happy, though in the eyes of an English reporter its good humor may have been more apparent than real. The Third Republic proclaimed nearly twenty-five years earlier had been under heavy strain. Its fifth president, Jean Casimir-Périer, heir to a great name and fortune, had resigned on January 5. An astute politican, Félix Faure, was chosen by the parliament as his successor. Less than a month before, on December 19, 1894, an Alsatian Jew, Captain Alfred Dreyfus, had on flimsy evidence been found guilty of treason, publicly degraded, and sent to the Devil's Island penal colony. L'affaire Dreyfus would cause the many disparate intellectual groups in France to polarize into extremes of right and left.

Internal politics were of little concern to the journalists responsible for keeping readers abreast of social and cultural events in Paris, however; they went there to cover the Salons, both the old one in the Palais de l'Industrie on the Champs Elysées, and the new one in the Palais des Arts Libéraux, close to the Eiffel Tower, on the Champ-de-Mars, in Europe's most fashionable capital. Ever since the French Republic had abolished the Académie Royale des Beaux-Arts and opened the Salon to any artist willing to submit work to a French jury, foreign work had been included. In 1880, the government transferred its responsibilities for the

1. *Illustrated London News*, May 25, 1895, p. 650.
2. Ibid.

Salon to the Société des Artistes Français, though the Salon continued to be held in the Palais de l'Industrie. In 1890 the Société Nationale des Beaux-Arts had split off from the Société des Artistes Français and was permitted to hold a Salon of its own, juried by its own members in the Palais des Arts Libéraux, erected on the Champ-de-Mars for the 1889 exposition. The reporters thus had two exhibitions to review.

Of the New Salon, the correspondent for the *Illustrated London News* wrote:

> In the exhibition of the Société Nationale des Beaux Arts, known popularly as the "new Salon," as might be expected, we find the latest modes in art. . . . Here are scenes of unrest and experiment, of tentative efforts to obtain new natural effects and fresh schemes of colour, of adventure carried beyond the verge of eccentricity on the one hand and the capturing of new domains for art on the other. Here from the fresco to the poster, from a great ideal painting to a design for a fan or a menu-card, nothing is deemed beyond the scope of artistic achievement. . . . The more the visitor is acquainted with the technique of art and especially decorative design, the more subjects he will find that demand and repay careful study, for Paris is still the representative art center. The supremacy may pass, but yet the active movements in other countries have not succeeded in out-rivalling the old capital of the Arts. The Salon therefore is more than a mere picture-show; it is a table of statistics whence the progress or retrogression of art in many aspects may be traced. . . . It is a show worth a special trip to Paris, because it is a collection of genuine efforts to see beauty in individual ways, experiments in novel materials and methods. It is full of suggestions and might serve to illustrate an exhaustive monograph on the art of the last days of the nineteenth century at its best and perhaps, to be quite frank, also at its worst.[3]

The English journals that reviewed exhibitions under the heading "Pictures of the Year" divided those columns more or less equally between the London and the continental shows. After the establishment of the Grosvenor Gallery it became customary for critics to review the two May openings, at the Royal Academy and the Grosvenor, under the "Pictures of the Year" caption, or at least to couple the two together as was the practice in *The Athenaeum, The Academy,* and the *Fortnightly Review.* For the June 1895 number of the *Fortnightly Review* "The Royal Academy and the New Gallery" was written by Claude Phillips, an art and music critic whose work also appeared in the *Daily Telegraph* (a widely circulated newspaper founded by his uncle), and who in the following year would become keeper of the notable Wallace Art Collection. In July the "Pictures of the Year" was given over to the "The French Salon," written by Elizabeth Robins Pennell.

A Philadelphia Quaker and already a known writer, Mrs. Pennell had come to London as a correspondent for the American monthly, *The Century,* with her husband, the etcher Joseph Pennell. He worked to improve his technique under the tutelage of his compatriot, James McNeill Whistler. Mrs. Pennell was soon employed writing for the *Pall Mall Gazette* and other English papers. The Pennells

3. Ibid., June 8, 1895, p. 722.

had arrived in England when the work of the younger followers of the Pre-Raphaelites was being exhibited. Whistler had a printing press in the rue Notre Dame des Champs in Paris, and both Pennells were frequently there. From Paris, Joseph made occasional sketching trips to Spain and Italy. On one of these occasions he left Elizabeth behind to fulfill her assignment to review the 1895 Salon. She wrote to him,

> I'm getting on. Have had my two days at the Champs Elysées where there are fewer pictures than usual so that it is a little easier work. And tomorrow I am bound for the Champ de Mars. Paris is hot. . . . I was extravagant and had a good lunch in the Salon and then economized and went to Duval for dinner. But I hate the Duvals. Saturday I had sandwiches in the Salon and am going to dine here. . . .[4]

To keep him abreast of her interests, she wrote:

> Claude Lantier to whom I refer in one place is the hero in the last book of Zola's[5] I have read which deals entirely with art students and art life in Paris and which I would like you to read if I didn't know it would make you—as it has me—blue for a month. . . .

Probably under its influence, Elizabeth closed her review with a reference to Zola.

Roger Marx, who wrote the 1895 Salon review for the *Gazette des Beaux-Arts*,[6] was a significant figure in the Parisian art world who would later be assigned the task of assembling the centennial exhibition for the Paris 1900 exposition. He concluded his article with the following words:

> Thus, among the works of the painters and sculptors, only those stand out where art expresses mind and beauty; it is no different for prints and decorative works. . . . Not too long ago some held as dogma that "observation of the real is everything." Now the same people are beginning to use a different language. In confining themselves to the strict reproduction of materiality, they admit, "the systematic realists have gone so far as to deny expression." Does it require more than this admission to foresee agreement and to promise the creator a definitive, unanimously agreed-upon emancipation? The exaltation of the individual advocated from the start thus returns at the end of this study as an echo and a conclusion. May the artists obey freely the compulsion of their inner genius, without being troubled by arguments, without taking orders from anyone, and may they accomplish their creative work in peace."[7]

The next year, 1896, was the last Salon to be held in the Palais de l'Industrie on the Champs Elysées, and the Société des Artistes Français devoted special effort

4. Elizabeth Robins Pennell, bequest, Library of Congress, box 307. "Duval" refers to a chain of inexpensive restaurants.

5. Emile Zola's *L'Oeuvre* (The Masterpiece) was published in 1886.

6. Roger Marx, "Les Salons de 1895," *Gazette des Beaux-Arts,* ser. 3, vol. 13 (1895): 353–60; 14 (1896):15–32; 105–22.

7. Ibid., *Gazette des Beaux-Arts,* ser. 3, vol. 14 (August 1895):122.

to it. To arrange the 4,879 entries, of which 2,093 were paintings, 1,073 drawings and watercolors, 505 engravings, 794 sculpture, and 414 represented architecture and decorative arts, modifications in the usual organization had to be made. Two rooms of paintings were added to the drawings and watercolors on the balcony. Etchings and lithographs were moved into new rooms. But the sculpture was, as always, arranged in the winter garden on the ground level.

At the Champ-de-Mars, the New Salon had arranged 1,794 paintings and drawings, 137 engravings and architectural designs, 486 sculptures, and numerous objets d'art in the Palais des Beaux-Arts. Among the last were Jean-Charles Cazin's ceramics, Alexandre Charpentier's metalwork, and Louis Tiffany's stained glass windows.

That year the *Fortnightly Review* assigned the formidable task of covering both Salons to Claude Phillips. Elizabeth Pennell had found reviewing the Salons in 1895 a "melancholy task"; Phillips found it no less so in 1896:

> No other result than weariness and ennui can well be expected from the examination of two exhibitions, the one of which comprises five thousand paintings and works of art of all kinds; while the other shows, spread over a space wellnigh as wide, upwards of two thousand similar objets d'art. The most disquieting symptom, not in the Salons of 1896 alone, but in those of the two or three years which have gone before, is a distressing emptiness, seeking to hide itself in a dazzle of technical fire-works, and a beating about the bush, not only for artistic conceptions, but for artistic emotions. Are we to lay the blame on the exhausting treadmill routine of life—even of art life—in a great restless city like Paris, as leaving to the artist of less than commanding genius and originality, no freshness of sensation, no personal or distinctive view of life and art; as forcing him, unless he would fall altogether behind in the race for life and fame, to see through the eyes, or in many cases, through the discolored spectacles, of some other, who by either strength of personality or boundless audacity in paradox, may have won the favor of the press and the public?[8]

Perhaps for this reason, the novelist Paul Adam, writing a criticism of the Salon for the *Gazette des Beaux-Arts,* opened it not, as was customary, with a consideration of painting, but with sculpture. Adam began by recalling Donatello's *David*, in which "one sees the power of a free being, conscious of containing within himself his cause and his ending." This he contrasts with Michelangelo's *Pietà*, in which is expressed the "pain of reason faced with the absolute enigma of God, to which that same Mary, the human illusion, gives rise. Free action and suffering passivity determine the two destinies of art."[9]

Raymond Bouyer, whose writings, with other Symbolists', appeared in *La Plume*, reviewed the 1896 Salon for *L'Artiste.* "The first impression is one of déjà vu, mitigated at the Champs Elysées, where the status quo reigns with 'the unfortunate, either obstinately black or insipidly procelain-like;' it is more pointed at

8. Claude Phillips, *Fortnightly Review*, 1896, p. 123.
9. Paul Adam, *Gazette des Beaux-Arts,* ser. 3, vol. 15 (June 1896): 450.

the Champ-de-Mars, which is the refuge of whimsies officially termed either 'decadent' or 'exotic.' In both places the number has grown, but nonetheless a quick mental auto-da-fé would only spare a minority. . . ."[10]

Emile Zola also had a melancholy word to say about the Salon that year. By 1896 Zola was a very significant figure in European art and literary circles, his influence springing both from his early art criticism and from his popular novels. The last of the twenty volumes of his Rougon-Macquart family saga was published in 1893. Called *Dr. Pascal: Life and Heredity,* it was the story of a man much like Zola himself. Dr. Pascal—the name is meant to recall Blaise Pascal, the seventeenth-century philosopher, physicist, and mathematician—affirms that "the progress of reason by means of science, truths slowly and permanently accumulated, was the only worthy objective," and belief in "these truths, ever increasing, would end in conferring on man incalculable power and serenity, if not happiness." It was therefore distressing for Zola to see reliance on science and the Realism that resulted from it being abandoned in art and literature in favor of the "symbolist, occultist, and decadent schools." Science had not fulfilled its promises.

Early in 1896, Zola accepted an invitation from *Le Figaro* to contribute an occasional article under the heading "Nouvelle Campagne." His contribution for the following May was "The Salon of 1896: The Painting Section." He saw in the 1896 Salon the popularization of the point of view and practices he and the rest of the avant-garde had begun to champion thirty years earlier in the Salon review of 1866, and the results filled him with dismay. Although he made no direct mention of the work of the current avant-garde that could be seen in the small exhibitions held in publishers' offices or by adventuresome dealers, he did find delight in the "reawakening of art for fabrics, furniture, jewelry—not, alas, because a modern style has been created, but because we are truly in the process of returning to the exquisite taste of former times in our everyday objects." Echoing Dr. Pascal, Zola concludes his consideration of the Salon with the assertion, "Others will come by new ways; but those who determined the evolution of an epoch will remain above the ruins of their schools. And definitely only the creators triumph—the makers of men, the genius which gives birth, which creates life and truth."[11]

Symptomatic of the mounting interest and recognition of the decorative arts that Zola expressed in his closing paragraph was the assigning of Emile Gallé, one of France's foremost artists, to supply a text for the illustrations of objets d'art on view in 1897 at the Salons in both Brussels and Paris for the *Gazette des Beaux-Arts.* Gallé had begun his training in the workshop of his father, a designer, manufacturer, and decorator of fine crystal and ceramics in Nancy. In 1862 he went to study in Weimar and Meissen and then returned to rejoin his father's

10. Raymond Bouyer, "L'Art aux Salons de 1896," *L'Artiste,* March 1896, p. 327. He quotes from the *Journal des Goncourts* 9 (June 12, 1894).

11. Emile Zola, "Salon of 1896: Peinture" *Le Figaro,* May 2. Reprinted in F. W. J. Hemmings and R. J. Niess, eds., *Emile Zola, "Salons" (Société de Publications Romanes et Françaises 63)* (Geneva, 1959), p. 270.

manufactory (where in the meantime furniture had been added to their line of products) after the outbreak of the Franco-Prussian War in 1870. For the 1889 centennial exposition Gallé, by an inspired use of his medium, glass, created masterpieces of form and color equal to those created in stone, bronze, paint, and canvas. The success of his work and his firm's pavilion did much to secure recognition and acceptance for decorative objects as an art form equivalent in aesthetic value to a picture or a statue. Gallé used verse to explain the forms he made, thereby linking his creations to Symbolism. By accenting or exaggerating the rhythmic motion found in the forms he selected for his objects, he made them dynamic. Supreme in the medium of glass, Gallé's atelier also designed, manufactured, and sold faience and furniture, in which they revived the art of marquetry, or inlaid work. Given the opportunity by a prestigious fine arts magazine, and with the assurance of genius, Gallé used his article first to challenge the Salon classification system and the inconsistencies that regulated the admission of an artist's work to it. Then, before directing attention to some of the objects displayed at the Salons, he raised a timely question, "What then do you love in the things of art?"

Pictures of the Year. No. II: The French Salons

ELIZABETH ROBINS PENNELL

It is amusing to find that the French critic suddenly begins to resent the prevalence of foreigners at the two Salons. What is to come, he is asking, of this *tohu-bohu étranger*, this invasion of the outer barbarian? Is it sensible to give the prefix *Nationale* to a Société des Beaux-Arts that fills the Champ de Mars with the work of Americans and Scandinavians, of Britons, and even hated Germans? Are French artists, as reward for their record of generosity, to be thrust into the background of their own hospitable galleries?

That this year the work of foreigners does abound in both old and new Salons is true enough. In the one you may see, among painters, Mr. Orchardson and Mr. MacEwen dividing chief honours, while the State has been in all haste to secure a canvas by Mr. Brangwyn, though, of course, with the populace, M. Detaille's equestrian portrait of the Prince of Wales is the one picture of the year; you may see, among sculptors, Mr. Duveneck, in a first effort, disputing distinction with the Falguières and Merciés; among engravers, Mr. Cole and Mr. Wolf challenging the Baudes and Léveillés in close competition for supremacy. In the other Salon you must note Mr. Guthrie, Mr. Lavery, and Mr. Walton, Klinger, Uhde, and Liebermann, Gandara, Alexander, and Zorn, among the most prominent exhibitors; and more than this, the infatuation for the stranger at the gates has gone so far that a separate gallery has been set apart for the drawings and pictures of Mr. La Farge, the distinguished American designer of stained glass, whose present work, however, would seem insignificant in a Bond Street "one-man" show. But, substitute the names of other artists, and the facts were virtually the same last year

and the year before, and for that matter, since there have been picture shows and art schools in Paris. In the French capital Constable and Bonington made their reputation, Fortuny and Vierge gained their laurels, Mr. Whistler first received recognition.

And, indeed, if this had not been so, the Salons would have rejoiced in no greater distinction than the annual exhibitions in other less liberal lands. It is to the foreigner they owe their fame among nations, so that it is not merely unreasonable, but ungrateful, for the critic now to grow restive under the foreign yoke. While in London the Royal Academy has continued as insular in its policy as its patrons in their taste; while Berlin and Vienna only at intervals have invited artists of every nationality to make a showing within their walls; while even Munich is but a temporary asylum for the successful canvases that have already started on their tour around the Continent; Paris has secured the great international monopoly, and in it found inexhaustible source of artistic revenue. Take the foreigner away, and the Salons would be shorn of their chief glory, their chief interest; Paris would cease to be the capital of the art world. Further, it might occur to resentful critics that the barbarian can be, and has been, turned to profit as a font of inspiration. Certain Frenchmen, when their imagination has failed them, have not hesitated to borrow from him in the past; but for Uhde and Liebermann would Jean Béraud's Magdalen ever have been painted? But for the English Pre-Raphaelites, would Rosicrucianism have served as a new game to play for a season? The stream of French invention may again run dry; and if it does, surely it will prove as useful to have a genius, even though he be but a foreigner, at hand.

However, as likely as not, the first rumours of discontent are taken all too seriously. For the last few years, to be accurate since the appearance of that very Magdalen by M. Béraud, the Salons have refrained from supplying the element of sensationalism, which is as indispensable to journalist in search of good copy as to exhibitor bidding for notoriety. The critic, rather than do without a sensation, must needs invent one for himself. And this is no longer easy. As subject for criticism contemporary methods and motives have been worn quite threadbare. Realism and impressionism have been first laughed to derision, and then praised to satiety. Mysticism has received its tribute of wonder; the New Testament, on modern canvas, been burdened with more than its own share of discussion; the *Pointillistes* have furnished theme for the fantastic writer, until, in making Mr. Watts their leader, he has outdone even his own ingenuity; the *plein-airistes* have bewildered the philosophic student, until he also has surpassed himself by finding for the crimson horses of M. Besnard[1] legitimate ancestors in the red sheep of Mr. Holman Hunt, who, probably, would be the first to disclaim the progeny. All that can be, has been said. But the brand-new movement still persists in not being inaugurated, the brand-new genius still remains obstinately in obscurity; who can marvel, then, if the critic, at his wit's ends for a novelty, has devised the "conquest of Paris" by foreign artists, as a peg upon which to hang an article, an argument, or a paragraph? He is really so little in earnest that, just at the moment the first murmurs of opposition are heard from the press, French publishers are busy

issuing one book after another to explain that it is in England the most vital and original expressions of modern art are to be found; that is to say, French critics, or writers upon art, are themselves claiming for at least one foreigner the very pre-eminence which they would deny to all in the Salons. For novelty's sake space on exhibition walls may be grudged to Sir Edward Burne-Jones and his fellow countrymen; for the same novelty's sake, English art—which to the Frenchman means the Pre-Raphaelitism he has so lately discovered—must be held up to public worship; the result is a contradiction that might confuse were much importance attached to it. Unfortunately, nowadays, art is neglected for the passing fad; and each spring's exhibitions are counted upon to create the new fashion in paint, with the same ease with which Worth produces the new gown, Poole the new coat. Once, when Corot painted and Millet, a man's greatest work was done before he was exploited; now it is "the latest thing" in geniuses that is hailed by the *feuille-toniste* as hero of the hour.

The fact is, the Salons themselves are entirely responsible for the vagaries of the critic. The inevitable outcome of the long succession of annual exhibitions has been to set greater value upon the exaggerated and extravagant in art than upon the beautiful; a truth which by constant repetition has degenerated into a commonplace. In the end it grows wearisome to protest against the flamboyant vulgarity of the Paris shows; even as here the laugh at academic babies and mustard-pots long since began to pall. The voice of M. Arséne Alexandre, as of one crying in the wilderness, has been raised in urgent plea, that, another year, *réclame* should go to the small canvas of genuine artistic merit, and thus once more make art, rather than fatal facility and ambitious problems, the standard. But his plea is scarce more youthful than the evil it would remedy. It is more sensible to accept the Salons for what they are, offering no vain scheme of reform; to face the acres of painted canvas with equanimity as an essential, if unfortunate, part of the spectacle, to feel all the more pleasure in the occasional picture that is, or seems, a masterpiece by force of contrast. If among so many painters one artist be found, why should there not be as much rejoicing as in the discovery of one poet among the multitude of rhymers? If the year's rhymes, like the year's paintings, could be hung side by side in an exhibition, the display would be scarce less dismal than the present collection at the Champs Elysées. The mistake is to expect each spring to work the miracle and to turn all our geese to swans.

The new Salon perseveres in proving the more interesting of the two; it still attracts the most distinguished artists, the most daring experimentalists. This year it loses by the absence of Mr. Whistler; there is nothing to take the place of his "Comte Montesquieu"; though the Glasgow portrait painters—Mr. Lavery, Mr. Guthrie, and Mr. Walton—have never shown to such advantage in Paris, though M. Gandara does his best to surpass his last year's success in a painting of the same marvellous white satin gown, now worn for the occasion by Madame Sara Bernhardt. M. Jean Béraud, whose *gaîté française* is to the Salon what Mr. Dicksee's sentiment is to the Academy, is also absent; and so are M. Raffaëlli, M. Sargent, M. Boldini, with whose accustomed contributions the exhibition can less

well afford to dispense. But Mr. Alfred Stevens still delights with his beautiful little portraits, his exquisite marines, rich gems of colour in a setting of commonplace that arrest and refresh the jaded eye at a glance. M. Cazin is still to the fore with a series of his serene, stately landscapes, their perfect serenity a reproach to the restlessness of the Eliots and Dauphins, while M. Sisley's sunshine, M. Montenard's Provençal glare, even M. Besnard's southern colour and light seem crude and flaring by comparison. And M. Aman-Jean still impresses by the refinement of his portraits and by the lovely decorative schemes of which he makes each the motive; their quiet harmony all but a rebuke to the obvious cleverness of Mr. Alexander, whose affectation, especially in a portrait of a woman in a tempestuous swirl of blue skirts, just now threatens to send him well over the verge of eccentricity. Here are pictures enough to redeem a far worse collection from mediocrity.

But the Champ de Mars would be notable, if for nothing else, for the return of M. Carrière. To me, his *"Théâtre Populaire"* is quite the most interesting picture the exhibitions of Paris, or London either, can present as excuse for their existence. But I think its interest depends, not so much upon its own fine qualities as upon the explanation it seems to offer for the failure of so much of the year's work. M. Carrière has chosen for his subject the theatre's audience, and not the stage; the drama for him has been not in the spectacle, but in the spectators, and the result he obtains justifies the preference. He shows the great swing made by the two tiers, one above the other; and the long curves, in their repetition, make an effective pattern on the canvas. Eager attention and strong emotion are expressed in the faces and attitudes of the men and women who lean far over the balcony, or have risen to their feet in the tenseness, the breathlessness of their expectation. And yet, with all the human feeling suggested, there is not one figure whose pose, whose action is not subordinated to the decorative needs of the composition. The light, the dust, the thick atmosphere of the theatre are rendered realistically, but only to fill the distance with strange shadows, with that mystery or evasiveness which is felt to be a charm in so many of the world's great pictures. The design has its faults. I cannot understand why it should be so sober and restrained in colour; or it may be my misfortune that I cannot see the interior of a theatre all blacks and silvery greys. Nor can I help thinking that the space in the right-hand corner, which is essential to balance the composition, is so shadowy, so very vague as to tend to mere emptiness or worse; or again it may be that I am not sensitive enough to the more refined subtleties of tone. But, whatever its faults, as a whole the *"Théâtre Populaire"* has something of that completeness, that repose which is indispensable to all great art; that certain indefinable quality which is stamped upon the Elgin marbles as upon the Infantas of Velasquez, upon the frank naturalism of Frans Hals as upon the romantic idyls of Corot. And it is just here that so many of the most accomplished paintings in the Champ de Mars are found wanting. There are painters innumerable—take the Norwegians Thaulow and Kroyer, for instance—who can seize upon those effects in nature which are most elusive, most difficult—the play of strong sunlight upon snow, the whirling,

eddying waters of a mill race—and transport them to canvas with a truth, a fidelity that is simply marvellous. But it is nature herself they give, not art. There are others as many—Besnard chief among them—who have been wrestling with problems from which the old men would have shrunk affrighted; and yet too often their success cannot carry them beyond the experimental, the tentative. Perhaps it is in the large canvasses that this "little less" is realised most keenly. You may turn to the "Joies de la Vie," by M. Roll, with its quite masterly studies of the nude and its well-observed foliage in summer sunlight; or to M. Lhermitte's "Les Halles," [fig. 116] which is really so extraordinary in its vigorous realism that you wonder why the crowd, just as it is thrown together pell-mell in the market-place, should have been thought a decoration for the walls of the Hôtel de Ville; or to Max Klinger's *"Jugement de Paris,"* with its absolutely individual treatment—interesting if brutal—of so hackneyed a theme. And yet in all three you cannot but miss the composition, the arrangement, the art that improves upon nature, even while adhering most closely to her: in a word, the poetry of paint which you feel instinctively in Carrière's monochrome, despite its severe reticence, its stern colour scheme.

I have said nothing of M. Puvis de Chavannes' large decorative panel which he calls *"Les Muses Inspiratrices acclament le Génie, messager de lumière,"* [fig. 117] because it is hardly possible to judge it fairly in its present position in the Champ de Mars. It is destined to adorn the Boston library, for which Mr. Sargent and Mr. Abbey have already produced the series of decorations shown in London within the twelvemonth.[. . .]

Draughtsman and wood engraver, lithographer and etcher will discover much at the new *Salon* to engross them. For it is not sufficient that the black-and-white man should do original work for him to be banished from the Champ de Mars, as is sure to happen at the Royal Academy. On the contrary, the more individual he shows himself, the more personal the note he strikes, the more certain he is to be greeted with respect and awarded the prominence he deserves. The prints are, on the whole, more satisfactory than the drawings; probably because so many illustrators, like M. Valloton and M. Jeanniot, for example, have of late turned their attention to lithography and wood engraving, and so the print actually gives their original work.[. . .] I noted with pleasure, however, that Max Klinger is now included among the etchers who exhibit. The brutality that, at times, may offend in his paintings never makes its way into his plates, and in designs like his "Dance" and his "Prometheus," there is all the rhythm of line, all the harmony of composition that his "Judgment of Paris" fails to present, and all the mysticism, if you will, in which a certain group of Germans excelled before Sâr Peladon made it the fashion in Paris. It is in this department, however, that the split in the ranks of French artists is most to be regretted. The lithographs of Dillon, Fantin and Willette, the wood engravings of Baude and Léveillé should be brought from the Champs Elysées to make the representative series at the Champ de Mars quite complete.

But the Committee at this Salon shows an unwise disposition to extend

otherwise the limits and scope of their exhibition. That they include a larger number of examples of decorative art would be only as it should, if these were more often as well worth the space reserved for them as the pottery of M. Cazin, work done some twenty years ago in London; the metal work of M. Charpentier, and the jewel-like stained glass of Mr. Lewis [Louis] Tiffany; the mistake is rather in the tendency to include several small, separate shows within the one large exhibition. Last year, for M. Tissot's drawings illustrating the "Life of Christ," a gallery was reserved. Now, not only do M. La Farge's indifferent drawings meet with similar favour, but another room has been spared for the very uninteresting series of illustrations by M. Dubufe—an arrangement that savours of the publisher's advertisement; and still a third for the life's work of the sculptor, Carriès.[2] In this last case, the actual choice calls for no criticism. Carriès, though he died at so early an age, had already achieved, and justly, an enviable reputation, and his busts and grotesques and pottery distinctly deserve to be thus collected together to form an exhibition. But another time and place would have served the purpose as well. Here they distract attention from the sculptors whose privilege it is to show only a year's, not a life's, work. This statement, however, must be modified when it comes to M. Bartholomé, since some time has passed since he began the tomb which is making such a talk in Paris studios, many of its single figures and certain sections having already been seen at the Champ de Mars. Now the monument is finished, and in its solemnity, its simple grandeur, it overshadows all the sculptures in the court, if I except the work of M. Rodin. The desire to accomplish in marble that which should be expressed only through the medium of paint is strengthening in the French sculptor, and as a consequence, his work seems as experimental, as restless, as theatrical, as the painter's canvas. But M. Bartholomé has treated his subject with the appropriate restraint; in the open frontal of the tomb stand two figures, a man and a woman, and on either side others crouch or lie prostrate, against the plain surface of the unadorned wall; in the emotion revealed, the grief, the despair, there may be little that is classic in feeling, but there is still the repose and dignity of attitude and gesture that belong to the fine sculpture of all time.[3] I am not sure, however, that to the beauty of its several groups, the effect of the whole design has not been somewhat sacrificed. I think there is even a finer sense of grandeur and bigness in the far less elaborate, and really less scholarly, tomb shown by Mr. Duveneck in the Champs Elysées. His inspiration clearly has been found in the Italian Renaissance; above the simple base, as in so many an Italian monument, the figure of a dead woman lies outstretched, her head upon a low cushion; her face is beautiful with the sweet serenity of death, a great palm-leaf rests lightly upon the drapery that partly follows, partly disguises the modelling of the form beneath; and this is all. But not the biggest and most theatrical of the many Joans of Arc that now appear at the opportune moment for notoriety, can destroy the impression of that simple, quiet figure of a woman at rest. M. Dubois' "Joan of Arc," however, must be excepted from the above generalisation. It, and M. MacMonnies' little Shakespeare, and M. Falguière's *bas-reliefs* are among the other sculptures to be noted.

Had I left myself space, I doubt if I should have devoted it to the paintings of the Champs Elysées. In the end, it becomes intolerable to repeat the same unpleasant truths spring after spring. Banality and commonplace—this is what you expect at the old Salon, and, moreover, what is provided for you without stint. You know beforehand that the monotony of mediocrity will be broken by the romantic landscapes of Pointelin, the conventional stateliness of Harpignies and Français, the decorative fancies of Fantin-Latour; you know that other exceptions will come from foreigners, who this year are Mr. MacEwen and Mr. Orchardson, with his "Madame de Récamier," Mr. Brangwyn and Mr. Austen Brown; you know that the colossal canvases, in their blatant ugliness, will irritate the more because most have been designed for definite ends and, therefore, the painter has had less excuse than if he had been working solely for an ephemeral Salon success. There is no more melancholy duty than the visit to the Champs Elysées. For everywhere you are confronted with an amazing ability, with the signs of technical training which the Academy walls could never boast, and it is the frightful waste of talent and industry, the utter uselessness of it all that depresses. M. Zola misunderstood the true tragedy of modern art—I should say modern painting— when he wrote *L'Œuvre*.

I confess I came away this year feeling that the fault must be mine; mine the failure in not detecting good work, or at all events loveliness in intention, if not in absolute accomplishment. It may be so. And yet I had not been back in London a week before, upon the walls of Christie's auction rooms, I had seen and recognised the beauty for which I had searched in vain at the Salon. There were pictures by the very men whom the French critic is busy discovering with so much joy— Ford Madox Brown, Rossetti, Burne-Jones—but of whose work he knows so little. And there, too, was a small—a very small—landscape by another Englishman, of whom French critics have yet to hear; though men had not begun to bother about values and tones, about *pleinairisme* and *vibrisme* and the rest, when Cotman[4] painted this quiet pool, shut in by green trees, with the one glimpse of a misty blue distance; and, in painting it, made a beautiful picture. It seemed to lend a clue to my own disappointment, to impress upon me more forcibly than ever the truth that should be blazoned in letters of gold on Champs-Elysées doors; for the many may, if they choose, cover canvas with paint, but to the few only is it given to create the perfect picture, the perfect poem.

From Elizabeth Robins Pennell, "Pictures of the Year. No. II: The French Salons," *Fortnightly Review*, 1895, pp. 45–52.

1. The reference is perhaps to F. A. Besnard's etching *Marché aux chevaux;* see the *Gazette des Beaux-Arts*, ser. 3, vol. 14 (1895):14.

2. Jean Carriès (1855–94). A gallery was reserved for his work.

3. *The Monument to the Dead* by Albert Bartholomé (1848–1928) is in the Père-Lachaise cemetery.

4. John S. Cotman (1782–1842), co-founder with John Crome (1768–1821) of the Norwich school of landscape painting.

The Salon of 1896: The Painting Section

EMILE ZOLA

Each year for the last quarter century I have overheard the same phrases spoken upon leaving the painting Salon: "Well, and this Salon?—Oh, the same as always!—Like last year's, then?—Lord, yes! Like last year and the years before." It would seem that the Salons have been unchangeable in their mediocrity and that they repeat themselves with such endless uniformity that it is not necessary to visit them in order to know what they contain.

This is a profound error. The truth of the matter is that their uninterrupted evolution has been so slow that it is difficult to notice. From year to year the changes are imperceptible, so natural do the transitions seem. [. . .]

But great heavens, what astonishment if one could call up with the wave of a magic wand the Salon of thirty years ago and set it next to the two Salons of today. How obvious it would be that Salons are not always the same, that they follow, but do not resemble, each other, that on the contrary nothing has evolved more profoundly than painting in the later part of this century, fired by an estimable fever for research and also, it must be admitted, by fashion. [. . .]

Pretend if you will that I have slept for thirty years. Yesterday I was still pounding the rough pavements of Paris with *Cézanne,* consumed by the desire to conquer it. Yesterday, I attended the Salon of 1866 with *Manet, Monet, and Pissarro,* whose pictures had been rudely refused. And now after a long night I awaken and go to the Salons of the Champ de Mars and the *Palais de l'Industrie.* O astonishment! O the always unexpected and the shattering miracle of life! O harvest, whose sowing I witnessed and which astonishes me as though it were the most unforeseen extravaganza!

The first thing that seizes my attention is the predominating note of lightness. [The Salon] could be all Manets, Monets, Pissarros! Formerly when one of their canvases was hung in a hall, it was like a ray of light among the other canvases concocted from the overbaked colors of the Academy. It was a window open on nature. The famous open air had entered. And behold, today there is nothing but open air; all follow in my friends' footsteps after having called them names and called me names as well. Well, so much the better. Conversions are always pleasant.

But what redoubles my astonishment is the converts' fervor, the abuse of light tonality which makes certain works look like rags bleached from too much washing. New religions, when they catch fashion's fancy, are horrifying in that they exceed all good sense, and faced with this bleached-out, whitewashed Salon of a disagreeable chalky paleness, I almost begin to miss the black bituminous Salon of olden times. It was too black, but this one is too white. Life is more varied, warmer, and more subtle. And I, who battled so violently for open air, light tonalities, find that this continual file of bloodless painting as pale as a

dream, of a premeditated anemia, aggravated by fashion, exasperates me bit by bit and makes me wish for an artist of roughness and shadows!

It is the same with the *tâche!* O Lord, how many lances have I broken for the triumph of the *tâche!* I praised Manet and I praise him still for having simplified procedures in painting objects and people in the atmosphere in which they are bathed, the way they act there, often simple *tâches* which the light devours. But could I foresee the frightening abuse that would be made of the *tâche* when the very accurate theory of the artist had triumphed? In the Salon there are no longer anything but *tâches*, a portrait is no longer anything more than a *tâche*, figures are nothing more than *tâches,* nothing but *tâches,* trees, houses, continents, and oceans. Here black reappears; a *tâche* is black when it is not white. One goes without transition from the entries of one painter's five or six canvases, which are simply a juxtaposition of white *tâches,* to the entries of another painter's five or six canvases, which are a juxtaposition of black *tâches.* Black on black, white on white, this is originality! Nothing easier, and my consternation grows.

But where my surprise turns to anger is when I see what madness the theory of reflection has given rise to over the past thirty years. Yet another of the victories we, the precursors, won. Quite correctly we maintain that the lighting of objects and figures is not simple, that underneath trees, for example, flesh takes on a greenish tone, that there is a continual exchange of reflections which must be taken into account if one wishes to give a work true living light. This fragments, breaks, and scatters itself incessantly. If one does not restrict oneself to academic subjects painted in the predetermined light of the studio, if one accosts immense, changeable nature, light becomes the soul of the work infinitely diversified. Only nothing is more delicate to seize and render than this refraction and these reflections, those plays of light which bathe without deforming objects and creatures. As soon as one insists, as soon as one starts to reason, one passes very quickly to caricature. And these are really disconcerting works, these multicolored women, these violet landscapes and orange horses, that are offered us with the scientific explanation that they are this way as a consequence of these reflections or that refraction of the solar spectrum. O the ladies with one blue cheek in the moonlight and the other vermilion in the light of a lampshade! O those horizons in which the trees are blue, the waters red, and the sky green! It is frightful, frightful, frightful!

I believe Monet and Pissarro were the first to study deliciously those reflections and that refraction of light. But with what refinement and with what art they did it. It then became the fashion, and I tremble with horror [at the result]! Where am I? In one of those old Salons des Refusés which the charitable heart of Napoleon III opened to painting's rebels and wanderers? It is very certain that fewer than half of these canvases would have entered the official Salon.

There is also a lamentable overflow of mysticism. Here I believe the culpable one to be that truly great and pure artist, *Puvis de Chavannes.* His progeny are a disaster, perhaps even more of a disaster than those of Manet and Monet and Pissarro.

He knows what he wants to do and how to do it. Nothing has a more distinct strength or health than his elongated, simplified figures. Perhaps they do not live our everyday life, [but] they do not live any less because of this; [they live] a life of their own, logical and complete, obeying laws imposed by the artist. I mean to say that they have their being in that world of immortal, artistic creation shaped by reason, passion, and willpower.

But O good Lord, his followers! What barely formed stutters, what a chaos of disagreeable pretensions! English aestheticism came and unsettled our firm, rational French genius. All sorts of influences, too long to analyze here, joined forces to toss our school into the defiance of nature, this hatred of flesh and sunlight, this return to the ecstasy of the primitives; and yet these primitives are guileless, very sincere imitators, while we are dealing with a fashion, with a whole troop of clever fakers and counterfeiters, avid for fame. The faith is missing, only an impotent and clever herd remains.

I know what may be said in their defense, and the movement I will call "idealist," simply to give it a label, had its raison d'être in a natural protest against the triumphant realism of the preceding period. It has manifested itself also in literature. It is a result of the law of evolution, where every over-vigorous action calls forth a reaction. That young artists find it necessary not to become immobilized in existing formulas must be admitted; [they see a] necessity to seek the novel, even the extravagant.

And I would be far from asserting that there have not been curious attempts, interesting discoveries, in this return to dream and legend, to the whole delicious flora of our ancient missals and stained-glass windows. From the point of view of the decorative arts above all, I am delighted by this reawakening of art for fabrics, furniture, jewelry—not, alas, because a modern style has been created, but because we are truly in the process of returning to the exquisite taste of former times in our everyday objects.

Only please, no painting of souls; nothing is as displeasing as the painting of ideas. That an artist places a thought in a head, yes, but let the head be there and surely painted and of a construction to outlast the centuries. Only life speaks of life, only living nature exhales beauty and truth. In an art as material as painting, I defy anyone to leave an immortal figure if it is not humanly drawn and painted, as simplified as you want, but keeping the logic of its anatomy and the healthy proportions of its form. What a frightful parade we have been spectators of for some time now, those asexual virgins having neither breasts nor thighs, those girls who are almost boys, those boys who are almost girls, those larvalike creatures winging through livid spaces, moving in vague countries of gray dawns and sooty twilights. O the nasty world, it becomes disgusting and nauseating!

Happily, I believe that this masquerade is beginning to disgust everyone, and it seems to me that the present Salon contained far fewer of these fetid lilies sprung from the marshes of false contemporary mysticism.

Here, therefore, is the summary of these last thirty years. Puvis de Chavannes grew in his solitary effort of artistic purity. Next to him, twenty artists of great

merit could be cited: *Alfred Stevens,* who also gained mastery by his fine and accurate sincerity; *Detaille,* whose precision and simplicity are admirable; the vastly ambitious Roll, the sunny painter of crowds and spaces. I name these, I should name others, for perhaps never have more meritorious attempts been made in every direction. But it must be admitted that no great new painter has revealed himself, no *Ingres,* no *Delacroix,* no *Courbet.*

Those light-colored paintings, those open windows of impressionism—but I know them, they are the Manets for which in my youth I risked a beating! Those studies of reflection, that flesh over which passes the green tones of foliage, those waters in which all the colors of the prism dance—I know them, they are the Monets I defended and for which I was treated as a madman! Those refractions of light, those horizons in which the trees become blue while the sky turns green, I know them, they are the Pissarros which had me barred from the newspapers because I dared to say that such effects could be found in nature!

And there are the canvases which were formerly violently refused at every Salon, exaggerated today, become frightful and innumerable! The seeds I saw put in the earth have grown and have borne a monstrous fruit. I recoil with fright. Never have I better realized the danger of formulas, the pitiable end of academies, of schools, when the initiators have done their work and the masses have departed. Every movement becomes exaggerated, turns to set procedures and lies, as soon as fashion takes it up. There is no truth, however good and just in the beginning, for which one would heroically give one's blood, that does not become imitation, the worst of errors, invading tares which must be mowed down without pity.

I wake and I shiver. Did I really go to battle for that? For that light painting, for those *tâches,* for those reflections, that refraction of light? Good Lord! Was I mad? But it is ugly! I detest it! O the vanity of discussions, the uselessness of formulas and schools! I left the two Salons this year asking myself with anguish if my former work had been evil.

No, I did my duty. I fought the good fight. I was twenty-six; I was with the young and the brave. What I defended I would still defend, because it was the audacity of the hour, the flag that must be planted on enemy soil. We were right, because we were the enthusiasts and the faithful. What little we accomplished of truth is today safely gained. And if the path we opened has become commonplace, it is because we widened it so that the art of a moment might pass through.

And the masters remain. Others will come by new ways; but those who determined the evolution of an epoch will remain above the ruins of their schools. And definitely only the creators triumph—the makers of men, the genius which gives birth, which creates life and truth.

Translated from Emile Zola, "Salon de 1896: Peinture," *Le Figaro,* May 2, 1896, as reprinted in Hemmings and Niess, *Emile Zola, "Salons,"* pp. 265–70.

The Salons of 1897: Objets d'Art
EMILE GALLÉ

> Why won't you also take a place
> among those who console us?
>
> —DIDEROT, *Salon of 1765*

The *Gazette des Beaux-Arts* wishes a text to accompany the illustrations of the objets d'art shown in the Salons of 1897.

Should I look for a dispute over words about the term *objets d'art* to break down your polished portals, my dear Director? Are those portals not open to all art? We are in agreement: you assured me that at your gallery there are no categories in art, that art recognizes only one class of works—good ones. We agree that among the several crafts, different methods of realization and expression—sculpture, architecture, painting, jewelry, pottery, cabinetmaking, engraving, hard or soft materials—none is excluded from divine creativity. All crafts in art, not only glassmaking, are gentlemanly.

Doubtless for a long time the doctrinaire narrowness and the administrative routine of the last three centuries will still continue to insist on regimenting and compartmentalizing us and Calvinistically to predestine one craft to win the palm—always to create the *works of art*—and the other never to produce anything but *objects*. Surely for the modern aesthete the uselessness of a work is no longer a criterion for art. But for how many warped spirits is the French legislation of 1806 still viable doctrine, lingering as it does to see to it that useful service graciously provided to mankind by a work of art is a reason for its devaluation, depreciation, and incompatibility with artistic and creative supremacy, with the privileges of the artist: with the intellectual essence and inheritance! It must be understood that French law is not kind to the objet d'art. For the law, for the administration, the objet d'art is nothing but "art *applied* to industry"—good or bad, caress, slap in the face, "application." The objet d'art is the child of the slave, ruled by lower justice or favor; it is the child of sin, not worthy of golden wrappings, of the robe of beauty and poetry. The shield of Achilles of which Homer sang, a tool, a lesser art; the heel of Achilles: great art, intellectuality!

The French sculptor may lynch on the boulevard the counterfeiter of his statue. The forger has no recourse. But the French sculptor of the caryatid would learn at his expense that the ownership of his objet d'art is under the jurisdiction of the Prud'hommesque, which is called the "legislation of the Prud'hommes."[1] So that the rights of Michelangelo are not the rights of Cellini. Rodin has the right of life and death over the counterfeiting of his works. It will be totally denied to M. Lalique over the forgery of his delicate creations. This has to be said.

For such is nearly always the doctrine of the so-called Salons of "the Fine Arts." There are no "fine arts" that are not framed on the walls or exhibited in a public place. Basically, perhaps it is only a *phobia* the organizers have against fragile and encumbering glass cases. At the international exposition in Brussels

this year there is a violent reaction against the intrusion of decorative objects into the Salon. At the most, three or four timorous admissions of the useful: a "candelabrum of the State Botanical Gardens," a shield by Hugh Armstead, a cup by Bartholdi, a vase by Etienne Leroux, some Sèvres vases. Therefore it can be stated unequivocally that a systematic exclusion of the Beautiful married to the Useful exists in the Fine Arts in Brussels. [. . .]

Another country, another criterion: at the customs house beyond the Rhine, a statue is not an Olympian work of art exempt from duty until after it is measured. A millimeter less than the standard, it drops to the status of an object: paperweights, a trinket subject to ordinary taxes. For example, the group *Victor Hugo,* by Rodin, 2 meters, *a work of art,* pass free. The *Muse of Hugo,* 1 meter 25 centemeters, luxury object, pay. This enormous simplification is not without its grandeur. It is to be recommended to the legislative rule-making dispensaries, not only those of this "dear country," but to those countries entangled in distinguishing between the Useful and the Trifling at the entrance to courts of justice and the Salons.

That is not all. A tenet generally prevails that the quality of the substance is the basis for classifying glyptics, the art of stonecutting. Engraving on stones: precious, hard, even ordinary stones—work of art! *Worthy to enter* into the International Salon of the Fine Arts at Brussels in 1897 and into the one in Paris in 1900. Stonecutting on soft materials, amber, crystal, glass paste, shells, plastic on metal and pliable substances, tin, wax, wood? You will not enter the International Salon of the Fine Arts at Brussels. Such are the specifications without exception due to favoritism which proves the rule.[2]

Here is the academic criterion; here is the official aesthetic of the day; *the density of the material!* The piece which is presented, is it a *work of art* or an *object?* Is it hard, or is it not hard? "Ask the question of the day!"

[. . .] At the Brussels Salon of Fine Arts, admission of a work to "Section II: sculpture, medals, cameos, engraved stones" was, according to the regulations, suspended pending *the appraisal of the lapidary.* The jury's decision, first and foremost, *depended on the density of the material.* Cameo, cornelian, glass, or shell. Engraved stone: quartz or paste. The judgment was removed from perception and left to the assaying tools. The archetypical cameo vase, the "Portland Vase" of the British Museum, would have been eliminated first because of its tender, nonprecious material and then because it was a vase: *non erat hic locus.* [. . .]

Let us not tire of saying over and over again that there are no castes among the artisans of art, that there are no mean and plebeian arts, servile arts and liberal arts, and finally, that the "Salon of the Fine Arts" in 1900 will be wherever there is an artist who has produced a work of genius and humanity. Whatever we do, the principle of the unity of art is irrevocably consecrated. Let us find a space here for the reproduction of a too-small number of the masterpieces of decorative arts and furniture in our Salons, [where we are] regretfully limited to a few especially striking examples among so many instructive pieces.

II. [...] What is it we love in things of Art? The palette that was used by the alchemist Turner, piously exhibited in the British Museum just as he left it one day, with his streaming enamels, his unparalleled mess of jewel tones, his lava flow of melted gems? Or else beyond the craftsman's savory stew, the vibration of your soul communicated to ours through the life of your works, intimately poignant. O poet Turner? [...]

But again French art, if I question it, in what language will it respond? That of China, and less well? That of Great Britain? That of sixteenth-century Italians? O again the frank dialect of the *huchiers*, of the imagers of "*la belle France*"? Let rather each age have its prattle, each season its song, each race its cry. The Germans sensibly say: "Let us speak as our beak grows." To each his own beak: crows croak; nightingales trill. Workers of France from wherever, persuade as we can.

Rich or poor craft, what does it matter? say I. First of all, do not, as Ruskin did, require impeccable execution. Do not allow dry, cold technique to rebut the infants of art. Brotherly, dogmatic, contradictory Ruskin! How much more the trembling hand touches me, the craft, its first ingenuousness, such as you wished in a burst of love to reestablish in your land, as if the century could be made to move backward! [...]

As for that other Ruskinian dogma, the inalterability of the material, which is concerned with his demands for a perfect work, a dogma which forgets the charm that is attached to things mortal, it is almost identical to the formula of our administrative doctrinarians in its distinction between the hard and the soft. Permanence, a prerequisite of art! The vanity of a worker more fragile than his vase. Of all the materials of which a work can be made, of all the natural or artificial compounds, are any of them proof against decomposition? Granite statuary is in the length of time as ephemeral a work as snow sculpture. The divine museum of art that is our globe will be closed. Generations of roses have bloomed. The genus rose, its species, and its varieties, even the family *rosaceae,* will disappear in their turn. The most artistic conceptions of flora and fauna will be replaced by the supreme Artist, by others in the succession of ages. Inalterability a precondition of great art! But the imprint of a dead leaf on Tertiary tuff, a Saurian footprint on clay, a raindrop on ashes, a half-buried potsherd are more persistent objets d'art than laws engraved on tablets of bronze. The works in glass of Koepping or Tiffany are fragile? Those of Ennion are even more fragile. Yet they are in our hands; but where are the works of Apelles and Polycletus, and the lively tesseras of Cicero? The time will even come when man, if he exists, will have no documents on which to base his memory and will ask, "But where are the chiseled granites of Egypt; but where is the wild rose and its flower?

Finally, should we impose on the objet d'art, in order to proclaim it perfect, the serenity that Ruskin demands of masterpieces? Olympian visages on Elysian amphora, immortal virgins and flowers in a cloudless British sky? Beneath the adornment of the utensils, slaves or companions of man's pleasures, no trace of the human condition? Ruskin tolerates the drop of sweat fallen from an accursed

forehead, but never the tear that collaborates and inscribes and signs it. I am willing, dream this dream, this prayer, to work toward the improvement that in the future objets d'art will be conceived only in joy and to the songs of the workshops. Try at the same time to suppress by thought every objet d'art born in sorrow, what will remain of art and of the sweetest honey of earth? Ampère said that "without sighs, the world would suffocate." Without sobs, art would expire.

The decorative artist has missions to accomplish, higher perhaps than sowing joy. He holds in his hands illusion, but also reality, promises and consolations, mirage and balm. I want the painter of the walls that enclose me to be a poet, to be a magician, that he create distant thickets out of those panelings, meadows of those carpets, and of those hangings, the airy regions in which, captive, I may breathe. [. . .]

Ruskin was able to carry out, in some fortunate workshops in his country, his generous dream, the objet d'art manufactured by love and joy. Let our French works be kneaded with humanity. Our Diderot in his *Salon* of 1765 solicited the worker and the decorative object of his era to make them more elegant and more loving: "Why," said he, "will you not come and seek yourself also among life's consolations? Inscribe on the doors of your workshop these words, 'Here the sorrowful will find eyes to weep for them.'"

III. It is easy to say that there is too much at the Palais de l'Industrie and too little at the Champ-de-Mars. In a great hurry, Our Lady of the Press of the day says her rosary of names and busily repeats the pairings, Puvis and Béraud, Prouvé and José, Carriès and Delaherche, Dampf and Faubourg-Antoine. Then she says, "That is enough, isn't it? Let's get down!"

But we ourselves have more than one day to go upstairs to search, to gather. Up there we have an ideal lodging for people with a small number of domestic possessions, servants, and friends. For us these things will be the ennobling of the necessities—shelter, welcome, retirement, company and consolation. [. . .]

IV. It is time to give decoration the reckoning of its day. We have seen above all ornamentation *for show,* decoration in which the French practitioner appears rich in science, in geometry, in archaeology, in scholarly learning, in technique, in equipment, in volition; yes, when it wishes, when it is in style, it *seems* dreamy and Rossetti-ish, or more modern than the modernists! It appears above all rather chilly of heart and empty of intimate, sincere tendencies.

More talent than results in intellectuality; more of the humanities than of humanity. Shows of sparks, rarely a glowing hearth! So much industry, so little congeniality. The *ornamentist* treats his models, those infinitely beautiful and respectable works, like a basketmaker weaving wicker, like the thresher in a barn beating his sheaves. This is the plan of *decoration for furnishing.* But where is "the tear of objects" and the expression that exhales in silence the sigh of the Spirit? Decoration! Decoration! Why will you not seat yourself also among the consolations for life's evils?" *Hic locus,* here is your place, here is your function. [. . .]³

Is it not time also to salute the access French jewelry is finding among the children of the noble family of art without "compartments"? M. Falize made last year a memorable contribution to the Salon des Champs-Elysées, in a work of reflection, volition, logic, intelligence, whose successful achievement depended on multiple collaborations and the perfecting of the most ingenious detail.

This year M. René Lalique was, at the same Palais de l'Industrie, the most incontestable winner in the fine arts. He brings to jewelry unexpected renewals and, dare I say it? the definitive preparation for modern jewels. This jewelry, if it does not yet have the virtues of the ideal piece of jewelry that every one dreams of, at least possesses all the necessary qualities: elegance of drafting, sureness in construction, sobriety in its prodigality, an almost impeccable tact, pretty crafts-manship, loving virtuosity, a talented passion for lovely materials, harmonious coloring, a sense of exquisite rhythms, fertility of invention, a science of effect, and above all a cold self-possession that never abandons it, in its scrutiny of nature an imperious synthesis preoccupied above all with furthering the progress of the personality, of the conquest of character and style. This is much. This is not in the least vulgar; so far from it that one dares not desire from such a self-assured pendant, from such a becoming *objet de cour* [coeur?], the cherished intimacies that they conceal. [. . .]

Let the young master Lalique, attracted by curiosity about living jewelers, leave his instinct for interrogating nature to go retreat into solitude. The re-spectful communion deserves a coup de grâce. Let Lalique therefore realize our hope. [. . .] Our descendants will ask of you, jewelers of the twentieth century, what bits of the ancestral spirits you have been able to deliver to these myste-rious confidants. [. . .]

Translated from Emile Gallé, "Les Salons de 1897," *Gazette des Beaux-Arts,* ser. 3, vol. 18 (September 1897):229–50.

1. Joseph Prud'homme, a character typifying the self-satisfied, narrow-minded, petty-bour-geois type, was created by Henri Monnier in 1830.

2. [Gallé:] The regulations for the fine arts in 1900 do not limit the materials in sculpture and medallions; but they are reactionary in that they limit the works of art to four academic sections with this comment: "This group is made up only of the fine arts. A special place is reserved for the decorative arts." This is to say that place in group XII, mixed with industrial products, since the exposition contains only "the latter or agricultural products and works of art." And elsewhere: "Section B contains industrial and agricultural products and *diverse objects other than works of art. . . .*"

3. [Gallé:] Only being able to describe here *oeuvres* in the strict sense of the word, I can only relate—for the date, for the hope—all the preparatory work for *oeuvres* which are imminent in furniture, and the approaching resolution of that great work, modern furniture: attempts and discov-eries by M. Benouville, woodwork carved with ears of rye; researches of M. Guimard to the profit of the *petit marteau;* under his pencil, sometimes too strongly influenced by the crick-crack flourishes of M. Horta, iron-mongery becomes wrought iron, coppersmith's work. The effort of Messrs. Sel-mersheim to invent a cabinetmaker's style in which the machine is the servant of the artist is con-genial. In their turn they use vegetable outlines to mold and knead furniture. Their attempts are frankly Anglophile, but keep a French feeling and an air of good company. They know that the abuse of decoration begins to be tiring; they replace it with the restful monochrome of plain wood by the unexpectedness and elegance of curves. Thus simplicity is often more skillful than complexity. See the two vases by M. Marioton, graceful *florilegium.*

1900: *Paris*

In 1900 there was no longer a Salon, as that term had been used since 1725. Weakened first in 1863 when the Salon des Refusés was organized, and then in 1890 when the Société Nationale des Beaux-Arts seceded from the state-endorsed Société des Artistes Français and was permitted to mount a "New Salon" in the 1889 Palais des Beaux-Arts, the Salon was phased out altogether in the last two years of the nineteenth century. The coup de grâce was given when the government razed the Palais de l'Industrie on the Champs Elysées, where the "Old Salon" had been hung, to make way for the 1900 universal exposition (fig. 118). Changes in architectural fashion, coupled with technical advances, made the once innovative iron-and-glass structure appear now as a sort of hybrid between a railway station and a storehouse, too dark for the display of pictures. Furthermore, by removing it, the contemporary penchant of urban planners for magnificent vistas would be satisfied. From the rotunda of the Champs Elysées one would be able to travel down the avenue Alexandre III across the Seine to the Palais des Invalides. Two splendid buildings which would afterward house permanent exhibitions, the Grand Palais and the Petit Palais, would be built on either side of the new avenue for the exposition.

The demolition of the Palais de l'Industrie was begun even before the Old Salon of 1896 had closed, and by September no trace of the building that had housed the Salons for twenty-five years remained. As the Salons had for so long constituted a truly universal showcase of both foreign and French contemporary art, space for the Old Salon had to be provided quickly so no interruption of the exhibitions would occur that would have a prejudicial effect on the Parisian art market. The Palais des Beaux-Arts was not large enough to show both Salons, so in 1898 the rival societies agreed to place their exhibitions in separate sections within the vast Galerie des Machines of the 1889 exposition—the Société des Artistes Français to occupy two sections, the Société Nationale des Beaux-Arts one. Finally, in 1900 the Salons were made a part of the universal exposition itself. They were incorporated into the "Decennial International Exhibition of the Fine Arts, 1890–1900" in the principal galleries, which, together with the "Centennial Exhibition of French Paintings and Sculptures, 1800–1889" in the secondary galleries, inaugurated the Grand Palais (plan 12; fig. 119).

Since any work that had been admitted to an earlier Salon, whether it re-

ceived an award or not, was eligible for inclusion in the retrospective exhibition, it proved to be a representative sampling of the styles, techniques, and subject matter that had been taught not only in the Academy and the ateliers of Paris, but throughout Europe since 1800. The responsibility for the retrospective exhibition was given to Roger Marx. While still a young critic for *Le Voltaire* and the *Revue Encyclopédique,* he had been among the first to direct attention to such talented contemporaries as Puvis de Chavannes, Gustave Moreau, Fantin-Latour, Degas, Rodin, Besnard, and Carrière. As secretary of the nation's department of fine arts, he had worked closely with the well-known critic Paul Mantz on the selection of works for the 1889 centennial fine arts exhibition. When Marx was charged with the retrospective for the 1900 exposition, he profited from this earlier experience and mounted a totally different show. For this achievement he won deserved praise from art critics, none more perceptive than that contributed by art historian André Michel, who reviewed the show for the *Gazette des Beaux-Arts.*

> After eleven years, the masters great and small of French painting in the nineteenth century are once more assembled. Our humble task is to gather up these witnesses and to compare them, to try above all to understand them thoroughly, thus to complete them, to verify them, and, if necessary, to correct here and there old notebooks, which cannot rise to the pretension of resembling even distantly a "history" of French painting.
>
> However, it is really for the historian that Mr. Roger Marx has tried to work. He is the principal, if not the sole, organizer of this "centennial." [He first] imposed upon himself the absolute, and perhaps excessive, rule of exhibiting nothing which had already been a part of the exposition of 1889 and [then set about] to discover, if not masterpieces, interesting and new items, otherwise unpublished. In addition to the recognized masters, he has not forgotten the secondary artists, those who were affected by the major driving influences much more than they affected them and upon whom the more or less imperious doctrines and theories—of which our century of reasoners, critics, and aestheticians has been particularly prodigal—were first exercised and upon whom their actions can be verified. Considered from this point of view, the centennial exposition of 1900, where, by the way, one encounters several authentic masterpieces, is rich in lessons from which writers and historians might derive as much profit as artists, and its organizers must be thanked for having furnished modern criticism with this occasion for an "examination of conscience."[1]

The centennial was covered by foreign reviewers as well as critics in the French daily press, belles-lettres periodicals, little magazines, and art magazines. The novelist Rémy de Gourmont, art editor of the *Mercure de France,* selected the Belgian Emile Verhaeren, regarded by the French Symbolists and their foreign colleagues and collaborators as one of the great contemporary lyric poets, to provide the subscribers with a summary of the art on view. His poems and a play, *Les Aubes,* had appeared in the *Mercure* in 1895 and 1897. Like the works of his

1. André Michel, "Les Arts à l'Exposition Universelle de 1900," *Gazette des Beaux-Arts,* ser. 3, vol. 23 (May 1900):441–42.

compatriot Maeterlinck and contemporaries Mallarmé, Verlaine, Gustave Kahn, and Jules Laforgue, his writings had contributed new vigor to French verse and prose through their use of provocative words, musical rhythms, and freedom from rhyme. Although Verhaeren first wrote as a Parnassian, observing rules and using words in a traditional manner, in 1881 he broke away from accepted subject matter and terminology and adopted the contemporary colorful vocabulary of industry, machines, and science for his descriptions, just as artists were adopting a new palette to represent the new subject matter drawn from contemporary every-day life.

Verhaeren built upon Théophile Gautier's belief that the works of great artists are not imitations of nature made according to rules, but transformations of the sensual experience of nature into art, unified and made harmonious through the faculties of the microcosm—"a small complete world" that Goethe had asserted every artist should carry within himself. In 1900, after viewing the retrospective and the objects of other times and cultures jumbled together at the exposition, Verhaeren the poet asserted, "Art must express emotion and thought. If what the public calls 'a rough sketch' expresses this with all its force, then it is the rough sketch, and not the laboriously and impeccably finished statue, its movement arrested and congealed, that endures as the completed work."[2] Other artists, eager to learn from where "new and better theories of art will come" may have followed Verhaeren's lead and looked for it among the arts of other countries, including those brought from the French colony of Indo-China and the African colonies of Germany and Belgium, all of which were prominently represented at the exposition. Still others turned their backs on the strange objects from alien cultures and sought inspiration instead in the humming cylindrical dynamos and clattering engines in the Galerie des Machines.

The Centennial Exhibition of French Art, 1800–1889
[HENRI ROUJON?]

[. . .] One may ask if it was opportune to repeat in 1900 a demonstration that had already been sketched out in 1889. At first it would doubtless seem that such an exhibition could only be a repeat of the exhibition of ten years ago. Traversing the galleries that it occupies in the Grand Palais des Beaux-Arts, people will promptly perceive, we believe, that it is nothing of the kind. If ten years are nothing in the history of humanity, ten years matter greatly in the history of a century of art; they constitute a distance almost sufficient to judge fairly some art forms whose works, initially somewhat disconcerting to eyes accustomed to look-ing at the past, end—by a wise selection and the trial of time—by appearing to us not as strange new things, but as the logical development of an art which must

2. Emile Verhaeren, "Chronique de l'Exposition," *Mercure de France* 36 (October 1900):176.

always be moving or evolving lest it perish. Considered as phenomena essential to its very existence, as inescapable consequences of certain premises, these evolutions appear not as the fruit of a caprice of this or that individual, but as inevitable conclusions translated by the artist's hands, which in this case are only instruments. Each artist, in bringing to this unconscious working a morsel of his personality, prepared in his turn a new evolution, a new stylistic transformation which is all the more imperceptible to us for occurring under our very eyes. Ten years are certainly not enough to judge a work of art impartially; but after twenty or thirty years, when passions have subsided, it is easy to discern the works that will definitively enter into history by the front door from those which, although more warmly welcomed at first because they were not such forceful personalities, fall back into inescapable oblivion.

From this point of view, decennial art exhibitions, or at least exhibitions held at dates quite far apart, are rich in important lessons different from those of the annual Salons. It is only there that it is possible to judge the true orientation of art and its close affinity with the ideas of an epoch.

To write this page of French art, in which painting holds a preponderant place, the organizers of the centennial exhibition of 1900 thought that they should not repeat any of the paintings which had been seen at the centennial exhibition of 1889. This legitimate preoccupation to represent by new examples every painter worthy of participating in the exhibit has involved them in long and difficult searches. Let us hope that the results will not seem too unworthy of their efforts and will not be judged unworthy of the reputation of French art. Their searches also enabled them to bring to light some works by little-known artists, particularly provincial artists; certainly no one can resent their having rescued from unjustifiable oblivion paintings which in other circumstances would have placed their authors in first rank.

The exhibition of painting is completed by a large collection of drawings by the masters of the century. It is here, even more than in the finished paintings, that one can come across the intimate thought of an artist and understand the artist's work process. It is the outstanding documentation on the art of an epoch, and [although shown in 1889] it was thought it should be repeated.

It was also thought that the history of French sculpture, which shone so brilliantly throughout the century, should be more generously endowed than in 1889; much borrowing either from provincial museums or from private collections has permitted the assembly of a veritable museum of French sculpture, in which the better-known names are represented by important works, and in which certain names unjustly forgotten by art historians until now are brought to light and with assurance take the place which is their right.

Medal work,[2] which in the second half and above all in the last quarter of the century has been profoundly transformed, has also developed in keeping with this renaissance.

As far as architecture is concerned, it has seemed preferable to represent it principally with drawings highlighting the particular tendencies of the art of the

century, and to provide valid knowledge of the transformation in the art of building, rather than to display restitutions of ancient monuments or medieval restoration projects. It will doubtless be an honor for our century and its architects to have saved many masterpieces of the past from destruction, but by concentrating too heavily on this point, as has been done too often in these circumstances, we risk making people forget that nineteenth-century architecture has included artists of great talent and strong personalities, capable of giving birth to original works.

In this general picture of the art of the century, engraving could not be forgotten: both original engraving and reproductive engraving, burin, etching, wood engraving, and lithography, all branches of that art whose tradition in France is particularly glorious, are represented by examples chosen by artists and collectors, to whom we address our thanks for the support they have lent the organizers.

It seemed from the beginning that this centennial exhibition [. . .] could give a better idea of French art in this century if it did not limit itself to showing the usual works of painting, sculpture, architecture, or engraving. A large place was given to interior furnishings, as if the works of art were placed again in the environment in which they were born. It is hoped that this attempt, which is one of the unique features of the centennial exhibition, will be well received by the public. In any case, even in the restricted scope in which it has been possible to be realized, it may be considered as a landmark in the history of art, the result of a series of efforts which cannot be too much encouraged; it consecrates the return to the healthy traditions of French art, which has never known either grand art or so-called industrial art but simply ART, all of whose manifestations have the right to equal respect, as manifestations in a given epoch representing the same ideas and the same social state. [. . .]

Translated from the preface to *Catalogue générale officiel: Oeuvres d'art, Exposition Centenniale de l'art français (1800–1889)* (Paris, n.d.). Henri Roujon, the national director of the fine arts, may have been its author.

1. Medals (*gravure en medailles*) were shown separately from sculptured medallions. The making of medals had enjoyed a renaissance in France.

An Account of the Centennial Fine Arts Exhibition
EMILE VERHAEREN

The Ecole [des Beaux-Arts] and its too often mediocre masters conceive of a work of art as something coldly and minutely predetermined. They slog along, expressing by means of meticulous formulas what they dare to call life. Never have they had the feeling that their creations appear to them as in a marvelous storm, in that devastating light which burns, transports, and eliminates the secondary, leaving the essential to stand by itself; they dawdle over trifles, petty details correctly

reproduced. Men whose skill has been laboriously acquired, they dread being accused of ignorance if their painting or statue should prove that their hand was not as expert in drawing toenails as in drawing proper facial planes. They are desperately explicit. They tell and retell. They are garrulous chatterboxes. They are never carried away. They are long-suffering; the best of them are conscientious.

Unfortunately, because of the futility of their labors and the insignificance of their exertions, even the latter end up by successfully completing only works of the nature of semi-manual labor, which one day will be perfected by modern mechanics as skilled as they.

To see at the centennial such formerly celebrated sculptors—Jaley, Bosio, Dejoux—or such painters [students of David] who mark the end of his school of painting, as Mieris and Van der Werf signaled the decline of Dutch painting, one comes to detest as veritable aesthetic monstrosities such supposedly perfect works, which lack nothing and lack everything. They are dead calligraphy but not living writing. Their dismal impeccability is more outrageous than it is boring. Perfection, the human dream that soars toward the divine, becomes something vulgar and commonplace, facile and debased, in which sculpture and painting have the baneful mission of propagating error. One turns one's back on this heap of effigies, scattered like white ninepins beneath rotundas, and on these kilometric cardboard boxes lined up in rows as far as the eye can see on the dados at the Palais. Salutary reflections come to mind as to where new and better theories of art will come from.

We find ourselves in the Indo-Chinese section[1] proceeding through the admirably reconstructed underground temple which has been sunk into the soil. To experience the violent impression it evokes, it should be visited at the hours when it is not crowded. We hardly pause at the unfortunate dioramas alongside, which create gaps here and there, but its arrangement, its columns, its capitals, whose proportions and images speak to us, astonish and seduce us.

The staircase that leads to the lower halls is populated with tragic griffins, parts of which are bare and rough, others worn by time; in the archway impassive faces gaze into eternity. No banal affected symmetry, no arbitrarily prescribed arrangement. The raw material there seems formidable and beautiful, and the life it reveals in the figures of idols and the furious expressions of beasts emanates from them and provokes mysterious or fearsome thoughts.

In the underground crypt the pillars rise, square, sturdy, and strong, a fantastic crouching faun superimposed. Stone giants and dragons, lions and pythons, support the sacred dwelling. Enormous empty spaces are included (for what rites or miracles?). The sun in its daily round displaces the light that falls from above, now illuminating, now plunging into shadow, this or that marvel, bringing intermittent mystery or sudden life to the walls filled from end to end with the sculptured presence of the gods.

In all, an extraordinary effect—and brought about by the fragmentary, the

unfinished, the rough, the incomplete. Everything seems embryonic and mysterious, everything seems powerful, about to evolve, about to come to life.

On leaving this temple I recalled my morning visits to the antiquities in the Louvre and the British Museum. Those friezes of the Parthenon, half destroyed; those Fates—the world's masterpieces of sculpture—those metopes, those battles, those foot races, those processions, all those marvels of ruin and beauty reveal themselves as important and powerful only by grace of their imbalance, their broken fragments, their partial destruction. Clean, polished, finished, what impressions might they have made? The details would have distracted the eye from the whole, the artful craftsmanship would have been shocking, and the too regular arrangement would have dominated by cold and perhaps banal lines.

At the Louvre the broken arms of the *Venus de Milo*, the bruised thighs and neck of the *Crouching Venus*, the head and the missing limbs of the *Victory of Samothrace* hardly detract from their perfection.

What is missing is imagined by each observer and is imagined according to his own personal conception of grandeur and majesty. Time—brutal, destructive, and savage—appears as the supreme artist. It not only hallows masterpieces but collaborates in their creation. It makes them sublime, after the greatest human geniuses have exhausted their talents. Time acts by elimination and erosion—all to the good. It softens, colors, it wears down marble. It enhances the grandeur of the ensemble, the splendor of bulk and mass. It returns them to the metamorphoses of life—birth and agony—and thereby embellishes them. Their fragile definition disappears; their painful precision vanishes.

There are two sculptors—among the greatest—who have sensed this marvelous action of nature and the duration of time on works of sculpture and who have been utterly influenced by it—Michelangelo and Rodin.

The Florentine shaped his marbles himself; he loved the medium; he found it beautiful and already alive in its heaviness and its mysterious quality. He brought this primitive and obscure life into expressive and passionate existence. His tragic figures, his powerful muscular bodies lay captive in their rough envelope. Often he left rude and uncarved raw marble in juxtaposition with worked and polished marble. He had no fear of breaking the barrier between the universe and his own personal works. The one is but an extension of the other, and such admirable colossi seem to be sculptured as much by nature as by his hand. What did he care for details, fiddle-faddle, meticulous and precise details, or working painstakingly from one point on a statue to another? Such practices serve only to diminish and to dwarf: he wanted none of it. O, his marvelous, melancholy dreamers, leaning upon tombs, his oppressed and sad slaves, his half-formed group in the Duomo of Florence! If the learned theorists ever thought of being logical they would have rejected them as not being "sculpture," for his work negates all that they were teaching and defending.

And yet in our century the Academy reigns supreme, more arrogantly than ever. One man, Auguste Rodin, has understood even better than Michelangelo has some of the profound and mysterious laws of his art.

He catches the variety and freshness of movement, simple poses unperceived until he observed them; passionate embraces, rare suppleness, shifting lines, unprecedented grace; elegance combined with strength, until suddenly—as in *Despair, La Revolte, Hugo, Balzac*—the somber power, whether roaring, calm, or frightening, achieved in primordial blocks of stone which lend to their creation a quasicosmic significance, the earth, a cliff, a mountain. The whole of life rolls over them in tides; they are out of place in an exhibition hall, they can come alive only in the midst of the natural movement of men and things. And within their plaster, bronze, or marble, paroxysms of grief, madness, grandeur, or fear are contained, like subterranean forces imprisoned in the earth. These are instantaneous reproductions of rhythms, snapshots of curves and bendings, transitions from one minute to the next, from one corporeal state to another, a thousand difficulties finally resolved after a series of experiments; elaborations, sometimes sudden, sometimes slow, of a prodigious synthesis in which the whole work of an Hugo or a Balzac breathes and comes to life again as if the hands of the sculptor have recreated genius with genius. Ah, now we find ourselves far from mere statuary and close to life itself! The essential is preserved, and everything appears to be in motion. What the subterranean Indo-Chinese temple suggests, what the remains of the art of antiquity evoke, Rodin achieves in these sculptures.

They give voice to the universal scream in which suffering and triumph are keener, sharper, and more agonizing than a thousand words correctly lined up according to the rules of syntax. Oh, this art of impetuous ardor, of tortured passion, of magnificent excess, of gasping yet beautiful humanity, of universally profound harmony, which, in the course of this century, has been supremely expressed by him alone!

In Rodin's modern sculpture it matters little that, as in antique sculpture, a hand is missing, a finger cut off; that an arm or a leg, as in Indo-Chinese art, may be but a fragment; that a torso is carelessly treated, while the head cries out with life. The fragmentary expression is so strong that it dominates the whole and gives blood, muscle, and movement to the entire mass. Art must express emotion and thought. If what the public calls "a rough sketch" expresses this with all its force, then it is the rough sketch, and not the laboriously and impeccably finished statue, its movement arrested and congealed, that endures as the completed work.

This truth is verified at every step. In this article we have tried to isolate this truth. We would like to have suggested that the noblest thing in art is not the achievement of a work but the gushing forth from both the intellect and the bowel with the whole of nature. Rough masterpieces, even unskilled ones—worn, ancient masterpieces, though amputated or decapitated—appear to be endowed with a profound and universal strength that other works do not have. The former seem to be part of the universality of things; the latter are on the verge of returning to that condition. These are not simply objects, they are reservoirs of continuing life. Geniuses like Michelangelo and Rodin, or the centuries of time, alone create them, although it is within the grasp of anyone, through perseverance and pain-

staking method, to create a correct statue, carefully finished and narrowly pre-scribed, refined and petty, for the admiration of crowds and juries.

Translated from Emile Verhaeren, "Chronique de l'Exposition," *Mercure de France* 36 (October 1900):170–76.

 1. Replicas of the immense Cambodian temples discovered at Angkor were skillfully built into the hillside on the west slope below the Trocadéro. They were reached by a dimly lit corridor. The grotto, illuminated by a blue-tinted electric light, was lined with sculptures gathered from various provinces in the French colony. Charles Lemire, "L'Art indo-chinois à l'exposition," in *La Grande Revue de l'Exposition* (Paris, 1900), pp. 209–14. The paintings of scenes in the Far East placed in niches in the wall of the stairway that descended to the grotto were by Louis Dumoulin.

Index

Dates, where known, are supplied in parentheses for all artists, art critics, and art historians.

Illustrations

1. B. E. Loviot, *Restoration of the Parthenon,* Ecole nationale supérieure des Beaux-Arts, Paris.
[1879–81: Paris, p. 206]

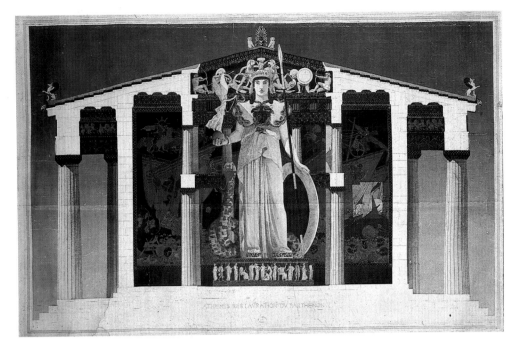

2. Walter Crane, *King Luckie-Boy's Party,* from *Walter Crane's Picture Book V,* Beinecke Rare Book and Manuscript Library, Yale University.
[1879–81: Paris, p. 239]

3. Edward Burne-Jones, *Danae* (*The Tower of Brass*), Glasgow Art Gallery and Museum.
[1881–82: London, p. 267]

4. Arthur Melville, *Audrey and Her Goats*, The Tate Gallery, London.
[1891: Munich, p. 308]

5. George Henry and Edward Hornel, *The Druids: Bringing in the Mistletoe*, Glasgow Art Gallery and Museum. [1891: Munich, p. 314]

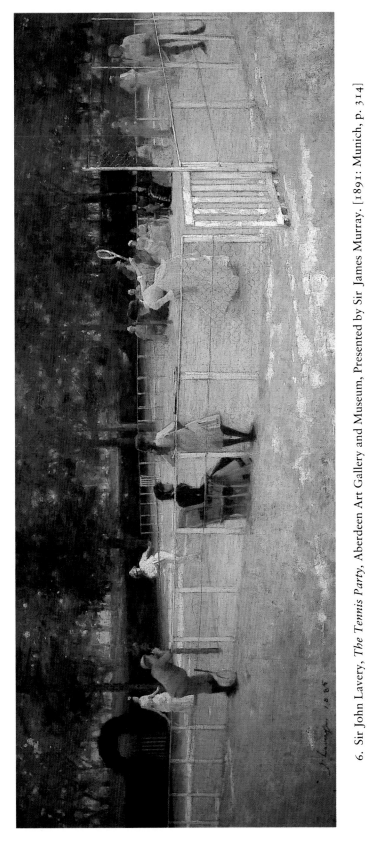

6. Sir John Lavery, *The Tennis Party*, Aberdeen Art Gallery and Museum, Presented by Sir James Murray. [1891: Munich, p. 314]

7. Giovanni Segantini, *The Return Home*, Nationalgalerie, Berlin. [1895: Venice, p. 339]

8. Frits Thaulow, *Thawing Ice*, Hirschl & Adler Galleries, New York. [1895–97: Paris, p. 368]

9. Seiki Kuroda, *The Girl of Brehat, Brittany,* Bridgestone Museum of Art, Ishibashi Foundation, Tokyo. [1900: Paris, p. 117]

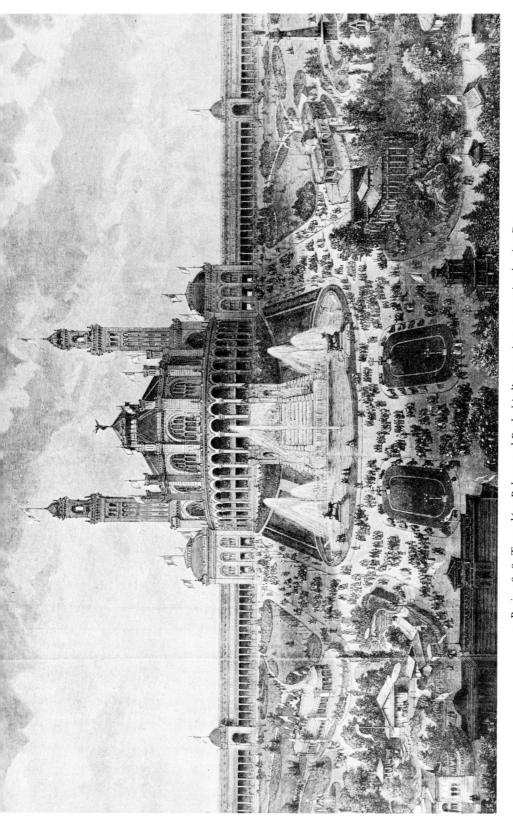

1. Paris 1878: Trocadéro Palace and Park, bird's-eye view, engraving by Ate Deroy.

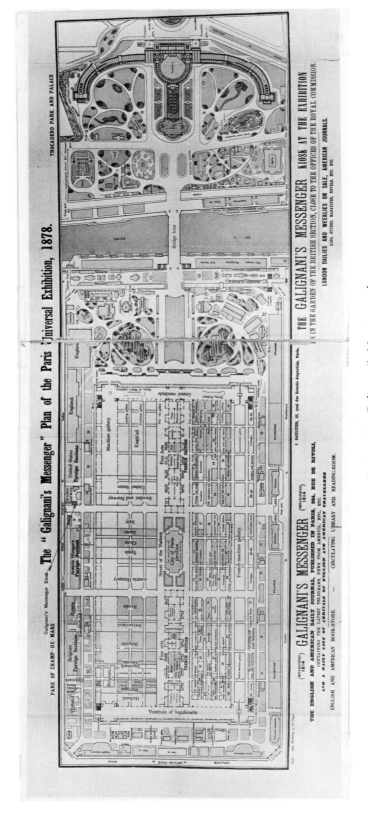

PLAN 1. Paris 1878: *Galignani's Messenger* plan.

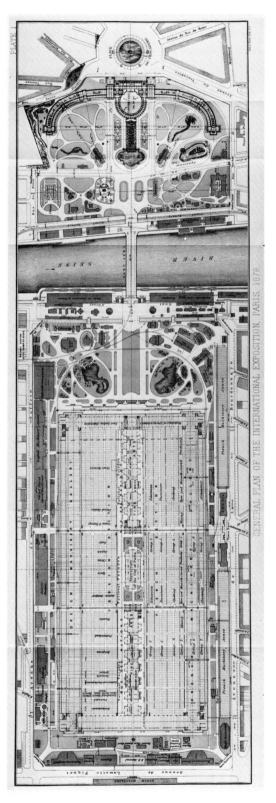

PLAN 2. Paris 1878: plan drawn by M. César Daly.

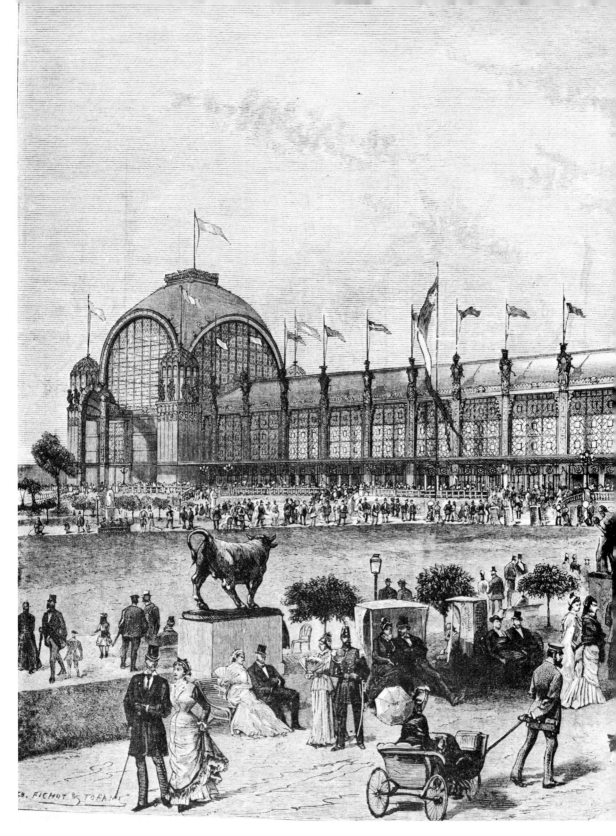

3. Paris 1878: Palais du Champ-de-Mars, principal facade and park.

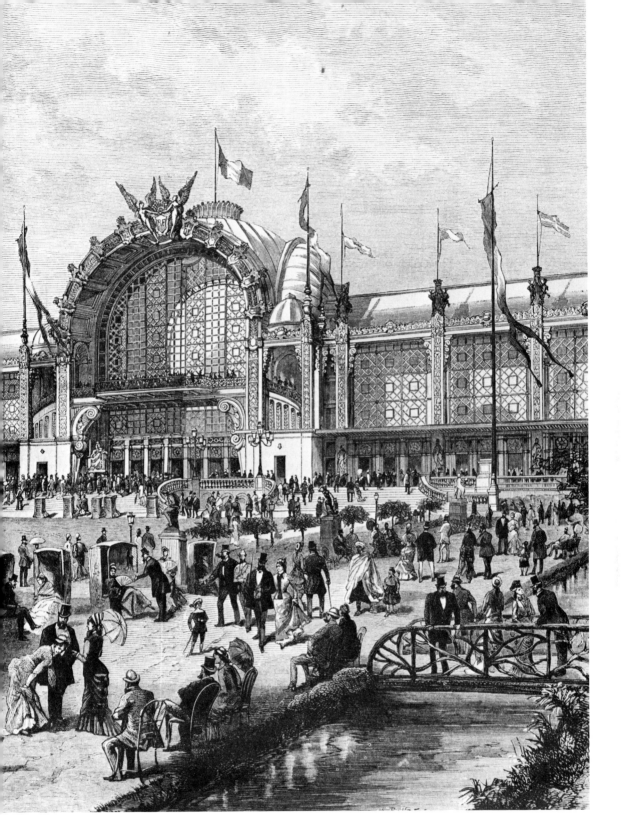

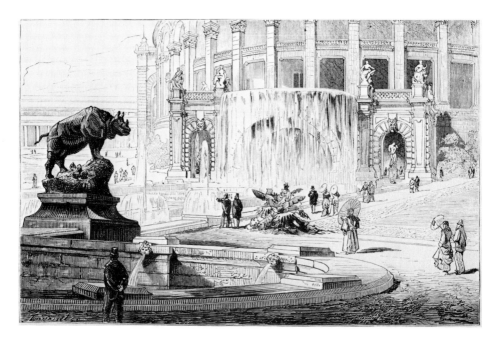

2. Paris 1878: Trocadéro, waterfall and rhinoceros.

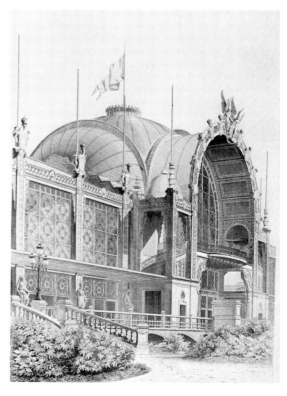

4. Paris 1878: Palais du Champ-de-Mars,
principal facade, designed by Gustave Eiffel.

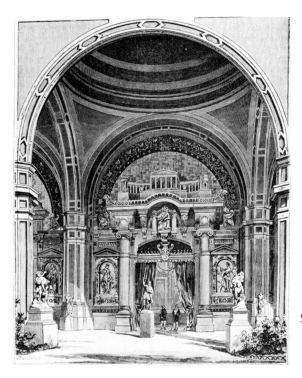

5. Paris 1878: Palais du Champ-de-Mars,
Porch of the Beaux-Arts (architect, F. Jaeger;
faience, Deck and Boulanger; engraving,
Soupey; drawing, Toussaint).

6. Paris 1878: Champ-de-Mars, Pavilion of the City of Paris.

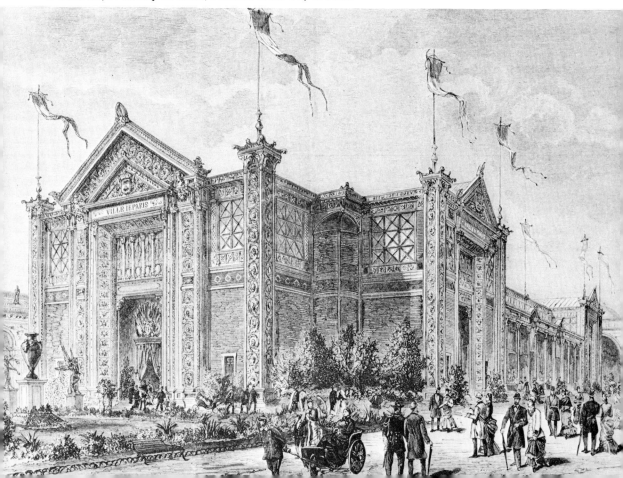

7. Paris 1878: Rue des Nations, facades of the pavilions of Annam (Indonesia), Persia, Siam, Tunis, and the Republic of Saint Marin.

8. Paris 1878: Rue des Nations, facade of the pavilion of Japan (Bibliothèque Nationale, Paris).

9. Paris 1878: Rue des Nations, facade of the pavilion of the United States (Bibliothèque Nationale, Paris).

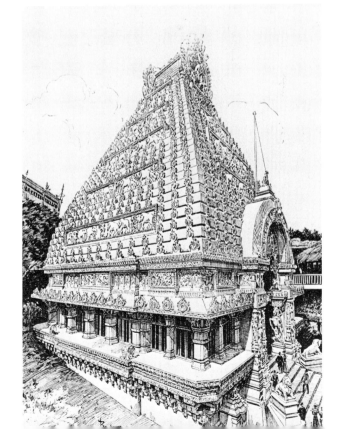

10. Paris 1878: Trocadéro, temple of the French Indies.

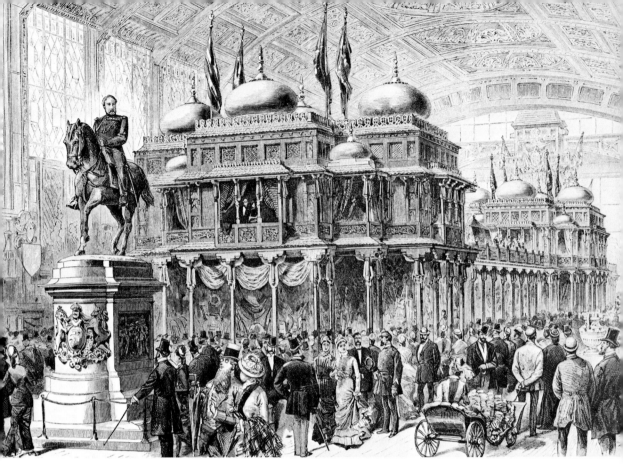

11. Paris 1878: Palais du Champ-de-Mars, Prince of Wales's Indian Pavilion.

12. Paris 1878: Palais du Champ-de-Mars, Prince of Wales's Indian Pavilion, smoking room (designer, Henry Scott).

13. Paris 1878: Palais du Champ-de-Mars, Anglo-Japanese drawing-room furniture, William Watt, Art Furniture Warehouse (designer, E. W. Godwin).

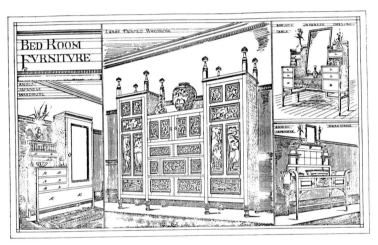

14. Paris 1878: Palais du Champ-de-Mars, bedroom furniture, Art Furniture Warehouse (designer, E. W. Godwin).

15. Paris 1878: Palais du Champ-de-Mars, Gustave Doré, the "Wine Harvest Vase."

16. Paris 1878: Palais du Champ-de-Mars, vase "Cupid's Lecture on Love," pâte-sur-pâte (designer, Mark L. Solon).

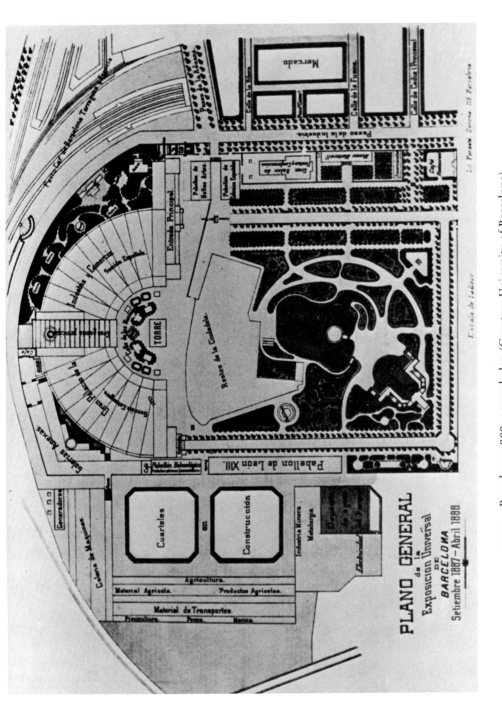

PLAN 3. Barcelona 1888: general plan (Courtesy University of Barcelona).

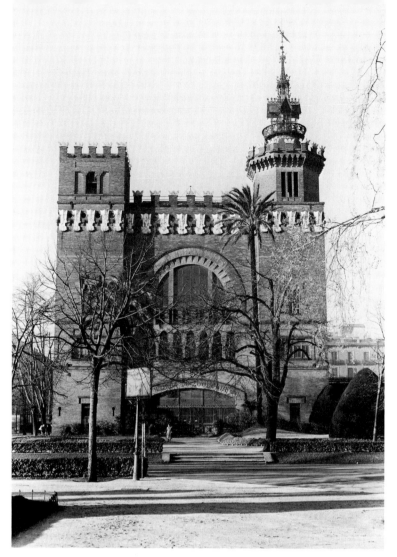

17. Barcelona 1888: Parque de la Ciudadela, Restaurante Exposición, exterior (Instituto Amatller de Arte Hispanico).

18. Barcelona 1888: Parque de la Ciudadela, Restaurante Exposición, interior stairway (Instituto Amatller de Arte Hispanico).

PLAN D'ENSEMBLE
DE
L'EXPOSITION UNIVERSELLE
DE
1889

Champ-de-Mars.... 1
Trocadéro.......... 2
Esplanade........ 3
Quai.............. 4

Palais de l'Exposition....
Pavillons concédés......
Pelouses et Jardins......
Fontaines et Pièces d'eau...

SEINE

BEAUX-ARTS

ARTS LIBÉRAUX

GALERIE DES MACHINES

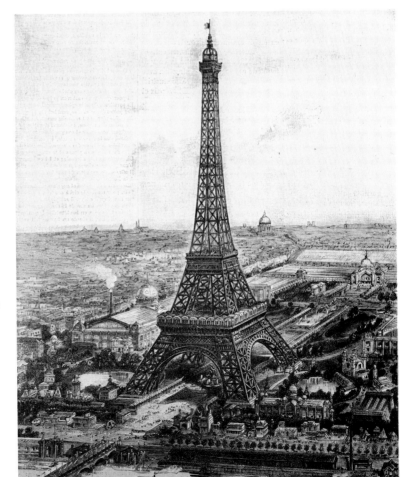

19. Paris 1889: Eiffel Tower,
general view taken from
the Trocadéro.
(Roger-Viollet).

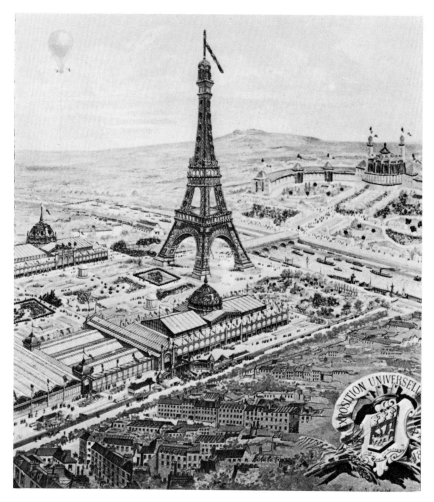

20. Paris 1889: Eiffel Tower, with view of the Trocadéro.

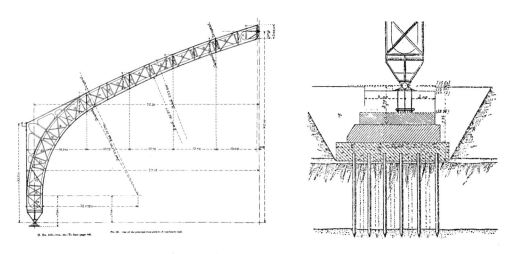

21. Paris 1889: Diagram of a principal truss girder. 22. Paris 1889: Diagram of foundation of a truss girder.

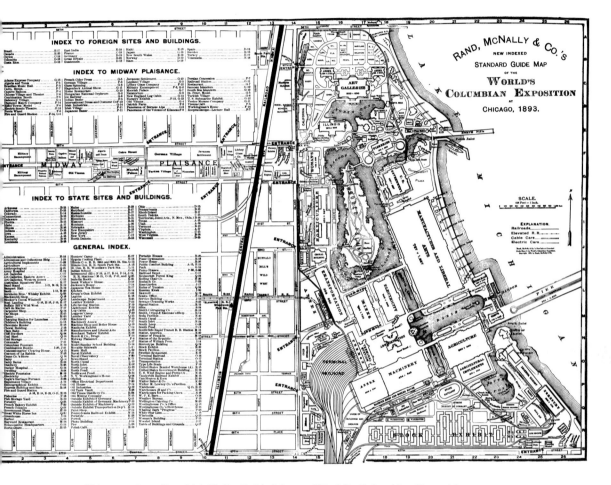

PLAN 5. Chicago 1893: Rand McNally Guide Map to World's Columbian Exposition.

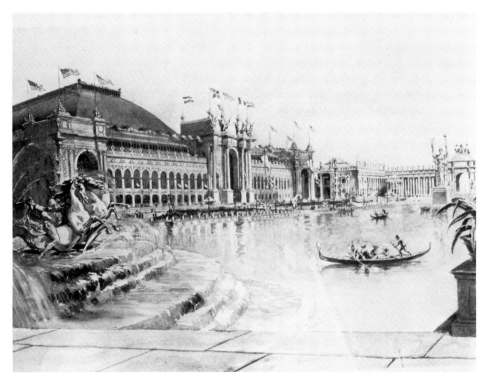

23. World's Columbian Exposition, Chicago 1893: View of the Grand Basin.

25. World's Columbian Exposition, Chicago 1893: The Transportation Building, Louis Sullivan and Dankmar Adler (Chicago Historical Society).

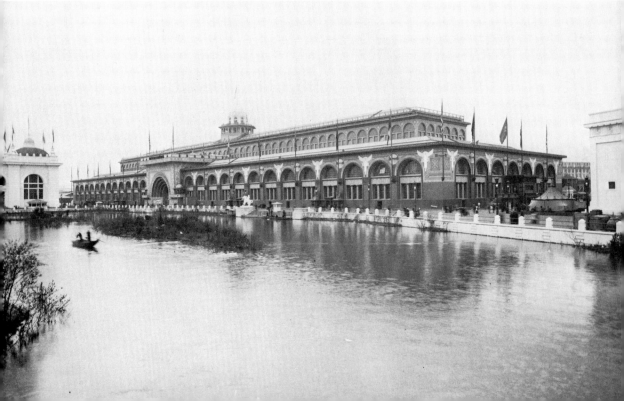

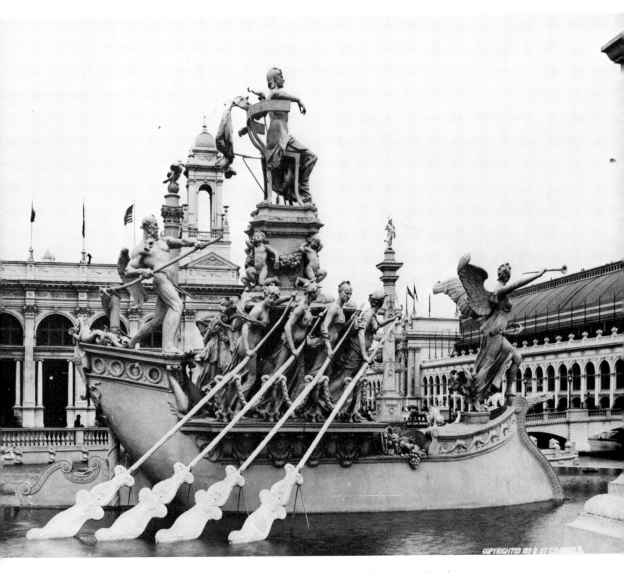

24. World's Columbian Exposition, Chicago 1893: The Court of Honor, Columbian Fountain by Frederick MacMonnies (Chicago Historical Society).

The Vermont State Building.

The Arkansas State Building.

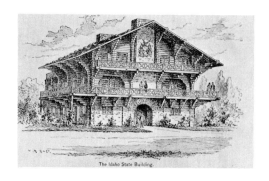

The Idaho State Building.

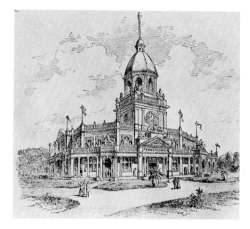

26a–e. World's Columbian Exposition, Chicago 1893: State Houses.

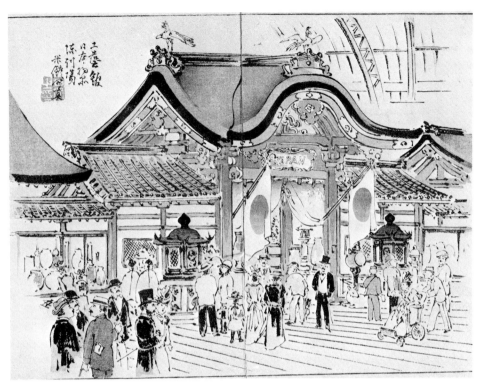

27. World's Columbian Exposition, Chicago 1893: The Hō-ō-Den (Phoenix Hall), entrance.

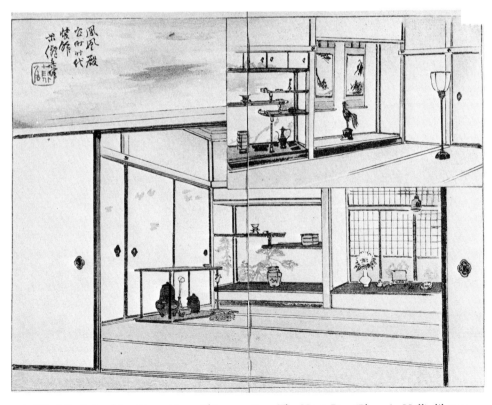

28. World's Columbian Exposition, Chicago 1893: The Hō-ō-Den (Phoenix Hall), library and tea room.

29. World's Columbian Exposition, Chicago 1893: The Hō-ō-Den (Phoenix Hall).

30. World's Columbian Exposition, Chicago 1893: American rocking chair, designer unknown.

31. World's Columbian Exposition, Chicago 1893: Stained glass window and lighting fixture, designer unknown.

32. World's Columbian Exposition, Chicago 1893: Magnolia vase, Louis Comfort Tiffany and Company (The Metropolitan Museum of Art, Gift of Mrs. Winthrop Atwell, 1899).

MERLEY　佛蘭西メルレイ氏筆油繪美術館陳列

33. World's Columbian Exposition, Chicago 1893: Beisen Kubota's copy of Jean J. Millet, *The Man with a Hoe.*

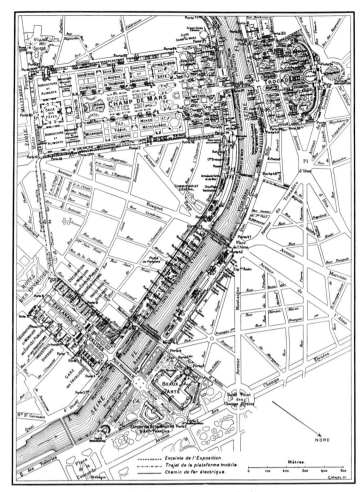

PLAN 6. Paris 1900: general plan.

PLAN 7. Paris 1900: bird's-eye view.

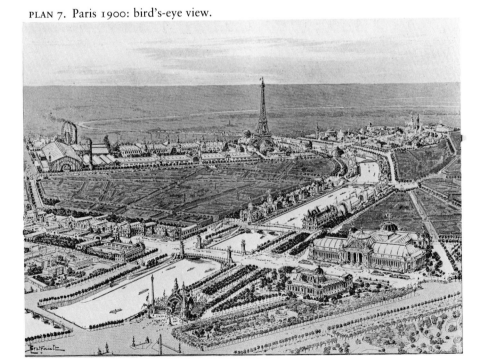

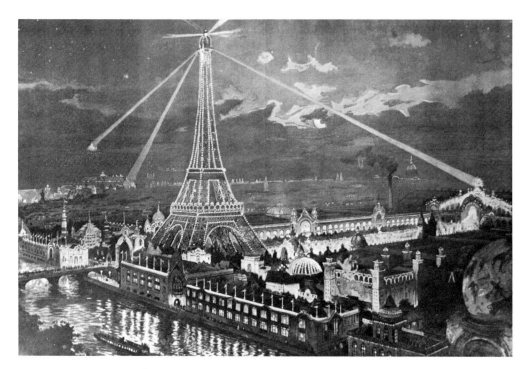

34. Paris 1900: Eiffel Tower and electrical illumination. "Les Fetes de Nuit à l'Exposition," from *l'Exposition de Paris* (Montgredie et Cie, 1900).

35. Paris 1900: Porte Monumentale, Place de la Concorde (Roger-Viollet).

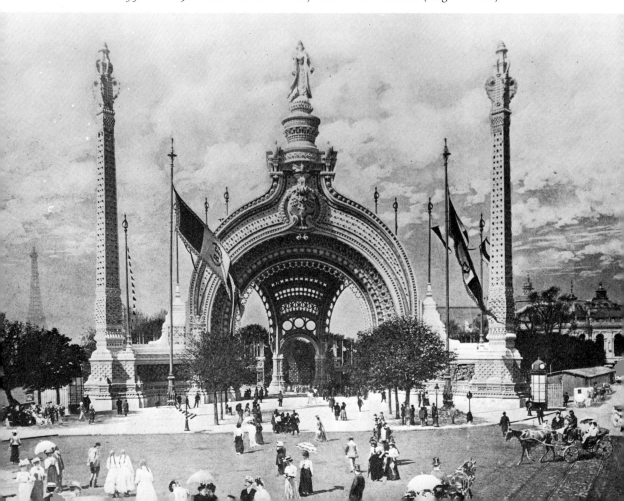

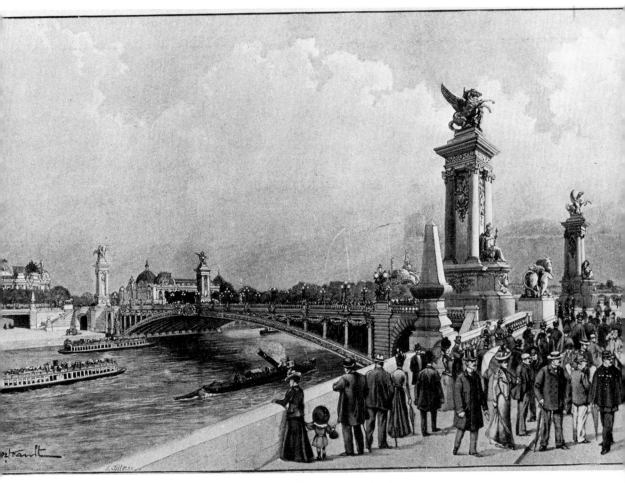

36. Paris 1900: Pont Alexandre III, engraving, *L'Illustration*, 14 April 1900.

37. Paris 1900: Esplanade des Invalides, *L'Illustration*, 14 April 1900.

39. Paris 1900: Pavilion of the Grand Duchy
of Finland (Eliel Saarinen, architect),
L'Illustration, September 1900.

38. Paris 1900: Buildings of the Foreign Powers, *L'Illustration*, April 1900.

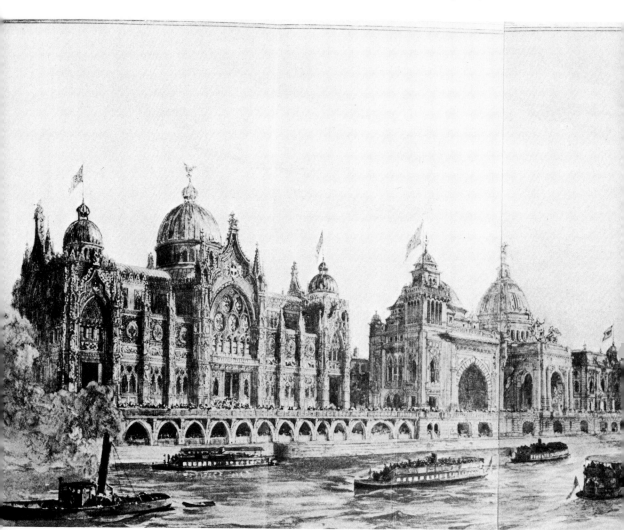

40. Paris 1900: Temple from Cambodia;
photograph by Emile Zola (Bibliothèque
Nationale, Paris).

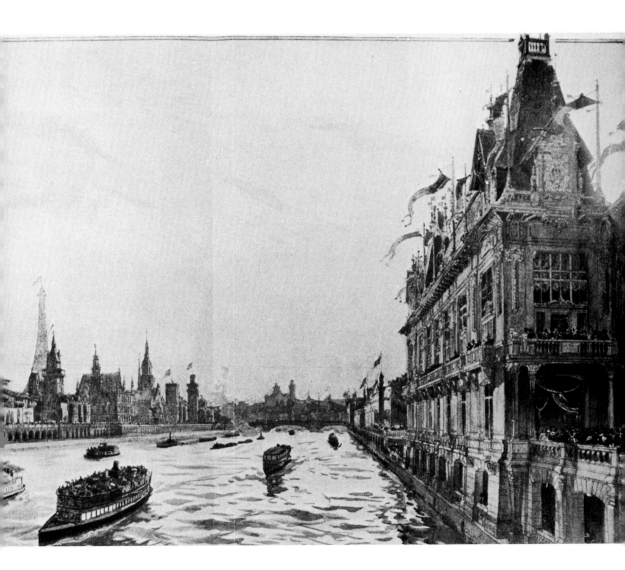

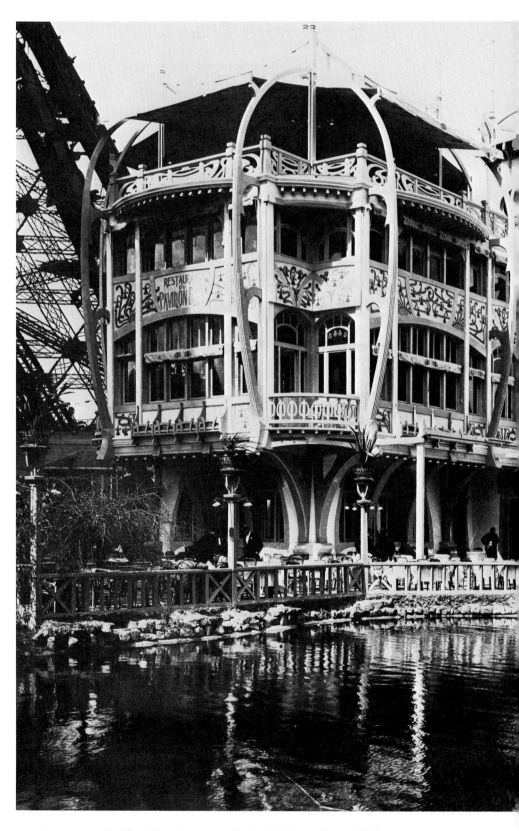

44. Paris 1900: Pavillon Bleu Restaurant, E. A. R. Dulong (Roger-Viollet).

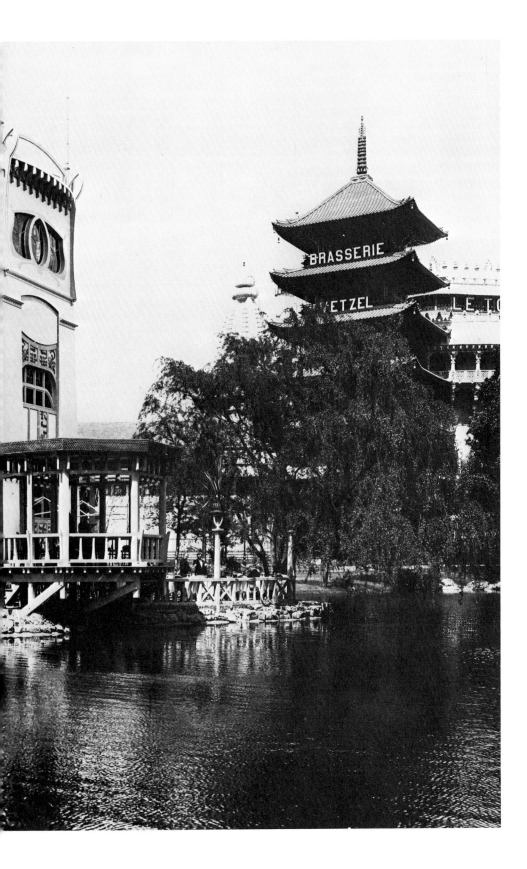

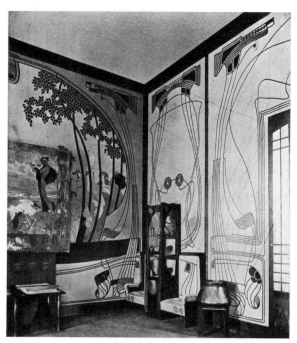

41. Paris 1900: Vienna School of Decorative Art, interior by Joseph Hoffman, *International Studio* 12 (1900–01).

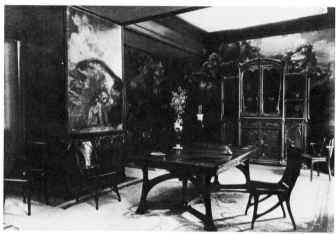

42. Paris 1900: L'Art Nouveau Pavilion, dining room designed by E. Gaillard, mural decorations by José-Maria Sert, *The Studio* 20 (August 1900).

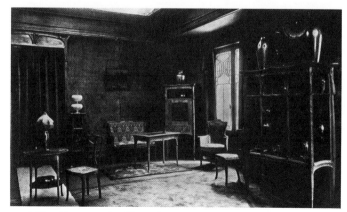

43. Paris 1900: L'Art Nouveau Pavilion, drawing room by E. Colonna, *The Studio* 20 (August 1900).

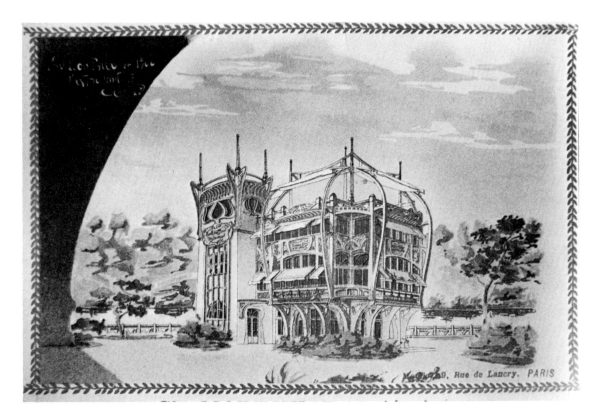

45a–b. Paris 1900: Pavillon Bleu Restaurant, publicity poster (Bibliothèque Historique de la Ville de Paris).

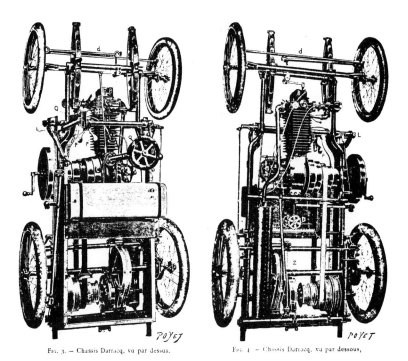

FIG. 3. — Chassis Darracq, vu par dessus. FIG. 4 — Chassis Darracq, vu par dessous,

46. Paris 1900: The Darracq automobile, chassis and engine, *Revue des Revues* 1 (November 1899).

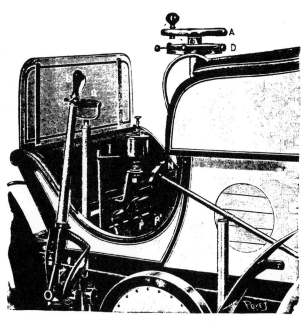

47. Paris 1900: The Darracq automobile, steering-driving components, *Revue des Revues* 1 (November 1899).

Le Nouvel Hippodrome

(1) Vue de l'Hippodrome. — (2) L'Arène. — (3) Le Manège. — (4) La Sellerie. — (5) Les Écuries. — Dessin de A. NORMAND. Voir l'article page 163.

48. Paris 1900: The New Hippodrome, Place d'Alma, Fives-Lille Company.

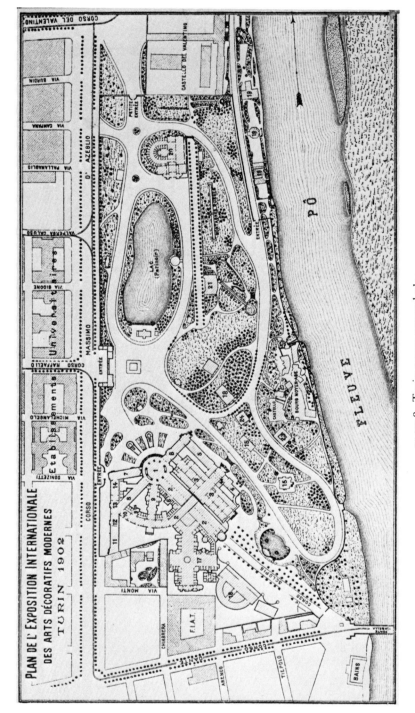

PLAN 8. Turin 1902: general plan.

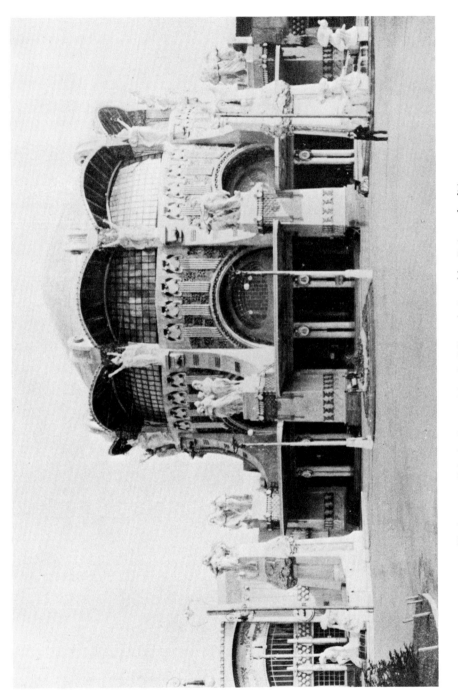

49. Turin 1902: Principal exposition building, designed by Raimondo d'Aronco.

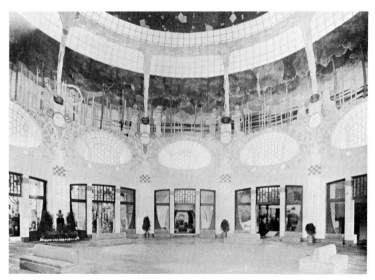

50. Turin 1902: Principal exposition building, foyer.

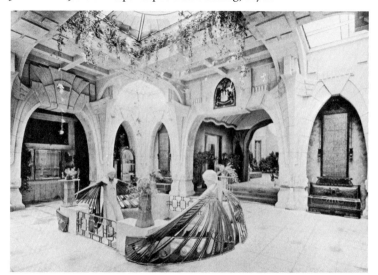

51. Turin 1902: German Empire, Hamburg Hall, designed by Peter Behrens.

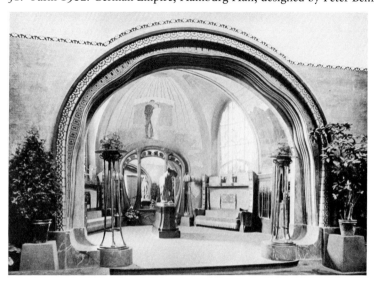

52. Turin 1902: German Empire, reception room, designed by B. Möhring.

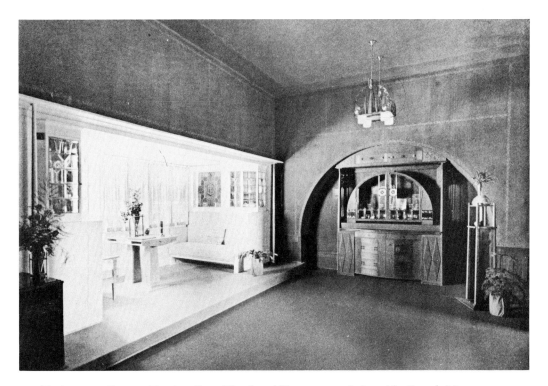

53. Turin 1902: German Empire, Grand Duchy of Hesse room, designed by Joseph M. Olbrich.

54. Turin 1902: German Empire, living room, designed by H. E. D. Berlepsch, Munich.

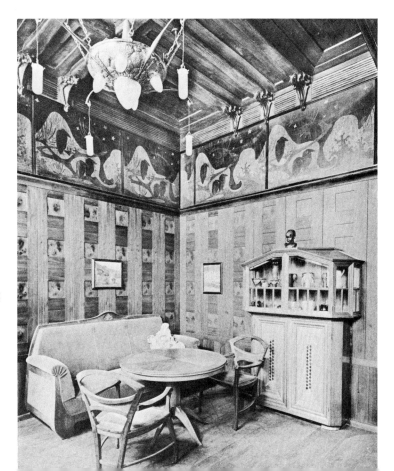

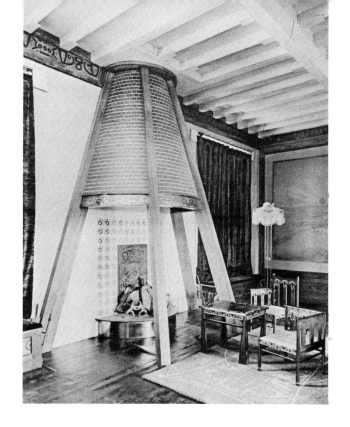

55. Turin 1902: German Empire, gentleman's room, designed by Bruno Paul.

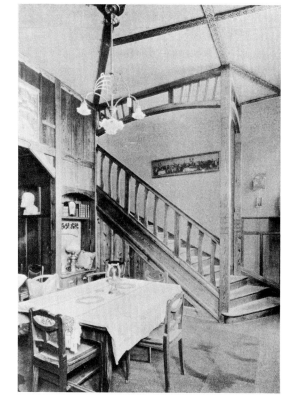

56. Turin 1902: Holland, living and dining room, designed by Th. Uiterwijk.

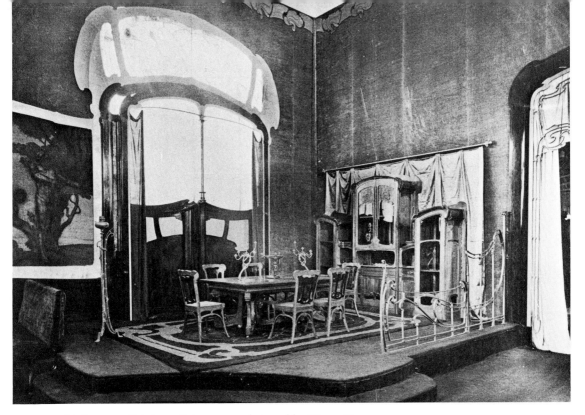

57. Turin 1902: Belgium, dining room, designed by Victor Horta.

58. Turin 1902: Photography Building, designed by Raimondo d'Aronco.

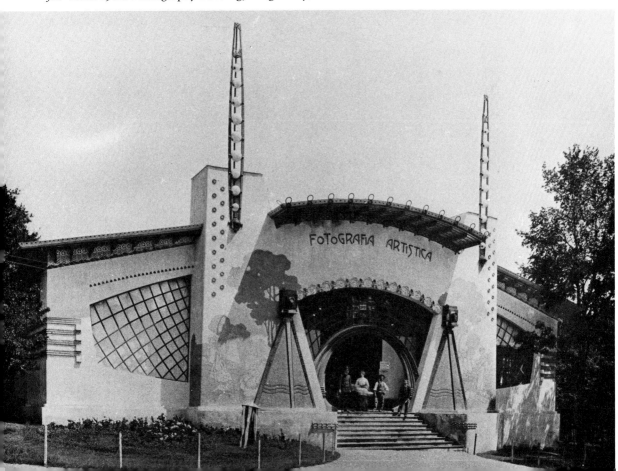

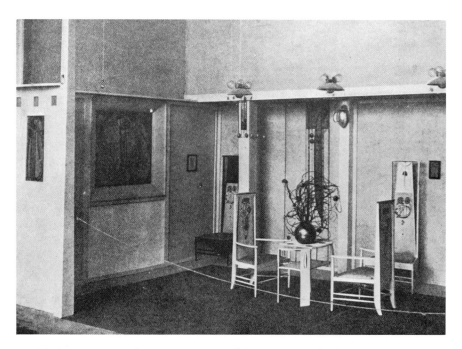

59. Turin 1902: Scottish section, portion of the "Rose Boudoir" designed by C. R. Mackintosh and Margaut M. Mackintosh.

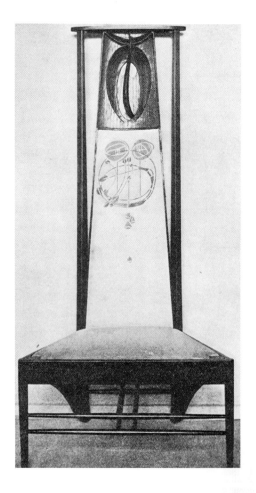

60. Turin 1902: Scottish section, chair designed by C. R. Mackintosh.

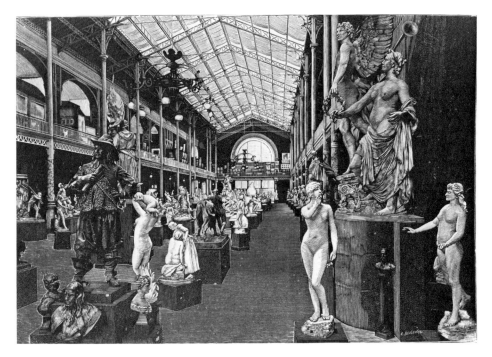

61. Paris 1876: Grand Palais des Beaux-Arts, sculpture section (Musée d'Orsay).

62. Paris, Salon of 1861: Grand Hall of the Palais de l'Industrie (Musée d'Orsay).

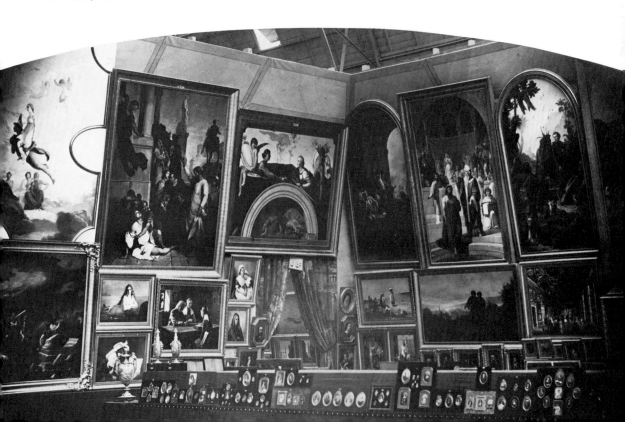

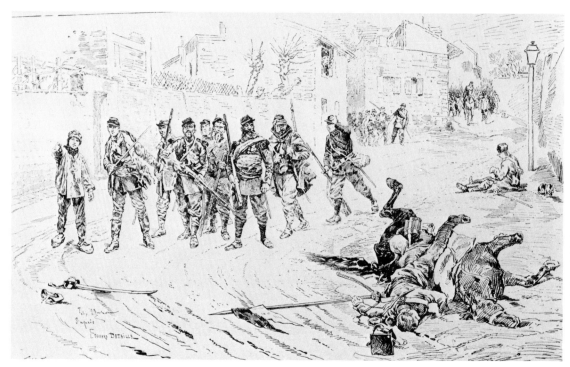

63. Paris 1876: Edouard Detaille, *En Reconnaissance*. From illustrated catalogue, Salon of 1876.

64. Paris 1876: Mihály Munkácsy, *In the Artist's Studio*.

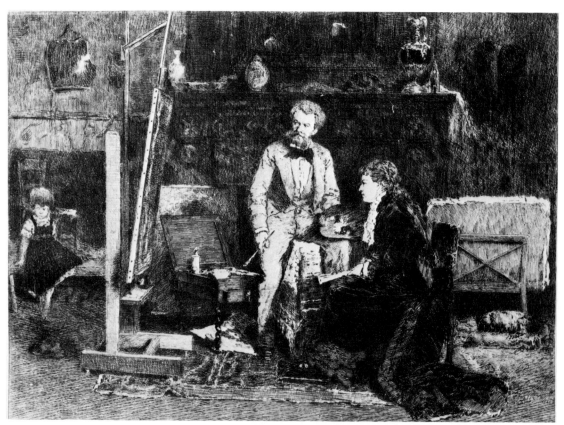

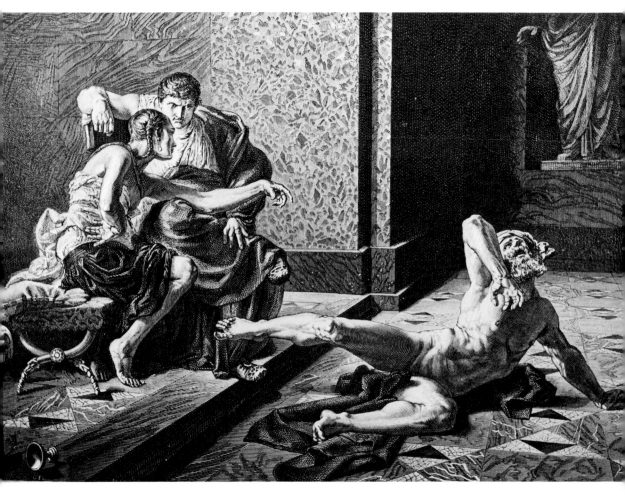

65. Paris 1876: Joseph Noël Sylvestre, *Locust Tries the Poison Prepared for Britannicus in the Presence of Nero.*

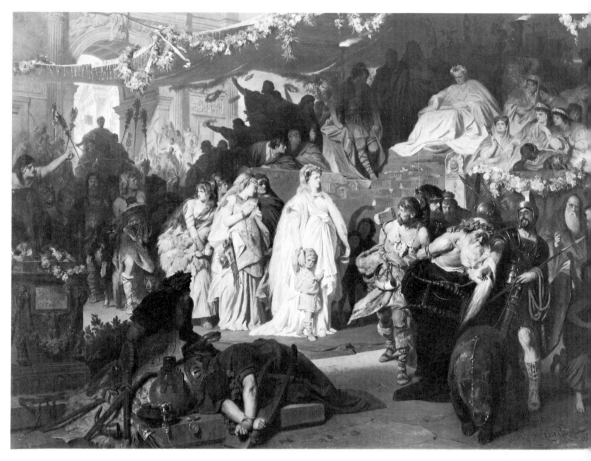

66. Munich 1879: Carl Theodor von Piloty, *Thusnelda at the Triumphal Entry of Germanicus into Rome* (The Metropolitan Museum of Art, Gift of Horace Russell, 1887).

67. Munich 1879: Frederick Lenbach, *Otto von Bismarck*. From *Magazine of Art* 9 (1895–96).

GÉNIE GARDANT LE SECRET DE LA TOMBE. FIGURE DÉCORATIVE.
Dessin de René Legrand d'après le marbre de René de Saint-Marceaux.
(Salon de 1879. — Médaille d'honneur.)

68. Paris 1879: René de Saint-Marceaux,
Genius Guarding the Secret of the Tomb.

69. Paris 1879: Adolphe
William Bourguereau,
The Birth of Venus.
From illustrated
catalogue, Salon
of 1879.

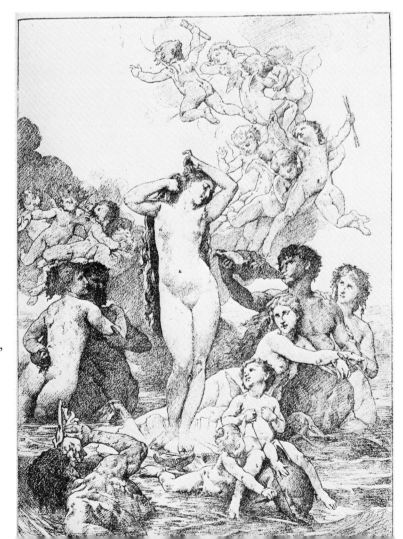

70. Paris 1879: Edouard Detaille, *The Battle of Champigny*, December 1870. From illustrated catalogue, Salon of 1879.

71. Paris 1879: Edouard Manet, *Boating* (sketch). From illustrated catalogue, Salon of 1879.

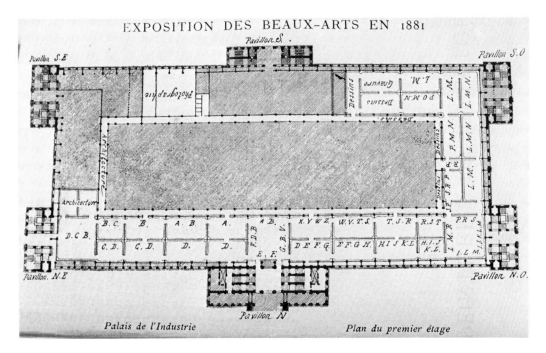

EXPOSITION DES BEAUX-ARTS EN 1881

Palais de l'Industrie *Plan du premier étage*

PLAN 9. Paris 1880: Palais de l'Industrie, plan for first floor.

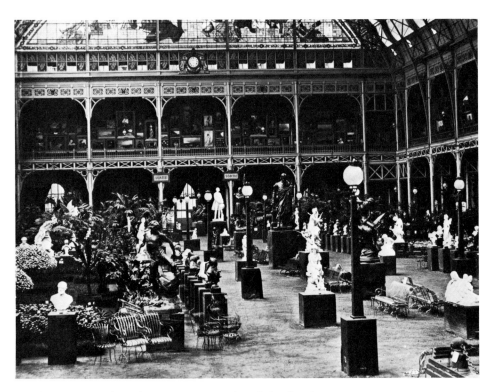

72. Paris 1880: Salon of 1880, interior, Palais de l'Industrie.

73. Paris 1880: Lawrence Alma-Tadema,
*On the Way to the Temple of
Ceres (Spring)*. From illustrated
catalogue, Salon of 1880.

74. Paris 1880: Jean Charles Cazin, *Ishmael*.
From illustrated catalogue, Salon of 1880.

75. Paris 1880: Léon Bonnat, *Job* (Bibliothèque Nationale, Paris).

76. Paris 1880: Pascal Adolphe Jean Dagnan-Bouveret, *An Accident.*
From illustrated catalogue, Salon of 1880.

77. Paris 1880: Hendrick Wilhelm Mesdag, *Return of the Fishermen, Schevening (Holland)*. From illustrated catalogue, Salon of 1880.

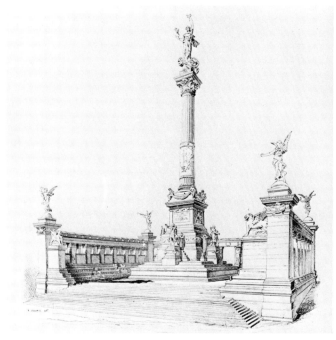

78. Paris 1881: Jean Camille Formigé and Pierre Jean Edmond Castan, *Monument Commemorating the Constitutional National Assembly of 1789 at Versailles*, engraving.

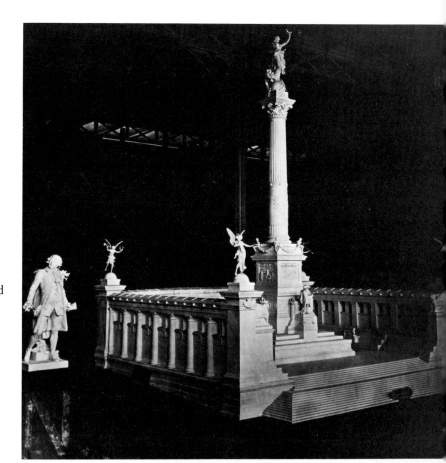

79. Paris 1881: Formigé and Castan monument (Musée d'Orsay).

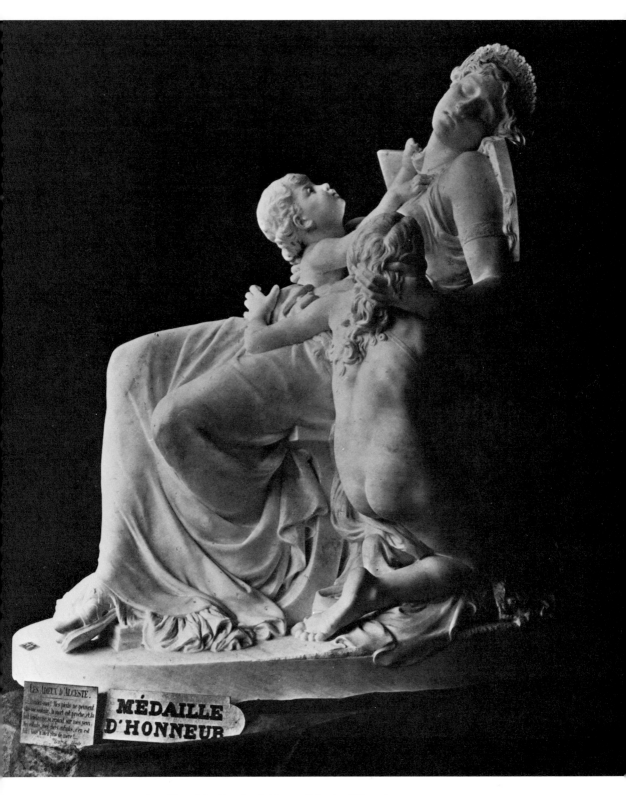

80. Paris 1881: André Allar, *The Death of Alceste* (Musée d'Orsay).

81. Paris 1881: Paul Baudry, *Glorification of the Law*, Salon of 1881, Palais des Champs Elysées (Musée d'Orsay).

82. Paris 1881: Giuseppe de Nittis,
Tuileries (Bibliothèque Nationale, Paris).

83. Paris 1881: Walter
Crane, "King Luckie-
Boy's Party," from
*Walter Crane's Picture
Book V.*

KING LUCKIEBOY sat in his lofty state
His Chancellor by him, [chair,
Attendants, too, nigh him,
For he was expecting some company there.
And Tempus, the footman, to usher them in,
At the drawing-room floor;
And a knock at the door [begin.
Came just at the hour they'd announced to

'T was General Janus, the first to arrive,
In snow-shoes and gaiters,
Escorted by skaters, [drive,
And looking quite blue with the cold of his
See him come in, with his footman Aquarius,
Who presents his Ah-kishes,
That's to say, his best wishes,
A choice of fresh colds, and compliments various

From "Under the Window"

84. Paris 1881: Kate Greenaway, "Five Maidens," from *Under the Window*.

"MARGERY BROWN, on the top of the hill,
Why are you standing, idle still?"
"Oh, I'm looking over to London town;
Shall I see the horsemen if I go down?"

"Margery Brown, on the top of the hill,
Why are you standing, listening still?"
"Oh, I hear the bells of London ring,
And I hear the men and the maidens sing."

"Margery Brown, on the top of the hill,
Why are you standing, waiting still?"
"Oh, a knight is there, but I can't go down,
For the bells ring strangely in London town."

85. Paris 1881: Kate Greenaway,
"Margery Brown," from
Under the Window.

86. Milan 1881: Gaetano Previati, *Christ Crucified*. From illustrated
catalogue, National Exhibition of Industry and Art.

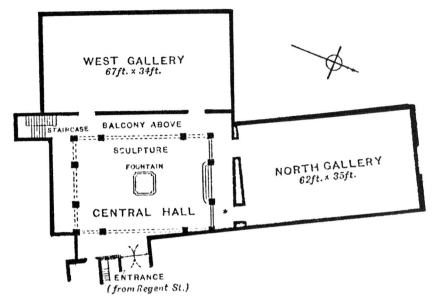

WEST GALLERY
67ft. x 34ft.

STAIRCASE BALCONY ABOVE

SCULPTURE

FOUNTAIN

NORTH GALLERY
62ft. x 35ft.

CENTRAL HALL

ENTRANCE
(from Regent St.)

GROUND PLAN.

PLAN 10. London 1881–82: Grosvenor Gallery, ground-floor plan (*Art in London*, 1881).

87. London 1881–82: "Academy Notes," *Illustrated London News*, April 30, 1881.

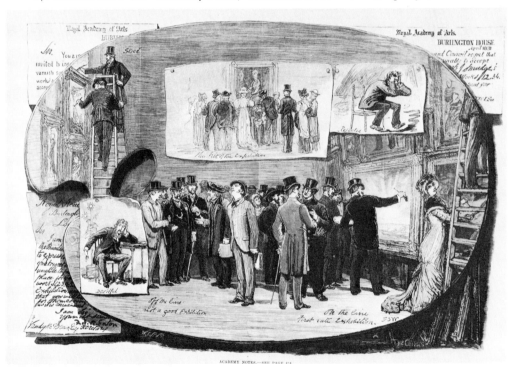

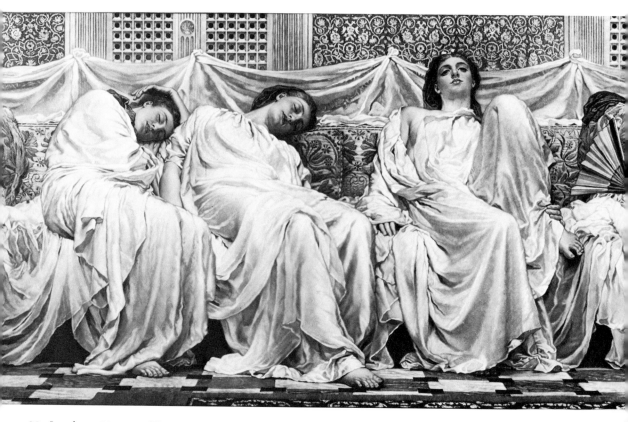

88. London 1881–82: Albert Moore, *The Dreamers*, engraved by J. G. Appleton (Victoria and Albert Museum).

89. London 1881–82: Hubert Herkomer, *Missing*, 1881. From *Magazine of Art*, July 1881.

90. London 1881–82: "Sketches of pictures in the Royal Academy Exhibition," *Illustrated London News*, June 25, 1881.

Elisha Raising the Son of the Shunamite. Sir F. Leighton, P.R.A.

91. London 1881–82: Frederick Leighton, *Elisha Raising the Son of the Shunamite*, from *Illustrated London News*, July 23, 1881.

92. London 1881–82: James Abbott McNeill Whistler, *Arrangement in Flesh-Colour and Black: Portrait of Théodore Duret* (The Metropolitan Museum of Art, Wolf Fund, 1913).

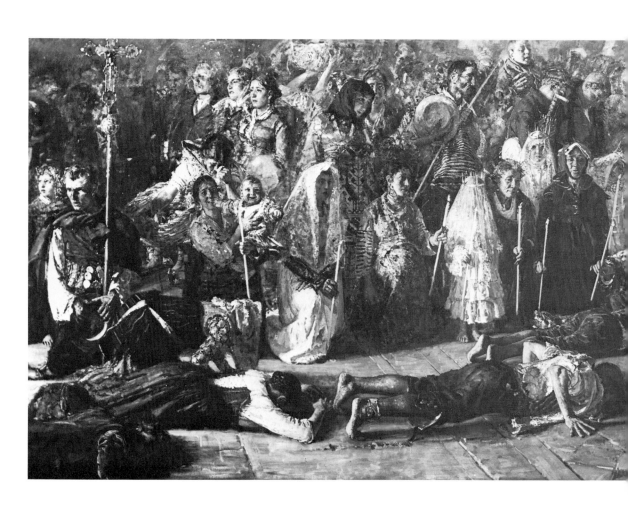

93. Rome 1882–83: Francesco Paolo Michetti, *The Vow*, Gallery of Modern Art, Rome
(Gabinetto Fotografico Nazionale).

94. Rome 1882–83: Edward Burne-Jones, Church of St. Paul, Rome, apse, model (Victoria and Albert Museum, London).

95. Berlin 1883: Adolf Menzel, *Parisian Week-Day*. From *Zeitschrift für bildende Kunst*, 1891.

96. Berlin 1883: Max Klinger, *Fear (A Glove)*, 1881 (Kunsthaus Zürich, Graphische Samm-
lung).

98. Munich 1888: Nino Costa, *Sea Coast, near Ostia, Sirocco Sky*, engraving by Dujardin.
From *The Portfolio*, 1887.

97. Munich 1888: Emmanuel Frémiet, *The Gorilla* (Musée d'Orsay).

99. Munich 1888: Albert Anker, *Civil Marriage*, 1887, heliogravure (Kunsthaus Zürich).

100. Munich 1888: Arnold Böcklin, *Odysseus and Kalypso*, 1883, heliogravure (Photographisches Union, Munich).

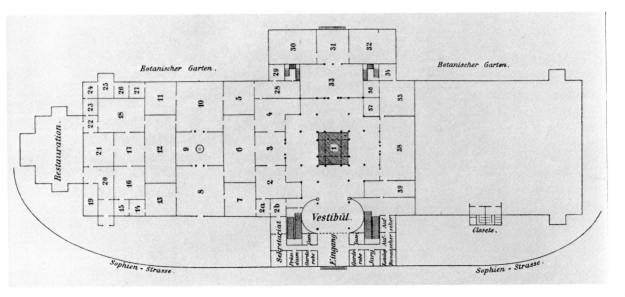

PLAN 11. Munich 1891: The Glaspalast.

101. Munich 1891: Joseph Block, *The Prodigal Son*, engraving, *Zeitschrift für bildende Kunst*, 1891.

102. Munich 1891: Albert Besnard, *Woman Warming Herself,* Musée du Luxembourg (Photo Giraudon).

104. Munich 1891: Karl Hartman, *Children Playing,* from illustrated catalogue, Second Annual Munich Exhibition.

103. Munich 1891: José Benlliure y Cil, *The Posada* (Victoria and Albert Museum, London).

105. Munich 1891: Max Klinger, *Pietà*, 1891, *Zeitschrift für bildende Kunst* 5 (December 1893).

106. Munich 1891: Max Liebermann, *On the Dunes*, from *Die Kunst für Alle 6* (1890–91).

107. Munich 1891: Hendrick Wilhelm Mesdag, *The Old Mill at Tivello*. From illustrated catalogue, Second Annual Munich Exhibition.

108. Munich 1891: Baldasar Schmitt, *Expulsion from Paradise*. From illustrated catalogue, Second Annual Munich Exhibition.

109. Munich 1891: Hans Siemiradski, *With Sympathy and Help*. From *Die Kunst für Alle* 6 (1890–91).

110. Munich 1891: Franz Stuck, *Lucifer*. From illustrated catalogue, Second Annual Munich Exhibition.

111. Munich 1891: Hans von Marées, *The Hesperides, 1884–87* (Bayerische Staats-gemäldesammlungen, Munich).

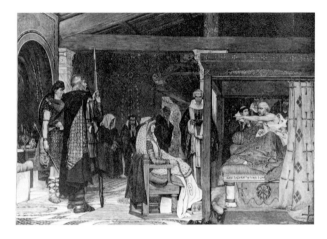

112. Vienna 1894: Lawrence Alma-Tadema, *Fredegonde at the Death Bed of Praetextus* (engraving by Bougt Honemann), from *Illustrated London News* 20 (1894).

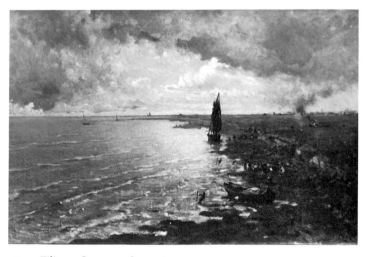

113. Venice 1895: Filippo Carcano, *Seascape, 1910.*

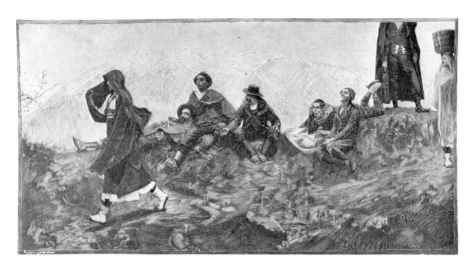

114. Venice 1895: Francesco Paolo Michetti, *Jorio's Daughter*.

115. Venice 1895: Jan Veth, *Adolf Menzel*.
From *Zeitschrift für bildende Kunst*, 1902–03.

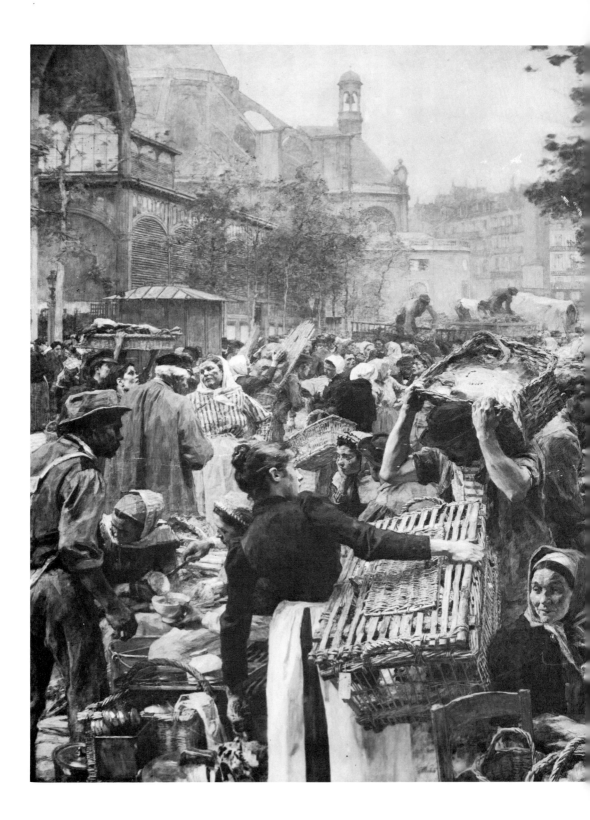

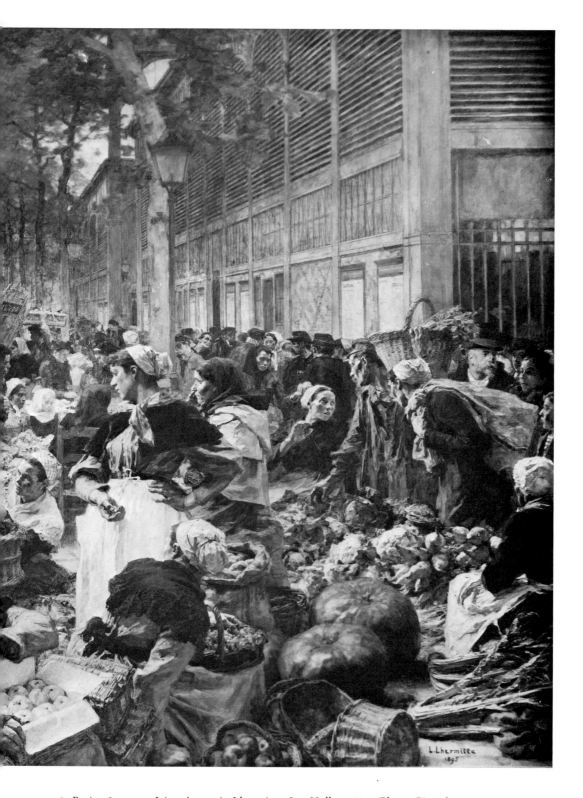

116. Paris 1895–97: Léon Augustin Lhermitte, *Les Halles*, 1895 (Photo Giraudon).

117. Paris 1895–97: Puvis de Chavannes, *Muses Welcoming the Genius of Enlightenment*, detail (Boston Public Library).

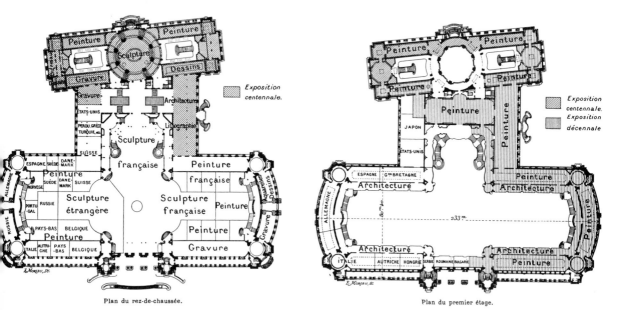

Plan du rez-de-chaussée.

Plan du premier étage.

Aménagement de l'Exposition des Beaux-Arts dans le Grand Palais de l'avenue Nicolas II.

PLAN 12. Paris 1900: Arrangement of the Exposition of Fine Arts, Grand Palais des Beaux-Arts (from *L'Illustration*, 12 May 1900).

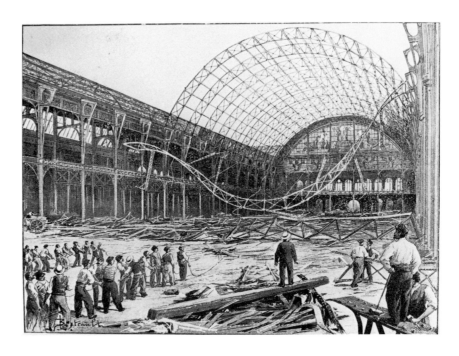

118. Paris 1900: The Demolition of the Palais de l'Industrie, from *L'Illustration*, 14 August 1897.

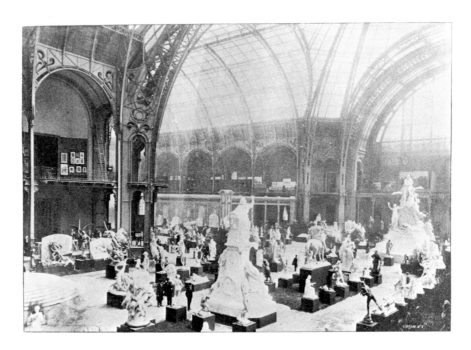

119. Paris 1900: Exhibition of French sculpture at the foot of the grand stairway, Grand Palais des Beaux-Arts.